DUMBARTON OAKS PAPERS

NUMBER SEVENTY-SEVEN

2023

Published by Dumbarton Oaks Research Library and Collection

Trustees for Harvard University

© 2023 Dumbarton Oaks
Trustees for Harvard University
Washington, DC

Printed in the United States of America.

Library of Congress Catalog Card Number 42-6499
ISSN 0070-7546

Editors
Colin M. Whiting
Nikos D. Kontogiannis

Editorial Board
Dimiter Angelov
John Duffy
Ioli Kalavrezou

Copyeditors
Peri Bearman
Alice Falk
Robin Surratt

Design and Production
Kathleen Sparkes

Production Coordinator
Abigail Anderson

Composition
Melissa Tandysh

The annual journal *Dumbarton Oaks Papers* was founded in 1941 for the publication of articles relating to Byzantine civilization—society and culture from roughly the fourth through the fifteenth century in the Roman Empire and in successor and neighboring states. Articles are written normally in English. Preference is given to articles of substantial length—at least 10,000 words, notes inclusive—but shorter pieces will be considered, particularly if they relate to objects in the Dumbarton Oaks collections. Articles should be prepared according to the submission guide, style guide, and list of abbreviations, which are available, along with more information about the journal and the submission process, at www.doaks.org /research/publications/series/dumbarton-oaks-papers.

Current and previous issues may be ordered at www.hup .harvard.edu/. Standing orders may be placed by contacting customer service at 800-405-1619 or customer.care@triliteral.org. Previous volumes of *Dumbarton Oaks Papers* are available in digital form through JSTOR.

Distributed by Harvard University Press

Contents

⋑⋐

Notes and Reports

⋑⋐

Robert W. Thomson during his tenure as Director of Dumbarton Oaks. Photo courtesy Dumbarton Oaks Archives.

Robert William Thomson

1934–2018

TIMOTHY GREENWOOD AND ROBIN DARLING YOUNG

The last sixty years have witnessed a transformation in the field of Armenian studies, as scholars from a wide range of disciplines have come to appreciate and engage with the rich canon of medieval Armenian literature. Although he would have been loath to acknowledge it, Robert William Thomson, fourth Director of Dumbarton Oaks, inaugural Mashtots Professor of Armenian Studies at Harvard University between 1969 and 1992, and Calouste Gulbenkian Professor of Armenian Studies at the University of Oxford between 1992 and 2001, was one of the principal architects behind this transformation. It is primarily as a result of his painstaking research and extraordinary publication record that so many medieval Armenian compositions—historical, theological, exegetical, hagiographical, philosophical, cosmographical—are now available and accessible in English for present and future generations to discover for themselves. While the works themselves will always be open to fresh interpretations and methodologies, his annotated translations and meticulous commentaries will remain at the heart of the field for many generations to come. A complete list of Robert Thomson's publications is available as an online supplement.[1] Thomson died on 20 November 2018 in hospital in Oxford of complications following a stroke sustained eleven days earlier.

Robert Thomson was born in London in 1934 but moved to Bournemouth on the south coast of England following the outbreak of war in 1939 and then to Edinburgh, where he was educated at George Watson's College. He studied Classics at the University of Cambridge, but before embarking on doctoral research, he spent a year at one of the last remaining Greek educational institutions in Istanbul, the Halki Theological School; this was closed in 1971 and remains so today. It was then a seminary with adjoining school and library, in a building on the site of a monastery originally founded by patriarch Photio; there, Thomson was able to meet with a wide variety of people and begin his long-standing association with projects in Turkey. In the course of his time in Istanbul, he climbed up onto the roof of Hagia Sophia, describing the passageway underneath the dome as "terrifying." He also traveled extensively in eastern Turkey. Returning to Cambridge, Thomson began his doctoral research under the supervision of Robert Casey on Syriac, and later Armenian, versions of works associated with Athanasius of Alexandria. He continued to visit Turkey during summer vacations and assisted in cleaning the frescoes of Hagia Sophia in Trebizond under the direction of David Talbot Rice, then professor of Byzantine art at the University of Edinburgh, whom he had met socially. Trebizond had another role in Robert's career, for it was here, several years later, that he met Giles Constable, quite by chance; as a result of Thomson's fluency in Turkish, they traveled together, visiting the ancient city of Ani and other Armenian sites. Constable, by then professor at Harvard, would in turn serve as the third

1 https://archive.org/details/DOP77_suppl_Greenwood.

Director of Dumbarton Oaks, appointing Thomson as a senior fellow in 1979.

Thomson's visits to Turkey as a doctoral student also proved to be formative in another respect. It was when traveling to Turkey in 1958 that Thomson stopped off in Vienna and first began to study classical Armenian with Father Nerses Akinean in the Armenian Mechitarist monastery. His knowledge of Armenian developed further on his return under the direction of Charles Dowsett, then lecturer in Armenian at the School of Oriental and African Studies in London. It was also at this time that Thomson began to learn Arabic with Edmund Bosworth, who had been appointed in 1957 to a lectureship in Arabic at the University of St Andrews. Thomson's father had accepted a ministerial appointment in the Church of Scotland in St Andrews and moved the family from Edinburgh. Therefore, when Thomson was appointed to a junior fellowship at Dumbarton Oaks in 1960–61 to finish his thesis, his remarkable talent for languages was already apparent.

In Thomson's own telling, that junior fellow year was a pivotal moment. While he was at Dumbarton Oaks, living in the close quarters of the then–Fellows' Building, he had the chance to converse with numerous scholars also resident or visiting there: the director at the time, Ernst Kitzinger, Ihor Ševčenko, Romilly Jenkins, André Grabar, and Milton Anastos. But perhaps most crucially, Sirarpie Der Nersessian, the first professor of Byzantine art and archaeology at Harvard, twice senior fellow at Dumbarton Oaks, and noted Armenian art historian, encouraged him to pursue various Armenian themes; indeed, Thomson later described her as the person who was most influential in his career. Thomson also met regularly with Irfan Shahîd, assisting him with reading passages in Syriac in exchange for reading passages together in Arabic. Toward the end of his fellowship, and with the encouragement of Der Nersessian, Thomson traveled to Harvard. There he met several friends of his former supervisor—Casey had died in 1959—as well as the chair of the Near Eastern Languages Department. At the time, efforts were underway at Harvard to establish a position in Armenian studies with the support and backing of the Armenian community in Cambridge and the Boston area. The chair suggested that Thomson should undertake a year of postgraduate study with Professor Gérard Garitte at the University of Louvain in Belgium, after which he would be appointed to a three-year

instructorship in Armenian at Harvard. It was therefore in these circumstances, before Thomson had yet defended his doctoral thesis, that he was appointed to his first academic position at Harvard. This association would last thirty years.

In 1961, Thomson traveled to Louvain. There he obtained a license in three Christian Oriental languages: Armenian, Arabic, and Georgian. He had intended to offer Syriac but the Syriac instructor knew, through Casey, that Thomson had already mastered Syriac and insisted he take Georgian instead. Thus Thomson acquired another language that proved to be influential in his subsequent research. The other member of Garitte's Armenian and Georgian classes that year was the renowned Bollandist scholar Michel van Esbroeck, and one can only imagine the level of debate during their meetings. The influence of Garitte on both was profound and can be traced in their respective scholarly careers. The following year saw the first fruits of Thomson's scholarship with the publication of two articles, one on an eighth-century Melkite colophon from Edessa, the other a study of the office of *vardapet* in the Armenian Church.[2] The first emerged from his doctoral research into the Syriac Athanasian corpus, the second from sustained engagement with a wide range of Armenian texts. From the very beginning, therefore, Thomson's publications attest his linguistic breadth and scholarly depth and these would characterize his scholarship across the next six decades. In the same year, Thomson married Judith, and each of his books would be dedicated to her, with one exception dedicated to their two children, Jasper and Crispin.

From 1963, Thomson was based at Harvard, initially as instructor in Armenian, and then from 1969 as Mashtots Professor of Armenian Studies. His presence there was the result of a cooperation between the Armenian community of the Boston area and the Center for Middle Eastern Studies at Harvard. The chair was established through the efforts of the Boston-area branch of the National Association for Armenian Studies and Research responding to the suggestion of Richard Frye, then professor of Iranian studies at Harvard, that Armenian studies should be conducted and made public more broadly in the United States

2 "An Eighth-Century Melkite Colophon from Edessa," *JTS* 13.2 (1962): 249–58; "*Vardapet* in the Early Armenian Church," *Muséon* 75 (1962): 367–84.

through the establishment of chairs by the donation of community organizations. Once NAASR had raised sufficient funds, it was possible for Thomson to become its first occupant and devote the majority of his scholarly attention to Armenian studies, concentrating on historiography, literature, and language.

In 1965, the first of four substantial volumes entitled *Athanasiana Syriaca* appeared in the CSCO series; the last was published in 1977.[3] These were the fruits of his doctoral research. Yet as has been noted above, Thomson's research interests had already shifted into the field of Armenian studies. His first period of tenure at Harvard coincided with the publication of several ground-breaking works: his translation and extensive literary analysis of the catechetical *Teaching of Saint Gregory*;[4] Agathangelos's *History of the Armenians*;[5] Moses Khorenats'i's *History of the Armenians*;[6] and Elishe's *History of Vardan and the Armenian War*;[7] and two language primers: *An Introduction to Classical Armenian*;[8] and, with Kevork Bardakjian, *A Textbook of Modern Western Armenian*.[9] If the wonderfully accurate translations and insightful commentaries opened up the works of medieval Armenian historical writing for wider scholarly appreciation, his introductory guides to Classical and Western Armenian answered the need for effective language teaching aids. Countless students will have encountered the mysteries of vocalic alternation through the opening pages of Thomson's *Introduction to Classical Armenian* and it remains the fundamental starting point five decades later.

In the spring term of 1977, at the invitation of another Dumbarton Oaks colleague, Byzantine historian Walter Kaegi, Thomson took up a visiting professorship in Armenian Studies at the University of Chicago. In the Oriental Institute there, he offered an introduction to the ancient Armenian language and an introduction to the study of classical Armenian literature. Since during that time he was also translating Moses Khorenats'i's *History*, he chose to give a public lecture on the topic. That chronicle, cherished in the Armenian community and long believed to date from the fifth century and to be the first history of the Armenian people, Thomson had convincingly demonstrated in its current form to be an eighth-century composition. A vigorous question-and-answer session followed, and Thomson relished the exchange as he expatiated on his conclusions. Graduate students present at the exchange remember Thomson's consummate skill as a lecturer and his evident appreciation of the subsequent discussion.

Thomson was appointed as senior fellow of Dumbarton Oaks for Byzantine Studies in 1979 and renewed his ties with the institution. He helped to convene the spring symposium of 1980 under the title "East of Byzantium: Syria and Armenia." It concentrated upon the history and literature of these adjacent yet distinct regions. The volume of the proceedings, which appeared two years later, contains contributions from the most prominent scholars then active in these disciplines, drawing attention to cultural production in regions variously within and beyond Byzantium and the mutual processes of interaction and exchange.[10] It is recognized as one of the field-changing volumes of the era.

Several years later, Derek Bok, then president of Harvard, invited Thomson to become director of Dumbarton Oaks. He agreed to serve as director for a five-year period and returned in 1984, in succession to Giles Constable. Thomson was an energetic director. He was involved in all the business of the institution, overseeing the three programs and reporting periodically to the president of Harvard, but also planning parties and suggesting music for concerts offered in the Music Room. As director of a well-established Washington institution, he occasionally met as well

3 *Athanasius Syriaca*, vol. 1, *De Incarnatione; Epistula ad Epictetum*, CSCO Scriptores Syri 114, 115 (Leuven, 1965); *Athanasiana Syriaca*, vol. 2, *Homily on Matthew 12, 32; Epistola ad Afros; Tomus ad Antiochenos; Epistola ad Maximum; Epistola ad Adelphium*, CSCO Scriptores Syri 118, 119 (Leuven, 1967); *Athanasiana Syriaca*, vol. 3, *De incarnatione contra Arianos; Contra Apollinarium I; De Cruce et Passione; Quod unus sit Christus; De Incarnatione Dei Verbi; Ad Jovianum*, CSCO Scriptores Syri 142, 143 (Leuven, 1972); *Athanasiana Syriaca*, vol. 4, *Expositio in Psalmos*, CSCO Scriptores Syri 167, 168 (Leuven, 1977).

4 *The Teaching of Saint Gregory: An Early Armenian Catechism*, Harvard Armenian Texts and Studies 3 (Cambridge, MA, 1970).

5 *History of the Armenians* (Albany, NY, 1976).

6 *History of the Armenians*, Harvard Armenian Texts and Studies 4 (Cambridge, MA, 1978).

7 *History of Vardan and the Armenian War*, Harvard Armenian Texts and Studies 5 (Harvard, MA, 1982).

8 *An Introduction to Classical Armenian* (Delmar, NY, 1975).

9 *A Textbook of Modern Western Armenian* (Delmar, NY, 1977).

10 N. G. Garsoïan, T. F. Mathews, and R. W. Thomson, eds., *East of Byzantium: Syria and Armenia in the Formative Period* (Washington, DC, 1982).

with directors of other scholarly institutions and museums in the city. He was interested, by his own account, both in sponsoring the work of individual scholars who sought the quiet and the specialized library of Dumbarton Oaks and also in the more public direction of the institution itself, which had turned from its earlier interest in archaeological investigations to the production of numerous scholarly volumes and, in those years, the *Oxford Dictionary of Byzantium* as well as the wider promotion of Byzantine studies in universities.

Yet Thomson did not cease to be a teacher when he came down from Harvard to be the director of Dumbarton Oaks. Importantly, every year he offered courses in Armenian or Georgian to local students and scholars who wanted to learn those languages. Every Thursday afternoon, in the Study, Thomson taught the languages with blackboard and chalk to those students who wanted to learn them, patiently explaining terms and expressions or diagramming the complex sentences beloved of early Armenian writers. He based his instruction upon his *Introduction*, supplemented with the more detailed works of Hübschmann and Meillet, and as students became more proficient, he would assign long texts for translation and reading in class. As he said in a different context, he was "no revolutionary" when it came to language instruction. He taught Armenian as a philologist, and encouraged his students to lay a solid foundation of grammar and vocabulary before setting sail into the waters of classical Armenian texts. There seemed to be no grammatical construction or Armenian expression he did not know, and he would gladly expatiate upon them all in a simultaneously crisp, businesslike, and generous manner. Any question proposed to him in class would yield an answer that was both clear and detailed. He welcomed consultation in his office nearby—an office that was itself a library, the shelves of which revealed a lifetime of collecting and arranging the books and periodicals crucial for his research. If a particular study was proposed to him by a younger scholar, he would answer, "There! Now you have your project!" Numerous students came from the Catholic University of America, and in particular from the Department of Semitic Languages and Literature; some of these students went on themselves to pursue careers that would either be focused upon or otherwise include the study of the Armenian language and its texts.

At the same time, even while directing operations at Dumbarton Oaks, Thomson continued his scholarship at his customary speed, attending conferences, publishing regularly and evidently beginning new work that was published after he returned to Harvard. Along with articles, he also worked on the Armenian translation of the works of Dionysius the Areopagite, in two volumes, and the *History* of Thomas Artsruni both of which were published while he was director, and had already started translating the historical works by Vardan Arewelts'i, the Anonymous Storyteller, and Lazar P'arpets'i, all of which appeared shortly after he concluded his tenure at Dumbarton Oaks.[11] It remains unclear where Thomson found the time to serve as Director, teach the language and conduct his own research but his own reminiscence of walking in the grounds before the gardeners had arrived implies a regime of very early mornings.

In 1992, Thomson returned to England, having accepted the position of Calouste Gulbenkian Professor of Armenian Studies at the University of Oxford, in succession to Dowsett. He held this position until his retirement in 2001. In addition to serving as Chair of the Faculty, Thomson continued to teach Classical Armenian and Georgian, both to students admitted onto dedicated Master's programs and those who wished to learn the languages. The style of teaching remained the same: careful explanation, increasing sophistication and then long passages to be read aloud, followed by translation and comment on individual points of grammar, now using a whiteboard and marker pen. In the meantime, he maintained his remarkable rhythm of publication. If any pattern can be detected in these years, it is a broadening of his vision of enquiry. On the one hand, he published a much-valued translation of *The Armenian History Attributed to Sebēos*, with accompanying historical commentary by James Howard-Johnston;[12] the significance of this work for the study of the first half of the seventh century, the emergence of Islam, and the Arab-Islamic conquests is now firmly established. He also translated the Georgian Chronicles, both in their original form (in Georgian)

11 *The Armenian Version of the Works Attributed to Dionysius the Areopagite*, CSCSO Scriptores Armeniaci 17, 18 (Leuven, 1987); *History of the House of the Artsrunik'*, Byzantine Texts in Translation (Detroit, 1985); "The Historical Compilation of Vardan Arewelc'i," *DOP* 43 (1989): 125–226 "The Anonymous Story-Teller (Also Known as 'Pseudo-Šapuh')," *Revue des Études Arméniennes* 21 (1988/89): 171–232; *The History of Łazar P'arpec'i* (Atlanta, 1991).

12 *The Armenian History Attributed to Sebēos*, TTH 31 (Liverpool, 1999).

and in an adapted version (in Armenian).[13] On the other hand, he produced an edition and translation of the Syriac version of the *Hexaemeron* by Basil of Caesarea,[14] and this would be followed by a translation of the Armenian version.[15] A third strand of research comprised a renewed engagement with homiletic and exegetical texts, although at this stage it was largely confined to articles. And in a further invaluable contribution to Armenian studies, in 1995 he published *A Bibliography of Classical Armenian Literature to 1500 AD*; together with its 2007 supplement, this constitutes the first point of reference for the study of any pre-modern Armenian work, whether translation or original composition.[16] This was generated from his own systematic card catalogue that he continued to update throughout his career.

Retirement brought no let-up in the pace of publication. Thomson remarked that the only thing that changed on retirement was that he could now read the morning papers at a more leisurely pace. The decade following his retirement saw a gradual reorientation away from historical literature and toward exegetical and homiletic material. His translations of the Armenian adaptation of the *Ecclesiastical History* of Socrates Scholasticus and the Armenian versions of the *Life of Sylvester* would be the final new historical translations,[17] although he returned to his first publications and produced revised editions of the *Teaching of Saint Gregory* and Moses Khorenats'i's *History*.[18] When revisiting Agathangelos's *History*, however, Thomson did far more than prepare a revised edition. *The Lives of Saint Gregory* offers an extended study of the subsequent

development of this composition across different versions in multiple languages and then supplies intercalated translations of the Armenian, Greek, Arabic, and Syriac versions.[19] One suspects that only Thomson was capable of producing this volume. He drew upon the important contributions of Garitte and van Esbroeck for the study of this complex body of traditions, and although he does not say as much, in many ways this volume stands as a testament to their shared language classes almost fifty years before.

In 2000, Thomson had published *A Homily on the Passion of Christ Attributed to Elishe*,[20] and this marked a renewed engagement with Armenian homiletic and especially exegetical works. In 2005, his edition, translation, and study of the ninth-century Hamam's *Commentary on the Book of Proverbs* appeared,[21] followed shortly after by his translation and study of Nersēs of Lambron's *Commentary on the Revelation of Saint John*[22] and the ninth-century Nonnus of Nisibis's *Commentary on the Gospel of Saint John*.[23] An edition, translation, and commentary of Nersēs of Lambron's little-studied *Commentary on the Dormition of Saint John* appeared in 2017.[24] By this time, Thomson had already been working for several years on Vardan Arewelts'i's vast *Commentary on the Psalms* and this research was approaching its conclusion at the time of his death; he sent a copy to the series' editor for comment on 6 November 2018, just three days before his stroke. Thomson always intended this would be his last major work; in correspondence he referred to it as his "chant du cygne"; to his family it was simply his "opus." This is presently in the final stages of preparation. A Biblical commentary prepared by a thirteenth-century

13 *Rewriting Caucasian History: The Medieval Armenian Adaptation of the Georgian Chronicles* (Oxford, 1996).

14 *The Syriac Version of the Hexaemeron by Basil of Caesarea*, CSCO Scriptores Syri 222, 223 (Leuven, 1995).

15 *Saint Basil of Caesarea and Armenian Cosmology: A Study of the Armenian Version of Saint Basil's* Hexaemeron *and Its Influence on Medieval Armenian Views about the Cosmos*, CSCO Subsidia 130 (Leuven, 2012).

16 *A Bibliography of Classical Armenian Literature to 1500 AD* (Turnhout, 1995); "Supplement to *A Bibliography of Classical Armenian Literature to 1500 AD*: Publications 1993–2005," *Muséon* 120 (2007): 163–223.

17 *The Armenian Adaptation of the Ecclesiastical History of Socrates Scholasticus*, Hebrew University Armenian Studies 3 (Leuven, 2001);

18 *The Teaching of Saint Gregory*, rev. ed. (New Rochelle, NY, 2001); *History of the Armenians*, rev. ed. (Ann Arbor, MI, 2006).

19 *The Lives of Saint Gregory: The Armenian, Greek, Arabic, and Syriac Versions of the History Attributed to Agathangelos* (Ann Arbor, MI, 2010); "The Armenian Versions of the Life of Silvester," *Journal of the Society for Armenian Studies* 14 (2005): 55–139.

20 *A Homily on the Passion of Christ Attributed to Elishe*, Eastern Christian Texts in Translation 5 (Leuven, 2000).

21 *Hamam: Commentary on the Book of Proverbs*, Hebrew University Armenian Studies 5 (Leuven, 2005).

22 *Commentary on the Revelation of Saint John*, Hebrew University Armenian Studies 9 (Leuven, 2007).

23 *Commentary on the Gospel of Saint John*, Writings from the Islamic World 1 (Atlanta, 2014).

24 *Nersēs of Lambron: Commentary on the Dormition of Saint John*, University of Pennsylvania Armenian Texts and Studies 1 (Leiden, 2017).

Armenian scholar better known for his historical composition—there could scarcely be a more appropriate choice for Thomson's final scholarly contribution.

Although Thomson usually worked alone, he was always generous in recognizing the contributions of others. He was also willing to collaborate with others. Three of his books were co-authored: with Kevork Bardakjian, *A Textbook of Modern Western Armenian*; with Bridget Kendall, *David the Invincible Philosopher: Definitions and Divisions of Philosophy*;[25] and with James Howard-Johnston, the *History Attributed to Sebēos*. Thomson was also keenly aware of the importance of collective academic institutions for fostering scholarly conversations, connections, and publications. In 1974, alongside Richard Hovannisian, Dickran Kouymjian, Nina Garsoïan, and Avedis Sanjian, he was one of the founder members of the Society for Armenian Studies and served on its board and the editorial board of its journal. He was a patron member of the Association Internationale des Études Arméniennes, serving on its committee and the Conseil Scientifique of the *Revue des Études Arméniennes*. In addition to his service at Dumbarton Oaks, Harvard, and Oxford, and the many conferences he convened or participated in across six decades—invariably accompanied by Judith—Thomson established and perpetuated the institutional framework within which the discipline of Armenian studies operates on both sides of the Atlantic today. It is particularly fitting that at the direction of his family, Thomson's working library should have made a final journey across the Atlantic to a permanent home at the Catholic University of America in Washington, DC, where it will be consulted by future generations of scholars.

Thomson received many distinctions for his contributions to Armenian studies. In 1995 he was elected a fellow of the British Academy. He received the Saint Sahak and Saint Mesrop Medal from the Catholicos of All Armenians, Vazgen I, "for his great service to the scholarly study of the history of the Armenian people." Such honors do not, however, do full justice to his nature. His deep learning was coupled with a sincere interest in, and commitment to, the scholarship of others. This was appreciated by the many colleagues and students from around the world who received a kind word or suggestion for future direction. Although naturally reserved, Thomson very much enjoyed being in company, listening to others and offering his thoughts, not as the world-famous Armenian scholar but as an interested and often amusing colleague, companion, and friend. Over the course of sixty years, Dumbarton Oaks, with its combination of scholarship and sociability, proved to be an ideal location for Robert to pursue his own research and shape the discipline for generations to come. In everything, he was supported by his wife, Judith, who survives him, along with his two sons and two grandchildren.

Timothy Greenwood
Department of Medieval History
University of St Andrews
71 South Street
St Andrews
Fife KY16 9QW
United Kingdom
twg3@st-andrews.ac.uk

Robin Darling Young
The Catholic University of America
School of Theology and Religious
 Studies/Church History
106 Caldwell Hall
620 Michigan Ave. NE
Washington, DC 20064
youngr@cua.edu

25 *David the Invincible Philosopher: Definitions and Divisions of Philosophy. English Translation of the Old Armenian Version with Introduction and Notes*, University of Pennsylvania Armenian Texts and Studies 5 (Chico, CA, 1983).

Cyril Mango at the reception ceremony for *ΑΕΤΟΣ* in 1998. Photo courtesy of Anne McCabe.

Cyril Alexander Mango

1928–2021

ANNE MCCABE AND MICHAEL FEATHERSTONE

At the risk of repeating what has been written elsewhere,[1] we offer here yet another tribute to an extraordinary scholar and teacher.

Adorning the library at Dumbarton Oaks is a pair of life-sized copies in watercolor of images from the mosaics of the Great Palace of the Byzantine emperors. One depicts a young child in a tunic holding an olive branch, the other a leafy tree. They are dated August 1944 through February 1945 and signed with a flourish, "Cyril A. Mango." It was a turbulent moment during World War II, the time of the Dumbarton Oaks Conversations, and Mango, tracing and coloring the mosaics tessera-by-tessera in Istanbul, was then 16 years old. The images are emblematic of Cyril Mango's life-long focus on Byzantium's monuments and of his ability to record and depict them elegantly, precisely, and with deep and affectionate understanding. His death at age 92, on 8 February 2021, has left the field of Byzantine studies bereft of one of its giants.

Another painting, hidden from the gaze of all but closest friends, was produced by Cyril Mango together with his wife, Marlia, and hung for years in their dining room in Brill (Fig. 1). It is a satirical-allegorical depiction, captioned in Byzantine Greek, of life at Dumbarton Oaks in the late 1960s. Under the aegis of a voluptuous Spirit of Mediterranean Culture, denizens of the place disport themselves to the strains of a musical trio, the paradisiac gardens in the background counterbalanced by an insatiable Hades below. Mango depicts himself as a drudge peering myopically at a scroll while shuffling behind Ihor Ševčenko, who, clad as a philosopher in toga and sandals, lifts high a tottering pile of books. Meanwhile, Marlia, in a short green dress, balances on a low rung of the "Worldly Ladder" supporting a pushy crowd clambering above her to reach for the golden largesse being showered by Dumbarton Oaks foundress Mildred Bliss. She, in turn, floats aloft on a cloud, as does long-time director of Dumbarton Oaks Jack Thacher, who, garbed in mauve drapery, flourishes a long cigarette-holder and puffs out a black demon. Meanwhile a militant "Spirit of Culture (*Paideia*)" decapitates the "Spirit of Teaching (*Didaskalia*)" with a sword while the "Demon of Yawning" loiters sleepily nearby.

Arriving at the Dumbarton Oaks Research Library and Collection barely a decade after its creation, Cyril Mango found something that existed in few places at the time, namely, a community of illustrious cosmopolitan fellows and visitors all focused on Byzantine studies, a superb library, and a supportive environment with few restrictions—not to mention

1 B. Pitarakis for the Istanbul Research Center: https://blog.iae .org.tr/en/genel-en/cyril-a-mango-an-englishman-in-istanbul-2; M. Georgopoulou for the American School of Classical Studies at Athens: https://www.ascsa.edu.gr/news/newsDetails/obituary -for-cyril-mango; W. Saunders for the *Guardian*: https://www .theguardian.com/books/2021/mar/23/cyril-mango-obituary; B. Ward-Perkins for the *Telegraph*: https://www.telegraph.co.uk/obituaries /2021/02/22/cyril-mango-revered-authority-byzantine-empire -obituary/.

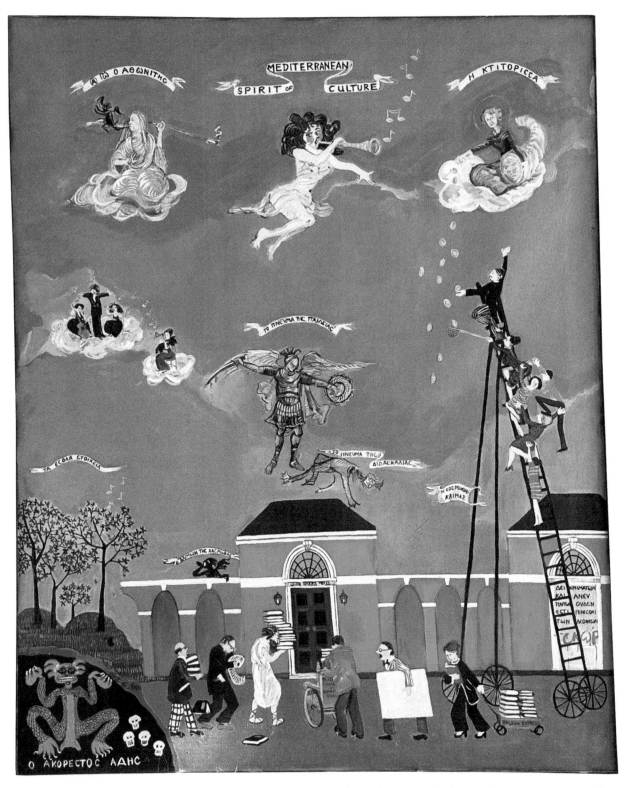

Fig. 1. Cyril and Marlia Mango, satirical-allegorical painting of Dumbarton Oaks, late 1960s. Photo courtesy of Marlia Mango.

the swimming pool. He stayed for nearly twenty years. The list of positions he held reads like a *kletorologion*, from junior fellow 1951–53 to fellow 1953–54, research associate 1954–55, instructor in Byzantine archaeology 1955–58, lecturer in Byzantine archaeology 1958–62, assistant professor of Byzantine archaeology 1962–63, member of the Board of Scholars of Byzantine Studies 1967–72, professor of Byzantine archaeology and director of fieldwork in 1968, and member of the research staff 1972–73. Mrs. Bliss, who in those early days still presided over afternoon tea, could certainly feel that she had gotten her money's worth. On behalf of Dumbarton Oaks, Mango made spectacular discoveries one after the other, published them in this journal, edited Greek texts, organized conferences, assembled sourcebooks, worked on restoration, excavation, and survey projects, and helped shape the character and august reputation of the institution.

Cyril Mango was laconic and reserved, and almost never spoke about himself. But in the preface to his *Studies on Constantinople*, for once he was more forthcoming: "My lifelong preoccupation with Byzantine Constantinople is not unconnected with the fact that I grew up in that city and was captivated at an early age by its mystery."[2] Late in life, he and his two brothers each reminisced, in interviews or private memoirs, about their early years.[3] If their recollections sound like the stuff of a novel, it is worth noting that the Mango household of the previous generation had provided the inspiration for Maria Iordanidou's *Loxandra* (Athens, 1963), the classic depiction of Greek society in Constantinople at the turn of the century. The literary dimension is of course enhanced by the fact that it was a paradise lost. Not only did Cyril Mango depart Istanbul after the war's end in 1945 to live abroad for the rest of his life—though returning frequently to visit—but the city he knew as a boy was irretrievably effaced by social and political change as well as by the destruction of the old urban fabric and surrounding landscapes.

The Mango family was originally from the Greek island of Chios, no doubt of Genoese descent given their Italian surname. Cyril's great-great-grandfather Capetan Andoni had escaped the massacre immortalized by Delacroix, relocating with his family initially to Syros and thence to Constantinople. Andoni's son Dimitri ran the Catholic printing press of St. Benoît in Pera. With his first wife, Carolina Calavassi, a Frankish Catholic from Syros, Dimitri had five children. His second marriage was to Roxana Melidi (the Loxandra of the novel); they lived at Balıklı outside the city walls and then moved to Tatavla (Kurtuluş).

Dimitri and Carolina's eldest son, Anthony Mango, Cyril's grandfather, started a business importing coal from Cardiff and Newcastle to fueling stations along the shipping routes from Hamburg to Novorossiysk. His companies were called Foscolo, Mango & Co., Mango, Doresa & Co. (based in London), and Mango, Sons & Co. (with an office in Piraeus), and they became prosperous. Anthony converted to Greek Orthodoxy and married Evangeline Margariti, whose family had come from northern Epirus to Istanbul. Together they had five sons; the youngest, Alexander, Cyril's father, studied law at Trinity College, Cambridge, became a British citizen, and practiced maritime law at the British consular court. Alexander caused the family some consternation by marrying a Russian refugee. Adelaide Damonova had grown up on the shores of the Caspian Sea, where her father worked as an engineer in the oil fields of Baku. Both her parents came from families of grain merchants, her father from Tambov and her mother from Nezhin in the neighboring Ukrainian province of Chernigov. After losing both her parents at a young age, Ada had fled the Bolshevik Revolution alone, traveling by train to Batum and by sea to Constantinople. It was there that she met her husband—their sons suspected that it might have been in one of the Russian nightclubs that were popular at the time with refugees and residents alike. Alexander and Ada had three boys, Antony (b. 1924), Andrew (b. 1926), and Cyril.

The youngest of Alexander and Ada's three sons, Cyril Mango was born on 14 April 1928, two years before the name of Constantinople was officially changed to Istanbul. His first years were spent at his paternal grandmother's house in Beyoğlu, on Topçekenler Sokak, across the street from the Greek Literary Society of Constantinople (Ἐν Κωνσταντινουπόλει Ἑλληνικός

2 *Studies on Constantinople* (Ashgate, 1993), ix.

3 David Barchard, "The Brothers Mango," *Cornucopia* 19 (1999), 18–20; Antony Mango, unpublished family memoir (2007); Andrew Mango, interview with Levantine Heritage Society: http://www.levantine heritage.com/testi25.htm; Cyril Mango, interview with Claudia Rapp and Vincenzo Ruggieri (2009); interview with Anna Bonnell-Freidin for Dumbarton Oaks (2009): https://www.doaks.org/research/library-archives/dumbarton-oaks-archives/historical-records/oral-history-project/cyril-mango-and-marlia-mundell-mango.

Φιλολογικός Σύλλογος), of which his grandfather had been a member. Cyril spoke Greek and English with his father and Russian with his mother, while the common language of his parents was French. The boys had Russian nannies and chattered in Russian among themselves. They were tutored at home by a Tsarist military officer, Alexander Nassonoff (for math and Russian), as well as by Madame Lucienne, a Lebanese lady (for French grammar) and a Greek, Mrs. Photiades (for *Katharevousa*). Though devout, the family went to church only during Easter week, either the Russian church of St. Andrew on Mumhane Caddesi or a Greek one nearby.

Every June the entire household, including retainers and cats, would decamp to the island of Prinkipo, only returning in September. It was idyllic for the young brothers, pelting one another with fruit in the statue-filled garden of the family summer house and making daily trips to the beach in a horse-drawn carriage with their mother, who loved to swim. At the time, the waters of the Marmara Sea were still crystal clear. The bathing establishment, another fashion imported by White Russians, was run by their tutor, Mr. Nassonoff. Cyril would often go for walks with his nanny to cemeteries to sketch tombstones and cypress trees in watercolor. It was on the island that Cyril first became enchanted by the Byzantine past—despite landing in the local police station as a consequence of exploring the ruined monastery of the empress Eirene. There was also the fascinating living Byzantine tradition at the Monastery of St. George, with pilgrims ascending barefoot to the church, where madmen were once chained up to be healed. The history of the island was brought to life, full of mystery, romanticism, and intrigue, by Gustave Schlumberger's *Les îles des princes* (Paris, 1884), the first (and only) Byzantine book encountered by Cyril among the French novels and classical texts of his father's library.

The boys were not sent to boarding school in England as their father had been, but attended the English High School for Boys in Nişantaşı. Finances became curtailed by increasing restrictions on minorities and by the decline in shipping following the Bolshevik takeover and the outbreak of World War II. Cyril began school at the age of twelve; his classmates were British, Jewish, and Maltese. A few years later, while still a schoolboy, he began to explore the city, taking the tram with a friend across the Galata Bridge,

through the old city, and along the ancient walls. At that time Istanbul had not outgrown itself, and the late Ottoman city with its tortuous streets was still substantially intact, not yet rent apart by the great boulevards of the 1950s and 60s or the metastatic development projects of more recent years.

Cyril's interest in antiquity was fostered by the principal of the school, a Scotsman named Iain C. G. Campbell, who had studied medieval history at St Andrews and had come to Istanbul to work on the Great Palace excavations in 1935. Another important influence was Ernest Mamboury, the Swiss scholar who taught at the Galatasaray Lycée while keeping an eye on everything of archaeological interest happening in town, from the Palace to investigations at the Column of Constantine and digging for the installation of sewers. Mamboury recognized Cyril's kindred spirit, later bequeathing him sketch plans and notes made on site and drawings of inscriptions, which offered a model to emulate. There was also the Greek Miltiadis Isaak Nomidis, proprietor of the Librairie de Péra, who was passionate about the topography of the city and had recently produced a plan of the land walls of Constantinople with the Byzantine inscriptions drawn in detail. After finishing high school at age sixteen, and with the war still on, Cyril went to work for the British Council, helping with publications and exhibitions. There he met distinguished expatriates, including Steven Runciman, with whom he continued explorations in the city and farther afield. The paintings of the Great Palace mosaics, made for an exhibition that was never held, date from this period.

Once the war had ended in 1945, encouraged by Iain Campbell, Cyril left Turkey for the first time to study at St Andrews, where he took a degree in Classics in 1949. The subject was taught in a dry, old-fashioned way through prose and verse composition—for example, by having to translate into Greek the lead article of *The Scotsman*—but larger-than-life figures such as H. J. Rose and D'Arcy Wentworth Thompson made an impression. During vacations, Cyril visited his brother Andrew in London, where he made use of the British Library and University of London libraries, which had more Byzantine material than was available at St Andrews. The fruits of these vacations were precocious articles on the *euripos* of the hippodrome, Byzantine brickstamps, and the Byzantine inscriptions of Constantinople, publications which earned him a

scholarship from the French government for a year's study in Paris. Byzantine studies had not yet taken off in Paris, although André Grabar held a seminar and Thomas Whittemore's Bibliothèque byzantine welcomed readers; certainly Mango maintained he was an autodidact and did not learn much from his supervisor, Rodolphe Guilland. His doctoral thesis, submitted in 1953, was on the Chalkê (or Bronze) Gate of the imperial palace, published as *The Brazen House* in 1959.

It was a friend from those Paris days, James Breckenridge, who told Cyril Mango about Dumbarton Oaks and fortuitously encouraged him to apply. At the time, under the direction of Jack Thacher, Bert Friend, and Royall Tyler, scholarly work at the institution was focused on the history of art, acquiring beautiful objects for the collection, and restoring the finest monuments. Some projects were theoretical in nature, such as attempts to recreate the form of the lost Church of the Holy Apostles and the Nea Ekklesia. But there were also more tangible projects in Istanbul inherited by Dumbarton Oaks from Thomas Whittemore's Byzantine Institute, which permitted Mango to return every summer to Turkey and to work with people of practical skills and mindset—the likes of architects Paul Underwood, Robert Van Nice, and Richard Anderson, and the restorer Ernest Hawkins—in contrast to the "men of ideas" in Washington. Fieldwork included restoration of the mosaics of St. Sophia, of the frescoes and mosaics of the monastery of Christ in Chora, of the monastery of the Virgin Pammakaristos, and of the Monastery of Constantine Lips, with publications by Mango in this journal and the Dumbarton Oaks Studies series.

The stimulating atmosphere of Dumbarton Oaks was enriched by fellows and visitors such as Alexander Vasiliev, Georg Ostrogorsky, and André Grabar. It was there that Mango met Ihor Ševčenko, an emigré of Ukrainian origin with a comparable gift for languages and scholarly acumen who became a lifelong friend. It was also at Dumbarton Oaks that Cyril met art historian Marlia Mundell, who was to become his wife, indefatigable travel companion, and partner in many projects from Oxford to Mesopotamia and Syria.

Mango left Dumbarton Oaks in 1963 to take up the Koraës chair at King's College London, succeeding Romilly Jenkins. His inaugural lecture on "Byzantinism and Romantic Hellenism" took up themes treated by Jenkins and humorously contrasted what one might call the the guiding ideologies of Byzantium and modern Greece, but elicited the ire of some who felt he was questioning the unbroken unity of Hellenism. He did not warm to London, where he had no teaching duties and was bored—he later also recalled that his house in Kensington still had outdoor plumbing. After five years he returned to Dumbarton Oaks, invited back with a letter signed by all the staff.

Returning to the institution in 1968, Mango was appointed professor of Byzantine archaeology and director of fieldwork. This period has been described by Giles Constable as "the golden age of field work at Dumbarton Oaks,"[4] and encompassed Mango's projects at the monasteries of St. Neophytos and of St. Chrysostom at Koutsovendis in Cyprus, his work in Istanbul, Bithynia, and eastern Thrace for the Corpus of Dated Byzantine Inscriptions, and even a season of excavations at Bargala in Macedonia. From a base at the Dumbarton Oaks apartment in the Cihangir district in Istanbul, Mango traveled throughout Turkey, often in the company of Ševčenko and their friend Nezih Fıratlı, director of the Istanbul Archaeological Museum, from Ainos/Enez in the north to Nisibis/Nusaybin in the south, examining inscriptions, monuments, and landscapes. Inscriptions, combining text and object, were an early love of Mango's—he had published a bibliographical survey of the Byzantine inscriptions of Constantinople at age 22—but Ševčenko proved a top-notch collaborator, helping to climb ladders and walls, take measurements and photographs for the catalogue, and wrest every possible type of information from the stone for their commentaries. Together Mango and Ševčenko made and published thrilling discoveries such as the lost church of St. Polyeuktos, built by Anicia Juliana in the sixth century, identified from two blocks of marble unearthed in construction, beautifully carved in high relief with peacocks and grapevines and fragments of hexameter verses preserved in the Palatine Anthology—a discovery that led to many seasons of excavation carried out by Martin Harrison and sponsored by Dumbarton Oaks with the Istanbul Archaeological Museum. There were other discoveries more humble but no less fascinating, such as the ruined monastery of Megas Agros on the south shore of the Sea of Marmara, the seat of Theophanes Confessor and important in the development of middle-Byzantine

4 "Dumbarton Oaks and Byzantine Field Work," *DOP* 37 (1983): 171–76, at 172.

church architecture; or the illiterately inscribed tomb-stone of the ninth-century high imperial official Sisinnios, revealed late at night in a vegetable garden on the north shore of the Marmara and photographed under Land Rover headlights, which provided an excellent raking light. Manuscripts, also combining text and archaeological object, were another shared interest, and Mango and Ševčenko jointly organized a colloquium at Dumbarton Oaks on Byzantine Books and Bookmen in 1971, bringing together experts in palaeography, codicology, and manuscript illumination to discuss practicalities from parchment production and price to public and private libraries, palimpsests, florilegia, and repairs. Together they also discovered a new manuscript of the *Book of Ceremonies*, spotting its palimpsest text on a microfilm. But disagreements over the transfer of the Byzantine professorships to Harvard's main campus and over certain museum acquisitions which could jeopardize fieldwork permits meant it soon was time to leave Dumbarton Oaks.

In 1973, Cyril Mango was appointed Bywater and Sotheby Professor of Byzantine and Modern Greek Language and Literature at the University of Oxford, the first Byzantinist to hold that chair. Initially there was a Byzantine Society which met informally, with lectures by Mango, Alan Cameron, Dimitri Obolensky, and Hugh Trevor-Roper attended by members of the wider community and the occasional undergraduate. In 1981 an official University Committee for Byzantine Studies was created, made up of members of the faculties of Modern Languages, Classics, Archaeology, Theology, Oriental Studies, and Modern History. The Committee convened a weekly seminar as well as offering taught master's programs whose curriculum equipped students with general history, art and architecture, historiography and hagiography, auxiliary disciplines (epigraphy, palaeography, sigillography), and special subjects. Seminars were attended by a crowd of eminent scholars working on diverse facets of Byzantine culture—Obolensky, Sebastian Brock, Henry Chadwick, James Howard-Johnston, Jeremy Johns, Robert Thomson, Bryan Ward-Perkins, Kallistos Ware, Nigel Wilson—with students from Greece, Turkey, the Balkans, and the Levant as well as the United Kingdom and United States. Under Mango's leadership Oxford became a pre-eminent center for Byzantine studies and a place where students could receive the training and mentorship that Mango had not benefited from himself.

Perpetually wreathed in clouds of pipe smoke, Mango maintained an imperturbable and Olympian aloofness tempered with irreverent humor. A stern gaze could be admonitory or amused. In teaching he rarely offered criticism or praise, simply setting an example to be followed. Students could not expect to be spoon-fed, but rather to be left alone and challenged with an unspoken "étonne-moi." His lectures, read deliberately and in gravelly tones, had an old-fashioned formality of phrasing; but beneath the polished surface, running throughout, was a strong current of teasing. A lecture entitled "Methodology" held up to the light a series of theoretical frameworks and tossed them into the dustbin one by one. It sounded terribly solemn but was hilarious to anyone who bothered to listen carefully to observations like "Marxism imposed a single method on all fields from archaeology to chicken-breeding. Now that Marxism is dead, scholars still hanker for a single method that will tell them what to do."

For each discipline he conveyed the essential, the big picture: statistics of types of inscriptions which illustrate the demise of the epigraphic habit coinciding with the break in urban life; categories of saints' lives indicating the decline in opportunities for martyrdom after the third century; the continuity of historiography, disguising the existence of a dark age, but also the hundred-year gap; the opacity of most Byzantine texts with respect to contemporary reality (the "distorting mirror" of his Oxford inaugural lecture) as well as the importance of archaeology for filling in the picture. Close readings of texts from beginning to end—a deceptively simple approach—were always placed in the context of manuscript transmission and reception and punctuated with illuminating or entertaining details: a text preserved in a single wine-stained manuscript, a piquant Greek word or phrase, an incident that gives profound insight into everyday life or the author's worldview. In the background there was always the map, the landscape, the archaeological context. The development of Byzantine sigillography was vividly sketched against successive phases of public works in Istanbul, when rebuilding in the wake of fires that destroyed the heart of the old city necessitated the removal of huge quantities of earth, probably including an imperial archive; the earth was dumped by the sea where beachcombers collected lead seals by the thousands on the pebbly shore to be sold by the amateur scholar George Zacos at his shop in the Grand Bazaar.

Cyril Mango had a habit of conjuring people up in a phrase, from St. Ambrose the level-headed civil servant, to Du Cange, who made great contributions without ever going to the East, to Gustave Schlumberger, who resided on the Faubourg Saint-Honoré. It would be imprudent to quote here his one-line annihilations of those who did not live up to his standards, but they remain indelibly engraved in the memory of those who were privy to them. Once he elaborated on the subject for the students at Oxford in a lighthearted talk entitled "Devotees of Byzantium," in which he classified Byzantinists (living and dead) variously as the pious, aesthetes, romantics, those who considered themselves heirs to the empire, and those for whose career choice there was no reasonable explanation.

Mango's approach was described by Ihor Ševčenko as "byzantinologie totale," but we never heard him use this rather pretentious term. Writing in turn about Ševčenko, Mango explained, "Scholarship is not so much the accumulation of ascertainable facts (important as they are) or the use of trendy techniques (more often than not unhelpful) as the application of intelligence and knowledge to making those facts meaningful by establishing connections."[5] Not one for grand narratives of political, military, or economic history, he preferred to focus on puzzles of cultural history. A hallmark of his work is the use or rediscovery of obscure or neglected evidence, whether in manuscripts, old editions, "difficult" languages, or early maps. One may think of the *Parastaseis syntomoi chronikai*, the Acts of the 787 Council, the Life of St. Artemios, the Freshfield Album, the diary of John Covel, drawings by Charles Texier, the Fossati papers, excavation notes by Macridy Bey or Mamboury. Monuments from the mosaics in the apse of the katholikon of St. Catherine's Monastery at Sinai to the church of St. Mary at Vize were interpreted in the light of textual evidence combined with firsthand inspection—a standard method, perhaps, for archaeologists working on Classical Athens, but less so in the field of Byzantine studies, where there is too often a divide between those who work on material culture ("to use the Marxist formulation," as Mango would say) and those who concern themselves with texts. He put

to shame both those scholars who have ready access to monuments and excavations but neglect written sources or wider contexts and those who are content to rehash well-known texts while neglecting what is on the ground. Often, Mango seemed to take a mischievous delight in pointing out, for example, that "The demons are given a more complete psychological portrait than St. Antony"; or that for Nektarios the Cretan, writing his *Epitomē tēs hierokosmikēs Historias* at Sinai in the seventeenth century, the sultans are the legitimate heirs of the emperors; or that the reliefs of the Golden Gate of Constantinople—the object of unsuccessful attempts at purchase or theft by agents of the Levant Company for the Earl of Arundel—are now nearly entirely lost, unlike the Arundel Marbles, which are safe in the Ashmolean Museum: "Advocates of archaeological correctness, take note!" His intent was to provoke not controversy but better understanding.

Cyril and Marlia often spent a month each year in Paris, where he was invited to lecture at the CNRS and Collège de France by André Guillou and Gilbert Dagron. In 1993 he reciprocated by holding the Society for the Promotion of Byzantine Studies Spring Symposium as a Franco-British collaboration in Oxford. At the opening of the symposium, in the neoclassical Taylorian wing of the Ashmolean Museum, Mango, somberly clad in academic gown, gave a tour-de-force lecture on the water supply of Constantinople. Dagron's equally erudite lecture on the fish, fishermen, and fisheries of Constantinople was delivered in the University Museum of Natural History, surrounded by thousands of bottled marine specimens.

Visits to Istanbul were frequent, whether for a tour of imperial caliber for Oxford students (in response to a plea to add field trips to the master's degree programs) or to inspect the excavations of the Theodosian Harbor at Yenikapı, the pottery kilns at Sirkeci, or the parking lot of the Four Seasons hotel, probable site of the Chalkê Gate. The Mangos would stay at the Kalyon Hotel on the site of the Palace of Marina and invite students to join them at the marvelously named old-fashioned fish restaurant Karışma Sen (Don't You Meddle!) on the Marmara shore.

His career at Dumbarton Oaks may have begun with work on the most central and beautiful ecclesiastical monuments of the Byzantine capital, but "What we need," Cyril Mango wrote, "is a systematic investigation of Byzantine cities and villages, of castles and farms, of

5 "Ihor Ševčenko as Byzantinist," in *Okeanos: Essays Presented to Ihor Ševčenko on His Sixtieth Birthday by His Colleagues and Students*, ed. C. Mango and O. Pritsak, Harvard Ukrainian Studies VII (1983), 1–3, at 2.

water-works, roads, and industrial installations in different provinces of the Empire."[6] The Oxford Mission to al-Andarin, directed by his wife, Marlia, put this into practice, with excavations of a late antique bathhouse in a Syrian town together with a survey of water-collecting, water-storage, and irrigation systems and farms in the surrounding countryside. It cannot have been easy for Mango, in his late 70s, to jolt across the desert in a pickup truck at dawn or spend long days in the heat and dust of the excavations. But he savored discoveries of the bath's sophisticated hydraulic engineering and luxurious marble decor (contrasting starkly with the team's spartan living conditions) as well as encounters with familiar post-Ottoman Levantine culture and traditional Bedouin life—although once the appearance of yet another colossal plate of spicy pickled eggplant (a local breakfast specialty) was greeted with "imam bayılmadı" ("the imam did not faint," a reference to a different eggplant dish called in Turkish imam bayıldı, "the imam fainted")!

Cyril Mango's publications, conveniently enumerated in a recent bibliography, speak for themselves;[7] we have no doubt that readers of *Dumbarton Oaks Papers* are well acquainted with them. They range from editions and translations of Greek texts, primarily sources for the so-called dark age and period of recovery (the *Chronicle* of Theophanes Confessor; the *Short History* of Nikephoros, Patriarch of Constantinople; the correspondence of Ignatios the Deacon; the *Homilies* of Photius) to works of synthesis ("Antique Statuary and the Byzantine Beholder"; *Byzantine Literature as a Distorting Mirror*; "The Legend of Leo the Wise") with dozens of archaeological puzzles solved along the way ("St. Michael and Attis"; "The Palace of Marina, the Poet Palladas, and the Bath of Leo VI"; "Ancient Spolia in the Great Palace of Constantinople"; "A Memorial to the Emperor Maurice"; "Sépultures et épitaphes aristocratiques à Byzance"). Some catalogue entries from the Corpus of Dated Byzantine Inscriptions were published individually, along with a survey, "Byzantine Epigraphy (4th to 10th Centuries)." Particularly valuable for students are Mango's distillations of his wide reading and travels into textbooks (*Byzantium: The Empire of the New Rome*; *Byzantine Architecture*; *The Art of the Byzantine Empire 312–1453: Sources and Documents*; the illustrated *Oxford History of Byzantium*). Mango joked about the bulk of the magnificent albums he produced with photographer Ahmet Ertuğ (*Hagia Sophia: A Vision for Empires*; *Chora: The Scroll of Heaven*; *Istanbul: City of Seven Hills*), but their texts may be read with profit by layman and specialist alike.

Although others have followed in his tracks, written at greater length on the same subjects, and even echoed his titles, Mango's publications stand the test of time not simply because of their substantial contributions but also because of their wit, elegance of style, and avoidance of jargon. In contrast to the purple prose that for centuries has been conventional in writing about Byzantium, Mango was resolutely unsentimental when it came to his subject, asking commonsense questions and providing answers based on solid evidence. Nonetheless it is clear that his work was impelled by a deep fascination and affection, that it was "play for mortal stakes." If what initially attracted him to Byzantium was its mystery, certainly in the course of his long career he managed to elucidate many of these mysteries and came to understand and explain the Byzantines on their own terms. One might say he felt at home with Byzantium.

There will be two additions to the bibliography. One is the *Corpus of Dated Inscriptions of Constantinople, Bithynia, and Eastern Thrace*, which presents a dated series with illustrations and commentary, and is intended as an aid for the study of undated inscriptions. Begun by Mango and Ševčenko as a Dumbarton Oaks project, it is being brought to completion by their student Anne McCabe under the auspices of the Centre for the Study of Ancient Documents, Oxford. The other is *Late Roman and Medieval Constantinople: A Study of Urban Transformation, A.D. 195–1204*, commissioned for Oxford University Press in the 1980s by J. K. Cordy, which occupied Mango until the end of his life. Rather than taking the topographical approach, standard since the age of Gyllius, the book treats the development of the city chronologically and thematically. Currently in press under Jonathan Bardill's guidance, it will be (as Ernest Mamboury once described his own excellent guidebook, *Istanbul touristique*), "un ouvrage digne de la grande ville."

A complete list of Cyril Mango's academic honors would render this tribute excessively lengthy, but one may note that he was a fellow of the British Academy

6 *Byzantium: The Empire of the New Rome* (London, 1980), 8.

7 I. Bitha, "Δημοσιεύματα του Cyril A. Mango (14 Απριλίου 1928–8 Φεβρουαρίου 2021)," *Δελτ.Χριστ.Ἀρχ.Ετ.* 43 (2022): 21–30. Publication details for the following works can be found in this publication.

and of the Society of Antiquaries, president of the British Society for the Promotion of Byzantine Studies, honorary president of the Association internationale des études byzantines, foreign corresponding member of the Académie des Inscriptions et Belles Lettres, and honorary member of the Christian Archaeological Society of Athens. His retirement was marked with a Festschrift entitled *Bosphorus*,[8] and his 70th birthday commemorated with a volume entitled *ΑΕΤΟΣ*,[9] a symposium at Dumbarton Oaks on "Constantinople: The Fabric of the City," and a cake in the shape of Buondelmonti's Constantinople offered by Oxford students. His 80th birthday was celebrated by a symposium entitled "Byzantine Athens: Monuments, Excavations, Inscriptions" at the Gennadius Library. At the end of his life, even after a stroke, Mango's memory and acerbic humor remained unimpaired, as did his command of languages. He expressed regret only for the multiplication of bureaucratic impediments to research, the degradation of monuments and landscapes, and the paucity of systematic excavations in Istanbul. We may give the last word to Ihor Ševčenko, who at Harvard seminars would occasionally ask in a rhetorical manner, "Who is the greatest Byzantinist in the world?" We students thought he meant himself. But he would reply, "Cyril Mango."

Cyril Mango is survived by his wife, Marlia, and by his daughters, Cecily and Susan, from previous marriages. He is buried in Oxford, the other Bosporus.

Anne McCabe
Centre for the Study of Ancient
 Documents
Ioannou Centre for Classical and
 Byzantine Studies
Oxford University
67 St. Giles
Oxford OX1 3LU
United Kingdom
anne@agathe.gr

Michael Featherstone
Centre national de la recherche
 scientifique (UMR 8216)
École des hautes études en sciences
 sociales
10 rue Monsieur le Prince
75006 Paris
France
feathers@ehess.fr

8 S. Efthymiadis, C. Rapp, and D. Tsougarakis, eds., *Bosphorus: Essays in Honour of Cyril Mango* (Amsterdam, 1995).

9 I. Ševčenko and I. Hütter, eds., *ΑΕΤΟΣ: Studies in Honour of Cyril Mango Presented to Him on April 14, 1998* (Stuttgart, 1998).

Susan A. Boyd, staff photo, early 1970s. Photo courtesy Dumbarton Oaks Archives.

Susan A. Boyd

1938–2022

JAMES N. CARDER

It is with great sadness that Dumbarton Oaks reports the death on 5 May 2022 of Susan A. Boyd, curator emerita of the Byzantine collection. She died at the age of 84. Born on 13 February 1938 and known as Sue to her friends and colleagues, she was a native and life-long resident of Washington, DC. She attended the Madeira School, a four-year college preparatory school for women in McLean, Virginia, where she graduated in 1956. She received a baccalaureate degree in art history from Smith College in 1960 and a master's degree in art history from the Institute of Fine Arts, New York University, in 1963, where her specialty was medieval art. Her master's thesis was on the Stavelot Triptych at the Morgan Library and Museum.[1] She also studied in Paris at the Sorbonne and the École du Louvre. Besides her professional interests in Byzantine art, art curation, and archaeology, Sue was also passionate about art history generally, classical music, opera and ballet, and traveling abroad.

In addition to being remembered for her forty-plus years of expert guidance of the Dumbarton Oaks Byzantine collection and her scholarly accomplishments, Sue has been celebrated as a compassionate friend and colleague. She personally engaged with scholars who came to Dumbarton Oaks, often inviting them to her home for dinner parties or to outside cultural events. In the interviews of the Oral History

Project at Dumbarton Oaks, many remember that Sue helped to create a special atmosphere of being part of a group that was well taken care of. Cécile Morrisson remembered Sue as a good friend and one of the great assets of Dumbarton Oaks. Similarly, Chris Harrison reminisced about his good working relationship with Sue, calling her a "class act" and stating that her retirement "left a horrible vacuum." Susan Toby Evans thanked Dumbarton Oaks for enabling "yet another memorable friendship" with Sue. Their collegial friendship led to their making a tour of Egypt together. I also frequently socialized and traveled with Sue, enjoying and sharing her interests in European history and culture, classical music and dance, and fine wines and cuisine. Indeed, with the announcement of Sue's death on various social media platforms, many shared their sadness and offered fond memories of the times they had spent in Sue's company.

Sue enjoyed a long career working in the Byzantine collection at Dumbarton Oaks. She was first employed as assistant for the collections in 1962. She was promoted to assistant for the Byzantine collection in 1964, assistant curator in 1966, associate curator in 1975, and, finally, curator in 1979, a position she held until her retirement from Dumbarton Oaks in 2004, when she was named curator emerita of the Byzantine collection. Outside of Dumbarton Oaks, Sue was professionally involved with the Byzantine Studies Conference (later the Byzantine Studies Association of North America, BSANA). She was elected to the United States National

1 Susan A. Boyd, "The Stavelot Triptych" (MA thesis, New York University, Institute of Fine Arts, 1963).

Committee for Byzantine Studies in 1982 and served as a member of the nominating committee. After retirement, she was elected twice to the governing board of BSANA (2005–2008).

Her accomplishments during her tenure at Dumbarton Oaks are many. She was instrumental in several reinstallations of the Byzantine collection, organized numerous special exhibitions, oversaw the acquisition and restoration of important art objects, participated in Dumbarton Oaks–sponsored archaeological projects, helped inaugurate a museum docent program, and served as editor of various Byzantine collection publications. She was an accomplished scholar in her own right and authored well-respected articles and catalogue entries, especially on early Christian liturgical silver plate and early Christian and Byzantine church decoration and wall paintings.

When Sue Boyd arrived at Dumbarton Oaks in November of 1962, the Byzantine collection had been uninstalled due to the construction of the nearby Pre-Columbian Gallery. Her early task was helping Assistant Curator Elizabeth Bland with the reinstallation of the Byzantine collection, which reopened to the public in December 1963. Two years later, she again assisted in the complete rethinking of the installation of that collection, this time due to the acquisition of new travertine display cases that were installed in 1965. In 1977, Sue received a National Museum Act Travel Grant to support her travel and research on Early Christian and Byzantine luxury minor arts in European museums and private collections. One of her largest responsibilities at Dumbarton Oaks involved coordinating the restoration of objects from the so-called Sion Treasure, acquired in 1963. This difficult work was undertaken at Harvard's Fogg Museum Conservation Laboratory between 1978 and 1985.[2] In 1982, Sue and her co-curators established

a docent program at Dumbarton Oaks, and the first docent tours were led in March of that year. In 1986, she oversaw the installation of the first track-lighting system in the Byzantine Gallery. Perhaps her biggest project was her stewardship of the design and construction of the Byzantine Gallery Courtyard addition between 1987 and 1988 in collaboration with designer Stephen Saitas of New York, and the resulting reinstallation and reopening of the Byzantine collection, the latter occurring in November 1989.

Early in her career at Dumbarton Oaks, Sue Boyd became interested in assisting in archaeological fieldwork missions at Byzantine sites. In 1964, A. Douglas Tushingham, who at the time was associate director of the British-Canadian-French Joint Expedition to Jerusalem (Western Hill), invited Sue to briefly join the excavation in order to be trained in archaeological methodology. This led to her participation in several Dumbarton Oaks–sponsored fieldwork research projects. In 1969, she worked at two Cypriot Byzantine monuments: the monastery church of the Panagia Amasgou in Monagri and the monastery of St. John Chrysostomos at Koutsovendis. At both sites, she was tasked with making detailed descriptive notes of the cleaned and restored wall frescoes.[3] The following year (1970) she was at the Byzantine site of Goren Kozjak of Bargala in Macedonia. In 1976, Sue spent five weeks in Kourion, Cyprus, to study and catalogue the marble and champlevé (enamel-inlaid) revetment fragments from an early Christian basilica, a study she would later publish.[4]

In 1979, the Byzantine collection began to sponsor special exhibitions, and Sue Boyd was instrumental

2 Susan A. Boyd, "The Sion Treasure: Status Report," in *Fifth Annual Byzantine Studies Conference: Abstracts of Papers* (Washington, DC, 1979), 6–8. See also Susan A. Boyd, "A 'Metropolitan' Treasure from a Church in the Provinces: An Introduction to the Study of the Sion Treasure," in *Ecclesiastical Silver Plate in Sixth-Century Byzantium: Papers of the Symposium Held May 16–18, 1986, at the Walters Art Gallery, Baltimore, and Dumbarton Oaks, Washington, D.C., Organized by Susan A. Boyd, Marlia Mundell Mango, and Gary Vikan*, ed. Susan A. Boyd and Marlia Mundell Mango (Washington, DC, 1992), 5–38, and Susan A. Boyd, "A Bishop's Gift: Openwork Lamps from the Sion Treasure," in *Argenterie romaine et byzantine: Actes de la table ronde, Paris 11–13 octobre 1983*, ed. Noël Duval and François Baratte (Paris, 1988), 191–209.

3 Susan Boyd, "The Church of the Panagia Amasgou, Monagri, Cyprus, and Its Wallpaintings," *DOP* 28 (1974): 276–349, and Cyril Mango with the collaboration of E. J. W. Hawkins and Susan Boyd, "The Monastery of St. Chrysostomos at Koutsovendis (Cyprus) and Its Wall Paintings: Part I, Description," *DOP* 44 (1990): 63–94.

4 Susan A. Boyd, "A Little-Known Technique of Architectural Sculpture: Champlevé Reliefs from Cyprus," in *JÖB* 32.5 (1982): 313–26; Susan Boyd, "The Decorative Program of the Champlevé Revetment from the Episcopal Basilica at Kourion in Cyprus," in *Actes du XI^e congrès international d'archéologie chrétienne: Lyon, Vienne, Grenoble, Genève, Aoste, 21–28 septembre 1986*), ed. Noël Duval (Rome, 1989), 1821–40; Susan A. Boyd, "Champlevé Production in Early Byzantine Cyprus," in *Medieval Cyprus: Studies in Art, Architecture, and History in Memory of Doula Mouriki*, ed. Nancy Patterson Ševčenko and Christopher Moss (Princeton, NJ, 1999), 49–70; and Susan A. Boyd, "A Note on Some Mythological Reliefs Carved in Champlevé," in *Mélanges Jean-Pierre Sodini* (Paris, 2005), 443–54.

in their conception, installation, and publication, often serving as exhibition curator or cocurator. The first exhibition was "The Chalice of the Abbot Suger" (1 May to 15 May 1979), cosponsored by the National Gallery of Art in Washington, DC, from which the chalice was borrowed. The exhibition was planned in connection with that year's Byzantine symposium on Byzantine Orthodox liturgy. This was followed by "The Sion Silver Treasure: Conservation and Restoration" (25 October 1979 to 2 September 1980), which overlapped with "Gifts from the Byzantine Court" (6 February to 1 June 1980). The latter focused on two recently acquired evangelist portrait pages (BZ.1979.31.1–2) from a Byzantine lectionary that were exhibited with two additional evangelist portrait pages borrowed from the Cleveland Museum of Art. There followed, in quick succession, a string of special exhibitions initiated by Sue Boyd and the Byzantine Collection staff, especially Gary Vikan, who was a research fellow in Byzantine art (1975–1978), associate curator of the Byzantine collection (1979–1981), associate in Byzantine art studies (1981–1983), and senior associate for Byzantine art studies (1983–1985), as well as Stephen Zwirn, who was assistant for the Byzantine collection (1986–1988) and assistant curator of the Byzantine collection (1988–2012). The exhibitions were often organized in conjunction with outside specialists. These included:

- "Questions of Authenticity among the Arts of Byzantium" (7 January to 11 May 1981), a loan exhibition and exhibition catalogue in collaboration with Gary Vikan.[5]
- "Byzantine Pilgrimage Art" (5 May to 5 September 1982), a loan exhibition and exhibition catalogue (revised in 2010) in collaboration with Gary Vikan.
- "Masterpieces of Byzantine Icon Painting" (27 April to 26 June 1983), a loan exhibition with a related publication that focused on the recent Dumbarton Oaks acquisition of the Icon of St. Peter (BZ.1982.2) in collaboration with Kurt Weitzmann. For the first time, this exhibition had a press conference and press preview.
- "Lighting in Early Byzantium" (2 October 1984 to 6 January 1985), a loan exhibition with a related

publication in collaboration with Maria G. Parani and Laskarina Bouras, the first Dumbarton Oaks Museum fellow.

- Four exhibitions specially organized for the 17th International Byzantine Congress, which met in Washington, DC, in August 1986. These included "The Craft of Ivory" (22 October 1985 to 26 January 1986), with a related publication in collaboration with Anthony Cutler, and "The Sion Silver Treasure" (1 April to 9 November 1986).
- "Byzantine Figural Processional Crosses" (23 September 1994 to 29 January 1995), a loan exhibition with a related publication in collaboration with John A. Cotsonis.
- "Byzantine Ceramics: Art and Science" (1 March to 11 June 1995), a loan exhibition.

During Sue's tenure as curator, the Dumbarton Oaks Byzantine collection acquired several important objects. Sue was instrumental in these acquisitions, including their conservation, installation in the galleries, and publication. These acquisitions include a tenth-century ivory of the Archangel Gabriel (BZ.1972.21), a late tenth- to early eleventh-century manuscript (MS 4) of the Gospels of Luke and John (BZ.1974.1), a fourth-century openwork gold bracelet with jeweled clasp (BZ.1975.1), a late fourth-century hexagonal gold pendant set with a medallion of Constantine I (BZ.1975.6.1–2), three jeweled openwork gold necklace fragments (BZ.1975.7), an eleventh-century Evangelist Mark page from a lectionary commissioned by Empress Katherine Komnena (BZ.1979.31.1), a late thirteenth-century icon of St. Peter (BZ.1982.2), a late eleventh- to twelfth-century pair of gold and cloisonné enamel pendants (kolti) with sirens (BZ.1999.13.a–b), and an eleventh- to twelfth-century chain of seven gold and cloisonné enamel medallions (BZ.1999.14).

Sue Boyd recorded two published oral history interviews, one on her tenure as curator (https://www.doaks.org/research/library-archives/dumbarton -oaks-archives/historical-records/oral-history-project/ susan-a-boyd) and another on her involvement with excavation and restoration projects in Istanbul and Cyprus (https://www.doaks.org/research/library -archives/dumbarton-oaks-archives/historical-records/ oral-history-project/susan-boyd-icfa).

jncarder@gmail.com

5 Susan Boyd and Gary Vikan, *Questions of Authenticity among the Arts of Byzantium: Catalogue of an Exhibition Held at Dumbarton Oaks, January 7–May 11, 1981* (Washington, DC, 1981).

Emperor and Archangel

Justinian at Germia

BRIAN CROKE

For his era, the Roman emperor Justinian (r. 527–565) was a very old man when he suddenly died a natural death in the imperial palace at Constantinople in November 565. He was in his eighty-fourth year. For the past thirty-eight years he had been sole emperor. Most of that long period he had spent inside the palace complex. Integral to the court routine were regular journeys in and around the city, mainly processional and in full imperial regalia, on horseback or sitting in a carriage. Almost annually, he journeyed to a nearby summer palace along the Bosporus or out at the Hebdomon (modern Bakırköy). Only twice did he travel as emperor beyond these boundaries of imperial infrastructure and comfort. In 559 Justinian accompanied an expedition sixty-five kilometers outside the city's land walls to Selymbria (modern Silivri), lodging at the imperial palace nearest the Long Walls that protected both the city's arable hinterland and its overland water supply. The aged emperor's morale-boosting presence was required by some urgent reconstruction, following recent earthquake damage and menacing Kutrigur Huns. Then he and his entourage returned promptly to the city with all due ceremony.[1] Justinian's

other, much longer and more challenging imperial journey into Asia Minor in October/November 563 is the subject of this investigation.

Now in his eighties, the emperor undertook a long and uncomfortable return journey to visit the pilgrimage site of the Archangel Michael at the Galatian town of Germia (modern Gümüskonak). Why and how the sedentary Justinian undertook such a relatively arduous journey, at such an advanced age, has never been explained nor has his personal attachment to the Archangel Michael site at Germia. Works devoted to Justinian either ignore the visit altogether or mention it merely in passing.[2] The recent upsurge of research on angels and their veneration in late antiquity and

1 Peter the Patrician, *On the Ceremonies* (J. F. Haldon, ed. and trans., *Constantine Porphyrogenitus: Three Treatises on Imperial Military Expeditions*, CFHB 28 [Vienna, 1990], 139; A. Moffatt and M. Tall, trans., *Constantine Porphyrogennetos: The Book of Ceremonies* [Canberra, 2012], 1:497–98); B. Croke, "Justinian's Constantinople," in *The Cambridge Companion to the Age of Justinian*, ed. M. Maas (Cambridge, 2005), 60–67; and B. Croke, *Roman Emperors in*

Context: Theodosius to Justinian (London, 2021), 253–60. The background details can be found in A. Sarantis, *Justinian's Balkan Wars: Campaigning, Diplomacy, and Development in Illyricum, Thrace and the Northern World, A.D. 527–65* (Prenton, 2016), 336–49.

2 To take only some recent examples, Justinian's expedition to Germia in 563 finds no mention at all in the lengthy and learned study of M. Meier, *Das andere Zeitalter Justinians: Kontingenzerfahrung und Kontingenzbewältigung im 6. Jahrhundert n. Chr.* (Göttingen, 2003), while it is treated cursorily in J. Moorhead, *Justinian* (London, 1994), 172; J. A. S. Evans, *The Age of Justinian: The Circumstances of Imperial Power* (New York, 1996), 272; G. Tate, *Justinien: L'épopée de l'Empire d'Orient* (Paris, 2004), 821; H. Leppin, *Justinian: Das christliche Experiment* (Stuttgart, 2011), 330; and P. Maraval, *Justinien: Le rêve d'un empire chrétien universel* (Paris, 2016), 314. More alert to the significance of the journey and the route is Michael Whitby, *The Wars of Justinian* (Barnsley, 2021), 20.

Byzantium,[3] combined with new archaeological analysis of ruins at the site of Germia itself,[4] has made possible a fuller understanding of this episode. Closer attention to the role of Archangel Michael in Justinian's political calculus, as well as the emperor's long attraction to the archangel's site at Germia, helps explain Justinian's motivation for the lengthy imperial journey, there and back, in 563.

For the Year of the World 6056 (corresponding to AD 563/564), the ninth-century chronicler Theophanes says this:

> Τούτῳ τῷ ἔτει μηνὶ Ὀκτωβρίῳ ἰνδικτιῶνος ιβ΄ ἀπῆλθεν ὁ βασιλεὺς Ἰουστινιανὸς χάριν εὐχῆς ἐν τοῖς Μυριαγγέλλοις ἤγουν ἐν Γερμίοις πόλει τῆς Γαλατίας. (In this year, in October of the twelfth indiction [commencing 1 September 563], the emperor Justinian, in fulfillment of a vow, visited Myriangeloi, otherwise known as Germia, a city in Galatia.)[5]

Although this event is explicitly attested by Theophanes alone, he probably copied it from the original contemporary chronicle of John Malalas (writing in the late 560s) because Theophanes relies on Malalas for so much of his own information on the latter part of the reign of Justinian. There is no reason to think that he did not continue to employ Malalas until 565, when Malalas concluded with the death of Justinian.[6] What Malalas (and Theophanes) are saying here is that it was in fulfillment of a certain vow (χάριν εὐχῆς) that Justinian undertook the longest journey of his long imperial life, deep into Asia Minor. Although Theophanes refers to the place by its sixth-century name of Myriangeloi,[7] the extant and abbreviated text of Malalas (as reflected in Theophanes) fails to say that there is only one reason

3 On angels, see G. Peers, *Subtle Bodies: Representing Angels in Byzantium* (Berkeley, CA, 2001); R. F. Johnson, *Saint Michael the Archangel in Medieval English Legend* (Woodbridge, 2005); R. Cline, *Ancient Angels: Conceptualizing Angeloi in the Roman Empire,* Religions in the Graeco-Roman World 172 (Leiden, 2011); J. C. Arnold, *The Footprints of Michael the Archangel: The Formation and Diffusion of a Saintly Cult, c. 300–c. 800* (New York, 2013); E. Muehlberger, *Angels in Late Ancient Christianity* (New York, 2013); M. Ahuvia, *On My Right Michael, on My Left Gabriel: Angels in Ancient Jewish Culture* (Oakland, CA, 2021); and several contributions in D. Lauritzen, ed., *Inventer les anges de l'Antiquité à Byzance: Conception, représentation, perception* (Paris, 2021).

4 On Germia, see P. Niewöhner, "Germia and Vicinity: Western Galatia during the Roman and Byzantine Period," *Araştırma Sonuçları Toplantısı* 28.1 (2010): 47–66; P. Niewöhner and K. Rheidt, "Die Michaelskirche in Germia (Galatien, Türkei): Ein kaiserlicher Wallfahrtsort und sein provinzielles Umfeld," *AA* 1 (2010): 137–60; P. Niewöhner, "Germia," in *The Archaeology of Byzantine Anatolia: From the End of Late Antiquity until the Coming of the Turks,* ed. P. Niewöhner (New York, 2017), 342–48; and P. Niewöhner, "Healing Springs of Anatolia: St. Michael and the Problem of the Pagan Legacy," in *Life Is Short, Art Long: The Art of Healing in Byzantium; New Perspectives,* ed. B. Pitarakis and G. Tanman (Istanbul, 2018), 97–124.

5 Theophanes, *Chronicle* AM 6056 (C. de Boor, ed., *Theophanis Chronographia,* vol. 1, *Textum graecum continens* [Leipzig, 1883], 240, lines 11–13, and C. Mango and R. Scott, trans., *The Chronicle of Theophanes Confessor: Byzantine and Near East History, AD 284–813* [New York, 1997], 353), noting that "visited" may be too decisive a translation in that Justinian may not have "visited" Germia in October 563 but rather that he set out (or departed) from

Constantinople in that month: that is, taking ἀπῆλθεν at its literal meaning (see LSJ, s.v. ἀπέρχομαι).

6 Unfortunately, the manuscript that provides the backbone of the text of Malalas (Oxford, Bodleian Library, Codex Barrocianus 182) breaks off at the previous year (562/563), but up to this point Theophanes had been following his sixth-century source closely, hence the inclusion of material from Theophanes in the modern edition and translation of Malalas for the years 563–565: John Malalas, *Chronicle* 18.148 (I. Thurn, ed., *Ioannis Malalae Chronographia* [Berlin, 2000], 431; E. Jeffreys, M. Jeffreys, and R. Scott, trans., *The Chronicle of John Malalas* [Melbourne, 1986], 305). The attribution of this section of Theophanes to Malalas has been clarified by E. Jeffreys, "The Transmission of Malalas' Chronicle," in *Studies in John Malalas,* ed. E. Jeffreys, B. Croke, and R. Scott (Sydney, 1990), 245–311, at 258, and explained further in R. Scott, "Writing the Reign of Justinian: Malalas versus Theophanes," in *The Sixth Century: End or Beginning?,* ed. P. Allen and E. Jeffreys (Brisbane, 1996), 20–34 (repr. in R. Scott, *Byzantine Chronicles and the Sixth Century* [Farnham, 2012]); R. Scott, "Narrating Justinian: From Malalas to Manasses," in *Byzantine Narrative: Papers in Honour of Roger Scott,* ed. J. Burke et al. (Melbourne, 2006), 29–46 (repr. in Scott, *Byzantine Chronicles*); and R. Scott, "Theophanes and Early Byzantine History: The First Half of Theophanes' Chronicle," in *Studies in Theophanes,* ed. M. Jankowiak and F. Montinaro (Paris, 2015), 239–60. See also I. Rochow, "Malalas bei Theophanes," *Klio* 65.1–2 (1983): 459–74.

7 The place was called Myriangeloi at least by 553 when it is recorded because its bishop Menas attended the Council of Constantinople: *ACO* 4.1: "de Myriangelis" (6.15, 22.38, 35.9, 41.39, 206.6), "Myriangeli" (228.5). The only other "Myriangeloi" in the province was not a bishopric but a church, located outside the provincial capital of Pessinus (*Vita Theodoris Sykeonis* 101.42 [A.-J. Festugière, ed., *Vie de Théodore de Sykeon,* vol. 1, *Texte grec* (Brussels, 1970), 81]). Another local name for Germia was simply "The Archangels" (*Vita Theodoris Sykeonis* 167.34 [Festugière, *Vie,* 155]). Although Menas is not recorded as representing the absent episcopal metropolis of Pessinus at the council, it is possible that he did so. The reconstruction of the attendees in R. Price, *The Acts of the Council of Constantinople of 553* (Liverpool, 2009), 2:289, n. 9, confuses "Germia" with "Germa."

the octogenarian emperor would ever contemplate such a trip there, namely, to pay homage to the Archangel Michael. Such a conspicuous and unusual absence from the court and capital required a convincing explanation, so it has to be assumed that the "vow" Theophanes (Malalas) mentions was publicly known and affirmed. The Archangel Michael had been solemnly invoked before,[8] but this invocation was to involve the emperor and his entourage in a round trip of some 1,200 kilometers. So, what could have sparked Justinian's vow?

Interpreting Justinian's Vow

Justinian's support and promotion of the cult of Archangel Michael throughout the empire was long manifest. Archangel Michael had always appeared on the emperor's gold solidi coinage and on other imperially sponsored iconography. Numerous shrines and churches were built or refurbished by Justinian to honor the archangel both at Constantinople and throughout the provinces,[9] while his major feasts were now entrenched in the liturgical calendar.[10] Oaths of imperial service were taken in his name, and it was during Justinian's reign that aristocrats came to include "Michael" among their several names.[11] Moreover, Michael had become the *archistrategos*, the guarantor of political stability, orthodoxy, and legitimacy for an emperor.[12] The term archistrategos was applied to Michael from as early as the third century.[13] In the time of Justinian we find it being used by Malalas,[14] as well as on inscriptions at places like Philomelion (modern Akşehir) and Ephesus.[15]

From the outset of Justinian's reign, Michael was already being represented on imperial solidi as the embodiment of an emperor's victoriousness.[16] On the well-known British Museum ivory (dating to the 520s), Michael holds a *globus cruciger* (a globe topped with a jeweled cross) in his right hand and a scepter in his

8 An example is the two inscriptions dedicated by the *actuarios* Kyriakos that were found on the island of Aigiale. They both read εἰς τὸν ἅγιον Μιχαῆλα (details in P. Nowakowski, *Cult of Saints*, E01269, http://csla.history.ox.ac.uk/record.php?recid=E01269). There are two extant sixth-century seals invoking Michael's help (ΜΙΧΑΗΛ ΒΟΗΘΗ): J. A. Cotsonis, *The Religious Figural Imagery of Byzantine Lead Seals II: Studies on Images of the Saints and on Personal Piety* (Abingdon, 2020), 102–4, 145.

9 Churches: details in R. Janin, "Les sanctuaires byzantins de saint Michel (Constantinople et banlieue)," *EO* 33.173 (1934): 28–52, and R. Janin, *La géographie ecclésiastique de l'empire byzantin*, part 1, *Le siège de Constantinople et le patriarcat oecuménique*, book 3, *Les églises et les monastères* (Paris, 1969); icons: *Anthologia Palatina* 1.34–35, with Peers, *Bodies*, 95–103; coinage: A. Bellinger, *Catalogue of the Byzantine Coins in the Dumbarton Oaks Collection and in the Whittemore Collection*, vol. 1, *Anastasius I to Maurice (491–602)* (Washington, DC, 1966), 62–193, and W. Hahn, *Money of the Incipient Byzantine Empire (Anastasius I–Justinian I, 491–565)* (Vienna, 2000), 42–71 (that is, assuming the unnamed angel is actually Archangel Michael, and there are sound reasons for so assuming, not least the considered judgment of expert numismatists [e.g., P. Grierson, *Byzantine Coins* (Berkeley, CA, 1982), 35]); oaths: Justinian, *Novellae* 8 (*CIC Nov* 89; D. J. D. Miller and P. Sarris, eds., *The Novels of Justinian: A Complete Annotated English Translation* [Cambridge, 2018], 154), and M. Wuk, "Constructing Christian Bureaucrats: Justinian and the Governor's Oath of Office," *JLA* 15.2 (2022): 462–93; and on how religious practice impacted the formation and wording of oaths: M. Wuk, "Provincial Negotiation of Religious Tensions: Late Antique Oath-Formulae in the Greek Documentary Papyri," *ZPapEpig* 215 (2020): 237–56.

10 Orthodox Eastern Church, *Le Typicon de la Grande Église: Ms. Sainte-Croix no. 40, Xᵉ siècle*, trans. J. Mateos (Rome, 1962), 1:194.14 (11 January, "myriads"), 310.5 (9 June), 312.12 (11 June), 316.7 (19 June), 350.13 (26 July), 16.16 (6 September), 68.24 (16 October, Gabriel), 94.9 (8 November), 126.17 (10 December). Most of these feasts were in place by the sixth century. In the 530s, the feast celebrated at Constantinople on 8 November was also celebrated at Oxyrhynchus (*POxy.* 1357).

11 E.g., "Fl. Marianus Micahelius Gabrihelius Petrus Iohannis Narses Aurelianus Limenius Stefanus Aurelianus" (*PLRE* 3:156); cf. others at *PLRE* 3:145–46, 639, 736–37, with yet others in inscriptions noted by D. Feissel and I. Kaygusuz, "Un mandement imperial du VIᵉ siècle dans une inscription d'Hadrianopolis d'Honoriade," *TM* 9 (1985): 397–419 (repr. in D. Feissel, *Documents, droit, diplomatique de l'Empire romain tardif* [Paris, 2010], 223–50, at 225).

12 J. P. Rohland, *Der Erzengel Michael: Arzt und Feldherr; Zwei Aspekte des vor- und frühbyzantinischen Michaelskultes* (Leiden, 1977), 124–26.

13 G. W. H. Lampe, ed., *A Patristic Greek Lexicon* (Oxford, 1961), s.v. ἀρχιστράτηγος, no. 3. The term is used to indicate Michael as God's commander-in chief in the Septuagint in Josh. 5:13 (ἐγὼ ἀρχιστράτηγος τῆς δυνάμεως τοῦ Κυρίου) (I am the commander-in-chief of the Lord's force), as interpreted in the third-century commentary on Joshua by Origen, *Selecta in Iesum Nave* (PG 12:821D).

14 Malalas, *Chronicle* 16.16 (Thurn, *Chronographia*, 330*22 [τὸν ναὸν τοῦ ἀρχιστρατήγου Μιχαῆλ]; Jeffreys, Jeffreys, and Scott, *Chronicle*, 226).

15 Philomelion (Pisidia): *MAMA* VII, no. 207, online at *Inscriptiones Christianae Graecae*, no. 618 (http://www.epigraph.topoi.org/); and Ephesus: *I. Ephesos*, no. 4145 (ἀρχιστράτηγε).

16 Peers, *Bodies*, 49–51, with examples in Hahn, *Money*, 112–14, pls. 13, 14. Again, this is assuming with Peers that the angel on the solidi is meant to be Michael (cf. Grierson, *Byzantine Coins*, 35).

left. These are the key symbols of imperial power.[17] In churches he was attired in imperial regalia and holding the scepter of sovereignty.[18] For example, in the sixth-century church of Sant'Apollinare in Classe, near Ravenna, a colored mosaic displays the same image where the archangel wears the purple imperial tunic.[19] By 515, a similar image in the Church of Michael in Antioch was attacked by patriarch Severus who decried the "presumptuous" craftsmen for depicting Michael and Gabriel "in the manner of lords or kings with a royal robe of purple" and with a crown, as well as for placing "in their right hand the sign of rulership and universal authority."[20] There may also have been an imperial depiction of Archangel Michael at Germia in the church that the emperor Justinian rebuilt.

Germia was a small, unfortified, and out-of-the-way destination. Its fame rested on its status as the location of healing waters attributed to Archangel Michael. One obvious explanation for Justinian's extraordinary expedition to Germia in 563, therefore, is pure piety, or pious obligation toward Archangel Michael. Piety alone, however, is insufficient to explain the venture. A pious need for supplicating Michael could easily have been satisfied locally. Germia was a pilgrimage center for Archangel Michael too, but it was much further away and involved a far more complicated, time-consuming, and lengthy journey from Constantinople. That Justinian made Germia his destination in 563 suggests a more complex motive than a mere desire to honor the archistrategos or seek his healing power. Indeed, it is more likely to have been in relation to his preservation from some personal crisis, that is to say, not unlike the vow of the exiled emperor Zeno (r. 474–491), who promised to construct a church at St. Thecla's shrine at Seleucia in 475/476 if he gained

back his throne.[21] A vow like that of Zeno, just as that of another emperor, Theodosius II (r. 401–450), proclaimed in 443, originates in the "condition of the state" (*statui rei publicae*).[22] Theodosius was drawing a lesson from his own vow (*voti causa*) leading to a pilgrimage to Aphrodisias during which he passed through Heraclea. There he was petitioned by the locals about the deficient state of their walls, their aqueduct, and other public facilities.[23] Further, the sisters of Theodosius had previously vowed a column and statue to their brother as emperor, should he be victorious against the Huns and Persians in the early 420s.[24] These are all very specific vows, in addition to the more general vows (*vota publica*) undertaken periodically by emperors every five years and advertised on their coinage. Justinian's vow to visit Germia is best seen as being the product of a specific set of circumstances, like those of Theodosius II and Zeno before him.

17 For the details of the ivory and identification of the angel with Michael, see O. M. Dalton, *Byzantine Art and Archaeology* (London, 1911), 200; J. Beckwith, *Early Christian and Byzantine Art* (New Haven, CT, 1986), 86; and A. Alföldi, *Die monarchische Repräsentation im römischen Kaiserreiche* (Darmstadt, 1970), 228–38. For the date, see A. Cutler, "The Making of the Justinian Diptychs," *Byzantion* 54.1 (1984): 112.

18 Arnold, *Footprints*, 82–83.

19 Alföldi, *Die monarchische Repräsentation*, 169.

20 Severus, *Homilies* 72 (*PO* 12.1:834) (P. Allen and C. T. R. Hayward, trans., *Severus of Antioch* [London, 2004], 132).

21 Evagrius, *HE* 3.8, and H. Elton, "Alahan and Zeno," *AnatSt* 52 (2002): 153. Similarly, Nicholas of Sion made a vow (τὴν εὐχὴν) to travel to the Holy Land from his native Lycia (*Vita Nicolai Sionitae* 9, in *The Life of Nicholas of Sion*, ed. and trans. I. Ševčenko and N. P. Ševčenko [Brookline, MA, 1984], 30–31); the same sort of vow was made by a certain pilgrim to visit Daniel the Stylite near Constantinople in the 470s (*Vita Danielis Stylitae* 87 [H. Delehaye, ed., *Les saints stylites* (Brussels, 1923), 82, line 25: γενομένης εὐχῆς]) and by Hypatius to visit the Holy Land if he were released from his captivity by Vitalian (Cyril of Scythopolis, *Vita Sabae* 56 [E. Schwartz, *Kyrillos von Skythopolis* (Leipzig, 1939), 151, line 15: εὐχῆς ἕνεκεν]).

22 Theodosius, *Novellae* 23 (Aphrodisias, 22 May 443): *Tunc enim maxime vota proficiunt, cum statui rei publicae, quae causa votorum est, consulatur* (T. Mommsen and P. M. Meyer, eds., *Theodosiani libri XVI cum Constitutionibvs Sirmondianis et leges novellae ad Theodosianvm pertinentes* [Berlin, 1905], 2:60–61). Around the same time, Theodosius II's wife, the empress Eudocia, linked her vow (ταύτην εὐχήν) to see Jerusalem with their daughter finally being married (καὶ γὰρ αὐτὴ ταύτην εὐχὴν ἐπιτελέσειν ἐπηγγέλλετο, ἐὰν τὴν θυγατέρα γαμηθεῖσαν ἐπόψηται [for she had promised to fulfill this vow if she saw her daughter married] [Socrates, *HE* 7.47]).

23 F. Millar, *A Greek Roman Empire: Power and Belief under Theodosius II (408–450)* (Berkeley, CA, 2006), 9–10, 92; cf. S. Destephen, "From Mobile Center to Constantinople: The Birth of Byzantine Imperial Government," *DOP* 73 (2019): 20–21.

24 An inscription at the Hebdomon outside of Constantinople reads [*victor pro*] *votis sororum*; see R. Demangel, *Contribution à la topographie de l'Hebdomon* (Paris, 1945), 33–40, as explained in B. Croke, "Evidence for the Hun Invasion of Thrace in A.D. 422," *GRBS* 18.4 (1977): 347–67, at 365–366 (repr. in B. Croke, *Christian Chronicles and Byzantine History, 5th–6th Centuries* [Brookfield, VT, 1992]).

Some view the aged Justinian's journey to Germia as nothing more than a desperate quest to restore waning health through the archangel's intercession. Like the piety to which it is linked, waning health also seems too low a bar for such a long-distance venture. Certainly, the emperor had been ill on previous occasions, once with the plague. On those occasions, however, he sought help (even saintly succor) locally, and he prevailed.[25] As far as can be ascertained, however, Justinian was not suffering from any debilitating ailment in 563, thereby necessitating such a lengthy journey. If all he needed in 563 was some miracle cure, or relief from illness, he had only to venture as far as the sacred waters of the Pege shrine at the city walls, where he had earlier enlarged the shrine.[26] If it was the particular intervention of Archangel Michael he was seeking, he would surely have satisfied himself by traveling up the Bosporus to the Michaelion at Anaplus, or across the Sea of Marmara to Pythia, where he and his wife Theodora had earlier developed a shrine for the archangel. It was a popular destination for pilgrims from Constantinople.[27] The beneficial effects of health-related pilgrimage were never amplified by distance; hence a detailed analysis of later Byzantine documents shows pilgrims who traveled in quest of a healing shrine ventured only a short distance from home.[28] Germia, by contrast, involved Justinian in traveling an unprecedented distance for his reign.

Students of Justinian have never paid much attention to this episode, beyond expressing surprise that such an old emperor should want to travel so far. Hence, it tends to be cast as an aberration from a devout but out-of-touch ruler securing his heavenly fortune as he approaches his earthly demise.[29] Georges Tate is exceptional in insisting that in 563 "ce grand sédentaire" (Justinian) was still an active ruler engaged on several fronts as he always had been, so this pilgrimage had less to do with his own personal safety and was more symbolic of his perpetual pursuit of public piety and Christian unity.[30] As usual, Ernst Stein is virtually the only one who has paused over the detail, noting too how unusual it was for the most sedentary of all emperors to suddenly undertake the long trip to Germia, especially as an octogenarian. Unlike Tate, Stein's explanation is that this episode is simply another indication of how Justinian had disconnected himself from day-to-day imperial duties to focus on his own spiritual welfare. What drove him to Germia was a need to venerate "a supposed tunic of the Lord."[31]

Leaving aside Stein's questionable judgment about Justinian's personal activism in the 560s, the notion that the emperor undertook this extraordinary venture in 563 just to venerate "a supposed tunic of the Lord" is at least contestable. First of all, this "supposed tunic of the Lord" cannot be dated until after Justinian's reign, when its preservation story is first told by Gregory of Tours in his *De gloria martyrum* (written in the mid-580s) and in the following century by Fredegarius, who was likely to have known Gregory's account but offered a separate version altogether. Gregory says he is relying on hearsay (*ferunt*) when he tells how the tunic

25 Justinian's known illnesses: in 523 while his uncle Justin was emperor (Procopius, *Secret History* 9.35–41); plague in 542 (Procopius, *Wars* 2.23.20 and Procopius, *Secret History* 4.1–3); almost dead but cured by the intervention of Saints Cosmas and Damian at an unknown date (Procopius, *Buildings* 1.6.5–6); serious knee ailment that was cured by a reliquary in the late 540s(?) (Procopius, *Buildings* 1.7.6–15); and a "headache" (migraine?) in 560 (Theophanes, *Chronicle* AM 6053 [de Boor, *Theophanis Chronographia*, 1:234, lines 26–27; Mango and Scott, *Chronicle of Theophanes*, 345]).

26 The shrine of the Virgin lay in a grove surrounding the spring outside the Silivri Gate. Justinian built both a church and a monastery there at some point; for details, see I. Kimmelfield, "The Shrine of the Theotokos at the Pege," in *Fountains and Water Culture in Byzantium*, ed. B. Shilling and P. Stephenson (Cambridge, 2016), 299–313.

27 Procopius, *Buildings* 5.3.16–20, and Rohland, *Erzengel*, 98–99. In 337, the emperor Constantine had diverted to the healing waters there after feeling ill on his way to the East (Socrates, *HE* 1.37.1–2).

28 A.-M. Talbot, "Pilgrimage to Healing Shrines: The Evidence of Miracle Accounts," *DOP* 56 (2002): 164–65.

29 Moorhead, *Justinian*, 172; Evans, *Age of Justinian*, 272 ("He was a troubled man"); and Leppin, *Justinian*, 330 ("vielleicht er sich höheren Unterstützung versichern"). For students of Christian pilgrimage, Justinian's expedition has been equally explained away, for example, as "une angoisse spirituelle" or "un acte isolé au sein de son règne" (S. Destephen, "Le prince chrétien en pèlerinage," *TM* 22.2 [2018]: 307) or merely "Justinien vieillissant" (P. Maraval, *Lieux saints et pèlerinages d'Orient: Histoire et géographie, des origines à la conquête arabe*, 2nd ed. [Paris, 2004], 370).

30 Tate, *Justinien*, 820–21.

31 E. Stein, *Histoire du Bas-Empire*, vol. 2, *De la disparition de l'Empire d'Occident à la mort de Justinien (476–565)* (Paris, 1949), 777: "cet empereur, le plus sédentaire de tous, n'avait quitté la capitale que pour résider de temps en temps dans la partie de la Thrace avoisinant Constantinople, il se résolut, en octobre 563, à entreprendre, déjà octogénaire, un long voyage jusqu'en Galatie pour aller en pèlerinage à l'église des Archanges (ou de Saint-Michel) de Germia, où l'on vénérait une prétendue tunique de Seigneur."

of Christ was currently (580s) being venerated in an unidentified "Galatian town," in a church dedicated to the "holy archangels." The town was "about 150 miles" from Constantinople. Gregory's informants—whether firsthand, secondhand, or thirdhand is unknowable—further told him that the church had a deep crypt where the venerable relic was contained in a wooden box.[32] Gregory's language is certainly unclear. By "civitatem Galatae," he would appear to be indicating a town in the Roman province of Galatia rather than a town called "Galatae," although that is certainly a feasible option.[33] An identification with Germia is also possible, as Stein presumed, because it was located in Galatia and had a church of the Archangel Michael. Yet Germia is not 150 miles from Constantinople but more than twice as far.[34] Besides Germia, however, there were many other churches dedicated to Michael in Galatia, as in other provinces in Asia Minor (particularly Phrygia and Lycia),[35] and at least one dedicated to the "Myriangeloi" outside Pessinus.[36] Nor is it clear how such a unique relic as Christ's tunic could have ended up in Germia

rather than somewhere more ecclesiastically and geographically prominent, not to mention somewhere closer to its original Palestinian location. Christ's tunic is not otherwise associated with the Archangel Michael but is completely separate, so it is not apparent why it would be in a church specifically dedicated to Michael, either at Germia or elsewhere.

While Gregory might be construed as reporting a relic that could be found at Germia well before he heard about it, Fredegarius only compounds the difficulties by dating the discovery of Christ's tunic to 590, at a place called Zaphrod (probably Sepphoris) in Palestine.[37] Later traditions are no help either. One tradition places the tunic of Christ in Trier and seeks to trace its arrival there to the early fourth century, although its earliest attestation there is in the eleventh century. Another tradition has Christ's tunic proffered to Charlemagne as a wedding gift by the Byzantine empress Irene. Their marriage never took place, but the relic ended up in a Carolingian convent at Argenteuil, near Paris. Even so, the Argenteuil tunic is not actually attested before the twelfth century either.[38] Gregory of Tours's account is therefore hardly a compelling case, although it has passed uncritically into the recent literature on Germia.[39] On the other hand, one contemporary who knew and visited the Michael pilgrimage site at Germia, and similar sites elsewhere, was Theodore of Sykeon (d. 613), but he never mentions any attraction at Germia other than veneration of Michael and some

32 B. Krusch, ed., *MGH Scriptores rerum Merovingicarum*, vol. 1.2, *Gregorii episcopi Turonensis miracula et opera minora* (Hanover, 1885), 42–43. This instance is not cited in Averil Cameron, "The Byzantine Sources of Gregory of Tours," *JTS* 26 (1975): 421–26 (repr. in Averil Cameron, *Continuity and Change in Sixth-Century Byzantium* [London, 1981]), although her conclusion that Gregory had direct access to information about Eastern events, orally in this case and far less reliable, is applicable here too.

33 E.g., R. Van Dam, *Gregory of Tours: Glory of the Martyrs* (Liverpool, 1988), 9, n. 13: "Galatea is probably the city of Galatz, north of Constantinople/Istanbul in Romania."

34 Hence, we have the cavalier suggestion of emending Gregory's "CL" to "CCL," advanced by E. Honigmann, "Pour l'atlas byzantine," *Byzantion* 11.2 (1936): 553.

35 For Galatia, see *Vita Theodoris Sykeonis* 35.17 (Festugière, *Vie*, 31); for modern Çiftlikköy (or Çiftlik) near Ankara, see P. Nowakowski, *Cult of Saints*, E00996, http://csla.history.ox.ac.uk/record.php?recid=E00996. The Çiftlikköy inscriptions actually name Justinian in setting the boundaries of the Archangel Michael church and are published in S. Mitchell, *Regional Epigraphic Catalogues of Asia Minor II: The Ankara District; The Inscriptions of North Galatia* (Oxford, 1982), 173–75 (nos. 207–8). For Phrygia, see details in F. R. Trombley, *Hellenic Religion and Christianization, c. 370–529* (Leiden, 1993), 1:152–56; Cline, *Ancient Angels*, 158–65; and P. Nowakowski, *Cult of Saints*, E00915, http://csla.history.ox.ac.uk/record.php?recid=E00915. In Lycia, several are named, although their modern locations are not always identifiable; see *Vita Nicolai Sionitae* 54 (Traglassos), 55 (Plenios), 56 (Nea Kome), 57 (Symbolon and Trebendai), 70 (Krova).

36 *Vita Theodoris Sykeonis* 101.40 (Festugière, *Vie*, 81).

37 The tunic, according to Fredegarius, was then brought into Jerusalem in a great procession involving the patriarchs of Constantinople and Antioch, as well as Jerusalem, and deposited in the Church of the Resurrection constructed by Emperor Constantine in the early fourth century. The veracity of Fredegarius's account is debatable (cf. H. Reimitz, *History, Frankish Identity and the Framing of Western Ethnicity, 550–850* [Cambridge, 2015], 190); for example, there is no evidence that the bishops of Constantinople, Antioch, and Jerusalem were ever together in Palestine.

38 It now resides in a large glass reliquary in the Basilica of St. Denis at Argenteuil and is occasionally displayed for reverence. For background, see J. Nickell, *Relics of the Christ* (Lexington, KY, 2007), 104–6; for dates and further detail, see C. Billot, "Des reliques de la Passion dans le royaume de France," in *Byzance et les reliques du Christ*, ed. J. Durand and B. Flusin (Paris, 2004), 239–48.

39 E.g., C. Mango, "St. Michael and Attis," Δελτ.Χριστ.Ἀρχ.Ἑτ., 4th ser., 12 (1984): 49; Tate, *Justinien*, 820; P. Niewöhner et al., "Bronze Age Höyüks, Iron Age Hilltop Forts, Roman Poleis and Byzantine Pilgrimage in Germia and Its Vicinity: 'Connectivity' and a Lack of 'Definite Places' on the Central Anatolian High Plateau," *AnatSt* 63 (2013): 98; and Niewöhner, "Healing Springs," 110.

relics of St. George.[40] So unique and important a relic as Christ's tunic would hardly go unremarked. There is therefore no need to think, let alone propose as Stein has done with others following him to the present day, that Justinian was attracted to Germia in 563 by the very presence of the tunic of Christ. For present purposes, it can be safely discarded. His motives lay elsewhere.

In particular, a more complex and likely motive for Justinian's journey is suggested by focusing on his long involvement with both the cult of Archangel Michael as archistrategos at Constantinople and at Germia before his visit in 563, as well as with the background events of 562/563, which gave rise to his "vow" in the first place. In the absence of an explicit statement in the solitary testimony of Theophanes, however, there is a need to seek out the likely circumstances that prompted Justinian's vow to visit the Germia shrine of Archangel Michael. Like any vow, it was no casual decision. The vow is more likely to be primarily associated with a crisis of sovereignty. Such a crisis would have involved Justinian's position and power being imperiled by a pressing political situation. Hence, he called on the divine assistance of the archistrategos Archangel Michael, adding a vow to venerate the archangel by visiting his major shrine at Germia.

That Justinian narrowly survived precisely such a crisis in January 532 during the Nika riots is well-known and well recorded. Not so well-known, however, nor so well recorded is the perilous situation he faced in 562. First, he was obliged to confront faction riots at Constantinople that threatened to spiral out of control in late 561 and 562, quickly followed in November 562 by a full-blown conspiracy against his life and throne that was only thwarted at the very last minute. His potential assassins were already entering the palace. Somewhere in these events is likely to be found the desperate response of Justinian that involved a vow to Archangel Michael as the archistrategos, however impulsive and unthinking he may have been in making his vow. Vows had been made to Michael before, such as that of Trophimus at Kidyessos in Phrygia.[41] Now,

imperial officials invoked Michael in vows they swore on appointment to Emperor Justinian.[42] It would be no surprise to find Justinian invoking Michael in his own vows. Presumably publicly witnessed, that vow in 562 was a vow Justinian would be expected to keep, even though it would have been much easier for him to simply forget his vow or downplay its import. Age and distance could easily excuse him.

Archangel Michael and Justinian's Vow

The years 562 and 563, Justinian's thirty-fifth and thirty-sixth years as emperor, were arguably the most unstable and unpredictable part of his rule for the past thirty years. They were preceded by lethal communal violence between the rival Greens and Blues in 560 and 561, plus a conspiracy to replace him as emperor in 560. Yet these years are not normally given the close attention they require. Instead, they tend to be compressed or skated over as part of Justinian's "final years."[43] Now in his eighties, and with an unusually long reign behind him, Justinian still remained conscious of just how close he came to forfeiting his throne in 532, the last time violence and arson by the Blues and Greens threatened imperial sovereignty. By now too, he had Procopius's popular account to remind him, especially that he had to overcome a proclaimed usurper to the throne in Hypatius.[44] In the intervening period, he had become much more confident and much better positioned to deal with opposition and conspiracies to unseat him. He had successfully dealt with one major plot initiated by a vengeful Artabanes in 548,[45] while late in 560, the city prefect Gerontius and his associates were accused by a former praetorian prefect of the East, Eugenius, of plotting to replace Justinian with Theodore, son of one

40 *Vita Theodoris Sykeonis* 71.5 (Festugière, *Vie*, 58). Moorhead, *Justinian*, 172, implies that George's remains were already in Germia in 563, which seems unlikely. They were the personal property of a later bishop.

41 *MAMA* XI, no. 167 (cf. *MAMA* IX, no. 551 [seeking Michael's protection for a sick child]).

42 Justinian, *Novellae* 8 (*CIC Nov* 89; Miller and Sarris, *Novels of Justinian*, 154).

43 E.g., Evans, *Age of Justinian*, 253 ("The final decade of Justinian's reign reads like the transcript of the Last Judgement upon his administration"); Moorhead, *Justinian*, 169; and Leppin, *Justinian*, 316–36 ("Ende in Isolation").

44 Procopius, *Wars* 1.24 (cf. Procopius, *Buildings* 1.1.20–21).

45 Procopius, *Wars* 7.32. Justinian's pardon of the conspirator Artabanes on this occasion was promoted as an exemplary indication of his clemency (lat. *clementia*; gr. φιλανθρωπία), as explained in D. A. Parnell, "Justinian's Clemency and God's Clemency," *Byzantina Symmeikta* 30 (2020): 16–17.

of the emperor's most loyal officials, Peter the Patrician.[46] Having survived the plot in 560, the emperor was sorely tested again in 561 and 562. The records are scanty for these years when the poorly preserved chronicle of John Malalas provides the only substantial contemporary, or near-contemporary, account. Although it is not possible to link Justinian's vow to visit Germia incontrovertibly to events in these years, both the timing and the circumstances of 562/563 were the very sort to stimulate such a personal safety vow involving the legitimizing protection of Archangel Michael. Such a link is therefore very plausible.

Justinian's anxiety would have increased when on Wednesday, 12 October 561, late at night, a large blaze raged from Caesarius's quarter near the Marmara harbor all the way up to the Forum Bovis, destroying all the workshops and porticos along the way.[47] Violence between Blues and Greens may have provided the trigger. A month later (November 561), serious civil strife (δημοτικὴ ταραχή) between the factions erupted in the hippodrome before Justinian had arrived to view the Saturday races. The Greens had set upon the Blues, usually favored by Justinian. When the news reached the emperor inside the imperial palace, he hurried up to the imperial box to see the situation for himself. Immediately, he dispatched the *comes domesticorum*, who led the various contingents of the palace guard, presumably with an armed force, to separate the rioting factions. Unfortunately, they failed to quell the mayhem. Many Blues and Greens had already been killed. Many more were wounded. Justinian was not reconciled with the Greens until Christmas 561.[48] This was the most severe and fatal rioting since the 530s and a reminder to Justinian of how urban violence and destruction could threaten an emperor's position as well.

While Justinian may have hoped that was the end of the matter, the severe rioting in October to December 561 was only the destabilizing prelude to events in 562. On 3 May, it emerged that another plot was being hatched to depose Justinian. This time, his late wife Theodora's relatives George and John accused Zemarchos (*curator* of the palace of Placidia) of making several "terrible statements against the emperor" (κατὰ τοῦ βασιλέως πολλὰ λαλήσας καὶ δεινά).[49] Zemarchus was dismissed.[50] Only a week later, the deep antagonism between the Blues and Greens, which had ended up threatening Justinian in October to December 561, once again flared up. The traditional 11 May games in the Hippodrome were always a cause of great celebration of the foundation over two centuries earlier of what was now the flourishing Roman capital of Constantinople. In 562, however, doubtless in response to well-placed fear of factional violence, Justinian postponed the celebration for two days to 13 May 562. Meanwhile, the warehouses along the shore near the Neorion harbor were incinerated. These were the warehouses that stored the oil, wine, and even some grain essential for the city's population.[51] Spoiling or destroying them had serious repercussions. While the violence raged, Justinian presumably remained within the safety of the palace but uncertain about what might happen next.

The violence in May 562, tantamount to a battle (μάχη, Malalas), lasted for two days and nights and constituted a severe threat to the government and authority of Justinian. His position had become almost as precarious as it had in 532 as he sought safety inside the palace. In the end, Justinian sent out the chief of his personal guard, the *comes excubitorum*, Marinus. This time he was accompanied by the *curopalates* (later emperor) Justin with a large military contingent, just as Justinian had dispensed Belisarius and other military leaders in 532 to enforce order at the point of the sword. Even so, Marinus and Justin had great difficulty bringing the factional rioters to heel. The city was barely under control, and despite its massive physical and military protection,

46 Theophanes, *Chronicle* AM 6053 (de Boor, *Theophanis Chronographia*, 1:235, lines 1–7; Mango and Scott, *Chronicles of Theophanes*, 345), and *PLRE* 3:1255–56 ("Theodorus 34").

47 Theophanes, *Chronicle* AM 6054 (de Boor, *Theophanis Chronographia*, 1:235, lines 26–29; Mango and Scott, *Chronicles of Theophanes*, 347).

48 Theophanes, *Chronicle* AM 6054 (de Boor, *Theophanis Chronographia*, 1:235.20–236.16; Mango and Scott, *Chronicles of Theophanes*, 347), which was presumably copied from Malalas and is lacunose at this point (cf. Malalas, *Chronicle* 18.131–32 [Thurn, *Chronographia*, 422; Jeffreys, Jeffreys, and Scott, *Chronicle*, 298–99]).

49 Theophanes, *Chronicle* AM 6054 (de Boor, *Theophanis Chronographia*, 1:237, lines 1–4; Mango and Scott, *Chronicles of Theophanes*, 347).

50 Malalas, *Chronicle* 18.134 (Thurn, *Chronographia*, 423, app. crit.; Jeffreys, Jeffreys, and Scott, *Chronicle*, 300), and *PLRE* 3:1253 ("Theodorus 25").

51 M. Mundell Mango, "The Commercial Map of Constantinople," *DOP* 54 (2000): 193, and P. Magdalino, "The Maritime Neighborhoods of Constantinople: Commercial and Residential Functions, Sixth to Twelfth Centuries," *DOP* 54 (2000): 211–12.

the palace could not easily secure the emperor and court for much longer. It was not far from the imperial palace that the Blues fomented another outbreak of violence in October 562, this time in the Pittakia. Again, Justinian punished a great many of them.[52]

No sooner had the faction rioting in October 562 been contained for the time being than another threatening plot against the emperor emerged the next month (November).[53] On this occasion, the plotters were a mixture of senior imperial administrators and officials in the employ of certain Roman aristocrats. The ringleader appears to have been a leading senator, Aetherius, who was curator of the house of Antiochus and had previously been accused of plotting against Justinian in 560. Those committed to murdering the emperor were (1) Marcellus, a financial manager or money changer (ἀργυροπράτης, literally "silversmith") from the household of Aetherius, who borrowed fifty pounds of gold from a certain Isaac to secure the involvement of (2) Ablabius, who was the son of a musician (μελιστής), Meltiades, and (3) Sergius, the nephew of Aetherius.[54] The plan was relatively straightforward. Marcellus and Ablabius would wait one evening until Justinian had finished dining in the imperial triclinium, then calmly enter and stab him to death. Marcellus had others tipped off to fabricate a commotion designed to cover the inevitably noisy crime. Exactly where these men were stationed is unclear, but for their mission to be effective, they must have been inside the palace itself. The text of Malalas, preserved as a verbatim excerpt from his work in a later collection on revolts, says the

following about their location: "at the Arma, the office of the Silentiarius, the Indoi and the Archangelos."[55] Each of these would appear to be spaces inside the palace, in which case the "Archangelon" would be the small chapel of Archangel Michael that Justinian had restored earlier.[56] For the plot to work, it presupposed both that Ablabius and Marcellus had easy access to the imperial dining room and that key palace guards, and possibly other household officials, were prepared to enter into such a plot to assassinate their long-serving emperor. To explain how events would unfold, the assassin Ablabius took into his confidence not only John, a financier for Domentziolus, but also Eusebius, the *comes foederatorum*, or head of the foreign military contingents that formed part of the emperor's army.[57] The atmosphere inside the palace must have been tense and divisive at this point for such a scenario to even be contemplated, let alone shared with one of Justinian's senior military officials. Ablabius must have had reason to trust the confidence of Eusebius, or else he was informing on his coconspirators in order to secure his own safety as well as that of Justinian. Eusebius, as comes foederatorum, was one of those ultimately responsible for preserving the emperor's safety. Indeed, on taking office he would have sworn an oath by the Virgin and the Archangel

52 Theophanes, *Chronicle* AM 6055 (de Boor, *Theophanis Chronographia*, 1:237, lines 6–7; Mango and Scott, *Chronicle of Theophanes*, 349). It was a consequence of these accumulated events that Justinian, followed later by Justin II as emperor, refashioned the harbor of Julian as the harbor of Sophia and relocated there many of the vulnerable warehouses previously on the Neorion harbor, opposite Sykai: *Parastaseis* 72 (T. Preger, ed., *Scriptores originum Constantinopolitanarum* [Leipzig, 1907], 1:67); *Patria of Constantinople* 2.68 (Preger, *Scriptores*, 2:188); Magdalino, "Maritime Neighborhoods," 212–19; and P. Magdalino, "Medieval Constantinople," in P. Magdalino, *Studies on the History and Topography of Byzantine Constantinople* (Aldershot, 2007), 21.

53 For the narrative of the plot, see Malalas, *Chronicle* 18.141, including *Excerpta de insidiis*, 173.30–175.18 (Thurn, *Chronographia*, 425–29; Jeffreys, Jeffreys, and Scott, *Chronicle*, 310–13).

54 Aetherius: *PLRE* 3:21–22 ("Aetherius 2"); Ablabius: *PLRE* 3:2–3 ("Ablabius 1"), with a discussion of whether or not μελιστής means "mint official"; Isaac: *PLRE* 3:719 ("Isaacius 4"); Marcellus: *PLRE* 3:816 ("Marcellus 4"); and Sergius: *PLRE* 3:1128 ("Sergius 6").

55 Malalas, *Chronicle* 18.141 (Thurn, *Chronographia*, 426*9–10; Jeffreys, Jeffreys, and Scott, *Chronicle*, 301): εἴς τε τὸ Ἄρμα καί εἰς τὸ Σελεντιαρίκιν καί κατὰ τοὺς Ἰνδούς καί κατὰ τὸν Ἀρχάγγελον. The precise meaning of κατὰ τοὺς Ἰνδούς is unclear, although it appears to be that part of the palace where the patricians robed for the installation of a new magistrate who ventured there on appointment (Constantine Porphyrogenitus, *Book of Ceremonies* 1.46 [Moffatt and Tall, *Constantine Porphyrogennetos*, 234]). Assuming that the tenth-century *de insidiis* extract from the imperial palace copy of Malalas accurately reflects the original text, Theophanes may have had difficulty making sense of Malalas at this point. Although he regularly recast the words and syntax of Malalas to make better sense or coherence for his own purposes, especially in the latter section of Malalas's chronicle (Jeffreys, "Transmission," 258), here he wrote, "Indians hidden in the office of the *silentiarius* and in the Archangel and in Arma," as translated by Mango and Scott (*Chronicle of Theophanes*, 349), as if they were all "Indians" lying in wait in various parts of the palace.

56 This was the chapel of Michael inside the palace where in 536 bishops were sent to search for Anthimus, who had failed to appear at the current council of bishops: *ACO* 3:80 (159.16), 82 (160.2), 113 (175.25).

57 John: *PLRE* 3:672–74 ("Ioannes 81"), and Eusebius: *PLRE* 3:468 ("Eusebius 4").

Michael to do precisely that.[58] So he did, but without tipping off the plotters about his double-dealing.

On the agreed day, Saturday, 25 November 562, the conspirators assembled and entered the palace, but the guards were waiting to pick them off. Marcellus was intercepted carrying a dagger, Ablabius a sword. Marcellus turned his dagger on himself then and there. Ablabius was deprived of his sword but lived to fight another day. The other plotter, Sergius, who was evidently not required inside the palace, fled to the Church of the Virgin at Blachernae. Later he was extracted from the church and questioned under torture, thereby implicating three more officials from the household of Justinian's former general Belisarius: Isaac, his financier who had actually lent Marcellus the requisite money to pay off Ablabius, another of Belisarius's financiers named Vitus, and one of his paymasters, Paulus.[59] All the surviving conspirators were then interrogated on behalf of the emperor by the new city prefect, Procopius, who was assisted by the *quaestor* Constantine, along with two of the imperial secretaries, Julian and Zenodorus, who recorded the conspirators' statements and joined in their interrogation.[60] As the inquiries advanced, yet other names emerged of individuals who had already fled the city. The conspiracy to murder Justinian proved very extensive. Had Eusebius not decided to defend Justinian by foiling the plot, it would certainly have resulted in the emperor's murder in 562. For the contemporary John Malalas, it was only "through God's good grace" (τοῦ θεοῦ οὕτως εὐδοκήσαντος) that the plot was discovered and Justinian spared.[61]

Above all, the plot to liquidate Justinian would have been incomplete without some clear sense, if not formal agreement, on who would immediately replace him on the throne. Yet no names appear to have emerged, although the likely candidates would have been canvassed in private conversations among the plotters. Their choice may have been Justin, the son of Germanus.[62] Exactly what triggered the plot, whether it was an outgrowth of the increasing urban violence and opposition to Justinian in 561/562 or some sort of organized disenchantment among the aristocracy, including the veteran Belisarius, is unclear. Often these events have been labeled the "bankers' revolt" because so many of the silversmiths or financial officials (*argyroprantes*) of different wealthy individuals were involved and because money had to be borrowed to bribe the chief conspirators.[63] Yet this characterization appears to be misplaced. Not only has the empire's financial situation in these years, and Justinian's capacity to engage with it, been exaggerated, but the individuals involved were not so much "bankers" as the financial officials of wealthy estate holders and managers. Along with merchants and other guilds, they had a ceremonial function in that they formed a separate welcoming group for greeting returning emperors, as in 559 for Justinian.[64] They were not senior figures themselves, just employed by those who were (Aetherius, Belisarius, Domentziolus).[65] Never mentioned at all is Justinian's right-hand man, his nephew Justin, as curopalates. Although Justin could number several of the conspirators among his associates,[66] his primary task was to defend the emperor, not threaten him.

In any event, investigations were carried out over the next two weeks, and on 5 December 562, Justinian formally summoned all imperial officeholders

58 Justinian, *Novellae* 8 (*CIC Nov* 89–91; Miller and Sarris, *Novels of Justinian*, 154–55), and Wuk, "Constructing Christian Bureaucrats."

59 *PLRE* 3:1387 ("Vitus"), 979 ("Paulus 18").

60 Procopius: *PLRE* 3:1066 ("Procopius 3"); Constantine: *PLRE* 3:342–43 ("Constantinus 4"); Julian: *PLRE* 3:735–36 ("Iulianus 15"); and Zenodorus: *PLRE* 3:1419 ("Zenodorus").

61 Malalas, *Chronicle* 18.141 (Thurn, *Chronographia*, 426.42–43; Jeffreys, Jeffreys, and Scott, *Chronicle*, 302).

62 This has been suggested by Whitby, *Wars*, 299 (cf. S. Lin, "Justin under Justinian: The Rise of Emperor Justin II Revisited," *DOP* 75 [2021]: 140).

63 W. Brandes, "Eine Verschwörung gegen Justinian im Jahre 562 und Johannes Malalas," in *Die Weltchronik des Johannes Malalas: Quellenfragen*, ed. L. Carrara, M. Meier, and C. Radtki-Jansen (Stuttgart, 2017), 357–92; Michael Whitby, "Armies and Society in the Later Roman World," in *CAH*, vol. 14, *Late Antiquity: Empire and Successors, A.D. 425–600*, ed. Averil Cameron, B. Ward-Perkins, and Michael Whitby (Cambridge, 2000), 475; and Whitby, *Wars*, 298. There may or may not be a connection between the argyroprantes being compelled by Justinian a few months earlier to put on a great light show of some sort (Malalas, *Chronicle* 18.137 [Thurn, *Chronographia*, 424.16–19; Jeffreys, Jeffreys, and Scott, *Chronicle*, 301]). Here they were in their role as a professional guild group.

64 Constantine Porphyrogenitus, *Book of Ceremonies*, book 1, appendix (J. Reiske, ed., *Constantini Porphyrogeniti Imperatoris de ceremoniis aulae byzantinae: Libri duo*, CSHB 16 [Bonn, 1829], 498; Moffatt and Tall, *Constantine Porphyrogennetos*, 498).

65 M. F. Hendy, *Studies in the Byzantine Monetary Economy, c. 330–1450* (Cambridge, 1985), 243.

66 Lin, "Justin under Justinian," 128, 158–59.

and senators, plus guardsmen and the new patriarch Eutychius, to attend an official hearing (*silentium et conventum*), probably in the imperial audience hall known as the *Magnaura*.[67] What the emperor wanted to reveal publicly, doubtless as a lesson to others and to flush out any waverers, was the detail of the recent plot against his life. There were verbatim depositions that had been taken from each of the captured conspirators. The emperor called for the detailed depositions to be read aloud, in turn: those of Sergius, Eusebius, then Belisarius's men, Vitus, and Paulus. As the courtiers and senators listened progressively and cumulatively to the graphic details of the plot, and how it was foiled, two particular reactions arose: anger at Belisarius for letting members of his staff get involved, plus suspicion of Constantine and Julian, who, although they were among the emperor's chief interrogators, were known to be associates of Aetherius. If not himself the instigator of the plot, it was clear that Aetherius knew about it in advance, probably from his own associate Marcellus and/or his nephew Sergius. Yet he seems to have managed to avoid implication or punishment, just as he had in 560 when he was accused of plotting to replace Justinian. There is no mention of Ablabius either. Perhaps a pardon was his reward for turning informer and helping subvert the plot.

What Justinian had intended, so it would appear, was to bring this whole messy situation to a clear resolution. Two outcomes therefore emerged from the emperor's briefing. Firstly, Belisarius was totally discredited. Justinian stripped him of all his staff, not just the conspirators administering his property and household wealth, and of imperial emoluments. The venerable former general was in no position to protest, gave up all his accused staff, and remained the subject of imperial anger. Rather than exile or other punishment, he was confined to his house. Secondly, as for the apparent leniency of Constantine and Julian toward the

suspicious Aetherius, a fresh investigation was ordered to be undertaken by the comes excubitorum Marinus and the general Constantianus. This took place on 11 December 562 and exonerated Constantine and Julian of any knowledge of the plot.

The imperial church of Hagia Sophia, closed for the past four years for repairs since its dome had partly fallen in, was about to be reopened with great fanfare. At the opening three weeks later, the plot's suppression, and the realization that Justinian had been fortunate to escape with his life and throne intact, was reinforced by Paul the Silentiary's panegyric of Justinian. Paul was addressing much of the same audience the emperor himself had recently addressed just days before. Having canvassed the emperor's virtues and good fortune, Paul turned to the recent conspiracy:

> The ambush was laid, the sword was at the ready, the appointed day had come. The conspirators had already passed into the palace and were grasping the inner door. Next, they intended to dash against your throne. But you realised this and had known long since. So you remained steadfast and had faith in Him alone who is your champion—I mean God—through whom you are victorious in all things. And you did not fail in your objective. For what followed? The leader of the ambush [Marcellus] fell by his own hand.[68]

Justinian would have forgiven him had he lived, according to Paul. Such is the emperor's propensity to mercy.[69]

This narrow escape from a concerted attempt on Justinian's life in 562 was attributed by Paul to the emperor's faith in God (τῷ σου προσπίζοντι τὸν θεὸν λέγω) and a few years later, as noted above, by Malalas

67 For details of the tribunal hearing, see Malalas, *Chronicle* 18.141 (Thurn, *Chronographia*, 428–29; Jeffreys, Jeffreys, and Scott, *Chronicle*, 303). The contemporary Malalas says that the briefing took place in the triclinium (John Malalas, *Chronicle* 18.141 [Thurn, *Chronographia*, 428.66 (cf. 428*41)]). If he means the imperial dining room, the space may have been too small to accommodate the number of those invited. Rather, it was probably held in the Magnaura, which is sometimes called the "large triclinium" (e.g., Constantine Porphyrogenitus, *De Caeremoniis* 2.15 [Reiske, *De cerimoniis*, 566]: ἐν τῷ μεγάλῳ τρικλίνῳ).

68 Paulus Silentarius, *Descriptio Sanctae Sophiae*, 24–29 (C. de Stefani, ed., *Paulus Silentiarius: Descriptio Sanctae Sophiae: Descriptio Ambonis* [Berlin, 2011], 2; P. N. Bell, trans., *Three Political Voices from the Age of Justinian: Agapetus*, Advice to the Emperor; *Dialogue on Political Science; Paul the Silentiary*, Description of Hagia Sophia [Liverpool, 2009], 190), and Mary Whitby, "The Occasion of Paul the Silentiary's *Ekphrasis* of S. Sophia," *CQ* 35.1 (1985): 220–22.

69 On this basis, it might be assumed that Ablabius (*PLRE* 3:3 ["Ablabius 1"]) was pardoned by Justinian, but there is no such evidence. More likely he was exiled, as was Sergius (*PLRE* 3:1128 ["Sergius 6"]). For this example of Justinian's mercy, see Parnell, "Justinian's Clemency," 19–20.

to "God's good grace" (τοῦ θεοῦ οὕτως εὐδοκήσαντος).[70] Agathias may also have had the 562 plot in mind if lauding Justinian for "shattering the hopes of disturbers," both domestic and external (ὁππότε καὶ ξείνοιο καὶ ἐνδαπίοιο κυδοιμοῦ / ἐλπίδες ἐθραύσθησαν ὑφ᾽ ἡμετέρῳ βασιλῆϊ).[71] Divine intervention was evidently Justinian's own explanation. Further, it was arguably the stimulus for his vow to the imperial protector Archangel Michael. Meanwhile, tensions between Blues and Greens continued to simmer and erupted violently once more in April 563 when the city prefect Procopius, who had played a key role in exposing the plotters against Justinian in November 562, was dismissed.[72]

The point of setting out in detail these events in 561 and 562 has been to illuminate the increasingly frightening position in which Justinian found himself, thereby leading him to offer a vow to Archangel Michael in exchange for his protection. Indeed, after this latest crackdown on the serious factional violence racking the city in May 563, Justinian must have wondered when it would ever stop. By now, however, it is likely that plans were already being formulated for the expedition to Germia in fulfillment of the emperor's "vow." Given the uncertain and violent circumstances that emerged in 562 and early 563, and that impacted Justinian and his safety so directly, it is very plausible that he entrusted the archistrategos Michael with his survival. Having done so, he felt obliged to fulfill the promise he had made to visit the Michael shrine at Germia to give thanks for his deliverance from recent threats and plots, especially the dangerous personal threat in November 562. The Archangel Michael had

fulfilled his role of protecting the emperor's hold on imperial power. The emperor's response was to acknowledge this intervention publicly, even if it meant preparing to undertake the longest journey of his already long reign. He was also taking the risk of leaving the capital without its emperor for an extended period at a time when his sovereignty was far from secure, and the inevitable succession no less certain, but it was an opportunity for Justin.[73] All this is not to say that the benefit of the healing waters of Germia, as well as the spiritual value of honoring Michael in the church that he and Theodora had earlier expanded, did not cross his mind. They were to constitute a spiritual and bodily bonus, rather than the primary motivation for the expedition.

Justinian's Expedition to Germia, October 563

Irrespective of the vow's occasion, Justinian clearly felt the arduous travel involved to Germia and back could not be ignored, let alone excused, by an aging body. It would have been shortly after the subsidence of the faction riots in April 563, if not actually before them, that preparations commenced for the imperial expedition to the shrine of Michael the Archangel and its sacred waters at Germia, where Justinian and Theodora had earlier (mid-540s) contributed to the renovation and expansion of the already existing fifth-century church.[74] Such an imperial expedition was never a spontaneous venture, not least because the emperor needed to be confident about the security of Constantinople in his absence. Even for a journey such as Justinian's to Germia, the planning needed to be comprehensive and meticulous, especially since no emperor in living memory had ever traveled as far as Justinian was now planning, nor left the capital without its emperor for so long. There was no recent precedent for preparing the supplies and transport logistics for such a journey. Emperors never ventured along the cursus publicus into Anatolia, at least not since Arcadius (r. 383–408) and his son Theodosius II (r. 401–450) over a century earlier.[75] At around six hundred kilometers over land and sea, it was the furthest Justinian had ever traveled from

70 Malalas, *Chronicle* 18.141 (Thurn, *Chronographia*, 426.42–43; Jeffreys, Jeffreys, and Scott, *Chronicle*, 302).

71 *Anthologia Palatina* 4.3, line 99 (preface to the *Cycle*), and B. Baldwin, "Four Problems in Agathias," *BZ* 70.2 (1977): 301. Whether this preface of Agathias was intended for Justinian or his successor Justin II is disputed. The case for Justin has been made by Averil Cameron and Alan Cameron, "The Cycle of Agathias," *JHS* 86 (1966): 6–25, but challenged by Baldwin, "Four Problems," 298–301, and B. Baldwin, "The Date of the Cycle of Agathias," *BZ* 73.2 (1980): 334–40, then reiterated by Averil Cameron, "The Career of Corippus Again," *CQ*, n.s., 30.2 (1980): 537 (repr. in Cameron, *Continuity and Change*).

72 Theophanes, *Chronicle* AM 6055 (de Boor, *Theophanis Chronographia*, 1:239.6–17; Mango and Scott, *Chronicle of Theophanes*, 350–51), taken from Malalas, *Chronicle* 18.146 (Thurn, *Theophanis Chronographia*, 1:430; Jeffreys, Jeffreys, and Scott, *Chronicle of Theophanes*, 304).

73 Lin, "Justin under Justinian," 140.

74 Niewöhner and Rheidt, "Michaelskirche," 143, 151, and Niewöhner et al., "Bronze Age Höyüks," 98.

75 Arcadius spent some of the summer months of 397, 398, 399, and 405 in Ankara (C. Foss, "Late Antique and Byzantine Ankara," *DOP*

the imperial capital in his entire reign, and he was now in his eighties. Certainly, it could have been a short, sharp journey (by horseback, litter, or carriage, or some combination) with minimal entourage and minimal local involvement. However, given Justinian's age and status, a less hurried journey is more likely. However extraordinary the expedition was, it had to begin with careful planning, just like any imperial expedition at any previous time.

Some idea of the precise planning required can be gleaned from a later Byzantine imperial guide, firstly ensuring up-to-date familiarity with the route and its safety, its towns, forts, and topography. Then there was the costing, as well as the most complex preparations of all, involving the packing of provisions and equipment, including necessary books and manuals, on the carefully calculated number of pack animals and other horses.[76] When the emperor Constantine proposed setting out on an expedition in the early fourth century, the first steps were to: (1) take advice on the best time to travel and the best route to follow; (2) know what places were along the way and how well provisioned they were in terms of food, water, and security; and (3) compile a list of the successive places along the route, how far apart they were, and how many people each could accommodate. Having decided on the timing of the journey, the emperor left to others the details of the costs and logistics.[77] The same could be expected for Justinian in 563.

The immediate decision for the journey to Germia, therefore, would have been to choose the most advantageous time of the year weather-wise both for the emperor and for the requirements of such an expedition. Clearly, the summer months in Galatia were too hot and the winter months, broadly speaking, too wet

and cold, with a threat of snow in places. Germia is subject to extremely cold temperatures and heavy snowfalls. Rain could be highly problematic too, even on the well-drained imperial roadways.[78] Spring and autumn presented the safest weather options. In Ankara, for example, the average daytime temperature in October is 20.5 degrees Celsius, and the average rainfall is six days per month. Notwithstanding ongoing unrest and violence between the Blues and Greens at Constantinople, the spring of 563 was already too soon for the planned imperial trip to Germia. That left the period from September to November as the optimal time.

Then there was determining the route. The main guide to any itinerary was not a detailed topographic map to scale, but just the list of the stopping and changing posts and inns along the way with the distances between them, further assisted by periodic milestones. Generally, this information sufficed for a Roman traveler to know where he was and how far he was from the next source of rest and replenishment.[79] Above all, an imperial itinerary is likely to have followed the route of the public communication and transport system—the cursus publicus. Moreover, the towns along the way, which were to provide the fit and fed animals and vehicles for transport from one place to the next, needed to know when their service would be required by the emperor and his party. Justinian and his officials would have sent the requisite advice ahead by imperial courier, not unlike the process outlined by the emperor Severus Alexander in the third century. Two months before the imperial journey, the emperor Severus published an edict outlining his travel plans. His edict specified "on that day, at that hour, I shall go forth from the city and, if the gods allow it, I will stay in the first station, detailing then the stations one after another, then the camps, and then where the provisions are to be had," all the way to his destination.[80] Again, Justinian is likely to have done something similar around August 563. The places through which the emperor himself would be passing through, or staying at overnight, needed

31 [1977]: 50–51), while his son Theodosius II had once traveled as far as Aphrodisias (Theodosius II, *Novellae* 23).

76 Constantine Porphyrogenitus, *Book of Ceremonies*, book 1, appendix 1 (Moffatt and Tall, *Constantine Porphyrogennetos*, 455–97). Roman emperors had always been subject to thorough planning for any imperial journey: F. Millar, *The Emperor in the Roman World (31 BC–AD 337)* (London, 1977), 28–40, and H. Halfmann, *Itinera principum: Geschichte und Typologie der Kaiserreisen im Römischen Reich* (Stuttgart, 1986).

77 Constantine Porphyrogenitus, *Book of Ceremonies*, book 1, appendix 1(Moffatt and Tall, *Constantine Porphyrogennetos*, 445–54). The precise implications of such a journey are detailed in Hendy, *Studies*, 304–15.

78 K. Belke, "Prokops *De Aedificiis*, Buch V, zu Kleinasien," *AntTard* 8 (2000): 122.

79 K. Brodersen, "The Presentation of Geographical Knowledge for Travel and Transport in the Roman World: Itineraria non tantum adnotata sed etiam picta," in *Travel and Geography in the Roman Empire*, ed. C. Adams and R. Laurence (London, 2001), 7–21.

80 *Hist. Aug. Alex. Sev.* 45.2–3.

to know in advance and ensure that adequate accommodation and provisions were available. To judge from the preparations made for the announced stay of the emperor Diocletian at Egyptian Panopolis in September 298, planning needed to cover not only suitable accommodation for the emperor but also the supply of meat, bread, wine, and vegetables for his sizable military escort.[81]

Over recent decades as emperor, Justinian had often spent time immersed in plans and approving projects to modify and upgrade the roads and bridges of Asia Minor and other parts of the empire, with a view to creating a more efficient and reliable transport system for imperial purposes.[82] Procopius's *Buildings*, completed before Justinian's journey to Germia even at the latest possible date for its composition (c. 560), is rich testimony to this program. Underlying the emperor's clear and systematic approach was the quest to make the highways faster and safer for the imperial officials and especially the army as it ventured back and forth between Constantinople and the eastern frontier regions of Armenia and Mesopotamia. In reality, the Justinianic road system with its strong bridges served the needs of the court and imperial business for the ensuing millennium.[83] For the first and only time for Justinian, the emperor would now benefit himself from all these improvements in roads and bridges.

Sometime by October 563, with all due preparations in place, Justinian and his entourage started out from Constantinople, probably from the Harbor of Julian. Their nearest imperial abodes and safe harbors were directly across the Bosporus. Chalcedon was a regular starting point for pilgrims setting out across Asia Minor to Palestine, as well as imperial administrative

and military officials on business.[84] Hieria on the Fenerbahçe peninsula had been extensively rebuilt by Justinian as a favorite place of his wife, Theodora. It was now the major harbor for emperors and imperial expeditions such as Justinian's to Germia in 563.[85] It is likely therefore that the emperor and his party spent the first night of their journey at Hieria. Otherwise, they might have put in further along the Asian coast at Rufinianai (modern Caddebostan), where there was an imperial palace, though not a large harbor.

Whether direct from Constantinople, or from the palace at Hieria, the long and complex travel train of people and imperial accoutrements was ferried across the Sea of Marmara, before inching its way overland to Ankara. The imperial boats and barges that occasionally transported the emperor on short journeys around the perimeter of the imperial city, or up the Bosporus to a summer palace, were now to take Justinian away from the neighborhood of Constantinople with great flourish. Precisely where they docked to commence the overland journey can only be guessed. Perhaps it was at Pylai (modern Yalova), where, thirty years before, the empress Theodora had been accompanied by an entourage of four thousand officials when she visited the hot springs at nearby Pythia.[86] The emperor Justinian's party in 563 may not have been as large but could still have numbered in the hundreds. At Pythia there was actually a new palace, baths, and aqueduct, plus a shrine of the Archangel Michael built or renovated by Justinian and Theodora in the 530s or 540s.[87] It may have been considered worth a detour if the imperial party landed elsewhere. Later Byzantine emperors, generally more mobile than Justinian had ever been, tended to make their Asian landfall at Pylai.[88]

81 T. C. Skeat, *Papyri from Panopolis in the Chester Beatty Library in Dublin* (Dublin, 1964), 1–55, with reference to *Panop.Beatty* 1.

82 A. Kolb, *Transport und Nachrichtentransfer im römischen Reich* (Berlin, 2000), 223–25.

83 W. M. Ramsay, *The Historical Geography of Asia Minor* (London, 1890), 78–79 (stressing the important role of Justinian), and K. Belke, "Transport and Communication," in *The Archaeology of Byzantine Anatolia: From the End of Late Antiquity until the Coming of the Turks*, ed. P. Niewöhner (Oxford, 2017), 28–38. Much can be relevantly applied to Justinian's trip through Bithynia and Galatia to Germia from J. Haldon, "Roads and Communications in the Byzantine Empire: Wagons, Horses, and Supplies," in *Logistics of Warfare in the Age of the Crusades*, ed. J. H. Pryor (Aldershot, 2006), 131–58.

84 K. Belke, "Tore nach Kleinasien: Die Konstantinopel gegenüberliegenden Häfen Chalkedon, Chrysopolis, Hiereia und Eutropiu Limen," in *Die byzantinischen Häfen Konstantinopels*, ed. F. Daim (Mainz, 2016), 162–65.

85 Procopius, *Buildings* 1.11.18–21, and Belke, "Tore nach Kleinasien," 167–79.

86 Malalas, *Chronicle* 18.25 (Thurn, *Chronographia*, 368; Jeffreys, Jeffreys, and Scott, *Chronicle*, 256).

87 Procopius, *Buildings* 5.3.16–20.

88 Constantine Porphyrogenitus, *Book of Ceremonies*, book 1, appendix 1 (Reiske, *De Ceremoniis*, 474; Moffatt and Tall, *Constantine Porphyrogennetos*, 474), and C. Mango, "The Empress Helena, Helenopolis, Pylae," *TM* 12 (1994): 155–58.

More likely as a landing point for Justinian and his entourage, however, was Helenopolis (modern Hersek), twenty kilometers east of Yalova, which was so silted up in later times that imperial expeditions could never use it. Helenopolis would have enabled the imperial fleet to sail close to the Asian coast before effecting a short crossing inside the Gulf of Nicomedia. Justinian had already turned the town into a major port and juncture for travel to and from Constantinople.[89] Indeed, in an invective mood, Procopius could castigate Justinian for neglecting the road links to Nicomedia by preferring the sea route from the city.[90] Now Justinian could see firsthand the new aqueduct that had secured the water supply of Helenopolis, as well as the baths and other facilities already built under his auspices. The town now had a palace as well, and Justinian would be the first emperor ever to stay there.[91] Certainly, it provided an appropriate venue to rest and stock up before the long inland part of the journey to Germia. From Helenopolis, the imperial party would have traveled to Nicaea, crossing over the new bridges that had mitigated the regular danger from the rushing Draco River[92] and arriving in the city through the still-preserved Istanbul Gate. At Nicaea, Justinian could see the aqueduct that had been rebuilt in recent years and traces of which still survive, as well as the churches and monasteries the emperor had built and the restored baths used by imperial couriers. The emperor and his party would have been accommodated at Nicaea's renovated palace.[93]

From Nicaea, there were basically two ways of reaching as far as Germia. Certainty is not attainable, but there is value in tracing the likely route taken by Justinian's expedition. The first and most direct route involved tracking south of Nicaea across to Dorylaeum (modern Eskişeher), then on to the road leading to Germa/Germakoloneia, and from there toward the Dindymon mountains through Eudoxias to Germia. This would involve reaching Dorylaeum from Nicaea either by the road through modern Bilecik and Bozöyük, or that through modern İnegöl and Pazaryeri.[94] In either case, although shorter, this would be the more topographically difficult route, with steep river valleys, and the less comfortable route for Justinian and his party because they would be traveling partly on inferior roads for a considerable part of the way. The second, less direct route was to travel east of Nicaea to Ankara, using the familiar "Pilgrim's Route" and finally down to Germakoloneia (near modern Babadat), then across to Germia (Fig. 1).[95] As a young soldier, Justinian may have traveled along the road to Ankara on his way further east with a Roman army contingent. However, he had not done so for half a century or more, certainly not since he became emperor and initiated various improvements to the road and its bridges.[96] Whether he insisted or not, this route was certainly more comfortable and manageable for the emperor, a better road with better facilities along the way. It was the highway that routinely saw imperial officials, both civilian and military, dignitaries and merchants, sometimes bishops and clergy, traveling on the public communications and transport system (cursus publicus) with its regular staging posts for changing horses (mutationes) and well-stocked inns for resting overnight (mansiones).[97] For these reasons, it is the more likely route for Justinian's journey to Germia. Hence, it is the route presumed here and followed in some detail, especially as it helps

89 Ramsay, *Historical Geography*, 187–88, and Belke, "Prokops *De Aedificiis*," 118.

90 Procopius, *Secret History* 30.8–9.

91 Procopius, *Buildings* 5.2.1–5.

92 Procopius, *Buildings* 5.2.6–13, and J. Lefort, "Les communications entre Constantinople et la Bithynie," in *Constantinople and Its Hinterland*, ed. C. Mango and G. Dagron (Aldershot, 1995), 212–15.

93 Procopius, *Buildings* 5.3.1–3.

94 K. Belke, *Galatien und Lykaonien*, TIB 4 (Vienna, 1984), 105–6, and Belke, "Prokops *De Aedificiis*," 122.

95 Calculated from data available at *Orbis* (orbis.stanford.edu). The known itineraries do not include Germia but do provide for nearby Germa/Germakoloneia where the road from Ankara crosses with that from Dorylaeum. Travelers to Germia would have diverted there for Eudoxias, then Germia. For the location, see Belke, *Galatien*, 166–68, 247, and R. J. A. Talbert et al., eds., *Barrington Atlas of the Greek and Roman World* (Princeton, 2000), map 62 (G3). Although it remains a trap for the unwary, the clear distinction between Germa/Germakoloneia and Germia was cleared up by M. Waelkens, "Germa, Germokoloneia et Germia," *Byzantion* 49 (1979): 447–64.

96 It has been proposed in C. Koehn, "Justinian στρατηγός," in *Le monde de Procope/The World of Procopius*, ed. G. Greatrex and S. Janniard (Paris, 2018), 222–24, and C. Koehn, *Justinian und die Armee des frühen Byzanz* (Berlin, 2018), 63–64, that Justinian might also have traveled this road as *Caesar* and *magister militum* in 525/526 on his way to supervise military operations in Armenia, but the argument is highly speculative.

97 Belke, "Transport and Communication," 28–38.

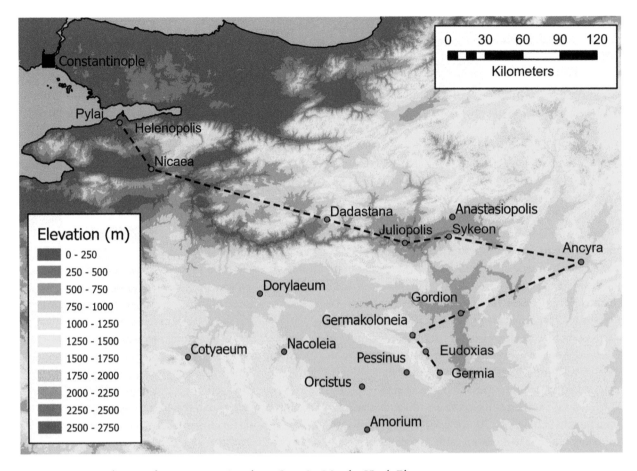

Fig. 1. Justinian's route from Constantinople to Germia. Map by Hugh Elton.

illuminate the relevance to Justinian of various points along the way.

The overland journey would have taken a minimum of around seventeen to eighteen days of traveling time, with the emperor presumably riding on horseback, perhaps even in a carriage or litter for part of the way. He would have been accompanied along the way by local dignitaries as well as his own permanent escort and rested overnight at imperial villas and specially prepared staging posts. Moreover, his route took in some of the most important cities of the East, such as Nicaea and Ankara, as well as Juliopolis and Germakoloneia. At all these places, Justinian would have been formally welcomed and feted. No city along the route had experienced a ceremonial imperial arrival (*adventus*) or departure (*profectio*) in living memory. Welcoming and hosting the emperor and his party was a momentous occasion locally, both for the hosts and for the local

aristocracy now given resident access to power.[98] Even for the traveling Justinian, imperial business constantly required attention. It was only to be expected that local towns and local aristocracies would take advantage of the emperor's presence and expect him to demonstrate his authority accordingly, just as Theodosius II was obliged to do at Heraclea in 443.[99] The civic and imperial officials would never have imagined they would have the opportunity to entertain the Roman emperor in their own town, and certainly not in his eighties. Since 527, they had known the emperor from his coins, and from the gold coins (solidi), they were familiar with the intimate connection of victory between Justinian

98 Millar, *Emperor*, 28–40, 640. In fact, the "the emperor functioned as a sort of moving capital of the empire in himself" (Millar, *Emperor*, 39).

99 Millar, *Emperor*, 38.

and Archangel Michael, which they would have easily taken to be the angel on the solidus reverse. So it would hardly surprise them to discover that the destination of Justinian's unexpected journey was to a place such as Germia that was firmly associated with Michael.

Normally, it would take ten days to cover the distance between Nicaea and Ankara, the longest stretch of the emperor's journey. According to the available itineraries, it involved a total of twelve stopovers (mansiones) with several intermediate stops to rest and change horses. This rate of slightly more than one mansio per day may not have applied to the emperor and his entourage, who would also have been carrying comfortable tents for their accommodation. When setting up tents inside a fortified camp, the emperor's space was protected by armed guards. Admittance beyond them required the current day's password, which could be "Archangel Michael."[100] The emperor's party might be expected to have covered one mansio per day, every day, thereby taking twelve days of traveling time between Nicaea and Ankara.

As already noted, anyone planning a journey from Nicaea to Ankara in the sixth century would have consulted and kept handy a list of the stopping points and cities along the route, together with the distance between each point readily recorded from Roman milestones. Several such lists are extant, including the earliest, known as the *Itinerarium Antonini*, followed by the later *itineraria* that formed part of an overall pilgrim journey to the Holy Land. Such a list may also have been used as the basis for publishing an advance outline of the proposed imperial journey in 563, if Justinian followed the imperial precedent illustrated by Severus Alexander and Constantine. For this section of the route, the itinerary of the fourth-century Bordeaux pilgrim runs as follows, with Roman miles expressed in closest approximate kilometers:[101]

From Nicaea to the change (mutatio) at Schine, eight miles (11.9 kilometers)

To the stopping place (mansio) at Midus (Moedos), seven miles (10.4 kilometers)

To the change at Chogea, six miles (8.9 kilometers)

To the change at Thatesus, ten miles (14.8 kilometers)

To the stop at Tutadus (Tottaion), nine miles (13.4 kilometers)

To the change at Protoniaca, eleven miles (16.3 kilometers)

To the change at Artemis, twelve miles (17.8 kilometers)

To the stop at Dableis, six miles (8.9 kilometers)

To the stop at Ceratae, six miles (8.9 kilometers), actually ten miles (14.8 kilometers)[102]

To the change at Fines (Bithynia/Galatia provincial boundary), ten miles (14.8 kilometers)

To the stop at Dadastana, six miles (8.9 kilometers), actually eleven miles (16.3 kilometers)[103]

To the change at Transmonte, six miles (8.9 kilometers), actually eleven miles (16.3 kilometers)[104]

To the change at Milia, eleven miles (16.3 kilometers)

To the stop at Juliopolis, eight miles (11.9 kilometers)

To the change at Hieronpotamon (Hieros/Siberis River), thirteen miles (19.3 kilometers)

To the stop at Lagania (Anastasiopolis), eleven miles (16.3 kilometers)

To the change at Petrobrogen, six miles (8.9 kilometers)

To the stop at Mnizos, ten miles (14.8 kilometers)

To the change at Prasmon, twelve miles (17.8 kilometers), actually seven miles (10.4 kilometers)[105]

100 Constantine Porphyrogenitus, *Book of Ceremonies*, book 1, appendix (Moffatt and Tall, *Constantine Porphyrogennetos*, 481). Other possible passwords were "the Savior" or the "Theotokos."

101 The route is traced through the comparative analysis of the *Itinerarium Antonini*, the Bordeaux Pilgrim, and the *Tabula Peutingeriana*, as set out (with their modern place-names where known) in D. H. French, *Roman Roads and Milestones of Asia Minor*, vol. 4, *The Roads*, fasc. 1, *Notes on the* Itineraria (Ankara, 2016), 21, table 2. See also Belke, *Galatien*, 95–96, 104–5.

102 As corrected by Belke, *Galatien*, 164.

103 As corrected by D. H. French, *Roman Roads and Milestones of Asia Minor*, fasc. 1, *The Pilgrim's Road* (Ankara, 1981), 106, table 3 (a), n. 1, and Belke, *Galatien*, 164.

104 As corrected by French, *Roman Roads*, fasc. 1, 106, table 3 (a), n. 3, and Belke, *Galatien*, 237.

105 As corrected in Belke, *Galatien*, 207.

To the stop at Manegordo, nine miles
 (13.4 kilometers), actually fourteen miles
 (20.7 kilometers)[106]

To the change at Cenaxis Palus, thirteen miles
 (19.3 kilometers), actually six miles
 (8.9 kilometers)[107]

To the stop at Ankara, thirteen miles
 (19.3 kilometers), actually six miles
 (8.9 kilometers)[108]

This is the route the emperor and his party would have followed between Nicaea and Ankara, but rather than travel as much as twenty-five or twenty-nine miles in a single day, the imperial party may have split these parts of the journey across two days, or sometimes covered two sections in one day. They would have noted the first- to fourth-century milestones of rounded limestone that marked off their journey as they traversed each mile, further and further on from Nicaea, the start of the road (caput viae).[109] The milestones generally gave an emperor's name and titulature in Latin while the distance was recorded in both Latin and Greek. Traveling fifteen miles on the first day and stopping at Midus, twenty-five miles on the second day of travel stopping at Tutadus, twenty-nine miles to Dableis, ten miles to Ceratae, then to the Galatian border town of Fines (near modern Ericek), followed by 11 miles to Dadastana then thirty miles to Juliopolis, which marked the end of the road from Nicaea.

Along the way, milestones denoted the progressive distance from Juliopolis all the way to Ankara.[110] Earlier, as part of the upgrading of this road that was so significant for the Roman army and administration, not to mention bishops and pilgrims, Justinian had a bridge built over the Skopas River that he now crossed himself.[111] At Juliopolis, now certainly identified as near modern Çayırhan, thirty-five kilometers east of Nallıhan and 110 kilometers west of Ankara, Justinian

arranged for strengthening of the city walls that were being eroded by the nearby Skopas River (modern Aladağ Çayı).[112] At the right time of year, he might have taken part in the all-night vigil at Juliopolis for St. Heuretus.[113] Nowadays, Juliopolis lies below the waters of the artificial Sarıyar Dam, although various inscriptions and architectural remains were retrieved before its submergence.[114] From Juliopolis, it was another twenty-four miles to Anastasiopolis (modern Dikmen Höyük). Missing from the fourth-century itinerary between Juliopolis and Anastasiopolis, but part of the route by 563, was Sykeon, only recently established as the modern village of Kiliseler.[115] If the emperor planned to stop at Sykeon, as would appear likely, he would have covered thirteen miles that day. From Anastasiopolis, a sixteen-mile journey brought the imperial party, via Petrobrogen, to the overnight stay at Mnizos.[116] Twenty-one miles from there they came to the next stop at Manegordo (modern Avdan), via Prasmon, which was twelve miles and at least a day's journey from Ankara.[117] The final stopping place before Ankara was Cenaxis Palus (possibly Çakırlar Çiftliği), which was six miles away.[118]

At Ankara, Justinian could be reminded of provincial reforms over recent decades that influenced the city as a provincial capital.[119] From Ankara, the imperial party would have taken the road in a southwesterly direction toward the town of Germa, also called Germakoloneia, which was a reminder that it

106 As corrected by French, *Roman Roads*, fasc. 1, 40, fig. 6, n. 8.

107 As corrected in Belke, *Galatien*, 151.

108 As corrected by French, *Roman Roads*, fasc. 1, 40, fig. 6, n. 9.

109 For the extant milestones, see D. H. French, *Roman Roads and Milestones of Asia Minor*, vol. 3, *Milestones*, fasc. 3.4, *Pontus et Bithynia* (Ankara, 2013).

110 French, *Roman Roads*, fasc. 3.4, 145, no. 93 (two miles); 146, no. 94 (eight miles); 144, no. 92 (nine miles).

111 Procopius, *Buildings* 5.4.1–4.

112 F. Onur, "Epigraphic Research around Juliopolis I: A Historical and Geographical Overview," *Gephyra* 11 (2014): 69.

113 *Vita Theodoris Sykeonis* 13 (cf. Onur, "Epigraphic Research," 70).

114 Belke, *Galatien*, 181–82, with inscriptions conveniently collected in Onur, "Epigraphic Research," 76–78.

115 D. Barchard, "Sykeon Rediscovered? A Site at Kiliseler near Beyparazı," *AnatSt* 53 (2003): 175–79. The best explanation for Sykeon's absence from the fourth-century itinerary is that it was actually the mutatio nearest the crossing of the Hieros/Siberis River, called "Hieronpotamon" in the *Peutinger Table* (and therefore the *Barrington Atlas*). So it was Hieronpotamon where Justinian crossed the bridge built just a few years prior (in 560/1): Belke, "Prokops *De Aedificiis*," 119.

116 Mnizos: French, *Roman Roads*, fasc. 1, 110; Belke, *Galatien*, 207; and Petrobrogen: French, *Roman Roads*, fasc. 1, 110; Belke, *Galatien*, 215.

117 Manegordo: French, *Roman Roads*, fasc. 1, 112; Belke, *Galatien*, 201; and Prasmon: French, *Roman Roads*, fasc. 1, 112; Belke, *Galatien*, 216–17.

118 Cenaxis Palus: French, *Roman Roads*, fasc. 1, 112, and Belke, *Galatien*, 151.

119 Foss, "Ankara," 56–58.

was a colony established long ago by Augustus. Here the route is less certain because it was not part of the Pilgrim Route left behind by Justinian when it took an easterly turn from Ankara toward Cappadocia and beyond. Still, the main route can be reconstructed from the available itineraries. Justinian's party would have traveled thirty-two miles from Ankara to Papira (near modern Aliköy),[120] then twenty-four miles from Papira to Gordion (modern Yassıhüyük),[121] and a further twenty miles from Gordion to Germakoloneia (ruins near modern Babadat).[122] This section may have taken up to five days of travel. It is from Germakoloneia that Justinian and his entourage diverted across to Eudoxias and on to Germia, a final day's journey of seventeen miles (twenty-eight kilometers), although an overnight stay at Eudoxias is not unlikely.[123] It was the inhabitants of Eudoxias and nearby Goeleon who walked most frequently to Germia. The total distance covered since Ankara was ninety-three miles (150 kilometers). After about twenty days of hard travel in October 563, the imperial entourage would have arrived at Germia.

The Emperor at Germia

Only recently has Germia been properly surveyed, explored, studied, and documented.[124] Rather than repurposing the site of a pagan healing shrine, so common in that part of Anatolia, Officials evidently established Germia as a specifically Christian healing shrine

at the nearby thermal springs.[125] An association with Archangel Michael may date from the fourth century, with the existence of the sacred healing pool at Germia perhaps explained by a miraculous geophysical intervention by the archangel. By Justinian's time, it was a healing shrine of Archangel Michael that drew pilgrims from far and wide, just like the emperor himself. The Michael church, expanded not long before, was now the largest church in central Anatolia.[126] The original church construction was initiated in the mid-fifth century by a Constantinopolitan aristocrat and consul named John Studius. He was the same person responsible not only for another Michael church, at Phrygian Nakoleia,[127] but also for the Stoudion church and monastery at Constantinople, which was constructed around the same time, that is, in the middle of the fifth century.[128] Studius's connection with this faraway Galatian shrine arose from his discovery at Constantinople of the healing properties of the sacred water brought to the capital by a citizen of Goeleon (modern Kayakent), near Germia. Cured of his ailment, Studius then made his own pilgrimage from Constantinople to Germia and arranged to build a church and hospital on the spot of Michael's miracle and its healing waters.[129] By Justinian's day, Germia and its church were well-known to any devotee of the archangel.

Today, the remains of the Michael church are scattered across no less than ten seemingly disconnected sections, but all are now acknowledged as part of the same large building. The Michael church comprised a two-story narthex, five aisles, a vaulted ceiling, and associated buildings. Research on the building has identified three distinct phases of construction at different periods: (1) an original three-aisled basilica built by Studius around 450, with alternate layers of brick and limestone but with brick arches that denote a Constantinopolitan style; (2) a local construction from the sixth century, turning the north and south walls

120 Belke, *Galatien*, 106.

121 Belke, *Galatien*, 117.

122 Belke, *Galatien*, 168–69. Germia's location was confirmed by Belke, *Galatien*, 166–68. Henri Grégoire had come to a similar conclusion earlier (reported in Honigmann, "Atlas byzantine," 548–53).

123 Eudoxias: Belke, *Galatien*, 163.

124 Niewöhner, "Germia and Vicinity"; Niewöhner et al., "Bronze Age Höyüks"; Niewöhner, "Germia"; and Niewöhner, "Healing Springs" build on the firsthand appreciation of Germia by Cyril Mango in 1982, resulting in seminal articles and photographs: Mango, "St. Michael and Attis," and C. Mango, "The Pilgrimage Centre of St. Michael at Germia," *JÖB* 36 (1986): 117–32. An evocative glimpse of Mango, pipe in hand, picking the brains of the local men about the remains at Gümüşkonak (Germia) in 1982, forms the frontispiece to I. Ševčenko and I. Hutter, *Ἀετός: Studies in Honour of Cyril Mango* (Stuttgart, 1998), just as later researchers discovered the locals were crucial sources of information for Germia and its surrounding district (Niewöhner et al., "Bronze Age Höyüks," 98–99). A striking reminder of the value of such local knowledge, even today, is the search for Sykeon (Barchard, "Sykeon Rediscovered?").

125 Even so, it has been suggested that Michael took over responsibility for healing, formerly attributed to the local god Mēn (Niewöhner, "Healing Springs," 122–24).

126 Niewöhner, "Germia and Vicinity," 48.

127 Niewöhner and Rheidt, "Michaelskirche," 135.

128 C. Mango, "The Date of the Studius Basilica at Istanbul," *BMGS* 4.1 (1978): 115–22.

129 For details, see Mango, "St. Michael and Attis," 51–59.

into arcaded aisles, probably by way of repair following serious damage but changing the character of the building to make it more Anatolian in design; and (3) a significant post-Justinianic enlargement and the creation of a dome to make it a fully cross-in-dome layout, perhaps coincident with the establishment of Germia as an autocephalous archbishopric in the seventh century.[130] It is the second of these phases that occurred in the time of Justinian.

Two decades previously, well before the death of Theodora in 548, Justinian and Theodora had been actively involved in building at Germia. The precise origin of the extant large capital containing their carved monograms is unclear, but it may derive from the rebuilding of this very church in the 530s or 540s, that is, before Theodora's death in 548.[131] What is clear is that there was a new phase of construction at this time, adding extra aisles to presumably accommodate increasing crowds coming to the church. If so, the plans for the church and the monitoring of its construction and opening were dealt with by the emperor in his palace at Constantinople, even though the design and the materials used (both limestone and marble) were local. Theodora's role should not be exaggerated. In the quest to magnify all the foundations to which the empress Theodora can be attached, much is made of the city of Germia being later called "the city of Theodora/the Theodorans" (θεοδωριατῶν . . . πόλις). Yet, it is misleading to claim that this was always an alternative name of Germia.[132] Not only does the first use of the name not come before 692 in the subscription of Bishop Moses at the Council in Trullo at Constantinople,[133] but it also requires the unlikely emendation of the "Bithynia" (Βιθυνῶν) of all seventy-two manuscripts used for the standard edition of the council's record to "Galatia II" (δευτέρας τῶν Γαλατῶν).[134] Further, according Theodora priority over her imperial husband in the building of the church 150 years after her death seems unlikely.

The columns and their capitals—in fact, most of the materials from which the church was constructed—were quarried and shaped locally. The surrounding hills provided the limestone and part of the large amount of marble, with the remainder brought in from further away. Apart from the Michael church, there was another domed church at Germia, perhaps dedicated to St. Sergius, but probably built after Justinian's time.[135] So, too, it was probably long after 563 that the local bishop, Aemilianus, acquired his relics of St. George. Later, he invited Theodore of Sykeon to Germia for the express purpose of acquiring the relics for his church of St. George at Sykeon. First, he prayed with Aemilianus in the Michael church.[136]

Germia was never a major town, but with its Michael church it remained predominantly a pilgrimage

130 Niewöhner, "Germia and Vicinity," 50, and Niewöhner et al., "Bronze Age Höyüks," 128–29. This construction was presumably undertaken after what appears to be the only, and temporary, capture of Germia by an Arab military contingent in 668 (Niewöhner, "Germia," 348).

131 What is unclear is whether the extant capital with a monogram of both Justinian and Theodora carved into it came from an expansion program for the Michael church around this time, or some other building altogether: Mango, "St. Michael and Attis," 52; Niewöhner and Rheidt, "Michaelskirche," 143, 151; and Niewöhner et al., "Bronze Age Höyüks," 98. On balance, however, it is more likely than not to have been part of the church: see A. V. Walser, "Germia: Ein anatolischer Pilgerort in byzantinischer Zeit," in *Für Seelenheil und Lebensglück: Das byzantinische Pilgerwesen und seine Wurzeln*, ed. D. Ariantzi and I. Eichner (Mainz, 2018), 177; Niewöhner, "Germia and Vicinity," 48; and I. Garipzanov, *Graphic Signs of Authority in Late Antiquity and the Early Middle Ages, 300–900* (Oxford, 2018), 184 (in the context of the wider use of the monograms of Justinian and Theodora, and of Justinian alone, at Constantinople and elsewhere).

132 U. Unterweger, "The Image of the Empress Theodora as Patron," *WJKg* 60.1 (2012): 101, and M. Ritter, *Zwischen Glaube und Geld: Zur Ökonomie des byzantinischen Pilgerwesens (4.–12. Jh.)* (Mainz, 2019), 35.

133 H. Ohme, *Das Concilium Quinisextum und seine Bischofsliste: Studien zum Konstantinopeler Konzil von 692* (Berlin, 1990), 67.14–15, subscription 39.

134 Other than a possible analogy with "the metropolis of Justinianopolis or Mokissos" (Ohme, *Concilium Quinisextum*, 66.15–17, subscription 30), the sole reason for this radical emendation seems to be that by 692 the Galatian Germia was an autocephalous bishopric where a monogram of Theodora could be found. This emendation remains problematic because (1) it is the only locational emendation required for the 226 episcopal subscriptions and (2) θεοδωριατῶν may be an epithet (such as "God-given"), rather than necessarily a person's name, but if so, Theodoros, the holy man from Sykeon, has an equal association with Germia as does Theodora. Germia is given the name "Theodorou" by the editor of the subscriptions to the Council in Trullo (Ohme, *Concilium Quinisextum*, 116, 117, 126), but "Theodorou" is evidently not otherwise attested for any location in Galatia II, let alone Germia.

135 Niewöhner, "Germia," 346.

136 *Vita Theodoris Sykeonis* 100–101. The relics (part of George's skull, a finger, and a tooth) were not necessarily housed in the Michael church at that point. They were evidently the private possession of the local bishop, Aemilianus.

center with no evidence of early decline. It was primarily a place of healing. Other buildings at Germia, including terrace walls, have also been identified, surveyed, and analyzed to some extent in recent times, but their extant remains are generally part of more modern houses and other constructions.[137] The city also had a palatial residence for the bishop and important guests. No guest could be more important than the emperor. The bishop's palace was probably where Justinian himself stayed.[138] If Menas was the bishop of Myriangeloi when Justinian visited in 563, then they may both have been renewing an acquaintanceship from the Council of 553 in Constantinople. At that time, the see was a suffragan of the metropolitan at Pessinus, twenty kilometers to the west. In fact, as it turned out, Menas was the only bishop of his province (Galatia II) at the council, although he is only ever referred to as "bishop of Myriangeloi," not as representing the province. The metropolitan bishop of Pessinus was absent either though illness or a vacant see.[139]

Then there was the large pool including the healing fishpond of Michael, but recent research at Germia has found nothing to substantiate Cyril Mango's hypothesis of a prior healing pool of the god Attis there.[140] The pool was the source of the health-restoring water that Studius discovered in Constantinople and that prompted his productive relationship with Germia more than a century before Justinian's visit. It was the reason most people came there. Unlike other nearby Roman settlements, there are no pre-Roman gravestones and inscriptions at Germia itself.[141] Germia may have been a small settlement, but it came to have large

necropoleis. This means that a great number chose to be buried near the shrine of Michael. Honoring the memory of the local dead brought many more pilgrims there.[142] Among the legible grave inscriptions are some for local craftsmen (goldsmith, blacksmith), while another mentions the previously unknown monastery of Constantine.[143] There were also other monasteries near Germia, and the remains of one have been identified as that of the Virgin Mother of God, or the monastery of Aligete.[144] Inscriptions at Germia itself are rare, but two of them illustrate Michael's attraction, both commemorating imperial government officials who presumably died on pilgrimage in Germia: one was Phokas, a *scriniarius* from Constantinople,[145] the other Soterichus, "having completely devoted himself to the commander in chief" (τῷ ἀρχιστρατήγῳ ἑαυτὸν ὅλον παραδούς), according to his tombstone.[146] On his visit to Germia, Justinian would have been accompanied by many officials of all ranks. Phokas may have been among them, or he may have been a private pilgrim on some other occasion.[147]

How long Justinian spent at Germia in October/November 563 is unknown, but we might safely assume a few days, if not longer. He would have attended a divine liturgy in the Michael church. One such celebration was surely that on 8 November 563, which would have been the annual feast day of Archangel Michael at Germia. Justinian was used to celebrating that day at Constantinople, and by 535, it was already an annual feast at Oxyrhynchus.[148] Presumably, the emperor's presence also attracted the citizens of nearby

137 Niewöhner, "Germia and Vicinity," 51–52.

138 Niewöhner, "Germia," 345.

139 Details in E. Chrysos, *Die Bischofslisten des V. öcumenischen Konzils* (Bonn, 1966), 87–88. By the 530s, Germia is listed as a provincial town of Galatia II under Pessinus in Hierocles, *Synecdemus* 698.4 (G. Parthey, *Hieroclis Synecdemus et notitiae graecae episcopatuum* [Berlin, 1866], 36). By 630 (the earliest reference), Myriangeloi had been removed from the authority of the metropolitan bishop of Pessinus to become a self-governing bishopric, directly responsible to the patriarch at Constantinople (Ohme, *Concilium Quinisextum*, 268–69). This elevated episcopal status may have been a consequence of Justinian's visit there in 563.

140 Mango, "St. Michael and Attis," 55–57, and Niewöhner, "Germia and Vicinity," 54; cf. Cline, *Ancient Angels*, xvi–xvii.

141 The most up-to-date and complete collection of inscriptions is A. V. Walser, "Kaiserzeitliche und frühbyzantinische Inschriften aus der Region von Germia in Nordwestgalatien," *Chiron* 43 (2013): 527–619.

142 Niewöhner, "Healing Springs," 113.

143 Niewöhner, "Germia and Vicinity," 55.

144 Niewöhner, "Germia," 347.

145 Mango, "Pilgrimage Centre," 129–30, no. 7 (reading "Thomas," but it's better translated as "Phocas"); Niewöhner, "Healing Springs," 112; and Walser, "Inschriften," 580.

146 Mango, "Pilgrimage Centre," 126–27, no. 1, and P. Nowakowski, *Cult of Saints*, E01005, http://csla.history.ox.ac.uk/record.php?recid=E01005.

147 Walser, "Inschriften," 581. Incidentally, there are no sixth-century seals from Germia. The oldest is from the seventh century and shows Michael with a staff and globe (Cotsonis, *Religious Figural Imagery*, 109), just as on Justinian's coins but not on seventh-century coins.

148 *POxy*. 1357, col. 2, line 8: εἰς τὸν ἅγι(ον) Μιχαηλᾶ ἡμέρα αὐτοῦ (cf. A. Papaconstantinou, "La liturgie stationnale à Oxyrhynchos dans la première moitié du 6ᵉ siècle réédition et commentaire du POxy. XI 1357," *REB* 54 [1996]: 14, col. 2, lines 8–9).

Eudoxias and Goeleon to visit and share in the celebrations as they were known to do regularly. Sometime later, Theodore of Sykeon took part in the assembly at Michael's church of the citizens of Eudoxias and Goeleon,[149] remembering again that it was people from Goeleon in Constantinople who had persuaded John Studius of the importance of Germia's healing waters in the first place.[150] Although it was not personal health reasons that primarily attracted Justinian to Germia in 563, he could still reap the rewards, spiritual and physical, of being a pilgrim like any other. He probably therefore spent time in the healing pool, allowing his aging flesh to be nibbled by the fish. These were the special "doctor fish" (*Cyprinion macrostomum*), flourishing in a warm pool with high levels of hydrogen sulphide. Also present, given its location, was restorative solar radiation.[151] While Justinian came to Germia to fulfill his vow of gratitude to Michael for the protection of the archistrategos when his sovereignty was seriously threatened in November 562, he could also feel fortified and renewed by the usual blessings of pilgrimage.

Return to Constantinople

Presumably, Justinian and his party traveled back to Constantinople by the same route that brought them to Germia (Fig. 1). Although possible, there is no evidence that their return journey involved taking a different route, that is, a more direct route that would lead them along the main road to Dorylaeum and beyond there by the more difficult roads to Nicaea.[152] From Germakoloneia, the imperial party traveled back to Ankara, and from Ankara via all the same places along the road to Nicaea. Again, on reaching Helenopolis, the imperial party boarded the barges and ferries taking them across the water toward Constantinople. On Justinian's return to the capital, again as recorded for

later times but probably no less valid for Justinian's time, his party would have been met by the city prefect on the Asian side of the Bosporus.[153] In late November 563, the city prefect may have been Andreas, who had come under fire earlier in the year when set upon by the Greens during the fierce faction riots in the city.[154] From there, Justinian could have crossed the Bosporus and come up to the Strategion forum or sailed directly into the palace's own landing wharf. Either way, he was met on arrival by the city prefect, Andreas, again.

In retrospect, it appears that Justinian left for Germia early in October 563, began the return journey around 9 November, and was back in Constantinople in late November.[155] Greater precision is not likely. All in all, the journey from Constantinople to Germia may have taken around twenty days. On top of that is the time spent in Germia itself. The return journey is not likely to have taken any less time than the outward journey, even with a small imperial party, and even though Justinian would not have been expected to spend so much time in the major towns along the route as he had done on the way there. If, as suggested here, Justinian left Germia around 9 November 563, he could have reached Constantinople on the last day or two of the month. At a rough estimate, the emperor was away from Constantinople for around fifty to fifty-five days. For all that period, he may well have left responsibility for managing the security of the city and palace to the proven hand of his nephew and imperial successor, Justin. Indeed, this interlude may have strengthened Justin's claim as the likely emperor after his uncle. He was not a Caesar, as Justinian once was to Emperor Justin in 525, but he did hold the unique

149 Eudoxias: *Vita Theodoris Sykeonis* 71.8–9 (Festugière, *Vie*, 58); Goeleon: 161.65–66 (Festugière, *Vie*, 140).

150 Preserved in the *Miracles* of Pantaleon (lines 19–32), edited in Mango, "St. Michael and Attis," 48.

151 Niewöhner et al., "Bronze Age Höyüks," 109; Niewöhner, "Healing Springs," 114, and for the distinctive role of the "doctor fish" at Germia, P. Bouras-Vallianatos, "Miraculous Fish Therapy for Leprosy ('Elephant Disease') and Other Skin Diseases in Byzantium," *BMGS* 40.1 (2016): 170–75.

152 Belke, *Galatien*, 105–6, and Belke, "Prokops De Aedificiis," 122.

153 Following the later pattern in Constantine Porphyrogenitus, *Book of Ceremonies*, book 1, appendix (Moffatt and Tall, *Constantine Porphyrogennetos*, 497).

154 *PLRE* 3:76 ("Andreas 7"), and Malalas, *Chronicle* 18.146 (Thurn, *Chronographia*, 430.5–17; Jeffreys, Jeffreys, and Scott, *Chronicle*, 304). He succeeded Procopius (*PLRE* 3:1066 ["Procopius 3"]) as city prefect in April 563 and the next known prefect was Addaeus in January 565 (*PLRE* 3:14–15: "Fl. Marianus Iacobus Marcellus Aninas Addaeus"), followed by Zemarchus and Julian in 565 (list of prefects at *PLRE* 3:1480).

155 Theophanes, *Chronicle* AM 6056 (de Boor, *Theophanis Chronographia*, 1:240.12–17; Mango and Scott, *Chronicle of Theophanes*, 353).

title of curopalates, which before long, if not already, marked him out as second to the emperor.[156]

By the end of November 563, Justinian was definitely back home in the capital. There he entertained an important visit from the Jafnid *phylarch* and Roman patrician Arethas.[157] At that time, Justinian showed no signs of undue fatigue or decline from his recent journey. Following the journey to Germia, Justinian was to live for another two years, but it was not long after returning from his expedition to Archangel Michael's shrine that the emperor became more committed to the "aphthartic" understanding of Christ's earthly reality, or the belief that Christ's human flesh was as incorruptible before his death as it was after it. In the course of these events, late in 564, Justinian engaged in direct discussions with certain African bishops he had summoned to the city.[158] They also disputed with the patriarch of Constantinople, Eutychius, who was dismissed by the emperor in January 565 over doctrinal differences.[159] Then, just a few months before his death in November 565, Justinian was again faced with severe civil unrest outside the gates of his palace. Again, he was required to dispatch military reinforcements. Ongoing battles between Green faction supporters and imperial troops in 565 resulted in considerable loss of life, as well as Justinian's replacement of the prefect Zemarchus with the more pugnacious Julian. Restoring law and order in

the city took the new prefect another ten months, that is, well into the reign of Justinian's successor, Justin II, in 566.[160]

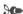

As the archistrategos, angelic commander-in-chief Archangel Michael was very important to Emperor Justinian. He was a heavenly guarantor of earthly imperial power and orthodoxy, the emperor's protector against usurpations and threats to his authority, such as the disconcerting conspiracy hatched against him in Constantinople in November 562. This conspiracy almost resulted in the death and deposition of Justinian. It was his most precarious moment as emperor since the Nika riots in January 532 and constitutes the most likely set of circumstances for a vow to present himself at the archangel's site at Germia. Following weeks of planning, in October 563 the emperor Justinian undertook an unprecedented journey from his palace at Constantinople through Asia Minor to the pilgrimage site of Archangel Michael at Germia.

Justinian's journey to Germia, in the light of his activities as emperor both before setting out from Constantinople and on his return, suggests that even in his eighties he was not a sickly or reclusive ruler. Moreover, none of the contemporary accounts of his reign implies any such perspective.[161] The eighty-year-old Emperor Justinian was just as engaged as the forty-year-old Emperor Justinian in determining and

156 Lin, "Justin under Justinian," 128. Only a few decades after Justin, Nicephorus explains why, as curopalates in 612, Heraclius's brother Theodore "held the second highest rank after that of emperor which in the language of courtiers is habitually called curopalates" (τὴν μετὰ βασιλέα πρώτην ἀρχὴν κεκτημένον [κουροπαλάτην δὲ αὐτὸν οἱ περὶ τὰ βασίλεια καλεῖν εἰώθασιν]) (C. Mango, ed., *Nikephoros Patriarch of Constantinople: Short History* [Washington, DC, 1990], 40–41, with *PLRE* 3:1277–79 ["Theodorus 163"]).

157 Theophanes, *Chronicle* AM 6056 (de Boor, *Theophanis Chronographia*, 1:240.14–17; Mango and Scott, *Chronicle of Theophanes*, 353). The emperor had endowed Arethas with the position of phylarch in 529 when they were both much younger: *PLRE* 3:54–55 ("Ambros"), 111–13 ("Arethas"). Further detail in I. Shahîd, *Byzantium and the Arabs in the Sixth Century*, vol. 1, part 1, *Political and Military History* (Washington, DC, 1995), 282–88, and I. Shahîd, *Byzantium and the Arabs in the Sixth Century*, vol. 1, part 2, *Ecclesiastical History* (Washington, DC, 1995), 780–88.

158 Victor of Tunnuna, *Chronicle* s.a. 564/565 (A. Placanica, ed., *Vittore da Tunnuna, Chronica: Chiesa e empero nell'età di Guistiniano* [Florence, 1997], 58).

159 S. Roggo, "The Deposition of Patriarch Eutychius of Constantinople in 565 and the Aphthartodocetic Edict of Justinian," *Byzantion* 89 (2019): 433–46.

160 Malalas, *Chronicle* 18.151 (Thurn, *Chronographia*, 431; Jeffreys, Jeffreys, and Scott, *Chronicle*, 305), and Victor of Tunnuna, *Chronicle*, s.a. 565/566.2 (Placanica, *Vittore*, 58).

161 Apart from the rhetorical flourish of Corippus (*In laudem Iustini* 2.260, with Averil Cameron, ed. and trans., *Flavius Cresconius Corippus in laudem Iustini Augusti minoris* [London, 1976], 170), the characterization of Justinian's later years as indolent and spendthrift overly depends on the retrospective preface to Justinian, *Novellae* 148 (*CIC Nov* 722), usually dated to Justin II's reign in 566 on the basis of a Latin subscription in Venice, Biblioteca Marciana, gr. 179. However, it is doubtful whether this law was issued by Justin, rather than by Justinian (late 550s) as clearly stated by a contemporary legal commentator, Theodore of Hermopolis, who was in no doubt that the law was promulgated in Justinian's time (ἐξεφωνήθη ἐν τοῖς χρόνοις βασιλείας Ἰουστινιάνου: C. E. Zachariae, ed., *Anekdota: Theodori Scholastici Breviarium Novellarum, collection regularum iuris ex institutionibus, fragmenta breviarii codices a Stephano antecessore compositi, Appendix Eclogae, fragmenta epitomae Novellarum graecae ab anonymo sive Iuliano confectae, fragmenta Novellarum ex variorum commentariis, edicta praefectorum praetorio* [Leipzig, 1843], 157).

promoting what he felt was the sure path to orthodoxy, and therefore imperial security, under divine favor. Archangel Michael was now the guarantor of both orthodox belief and imperial legitimacy. For Justinian, belief and legitimacy were inextricably intertwined. The expedition to Germia in October/November 563 highlights Justinian's focus on imperial business even at his advanced age. Recent research at Germia and on angels, including Archangel Michael, helps to make more sense of this episode and to fit it more naturally into the story of the active later years of Justinian's reign.

Brian Croke
brian.croke0@gmail.com

❧ Through many versions over several years, this paper has been vastly improved by the input of Roger Scott, Hugh Elton, and Max Ritter, as well as the *DOP* readers and editor Colin Whiting. I am grateful to them all, and especially to Hugh Elton for providing the customized map.

Making Sense of a Mediterranean Controversy in Byzantine Africa

The Collectio Sichardiana *and Justinian I's Condemnation of the Three Chapters*

OMRI MATARASSO

In the summer of 431, more than one hundred and fifty bishops gathered in the city of Ephesus and deposed the bishop of the Byzantine capital, Nestorius of Constantinople.[1] With their judgment, the gathered bishops started a chain reaction across the Mediterranean world. Disorder and violence quickly spread from Ephesus to the imperial city as crowds protested or celebrated the conciliar decision.[2] Two opposing factions subsequently crystallized among the bishops in Ephesus, and a competition ensued over the loyalties of clerics from both the western and eastern provinces of the empire. Each faction advocated and cohered around elaborate Christological formulas, reflecting the core issues underlying Nestorius's deposition. But beyond their theological concerns, the two factions also attempted to expand their spheres of influence by bolstering complex networks of clerics and state officials bound to each other by relations of family, friendship, and patronage.[3] The controversy took on an inertia of its own as a result of the factionalism that emerged in Ephesus: its various manifestations

in expressions of loyalty to the legacy of bishops and of solidarity within social circles would play as significant a role as theological disagreements in the ensuing controversy.

Following the conclusion of the conciliar proceedings in Ephesus and the dispersal of the participants, members of the two factions continued their lobbying measures, ranging from writing letters and doctrinal treatises to distributing gifts and payments among state officials and their families.[4] The continued ecclesiastical disturbances, however, led the imperial court to exert its own pressure on the parties involved. By 433 this effort paid off when Cyril of Alexandria and John of Antioch, the leaders of the two factions, signed a reconciliation agreement. Known ever since as the *Formula of Reunion*, the agreement established a theological middle ground between the factions and confirmed Nestorius's deposition.[5] But it took no longer than three years for the dispute between the two factions to resurface, this time over the teachings of the deceased Antiochene theologian Theodore of

1 The Council of Ephesus, first session (22 June 431), *Nestorii depositio ad eum missa a concilio* (*CPG* 8676), *Collectio Vaticana* 63, *ACO* 1.1.2, 64; trans. in R. Price and T. Graumann, *The Council of Ephesus of 431: Documents and Proceedings*, TTH 72 (Liverpool, 2020), 280.

2 T. E. Gregory, *Vox Populi: Popular Opinion and Violence in the Religious Controversies of the Fifth Century A.D.* (Columbus, OH, 1979), 100–116.

3 A. M. Schor, *Theodoret's People: Social Networks and Religious Conflict in Late Roman Syria* (Berkeley, 2011).

4 F. Millar, *A Greek Roman Empire: Power and Belief under Theodosius II, 408–450* (Berkeley, 2006), 157–73; G. Bevan, *The New Judas: The Case of Nestorius in Ecclesiastical Politics, 428–451 CE* (Bristol, 2016), 194–206; and W. F. Beers, "'Furnish Whatever Is Lacking to Their Avarice': The Payment Programme of Cyril of Alexandria," in *From Constantinople to the Frontier: The City and the Cities*, ed. N. S. M. Matheou, T. Kampianaki, and L. M. Bondioli (Leiden, 2016), 67–83.

5 Bevan, *New Judas*, 205–36, and Schor, *Theodoret's People*, 100–109.

Mopsuestia (d. 428). By the end of the decade the issue was resolved, but not without rousing and antagonizing clerics and ordinary believers from Egypt through Syria and from the western shores of the Black Sea all the way to Armenia.[6]

With the passing of John of Antioch in 442 and Cyril of Alexandria in 444, a new generation of revitalized disputers tried to fill their shoes. But regardless of the involvement of new personalities and their evolving motives, the factionalism originating in the conciliar proceedings in Ephesus and the theological Pandora's box opened by the nuanced dispute over Nestorius's teachings had already left a lasting mark on the Christian world. Most significantly, these developments fueled a process of canonization of texts and ideas that would sustain centuries of controversies: in any significant Christological pronouncement since Ephesus and its immediate aftermath, we will find a stable and persistent "Ephesian" layer consisting of references and citations of texts from the original clash between Nestorius, Cyril of Alexandria, and John of Antioch.[7] Alongside allusions to and citations from the Bible and the Nicene Creed, this "Ephesian" layer, too, would become one of the most consistent features in the documentation surrounding the Christological controversies that divide the churches of the Middle East until this very day.[8]

In this paper I would like to suggest that controversy may not only separate and divide but also, perhaps paradoxically, connect people together—if only momentarily. In the following pages we will see how a collection of documents pertaining to the early fifth-century Nestorian Controversy presents an elaborate narrative of a dispute stretching across the Mediterranean world. Assembled in the middle of the sixth century, the *Collectio Sichardiana* weaves together texts and ideas originating from diverse regions and intellectual traditions. Once we appreciate its underlying mechanics of transmission, arrangement, and redaction of texts, the *Sichardiana* illustrates the extent of interregional intellectual connectivity of the Mediterranean world in the middle of the sixth century.

When we reconstruct the historical circumstances in which the *Sichardiana* was engendered, the emerging narrative also receives a very local twist. Despite the survival of the collection's material remains in European copies spanning the late sixth century to the sixteenth, in the following pages I will present a detailed argument in favor of tracing the *Sichardiana*'s provenance to North Africa of the period following its Byzantine reconquest in 533–34. The collection was a local African response to Justinian I's doctrinal edict against the Three Chapters. The controversy that followed Justinian's edict gave renewed relevance to the dispute over Nestorius's teachings from the previous century and shook the great ecclesiastical centers around the eastern Mediterranean. This time, however, pockets of resistance also appeared in Italy,[9] Merovingian Gaul,[10] and, as we will see below, Byzantine Africa. Complementing and standing in conversation with recent scholarship of the late ancient and early medieval African church that focuses on the movement of its cultural artifacts, especially its elaborate cult of saints, throughout the wider Mediterranean world,[11] my reconstruction of the *Sichardiana* highlights the opposite direction of this movement: the local African reception of a wide range of materials documenting supposedly faraway disputes couched in arcane terminologies and carried in languages that were

6 Bevan, *New Judas*, 256–79; N. Constas, *Proclus of Constantinople and the Cult of the Virgin in Late Antiquity: Homilies 1–5, Texts and Translations* (Leiden, 2003), 96–124.

7 Most notably, in the definition of faith pronounced at the Council of Chalcedon of 451, in Emperor Zeno's *Henotikon* of 482, and in Pope Hormisdas's *Libellus* of 515: A. Grillmeier, *Christ in the Christian Tradition*, vol. 1, *From the Apostolic Age to Chalcedon (451)*, 2nd ed., trans. J. Bowden (Atlanta, 1975), 543–50; A. Grillmeier, *Christ in the Christian Tradition*, vol. 2:1, *From the Council of Chalcedon (451) to Gregory the Great (590–604)*, trans. P. Allen and J. Cawte (Atlanta, 1987), 254–56; and V. L. Menze, *Justinian and the Making of the Syrian Orthodox Church* (Oxford, 2008), 68–69.

8 For a deliberation over the "Ephesian" layer in a modern context, see, for example, J. S. Romanides, ed., "Unofficial Consultation between Theologians of Eastern Orthodox and Oriental Orthodox Churches, August 11–15, 1964: Papers and Minutes," *GOTR* 10.2 (1964–65): 7–160, esp. 93–95, for a discussion of the *Formula of Reunion*.

9 C. Straw, "Much Ado about Nothing: Gregory the Great's Apology to the Istrians," in *The Crisis of the Oikoumene: The Three Chapters and the Failed Quest for Unity in the Sixth Century Mediterranean*, ed. C. Chazelle and C. Cubitt (Turnhout, 2007), 121–60.

10 T. Stüber, "The Fifth Council of Orléans and the Reception of the 'Three Chapters Controversy' in Merovingian Gaul," in *The Merovingian Kingdom and the Mediterranean World, Revisiting the Sources*, ed. S. Esders, Y. Hen, P. Lucas, and T. Rotman (London, 2019), 93–102.

11 J. P. Conant, "Europe and the African Cult of Saints, circa 350–900: An Essay in Mediterranean Communications," *Speculum* 85.1 (2010): 1–46, and B. D. Shaw, "Doing It in Greek: Translating Perpetua," *Studies in Late Antiquity* 4.3 (2020): 309–45.

foreign to members of the African church. At the same time, my reconstruction of the *Sichardiana*'s origins and temporal layers uncovers how African Christians made sense of an episode of Mediterranean history in a way that spoke to their local concerns. The *Collectio Sichardiana*, therefore, is not only a hitherto unappreciated source from late antique North Africa but also a window into the local African scholarly environment in which the collection was assembled, and whose participants navigated with ease any perceived intellectual boundary between the Latin West and Greek East.

Following a brief overview of the Three Chapters Controversy, I will start my analysis of the *Sichardiana* with the three sources that fragmentarily transmit the collection: two medieval manuscripts and one early modern printed volume. An understanding of the wider documentary context and editorial visions underlying the *Sichardiana*'s three sources will help us understand why the *Sichardiana* survives in such a fragmented manner. It will also demonstrate the embeddedness of the *Sichardiana* in its two manuscript sources, and especially in the late sixth-century Verona, Biblioteca Capitolare, MS LIX (57).[12] This embeddedness even suggests that some documents in Verona LIX (57) might have been part of the original *Sichardiana* but have never been recognized as such (see below, "A Dialogue between Equals" and "The *Sichardiana* and the Canonical Collection of Verona LIX (57)"). A better understanding of the three sources that transmit the *Sichardiana* invalidates the possibility that the collection originated in a high medieval or early modern context and provides the first hint that the collection was assembled in late antiquity.

I will strengthen the argument in favor of the collection's late antique provenance by delving more deeply into the contents of the *Sichardiana*, an effort that will occupy the bulk of this paper. Starting my analysis with the rubrics of the collection's documents and their peculiar transmission in the collection's manuscripts, I will outline the careful order of presentation of the collection's documents, as well as both the information the documents divulge and the topics on which they maintain silence. My analysis of the *Sichardiana*'s structure and contents will reveal its editor's underlying apologetic project toward the Three Chapters. As I will argue in the concluding sections of this paper, the nuances and peculiarities embedded in this apologetic project point us to Byzantine Africa as the geographical origin of the collection's assembly.

The Three Chapters Controversy

Sometime between 543 and 545, Emperor Justinian I issued a doctrinal edict in which he condemned the person and works of Theodore of Mopsuestia (d. 428), the letter by Ibas of Edessa (d. 457) to Mari "the Persian,"[13] and certain writings by Theodoret of Cyrrhus (d. 460).[14] With his request to clerics around the empire to condemn the "Three Chapters," as the three condemned elements in the edict became known, Justinian attempted to mend the schism between the supporters and opponents of the definition of faith issued in the previous century at the Council of Chalcedon of 451. The controversial aspect of the Chalcedonian definition was its statement that Christ is one person in two natures, divine and human. The opponents of Chalcedon saw the council's definition as a confirmation of Nestorius's teachings: even though the condemnation of Nestorius issued by the Council of Ephesus of 431 had been repeated during the first session of the Council of Chalcedon,[15] the opponents of Chalcedon argued that its strong dyophysite definition was nevertheless Nestorian in nature, implying a separation of the divinity and humanity of Christ into two ontologically distinct persons.[16] With the condemnation of the Three Chapters, Justinian tried to distance the Chalcedonian definition from any hint of Nestorius's teachings by condemning fifth-century texts and persons who were perceived to have shared his views. At the same time, Justinian also defined the Three

12 For the mismatched Latin and Arabic numbers in the Biblioteca Capitolare's shelf marks, see W. Telfer, "The Codex Verona LX (58)," *HTR* 36.3 (1943): 245–46.

13 M. Van Esbroeck, "Who Is Mari, the Addressee of Ibas' Letter?" *JTS* 38.1 (1987): 129–35.

14 Further details on Justinian's edict (*CPG* 6881) are in A. Grillmeier with T. Hainthaler, *Christ in the Christian Tradition*, vol. 2.2, *From the Council of Chalcedon (451) to Gregory the Great (590–604)*, trans. P. Allen and J. Cawte (Louisville, KY, 1994), 421–22, and T. C. Lounghis, B. N. Blysidu, and S. Lampkes, eds., *Regesten der Kaiserurkunden des oströmischen Reiches von 476 bis 565* (Nicosia, 2005), no. 1288, 315.

15 R. Price and M. Gaddis, *The Acts of the Council of Chalcedon*, 3 vols., TTH 45 (Liverpool, 2005), 1:323.

16 Price and Gaddis, *Council of Chalcedon*, 1:51–56.

Chapters in their opposition to the teachings of Cyril of Alexandria, the most adamant opponent of Nestorius in the fifth century: Theodore of Mopsuestia, whose orthodoxy Cyril had already questioned in the Council of Ephesus of 431, had been Nestorius's teacher. Both Ibas in his letter to Mari and Theodoret in several of his writings criticized Cyril's theology, and in particular his anti-Nestorian *Twelve Chapters*. Therefore, by focusing on texts and persons who were affiliated with Nestorius and opposed to Cyril's teachings, Justinian demonstrated that there is no incongruity between rejecting Nestorius and accepting the Chalcedonian definition.[17]

Significant resistance to the condemnation of the Three Chapters rose from several groups of supporters of Chalcedon. One notable issue identified by the Chalcedonians was the possibility that Justinian's measures undermined the Council of Chalcedon itself. For among the decrees issued at the council we find the reinstatement of Theodoret and Ibas to the episcopal offices from which they had been previously deposed.[18] Condemning writings of Theodoret and Ibas, the Chalcedonians reasoned, was equivalent to condemning outright two bishops who had subscribed and adhered to the Chalcedonian definition. It also potentially besmirched the decrees of Chalcedon, which acquitted and absolved them of an unjust deposition.[19]

Another difficulty with Justinian's condemnation was its perceived affront to accepted ecclesiastical norms. Certain supporters of Chalcedon argued that it is certainly legitimate to condemn heretical teachings, such as those allegedly found in some of the writings of the late Theodore of Mopsuestia, but it is unjustifiable to judge, to condemn, or to anathematize Christians who had passed away while in communion with the church. This sentiment is explicitly expressed in the *Constitutum de tribus capitulis* (also known as the *First Constitutum*) of Pope Vigilius (537–555).[20] In order to strengthen his argument, Vigilius even refers to the writings of Cyril of Alexandria himself. Vigilius quotes a segment from Cyril's letter to John of Antioch recounting one of the sessions from the Council of Ephesus of 431.[21] As part of the mounting evidence collected against Nestorius in Ephesus, a certain Charisios of Philadelphia (in Lydia, Asia Minor) had come before the council and presented a suspicious creed attributed to him.[22] But as Cyril soon found out, the creed should have been attributed not to Nestorius but rather to his deceased teacher, Theodore of Mopsuestia. In the letter cited by Vigilius, Cyril clarifies that he and his fellow bishops at the Council of Ephesus did not dare to condemn the deceased Theodore or anyone "who departed this life in the episcopacy."[23] Expanding on Cyril's words, Vigilius concludes the citation by stressing that "what the blessed Cyril described above ... was something he wanted to be understood as suitable for extension into a rule of the Church."[24]

Among the Chalcedonians who resisted Justinian's condemnation of the Three Chapters we find a notable faction in North Africa. Added to the above arguments based on the perceived affronts to ecclesiastical norms

17 R. Price, *The Acts of the Council of Constantinople of 553, with Related Texts on the Three Chapters Controversy*, 2 vols., TTH 51 (Liverpool, 2009), 1:76–98.

18 For the Chalcedonian sessions concerning the reinstatement of Theodoret and Ibas, see Price and Gaddis, *Council of Chalcedon*, 2:250–309.

19 For an example, see below, n. 25. For further references to Chalcedonian authors who expressed this sentiment, see Straw, "Much Ado about Nothing," 130–31.

20 Pope Vigilius, *Epistola LXXXIII: Constitutum de tribus capitulis*, §§234–35, *Collectio Avellana*, in O. Günther, ed., *Epistulae imperatorum, pontificum, aliorum inde ab. a. CCCLXVII usque ad a. DLIII datae, Avellana quae dicitur collectio*, part 1, *Prolegomena, epistulae I–CIV*, CSEL 35 (Prague, 1895), 296:18–25: "we are making the greatest possible provision by the enactment of our present decree to ensure, as we said above, that there be no disparagement of persons who went to their rest in the peace and communion of the universal church on the basis of this our condemnation of perverse doctrine, but that, now that the execrable doctrines in [*sic*] the heresiarchs Nestorius and Eutyches and all their followers have been condemned, no contumely should result for those priests who, as has been said, died in the peace of the catholic church" (trans. Price, *Council of Constantinople*, 2:194).

21 Pope Vigilius, *Constitutum de tribus capitulis*, §§204–7, 286–88. I discuss Cyril's letter to John in further detail below.

22 The entire episode is transmitted in the Ephesian acts: *Gesta Ephesina, Actio VI* (CPG 8721), *Collectio Atheniensis 73–76, ACO* 1.1.7, 84–117; the creed can be found in 97:25–100:4 (trans. in Price and Graumann, *Council of Ephesus* [n. 1 above], 444–85). For a detailed discussion of this incident, see F. Millar, "Repentant Heretics in Fifth-Century Lydia: Identity and Literacy," *Scripta Classica Israelica* 23 (2004): 111–30.

23 This part of the letter is quoted in Vigilius, *Constitutum de tribus capitulis*, §207, 288:9–12.

24 Vigilius, *Constitutum de tribus capitulis*, §207, 288:1–4 (trans. Price, *Council of Constantinople*, 2:187).

and the integrity of Chalcedon,[25] we find complaints among some Africans on the improper involvement of the emperor in the affairs of their local church.[26] This argument corresponds well with contemporary local sentiments regarding Byzantine rule in North Africa. Following the Byzantine reconquest of North Africa in 533–34 and the liberation of its population from the Vandals who had held the region since the previous century, Justinian quickly incorporated the territory into the administrative structure of empire. But the return of North Africa back into the Byzantine fold came at a price: the end of the region's local administrative independence, which flourished throughout the Vandal period. Under the new Byzantine regime, Africa was to be administered by representatives of a faraway court in Constantinople at the expense of local African notables.[27] And with Justinian's condemnation of the Three Chapters, the Africans were discouraged to learn that the faraway court was eager to involve itself not only in their local administrative affairs but also in ecclesiastical matters.

A related problem that the Africans found in the doctrinal request at their doorstep was simply that they were not familiar enough with the teachings of Theodore, Ibas, and Theodoret. African clerics even explicitly raised this problem in their communications with Justinian.[28] Gradually, however, certain Africans took upon themselves the challenge of investigating the complexities surrounding the lives and teachings

of the Three Chapters. Among the most notable surviving works on the subject are Liberatus of Carthage's *Breviarium causae Nestorianorum et Eutychianorum* and Facundus of Hermiane's *Pro defensione trium capitulorum*.[29] As I will demonstrate below, the *Collectio Sichardiana* should also be counted among the African scholarly investigations into the controversy with which Theodore, Ibas, and Theodoret had been involved.

Reconstructing the *Collectio Sichardiana*

In this section I will review the three sources that transmit the *Sichardiana*. Since the collection has survived fragmentarily in three different sources, a deeper understanding of the scholarly objectives and editorial principles that shaped these sources may explain why no source transmits the *Sichardiana* in full. While much more can be said about each of the collection's three sources (on which scholarship is severely lacking), the chief goal of this section will be to highlight some of the shared structural ways in which the *Sichardiana* documents were chosen, arranged, and copied in the three sources, particularly in the late sixth-century Verona LIX (57). As I will show in the following pages, the deep embeddedness of the *Sichardiana* in Verona LIX (57) will offer us the first evidence for the collection's late antique provenance.

Before we continue it should be noted that the most accessible version of the *Collectio Sichardiana* can be found in Eduard Schwartz's *Acta Conciliorum Oecumenicorum* (henceforth *ACO*; see Appendix I).[30] An important aspect of the *ACO*, which we should keep in mind before delving into its rich documentary contents, is that rather than being a critical edition of conciliar documents, the work is first and foremost a critical edition of late antique and medieval *collections* of conciliar documents. Schwartz's efforts to reconstruct conciliar collections were chiefly motivated by his realization that in order to understand the great

25 E.g., Fulgentius Ferrandus, *Epistola VI: Ad Pelagium et Anatolium Diaconos urbis Romae*, PL 67, 923: *Totum concilium Chalcedonense, cum est totum concilium Chalcedonense, verum est: nulla pars illius habet ullam reprehensionem; quidquid ibi dictum, gestum, judicatum novimus atque firmatum, sancti Spiritus operata est ineffabilis et secreta potentia*, and Ferrandus, *Epistola VI*, PL 67, 925: *Quid erit firmum, si quod statuit Chalcedonense concilium vocatur in dubium?*

26 R. Eno, "Doctrinal Authority in the African Ecclesiology of the Sixth Century: Ferrandus and Facundus," *REAug* 22 (1976): 101–2.

27 A. Cameron, "Byzantine Africa: The Literary Evidence," in *Excavations at Carthage 1978, Conducted by the University of Michigan*, vol. 7, ed. J. H. Humphrey (Ann Arbor, 1982), 45, and J. Conant, *Staying Roman: Conquest and Identity in Africa and the Mediterranean, 439–700* (Cambridge, 2012), 196–251.

28 E.g., Pontianus, *Ep. ad Justinianum*, PL 67:996–97: *In extremo itaque epistolae vestrae cognovimus . . . debere nos Theodorum, et scripta Theodoreti et epistolam Ibae damnare. Eorum dicta ad nos usque nunc minime pervenerunt. Quod si et pervenerint, et aliqua ibi apocrypha, quae contra fidei regulam dicta sint, legerimus.* See also Y. Modéran, "L'Afrique reconquise et les Trois Chapitres," in Chazelle and Cubitt, *The Crisis of the Oikoumene* (n. 9 above), 44–45.

29 Modéran, "L'Afrique reconquise et les Trois Chapitres," 61, and S. Adamiak, *Carthage, Constantinople and Rome: Imperial and Papal Interventions in the Life of the Church in Byzantine Africa (533–698)* (Rome, 2016), 86. See also Liberatus's words from his introduction: Libératus de Carthage, *Abrégé de l'histoire des nestoriens et des eutychiens*, ed. E. Schwartz, trans. F. Cassingena-Trévedy and P. Blaudeau, SC 607 (Paris, 2019), 132:11–12: *libenter offero catholicis fratribus ignorantibus acta ipsarum heresum [sic] et legere volentibus.*

30 *ACO* 1.5.2, 247–318.

church councils of the medieval past, it is not enough to investigate the texts documenting the councils themselves. Attention should also be given to the collections that transmit these texts.[31] The collections can teach us how conciliar documents were received, used, and even abused by interested parties from subsequent generations and, in particular, from subsequent church councils. Schwartz therefore termed those collections *publizistische Sammlungen*, a term highlighting that the various texts within them were not arbitrarily chosen and placed side by side. Rather, the texts were carefully edited into politically and theologically motivated publications assembled to promote the specific objectives of factions of clerics who participated in the Christological controversies of late antiquity and beyond.[32] By investigating the origins, purposes, and overarching themes of conciliar collections, scholars could begin to understand how the texts within them were used to promote, to defend, or to contest certain positions in subsequent ecclesiastical and theological disputes. The following analysis of the *Sichardiana* will exemplify such an investigation.

The oldest witness of the *Sichardiana* is Verona LIX (57), a late sixth-century manuscript housed in the Biblioteca Capitolare of Verona, Italy.[33] At first glance, the contribution of this witness seems limited, since only four out of the eighteen documents

of the *Sichardiana* are transmitted in it.[34] However, a deeper appreciation of the manuscript's contents provide a slightly different perspective: the key to Schwartz's reconstruction of the *Sichardiana* is a rare and peculiar version of Cyril of Alexandria's *Contra Theodoretum* (*CPG* 5222), which is reconstructed as the fourth document in the collection (henceforth *Coll. Sich.* 4). The document is by far the longest text of the collection. In terms of raw content, its text covers roughly 44 percent of the *Sichardiana* as it is printed in the *ACO* (see Appendix II). Together with the three other *Sichardiana* documents in Verona LIX (57), slightly more than 50 percent of the collection survives in this late sixth-century witness. This does not include several other documents in the manuscript that, as I will argue below, complement the contents of the *Sichardiana* documents and should be considered as additional and hitherto unappreciated parts of the original collection.[35] Verona LIX (57), therefore, provides our first hint toward establishing the *Sichardiana*'s terminus ante quem in the late sixth century.

I will give further details on the peculiarities of *Coll. Sich.* 4 below, but for now it will be enough to note that the text is a redacted, expanded, and interpolated version of the original Greek treatise of Cyril's *Contra Theodoretum*. That treatise was translated into Latin perhaps as early as the 430s (i.e., very close to its original date of composition), and by the middle of the sixth century the translation was certainly circulating in the Latin West.[36] The version of the treatise in *Coll. Sich.* 4,

31 Eduard Schwartz's *Wissenschaftlicher Lebenslauf* (1932), reprinted in his *Gesammelte Schriften*, vol. 2, *Zur Geschichte und Literatur der Hellenen und Römer* (Berlin, 1956), 12–15.

32 Further information on these publishing activities can be found in the prefaces to the different parts and volumes of the *ACO* as well as in E. Schwartz, *Publizistische Sammlungen zum acacianischen Schisma*, AbhMünch, Phil.-hist.Kl. (Munich, 1934), 262–303. See also E. Schwartz, "Die Kanonessammlungen der alten Reichskirche," *ZSavKan* 56.25 (1936): 75–76, and P. Blaudeau, "Qu'est-ce que la géo-ecclésiologie? Éléments de définition appliqués à la période tardo-antique (IVe–VIe s.)," in *Costellazioni geo-ecclesiali da Costantino a Giustiniano: Dalle chiese principali alle chiese patriarcali*, XLIII Incontro di Studiosi dell'Antichità Cristiana (Rome, 2017), 53.

33 A. Spagnolo, *I Manoscritti della Biblioteca Capitolare di Verona*, ed. S. Marchi (Verona, 1996), 111, and F. Maassen, *Geschichte der Quellen und der Literatur des canonischen Rechts, im Abendlande bis zum Ausgange des Mittelalters* (Gratz, 1870), 761–62. Although the above publications stretch the possible dating of the manuscript to the seventh century, in this paper I follow the suggestion of Cuthbert Turner for the late sixth century: C. Turner, "The Genuineness of the Sardican Canons," *JTS* 3 (1902): 381, n. 1, and "The Verona Manuscripts of Canons: The Theodosian MS. and Its Connection with St. Cyril," *The Guardian*, 11 December 1895, 1921–20.

34 Throughout the following discussion of the *Sichardiana*'s three sources, the reader is advised to consult Appendix II of this paper, which outlines how the *Sichardiana*'s documents are distributed in them.

35 These are the Chalcedonian acts in fols. 170r–209v, which I discuss below in "A Dialogue between Equals," and the canonical collection in fols. 216r–255v, which I discuss in "The Beginning of Canonical Codification in North Africa and the Canonical Collection of Verona LIX (57)" and "The *Sichardiana* and the Canonical Collection of Verona LIX (57)." It is also possible that some items from the Christological florilegia segment of the manuscript in fols. 82r–129v were part of the original *Sichardiana*, on which see below, nn. 55–58, 204.

36 The translation has survived in the sixth-century *Collectio Palatina* 40, 142–65, edited in *ACO* 1.5.1. Because the entire collection was misattributed to the early fifth-century author and translator Marius Mercator, scholars still do not agree on exactly which texts can be traced to Marius Mercator himself and which were translated and added later to the collection; further discussion is available

however, represents a different transmission history: its peculiarities do not seem like innovations originating in the Latin West, since we find similar witnesses of this version in Greek medieval manuscripts.[37] In the Latin tradition, *Coll. Sich.* 4 has survived solely in the three sources of the *Sichardiana*: besides Verona LIX (57), the treatise is transmitted in the thirteenth-century Paris, Bibliothèque de l'Arsenal MS 341 (henceforth Arsenal 341),[38] and in Johannes Sichard's printed edition from 1528, titled *Antidotum contra diversas omnium fere seculorum haereses* (henceforth *Antidotum*).[39] Unlike the Greek manuscript witnesses of *Coll. Sich.* 4, which transmit it in varying contexts without any notable shared texts between them, the Latin tradition of *Coll. Sich.* 4 surrounds it with the same texts, which are also organized one after the other in similar ways: Verona LIX (57) and Arsenal 341 share *Coll. Sich.* 11 and 12, and in both manuscripts these two documents are presented one after the other; Arsenal 341 and Sichard's *Antidotum* have six documents in common, *Coll. Sich.* 7–10 and 16–17, and, likewise, in

these two sources the documents are presented in the same sequence. *Coll. Sich.* 4 is the only document that survives in all three sources of the *Sichardiana*.

This sharing of documents between the three sources of the *Sichardiana* suggests that we are dealing with a single collection of documents that has survived in a fragmented manner and not independently. It is nevertheless worth asking why the three sources transmit such a fragmented witness of the original collection. I can offer only conjectural answers, because the evidence surrounding the *Sichardiana*'s three sources is limited. However, a deeper familiarity with the contents of the three sources can shed light on some of the editorial features that shaped these sources. And, as we will see in the following pages, one of the most common editorial features identifiable in all three sources of the *Sichardiana* is their tendency not to transmit and preserve their own source materials in their integrity.

Arsenal 341

In its preserved state, Arsenal 341 consists of two distinct manuscripts that were joined into one codex, in which the two underlying manuscripts were further divided into three parts.[40] Parts one and three of Arsenal 341 are clearly the product of the same scribe, as can be easily recognized in the distinct handwriting and in some repeated stylistic attributes, such as the frequent use of red ink in rubrics and in beginnings of sentences or paragraphs. The contents of parts one and three also exhibit similarities in their choice of seemingly eclectic collections of late ancient texts: part one transmits Latin translations of various texts attributed to Athanasius of Alexandria (some are not genuine),[41] and concludes with an obviously forged

in Schwartz's preface to *ACO* 1.5.1, v–ix, and W. C. Bark, "John Maxentius and the Collectio Palatina," *HTR* 36.2 (1943): 93–107.

37 See the eleventh-century Vatican gr. 1431, fols. 66v–98v, reviewed in H.-G. Opitz, *Untersuchungen zur Überlieferung der Schriften des Athanasius* (Berlin, 1935), 80–81; the twelfth-century Austrian National Library, cod. theol. gr. 40, fols. 76v–95r, reviewed in H. Hunger and O. Kresten, *Katalog der griechischen Handschriften der Österreichischen Nationalbibliothek*, vol. 3.1, *Codices theologici 1–100* (Vienna, 1976), 72–78; and the thirteenth-century Athens, Byzantine and Christian Museum (BXM), XAE 760, fols. 111v–136r, reviewed in N. A. Bees, "Κατάλογος τῶν χειρογράφων κωδίκων τῆς Χριστιανικῆς Ἀρχαιολογικῆς Ἑταιρείας Ἀθηνῶν," *Δελτ.Χριστ.Ἀρχ.Ετ.* 6, B.A. (1906): no. 9, 56–57. The three manuscripts were consulted in Schwartz's editions of Cyril's *Contra Theodoretum* (*ACO* 1.1.6, 110–46) and his *Contra Orientales* (*ACO* 1.1.7, 33–65), and are normally referred to as AWR or witnesses of recension Ψ.

38 H. Martin, *Catalogue des manuscrits de la Bibliothèque de l'Arsenal*, vol. 1 (Paris, 1885), 206–8. Martin dated the manuscript to the fifteenth century, yet Schwartz, while referring to Martin's catalog, continuously highlighted its thirteenth-century hand: see E. Schwartz, *Konzilstudien*, Schriften der wissenschaftlichen Gesellschaft in Strassburg, vol. 20 (Strassburg, 1914), 57, and his preface to *ACO* 1.5.2, ii. The manuscript is actually composed of two distinct manuscripts that were later combined into one codex (for more on this, see below, "Arsenal 341"). Although both might have been composed in the same scriptorium, the stark differences between the two in script and contents suggest the possibility of different dates of composition.

39 Johannes Sichard, *Antidotum contra diversas omnium fere seculorum haereses* (Basel, 1528).

40 In its preserved state at the Bibliothèque de l'Arsenal, the codex's folios are numbered rather confusingly: part one goes from fol. 1r to fol. 113r; part two, from fol. 1r to fol. 84r; but part three, from fol. 85r to 133v. When citing texts from the manuscript, I will therefore also indicate their corresponding part.

41 Most notably, the Pseudo-Athanasian *De Trinitate*. In part 1, fols. 40v–63v, Arsenal 341 transmits books 1–7 of the work's so-called first recension, together with book 8, which according to the scholarly consensus had a different author from the previous books. A recent and very useful study of this highly contested work and its rich scholarship is available in J. Kwon, "A Theological Investigation of the *De Trinitate* Attributed to Eusebius of Vercelli" (PhD diss., Columbia University, 2011). I wish to thank Dr. Kwon for sharing his work with me.

letter of Pope Mark (336) to Athanasius;[42] part three consists of the twelve *Sichardiana* documents (*Coll. Sich.* 4, 7–17), which are followed by one additional document that concludes the manuscript—a letter by the founder of the Carthusian order, Bruno of Cologne (d. 1101), to Raoul le Verd, which notably deviates from the late ancient provenance of all previous texts.[43] In contrast to the similarities between parts one and three of Arsenal 341, part two exhibits some unique features, most notably in its script. Unlike parts one and three, which display a bold, cursive, and, at times, almost illegible hand, part two shows a much thinner, clearer, and more carefully and regularly written script, which almost gives the impression that we are dealing with a printed text. In addition, as opposed to the assortment of texts of parts one and three, part two transmits only a single text: Augustine's *De consensu evangelistarum libri quattuor*.[44] It certainly seems like all three parts were intentionally distinguished as distinct segments by their copyists, as we can learn from the decorative script in the rubrics found in the first folios of each part. Lastly, the survival of two brief colophons suggests that all three parts originated in the community of canons regular from Val Saint-Martin, Leuven; no further details, such as the scribe's name or the date of completion, are included.[45] Schwartz dated the manuscript to the thirteenth century.[46]

The fragmented manner of Arsenal 341's survival makes it difficult to reconstruct the underlying editorial vision behind its three parts. It is clear, however, that as a whole Arsenal 341 is dedicated to patristic texts written hundreds of years before the manuscript's completion. It is also notable that part three of the manuscript transmits twelve *Sichardiana* documents, eleven of them in an uninterrupted sequence (*Coll. Sich.* 7–17, as

well as *Coll. Sich.* 4). With our current limited understanding of the manuscript's history, we cannot really tell whether other *Sichardiana* documents are missing due to an intentional decision not to copy them or due to a damaged source. It is nevertheless fortunate that the manuscript transmits a relatively high degree of integrity of the original collection in the uninterrupted sequence. And together with *Coll. Sich.* 4, Arsenal 341 offers, in terms of raw content, roughly 75 percent of the collection as it is printed in the *ACO* (see Appendix II).

Sichard's *Antidotum*

Like Arsenal 341, Sichard's *Antidotum* also transmits twelve *Sichardiana* documents (although not the same ones: the *Antidotum* offers *Coll. Sich.* 1–10 and 16–17), ten of which seem to have survived in their original sequence (*Coll. Sich* 1–10). In terms of raw content, we are dealing here with over 88 percent of the collection as it is printed in the *ACO*. But unlike the two other manuscript sources of the *Sichardiana*, the *Antidotum* is a printed edition that was assembled with relative care for a very specific aim. As we can quickly learn from its bombastic title (roughly translated as "Antidote against the different heresies of nearly all ages"), as well as its index, table of contents, and dedicatory introduction to the king of Poland, Sigismund I (r. 1506–1548),[47] Sichard's overt intention was to gather patristic texts concerned with refuting past heresies. In the segment of the *Antidotum* dedicated to the works of Cyril of Alexandria and Proclus of Constantinople (434–46) against the heresy of Nestorius, we find *Coll. Sich.* 1–10 and 16–17 presented consecutively. Even though this section of the *Antidotum* is dedicated to the works of Cyril and Proclus against Nestorius,[48] some of the texts in this sequence of documents are attributed to other authors such as John of Antioch (*Coll. Sich.* 5–6), Theodoret of Cyrrhus (the third introductory letter of *Coll. Sich.* 4), Dionysius Exiguus (*Coll. Sich.* 7, 16), and even Nestorius himself (*Coll. Sich.* 2–3). For the suspicious reader, the range of authorship is the first hint that this section of the *Antidotum* is not merely a collected anthology of texts by Cyril and Proclus.

Sichard did not leave behind any information on the manuscripts or libraries from which he had gathered any of the texts edited in his *Antidotum*. However,

42 Arsenal 341, part 1, fols. 111r–112v. The letter is edited in PG 28, 1445 (cf. *CPG* 2292). See also C. Müller, "Das Phänomen des lateinischen Athanasius," in *Von Arius zum Athanasianum: Studien zur Edition der "Athanasius Werke,"* ed. A. von Stockhausen and H. C. Brennecke (Berlin, 2010), 29–30, n. 107, and F. Hurst, *Einfluss und Verbreitung der pseudoisidorischen Fälschungen: Von ihrem Auftauchen bis in die neuere Zeit* (Stuttgart, 1972), 186.

43 Arsenal 341, part 3, fols. 131r–135r.

44 See J.-M. Roessli, "*De consensu evangelistarum*," in *The Oxford Guide to the Historical Reception of Augustine*, ed. K. Pollman et al. (Oxford, 2013), 261–66.

45 Arsenal 341, part 1, fol. 114r, and part 2, fol. 84r.

46 See above, n. 38.

47 Sichard, *Antidotum*, fols. α4r–γ5v, α1v, and α2r–α3v, respectively.

48 As confirmed also in the table of contents (fol. α1v).

the relatively rich information we have about Sichard's life and scholarly endeavors have made him and his numerous scholarly editions indispensable in many modern discussions of the philological and transmission history of a wide range of classical and medieval texts.[49] Together with the distinct similarities between the sequence of the documents in the *Antidotum*'s segment dedicated to Cyril's and Proclus's texts and the documents we find in Arsenal 341 and Verona LIX (57), it certainly seems that Sichard did not merely edit and arrange these documents according to his own vision, but kept some measure of integrity of the original collection upon which he relied.

The transmission of the *Sichardiana* documents in the *Antidotum* is nevertheless fragmentary. We can therefore still ask why that is so. In contrast to Arsenal 341, about whose underlying editorial vision we have very little information, the overly anti-Nestorian sentiment of the segment where Sichard edited the *Sichardiana* documents can help explain why *Coll. Sich.* 11–15 and 18 were not edited into the *Antidotum*. As we will see in greater detail below, all these documents are barely focused on Nestorius at all—most notably *Coll. Sich.* 11–12, which cover the Christological middle ground between Cyril of Alexandria and John of Antioch; *Coll. Sich.* 13, which is a letter by Cyril from 419 that precedes the Nestorian Controversy by a decade; and *Coll. Sich.* 14–15, which deal with Theodore of Mopsuestia's teachings. We can therefore hypothesize that in his attempt to maintain the segment of the *Antidotum* focused on Nestorius, Sichard saw no issue with leaving out texts that have very little to do with Nestorius.

Verona LIX (57)

The oldest source of the *Sichardiana* is a damaged manuscript whose beginning and ending have not survived.

Neither a colophon nor any other explicit indication of the date of the manuscript's composition has survived in Verona LIX (57). The manuscript's dating to the late sixth century is based solely on its contents and the early medieval half-uncial script in which it was written: both its script and assortment of contents exhibit similarities with other early medieval manuscripts in the Biblioteca Capitolare and suggest that the manuscript was copied in Verona itself.[50] Despite its fragmentary nature, the surviving manuscript is very long, with 255 legible folios, each of roughly 25 lines. The manuscript's length, its rich and diverse contents, and the peculiar versions of some of its documents make it quite challenging to catalog. Although Antonio Spagnolo's early twentieth-century catalog of the Biblioteca Capitolare's manuscripts was reissued and revised in 1996,[51] scholarship has improved tremendously in terms of the available editions, translations, and research of numerous documents transmitted in Verona LIX (57). Providing a detailed review of each document of the manuscript would go beyond the confines of this paper, but I will dedicate several discussions here to the wider documentary context of Verona LIX (57) insofar as it relates to the contents of the *Sichardiana*. A brief overview of the manuscript's outline will therefore benefit our attempt to understand why the *Sichardiana* is transmitted in such a fragmentary manner among its folios.

In its preserved state without its opening and close, Verona LIX (57) transmits thirty-five documents, beginning with document number 22 and ending with document number 57.[52] The order of presentation of

49 A short biography composed by his contemporary Conrad von Humbracht tells us that sometime in the 1520s, Sichard, then a teacher of rhetoric who specialized in Latin authors from the Roman period, obtained from the archduke of Austria and future emperor of the Holy Roman Empire, Ferdinand I (1503–1564), a grant that gave him access to monastic libraries in Germany. Drawing on the manuscripts consulted during this research, Sichard published numerous editions of ancient and medieval texts: P. Lehmann, *Iohannes Sichardus und die von ihm benutzten Bibliotheken und Handschriften* (Munich, 1911), 17–23, and 46–48 for some examples of Sichard's contributions to the field of philology.

50 E. A. Lowe, ed., *Codices latini antiquiores: A Palaeographical Guide to Latin Manuscripts Prior to the Ninth Century*, 12 vols. (Oxford, 1934–71) (henceforth *CLA*), 4: no. 509, and below, n. 206.

51 Spagnolo, *I Manoscritti della Biblioteca Capitolare di Verona* (n. 33 above).

52 The manuscript starts in the middle of a text whose rubric has not survived. The rubric of the next document, found in fol. 3r, numbers it as the 23rd document. The manuscript breaks in the middle of the 57th document. In Spagnolo's catalog of Verona LIX (57), we find 91 rubrics of separate texts, but this does not follow the manuscript's own division of documents. Confusingly enough, Spagnolo's catalog enumerates the texts in Latin numbers, which gives the impression that these 91 rubrics originate in the manuscript itself. Although the catalog's careful attention to detail could be helpful in highlighting additional documents that may hide under a single rubric, it also significantly deviates from how the manuscript itself is divided. For example, the version of Cyril's *Contra Theodoretum* (*Coll. Sich.* 4) is divided into four rubrics in the manuscript (docs. 26–29; see below, n. 54), but in the catalog, it

these documents seems to correspond to three main thematic segments according to which the manuscript was divided: The first segment (fols. 1r–11v, docs. 22–25) offers texts dealing with orthodox and heterodox creeds mainly as they pertain to Trinitarian theology.[53] The second segment (fols. 12r–129v, docs. 26–38) covers detailed Christological discussions, which can be further divided into two parts: the *Sichardiana* section of the manuscript (fols. 12v–82r, docs. 26–32), which I will review in detail below,[54] and the second part (fols. 82r–129v; docs. 33–38) offering relevant florilegia on matters pertaining to the divinity and humanity of Christ, among which we find florilegia read at the

Councils of Ephesus (431)[55] and Chalcedon (451),[56] as well as a few sets of florilegia attributed to Augustine, although some include citations from other authors[57] or nongenuine Augustinian works.[58] The third and

is divided into 53 rubrics: each of Cyril's twelve anathemas—as well as Cyril's explanation of each anathema, refutation by Theodoret (or by the *Orientales*, when interpolated), and following rebuttal by Cyril—is enumerated as a separate text in the catalog.

53 We start in fols. 1r–3r with a fragment of book 10 of the Pseudo-Athanasian *De Trinitate*. The fragment here was consulted in Pseudo-Athanasius, *De Trinitate, libri X–XII*, ed. M. Simonetti (Bologna, 1956), 36:5–39:18. The following document's rubric is *XXIII Incipit scī Athanasi* [*sic*] *de symbolo* (fols. 3r–7r), which is a unique text that includes citations of the Apostles' Creed. See *CPL* 1744a, and L. H. Westra, *The Apostle's Creed: Origin, History, and Some Early Commentaries* (Turnhout, 2002), 351–61, 459–65. The next two items, which conclude the manuscript's credal segment, are unique witnesses of book 6 of the Pseudo-Athanasian *De Trinitate*. Their rubric is *XXIV Inc̄ fides scī Athanasi* (fols. 7r–10r), and *XXV Item de variis generibus lebrarum* [sc. *leprarum*] (fols. 10r–11v). The division of book 6 into two rubrics may provide further proof of the editorial liberties taken by the manuscript's compiler (discussed in the following notes and sections of this paper). However, the division of book 6 into two rubrics also follows the inherent structure of the book's content and may suggest that our compiler was a careful reader. On book 6's structure, see Kwon, "Theological Investigation," 47–48.

54 The segment is divided into seven documents: *XXVI Inc̄ epistula scī Cyrilli epī Alexandriae ad Eyoptium epm̄ ad ea quae a Theodorito epō Cyrri dicta sunt contra XII anathemata* (fols. 12r–13v), *XXVII Inc̄ praefatio scī Cyrilli epī Alexandrini in interpraetatione XII capitulorum in epistula ad Nestorium scriptam* [*sic*] (fols. 13v–15r), *XXVIII Inc̄ scī Theodoriti epī Cyrri civitatis ad scm̄ Iohannem epm̄ Antiochenum epistula, in qua ostendit se scripsisse contra XII capitula beati Cyrilli* (fols. 15r–16v), *XXVIIII Inc̄ anathematismus primus scī Quirilli* [*sic*] (fols. 16v–73r), *XXX Inc̄ adlocutio beatissimi Pauli quae praesente Quirillo in Alexandria facta est, per quem beatissimus Iohannis ad scaē memoriae Quirillum unitiuam de pace direxit epistulam* (fols. 73r–76v), *XXXI Inc̄ beati Quirilli adlocutio quam in ecclesia fecit post adlocutionem beati Pauli Emeseni ubi dicta eius adfirmat* (fols. 76v–77v), and *XXXII Inc̄ epistula scīssimi Theodoriti epī Cyrri ad Dioscorum Alexandrinum post primam ante secundum Ephesenam* (fols. 77v–81v).

55 *XXXIII Incipiunt testimonia scōrum patrum quae in synodo confirmata sunt de actione prima* (fols. 82r–90r). The version here is actually not from the first session but from the one known as the sixth, which convened on 22 July 431 (see *CPG* 8721). For the Greek original, see *ACO* 1.1.7, 89:26–95:18; trans. in Price and Graumann, *Council of Ephesus* (n. 1 above), 448–57. Further Latin translations of the florilegium can be found in *ACO* 1.3, 121:25–127; *ACO* 1.5.1, 89:26–96:2; and *ACO* 2.3.1, 196:10–210, as well as an abbreviated Latin version in *ACO* 2.2.1, 74:35–75:37.

56 Verona LIX (57) offers two florilegia from Chalcedon. The first was read at the end of the council as part of a special address to Emperor Marcian (*CPG* 9021): *XXXIIII Incipiunt testimonia scōrum patrum qui duas naturas in Xpō confessi sunt consubstantialem patri Dm̄ Verbum etiam nobis secundum carnem ex Maria consubstantialem veraciter adserentes* (fols. 90r–92v). For the Greek original, see *ACO* 2.1.3, 114[473]:4–116[475]:12. A Latin translation is edited in *ACO* 2.3.3, 119[558]:18–122[561]:12; trans. in Price and Gaddis, *Council of Chalcedon* (n. 15 above), 3:117–20. The second florilegium is the one appended to the well-known Tome of Leo (on this text, see below, n. 64): *XXXVII Incipiunt exempla catholica beatissimorum patrum de incarnatione dni et saluatoris nostri Ihū Xpī quae in scā et venerabili Calchedonensi* [*sic*] *synodo confirmata sunt adversum Nestorianos et Eutychianos adque hereticos* [*sic*] (fols. 96v–104v). The Augustinian citations in the Tome's florilegium were separated to the next rubric and can be found in fols. 104v–105v. In general, the transmission history of the florilegium is very unstable and includes different arrangements of the patristic citations (see the critical apparatus in *ACO* 2.4, 119–31). The Greek version as it was read in the council is edited in *ACO* 2.1.1, 20:6–25:6.

57 *XXXV Inc̄ de incarnatione et passione vel resurrectione dnī n̄i Ihū Xpī scī Augustini* (fols. 93r–96r). Antoine Chavasse demonstrated in 1966 that this text, which scholars until then had identified as a Pseudo-Augustinian sermon, is in fact an elaborate patristic florilegium in which the citations, presented in continuous and uninterrupted series, are not attributed to their original authors. The work includes citations from a wide range of patristic authorities, including Vincent of Lérins, Pope Leo I, Leporius, Augustine, Gennadius of Massilia, Cyril of Alexandria, Philastrius of Brescia, the Pseudo-Athanasian *De Trinitate*, and the Apostles' Creed. The text is edited in A. Mai, *Nova Patrum Bibliotecha*, vol. 1 (Rome, 1852), 391–93. See A. Chavasse, "Un curieux centon christologique du VIᵉ siècle," *Revue de droit canonique* 16 (1966): 87–97.

58 The bulk of Augustinian florilegia in the manuscript is organized under one rubric: *XXXVIII Item beatissimi Augustini epī et confessoris Hypponi Regiensium de duabus naturis in una dnī n̄i Ihū Xpī persona* (fols. 104v–129v). The contents under this rubric can be divided into three parts: Part one (fols. 104v–105v) includes dyophysite Augustinian citations from Leo's Tome (see above, n. 56, and below, n. 64). Part two (fols. 105v–117r) offers nine extracts from authentic works of Augustine that also deal with Christ's two natures. Part 3 (fols. 117v–129v) consists of four brief sermons interspersed

last segment of the manuscript (fols. 129v–255v, docs. 39–57) focuses on ecclesiastical norms and regulations through canonical collections,[59] conciliar acts,[60] sermons concerning pastoral duties,[61] questions and answers regarding ecclesiastical discipline,[62] and papal

letters that deal, in one way or another, with Rome's prerogative in arbitrating ecclesiastical disputes.[63]

The compiler of Verona LIX (57) arranged the manuscript into different thematic segments and parts either by choosing independent works that fit their thematic surroundings or by dividing the same work into different rubrics, parts, or thematic segments.[64] The approach suggests that the manuscript's compiler did not merely copy groups of texts indiscriminately but gave careful thought to the manuscript's contents and their arrangement. Appreciating the editorial liberties taken by the compiler of Verona LIX (57) may help explain why it transmits the *Sichardiana* in such a fragmented way: as several texts transmitted in the manuscript demonstrate, the compiler of Verona LIX (57) chose from the original *Sichardiana* only documents that fit the manuscript's editorial vision. Like Sichard in his *Antidotum*,

with comments pertaining to Christology and Trinitarian theology. According to Cyrille Lambot, the four sermons of part 3 should not be attributed to Augustine ("Le florilège augustinien de Vérone," *RBén* 79.1–2 [1969]: 70–81). The four sermons nevertheless exhibit a unique style of their own, suggesting that they should be attributed to a single author. Part 3, because it offers four stand-alone sermons rather than providing brief citations in the form of a florilegium, diverges from the florilegia that precede it in the manuscript. But the sermons' strong emphases on Christological matters conveniently fit this segment of the manuscript: the four sermons conclude the Christological segment of the manuscript and creatively lead us to the next segment, where we will find six more sermons from the same Pseudo-Augustinian author, though with a focus on clerics' pastoral duties. These six sermons, therefore, shift the theme of the manuscript from matters of Christology to matters of ecclesiastical norms and regulations.

59 These are reviewed below, in "The Beginning of Canonical Codification in North Africa and the Canonical Collection of Verona LIX (57)" and "The *Sichardiana* and the Canonical Collection of Verona LIX (57)." The rubrics are *LII Incipiunt canones ecclesiae seu statutae concilii Nicaeni in quo fuerunt epī CCCXVIII* (fols. 216r–234r), *LIII Incᵊ concilium sive synodus aput Ancyra* (fols. 234r–240r), *LIIII Incᵊ concilium Novecaesariensis* (fols. 240r–242r), *LV Incᵊ canones Gangrenses* (fols. 242v–247r), *LVI Incᵊ concilium Antyochenum* (fols. 247r–254r), and *LVII Incipiunt regulae sive definitiones secundum Laodiciam Phyrgiae Pagatianae* (fols. 254r–255v).

60 These are reviewed below, in "A Dialogue between Equals." The rubrics are *XLVII Incᵊ actio octava scī synodi Calchedonensis de scō Theodorito* (fols. 170r–174r), *XLVIII Incᵊ actio nona* (fols. 174r–178v), and *XLVIIII Incᵊ actio decima* (ff. 178v–209v).

61 These are the six sermons—by the same Pseudo-Augustinian author of part 3 of doc. 38—that I mentioned in the end of n. 58 above and that Lambot analyzed in his "Le florilège augustinien." The rubrics are *XXXVIIII Item eiusdem omelia de eo quod neofitis ex oleo scō aures a sacerdotibus et nares inliniantur* (fols. 129v–134r), edited in PL 40:1207–10; *XL Item eiusdem de mysterio et scītate baptismatis* (fols. 134r–139r), edited in PL 40:1209–12; *XLI Item eiusdem de hunctio capitis et de pedibus labandis* (fols. 139r–142v), edited in PL 40:1212–14; *XLII Item eiusdem ubi post baptismum spes paenitentiae concessa est* (fols. 142v–146r); edited in Mai, *Nova*, 385–87; *XLIII Item eiusdem de paenitentiae* (fols. 146r–149v), edited in Mai, *Nova*, 387–89; and *XLIIII Item eiusdem de resurrectione carnis et vivorum et mortuorum iudicii xpīanorum fides* (fols. 149v–152v), edited in Mai, *Nova*, 389–91.

62 From the letter of Pope Leo to Rusticus, the bishop of Narbonne (*ep.* 167; PL 54:1197–1209). The letter is divided into two rubrics in the manuscript: under the first we find the letter itself and under the second a series of questions and answers: *L Leo epᵊ Rustico epō Narbonensi* (fols. 210r–211v); *LI Incipiunt inquisitiones de praesbyteris vel diacones qui se episcopus esse mentiti sunt et de his quos clericos*

ordinarunt (fols. 211v–215v). For a recent critical edition of the letter, see M. Hoskin, "Prolegomena to a Critical Edition of the Letters of Pope Leo the Great: A Study of the Manuscripts" (PhD diss., University of Edinburgh, 2015), 337–58, 434–35.

63 The first is Leo's Tome (on which see below, n. 64): *XLV Incᵊ epistula Leonis papae ad Flavianum epm̄ Constantinopolitanae ecclesiae* (fols. 152v–162v). The second papal letter is Pope Innocent I's (401–417) letter to the bishops in Illyricum (*ep.* 17; PL 20:526–37): *XLVI Innocentius · Rufo · Eusebio · Eustasio · Claudio · Maximo · Eugenio · Gerontio · Iohanni · Polycronio · Sofronio · Flaviano · Hilario · Machedonio · Calicrati · Zosimo · Profuturo · Nicite · Hermogeni · Vincentio · Asiologo · Terentiano · Herodiano · et Marciano epīs Machedonibus et Dacie in dnō salutem* (fols. 162v–169v). For a detailed discussion of this letter, see G. D. Dunn, "Innocent I and the Illyrian Churches on the Question of Heretical Ordination," *Journal of the Australian Early Medieval Association* 4 (2008): 65–81. See also Dunn, "The Church of Rome as a Court of Appeal in the Early Fifth Century: The Evidence of Innocent I and the Illyrian Churches," *JEH* 64.4 (2013): 679–99.

64 I will review two examples of this below in "A Dialogue between Equals" and "The *Sichardiana* and the Canonical Collection of Verona LIX (57)." For an example from the first segment of the manuscript (docs. 24–25), see above, n. 53. The clearest editorial example, however, is the manuscript's treatment of the well-known Tome of Leo, i.e., Pope Leo I's letter to Flavian of Constantinople, dated 17 June 449 (*ep.* 28; *CPG* 8922; *ACO* 2.2.1, 24:16–33:10). The Tome and its appended florilegium were translated into Greek and read and discussed at the Council of Chalcedon during its second session (10 October 451) and its fourth (17 October 451). In Verona LIX (57), the Tome's florilegium is divided into two documents (docs. 37 and 38), which occur in the Christological florilegia section of the manuscript (see above, n. 56). Forty-seven folios later, the actual Tome occurs as doc. 45, in the third segment of the manuscript concerning ecclesiastical norms and regulations (see above, n. 63). For further details on Leo's Tome and its florilegium, see Price and Gaddis, *Council of Chalcedon*, 2:14–24, 3:161–62.

our compiler too might have left out any document from the original *Sichardiana* that diverged from the intense Christological discussions in the manuscript's second thematic segment (fols. 12r–129v; docs. 26–38).

A deeper understanding of the manuscript's editorial vision may also clarify why the *Sichardiana* documents transmitted in it closely complement other documents in the manuscript despite being separated from them by different rubrics, parts, or segments. But before we will be able to appreciate the relation of the *Sichardiana* to other documents of Verona LIX (57), it will be necessary to understand in more detail the *Sichardiana*'s actual contents. In the following pages, I wish to explore some of the ways in which the collection constructs the theological dispute that gave rise to the Three Chapters Controversy. An appreciation of how the *Sichardiana* constructs the controversy will help in demonstrating the conceptual unity of the collection's documents, the late antique provenance of their assembly, and even the geographical background of their editor.

A Dialogue between Equals

The starting point of my analysis will be the fourth document of the collection, *Coll. Sich.* 4. The document, as already mentioned, is transmitted in all three sources of the *Sichardiana* and represents the bulk of the collection. *Coll. Sich.* 4's towering role in the collection is due not only to its length but also to its main themes, which reverberate throughout the entire collection and which we will continue to encounter throughout this paper. In this section, I will especially focus on the rubrics of the individual segments of *Coll. Sich.* 4, as well as the correspondence of these rubrics to others throughout the *Sichardiana*. Attention to the collection's rubrics will demonstrate one way in which its editor tried to frame the dispute as it is reported in the *Sichardiana* documents. As I will show in the following pages, the collection's careful definition of the competing sides of the dispute was the first editorial step toward presenting a coherent apologetic argument in favor of the Three Chapters. And according to this apologetic argument, the original dispute between Cyril of Alexandria and the "Antiochenes," as members of John of Antioch's faction in Ephesus are normally known in scholarship,[65] was

not between an orthodox father and his heretical rivals but rather between equally orthodox theologians.

The core text around which *Coll. Sich.* 4 was constructed is Cyril's *Contra Theodoretum* (CPG 5222), a detailed apologetic treatise written in response to Theodoret of Cyrrhus's refutation of Cyril's *Twelve Chapters*.[66] Both Theodoret's refutations and Cyril's apology were published some months before the Council of Ephesus gathered in the summer of 431.[67] During roughly the same period before the council, Cyril wrote another apology in response to a refutation attributed to multiple anonymous authors from the ecclesiastical province of Oriens; hence the treatise is known as the *Contra Orientales* (CPG 5221).[68] In the late summer of 431, during the ecumenical proceedings in Ephesus, Cyril wrote a third apologetic treatise, known as the *Explanatio XII Capitulorum* (CPG 5223).[69] All three apologetic treatises are well attested in the Greek, Latin, and Syriac manuscript traditions and normally appear as separate works. In *Coll. Sich.* 4, however, the three treatises are combined into one text.

What could be the purpose of combining the three treatises as they are presented in *Coll. Sich.* 4? An immediate answer that comes to mind is an educational purpose: the text, which offers highly detailed explanations from both Cyril and some of his most sophisticated challengers, could greatly benefit any student interested in understanding this complicated

65 Although the surviving sources more commonly refer to this collective as the *Orientales* (or Ἀνατολικοί), for various reasons the

designation "Antiochenes" is more frequently used in scholarship: A. M. Schor, "Theodoret on the 'School of Antioch': A Network Approach," *JEChrSt* 15.4 (2007): 522–26, and Grillmeier, *Christ in the Christian Tradition* (n. 7 above), 1:414–37. See also Cyril's reference to this collective as his "Antiochene brothers," cited below, n. 115.

66 Theodoret's original refutation has survived only in Cyril's *Contra Theodoretum*: Cyril of Alexandria, *Apologia XII anathematismorum contra Theodoretum* (CPG 5222), *Collectio Vaticana* 167–69, *ACO* 1.1.6, 110–46. For further details on this treatise, see Daniel King's introduction to Cyril of Alexandria, *Three Christological Treatises*, trans. King, Fathers of the Church 129 (Washington, DC, 2014), 3–32.

67 King, introduction to Cyril, *Three Christological Treatises*, 6–8.

68 Cyril of Alexandria, *Apologia XII capitulorum contra Orientales* (CPG 5221), *Collectio Atheniensis* 24, *ACO* 1.1.7, 33–65; dated in P. Evieux, "André de Samosate: Un adversaire de Cyrille d'Alexandrie durant la crise nestorienne," *REB* 32 (1974): 267–69.

69 Cyril of Alexandria, *Explanatio XII capitulorum* (CPG 5223), *Collectio Vaticana* 148, *ACO* 1.1.5, 15–25. The treatise's rubric places its composition in the context of the conciliar proceedings in Ephesus. It is likely that Cyril wrote it in July while he was under house arrest (Bevan, *New Judas* [n. 4 above], 186).

theological controversy. It is therefore not surprising to find *Coll. Sich.* 4 placed early in the *Sichardiana*, a collection of documents that attempted to make sense of the controversy. But if we look beyond the actual contents and examine how the different treatises were joined and framed, we can identify another layer of meaning embedded in *Coll. Sich.* 4 that reverberates throughout other documents of the *Sichardiana*: as we read through the text, one strong impression we get is that the dispute is constructed not as a battle between an orthodox teacher and his rival dissidents but rather as a dialogue between equals.

Coll. Sich. 4 begins with a sequence of three introductory letters: two of them (the first and third letters in the sequence) normally preface the original Greek version of *Contra Theodoretum*,[70] while the third letter originally prefaces Cyril's *Explanatio*.[71] Following the three introductory letters, the treatise offers detailed discussions of each and every one of Cyril's twelve chapters in a very schematic way: after presenting one of Cyril's twelve chapters, the text offers Theodoret's refutation of that chapter, followed by Cyril's explanation of that chapter (from his *Explanatio*), and concluding with Cyril's response to the points raised in Theodoret's refutation.[72]

The individual sections that make up the discussion of each of Cyril's chapters become much more revealing when we look at their particular rubrics as they are transmitted in the three sources of *Sichardiana*. In Verona LIX (57), after each chapter of *sanctus Quirillus* [*sic*] is presented, the refutation of none other than *sanctus* or *beatus Theodoretus* follows.[73] The clear editorial intervention here, as Theodoret is qualified as *sanctus*, becomes much more noticeable when we look through the manuscript traditions of the *Contra Theodoretum*. Not only does the presentation of Theodoret as *sanctus* occur only in Verona LIX (57), but in the rubrics of his refutations preserved in some Latin and Syriac manuscripts, Theodoret's name is frequently omitted—he is merely referred to as a heretic.[74] In the manuscript traditions, it is much more common to find references to ἅγιος or *sanctus* Cyril in the rubrics of the treatise, with Theodoret given no special qualifier as either saint or heretic, and this is what we find in Arsenal 341. In the process of preparing Arsenal 341, the

70 The first is Cyril of Alexandria, *Letter to Euoptius of Ptolemais* (*ep.* 84; *CPG* 5384), *Coll. Sich.* 4, 249–50; Greek in *ACO* 1.1.6, 110–11. The third is Theodoret of Cyrrhus, *Letter to John of Antioch* (*ep.* 150; *CPG* 6264), *Coll. Sich.* 4, 251–52; Greek in *ACO* 1.1.6, 107–8. The three sources of the *Sichardiana* exhibit a slight discrepancy in their transmission of Theodoret's letter to John. In Verona LIX (57), Theodoret's letter (fols. 15r–16v) is immediately followed by Cyril's first anathema (fol. 16v), and then by Theodoret's refutation of the first anathema (fols. 16v–18v). This seems to be the original order of Theodoret's treatise, as we learn from his brief comment about the treatise's structure: *Coll. Sich.* 4, 252:18–20 (for the Greek, see *ACO* 1.1.6, 108:18–20). In both Arsenal 341 and Sichard's *Antidotum*, however, the last paragraph of Theodoret's letter to John is omitted (see *ACO* 1.5.2, 252:4–20 [from *ego*] = *ACO* 1.1.6, 108:2–20 [from ἐγώ]). In addition, in both sources Cyril's first anathema is placed *before* Theodoret's letter and his refutation (fols. 86r–87v in Arsenal 341; fols. 153r–153v in the *Antidotum*). This contrasts with Verona LIX (57), where the first anathema is found *between* Theodoret's letter and his refutation. As Schwartz notes in *ACO* 1.1.6, 170, variations in the inner arrangement of Theodoret's letter to John are not uncommon in the manuscript tradition, sometimes even resembling what we see in Arsenal 341 and the *Antidotum* (see also E. Schwartz, *Neue Aktenstücke zum ephesinischen Konzil von 431*, AbhMünch, Phil.-hist.Kl. [Munich, 1920], 6). Medieval copyists of Cyril's *Contra Theodoretum* most likely faced an editorial challenge when they tried to extract the relevant piece from Theodoret's text—his refutation—while either shortening or omitting entirely other content. The following eleven anathemas posed no difficulties, since Theodoret's refutations followed each anathema without any digressions. It is also possible that Theodoret's rather harsh words in the omitted paragraph (e.g., referring to the *Twelve Chapters* as αἱρετικὴ κακοδοξία) sat uncomfortably with some medieval readers. The copyist of Verona LIX (57), as we will see in other examples below, did not seem to have had much of an issue with the letter's contents.

71 *Coll. Sich.* 4, 250–51.

72 Even when *Coll. Sich.* 4 includes interpolations from the *Contra Orientales*, the individual rubrics continue to refer to Theodoret as the author of the refutations. In the sections where we would find Theodoret's refutations of the eleventh and twelfth chapters, we find instead the refutations of those chapters from the *Contra Orientales*. Cyril's responses to both refutations also come from the *Contra Orientales*. In addition, Cyril's response to Theodoret's refutation of the tenth chapter contains an interpolation from his response to the refutation of the tenth from the *Contra Orientales*. Further details on these interpolations can be found in Schwartz, *Konzilstudien* (n. 38 above), 57–58.

73 In Verona LIX (57), fols. 22v, 26r, we find *Repraehensio a scō facta Theodorito*; in fols. 32r, 39r, 42v, 45r, 47v, *Repraehensio scī Theodoreti*; and in fols. 49v, 53, 62r, 68r, *Repraehensio beati Theodoreti*.

74 Follow the references to recension ΛρΣ in the critical apparatus of the treatise in *ACO* 1.1.6, 107–46, e.g., 116:14. ΛρΣ refers to Latin (Λ) of the *Collectio Palatina* (p) (edited in *ACO* 1.5.1; the *Contra Theodoretum* in 142–65), and Syriac (Σ) of British Library, Add. 12,156 (see W. Wright, *Catalogue of Syriac Manuscripts in the British Museum Acquired since the Year 1838*, vol. 2 [London, 1871], 647). In the apparatus of *ACO* 1.1.6, when Schwartz presents Greek rubrics of Theodoret's refutations from recension ΛρΣ, he is translating from Syriac.

reader and copyist of the manuscript might have been presented with a difficulty when they encountered in *Coll. Sich.* 4 references to *sanctus* Theodoret, especially next to a figure of the stature of Cyril of Alexandria. But in Sichard's *Antidotum*, neither Cyril nor Theodoret is titled *sanctus*. The removal of such honorifics from other *Sichardiana* documents transmitted in Sichard's *Antidotum* reveals that the change was intentional, perhaps reflecting Sichard's attempt to present his edition of early medieval texts through a prism of impartial scholarship.[75]

Despite the survival of references to Theodoret as *sanctus* only in Verona LIX (57), a similar source of *Coll. Sich.* 4 seems to have dictated the rubrics found in all three sources. Perhaps because of contemporary printing and scholarly standards, Sichard attempted to maintain an unbiased regularity in his rubrics. From the three sources of the *Sichardiana*, his printed *Coll. Sich.* 4 includes the fewest variations: following the presentation of each of Cyril's chapters, the section covering Theodoret's refutation is regularly titled *Theodoreti Reprehensio*, that of the following explanation from Cyril as *Cyrilli Interpretatio*, and the discussion of each chapter concludes with *Cyrilli Oppositio*. This is largely the same scheme that we find in the rubrics of *Coll. Sich.* 4 in Arsenal 341 and Verona LIX (57), except the qualifier *sanctus* is added to Cyril in the former, and to both Cyril and Theodoret in the latter. Interestingly enough, when we find a deviation from the *Reprehensio–Interpretatio–Oppositio* scheme, it normally presents itself in all three sources. Thus, in the discussion of the third chapter, Cyril's response to Theodoret's refutation is titled a *Contradictio* in all three sources instead of an *Oppositio*.[76] In the discussions of the fourth and fifth chapters, instead of an *Interpretatio*, Cyril's explanation of the chapters is titled a *Resolutio* in Verona LIX (57) and Arsenal 341, while Sichard resorts to *Responsio*.[77] More minor variations in the rubrics, especially between Verona LIX (57) and Arsenal 341, seem to indicate issues related to

reading aloud and copying the source material rather than variations in the source material itself.[78]

Although *sanctus Theodoretus* is found in *Coll. Sich.* 4 only in Verona LIX (57), the phenomenon of defining Theodoret and members of the Antiochene faction as equals to Cyril in their qualifications as *sancti* occurs in other *Sichardiana* texts, even texts transmitted in Arsenal 341. In *Coll. Sich.* 11, there appears an address (*allocutio*) by Paul of Emesa that was presented to Cyril of Alexandria in 432.[79] Paul had been a member of the Antiochene faction since the Council of Ephesus, and John of Antioch, the leader of the Antiochenes, sent him to Alexandria in 432 to a conference with Cyril in an attempt to conclude the controversy and reach a theological settlement between the factions. The address preserved in *Coll. Sich.* 11 comes from that conference.[80] In the following document of the *Sichardiana*, *Coll. Sich.* 12, we find Cyril's address in response to Paul of Emesa's.[81] I will further discuss both addresses below, but for now it suffices to note that the two documents have survived in both Verona LIX (57) and Arsenal 341, but not in the Sichard's *Antidotum*.[82] In Arsenal 341, the rubric of *Coll. Sich.* 11 shares some of the historical circumstances behind Paul of Emesa's address by highlighting that Paul arrived in Alexandria with a letter of none other than *sanctus* John of Antioch.[83] In Verona LIX (57), the rubric of *Coll.*

78 For example, *Oppositio* sometimes becomes *Obpositio* or *Abpositio*, or Cyril becomes *Ciril* or *Quirril*. The copyist of Arsenal 341 relied extensively on shortened word forms throughout the entire manuscript, both in the rubrics and in the texts themselves. The notable variations in the occurrences of the word *reprehensio* might shed light on the copyist's possible dysgraphia: except one instance where the word is rendered *reprehonsio* (with an *o*), we find very inconsistent use of its shortened word forms—e.g., *rn̄sionēs* (sc. *reprehensiones*) in fol. 86r, *rephensio* in fol. 86v, *reprehēsio* in fol. 93r, and *reprehē* in fol. 108r. Perhaps in order to avoid this difficult word, the copyist frequently replaced it with *responsio* in the titles of Theodoret's refutations.

79 Paul of Emesa, *Second Homily: About the Nativity* (CPG 6366), *Coll. Sich.* 11, 307:4–309:34.

80 For a detailed review of these negotiations, see Bevan, *New Judas*, 210–26, and especially 217–19 for the role of Paul of Emesa.

81 Cyril of Alexandria, *Third Homily: Response to Paul of Emesa* (CPG 5247), *Coll. Sich.* 12, 310:1–25.

82 Verona LIX (57), fols. 73r–77v (docs. 30–31), and Arsenal 341, part 3, fols. 119r–121r.

83 Arsenal 341, part 3, fol. 119r: *Incipit Pauli Emisceni* [sic] *ēpla qui ēplam scī Iohīs Antiocheni in Alexādriā deportavit allocutionem fecit in Allexādria* [sic] *ecclesia maiori sedente et audiente beato Cyrillo, docēs*

75 See another example discussed below, n. 100, where Sichard removed honorifics that are transmitted elsewhere.

76 Verona LIX (57), fol. 28v; Arsenal 341, part 3, fol. 91v; and *Antidotum*, fol. 156r.

77 Verona LIX (57), fols. 34v, 40r; Arsenal 341, part 3, fols. 94r, 96v; and *Antidotum*, fols. 157v, 159r.

Sich. 11 titles both Paul of Emesa and John of Antioch *beatissimi*, but the rubric's phrasing is slightly different from what we find in Arsenal 341.[84] In *Coll. Sich.* 12, however, both manuscripts present very similar rubrics in which *beatus* Paul is mentioned next to *beatus* Cyril.[85] A few documents later, in *Coll. Sich.* 15,[86] we find a letter from Cyril to John of Antioch in which both are titled *beati*.[87] Arsenal 341 is the only source of the *Sichardiana* that transmits *Coll. Sich.* 15.

The above examples from Arsenal 341 further suggest that the manuscript's underlying source of the *Sichardiana* documents was very similar to the underlying source of the *Sichardiana* documents in Verona LIX (57), the collection's oldest witness. The copyists of both manuscripts usually followed the same rubrics found in that shared source—even, at times, when their shared source referred to members of the Antiochene faction as *beati* or *sancti*. Yet as we have seen in *Coll. Sich.* 4, the copyist of Arsenal 341 was not as consistent as the copyist of Verona LIX (57) in honoring the Antiochenes.[88]

We can offer only conjectures as to why it is so. Perhaps the notoriety of Theodoret of Cyrrhus as opposed to the relative anonymity of John of Antioch and Paul of Emesa made it easier for the thirteenth-century copyist of Arsenal 341 to remove the honorific titles of the former and retain them for the latter.

In two more places in Verona LIX (57) Theodoret and John of Antioch are titled *sancti*,[89] and there is a third example that is worth dwelling upon before concluding this section. Roughly ninety folios after the Christological segment of Verona LIX (57) where the *Sichardiana* documents are located, we find a series of three documents containing the acts of the eighth, ninth, and tenth sessions of the Council of Chalcedon.[90] From the perspective of the Three Chapters Controversy of the following sixth century, these three conciliar sessions are of significant interest, for in them Theodoret of Cyrrhus and Ibas of Edessa, two of the so-called Chapters, were acquitted of their previous charges and restored to their episcopal sees.[91] In Verona LIX (57), the rubric of the first document in this series of three offers a brief clarification about the session's main order of business: *Inc̄ actio octava sc̄i synodi Calchedonensis* [*sic*] *de sc̄o Theodorito*. The rubrics of the two following documents are very brief and merely mention the sessions' numbers.[92] As far as I can tell, no other manuscript that transmits the Chalcedonian acts in any form presents Theodoret, in this session or otherwise, as *sanctus*.

The correspondence between the subject of the three Chalcedonian acts in Verona LIX (57) and the overall apologetic themes of the *Sichardiana* documents, as well as the way in which the rubric of the eighth session, like other *Sichardiana* documents,

duas naturas in Xp̄o et nō duas [sc. *unam*?] *debere predicari et impassilem* [*sic*] *credimus deitatem et scārā scpturarū dividi voces.* The letter by John of Antioch that is mentioned at the beginning of the rubric is probably *CPG* 6309, edited in *Collectio Atheniensis* 108, *ACO* 1.1.7, 151–55.

84 Verona LIX (57), fol. 73r: *XXX Inc̄ adlocutio beatissimi Pauli quae praesente Quirillo in Alexandria facta est, per quem beatissimus Iohannis ad scaē memoriae Quirillum unitiuam de pace direxit epistulam.*

85 Verona LIX (57), fol. 76v: *XXXI Inc̄ beati Quirilli adlocutio quam in ecclesia fecit post adlocutionem beati Pauli Emeseni ubi dicta eius adfirmat;* Arsenal 341, part 3, fol. 120v: *Incipit beati Cyrilli allocutio in ecclesia ubi allocutoēm beati Pauli Emisceni recapitulans affirmat.*

86 Cyril of Alexandria, *Letter to John of Antioch (pro Theodoro)* (*ep.* 91; *CPG* 5391), *Coll. Sich.* 15, 314:7–315:20.

87 Arsenal 341, part 3, fol. 123v: *Incipit ēpla bt̄i Cyrilli ad bt̄m Iohēm Antiochenū ep̄m et ad sinodū* [*sic*] *que sub illo ē cōgregata pro Theodoro.*

88 Even though the honorifics in the *Sichardiana* documents are more frequently found in Verona LIX (57), it is unlikely in my opinion that they are merely a unique contribution by the manuscript's copyist rather than the copyist's faithful reproduction of the source's rubrics. The first piece of evidence is the survival of honorifics also in Arsenal 341, as noted above. Further evidence is the general use of honorifics throughout Verona LIX (57). Although honorifics such as *sanctus* and *beatus* occur frequently even outside the manuscript's Christological segment (e.g., in the rubrics of texts of *sc̄i Athanasii* or *sc̄i Augustini*), both personal names and councils sometimes appear without any honorifics, such as in Pope Leo's documents (docs. 45, 50–51; above, nn. 62–63), Pope Innocent I's (doc. 46; above, n. 63), and in all the councils, including Nicaea, mentioned in the canonical collection that conclude the manuscript (docs. 52–57; above, n. 59).

The latter stands in stark contrast to every document related to the Council of Chalcedon in which it receives the honorific *sancta*.

89 Verona LIX (57), fol. 16v: *XXVIII Inc̄ sc̄i Theodoriti ep̄i Cyrri civitatis ad sc̄m Iohannem ep̄m Antiochenum epistula in qua ostendit se scripsisse contra XII capitula beati Cyrilli,* and fol. 77v: *XXXII Inc̄ epistula sc̄issimi Theodoriti ep̄i Cyri ad Dioscorum Alexandrinum post primam ante secundum Ephesenam.*

90 Verona LIX (57), fols. 170r–209v (docs. 47–49). See also *CPG* 9010, 9011, 9013. Note that these sessions are numbered differently in the Latin and Greek transmissions of the acts: Price and Gaddis, *Council of Chalcedon* (n. 15 above), 2:250, 258, 265.

91 Price and Gaddis, *Council of Chalcedon*, 2:250–309.

92 Verona LIX (57), fol. 174r: *XLVIII Inc̄ actio nona,* and fol. 178v: *XLVIIII Inc̄ actio decima.*

honors Theodoret as *sanctus*, strongly suggests that these three Chalcedonian acts were part of the same *Sichardiana* source copied into Verona LIX (57). As we have already seen, the compiler of Verona LIX (57) frequently neglected to maintain the integrity of some of his documents as he separated them into different rubrics and sections of the manuscript. It should therefore not surprise us that the compiler could also have separated different documents *from the same source material* into different sections of the manuscript. Here, keeping the Chalcedonian acts next to the *Sichardiana* documents (fols. 12v–82r) would have disturbed the in-depth theological discussion preserved in the Christological segment of the manuscript (fols. 12r–129v). Instead, the compiler of Verona LIX (57) pushed the three Chalcedonian acts to the last segment of the manuscript dealing with ecclesiastical norms and regulations (fols. 129v–255v; the acts are in 170r–209v). Surrounded by texts concerning pastoral duties, canonical regulations, and ecclesiastical discipline, the Chalcedonian acts—with their detailed information on conciliar procedure—fit right in.

The rubrics of the *Sichardiana* documents help us identify one way in which the collection framed the dispute between Cyril and the Antiochenes in equalizing terms. As we will see in detail in the following pages, referring to both sides as *sancti* or *beati* would complement the careful distinction made in the *Sichardiana* documents between the different factions of the dispute. A close reading of the rubrics transmitted in the manuscript sources also suggests that the collection as it is currently printed in the *ACO* should be expanded and include the Chalcedonian acts transmitted in Verona LIX (57). While the contribution of Sichard's *Antidotum* to this analysis of rubrics is limited, the general correspondence of its rubrics to the ones surviving in the two manuscript sources nevertheless demonstrates that all three sources relied on a very similar earlier source, which has not survived independently.

The Tripartite Factionalism in Ephesus according to the *Sichardiana*

Despite attempts to present the dispute between Cyril and the Antiochenes as a dialogue between equals, evidence of factionalism is not glossed over in the *Sichardiana*. There was a major debate between Cyril

and the Antiochenes, and it receives ample treatment in the collection's documents. But as I will demonstrate in this section, the nuanced editorial manner in which the *Sichardiana* attempts to construct the debaters' positions embeds within it an elaborate apologetic argument: simultaneous with the attempt of the *Sichardiana*'s documents and their rubrics to bring Cyril and the Antiochenes closer together, the collection also attempts to position each of them in opposition to Nestorius. In the case of Cyril, this was fairly easy, since in most of his writings from the period we find explicit attacks against Nestorius. The *Sichardiana*'s attempt to position the Antiochenes in opposition to Nestorius was more challenging, however. Explicit voices against Nestorius would start rising in Antiochene circles only after the signing of the *Formula of Reunion* in 433.[93] Until then, the surviving evidence shows little hint of tension or rivalry between the Antiochenes and Nestorius.[94] But as I will demonstrate below, a few careful editorial choices in the *Sichardiana* seem to have overcome this difficulty.

The *Sichardiana*'s editorial construction of the opposition to Nestorius is exemplified in the second introductory letter of *Coll. Sich.* 4, which was originally Cyril's preface to his *Explanatio* (*CPG* 5223) and

93 The best-known case of Antiochene defection to Cyril's anti-Nestorian side is Rabbula of Edessa's. Scholars disagree over whether he joined Cyril before the ecumenical gathering in Ephesus in the summer of 431 or later in 432 (Schor, *Theodoret's People* [n. 3 above], 236, n. 88). We have further evidence of some defections from the Antiochene faction throughout the proceedings in Ephesus, although it would be difficult to see many of the defectors as integral members of the Antiochene network. See Schor's *Theodoret's People* for the most detailed study of the Antiochene network's robustness and coherence until 433. For further details on the defections throughout the proceedings, see R. Price, "Politics and Bishops' Lists at the First Council of Ephesus," *AnnHistCon* 44 (2012): 395–420.

94 Some scholars have argued that there was a personal breach between Nestorius and John of Antioch in the months leading to Ephesus and perhaps throughout the ecumenical gathering, too: see Bevan, *New Judas*, 142, 164, who generally follows Donald Fairbairn, "Allies or Merely Friends? John of Antioch and Nestorius," *JEH* 58.3 (2007): 383–99. In *Theodoret's People*, Schor outlines how the Antiochene network disintegrated, but this development started only in 433, following the peace between Cyril and John. We therefore need to be careful not to read the evidence from 431 anachronistically. I do not subscribe to the interpretation that there existed a conflict between John and Nestorius in Ephesus, but a detailed presentation of my arguments on the matter, chiefly based on *Coll. Sich.* 5 and 6, lies outside the scope of this paper.

is one of Cyril's most aggressive texts in the collection.[95] There, we find continuous attacks on Nestorius and on "certain people" who, according to Cyril, either did not understand his *Twelve Chapters* or attacked them merely because they were, in fact, the "guardians of Nestorius's wicked heresy."[96] Throughout his detailed apologetic responses in *Coll. Sich.* 4, Cyril nuances the distinction between Nestorius and his supposed "guardians" by stating that the sole intention behind the *Twelve Chapters* was to counter Nestorius's specific utterances, which Cyril even frequently cites in detail.[97] As Cyril clarifies in even stronger terms in the following documents of the *Sichardiana*, he never meant to offend or to attack his "Antiochene brothers."[98] Historically, Cyril's complete focus on Nestorius, which is repeated throughout his texts in the *Sichardiana*, was not easily registered by the Antiochenes. The clearest example of this misunderstanding is that in *Coll. Sich.* 4, as well as in all the *Sichardiana* documents that transmit texts or citations from the Antiochenes themselves, none of them ever tries to present his personal or their collective position as a defense of Nestorius or his teachings. In fact, outside of one single example in the concluding paragraph of the last document of the *Sichardiana* (*Coll. Sich.* 18), where Theodoret of Cyrrhus spells out in a letter dated to 448 that he and John of Antioch had repeatedly condemned Nestorius and his teachings,[99] the name of Nestorius is never even brought up in any of the Antiochene texts in the *Sichardiana*.

The Antiochenes' distance from Nestorius is expressed most notably in the two documents immediately following *Coll. Sich.* 4. The first is *Coll. Sich.* 5, a synodal document from the Antiochene counter-council headed by John of Antioch in Ephesus in the summer of 431.[100] At no point throughout the proceedings in Ephesus did John's counter-council ever join Cyril's council; it is only the latter that eventually would become recognized as the First Ecumenical Council of Ephesus.[101] In *Coll. Sich.* 5, we find a report of the Antiochenes' objections to Cyril's *Twelve Chapters* on procedural grounds (discussed in further detail in "The African Connection" below), and of the general difficulties they experienced throughout the summer in Ephesus. Appended to the synodal text is the next document of the collection, *Coll. Sich.* 6.[102] The document is a detailed refutation of Cyril's *Twelve Chapters* and complements the previous complaints against that work, but here on theological grounds. There is no mention of or even allusion to Nestorius in either document, despite their official affiliation with the Antiochene counter-council.

Through *Coll. Sich.* 5 and 6 we are therefore presented with two themes that complement what we have seen in *Coll. Sich.* 4: first, further details on the core theological argument between the factions, and second, an additional expression of the peculiar factionalism underlying the dispute. Although it was Nestorius whose teachings had engendered it, as it is depicted in the *Sichardiana*, Nestorius consequently played a

95 While writing this apology, Cyril was placed under house arrest and his deposition from the Alexandrian see, decreed a few weeks back at the Antiochene counter-council, was confirmed by Emperor Theodosius II: Bevan, *New Judas*, 181–86, and more broadly 153–86 for the Antiochene counter-council.

96 *Coll. Sich.* 4, 251:13–15: *Offenduntur itaque meis sermonibus aliqui, aut non intellegentes vere horum quae sunt scripta virtutem aut effecti scelestae Nestorii haereseos protectores partitique impietatem et eadem quae ille sapientes.*

97 Several references throughout the work might demonstrate this point, but it is summarized quite succinctly in Cyril's response to Theodoret's refutation of the ninth chapter—*Coll. Sich.* 4, 273:36–274:1: *Dudum dixi quia Nestorii superfluitatibus seu blasphemiis et multum neglegenter dictis virtus repugnat capitulorum*—which is followed by several citations from Nestorius himself to strengthen this point.

98 Cyril of Alexandria, *Letter to Acacius of Melitene* (ep. 40; *CPG* 5340), *Coll. Sich.* 10, 304:13. See also below, n. 115.

99 See below, n. 143.

100 John of Antioch et al., *The Synod of Orientals' Exposition of Faith* (*CPG* 6353), *Coll. Sich.* 5, 287:18–288:29. With the rubric *Synodi orientalium decreta atque eorum confessio qui cum Ioan. Antiocheno senserunt* (= Sichard, *Antidotum*, fol. 168r). In line with my previous observation that Sichard excised honorifics from the rubrics of documents in his edition, it is interesting to note that *Coll. Sich.* 5 has also survived in a Greek conciliar collection and in another Latin collection. In the rubrics transmitted in both collections, John of Antioch's council retains its honorific ἁγία and *sancta*, respectively: the Greek is in *Collectio Vaticana* 96, *ACO* 1.1.3, 38:10, and the Latin (different translation from the one transmitted in the *Sichardiana*) in *Collectio Casinensis* 110, *ACO* 1.4, 61:32.

101 Bevan, *New Judas*, 162–81.

102 Anonymous, *Refutation of Cyril of Alexandria's Twelve Chapters* (*CPG* 6360), *Coll. Sich.* 6, 288:30–294:42. In Sichard's *Antidotum*—the only source of the *Sichardiana* in which it has survived—the text is appended to *Coll. Sich.* 5 without interruption. Owing to the notable shift in content, as well as the survival of other independent versions of *Coll. Sich.* 5 without the refutation in *Coll. Sich.* 6, Schwartz justifiably divided the seemingly single synodal document into two.

rather ambiguous role in the dispute. When we take this ambiguity into account, the emerging factionalism could be defined as tripartite: the Antiochenes on the one side, Cyril on the other, and Nestorius, whom the Antiochenes ignore and Cyril constantly attacks, somewhere in between.

The tripartite factionalism reflected through *Coll. Sich.* 4, 5, and 6 is particularly evident in the three opening documents of the collection:[103] *Coll. Sich.* 1 opens with one of the most important documents of the Nestorian Controversy, Cyril of Alexandria's *Third*

Letter to Nestorius, to which Cyril originally appended his *Twelve Chapters*.[104] The following document, *Coll. Sich.* 2, consists of twelve counter-chapters that are falsely attributed to Nestorius in the manuscript tradition.[105] They are followed by *Coll. Sich.* 3, which offers the suspicious creed that Charisios of Philadelphia had brought before Cyril's council in Ephesus,[106] and which we have previously examined in the context of Pope Vigilius's *First Constitutum* (see above, "The Three Chapters Controversy"). In the *Sichardiana*, the creed's rubric explicitly attributes it to Nestorius,[107] as Charisios had originally presented it, and as Cyril soon found out was incorrect.

It is not difficult to notice the intense focus in the introductory segment of the *Sichardiana* on Nestorius—first in Cyril's letter to Nestorius, which, beyond its appended anti-Nestorian *Twelve Chapters*, both includes a detailed refutation of Nestorius's heretical teachings (*Coll. Sich.* 1) and then repeats those teachings in Nestorius's supposed counter-chapters and creed (*Coll. Sich.* 2–3). The focus on Nestorius's role as the catalyst of the controversy may be glossed as a mere confirmation of what scholars have known for centuries about its history, though drawn here from two nongenuine Nestorian works (*Coll. Sich.* 2–3). But in light of the following documents of the *Sichardiana*, the placement of *Coll. Sich.* 1–3 as the introduction of the collection also presents an implicit argument: the complete silence in this introductory segment on the Antiochenes contributes to the tripartite factionalism that the *Sichardiana* carefully constructs in the following documents. After all, the more the *Sichardiana* centers on and magnifies the role of Nestorius in instigating

103 It is worth noting that the only source of the *Sichardiana* that transmits *Coll. Sich.* 1–3 is Sichard's *Antidotum*. Schwartz attempted to strengthen the three documents' ancient relation to the rest of the *Sichardiana* by pointing to another conciliar collection: the *Collectio Palatina*, a Latin collection from the time of the Theopaschite controversy of the early sixth century. The *Palatina* relies on some translations of originally Greek texts that were made by Dionysius Exiguus (fl. late fifth and early sixth century). The *Sichardiana* also transmits some of Dionysius's translations (*Coll. Sich.* 8–10, 17), as well as two introductory letters to these translations, which Dionysius dedicated to some of the main protagonists from the Theopaschite controversy (*Coll. Sich.* 7, 16). In addition, the *Palatina* includes a sequence of texts that is similar to the *Sichardiana* sequence of *Coll. Sich.* 2–4: it starts with a *disputatio* (*Coll. Pal.* 37) about Cyril's chapters and Nestorius's counter-chapters, which include the same version of the counter-chapters as does *Coll. Sich.* 2. The *disputatio* is followed by the acts of the sixth session of Cyril's council in Ephesus (*Coll. Pal.* 38), in which Charisios of Philadelphia presented the questionable "Nestorian" creed. There are no similarities in the translation between the version of the creed in *Coll. Pal.* 38 and in *Coll. Sich.* 3. Lastly, *Coll. Pal.* 39–40 include translations from the Greek original of Cyril's *Contra Orientales* (*Coll. Pal.* 39) and his *Contra Theodoretum* (*Coll. Pal.* 40). As previously mentioned (see above, n. 72), the version of the *Contra Theodoretum* in *Coll. Sich.* 4 contains some interpolations from the *Contra Orientales*. A recent reconstruction of the Theopaschite controversy's main developments is available in M. J. Pereira, "Reception, Interpretation and Doctrine in the Sixth Century: John Maxentius and the Scythian Monks" (PhD diss., Columbia University, 2015), 194–207. The *Palatina* is edited in *ACO* 1.5.1. For Schwartz's discussion of the reverberations of the *Palatina* in the *Sichardiana*, see *ACO* 1.5.2, iii–iv.

Further evidence that the sequence of *Coll. Sich.* 1–3 is not an innovation by Sichard comes from a ninth-century manuscript originally from Fleury-sur-Loire but now housed in Berlin's Staatsbibliothek, MS Lat. 78 (Phill. 1671). At the end of the manuscript, we find the exact same versions of *Coll. Sich.* 1–3 presented in the same sequence as they occur in Sichard's *Antidotum*. Berlin Lat. 78 does not transmit any other *Sichardiana* documents, but the manuscript does include some peculiar florilegia whose earliest or only other witness is Verona LIX (57). On Berlin Lat. 78, see V. Rose, *Verzeichniss der lateinischen Handschriften der Königlichen Bibliothek zu Berlin*, vol. 1, *Die Meermann-Handschriften des Sir Thomas Phillipps* (Berlin, 1893), 142–49.

104 Cyril of Alexandria, *Third Letter to Nestorius* (*CPG* 5317), *Coll. Sich.* 1, 247 (incipit and explicit only); edited in *ACO* 1.5.1, 236:1–244:15. See also A. de Halleux, "Les douze chapitres cyrilliens au Concile d'Éphèse (430–433)," *Revue théologique de Louvain* 23.4 (1992): 425–58, and esp. 436–37 for evidence of the *Chapters'* early circulation throughout the Roman East.

105 Pseudo-Nestorius, *Twelve Counter-Chapters* (*CPG* 5761), *Coll. Sich.* 2, 247:8–249:7; see also E. Schwartz, "Die sogenannten Gegenanathematismen des Nestorius," *SBMünch* (1922): 27–28, and V. Grumel, ed., *Les regestes des actes du patriarcat de Constantinople*, vol. 1, *Les actes des patriarches*, fasc. 1, *Les regestes des 381 à 716*, 2nd ed. (Paris, 1972), no. 61, 50.

106 Pseudo-Nestorius, *Exposition of Faith* (*CPG* 8721), *Coll. Sich.* 3, 249 (incipit only); edited in *ACO* 2.3.1, 213:5–215:21.

107 Sichard, *Antidotum* (n. 39 above), fol. 151v: *Exemplar sacrilegae expositionis Nestorii*.

the dispute, the more it shifts blame away from the Antiochenes and their actions both before Ephesus (their refutations of Cyril's *Twelve Chapters*) and throughout (their conciliar activities against Cyril and his allies).[108] Consequently, the Antiochenes are moved closer to Cyril's side and farther from Nestorius's.

In the decades and centuries after Ephesus, highlighting the existence of a tripartite factionalism in the dispute over Nestorius's teaching would become significant in any argument against the condemnation of the Antiochenes (e.g., Theodoret of Cyrrhus and Ibas of Edessa) or their intellectual forefathers (e.g., Theodore of Mopsuestia). It is only through such a tripartite division of the controversy that one could coherently argue that the Antiochenes were, in fact, an intellectual and sociological faction distinct from that of Nestorius, and that they did not share his teachings. Reconstructing the tripartite division of the controversy, accordingly, could undermine attempts to condemn the Three Chapters as sympathizing with Nestorianism and opposed to Cyril of Alexandria.

The Theological Congruity between Cyril and the Antiochenes

As the following *Sichardiana* documents will show, highlighting the tripartite factionalism underlying the dispute was only one apologetic step taken in favor of the Antiochenes and, consequently, the Three Chapters. The next step was to show that the controversy in Ephesus between Cyril and the Antiochenes was not a controversy at all. Through this conceptual maneuver, the apologetic narrative of the *Sichardiana* shows us that the Antiochenes' teachings not only shared nothing with Nestorianism but were in line with Cyril's teachings all along.

The next thematic segment of the *Sichardiana* (*Coll. Sich.* 7–12) covers Cyril of Alexandria's personal testimony of the theological congruity between him and the Antiochenes. The segment opens with a brief introductory note (*Coll. Sich.* 7) written by Dionysius

Exiguus,[109] the sixth-century translator of the following three letters by Cyril: two letters to Succensus of Diocaesarea (*Coll. Sich.* 8 and 9),[110] and another to Acacius of Melitene (*Coll. Sich.* 10).[111] The insertion of Dionysius's relatively late text (dated early sixth century) does not disrupt the thematic flow of the segment, since it contains a short clarification on the circumstances under which Cyril originally composed the following three letters, describing them as part of Cyril's battle against the spread of Nestorius's heretical thought.[112] While this comment may seem somewhat vague, it is significant since the following three letters to Succensus and Acacius contain some of the clearest dyophysite expressions in Cyril's extant writings.[113] We are therefore presented with Cyril's fight against Nestorianism through his clarifications on the proper manner in which the two natures of Christ should be perceived and described.[114] Especially significant are Cyril's details on the tripartite factionalism of the dispute, when he distinguishes between the orthodox dyophysite language of his fellow "Antiochene brothers" and the extreme division of Christ's two natures by

108 Their most notable actions were their condemnation of Cyril's teachings as heretical, their decree of excommunication against Cyril and his allies, and their verdict of Cyril's deposition from the Alexandrian see. The latter was even temporarily confirmed by Emperor Theodosius II. For further details on the Antiochene counter-council, see above, n. 95.

109 Dionysius Exiguus, *Letter to John and Leontius* (*CPL* 653a), *Coll. Sich.* 7, 294:43–295:27.

110 Cyril of Alexandria, *First Letter to Succensus of Diocaesarea* (*ep.* 45; *CPG* 5345), *Coll. Sich.* 8, 295:28–299:26, and Cyril of Alexandria, *Second Letter to Succensus of Diocaesarea* (*ep.* 46; *CPG* 5346), *Coll. Sich.* 9, 299:27–302:41.

111 Cyril of Alexandria, *Letter to Acacius of Melitene* (*ep.* 40; *CPG* 5340), *Coll. Sich.* 10, 303:1–307:3.

112 *Coll. Sich.* 7, 295:17–23.

113 E.g., Lionel Wickham sees certain phrases in the third paragraph of Cyril's *Second Letter to Succensus* (*Coll. Sich.* 9) as "the closest Cyril comes to the ἐν δύο φύσεσι of the Chalcedonian definition" (L. R. Wickham, *Cyril of Alexandria, Select Letters* [Oxford, 1983], 89, n. 3). Further review of the dyophysite language in these three letters is offered in H. Van Loon, *The Dyophysite Christology of Cyril of Alexandria* (Leiden, 2009), 524–29.

114 E.g., *Coll. Sich.* 8, 295:33–35 (cf. the Greek in *ACO* 1.1.6, 151:13–15): *Quia vero tua perfectio sciscitatur utrum dicere in Christo duas naturas aliquando vel non dicere debeamus, ad hoc tibi respondere necessarium credidi.* The most explicit answer to this question is provided within a few paragraphs, in *Coll. Sich.* 8, 297:14–16 (cf. *ACO* 1.1.6, 153:23–154:3): *Quantum ergo pertinet ad intellegendum solummodo et contemplandum oculis animae quomodo sit incarnatus unigenitus, duas naturas adunatas esse perspicimus, sed unum Christum filium et dominum dei verbum factum hominem incarnatumque profitemur.*

Nestorius, which consequently leads to the undermining of Christ's ontological unity.[115]

Cyril's attempt to defuse the factionalist tension while sharpening his attacks on Nestorius had a lot to do with the immediate context in which he wrote the three letters transmitted in *Coll. Sich.* 8–10. They belong to the period immediately following the peace with John of Antioch in 433, which culminated in the *Formula of Reunion*.[116] In the three letters, Cyril responds to questions directed at him by his supporters who found it difficult to reconcile certain statements in the *Formula* with the principles they had fought for in Ephesus. The Christological doctrine articulated in the *Formula* contains not only very strong dyophysite language but also some notions that appear very similar to those Cyril had explicitly anathematized in his *Twelve Chapters*.[117]

The next two documents of the *Sichardiana* are *Coll. Sich.* 11 and 12; they include Paul of Emesa's and Cyril's addresses, whose rubrics we reviewed earlier (see above, "A Dialogue between Equals"). Both documents belong to the period immediately before the signing of the *Formula* and thus before Cyril's letters to Succensus and Acacius in *Coll. Sich.* 8–10.[118] Despite the slight chronological divergence, the thematic flow is not interrupted, since the two addresses provide further examples of the apparent congruity between Cyril's Christology and the Antiochenes'. In *Coll. Sich.* 11, Paul of Emesa, whom John of Antioch delegated to reach a theological settlement with Cyril, presents in his address a short exposition of Antiochene Christology. In response, Cyril offers his own address in *Coll. Sich.* 12, where he repeats almost verbatim Paul's Christological statements and explicitly subscribes to them. This is a notable deviation from extant Greek versions of Cyril's address, and it led Schwartz to suggest that the Latin version transmitted in the *Sichardiana* is probably a forgery.[119] The antiquity of this forgery is confirmed by its transmission in the earliest witness of the *Sichardiana*, the late sixth-century Verona LIX (57), as well as its citation and discussion in the sixth-century *Breviarium causae Nestorianorum et Eutychianorum* of Liberatus of Carthage.[120]

Theodore of Mopsuestia and the Conclusion of the *Sichardiana*

Following the two addresses of Cyril of Alexandria and Paul of Emesa in *Coll. Sich.* 11 and 12, we find in *Coll. Sich.* 13 a letter by Cyril, dated to 419, whose contents do not easily fit the thematic concerns of the *Sichardiana*.[121] Below, I will further discuss the letter and its significance in the collection, but for now it will suffice to note that the letter functions as a very convenient partition between the previous segment of the collection, concerning the Christological congruity between Cyril and the Antiochenes, and the following thematic segment, which deals with the dispute between Cyril and the Antiochenes over the famed Antiochene teacher Theodore of Mopsuestia. Here we will see further articulations of the tripartite factionalism of the dispute as they survive from a slightly later stage of the Nestorian Controversy, from the second half of the 430s. In this thematic segment of the collection, we will see how the *Sichardiana* includes some important testimonies of Cyril's support of the Antiochenes' campaign against the condemnation of Theodore, as well as additional evidence that helps diminish the historical significance of the dispute between Cyril and the Antiochenes.

115 See Cyril's detailed comparisons between Nestorius's teachings and the Antiochenes' in *Coll. Sich.* 10, 303:1–12, 304:5–18. The phrase "Antiochene brothers" appears in 304:13.

116 Cyril of Alexandria, *Letter to John of Antioch (About the Peace)* (*ep.* 39; *CPG* 5339), *Coll. Vat.* 127, *ACO* 1.1.4, 17:9–20. See also Wickham, *Cyril of Alexandria*, 222.

117 *Coll. Sich.* 9 (*CPG* 5346) is essentially Cyril's detailed response to Succensus's concerns that it is difficult to reconcile the strong dyophysite language of the *Formula of Reunion* with what would become one of the most well-known Miaphysite formulas, "one incarnated nature of the Word," which Cyril promoted since the beginning of the controversy. For early occurrences of the formula, see Van Loon, *The Dyophysite Christology*, 521–24. For further information on this episode between Cyril and his supporters, see Wickham, *Cyril of Alexandria*, xxvi, and Bevan, *New Judas*, 228.

118 Bevan, *New Judas*, 217–19.

119 Schwartz, *Konzilstudien* (n. 38 above), 59–60.

120 Libératus de Carthage, *Abrégé de l'histoire* (n. 29 above), chap. 8, 168–78, esp. 172–74. See also Schwartz, *Konzilstudien*, 60–61, and U. Heil, "Liberatus von Karthago und die 'Drei Kapitel': Anmerkungen zum *Breviarium causae Nestorianorum et Eutychianorum* 8–10," *Zeitschrift für Antikes Christentum* 14.1 (2010): 40–44.

121 Cyril of Alexandria, *Letter to the Carthaginian Council* (*ep.* 85; *CPG* 5385), *Coll. Sich.* 13, 310 (incipit only); edited in C. Munier, *Concilia Africae, a. 345–a. 525*, CCSL 149 (Turnhout, 1974), 162–63. See also P. P. Joannou, ed., *Discipline générale antique (IVᵉ–IXᵉ s.)*, t. 1, vol. 2, *Les canons des synodes particuliers* (Grottaferrata, 1962), 422–24.

The four documents that deal with the dispute over the legacy of Theodore of Mopsuestia, *Coll. Sich.* 14–17, belong to a complicated and fragmentarily documented controversy between Cyril and the Antiochenes that erupted a few years after the signing of the *Formula of Reunion* in 433. The sequence in which the documents are presented in the *Sichardiana* confuses the chronology of different episodes and thus offers very little help in elucidating the controversy's complicated developments. The opening document in the segment (*Coll. Sich.* 14) is a synodal letter of the Antiochenes from 438,[122] in which they respond to attempts by Cyril and Proclus of Constantinople to promote the widespread condemnation of the teaching of Theodore of Mopsuestia, who had passed away a decade earlier.[123] The Antiochenes' synodal letter is then followed by *Coll. Sich.* 15, whose title suggests that it is Cyril's response to the Antiochenes, yet it is actually Cyril's response to a different letter by John of Antioch that has not survived.[124] Following these two documents are Dionysius Exiguus's introductory letter to his translation of Proclus's *Tome to the Armenians* (*Coll. Sich.* 16) and the *Tome* itself (*Coll. Sich.* 17).[125] Proclus composed his *Tome* in 435 as an answer to reports about the circulation in Armenia of questionable teachings attributed to Theodore of Mopsuestia. The *Tome* offers doctrinal clarifications, but without naming Theodore as the source of the teachings to which the *Tome* is responding.[126] A short summary of the affair, including an explanation of Theodore's role in it, is offered in Dionysius's introductory letter. This controversy is complex, but here it will suffice to describe the entire affair as it unfolds in the *Sichardiana* documents.

The Antiochenes' synodal letter to Cyril (*Coll. Sich.* 14), which opens the segment, touches upon two significant topics for the *Sichardiana*'s apologetic arc.

The first is reflected in the letter's explicit statement that John of Antioch and his fellow Antiochenes consider Proclus's *Tome* "a truly correct and pious work" and confirm that they accept its content in its entirety.[127] This statement early in the letter is significant, for the *Tome* was perceived by subsequent generations not only as an important Christological milestone that anticipated the Chalcedonian definition but also as a notable "mediating position" between the Christologies of Alexandria and Antioch.[128] The contents of both Proclus's *Tome* (*Coll. Sich.* 17) and the Antiochenes' synodal letter (*Coll. Sich.* 14) therefore complement the *Sichardiana*'s attempt to highlight the Christological congruity between Cyril and the Antiochenes.

The second significant topic in the Antiochenes' synodal letter has to do with their stance toward their Antiochene teacher, Theodore of Mopsuestia. This stance is clarified in the letter's title: "The letter of <John of> Antioch and the synod of the entire Oriens to saint Cyril, in favor of Theodore (*pro Theodoro*)."[129] Amid their various expressions of support toward Theodore and his intellectual heritage, we find the Antiochenes' complaints about being requested to condemn a series of extracts attributed to Theodore that appear in a version of Proclus's *Tome* different from the one they had previously received from Constantinople.[130] More interesting than the varied arguments presented by

122 John of Antioch et al., *Letter to Cyril (pro Theodoro)* (CPG 6312), *Coll. Sich.* 14, 311:1–314:6.

123 Bevan, *New Judas*, 271–79.

124 Cyril of Alexandria, *Letter to John of Antioch (pro Theodoro)* (*ep.* 91; CPG 5391), *Coll. Sich.* 15, 314:7–315:20. See also Schwartz, *Konzilstudien*, 32, n. 5.

125 Dionysius Exiguus, *Letter to Felicianus and Pastor* (CPL 653c), *Coll. Sich.* 16, 315 (rubric only); edited in *ACO* 4.2, 196:1–197:22; Proclus of Constantinople, *Tome to the Armenians* (CPG 5897), *Coll. Sich.* 17, 315 (rubric only); edited in *ACO* 4.2, 197:23–205:42.

126 Constas, *Proclus* (n. 6 above), 101–12. See CPG 5897, and Grumel, *Les regestes* (n. 105 above), no. 78, 63–64.

127 *Coll. Sich.* 14, 311:24–27: *Sanctissimo enim episcopo Proclo tomum recte re vera et pie habentem quem ad Armenios scripsit, nobis destinante et nostrum quaerente consensum, omnia facta sunt a nobis et in nullo minus fecimus.*

128 Constas, *Proclus*, 109: "[T]he *Tome* of Proclus adopts a 'mediating position' between the christologies of Antioch and Alexandria, a view held by virtually all commentators on this work." This remark is followed by a rich footnote with further references.

129 *Coll. Sich.* 14, 310:30–31: *Incipit eplā <Iohannis> Ātiocheni et totius sinodi [sic] Oriētis ad scm̄ Cyrillū pro Theodoro.* The letter survives solely in Arsenal 341 (fols. 121v–123v), and its rubric, as noted in the transcription and translation, skipped the name of John for some reason. Since neither Arsenal 341 nor any other source I am familiar with ever refers to John just with the title "the Antiochene," there seems to be a mistake with the copy of the rubric here. It is even possible that the honorific *sanctus* or *beatus* was added here to John's name, as it was added in the rubric of the following document, *Coll. Sich.* 15, which also survives in Arsenal 341 (see below, n. 131, and above, n. 87).

130 *Coll. Sich.* 15, 311:30–34: *Aliud etiam malum est in istorum infestatione immanius: est eis et alter tomus, excerpta quaedam habens beati Theodori qui fuit Mopsuestiae episcopus, et quae ille in diversis libris dixisse videtur, volentes eis anathema inferre. Propter hoc petimus . . . dignare considerare malum opus hoc esse.*

the Antiochenes as to why they would never condemn Theodore is Cyril's amicable agreement with their concerns expressed in his supposed response (*Coll. Sich.* 15). Like the title of the Antiochenes' synodal letter, the title of Cyril's letter also foreshadows its content: "The letter of the blessed Cyril to the blessed John, the bishop of Antioch, and to the synod under him that gathered in favor of Theodore (*pro Theodoro*)."[131] And as we have seen in the Antiochenes' letter, here, too, Cyril explains why he would never condemn Theodore: "For it is a serious thing," argues Cyril, "to scoff at the dead, even if they were laypeople, much more at those who departed from this life in the episcopacy."[132] Moreover, Cyril recounts the episode from the Council of Ephesus when Charisios of Philadelphia had presented the questionable creed attributed to Nestorius that, as Cyril soon found out, should have been attributed to Theodore instead. Cyril highlights in the letter to John that while the creed was worthy of condemnation, the council did not dare to mention the name of Theodore nor "subject his name to an anathema . . . lest the Orientals who hold him in greater honor may, by chance, sever themselves from the unity of the body of the universal church and side with the hateful and condemned faction [i.e., Nestorius's]."[133] Cyril's letter, which includes an explicit argument against the condemnation of Theodore of Mopsuestia and, therefore, an indirect argument against his condemnation by Justinian a century later, was subsequently quoted in several apologetic works in favor of the Three Chapters, as we have seen in Pope Vigilius's *First Constitutum*.[134] For identical reasons, the letter was deemed a forgery

by the Second Ecumenical Council of Constantinople convened under Justinian in 553.[135]

Cyril's reason for not condemning Theodore's creed is worth lingering on. The tripartite factionalism that I have previously highlighted is clearly articulated here: Cyril and his council, on the one hand; the Antiochenes ("the Orientals") who hold Theodore in great honor, on the other hand; and between them "the hateful and condemned faction"—that is, Nestorius and his supposed faction in Ephesus.[136] But beyond outlining the tripartite factionalism, Cyril also attempts through his reasoning to bridge the factional divide between him and the Antiochenes: his reluctance to alienate the Antiochenes was the chief motivation for his refusal to condemn Theodore and the creed attributed to him. The historical inaccuracy of Cyril's claim should not be our immediate concern here.[137] What is more significant for our present purpose is the *Sichardiana*'s depiction of the affair: despite clear evidence of a dispute between Cyril and the Antiochenes, the dispute, as we learn from the *Sichardiana*, was limited in scope. As Cyril's own words testify, he was actively making sure that the Antiochenes would not be severed from the church owing to their perceived association with questionable teachings.

The anachronistic revisionism of the factionalist rivalry between Cyril and the Antiochenes is exemplified most clearly in the concluding letter of the collection,

131 *Coll. Sich.* 15, 314:7–8: *Epistula beati Cyrilli ad beatum Iohannem Antiochenum episcopum et ad synodum quae sub illo est congregata pro Theodoro.*

132 *Coll. Sich.* 15, 315:16–17: *grave est enim insultare defunctis, vel si laici fuerint, nedum illis qui in episcopatu hanc vitam deposuerunt.*

133 *Coll. Sich.* 15, 315:2–11, and in particular lines 7–10: *. . . dispensative mentionem viri non fecit* [i.e., Cyril's council] *neque eum nominatim anathemati subdidit neque alios, per dispensationem, sicuti est arbitrari, ne forte maiori opinioni illius viri, per quam eum adtendentes Orientales se ipsos dirumpant ab unitate corporis universalis ecclesiae et addant parti odibili et maledictae.*

134 Price, *Council of Constantinople* (n. 17 above), 1:325, n. 249, and above, n. 24.

135 Only a few documents from the Council of Constantinople of 553 have survived in their original Greek, and we have the complete conciliar acts only in their Latin translation (edited in *ACO* 4.1). In that translation, the above letter from Cyril, which was condemned in the council, is different from the translation transmitted in *Coll. Sich.* 15. As Richard Price has noted, "both translations struggle with what was clearly a tortuous piece of Greek (*not* a forgery), betraying Cyril's embarrassment at having to deplore a campaign against Theodore in which he himself had played an active part" (his italics; Price, *Council of Constantinople*, 1:325, n. 249; for the presentation of the letter at the council, see 1:324–27).

136 I added "supposed" because I am not familiar with any evidence that the Antiochenes were split into two factions in Ephesus; see above, n. 94.

137 Cyril condemned and excommunicated John of Antioch and those who participated in his counter-council on 17 July: *Gesta Ephesina, Actio IV et V* (*CPG* 8716), *Collectio Vaticana* 90, *ACO* 1.1.3, 24–26. Charisios presented his evidence against Nestorius in the 22 July session of Cyril's council (see above, n. 22). By then, Cyril had already severed the Antiochenes from, as he phrased it, "the unity of the body of the universal church" five days earlier, a split that lasted until the official peace between the two factions two years later in 433.

Coll. Sich. 18, which offers Theodoret of Cyrrhus's letter to Dioscorus of Alexandria, Cyril's successor of the Alexandrian see (444–51).[138] The letter, dated to 448,[139] belongs to a renewed phase of the Nestorian Controversy, which would lead to Theodoret's deposition in the Second Council of Ephesus of 449 and culminate in the Council of Chalcedon of 451, where Dioscorus himself would be deposed and Theodoret reinstated. For our purposes, the key significance of the letter lies in how Theodoret depicts the factionalism between Cyril and the Antiochenes—or, perhaps more accurately, in how Theodoret attempts to argue that there actually never existed any factionalist tension. In the letter, Theodoret reports on his and John of Antioch's warm and long friendship with Cyril, during which they frequently exchanged many amicable letters on matters of theology.[140] Theodoret also includes some strong anti-Nestorian sentiments, such as his claim that he does not divide the Only Begotten into two sons (i.e., divine and human),[141] that he accepts the epithet *Theotokos* (the core issue that had originally sparked the dispute between Cyril and Nestorius),[142]

and that he had personally subscribed to several condemnations of Nestorius.[143]

When we view Theodoret's letter as the conclusion of the affair to which we were introduced in *Coll. Sich.* 1, its outline becomes clear: John of Antioch was the leader of a moderate faction of Antiochenes, to which Theodoret of Cyrrhus also belonged. Members of this faction explicitly and actively distanced themselves from Nestorius,[144] while simultaneously honoring Theodore of Mopsuestia as their spiritual forefather. Most importantly, following the temporary dispute between the two sides in Ephesus, the Antiochenes made peace with Cyril, reached an official Christological agreement with him, and thus confirmed their orthodoxy. In sum, not only were the Antiochenes not Nestorians but they were close colleagues of Cyril, the champion against the Nestorian heresy, whose achievements and status established him as a pillar of orthodoxy in many Christian traditions. When the dispute surrounding Nestorius's teaching is explained in such terms, how could anyone support Justinian's condemnation of the Three Chapters?

The African Connection

In the previous sections of this paper, I reviewed the *Sichardiana*'s material remains and textual contents in order to highlight the collection's apologetic arguments regarding the Three Chapters and to confirm the late antique provenance of the collection's assembly. In the remaining sections of this paper, I wish to attempt to narrow down the collection's geographical origin. My argument will proceed in two steps: I will begin by highlighting some relevant cross-references that would provide the first hint at North Africa as the geographical origin of the collection's assembly. In the second step, I will review a prevailing emphasis in the collection on a peculiar tradition surrounding the Council of Nicaea of 325, which I believe will further strengthen the suggestion that the collection originated in Byzantine Africa.

138 Theodoret of Cyrrhus, *Letter to Dioscorus of Alexandria* (ep. 83; CPG 6240), *Coll. Sich.* 18, 315:23–318:16.

139 Théodoret de Cyr, *Correspondance*, vol. 2, ed. T. Azéma, SC 98 (Paris, 1964), 204, n. 3.

140 *Coll. Sich.* 18, 317:37–43: *Quia vero beatae sanctaeque memoriae Quirillus saepe nobis scripsit, credo palam nosse etiam tuam beatitudinem. Et quando contra Iulianum conscriptiones factas in Antiochiam destinavit, similiter et quae in apopompaeo scripta sunt, beatum Iohannem tunc Antiochinorum episcopum [rogavit] ut haec ostenderet splendentibus in Oriente doctoribus, cuius litteris oboediens beatus Iohannis direxit nobis libros, quos relegentes et admirati sumus et scripsimus beatae memoriae Quirillo et rescripsit iterum nobis et integritatem nostram adfectumque testatus est. Et servantur haec litterae apud nos.*

141 *Coll. Sich.* 18, 318:11–13: *Si quis non confitetur sanctam virginem dei genetricem aut purum hominem vocat dominum Iesum Christum aut in duos partitur unum unigenitum et primogenitum omnis creaturae, cadat ab spe quae in Christo est.* Interestingly, the emphasis here—that Theodoret does not divide the Only Begotten (*unigenitus*) into "two sons"—was not rendered into Latin as explicitly as it is stated in the Greek of the original letter. Cf. Théodoret de Cyr, *Correspondance*, 218: . . . ἡ εἰς δύο υἱοὺς μερίζει τὸν ἕνα Μονογενῆ.

142 *Coll. Sich.* 18, 317:5–9: *Propterea enim et dei genetricem vocamus sanctam virginem et hanc adpellationem respuentes alienos a pietate decernimus, similiter autem et eos qui in duas personas aut in duos filios aut duos dominos dividunt unum dominum nostrum Iesum Christum, adulteros nominamus et a Christo amabilium consortio removemus.*

143 *Coll. Sich.* 18, 318:1–2: *Quia vero nos dictatis tomis contra Nestorium a beatae memoriae Iohanne suscripsimus, testantur manus.*

144 The strongest expressions in the *Sichardiana* are from Theodoret's letter to Dioscorus (see above, nn. 141–43), John's letter to Cyril (*Coll. Sich.* 14, 311:17–22), and Cyril's letter to Acacius of Melitene (*Coll. Sich.* 10, 303:1–12, 304:5–18).

There are two explicit clues in the *Sichardiana* that point to its connection to the African reception of Justinian's condemnation of the Three Chapters. The first hint comes from the apparent relation between the *Sichardiana* and Liberatus of Carthage's *Breviarium*, one of the better-known investigative efforts into the history of Three Chapters that came out of Byzantine Africa.[145] As already mentioned, Liberatus cites the very same Latin version of Cyril of Alexandria's response to Paul of Emesa's address as the one found in the *Sichardiana*. The text in *Coll. Sich.* 12 establishes in Cyril's own (forged, most likely) words his subscription to the same Christological vision as that of his fellow Antiochenes. Relatedly, Liberatus's *Breviarium* also constructs the argument between Cyril and the Antiochenes as a temporary dispute between professional theologians in a manner similar to its construction in the *Sichardiana*.[146] Such a construction corresponds well with Leslie Dossey's recent observation that the Three Chapters Controversy was understood and played out in North Africa as "a broader defense of the right of *doctores*—clerical experts in divine law—to interpret texts for themselves."[147]

Another hint at the *Sichardiana*'s African connection is *Coll. Sich.* 13, a document that I have described as a convenient partition between the segment of the collection dealing with the Christological congruity between Cyril and the Antiochenes (*Coll. Sich.* 7–12) and the segment dealing with Theodore of Mopsuestia (*Coll. Sich.* 14–17). *Coll. Sich.* 13 is a brief letter by Cyril to the bishop of Carthage, Aurelius, and the council that gathered under his leadership in 419. The letter does not correspond straightforwardly to any of the *Sichardiana*'s documents and contents. In the letter, Cyril responds to a request of Aurelius and the Carthaginian council for "the authentic copies from the Council of Nicaea," which, he notes, have been sent along with the letter.[148] No appended document related to Nicaea has survived in any of the

manuscript witnesses of this letter, including in the *Sichardiana*. Because of its seemingly unrelated content and its transmission solely in one manuscript source of the *Sichardiana*, Arsenal 341, Schwartz did not think that the letter belonged to the original collection. Consequently, it was not printed in the *ACO*.[149] In the following pages I will argue to the contrary. Cyril's letter to the Carthaginians belongs to another, more subtle theme that runs through the collection, which aims to highlight another layer of theological congruity between Cyril and the Antiochenes: their adherence not only to the Council of Nicaea of 325 but also to a very particular version of the Nicene Creed.

First, a clarification: the existence of strong emphases on the Nicene tradition in almost all the documents of the *Sichardiana* should be one of their least surprising features. After the end of the fourth century, Nicene Christianity became the only accepted (and legal) form of Christianity in the Roman East.[150] Moreover, while the Christological controversies of the following centuries have brought to light divergent doctrinal and theological traditions that would gradually fragment the eastern churches, it is safe to say that all the involved parties were essentially Nicenes. Nevertheless, in many of the surviving texts documenting them, the controversies are frequently depicted as campaigns of staunch defenders of the Nicene faith battling the supposedly anti-Nicene doctrines, and even alleged Arianism, of their opponents. In analyzing such depictions, it is certainly worth considering claims that particular Christological positions could undermine Trinitarian elements of Nicene theology. However, the frequent depictions of the Christological controversies in terms of the conflicts surrounding the Council of Nicaea also appear, in many cases, to be rhetorical tropes.[151]

145 See Philippe Blaudeau's introduction to Libératus de Carthage, *Abrégé de l'histoire* (n. 29 above), 7–90.

146 Heil, "Liberatus von Karthago" (n. 120 above), 48.

147 L. Dossey, "Exegesis and Dissent in Byzantine North Africa," in *North Africa under Byzantium and Early Islam*, ed. S. T. Stevens and J. P. Conant (Cambridge, MA, 2016), 252.

148 Cyril of Alexandria, *Letter to the Carthaginian Council* (*ep.* 85; *CPG* 5385), in Munier, *Concilia Africae* (n. 121 above), 162:14–25.

149 See Schwartz's short remark in his preface to *ACO* 1.5.2, ii, and in Schwartz, *Konzilstudien* (n. 38 above), 62.

150 R. P. C. Hanson, *The Search for the Christian Doctrine of God: The Arian Controversy, 318–381* (Edinburgh, 1988), 820–23.

151 The attempt by Cyril's council in Ephesus to demonstrate that Nestorius's *Second Letter to Cyril* (*CPG* 5669) deviates from the Nicene Creed (although in this very letter Nestorius cites and confesses the creed) seems to me an appropriate example of this argument. See a relevant analysis of this stage of the proceedings in T. Graumann, "'Reading' the First Council of Ephesus (431)," in *Chalcedon in Context: Church Councils, 400–700*, ed. R. Price and M. Whitby (Liverpool, 2009), 36–38. That this attempt was largely theatrical can be corroborated by properly understanding the methodology according to which Cyril's council examined and

If, as suggested above, we should seriously consider the possibility that the *Sichardiana* originated in sixth-century Byzantine Africa, then the Nicene theme of the collection suddenly becomes much more significant than a trope. For in North Africa, especially between the fifth and early sixth centuries, expressing one's adherence to the Council of Nicaea was not a mere rhetorical ploy but a very real and relevant struggle of the local Christian community. Since the Vandal conquest of the region in the 430s, a notable line of demarcation between the new conquerors and the local Roman population was drawn in terms of religious confession. The prevailing Nicene confession among African Christians stood at odds with the Vandals' strand of Arianism, a non-Nicene confession that emphasizes the existence of a hierarchy (instead of the Nicene consubstantiality) between the persons of the Trinity. The Vandals appear to have sought to eliminate this local confessional demarcation by heavily promoting their own version of Christianity.[152] At times, these attempts became full-blown waves of persecution, during which members of the local Nicene clergy were exiled and subjected to confiscation of property and even to violence.[153]

Following the reconquest of North Africa by the Byzantine forces of Justinian, it must have been a relief for the local Christian community to find itself once again under a Nicene ruler. But as it soon found out, this relief was short-lived. Within a decade of the Byzantine reconquest, members of the African clergy were faced with Justinian's demand to condemn the teachings of Theodore, Theodoret, and Ibas, who were not only long dead but also, as it was discovered after some investigation, staunch Nicenes. In Africa, in contrast to other locales around the Mediterranean, the persecution and condemnation of Nicene Christians

was not a distant memory. Some of the very same clerics who were asked to condemn the Three Chapters had actually lived through and personally experienced the anti-Nicene persecutions of the Vandals.[154] The possible undermining of the Nicene faith was thus an added concern of the Africans who resisted Justinian's condemnation of the Three Chapters.[155]

Establishing that the Antiochenes were positively Nicenes is thus fully consistent with the African argument against the condemnation of the Three Chapters. And one of the clearest expressions of the Antiochenes' Nicene adherence is their synodal document transmitted in *Coll. Sich.* 5, a document that is also known as the Antiochenes' *Confessio* (*CPG* 6353).[156] The *Confessio*, which was written sometime in August 431 (more than two months after the ecumenical gathering in Ephesus had begun), includes a summary of the controversy from the Antiochenes' perspective: following the arrival of all the bishops to Ephesus in order to solve the recent unspecified "ecclesiastical issues" (i.e., the dispute between Nestorius, whom they never mention, and Cyril), the disturbances raised by Cyril greatly delayed any progress to reach a settlement. Most worrisome, the Antiochenes report, were Cyril's attempts to introduce innovations into the official teachings of the church with his "heretical *Chapters*," to which he requested all present bishops to subscribe.[157] The Antiochenes, in response, began a campaign to persuade the bishops

judged Nestorius, on which see P. T. R. Gray, "'The Select Fathers': Canonizing the Patristic Past," *StP* 23 (1989): 24–25. The legal significance of associating one's opponents with illegal heresies should also be considered: A. Cameron, "Enforcing Orthodoxy in Byzantium," in *Discipline and Diversity*, ed. K. Cooper and J. Gregory, Studies in Church History 43 (Woodbridge, Suffolk, 2007), 8–9.

152 On the Vandals' Arianizing policies, including an important emphasis on the difficulties of accurately evaluating them from the surviving evidence, see Conant, *Staying Roman* (n. 27 above), 159–95. See also Y. Modéran, "Une guerre de religion: Les deux Églises d'Afrique à l'époque vandale," *AntTard* 11 (2003): 21–44.

153 Mistreatment spiked especially during the late fifth-century persecution described in Victor of Vita's *Historia persecutionis Africanae provinciae*. See the analysis in Conant, *Staying Roman*, 180–86.

154 For prosopographical details, see Modéran, "L'Afrique reconquise et les Trois Chapitres" (n. 28 above), 50–54.

155 Modéran, "L'Afrique reconquise et les Trois Chapitres," 53.

156 So the document refers to itself in *Coll. Sich.* 5, 288:4—Ὁμολογία, in the Greek original: *Collectio Vaticana* 96, *ACO* 1.1.3, 38:27. We find an additional reference to this document as a *confessio/*ὁμολογία in another synodal letter by the Antiochenes: John of Antioch et al., *Letter to Theodosius and Valentinian* (*CPG* 6328), *Collectio Atheniensis* 48, *ACO* 1.1.7, 69:42 (Greek); *Collectio Casinensis* 105, *ACO* 1.4, 56:18 (Latin).

157 In the surviving evidence from Cyril's faction in Ephesus, there is no indication that Cyril had explicitly made such a request. The accusation is repeated in another synodal letter of the Antiochenes: John of Antioch et al., *Letter to the People of Constantinople* (*CPG* 6343), *Collectio Vaticana* 157, *ACO* 1.1.5, 129:11–14 (trans. in Price and Graumann, *Council of Ephesus* [n. 1 above], 334–35). The Antiochenes may be referring here to the fact that Cyril's *Third Letter to Nestorius* and its appended *Twelve Chapters* were joined with official conciliar documents, to which the present bishops in Ephesus might have been asked to subscribe. The transmission history of Cyril's *Third Letter* and its appended *Chapters* in conciliar contexts, from Ephesus 431 onward,

who had subscribed to Cyril's *Chapters* that they all should be content with the Nicene faith alone and not be compelled to add anything to it.[158] Moreover, as a direct response to Cyril's measures to confirm his *Chapters* "by decree and subscriptions of bishops,"[159] the Antiochenes were compelled to produce this *Confessio* and to confirm it with their own subscriptions.[160] According to the Antiochenes, the *Confessio* is "sufficient to teach the soundness of piety, to show the path of truth, and to confute the error of heretical perverseness."[161] The *Confessio* then cites the Nicene Creed in full. Following the familiar phrasing of the creed, we are presented with this brief note:

> This is the faith that the fathers have set forth, first against the blasphemous Arius who said that the Son of God was created, and then against all the heresies of Sabellius, Photinus, Paul of Samosata, Mani, Valentinus, Marcion, and against all the heresies that rose against the Catholic Church and which the 318 bishops who gathered in Nicaea condemned.[162]

Immediately thereafter, the Antiochenes add that they "confess this exposition of faith to be perpetual."[163] Their remark strongly suggests that the Antiochenes perceived this note to be an inherent part of the Nicene Creed to which they just confessed. As scholars since the late nineteenth century have observed, very few versions of the Nicene Creed are accompanied by the above note; yet every manuscript that preserves this note with the Nicene Creed also preserves among its folios some of the earliest documentary evidence surrounding the Council of Nicaea.[164] The note is sometimes referred to in scholarship as the "historical note" or "Antiochene supplement" of the Nicene Creed; in the Latin manuscript tradition, it serves as one criterion among many others in reconstructing the earliest recensions of canonical codifications in the Latin West,[165] a point on which I will expand below. The note's occurrence in the Greek tradition is much rarer, however, and can thus serve as an easier starting point in our attempt to understand its significance in the *Sichardiana*.

The note survives in Greek solely in two late antique texts: in the Greek original of the Orientals' *Confessio*,[166] and in a late fifth-century *Ecclesiastical History* by an anonymous cleric from Cyzicus—a work that until recently has been wrongly attributed to a certain Gelasius of Cyzicus.[167] Despite its title, the Cyzicenus's work deviates from the genre of church history, since it focuses almost exclusively on one historical event: the synodal gathering in Nicaea in 325, which would become known as the first ecumenical church council.[168] One of the most debatable aspects of this

is still an open question in scholarship: Graumann, "'Reading' the First Council of Ephesus," 36–41.

158 *Coll. Sich.* 5, 287:30–34: *temptavimus quidem eos episcopos qui consenserant Aegyptio et capitulis haereticis ab eo expositis subscripserant, suadere adimere quidem illa quae orthodoxae fidei evidenter adferunt corruptelam, contentos vero esse expositione quae apud Nicaeam fuerat dudum facta.*

159 *Coll. Sich.* 5, 288:28.

160 Individual subscriptions are not included in any of the extant versions of this document. Evidence that there were subscriptions is presented in the *Confessio* itself (see below, n. 161) and in another document appended to the *Confessio* in the Greek manuscript tradition: *Mandatum Orientalium episcopis Constantinopolim directis* (*CPG* 8742), *Collectio Vaticana* 96, *ACO* 1.1.3, 38:4–5.

161 *Coll. Sich.* 5, 288:2–6: *compulsi sumus nos, qui fidei sanae patrum permanemus et nihil ei extraneum inferre concedimus, scripturaliter eam exponere et propriis subscriptionibus nostram confessionem firmare. Sufficit enim paucorum horum sermonum expositio et pietatis docere cautelam et veritatis ostendere semitam et haereticae arguere pravitatis errorem.*

162 *Coll. Sich.* 5, 288:18–22: *Haec est fides quam exposuerunt patres primum adversus Arium blasphemantem et dicentem creaturam filium dei et adversus omnes haereses Sabellii et Photini et Pauli Samosateni et Manichaei et Valentini et Marcionis et adversus omnes haereses quae insurrexerunt adversus catholicam ecclesiam, quas condemnaverunt CCCXVIII episcopi qui apud Nicaeam convenerunt.*

163 *Coll. Sich.* 5, 288:22: *Huic expositioni fidei permanere confitemur nos.* Cf. the phrasing in the Greek original of the document in *ACO* 1.1.3, 39:12.

164 The note is edited in C. H. Turner, ed., *Ecclesiae occidentalis monumenta iuris antiquissima: Canonum et conciliorum graecorum interpretationes latinae*, 1.1.2 (Oxford, 1904), 110–11.

165 Maassen, *Geschichte der Quellen* (n. 33 above), 39–40; E. Honigmann, "La liste originale des pères de Nicée: À propos de l'Évêché de 'Sodoma' en Arabie," *Byzantion* 14.1 (1939): 72–74; and Schwartz, "Kanonessammlungen" (n. 32 above), 14–15.

166 John of Antioch et al., *Expositio fidei synodi Orientalium* (*CPG* 6353), *Collectio Vaticana* 96, *ACO* 1.1.3, 39:12–2.

167 G. C. Hansen, ed., *Anonyme Kirchengeschichte (Gelasius Cyzicenus, CPG 6304)*, 2.27.7–9 (Berlin, 2002), 84:20–27.

168 G. Marasco, "The Church Historians (II): Philostorgius and Gelasius of Cyzicus," in *Greek & Roman Historiography in Late Antiquity: Fourth to Sixth Century A.D.*, ed. Marasco (Leiden, 2003), 287.

work is the question of its sources. In its introduction, the anonymous author states that he bases his history on an ancient book containing documentation of the entire proceedings of the Council of Nicaea.[169] As scholars have demonstrated, however, not only do the supposedly unique Nicene sources brought forth in the work appear to be inauthentic,[170] but most of the text generally follows the accounts of other well-known fourth- and fifth-century historians who wrote about the Council of Nicaea.[171] Moreover, as scholars' interest in the literary practice of composing and transmitting conciliar acts has grown, it has been argued that in fact the Council of Nicaea might have never produced official records, at least not in any form similar to that in which church councils have produced them since the early fifth century.[172]

While the Cyzicenus's work seems to teach us nothing new about the early fourth-century debates surrounding Nicaea, this might not be the case with regard to the later reception of Nicene documentation, especially in the fifth and sixth centuries. Consider the following evidence from the Cyzicenus's history combined with the *Collectio Sichardiana*: in the general context of establishing the Nicene allegiance of the Antiochenes in the *Sichardiana*, the Antiochenes' *Confessio* is included (*Coll. Sich.* 5), wherein we find the Nicene Creed and its rare endnote. The only other Greek version of the creed with its rare note is found in the Cyzicenus's late fifth-century *Ecclesiastical History*; and, as mentioned above, the *History* purports to be based on what the author believed to be the official records of Nicaea. Relatedly, in *Coll. Sich.* 13 we find a letter by Cyril addressed to a Carthaginian council, in which it is mentioned that "the most genuine copies" of the Council of Nicaea are sent along with this letter, as

requested;[173] the appended "genuine copies" in Cyril's letter have not survived. It certainly seems, therefore, that since the early fifth century, a document believed to contain the authentic records of the Council of Nicaea was circulating around the Mediterranean.

In light of the evidence for this elusive Nicene document, I would like to offer the following hypothesis in an attempt to highlight its relevance to the apologetic project underlying the *Sichardiana*. In the sixth century, the African editor of the *Sichardiana* had access to a document believed to preserve the records of the Nicene proceedings. This document was believed to have been the same as the one Cyril had sent to the Carthaginians in 419, as reported in his letter preserved in *Coll. Sich.* 13. This Nicene document also seems to have been available to the Antiochenes who gathered in 431 in Ephesus, as demonstrated by their *Confessio* in *Coll. Sich.* 5, which includes the Nicene Creed followed by its rare endnote.[174] Thus, by including the *Confessio* and Cyril's letter in the collection, the editor of *Sichardiana* could have established not only the strong Nicene adherence of the Antiochenes but also their adherence to the very same creed that Cyril had sent to Carthage a century earlier.

One way to test this hypothesis would be to examine the Nicene records that Cyril appended to his letter to Carthage. Unfortunately, only Cyril's actual letter, without those records, has survived in the manuscript tradition, though there have been several contested attempts to reconstruct them.[175] But since my main

169 Hansen, *Anonyme Kirchengeschichte*, 1.pro.2, 1:11–15: πάντα τὰ ἐν ἐκείνῃ τῇ ἐναρέτῳ καὶ ἁγίᾳ συνόδῳ λεχθέντα τε καὶ πραχθέντα καὶ διατυπωθέντα πάλαι τε καὶ πρόπαλαι ἀναγνοὺς ἔτι ἐν τῇ πατρῴᾳ οἰκίᾳ διάγων, εὑρηκὼς αὐτὰ ἐν βίβλῳ ἀρχαιοτάτῃ ἐγγεγραμμένα ἐν μεμβράναις ἅπαντα ἀπαραλείπτως ἐχούσαις.

170 Hansen, *Anonyme Kirchengeschichte*, xli–lv; Marasco, "The Church Historians (II)," 285–86; and C. T. H. R. Erhardt, "Constantinian Documents in Gelasius of Cyzicus, Ecclesiastical History," *JbAC* 23 (1980): 48–57.

171 Marasco, "The Church Historians (II)," 285.

172 E. Chrysos, "The Synodal Acts as Literary Products," in *L'icône dans la théologie et l'art*, Études théologiques 9 (Chambésy, 1990), 89.

173 Cyril of Alexandria, *Letter to the Carthaginian Council* (*ep.* 85; *CPG* 5385), in Munier, *Concilia Africae* (n. 121 above), 162:16–20: *quibus a nobis speratis, ut de scrinio nostrae ecclesiae verissima exemplaria ex authentico synodo apud Nicaenam civitatem metropolim Bythiniae a sanctis patribus constituta atque firmata, sub nostrae fidei professione vestrae dilectioni porrigamus.* The surviving Greek version of the letter seems to be a translation from Latin; see below, n. 203. As mentioned earlier, Schwartz did not edit this letter in the *ACO*.

174 The note is also alluded to in John of Antioch, *Ep. ad Proclum episc. Constantinopolis* (*CPG* 6317), *Collectio Casinensis* 287, *ACO* 1.4, 209:14–20.

175 The attempts at reconstruction centered on materials transmitted in Verona LX (58). For a detailed review of the relevant scholarship, see A. Camplani, "Lettere Episcopali, Storiografia Patriarcale e Letteratura Canonica: A Proposito del *Codex veronensis* LX (58)," *Rivista di storia del cristianesimo* 3.1 (2006): 117–64, esp. 146–56. The most serious rebuttal to these reconstructions is offered in L. L. Field, *On the Communion of Damasus and Meletius: Fourth-Century Synodal Formulae in the Codex Veronensis LX* (Toronto, 2004), 56–116, esp. 64–82.

interest in this paper is to investigate the *Sichardiana* itself, its sources, and the sixth-century North African context in which it was assembled, I can redefine the test case of my hypothesis and slightly narrow it down in scope: rather than trying to reconstruct and track down the early fifth-century Nicene records that Cyril had sent to Carthage, what I am actually interested in establishing is what kind of Nicene records could have been available to the sixth-century editor of the *Sichardiana*, records that could have been easily identified with what Cyril had sent to Carthage more than a century before. The answer to this question, I would argue, is found in the canonical collection surviving in the last folios of Verona LIX (57).

The Beginning of Canonical Codification in North Africa and the Canonical Collection of Verona LIX (57)

In order to appreciate the historical significance of the canonical collection transmitted in Verona LIX (57), as well as its relevance to my argument for the North African provenance of the *Sichardiana*, I will review in this section a series of events that took place more than a decade before the Council of Ephesus of 431, and mainly involved participants from Italy and North Africa. This shift to the western Mediterranean will be a significant detour from matters pertaining to the Christological controversies that have concerned us throughout the bulk of this paper. In attempt to ease the somewhat disorienting effect of the following detour, I offer in the last paragraph of this section a summary of its main contributions to my overall argument. The reader is welcome to skip straight to that paragraph, or to continue along as we delve into the earliest documented history of the arrival and codification of Greek canonical legislation in the Latin West.

On 25 May 419, two hundred and seventeen African bishops gathered in Carthage to discuss a peculiar dispute originating in Sicca Veneria (in present-day northwestern Tunisia). The year before, the bishop of Sicca, Urban, had deposed and excommunicated a local priest by the name of Apiarius. Apiarius, in response, sought redress from none other than Pope Zosimus (417–418). The bishop of Rome seems to have predicted that his involvement in a relatively minor and faraway dispute might be contested locally. In his official rejoinder, accordingly, he added some arguments to justify

his involvement, such as the right of clerics to appeal to Rome as confirmed in two canons issued at the Council of Nicaea from the previous century. But the African audience who received Zosimus's reply was baffled: nowhere in the Nicene records held in their archives could they find the two canons cited by Zosimus. As a result, the Carthaginian council of 419 was convoked. Its decisions reflect the seriousness with which the Africans took the unexpected turn of Apiarius's case: following a confession of his offenses, the council reinstated Apiarius (although he was not allowed to continue his office in Sicca) and commenced an investigation into the surviving records of the Council of Nicaea. The investigation's first order of business was to issue official requests to the churches of Alexandria, Antioch, and Constantinople for copies of their Nicene records.[176] The response of Alexandria to this request, but without any appended Nicene records, has survived in Cyril of Alexandria's letter to the Carthaginian council of 419 (*CPG* 5385), the same letter that is also transmitted in the *Sichardiana* (*Coll. Sich.* 13).

By late 424, the affair of Apiarius resurfaces in our sources, when, again, he appeared before a Carthaginian council. This time his offenses had occurred in the coastal town of Tabraca, and following a local judgment of excommunication against him, Apiarius, again, had turned to Rome. In an almost comical repetition of the affair from 419, the bishop of Rome, now Pope Celestine (422–432), restored Apiarius into communion and sent envoys to Africa to justify this decision while relying—again—on Nicene canons that the Africans could not find in their archives. This time, however, the Africans were prepared with the preliminary results of their investigation from 419, which included the Nicene records they had received from the Greek East. In their letter to Pope Celestine, the Africans emphasize that they had forwarded to Rome those Nicene records in 419, and the records show that

176 A thorough review of this incident is available in B. J. Kidd, *A History of the Church to A.D. 461*, vol. 3, *A.D. 408–461* (Oxford, 1922), 162–71. The reconstruction of the affair is based on the so-called Apiarian Codex, edited in Munier, *Concilia Africae*, 79–172. See also F. L. Cross, "History and Fiction in the African Councils," *JTS*, n.s., 12.2 (1961): 227–47, esp. 240–44, and J. Gaudemet, *Les sources du droit de l'Église en Occident du II^e au VII^e siècle* (Paris, 1985), 81–82.

the canons already cited by Rome on two occasions are not part of the Nicene records preserved elsewhere.[177]

With the evidence surrounding the Carthaginian council of 424–25, the case of Apiarius concludes in our surviving sources. Even though we have no clear indications of the future of either Apiarius or the investigation into the divergent Nicene records that had arrived in Africa and Rome after 419, later generations of scholars have continued to study this episode and to emphasize its significance. For Protestant and Catholic authors since the Reformation, Apiarius's case has symbolized a challenging and, at times, an embarrassing episode in the history of the papacy.[178] For scholars of canon law, the case sheds light on the earliest recorded efforts to investigate and to codify canonical legislation in the Latin West. It is exactly in the manuscript traditions of the documentation surrounding Apiarius's case where we find evidence of some of the earliest Latin canonical collections, which include not only canons originally issued in Western church councils but also translated canons that correspond to one of the earliest known canonical collections in the Greek East. This ancient Greek canonical collection seems to have reached the West and been translated into Latin as a result of the Africans' request for the Nicene records preserved in the archives of Alexandria, Antioch, and Constantinople.

The oldest surviving Latin canonical collection is known to scholars by a variety of names; the better-known ones include the ancient *Isidoriana* (owing to its mistaken authorial attribution to Isidore of Seville),[179] the Freising-Würzburg version (after the two chief manuscripts that transmit it),[180] and, most recently,

the *Corpus Canonum Africano-Romanum* (a name that reflects the debates in scholarship about the collection's origin, either Roman or African). The collection seems to have emerged as a response to Apiarius's case and is thus dated to ca. 419.[181] Throughout the twentieth century, scholars proposed different interpretations of the collection's position regarding the Apiarius case, viewing the collection as supporting either Rome, and its prerogatives to adjudicate Apiarius's case, or the Africans who proved that Rome was relying on canons that cannot be found in any preserved records of the Council of Nicaea. It was in 1992 when Hubert Mordek suggested that, in fact, the collection exhibits both pro-Roman and pro-African elements, and it thus deserves to be recognized as a hybrid African-Roman work.[182]

Next to its documentation of Apiarius's case,[183] the *Corpus Canonum Africano-Romanum* (henceforth *CCAR*) includes a translated version of one of the oldest canonical collections from the Greek East—a collection usually known in scholarship as the Antiochene Corpus,[184] which seems to have been included in the replies of the eastern churches to the Africans' request for their Nicene records. The Antiochene Corpus is notable for the particular councils it includes, their semichronological order of presentation, and the enumeration system of their canons: while each council is presented with its own rubric, the councils' canons are numbered sequentially from *i* to *clx*, and they include,

177 Munier, *Concilia Africae*, 166–72, esp. 169–72, for the Carthaginian council's (of 424–25) letter to Celestine. See also *CPL* 1765g, and Kidd, *A History of the Church*, 169–71. In the letter, the Carthaginians mention only the replies of Constantinople and Alexandria. It seems that Antioch's reply, if it had ever been sent, never reached Carthage.

178 See the comments and references in Kidd, *A History of the Church*, 162–71. See also C. H. Turner, "Chapters in the History of Latin MSS of Canons, V. The Version called Prisca: (*a*) the Justel MS (J) now Bodl. e Mus. 100–102, and the *editio princeps* (Paris, 1661)," *JTS* 30.120 (1929): 342–46.

179 Maassen, *Geschichte der Quellen* (n. 33 above), 12–21, 71–87; Schwartz, "Kanonessammlungen" (n. 32 above), 11–27; and Gaudemet, *Les sources du droit de l'Église*, 76–78.

180 Schwartz, "Kanonessammlungen," 11–12, n. 2. This text was first collated in Maassen, *Geschichte der Quellen*, 924–38, and thus

the collection is sometimes also known as the Maassen consensus or the like. For further bibliography, see L. Kéry, *Canonical Collections of the Early Middle Ages (ca. 400–1140): A Bibliographical Guide to the Manuscripts and Literature* (Washington, DC, 1999), 2–3 (on the *Collectio Frisingensis prima*), 4–5 (on the *Collectio Wirceburgensis*).

181 Turner, "Chapters in the History of Latin MSS of Canons, V.," 337–40, and H. Mordek, "Karthago oder Rom? Zu den Anfängen der kirchlichen Rechtsquellen im Abendland," in *Studia in honorem eminentissimi Cardinalis Alphonsi. M. Stickler*, ed. R. J. Castillo Lara (Rome, 1992), 362–64. See also H. Hess, *The Canons of the Council of Sardica, A.D. 343: A Landmark in the Early Development of Canon Law* (Oxford, 1958), 153–54, and the bibliography in Kéry, *Canonical Collections*, 1–2.

182 Mordek, "Karthago oder Rom?," 359–74.

183 Cross, "History and Fiction," 240–44.

184 Schwartz, "Kanonessammlungen," 27–43; Gaudemet, *Les sources du droit de l'Église*, 75–76; D. Wagschal, *Law and Legality in the Greek East: The Byzantine Canonical Tradition, 381–883* (Oxford, 2015), 32–34; and A. Mardirossian, *La collection canonique d'Antioche: Droit et hérésie à travers le premier recueil de législation ecclésiastique (IVe siècle)* (Paris, 2010).

in the following order, the canons issued at the councils of Nicaea (325), Ancyra (314), Neocaesarea (314?), Gangra (340?), Antioch (328?), Laodicea (343?), and Constantinople (381).[185]

In the *CCAR*, the translated version of the Antiochene Corpus preserves the above characteristics but with a unique and very notable twist: following the twenty Nicene canons that open the collection, we find a new rubric introducing us to a new set of forty canons, which are numbered independently, without disturbing the enumeration of canons that follow (i.e., from *xxi* to *clx*). These forty canons, the rubric states, come from "the Council of Nicaea of twenty bishops, which are not held in Greek, but are found in Latin in the following manner."[186] Below the rubric, a short preface attempts to clarify that the following canons are those that "were titled by the twenty bishops at Serdica."[187] These are, in fact, the forty canons from the (Western) Council of Serdica of 343,[188] among which we find the two supposedly Nicene canons that Rome cited twice in the Apiarius controversy.[189] As would become clearer in later Latin canonical collections and through highly nuanced scholarly work on early canon law, the Nicene and Serdican canons were preserved as a continuous series in the papacy's archive. As a result, the canons of Serdica were mistakenly understood in Rome, at least until the late fifth century, to have been issued at the Council of Nicaea.[190]

In early Latin manuscripts that transmit canonical collections, we sometimes find a different family of recensions of the Antiochene Corpus. Though similar to the Antiochene Corpus as it occurs in the *CCAR*, these recensions are nevertheless distinct from it and represent slightly different translations of the original Greek material. As we will see below, they also sometimes include material from the Antiochene Corpus that has not survived in the *CCAR*. This family of recensions is known as the vulgate *Isidoriana* (as opposed to the ancient *Isidoriana* of the *CCAR*).[191] Most importantly for our purposes, beyond their transmission of the Antiochene Corpus, the vulgate *Isidoriana* recensions continued to treat the Nicene and Serdican canons as a continuous series, despite the emergence of new canonical collections from the middle of the fifth century that both properly identified the Serdican canons and separated them from the Nicene canons under different rubrics.[192]

In the last folios of Verona LIX (57) we find one of the earliest preserved witnesses of the Antiochene Corpus of the vulgate *Isidoriana* recension.[193] It contains the same sequence of councils and their canons as we find in the ancient *Isidoriana* of the *CCAR*,[194] including the Nicene and Serdican canons in a continuous series. Here, however, the series is not interpreted by any rubric or an explanatory preface as in the *CCAR*; the canons of Nicaea and Serdica are simply presented one after the other, without interruption, and under

185 It should be noted that the canons of the Council of Constantinople (381) are enumerated independently, probably indicating their later addition to the Antiochene Corpus. For the uncertain dates of some of those councils, see Mardirossian, *La collection canonique d'Antioche*, 73–134.

186 Turner, *Ecclesiae* (n. 164 above), 1.2.3, 540: *Incipit concilium Nichenum [sic] XX episcoporum [regulae] quae in graeco non habentur sed in latio inveniuntur ita*; see 535 for further details on the manuscripts where the above note is found. See also Schwartz, "Kanonessammlungen," 69, n. 1.

187 Turner, *Ecclesiae*, 1.2.3, 540:16–23: *Praeterea sunt aliae quadraginta regulae quae per Osium episcopum Cordobensium currunt, quae titulantur tamquam viginti episcoporum aput Serdicam: quae tamen non aput graecos sed aput latinos magis inveniuntur.*

188 Hess, *Canons of the Council of Sardica*, 1–67 = H. Hess, *The Early Development of Canon Law and the Council of Serdica* (Oxford, 2002), 93–140.

189 Namely, the seventh and seventeenth canons of Serdica, on which see Hess, *The Early Development of Canon Law*, 190–200.

190 See Hess, *The Early Development of Canon Law*, 124–10, as well as almost all the scholarship cited in this section of the paper.

191 Maassen, *Geschichte der Quellen*, 13–16 (concerning the vulgate recensions of Nicaea), 83–87 (concerning other councils from the Antiochene Corpus, with sporadic references to their vulgate recensions). See also Field, *On the Communion*, 83, n. 106.

192 Most notably, the *Prisca* and the early sixth-century *Dionysiana* (Maassen, *Geschichte der Quellen*, 65–130, and Schwartz, "Kanonessammlungen").

193 Maassen, *Geschichte der Quellen*, 13–16, 83–87. Maassen normally refers to Verona LIX (57) as the *veroneser Fragment*; see Maassen, *Geschichte der Quellen*, 761–63, and above, n. 59.

194 Two important exceptions are worth noting: First, the collection of Verona LIX (57) lacks the canons of Constantinople (381), but this could be due to the breaking of the manuscript in the middle of the canons of Laodicea, after which the canons of Constantinople normally occur in the Corpus. And second, the collection of Verona LIX (57) does not enumerate its canons at all. It thereby avoids the confusing enumeration in the ancient *Isidoriana*, according to which the canons of Nicaea are numbered from *i* to *xx*, the following canons of Serdica from *i* to *xl*, and the canons of Ancyra onward from *xxi* to *clx*.

a shared rubric that identifies them all as Nicene.[195] Another notable departure of the vulgate recension of Verona LIX (57) from the ancient *Isidoriana* is its transmitted Nicene Creed, which includes the rare endnote we have encountered before in the Antiochenes' *Confessio* of *Coll. Sich.* 5. In Verona LIX (57), following the continuous series of Nicene and Serdican canons, the manuscript presents the Nicene Creed with its rare endnote, followed by a list of participants in the Council of Nicaea. This particular order of presentation—canons, credal statement, list of participants—seems to be one of the few common features in the surviving Latin witnesses of the creed's rare endnote.[196] This observation corresponds to Eduard Schwartz's reconstruction of the original Greek Antiochene Corpus, which, after each block of canons from a particular council, normally included a credal statement and the council's list of participants.[197] The survival of these additions in the Nicene section of the canonical collection of Verona LIX (57) thus highlights an important challenge to the familiar scholarly typologies of canonical collections: in this case, we find a witness of the vulgate *Isidoriana* recension transmitting material older than the ancient *Isidoriana*.

To sum up the key information I reviewed in this section: The canonical collection of Verona LIX (57) transmits one of the oldest preserved Latin translations of an even older Greek canonical collection. The latter is known in scholarship as the Antiochene Corpus. The surviving evidence strongly suggests that Cyril of Alexandria, among others, was involved in dispatching the Antiochene Corpus to North Africa, from where it was subsequently transmitted to Rome. The historical circumstance that led to the corpus's arrival in North Africa and its translation into Latin was a legislative exchange between Carthage and Rome in 419. The canonical collection of Verona LIX (57) reflects the fundamental matter around which that legislative

exchange revolved: the inclusion of the canons of the Council of Serdica (343) together with, and under the same rubric of, the canons of the Council of Nicaea (325). In terms of my argument in favor of tracing the *Sichardiana*'s provenance to Byzantine Africa, the discussion in this section offered us two key pieces of evidence: first, the African connection underlying the history of the canonical collection of Verona LIX (57); and second, the canonical collection's relation to the *Sichardiana*. The relation is demonstrated through the rare endnote of the Nicene Creed, which is transmitted in both the canonical collection and the Antiochenes' *Confessio* (*Coll. Sich.* 5), and through the *Sichardiana*'s transmission of Cyril's letter to the Carthaginian council (*Coll. Sich.* 13), a letter whose history is embedded in the same circumstances that engendered the canonical collection.

The *Sichardiana* and the Canonical Collection of Verona LIX (57)

Before taking the above detour where I reviewed the early history of canonical codification in the Latin West, I suggested that the sixth-century North African editor of the *Sichardiana* could have associated the canonical collection of Verona LIX (57) (henceforth *V*) with the Nicene material that Cyril had sent to Africa in the early fifth century. What we have learned so far from the scholarly debates around early canonical codification makes such an association historically inaccurate: since the Nicene–Serdican connection was a western innovation, its occurrence in *V* proves without a doubt that the canonical collection could not have been the one sent from the Greek East in the early fifth century.[198] But our ability to discern the historical inaccuracy of the above claim does not prove that late antique contemporaries could easily do the same. And rather than expecting from the late antique texts we study—in this case, the *Sichardiana*—the same standards of historical research respected by modern scholars, we should

195 Verona LIX (57), fol. 216r (see above, n. 59). The Serdican canons start in fol. 222r immediately after the twentieth canon of Nicaea.

196 Schwartz, "Kanonessammlungen," 14–15, where he suggests that the original function of the note in the original Greek Antiochene Corpus was to introduce the following list of participants. Recall that the note has not survived in Greek in the context of a canonical collection, appearing only in the Antiochenes' *Confessio* and the Cyzicenus's *Ecclesiastical History* (see above, nn. 166–67). See also Turner, *Ecclesiae*, 1.1.2, 110–11.

197 Schwartz, "Kanonessammlungen," 3–18.

198 Moreover, the Serdican canons were unheard of in Greek canonical collections before the middle of the sixth century, and were never part of any surviving Greek recensions of the Antiochene Corpus as they were in its translated Latin versions: Wagschal, *Law and Legality*, 39, and H. Ohme, "Sources of the Greek Canon Law to the Quinisext Council (691/2): Councils and Church Fathers," in *The History of Byzantine and Eastern Canon Law to 1500*, ed. W. Hartmann and K. Pennington (Washington, DC, 2021), 74.

instead be open to the peculiar perspectives and limited conditions that framed their authors' research, methodologies, and scholarly objectives.

The transmission of the vulgate *Isidoriana* in early medieval manuscripts demonstrates that the Roman consolidation of the Nicene and Serdican canons into a continuous series had an impact far and wide as it spread throughout the Latin West.[199] Its effects even reached North Africa, where we find the most direct evidence of questioning the Nicene attribution of the Serdican canons, as we saw in the previous section. In an apparent African section of the *Corpus Canonum Africano-Romanum*, for example, we find hints that suggest an acceptance of the Serdican canons as part of the Nicene tradition.[200] Another example comes from the *Breviatio Canonum* by the Carthaginian deacon Fulgentius Ferrandus (d. 546 or 547). In the *Breviatio*'s treatment of the Serdican canons, Ferrandus makes a telling error that demonstrates the continued presence of the Nicene–Serdican connection in sixth-century North Africa: when he catalogs the first canon of the Council of Serdica, he actually refers to the contents of the twentieth (and last) canon of Nicaea.[201] This mistake reveals that Ferrandus did not properly identify where the Nicene canons end and the first Serdican canon begins, since he probably relied on a canonical collection that treated the Nicene and Serdican canons as a continuous series.

It is therefore clear that *V* is a canonical collection that certainly could have been available in a sixth-century North African archive. And if, when collecting the documents of the *Sichardiana*, its editor turned to an archival folder pertaining to Apiarius's case that included the episode when Cyril of Alexandria had sent the Nicene records to Carthage, *V* certainly could

have represented an old, perhaps the oldest, canonical collection in that folder. It surely was enough for the editor of the *Sichardiana* that the particular version of the Nicene Creed in *V* matched the particular version of the creed in the Antiochenes' *Confessio*. Our editor was thus able to show clearly that the Antiochenes confessed to an ancient version of the creed that corresponds to what he was able to find in the archive.[202]

Like the editor of the *Sichardiana*, the compiler of Verona LIX (57), too, treated his source material in accordance with standards of historical research that would fall short of our own. As I have shown in the review of the contents of this late sixth-century manuscript, its compiler was very open to separating and to excising materials that did not fit the clear categories according to which the manuscript was organized. If the source material included texts that did not conform to the manuscript's editorial vision, the compiler of Verona LIX (57) either discarded them (such as the numerous items from the *Sichardiana*) or moved them to the segment of the manuscript deemed appropriate. *V* was one of the victims of this editorial vision: our compiler pushed the canonical collection found in the *Sichardiana* to the next segment of the manuscript covering ecclesiastical norms and regulations. The Christological segment of the manuscript (fols. 82r–129v) was consequently cleared from the rather long canonical detour of *V*.

When we think through the editorial options underlying the *Sichardiana* and Verona LIX (57), the letter of Cyril to the Carthaginian council of 419 stands out. The letter, as previously discussed, includes no relevant information on the Nestorian Controversy, which it precedes by roughly a decade. Its absence from Verona LIX (57) also makes sense given what we know

199 Ohme, "Sources of the Greek Canon Law," 74. See also Maassen, *Geschichte der Quellen*, 52–55.

200 Field, *On the Communion*, 81–82; Turner, *Ecclesiae*, 1.2.3, 540–42.

201 Fulgentius Ferrandus, *Breviatio Canonum* (CPL 1768), in Munier, *Concilia Africae* (n. 121 above), 305. In chapter 214, under the theme concerning not kneeling in services throughout the fifty days before Easter (*ut diebus quinquagesimae genua non flectantur*), the *Breviatio* refers us to *Concilio Sardicensi, tit. I*. See also Maassen, *Geschichte der Quellen*, 56, 800, as well as Gaudemet, *Les sources du droit de l'Église*, 137–38. Cf. the twentieth Nicene canon as it occurs in various early Latin canonical collections: Turner, *Ecclesiae*, 1.1.2, 142, 231, 243, 273.

202 This hypothesis can even be stretched further: perhaps the Nicene Creed with its rare endnote enabled the editor of the *Sichardiana* to connect not only the Antiochenes and Cyril but also both of them to African Christians. From among the Latin witnesses of this endnote we find one transmission from the proceedings of the Carthaginian council of 419 concerning Apiarius's case (Turner, *Ecclesiae*, 1.1.2, 110; and more generally above, n. 176). During the proceedings, the Africans read the Nicene records preserved in their archive, which included the creed with its rare endnote. The version of the Nicene records read at the Carthaginian council is known in scholarship as the *versio Caeciliani*, named after one of the very few western participants in Nicaea, Caecilianus of Carthage (311–345). For further details on the *Caeciliani*, see Schwartz, "Kanonessammlungen," 45–48.

about its compiler's editorial approach of excising items that contributed little to the section of the manuscript in which they were placed. It was probably for similar reasons that Sichard did not include the letter in his *Antidotum*. Its survival in the *Sichardiana* portion of Arsenal 341 is therefore both fortunate and unique: when we look through the Greek and Latin manuscripts that transmit Cyril's letter, the overwhelming consensus is that the letter's transmission is part of the documentation pertaining to the Carthaginian council of 419.[203] The letter's occurrence in Arsenal 341, in the midst of Christological texts relevant to the debates surrounding Ephesus, is therefore unique and highly unusual.

Schwartz, as noted before, dismissed Cyril's letter and saw its occurrence in Arsenal 341 as an insertion that has nothing with the sequence of documents surrounding it in the manuscript. According to my reconstruction of the *Sichardiana*'s thematic layers, however, the letter perfectly fits the collection: it corresponds to the Nicene theme of the *Sichardiana*, which highlights the staunch Nicene attitudes of the Antiochenes. The editor of the *Sichardiana* did not merely demonstrate the Nicene support of the Antiochenes but also emphasized a very particular version of the Nicene Creed confessed by Cyril and the Antiochene faction of John of Antioch. The *Sichardiana* makes this connection through the Antiochenes' *Confessio* (*Coll. Sich.* 5) and Cyril's letter to the Carthaginian council (*Coll. Sich.* 13), together with the ancient Nicene records of *V*, the canonical collection of the vulgate *Isidoriana* recension transmitted in Verona LIX (57). The editor of the *Sichardiana* could have easily associated the Nicene

records of *V* with the appended records mentioned in Cyril's letter; but when the *Sichardiana* reached the hands of the compiler of Verona LIX (57), *V* was removed from its original documentary context and placed in a different segment of the manuscript.

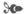

My analysis of the *Sichardiana* began with its three sources. Exploring the contents of Verona LIX (57), Arsenal 341, and Sichard's *Antidotum*, I tried to contextualize the fragmentary nature of the *Sichardiana*'s survival. Either because of their own fragmented survival or because of the editorial decisions that shaped them, the *Sichardiana*'s three sources tended not to transmit and to preserve their own source materials in their integrity. This was especially the case with the oldest witness of the collection, Verona LIX (57). In delving deeper into the contents of *Sichardiana*, I returned to various documents in Verona LIX (57) that seem to complement the *Sichardiana* but, because of the editorial decisions that shaped the manuscript, were separated to different locations in the manuscript: the Chalcedonian acts and the vulgate *Isidoriana* canonical collection were moved to the segment dedicated to ecclesiastical norms and regulations, and it is a distinct possibility that some florilegia were separated from their original *Sichardiana* context and concentrated in their own dedicated part of the manuscript.[204] Even though the late sixth-century Verona LIX (57) transmits only four of the collection's documents, the thematic embeddedness of the *Sichardiana* in this late antique witness suggests the sixth century as the terminus ante quem of

203 All the Latin manuscripts edited in Munier come from canonical collections that include the acts of the Carthaginian council of 419. See the critical apparatus in his *Concilia Africae*, 162, xviii, for further bibliography on the relevant recensions, as well as Maassen, *Geschichte der Quellen*, 358. We find a similar transmission context in the Greek tradition of the letter: in Joannou's *Discipline générale antique* (n. 121 above), it appears as part of the records of the Carthaginian council of 419, which were translated from Latin into Greek. Together with other acts of African councils, they were all incorporated into Greek canonical collections from the late sixth century, on which see Ohme, "Sources of the Greek Canon Law," 75, and Wagschal, *Law and Legality*, 39–40. It therefore seems that the Greek tradition of Cyril's letter preserves not its original Greek but rather its retranslation from Latin: the letter most likely had been originally composed in Greek, later translated into Latin for the records of the Carthaginian council of 419, and then translated back into Greek together with the Carthaginian materials among which we find the letter in the Greek canonical tradition.

204 As the Christological controversies of late antiquity show, the patristic florilegium was a common literary tool used by the debaters when arguing their cases: Gray, "'The Select Fathers'" (n. 151 above), 21–36. The inclusion of florilegia among the original *Sichardiana* documents should therefore not surprise us. The florilegia with the strongest dyophysite leaning in Verona LIX (57) are those from Leo's Tome (see above, nn. 56, 64) and from the concluding address of the Council of Chalcedon to Emperor Marcian (see above, n. 56). The textual history of the latter is particularly revealing: There is evidence to suggest that the florilegium was not part of the original Greek publication of the council's acts and was added only later in the 450s following its contentious reception. The notable dyophysite, pro-Antiochene slant of the florilegium, as well as the choice of some particular citations, has led scholars to suggest that none other than Theodoret of Cyrrhus was behind its assembly (Price and Gaddis, *Council of Chalcedon* [n. 15 above], 3:104–7).

the collection's assembly, and invalidates the possibility that the collection originated in a later medieval or early modern context.

In continuing to explore the contents of the *Sichardiana*, I highlighted further evidence to strengthen the collection's late antique provenance. Throughout the documents of the *Sichardiana*, the dispute underlying the Three Chapters Controversy played out via a tripartite factionalism: the Antiochene faction, with which the Three Chapters were affiliated; Cyril of Alexandria's faction, which led the anti-Nestorian efforts in Ephesus throughout the summer of 431; and finally Nestorius's faction. Referring to both the Antiochenes and Cyril in the collection's rubrics with similar honorifics such as *beatus* and *sanctus* (*Coll. Sich.* 4, 11, 12, 15), the editor of the *Sichardiana* leveled the playing field and framed the underlying dispute as a dialogue between equally orthodox theologians. Documents that demonstrate how much the Christological visions of both the Antiochenes and Cyril complemented each other (*Coll. Sich.* 7–12, 15, 18) further diminished the historical significance of the dispute between the two factions and clarified that the core dispute was not even between them. It was fueled purely by Nestorius's teachings. Although scholars of the Nestorian Controversy have appreciated this seemingly obvious fact for centuries, we also know that the controversy was greatly exacerbated by the Antiochenes' conciliar actions against Cyril and members of his faction in Ephesus, as well as by the Antiochenes' attacks against and refutations of Cyril's *Twelve Chapters*. The Antiochene contributions to the dispute are either ignored or brushed aside in the *Sichardiana*. Instead, the collection's focus on Nestorius is foregrounded in the three opening documents (*Coll. Sich.* 1–3) and in the continuous clarifications of Cyril on the matter (*Coll. Sich.* 1, 4, 10, 15). On the Antiochene side, however, the lack of anti-Nestorian sentiments in the surviving evidence led the collection's editor to take a different editorial approach: to choose documents with Antiochene texts and citations that completely ignore Nestorius or his teaching (esp. *Coll. Sich.* 5–6, 14). It is only in the conclusion of the last document of the collection (*Coll. Sich.* 18, dated to 448!) that we find the sole example of an Antiochene condemnation of Nestorius and his teachings. According to the tripartite factionalism of the dispute as it is constructed in the *Sichardiana*, the Antiochenes were a distinct faction from Nestorius's, did not share

his teaching, and actually had more in common with Cyril than with Nestorius, whom they continuously ignored and never defended in their official letters, Christological treatises, and synodal documents. The dispute's tripartite factionalism correlates to prevailing apologetic arguments against the condemnation of the Three Chapters during the middle of the sixth century. I therefore argue that the collection was assembled for similar apologetic purposes in the same period.

The next stage of my analysis attempted to narrow down the *Sichardiana*'s geographical origin. Alongside implicit or explicit references to Byzantine Africa in two documents (*Coll. Sich.* 12 and 13), the emphasis in the *Sichardiana* on the Nicene adherence of the Antiochenes offered us an important clue: not only do we know of significant resistance to the condemnation of the Three Chapters in mid-sixth-century North Africa, but we also have evidence that some North Africans highlighted exactly the Antiochenes' adherence to the Council of Nicaea in their attempt to argue against the condemnation of the Three Chapters. Such an argument corresponds well with the not-too-distant memories of the anti-Nicene persecutions that the African church had suffered under the Vandals. And Justinian I's request that African clerics condemn the Three Chapters, who, as the Africans quickly learned, had been staunch Nicenes, did not sit well with some of them who had personally experienced the Vandal persecutions.

This likely was not enough, however, for the editor of the *Sichardiana* to show that the Antiochenes had been staunch Nicenes. There is evidence to suggest that our editor attempted to demonstrate that the Antiochenes and Cyril had confessed to the very same and rarely attested version of the Nicene Creed, which Cyril might have also sent to Carthage in the early fifth century along with other Nicene records (*Coll. Sich.* 13). The survival of the rare version of the Nicene Creed in the Antiochenes' *Confessio* (*Coll. Sich.* 5) and in the vulgate *Isidoriana* canonical collection of Verona LIX (57) does not seem like a coincidence. Especially in light of what we know of the editorial liberties taken by the manuscript's compiler, it is a distinct possibility that the *Sichardiana* documents and the canonical collection of Verona LIX (57) were part of the same source. Adding weight to this suggestion is the peculiar historical background of the canonical collection of Verona LIX (57) and its North African connection.

In order to strengthen even further my argument for the North African provenance of the *Sichardiana*, I would have to deal with a lingering problem that this paper has so far avoided: the possibility that the *Sichardiana* was actually envisioned and assembled in Europe, specifically in Verona or its north Italian surroundings. After all, the earliest evidence we have of the *Sichardiana* survives in a late sixth-century manuscript from Verona. Dealing with this problem satisfactorily would exceed the scope of this paper, especially since its solution, I believe, rests on exploring a significantly broader research problem that was highlighted throughout the twentieth century but has yet to receive the appropriate scholarly attention: despite the survival of very few manuscripts from late antique North Africa,[205] we find a notable concentration of North African materials—especially letters, treatises, and canonical collections—in a group of early medieval manuscripts that are housed in the Biblioteca Capitolare of Verona,[206] or in manuscripts whose provenance traces back to Verona.[207] It has even been suggested that the half-uncial script in which some of these manuscripts were written, including Verona LIX (57), is of North African origin.[208] What is particularly striking about the Verona manuscripts of African background is that, like Verona LIX (57), they frequently transmit various texts whose contents relate to the wider Mediterranean world of late antique Christianity. As we have seen in Verona LIX (57) and the *Collectio Sichardiana*, further evidence of this elaborate North African scholarly tradition is dispersed in other European manuscripts. The reconstruction of this opaque scholarly tradition would better contextualize the African background of the *Sichardiana* and thereby undercut the possibility that its origin was European. Moreover, a better understanding of the North African scholarly tradition would demonstrate its hitherto unappreciated participation in and contribution to intellectual trends that crossed the Mediterranean world of late antiquity and beyond.

Department of History
129 Dickinson Hall
Princeton University
Princeton, NJ 08544
omrim@princeton.edu

205 *CLA* 12:viii–ix, and further relevant references in Field, *On the Communion*, 85, n. 115.

206 Verona I (1), *CLA* 4: no. 476; Verona XXII (20), *CLA* 4: no. 490; Verona LIII (51), *CLA* 4: no. 506; and Verona LX (58), *CLA* 4: no. 510. See also T. Licht, *Halbunziale: Schriftkultur im Zeitalter der ersten lateinischen Minuskel (III.–IX. Jahrhundert)* (Stuttgart, 2018), 209–17. It would also be worth exploring the Ephesian and Chalcedonian conciliar materials transmitted in two slightly older manuscripts (ninth or tenth century), Verona LVII (55) and Verona LVIII (56); for further details on these two, see Spagnolo, *Manoscritti* (n. 33 above), 107–10.

207 Vat. Lat. 1322, *CLA* 1: no. 8, and Paris BnF lat. 12214, *CLA* 5: no. 635.

208 Field, *On the Communion*, 95–97.

❧ I WOULD LIKE TO OFFER MY THANKS TO Walter Beers, Avshalom Laniado, Helmut Reimitz, and Jack Tannous for their input throughout the course of researching and writing this paper. I am also thankful for the invaluable feedback from the anonymous reviewers arranged by *DOP*. None of the above should be implicated in this paper's deficiencies and weaknesses.

Appendix I: The *Sichardiana* Documents in the *ACO*

An almost complete version of the *Sichardiana* is printed in *ACO* 1.5.2, 247–318. Several documents, however, are presented there with only their incipit, explicit, or rubric. In such cases, I will refer to the page(s) in *ACO* 1.5.2 where the incipit, explicit, or rubric is found, followed by the edition (*ACO* or otherwise) where the full text can be found. Documents' titles normally follow the entries in the *CPG*.

Coll. Sich. 1 Cyril of Alexandria, *Third Letter to Nestorius* (*CPG* 5317), *ACO* 1.5.2, 247
(incipit and explicit only). See *ACO* 1.5.1, 236:1–244:15.

Coll. Sich. 2 Pseudo-Nestorius, *Twelve Counter-Chapters against Cyril* (*CPG* 5761),
ACO 1.5.2, 247:8–249:7.

Coll. Sich. 3 Pseudo-Nestorius, *Exposition of Faith* (*CPG* 8721), *ACO* 1.5.2, 249 (incipit only).
See *ACO* 2.3.1, 213:5–215:21.

Coll. Sich. 4 Cyril of Alexandria, *Contra Theodoretum* (*CPG* 5222), *ACO* 1.5.2, 249:12–287:17,
with interpolation from Cyril's *Apologia XII capitulorum contra Orientales* (*CPG* 5221)
and *Explanatio XII capitulorum* (*CPG* 5223).

Coll. Sich. 5 John of Antioch et al., *The Synod of Orientals' Exposition of Faith* (*CPG* 6353),
ACO 1.5.2, 287:18–288:29.

Coll. Sich. 6 Anonymous, *Refutation of Cyril of Alexandria's Twelve Chapters* (*CPG* 6360),
ACO 1.5.2, 288:30–294:42.

Coll. Sich. 7 Dionysius Exiguus, *Letter to John and Leontius* (*CPL* 653a), *ACO* 1.5.2, 294:43–295:27.

Coll. Sich. 8 Cyril of Alexandria, *First Letter to Succensus of Diocaesarea* (*ep.* 45; *CPG* 5345),
ACO 1.5.2, 295:28–299:26.

Coll. Sich. 9 Cyril of Alexandria, *Second Letter to Succensus of Diocaesarea* (*ep.* 46; *CPG* 5346),
ACO 1.5.2, 299:27–302:41.

Coll. Sich. 10 Cyril of Alexandria, *Letter to Acacius of Melitene* (*ep.* 40; *CPG* 5340), *ACO* 1.5.2, 303:1–307:3.

Coll. Sich. 11 Paul of Emesa, *Second Homily: About the Nativity* (*CPG* 6366), *ACO* 1.5.2, 307:4–309:34.

Coll. Sich. 12 Cyril of Alexandria, *Third Homily: Response to Paul of Emesa* (*CPG* 5247),
ACO 1.5.2, 310:1–25.

Coll. Sich. 13 Cyril of Alexandria, *Letter to the Carthaginian Council* (*ep.* 85; *CPG* 5385), *ACO* 1.5.2, 310
(incipit only). See C. Munier, *Concilia Africae, a. 345–a. 525*, CCSL 149 (Turnhout, 1974),
162–63. See also P. P. Joannou, ed., *Discipline générale antique (IVᵉ–IXᵉ s.)*, t. 1, vol. 2
(Grottaferrata, 1962), 422–24.

Coll. Sich. 14 John of Antioch et al., *Letter to Cyril (pro Theodoro)* (*CPG* 6312), *ACO* 1.5.2, 311:1–314:6.

Coll. Sich. 15 Cyril of Alexandria, *Letter to John of Antioch (pro Theodoro)* (*ep.* 91; *CPG* 5391),
ACO 1.5.2, 314:7–315:20.

Coll. Sich. 16	Dionysius Exiguus, *Letter to Felicianus and Pastor* (*CPL* 653c), *ACO* 1.5.2, 315 (title only). See *ACO* 4.2, 196:1–197:22.
Coll. Sich. 17	Proclus of Constantinople, *Tome to the Armenians* (*CPG* 5897), *ACO* 1.5.2, 315 (title only). See *ACO* 4.2, 197:23–205:42.
Coll. Sich. 18	Theodoret of Cyrrhus, *Letter to Dioscorus of Alexandria* (*ep.* 83; *CPG* 6240), *ACO* 1.5.2, 315:23–318:16.

Appendix II: The Distribution of the *Sichardiana*'s Documents in Its Three Sources

Document	≈ length in pp.[1]	*Antidotum*	Arsenal 341	Verona LIX (57)
Coll. Sich. 1	8 (9%)	148r–150r		
Coll. Sich. 2	2 (2%)	150v–151r		
Coll. Sich. 3	2 (2%)	151r–152r		
Coll. Sich. 4	38 (44%)	152r–167r	85r–110r	12r–72v
Coll. Sich. 5	1 (1%)	167v–168r		
Coll. Sich. 6	6 (7%)	168r–170v[2]		
Coll. Sich. 7	1 (1%)	170v–171r	110r–110v	
Coll. Sich. 8	4 (4.5%)	171r–172v	110v–113v	
Coll. Sich. 9	3 (3.5%)	172v–173v	113v–116r	
Coll. Sich. 10	4 (4.5%)	173v–175r[3]	116r–119r[4]	
Coll. Sich. 11	2 (2%)		119r–120v	73r–76v
Coll. Sich. 12	1 (1%)		120v–121r	76v–77v
Coll. Sich. 13	0.5 (0.5%)		121r–121v	
Coll. Sich. 14	3 (3.5%)		121v–123v	
Coll. Sich. 15	1 (1%)		123v–124v	
Coll. Sich. 16	1 (1%)	175v	124v–125v	
Coll. Sich. 17	8 (9%)	176r–181r	125v–131v	
Coll. Sich. 18	3 (3.5%)			77v–81v

1 I determined the approximate length according to the printed edition of the documents as cited in Appendix I.

2 Begins in fol. 168r, line 22, with Cyril's first anathema. The document begins without either a rubric or any break that distinguishes it from the previous document. See above, n. 102, for further details.

3 Begins in fol. 173v, line 48, with the words *Christum denique vocitatum*. The letter is introduced without either a rubric or any break that distinguishes it from the previous document. The merging of *Coll. Sich.* 9 and 10 into a single document occurs also in Arsenal 341 (see the next note). A brief discussion is offered in *ACO* 1.5.2, 303.

4 Begins in fol. 116r, line 23 (first column), with the words *Xpm̄ denique vocitatū*. See the previous note.

Another Heaven

Imperial Audiences and the Aesthetics of Ideology in Late Antique Ceremonial

CHRISTIAN ROLLINGER

Throughout the twentieth and twenty-first centuries, the modes of monarchical representation in imperial ceremonies of late antiquity and their connection to imperial ideology have received scholarly attention from ancient historians and Byzantinists alike. Given this, one may be forgiven for thinking that hardly anything new can be added.[1] In fact, it might even be argued that following a veritable boom in ritual studies across a variety of historical disciplines and periods in the latter half of the last century, too much attention has been paid to it. In *The Byzantine*

Republic, Anthony Kaldellis points out, rightly, that the scholarship on late antique and Byzantine political ideology and that on actual politics is out of sync.[2] In terms of political ideology, he contends, the "imperial idea" of Byzantium—the notion of the emperor as the divinely sanctioned, absolute ruler—still dominates scholarship and has obfuscated what actually made the late antique, Byzantine state work[3]—that

1 See, to reference only the most important works, A. Alföldi, *Die monarchische Repräsentation im römischen Kaiserreiche: Mit Register von Elisabeth Alföldi-Rosenbaum* (Darmstadt, 1970), first published in the 1930s as two separate articles, and O. Treitinger, *Die oströmische Kaiser- und Reichsidee nach ihrer Gestaltung im höfischen Zeremoniell: Vom oströmischen Staats- und Reichsgedanken* (Darmstadt, 1956). Recent decades have seen a renewed interest in the subject. See especially S. MacCormack, *Art and Ceremony in Late Antiquity* (Berkeley, 1981); M. McCormick, "Analyzing Imperial Ceremonies," *JÖB* 35 (1985): 1–20; M. McCormick, *Eternal Victory: Triumphal Rulership in Late Antiquity, Byzantium and the Early Medieval West* (Cambridge, 1986); I. Tantillo, "I cerimoniali di corte in età tardoromana (284–395 d.C.)," in *Le corti nell'alto medioevo: Spoleto, 24–29 aprile 2014*, vol. 1 (Spoleto, 2015), 543–86; F. Guidetti, "Gerarchie visibili: La rappresentazione dell'ordine cosmico e sociale nell'arte e nel cerimoniale tardoromani," in *Hierarchie und Ritual: Zur philosophischen Spiritualität in der Spätantike*, ed. C. Tomassi, L. Soares Santoprete, and H. Seng (Heidelberg, 2018), 9–42. For an in-depth, book-length treatment of late antique political ceremonial, see C. Rollinger, *Zeremoniell und Herrschaft in der Spätantike: Die Rituale des Kaiserhofs in Konstantinopel (4.–7. Jh.)* (Stuttgart, forthcoming).

2 A. Kaldellis *The Byzantine Republic: People and Power in New Rome* (Cambridge, MA, 2015). For the purpose of this article, late antiquity is defined roughly as the period between the accession of Constantine I and the Heraclian dynasty; the period beginning with the eighth century is designated early Byzantine. As for ideology, I refer the reader to N. Wiater, *The Ideology of Classicism: Language, History, and Identity in Dionysius of Halicarnassus* (Berlin, 2011), 21–22, who has defined the concept of ideology as the sum of "discursive practices" and quotes Paul Ricoeur ("Can There Be a Scientific Concept of Ideology?," in *Phenomenology and the Social Sciences*, ed. J. Bien [The Hague, 1978], 44–59, at 47) in asserting that it contributes to the "shaping of the world according to a set of rules or norms which are provided by the social worlds in which we are organized—'something out of which we think, rather than something that we think.'"

3 Kaldellis, *The Byzantine Republic*, 165–98; cf. Av. Cameron, *The Byzantines* (Malden, MA, 2006), 97: "Insofar as there was an official political theory underpinning the Byzantine state, it consisted of the Christianized-ruler theory worked out for Constantine the Great by Eusebius of Caesarea, according to which the empire was the microcosm of heaven and the emperor placed there by God to ensure the maintenance of true religion." On the late antique development of this idea, see F. Kolb, *Herrscherideologie in der Spätantike* (Berlin, 2001); M. Meier, "Der Monarch auf der Suche nach seinem Platz: Kaiserherrschaft im frühen Byzanz (5. bis 7. Jahrhundert n.Chr.)," in

is, why emperors were able to rule, how they were able to gain acceptance or legitimacy, and on what their acceptance depended.[4] A "comprehensive account of a people's political ontology must, after all, be able to explain their political behavior," but the imperial idea does not do so. Instead, Kaldellis writes, it is a "castle in the sky (which is what I think the Byzantine court was in fact constructing)."[5] In addition, as pointed out two decades ago by Philippe Buc in the provocative *Dangers of Ritual*, historians cannot observe rituals and ceremonies of past societies but only read about them in sources with their own discursive, cultural, and political biases.[6] Trying to identify and "read" the ritual meanings of such ceremonies is thus fraught with significant epistemological difficulties. Such "meanings"

are considerably less fixed than historians of the past decades have confidently assumed.[7]

Ceremonial in and of itself explains nothing, and Kaldellis is right in maintaining that the imperial idea alone is not a sufficient basis for understanding the late antique or Byzantine emperorship. To approach these subjects otherwise, as has mostly been done for the past century, is to privilege the view officially propagated by the court. The intention here, however, is not to outline a political theory of late antique statesmanship, but to stress the importance of understanding the official view in all of its dimensions and expressions. Ceremonies in particular never have only one meaning or intention, though they may well have a primary one, intended and constructed by the masters of ceremony. There are a plethora of secondary meanings and symbolic implications that depend on the sociocultural, religious, and political contexts of each participant in the ceremony.

The focus here is therefore on both the imperial court's "castle in the sky" and the way in which imperial ideologemes are enacted, performed, and received in ceremonial. The two goals are to analyze a specific form of late antique imperial ceremony, to show what messages and ideologemes were meant to be communicated, and to examine how the ideological themes of emperorship expounded upon in the literary sources find their reflections and embodiments in actual ceremonies.[8] A holistic approach to imperial ceremonial is

Monarchische Herrschaft im Altertum, ed. S. Rebenich and J. Wienand (Berlin, 2017), 509–44.

4 By acceptance, I mean the acquiescence of decisive sectors of Roman society in the rule of a specific emperor or dynasty. Egon Flaig first introduced the concept of Roman emperorship as an *Akzeptanzsystem* (acceptance system) in 1992. More recently, see E. Flaig, *Den Kaiser herausfordern: Die Usurpation im Römischen Reich*, 2nd rev. ed. (Frankfurt am Main), 2019. See H. Brandt, *Die Kaiserzeit: Römische Geschichte von Octavian bis Diocletian* (Munich, 2021), for a general overview of Roman imperial history from this perspective, and R. Pfeilschifter, *Der Kaiser und Konstantinopel: Kommunikation und Konfliktaustrag in einer spätantiken Metropole* (Berlin, 2013), for the late antique monarchy as an *Akzeptanzsystem*. This approach deserves wider reception in the Anglosphere than it has so far received. B. Chrubasik, *Kings and Usurpers in the Seleukid Empire: The Men Who Would Be King* (Oxford, 2016), appears to be the only book-length engagement with it so far. On the problems of "legitimacy" as a concept, see J. Lendon, "The Legitimacy of the Roman Emperor: Against Weberian Legitimacy and Imperial 'Strategies of Legitimation,'" in *Herrschaftsstrukturen und Herrschaftspraxis: Konzepte, Prinzipien und Strategien der Administration im römischen Kaiserreich*, ed. A. Kolb (Berlin, 2006), 53–66, and cf. U. Gotter, "Die Nemesis des Allgemein-Gültigen: Max Webers Charisma-Konzept und die antiken Monarchien," in *Das Charisma: Funktionen und symbolische Repräsentationen*, ed. P. Rychterová, S. Seit, and R. Veit (Berlin, 2008), 173–86.

5 Kaldellis, *Byzantine Republic*, 168.

6 P. Buc, *The Dangers of Ritual: Between Early Medieval Texts and Social Scientific Theory* (Princeton, 2001), passim. See also McCormick, "Analyzing Imperial Ceremonies," on methodological issues of studying Byzantine ceremonies in particular. The difference between ritual and ceremony (and symbolic acts) is difficult to pin down exactly. For the purposes of this article, and conscious of the potential aporia of such a definition, ritual is considered to be a transformative performative action—e.g., a coronation or baptism—and ceremony to be a representative performance. The former leads to a change in status, the latter affirms it.

7 This is the main criticism of Buc, *Dangers of Ritual*, but see the reply in G. Koziol, "The Dangers of Polemic: Is Ritual Still an Interesting Topic of Historical Study?," *EME* 11 (2002): 367–88. Koziol is one of the main advocates of medieval ritual studies. Also see the more measured reflections in C. Pössel, "The Magic of Early Medieval Ritual," *EME* 17 (2009): 111–25, esp. 112: "It is always useful, after some years of research, to have somebody like Philippe Buc come along and wonder if it's not all bunk, after all." Buc's criticism applies most of all to the application of ritual studies in Western medieval contexts, where they are both more established and often more pointed than in ancient history or Byzantine studies. Nevertheless, Pössel's point—that ritual interpreted as a quasi-magical, transformative moment has been mystified and overstretched as an end-all argument—is salient for both disciplines.

8 The ideologeme is the basic, fundamental unit of ideology; see M. Bakhtin, *The Dialogic Imagination* (Austin, 1981), 429. See also T. Lylo, "Ideologemes as a Representative of the Basis Concept of Ideology in the Media Discourse," *Social Communication* 1 (2017): 14–20, esp. 19: "The ideologeme is a unit of ideology and its explication. It can not only form an individual's attitude to reality, but primarily it can construct this reality on the axiological level and even replace it."

taken by reconstructing the choreography and grammar of ceremonial performances, interpreting their semiotics, and identifying their ideological background. Doing so involves combining an analysis of literary ekphrases and narratives with an investigation of the materiality and sensuality of court ceremonial. For this purpose, Alexei Lidov's concept of hierotopy, which he developed within the context of Byzantine art history and icon veneration, is adapted and used as a theoretical and methodological framework. The goal is, again, twofold: first, to show by example that this framework can be gainfully adapted to study imperial ceremonies and performance generally and, second, to argue that ceremonial was not simply unidirectional, but that its top–down planning and performance allowed for bottom–up perceptions and interpretations as well.

The analysis focuses on one particular form of ceremony—the audience, or reception.[9] This is in part because the audience—the emperor's reception of "visitors" or courtiers in a formal setting—was one of the most strictly choreographed and tightly controlled ceremonies known. Those invited and received at the audience came to the emperor as if going to stand before God himself. The ceremony took place at the Great Palace, deep inside the labyrinthine, centuries-old assemblage of residential, administrative, and generally imposing imperial buildings that occupied the entire southeastern corner of Constantinople. The location afforded the masters of ceremony complete control over the mise-en-scène as well as the dramatis personae; they chose whom they allowed into their midst and then determined what path they would take to get to the specified audience hall in addition to what buildings, views, artworks, décors, and assembled groups of courtiers or soldiers they would see. The goal was to leave little chance for the unforeseen and little to no margin for improvisation that might tarnish the image of imperial order and majesty that the ceremony was meant to impart. During perambulations or processions through the city, residents sometimes pelted emperors with stones, as Theodosius II (r. 402–450) experienced in 431. In the Hippodrome, the crowd might jeer, make impertinent demands, or even riot, as Anastasios (r. 491–518) and Justinian (r. 527–565) found on several occasions.[10] At the court, however,

9 The audience has been somewhat understudied compared to more spectacular occasions, such as a triumph (*adventus*) or coronation, but see A. Becker, "Verbal and Nonverbal Diplomatic Communication at the Imperial Court of Constantinople (Fifth–Sixth Centuries)," *DOP* 72 (2018): 79–82; A. Becker, *Dieu, le souverain et la cour: Stratégies et rituels de légitimation du pouvoir impérial dans l'Antiquité tardive et au haut Moyen Âge* (Bordeaux, 2022), 149–254; C. Rollinger, "The Importance of Being Splendid: Competition, Ceremonial and the Semiotics of Status at the Court of the Late Roman Emperors (4th–6th Centuries)," in *Gaining and Losing Imperial Favour in Late Antiquity: Representation and Reality*, ed. K. Choda, M. Sterk de Leeuw, and F. Schulz (Leiden, 2020), 36–72; C. Rollinger, "These Boots Aren't Made for Walking: Tetrarchic Ceremonies as a Language of Authority," in *The Tetrarchy as Ideology: Reconfigurations and Representations of an Imperial* Power, ed. F. Carlà-Uhink and C. Rollinger (Stuttgart, 2023), 93–118; Rollinger, *Zeremoniell und Herrschaft* (chap. 5). For an innovative study of imperial admission ceremonies during the Principate, and a short coda on their development in late antiquity, see M. Lindholmer, "Rituals of Power: The Roman Imperial Admission from the Severans to the Fourth Century" (PhD diss., University of St. Andrews, 2020); M. Lindholmer, "Cassius Dio and the Ritual of the Imperial Admission," in *The Intellectual Climate of Cassius Dio: Greek and Roman Pasts*, ed. A. M. Kemezis, C. Bailey, and B. Poletti (Leiden, 2022), 226–52. As with most other ceremonial matters, the later forms of such audiences and receptions (i.e., middle Byzantine court ceremonial) have received more attention than those from earlier periods, particularly the admissions of foreign ambassadors. See F. Tinnefeld, "Ceremonies for Foreign Ambassadors at the Court of Byzantium and Their Political Background," *ByzF* 19 (1993): 193–213; O. Kresten, "Sprachliche und inhaltliche Beobachtungen zu Kapitel I 96 des sogenannten 'Zeremonienbuches,'" *BZ* 93 (2000): 474–89; F. A. Bauer, "Potentieller Besitz: Geschenke im Rahmen des byzantinischen Kaiserzeremoniells," in *Visualisierungen von Herrschaft: Frühmittelalterlicher Residenzen.*

Gestalt und Zeremoniell—Internationales Kolloquium, 3./4. Juni 2004 in Istanbul, ed. F. A. Bauer (Istanbul, 2006), 135–70; M. Luchterhandt, "Bilder ohne Worte: Protokoll und höfischer Luxus in den Empfangszeremonien des mittelbyzantinischen Kaiserhofs," in *Streit am Hof im frühen Mittelalter*, ed. M. Becher and A. Plassmann (Göttingen, 2011), 331–64; N. Drocourt, *Diplomatie sur le Bosphore: Les ambassadeurs étrangers dans l'empire byzantin des années 640 à 1204*, 2 vols. (Louvain, 2015), 2:487–584; T. Hoffmann, "Von verlorenen Hufeisen und brennenden Nüssen–Über Konflikte im Rahmen des 'diplomatischen' Zeremoniells des byzantinischen Kaiserhofes," in *Transcultural Approaches to the Concept of Imperial Rule in the Middle Ages*, ed. C. Scholl, T. Gebhardt, and J. Clauß (Frankfurt am Main, 2017), 221–44; A. Beihammer, "Ceremonies and Court Rituals in Byzantine Imperial Audiences in the Time of the First Crusade," in *The Ceremonial of Audience: Transcultural Approaches*, ed. E. Orthmann and A. Kollatz (Bonn, 2019), 37–62.

10 For stones thrown at Theodosius, see Marc. Com. ad a. 431.3 (T. Mommsen, ed., *Chronica minora saec. IV. V. VI. VII*, vol. 2 [Berlin, 1894], 37–108); for Anastasios confronting protests connected to changes introduced to the Trisagion formula in 512, see Marc. Com. ad a. 512.2–8 (ed. Mommsen); for Justinian being importuned with demands for bread in the Hippodrome, with a Persian envoy accompanying him in the *kathisma*, see John Malalas, *Chronicle* 18.121

the palace staff exerted a greater degree of control over the performance, and when someone, such as an ambassador, opened the door to potential embarrassment by refusing to adhere to ceremonial niceties, the episode remained shielded from the full view of the public. As a result, one finds little to no mention of such events.[11] This makes the audience ceremonial in the palace eminently suited for the case study here.

There are also important practical advantages to focusing on the audience. For one, extensive and detailed sources recount specific audiences, and

normative, prescriptive texts outline different ceremonial settings. The *Book of Ceremonies,* ordered by Emperor Constantine VII (r. 913–959) and one of two main sources used here, includes accounts of a specific audience granted to Iesdekos, a Persian ambassador in the sixth century, as well as general outlines for audiences involving other visitors.[12] These chapters have been shown to be the work of Peter the Patrician, *magister officiorum* to Justinian, and bear traces not only of his contemporaneousness to the events described therein, but also of his responsibilities as magister, the person tasked with arranging diplomatic exchanges and palace ceremonies on the whole and one of the most senior administrative officials in the empire.[13] The roughly contemporary and remarkably understudied panegyric of Flavius Corippus supplements Peter's contributions. With *In Praise of Justin* composed on the occasion of the accession of Justin II (r. 565–578), Corippus provides a quasi-official description of events surrounding the events during the first days of his rule, delineating the communicative intentions of the court.[14] His set pieces

(J. Thurn, ed., *Ioannis Malalae Chronographia,* CFHB 35 [Berlin, 2000], 418), and compare the angry back-and-forth in Theophanes the Confessor, *Chronicle* AM 6024 (C. de Boor, ed., *Theophanis Chronographia,* 2 vols. [Leipzig, 1883], 181–83), and *Chron. Pasch.,* ad a. 531 (L. Dindorf, ed., *Chronicon Paschale,* CSHB [Bonn, 1832], 620).

11 The issue of ceremonial violations, though of great interest, can only be briefly alluded to here. Drocourt, *Diplomatie sur le Bosphore,* 2:572–83, discusses them in more detail, but tellingly, all of the examples are of a later date than discussed here, touching on Byzantine diplomatic relations with Islamic and Latin polities. There are occasional hints of similar events in late antiquity, but they are seldom recounted in any detail, including the reactions by palace staff. Valentinian I, notorious for his angry outbursts, is said to have died from a stroke brought on by a fit of apoplectic rage at the impertinence of ambassadors from the Quadi during negotiations; it appears that he yelled until he collapsed on the floor, dead. See Socrates, *Historia Ecclesiastica* 4.31; Amm. Marc. 30.6.1–6; Zos. 4.17. It should be noted, however, that imperial rage was not necessarily negatively connoted in late antiquity, but could be judged an appropriate, and indeed virtuous, response. See C. Malone, "The Virtue of Rage in the Fourth Century," in *Studies in Emotions and Power in the Late Roman World: Papers in Honour of Ron Newbold,* ed. B. Sidwell and D. Dzino (Piscataway, NJ, 2010), 59–86; B. Sidwell, *The Portrayal and Role of Anger in the Res Gestae of Ammianus Marcellinus* (Piscataway, NJ, 2013), 131–84. Other cases of ceremonial violations mostly involve holy men and ascetics, who enjoyed a degree of παρρησία (candor) unimaginable otherwise. See A. Hasse-Ungeheuer, *Das Mönchtum in der Religionspolitik Kaiser Justinians I: Die Engel des Himmels und der Stellvertreter Gottes auf Erden* (Berlin, 2016), 292–95; H. Leppin, "Power from Humility: Justinian and the Religious Authority of Monks," in *The Power of Religion in Late Antiquity,* ed. A. Cain and N. Lenski (Farnham, 2009), 155–64. The Syrian hermit Mare not only exploded in a fit of rage during an audience with Justinian, but also threw a gift of gold coins across the room, denouncing the imperial couple. His biographer, John of Ephesus, forgoes quoting the holy man verbatim for fear that no one would believe him and because it seemed unwise to him to besmirch the saint's reputation; he asserts that the rulers bore his outburst humbly: John of Ephesus, *Lives of the Eastern Saints,* ed. and trans. E. W. Brooks, PO 18 [Paris, 1924], 630–31. In another case, however, Justinian seems to have lost his patience with the Syrian stylite Zoora and threatened him with physical violence: John of Ephesus, *Lives of the Eastern Saints,* ed. and trans. E. W. Brooks, PO 17 [Paris, 1923], 21–26.

12 *Book of Ceremonies* 1.87–90. References to the *Book of Ceremonies* follow the (erroneous) chapter numbering of J. J. Reiske, ed., *Constantini Porphyrogeniti Imperatoris de Cerimoniis Aulae Byzantinae libri duo,* 2 vols., CSHB (Bonn, 1829). Preference is given to this conventional style over the more accurate manuscript numbering adopted in G. Dagron and B. Flusin, ed., *Constantini Porphyrogeniti Liber de cerimoniis,* 6 vols., CFHB 52 (Paris, 2020), as it remains the most commonly used format, but the newly corrected Greek text of Dagron and Flusin is used throughout; A. Moffatt and M. Tall, trans., *Constantine Porphyrogennetos: The Book of Ceremonies* (Canberra, 2012), is used for the translations and modified as necessary. The audience of Iesdekos can be roughly dated since it is known from Procopius and Menander the Guardsman that embassies under Iesdekos arrived in Constantinople in 547, 551, and 557: Procopius, *History of the Wars* 2.28.16 (Isdigousnas), and Menander the Guardsman, *History,* ed. R. C. Blockley (Liverpool, 1985), 6.1, 9.1 (Iesdegousnaph). Cf. I. Dimitroukas, "The Trip of the Great Persian Embassies to Byzantium during the Reign of Justinian I (527–565) and Its Logistics," *Byzantina Symmeikta* 18 (2008): 171–84.

13 On Peter's authorship, which is not in dispute, see Dagron and Flusin, *De cerimoniis,* 1:64–70, 4.1:479–81.

14 For the Latin text, the Budé edition is used: S. Antès, ed., *Éloge de l'Empereur Justin II* (Paris, 2002); translations are from Flavius Cresconius Corippus, *In laudem Iustini Augusti minoris: Libri VI,* ed. and trans. Av. Cameron (London, 1976), modified where necessary. In general, work on Corippus has focused on the *Iohannis,* his more well-known epos, but see the papers collected in B. Goldlust, ed., *Corippe, un poète latin entre deux mondes* (Lyon, 2015). On his name, which should probably be rendered as Goripppus, but which will be used in the traditional style here, see P. Riedlberger, "Again on the

include an Avar embassy to Constantinople in 565 led by a man called Targitius that not only includes quite significant ceremonial details, confirming or expanding the image provided in the *Book of Ceremonies*, but also tries to convey an impression of the ceremonial aesthetics to the reader.[15]

Some might consider the nature of the sources used here a double-edged sword. On the one hand, they present the rare situation of having two first-rate and almost contemporary source accounts of audiences, and although they belong to two distinct genres of writing, and each poses its own problems in interpretation, they allow one to reconstruct sixth-century audience protocol in surprising detail.[16] On the other hand, both authors focused on a specific form of audience ceremonial—that of the diplomatic exchange,[17] involving the reception of foreign embassies, forgoing

those for courtiers, senators, or other members of the Roman elite or court. Rather than being a hindrance, however, for the purposes here, this is in fact an advantage. For one, the diplomatic context would have led to an even greater determination by palace, or *magisterium*, staff to exert tight control over the whole affair, since presenting the intended image of imperial might would have been particularly important on these occasions. In addition, the presence at these events of courtiers and senators, as well as foreign diplomats from different sociocultural backgrounds, lends itself well to the analysis here. Notably, for example, no chapter in the *Book of Ceremonies* details general late antique receptions, or admissions, of senators or officials other than to communicate appointments, promotions, and retirements.[18] Such admissions, akin to the *salutationes* of the Principate, are mentioned only in short asides or as preludes to other audiences, such as diplomatic ones.[19] There are hints in the sources that imperial admissions—that is, the ceremonialized but quotidian salutation of the emperors from the Principate—survived into late antiquity and were further developed, for instance, first by adopting the *adoratio* (genuflection) and later the complete *proskynesis* (prostration) as ceremonial forms of greeting the emperor.[20] As mentioned, imperial ceremonial should not be conceived of as addressing only a single, primary audience, but rather as communicating different (albeit overlapping) ideological messages to several different (and overlapping) audiences at the same time. The full import of the semiotically and ideologically charged performances of diplomatic ceremonial can only be understood if one also considers these secondary addressees. Thus, a first and a second "reading" of the audience ceremonies described in the sources is proposed to show that in interpreting them, care should be taken to differentiate between individual ideological and performative levels.

Name 'Gorippus': State of the Question–New Evidence–Rebuttal of Counterarguments–The Case of the Suda," in Goldlust, *Corippe, un poète latin entre deux mondes*, 29–31.

15 Corippus, *In Praise of Emperor Justin* 3.151–407. A second account of this embassy, differing quite noticeably from that of Corippus, is given in Menander the Guardsman, *History,* frag. 8 (ed. Blockley), which makes no mention of the ceremonial elements. By contrast, the Avar audience is one of the main set pieces of Corippus's panegyric, and it serves as a showcase for explaining and celebrating a change in Roman policy toward the Avars that would lead to military conflict and significant reversals for the Roman Empire. See W. Pohl, *Die Awaren: Ein Steppenvolk in Mitteleuropa 567–822 n.Chr.* (Munich, 1988), 48–51; G. Kardaras, *Byzantium and the Avars, 6th–9th Century AD: Political, Diplomatic and Cultural Relations* (Leiden, 2018), 20–42.

16 Cf. Bauer, "Potentieller Besitz," for a comparative analysis of these two sources and the later narrative of Liudprand of Cremona.

17 Surprisingly, while all recent major studies on late antique diplomacy stress the importance of ceremonial in diplomatic protocol, they do so somewhat cursorily, without engaging in-depth with the sources describing it, and without giving much thought to the role of ceremonial in interstate communication. See A. Gillett, *Envoys and Political Communication in the Late Antique West, 411–533* (Cambridge, 2003); E. Nechaeva, *Embassies–Negotiations–Gifts: Systems of East Roman Diplomacy in Late Antiquity* (Stuttgart, 2014). W. Pohl, "Ritualized Encounters: Late Roman Diplomacy and the Barbarians, Fifth–Sixth Century," in *Court Ceremonies and Rituals of Power in Byzantium and the Medieval Mediterranean*, ed. A. Beihammer, S. Constantinou, and M. Parani (Leiden, 2013), 67–86, is a notable exception. A. Becker, *Les relations diplomatiques romano-barbares en Occident au Vᵉ siècle: acteurs, fonctions, modalités* (Paris, 2013) does engage with diplomatic protocol, albeit very briefly (but cf. Becker, "Verbal and Nonverbal"); the discussion in Becker, *Dieu, le souverain et la cour*, 151–88, is more detailed. Drocourt, *Diplomatie sur le Bosphore*, 2:487–585, is a detailed analysis of the ceremonial elements of diplomacy, but mostly focuses

on early and middle Byzantine contexts (though with frequent references to late antiquity).

18 *Book of Ceremonies* 1.84–86 (ed. Reiske, 286–389). Cf. Rollinger, "Being Splendid."

19 On the salutationes, see Lindholmer, "Rituals of Power."

20 Generally, on the potential survival of salutations into late antiquity, see Lindholmer, "Rituals of Power," 81–152; cf. Rollinger, "These Boots."

The first of this article's three main sections consists of a general description of audiences, particularly those involving foreign envoys, in the sixth century and proposes the first reading of this particular kind of ceremony—that is, the primary communicative intent of the creators and performers toward their primary audience, the envoys. By necessity, this constitutes a generalized and diachronic view of the ceremonial, extracted from the sources, which are a mixture of historical accounts, prescriptive texts, and panegyrics. Drawing an image of the audience in general relies particularly on the *Book of Ceremonies* and on Corippus, judiciously supplemented at points by pertinent earlier and later sources. This generalized reconstruction serves as an abstract template for diplomatic audiences, which were naturally subject to change across the centuries and moreover could be (and were) modified according to political aims and case-specific constraints. The short second section introduces, adapts, and applies the conceptual and methodological foundations developed by Alexei Lidov, which are then used in the third section to undertake a second reading to arrive at a fuller understanding of the ceremonial. The intention is not only to provide a better, more complete understanding of ceremonial as such, but also to offer a new approach to the study of late antique imperial ceremonial and its connection to imperial ideology.

Audiences and Their Reconstruction: A First Reading

In the run-up to the diplomatic audience proper, those to be received by the emperor were led through the city, from their lodgings to the Chalkê Gate, the main entrance of the Great Palace, and from there onto the palace grounds. Inside the palace en route to the audience, they passed the offices of the magisterium and a porticus that the middle Byzantine sources call the Makron of the Kandidatoi, likely abutting the guard barracks. Corippus does not identify the precise location for the audience itself, hinting only that it takes place in a "lofty hall in the huge building."[21] It may be that the various audiences were held in a different building, but little can be gleaned from the sources. A description in the *Book of Ceremonies,* however, reveals

that late antique diplomatic audiences took place at the least in the so-called Great Consistory, a building about which little else is known.[22] Before entering the Consistory, the envoy and his entourage were first led into the Anticonsistory (or Winter Consistory), a separate, adjacent waiting area.[23] Armed guards, standard bearers, and other representatives of the palace were

21 Corippus, *In Praise of Emperor Justin* 3.191–93: *atria praelargis extant altissima tectis.*

22 The Consistory was the main audience hall of the palace until the construction of the Chrysotriklinos in the second half of the sixth century. The Magnaura, mentioned by Liudprand and in the *Book of Ceremonies* 2.15 as the main diplomatic audience hall, was of an even later date. See J. Kostenec, "Studies on the Great Palace in Constantinople II: The Magnaura," *BSl* 60 (1999): 161–82. The Consistory was likely laid out in the shape of an apsidal basilica, for which there exists ample parallel evidence in private, episcopal, and imperial architecture of late antiquity. It may have had three naves separated by rows of columns, as the Hall of the Nineteen Couches did, though that is uncertain. The *Book of Ceremonies* 1.46 (ed. Reiske 234) states that there were three doors, inlaid with ivory (οἱ τρεῖς πυλῶνες οἱ ἐλεφάντινοι τοῦ κονσιστωρίου) at each end of the building, but this does not necessarily imply a similar arrangement on the inside. It is equally possible that the building instead followed the example of the Constantinian Aula Palatina in Trier, which has only one main nave. The Consistory was located in the so-called Daphne, the oldest area of the palace, which included the earliest attested buildings and likely dated back to Constantine (r. 306–337) himself. J. Kostenec, "The Heart of the Empire: The Great Palace of the Byzantine Emperors Reconsidered," in *Secular Buildings and the Archaeology of Everyday Life in the Byzantine Empire*, ed. K. Dark (Oxford, 2004), 4–6, on the other hand, sees the Consistory as a later addition, perhaps built under Constantius II (r. 337–361). It was perhaps aligned on a west–east axis: N. Westbrook, *The Great Palace in Constantinople: An Architectural Interpretation* (Turnhout, 2019), 176, fig. 51; contra, R. Guilland, *Études de topographie de Constantinople byzantine*, 2 vols. (Amsterdam, 1969), 1:56, and Kostenec, "The Heart of the Empire," esp. 8, both of whom posit a north–south axis, abutting the Delphax, or Great Tribunal, a spacious inner court used for assemblies around which the main palace buildings—the Hall of the Nineteen Couches, Augousteus, and Consistory—were arranged. On the Daphne area, see A. Calahorra Bartolomé, "On the Toponymics of the Great Palace of Constantinople: The Daphne," *BZ* 114 (2022): 1–46; cf. J. Ebersolt, *Le Grand Palais de Constantinople et le Livre des Cérémonies* (Paris, 1910), 39–48, and Guilland, *Études*, 1:56–69, on the possible Constantinian origins.

23 The question of the relationship between the Small and Large Consistory is difficult to answer. Occasionally, Summer and Winter Consistories are also mentioned, but these are likely just alternative descriptors for the same buildings. The Small Consistory may be the entrance area identified as the *anticonsistorion* in the *Book of Ceremonies* 1.89. Westbrook, *Great Palace*, 206, designates the Winter Consistory an ancillary room to the (Summer) Consistory. For the purposes of the description of the ceremony, I assume that the Small/Winter Consistory denotes the entrance area, that is, the Anticonsistory.

posted everywhere, including in large numbers at the entrances to the Consistory.[24] Before the ceremony began, the emperor entered, accompanied by the magister officiorum and court eunuchs, and sat on the throne, situated in the middle of the room.[25] If the Consistory was, in fact, an apsidal audience hall, the throne would likely have been positioned in the apse itself. An elaborate, dome-shaped canopy covered the throne, which at that point was hidden from view by curtains hanging between the canopy's arches. The throne was likely elevated on a podium from which three steps led into the main area of the hall.[26]

With the emperor seated, the courtiers and officials (ἄρχοντες, in the *Book of Ceremonies*) filed in to assemble in the Consistory, wearing dark russet chlamyses of pure silk.[27] At the same time, the *admissionalis*, the official in charge of the ceremony, and officials

from the *scrinium barbarorum*, which oversaw foreign affairs, escorted the envoys to their designated positions in the Anticonsistory—"at the wall opposite the curtain" of the Consistory, which indicates that Anticonsistory and Consistory were also separated by curtains, like the emperor was from those in attendance.[28] While the envoys assumed their places, the emperor received courtiers and officials, that is, they entered the Consistory and formally greeted him with an act of *adoratio purpurae*, prostrating themselves and kissing the imperial feet.[29] After this reception, they returned to their places along the longitudinal walls, ordered according to their status and rank in the court hierarchy.[30] According to Corippus, benches decorated with precious fabrics and pillows lined the walls of the Consistory; it is implied that the courtiers and officials followed the ceremony from these benches. If true, this would likely mean the benches were movable grandstands, similar to the ones detailed in Corippus's later description of the consular procession of Justin II that were constructed or brought in especially for the occasion.[31] One would usually expect participants in imperial ceremonies to be standing in the presence of the emperor, and it is possible that this was the case here as well. Courtiers standing in a row on graduated, raised benches, arranged one behind the other, would have ensured that every participant had a good view of the ceremony, while at the same time providing a visually impressive spectacle. The *Book of Ceremonies* does not mention benches.

Only after this reception did the magister call for the official ceremony to begin. On his order, a decurion

24 Corippus, *In Praise of Emperor Justin* 3.207–9. Cf. *Book of Ceremonies* 1.89 (ed. Reiske, 404), for the "bearers of the labara." There is also mention of pages (ed. Reiske, 405.1–2), literally "boys of the nobility" (πούερας εὐσχήμους), a transliteration of the Latin *pueros* and a hapax; the explanatory scholion to the Lipsiensis manuscript adds "children, boys" (παῖδας). As far as I am aware, this is the only attestation of such pages, rendering it difficult to know what to make of it.

25 *Book of Ceremonies* 1.89 (ed. Reiske, 405), actually only mentions a "patrician" accompanying the emperor, which has been taken as a reference to Peter. Becker, *Dieu, le souverain et la cour*, 164, notes, however, that this is not the only official with patrician status, and it may be that it was the chamberlain of the palace (*praepositus sacri cubiculi*) who accompanied him.

26 For curtains sectioning off an area inside the Consistory, likely the location of the throne and canopy, see Cyril of Scythopolis, *Life of Saint Sabas* 51, 71 (E. Schwartz, ed., *Kyrill von Skythopolis* [Leipzig, 1939]). Similarly, *Book of Ceremonies* 1.1 attests that the imperial table (*akkoubiton*) in the Hall of the Nineteen Couches, could be hidden behind curtains. The existence of a podium or tribunal on which the throne was situated is admittedly conjectural, but in middle Byzantine sources, the imperial position is usually described as being up three steps. See, for example, the *Kletorologion* of Philotheos (N. Oikonomidès, ed. and trans., *Les listes de préséance byzantines des IXᵉ et Xᵉ siècles* [Paris, 1972], 167–69). On ceremonial curtains in general, see M. Parani, "Mediating Presence: Curtains in Middle and Late Byzantine Imperial Ceremonial and Portraiture," *BMGS* 42 (2018): 1–25.

27 *Book of Ceremonies* 1.89 (ed. Reiske, 405). Irritatingly, Corippus, *In Praise of Emperor Justin* 3.209–14, gives an inverse ceremonial order. In his narrative, the emperor, surrounded by eunuchs and high officials, enters last, after all the other officials have taken their places inside the hall. Becker, *Dieu, le souverain et la cour*, 164 n. 71, assumes on the basis of Corippus, *In Praise of Emperor Justin* 3.232–33 (*ut laetus princeps solium conscendit in altum / membraque purpurae praecelsus veste locavit*), that the emperor changes his costume while seated

on the throne, but this seems implausible and is likely a misreading of the text.

28 *Book of Ceremonies* 1.89 (ed. Reiske, 405): εἰς τὸν τοῖχον ἄντις τοῦ βήλου.

29 This may in fact be an instance of the survival into the late antique of earlier imperial admissions of the Principate, mentioned above.

30 *Book of Ceremonies* 1.89 (ed. Reiske, 405).

31 Corippus, *In Praise of Emperor Justin* 3.205–6: *longoque sedilia compta tenore / clara superpositis ornabant atria velis*; and 3.253–54: *caveam turbasque faventes / lustrant*. In the latter section, Corippus depicts the impressionable envoys as analogous to animals being led into the arena for the slaughter. Thus *cavea*, the term he uses for "grandstands" or "arena seating," is possibly a rhetorical means of reinforcing that analogy, rather than a factual description. For the grandstand during the consular procession, see Corippus, *In Praise of Emperor Justin* 4.50–85.

led the *candidati,* the forty elite bodyguards selected for the event as the emperor's guard, into the Consistory and ordered them to take up positions along the left and right walls, positioned in front of the courtiers but, significantly, behind the consuls and consulars.[32] The decurion then returned to the antechamber and gave the order *"Leva!"*—to raise the curtains; remarkably, the order is still rendered in Latin in the tenth-century *Book of Ceremonies.*[33] As the curtains were raised, the envoy and his entourage collectively performed proskynesis in the Anticonsistory, touching their heads to the floor, then rose to proceed into the Consistory proper. Here, they again performed proskynesis, at least twice or perhaps three times: immediately after crossing the threshold, "in the middle" (ἐν τῷ μέσῳ) of the room, and perhaps once again closer to the emperor, whose feet they were required to kiss. Circular porphyry slabs (*rota*) embedded in the floor marked the respective positions to be taken by the envoys; the *Book of Ceremonies* attests this for the location of the first proskynesis, at the least, and such slabs survive to this day in Hagia Sophia.[34] After the first proskynesis of the envoys in the Consistory, attendants pulled aside the curtains shielding the emperor from view.[35] After the envoys had risen for the last time, the diplomatic *honneurs* were exchanged. The lead envoy and the emperor exchanged a few words of greeting; if the envoys were Persian, the emperor enquired about his peer, the Persian ruler. The head envoy then offered the traditional gifts; the presentation, receiving, and cataloguing of such gifts took a significant amount of time and followed a precise administrative choreography.[36] Such was the initial audience.

No proper diplomatic business or negotiation was undertaken on this occasion. With the handing over of the gifts, the audience effectively ended, and the emperor promised to meet again in a few days for discussions. Upon leaving the Consistory, the envoys again performed proskynesis at the appropriate places, the imperial curtains were closed (likely after the first proskynesis), and the envoys left the room. Next, the magister gave the order *"Transfer!"*[37] With that, the decurion of the guard led the candidati out, followed by the courtiers and officials. The emperor rose and left the Consistory after everyone else had filed out, reinforcing the illusion of a perennially enthroned emperor. During the diplomatic ceremony in the presence of the envoys, he is never seen in motion—neither sitting down or rising from the throne.

It is no great challenge to identify the prima facie communicative intent behind the diplomatic audience. As the majority of known accounts attest, such elaborate ceremonial receptions for envoys and ambassadors took place "to better overawe foreign emissaries at court"; they served as "an instrument of persuasion."[38] Audrey Becker, in her study of diplomatic relations between Romans and "barbarians" in the fifth century, emphasized the key role of the imperial audience in late antique diplomacy.[39] In her persuasive view, audiences were contests of one-upmanship, moments in which hierarchies and tensions between polities became manifest and in which each side attempted to outdo the other, "de s'imposer à l'autre."[40] This hypothesis, which she applied specifically to the Western Roman Empire, can be transposed without qualification to the Eastern Roman Empire. A statement by Franz Alto Bauer applies to all embassies, but perhaps especially for those described in the *Book of Ceremonies* and Corippus: "The

32 *Book of Ceremonies* 1.89 (ed. Reiske, 406).

33 Cf. B. Adamik, "Zur Problematik der lateinischsprachigen Bevölkerung in Konstantinopel: Das Zeugnis der lateinischen Texte in dem Werk *De cerimoniis aulae Byzantinae* des Kaisers Konstantin VII. Porphyrogennetos," in *Latin vulgaire–latin tardif VI: Actes du VIᵉ colloque international sur le latin vulgaire et tardif, Helsinki, 29 août–2 septembre 2000,* ed. H. Solin, M. Leiwo, and H. Hallo-Aho (Hildesheim, 2003), 201–18, esp. 212.

34 *Book of Ceremonies* 1.89 (ed. Reiske, 406): πορφυροῦν μάρμαρον. For similar floor markings, see P. Schreiner, "Omphalion und Rota Porphyretica: Zum Kaiserzeremoniell in Konstantinopel und Rom," in *Byzance et les Slaves: Mélanges Ivan Dujcev* (Paris, 1979), 401–10. In Corippus's description, the floors and walls are covered with textiles (carpets and wall hangings): Corippus, *In Praise of Emperor Justin* 3.10–19. This may signify an alternative decorative pattern, but it is equally possible that the carpets did not cover the whole interior of the Consistory. Cf. *Book of Ceremonies* 2.15 (ed. Reiske, 571–74), for later audiences in the Magnaura. The *Book of Ceremonies* provides a detailed list of decorative and functional elements such as *polykandela.*

35 Corippus, *In Praise of Emperor Justin* 3.252–64.

36 *Book of Ceremonies* 1.89 (ed. Reiske, 407).

37 The Lipsiensis has "STRANFER" in Latin letters; a scholion explains the meaning of the by-then unknown order in Greek: *Book of Ceremonies* 1.89 (ed. Reiske, 407).

38 E. Luttwak, *The Grand Strategy of the Byzantine Empire* (Cambridge, MA, 2009), 125.

39 Becker, *Relations diplomatiques,* 167.

40 Becker, *Relations diplomatiques,* 166.

display, but even more the limited granting of a part of imperial ceremonial goods . . . showed the emperor's resources, created the illusion of never-ending wealth, and strengthened the spiritual orientation towards Byzantium."[41]

Firsthand accounts survive from a tenth-century emissary to the court in Constantinople that offer important, if indirect, insight into the purpose of the audience ceremonial from the perspective of its principal addressee—the envoy himself. Liudprand of Cremona was the emissary first of Berengar of Italy and then of Otto I to the emperors Constantine VII, Nikephoros Phokas (r. 963–969), and John Tzimiskes (r. 969–976), and in his historical narratives (the *Antapodosis* and the *Relatio de legationis Constantinopolitana*), he provides an on-the-ground perspective. Liudprand, to be sure, is a late source in the context of the present study, and one must treat the information proffered by him with due care.[42] Not only had the ceremonies he describes changed markedly from those of the sixth century, but so had the buildings of the palace, the relationship between Byzantium and the former *pars occidentalis* of the empire, and, indeed, the empire over which the emperors on the Bosporus presided. It is apparent from his account, however, that contemporary diplomatic protocol, while certainly different and more elaborate and theatrical, remained structurally similar to that of the sixth century. His wonder at the ceremony and the splendor of the surroundings can still be felt in his account, though he did his level best not to embarrass himself in front of the emperor, and certainly not in the minds of his readers.

As a shrewd diplomat, Liudprand had inquired among other envoys about the details of the ceremony. Having been forewarned, he adopted an attitude of ostentatious nonchalance in his report, emphasizing that he was "not moved by either terror or admiration" (*nullo . . . terrore, nulla admiratione commotus*) at the reception.[43] It seems apparent that the purpose of the entire ceremony in the sixth century as well as in the tenth was to evoke precisely these emotions: terror and

fear of the power and majesty of emperor and empire accompanied by admiration and astonishment at the splendor and wealth of the court.[44] Both sets of emotions, which the theatrical staging and the exuberant pomp of the ceremony were in aid of, served the narrative of the civilizational superiority of the Roman state. Corippus, presenting the quasi-official view of the court, compares the Avar envoys of 565 to the animals being herded into the arena during a *venatio*—impressed by the splendor of the palace, cowed by the presence of splendid palace guards, and in awe of the assembled officials and courtiers watching them.[45] Moreover, this comparison also plays into the trope of Roman civilizational superiority, for the envoys were like wild animals, literally brought to their knees before the majesty of the Roman people, personified by the emperor.

The physical setting that the envoys encountered during such embassies must have indeed been intimidating, both by virtue of the décor and the pomp and circumstance, but also, and perhaps more tangibly, by the large number of armed bodyguards and soldiers, whose presence is attested in the *Book of Ceremonies* and whose effects on the envoys Corippus dramatically describes in his panegyric. In the palace, emissaries were

41 Bauer, "Potentieller Besitz," 164.

42 Pfeilschifter, *Kaiser und Konstantinopel*, 87–91.

43 Liudprand of Cremona, *Antapodosis* 6.5 (P. Chiesa, ed., *Liutprandi Cremonensis Opera Omnia*, CCCM 156 [Turnhout, 1998]). The exact date of his first embassy is still debated, with proposals ranging from 947 to 950, but his second sojourn was in 968.

44 Cf. the telling reasoning behind the compilation of the *Book of Ceremonies* by Constantine VII, as expressed in the preface of book 2: Constantine ordered the compilation in order to make the emperorship seem more "imperial" and awe inspiring (τὴν μὲν βασιλείαν ταύτῃ βασιλικωτέραν καὶ φωβερωτέραν ἀποδεικνύντες). This is also what drove such technological marvels as the Throne of Solomon, or the hydraulic menagerie in the throne room famously described by Liudprand, *Antapodosis* 6.5 (ed. Chiesa) and for which there is no late antique equivalent. On the hydraulic automata, see G. Brett, "The Automata in the Byzantine 'Throne of Solomon,'" *Speculum* 29 (1954): 477–87; N. Maliaras, *Die Orgel im byzantinischen Hofzeremoniell des 9. und des 10. Jahrhunderts: Eine Quellenuntersuchung* (Munich, 1991), 137–79; C. Canavas, "Automaten in Byzanz: Der Thron von Magnaura," in *Automaten in Kunst und Literatur des Mittelalters und der Frühen Neuzeit*, ed. K. Grubmüller and M. Stock (Wiesbaden, 2003), 49–72. Scholars have previously been content to regard such ceremonial gimmicks as vain pretense (e.g., A. Toynbee, *Constantine Porphyrogenitus and His World* [London, 1973], 498), yet these *Verwunderungsmaschinen*, as Constantin Canavas called them, have a long tradition in monarchical contexts (e.g., H. von Hesberg, *Mechanische Kunstwerke und ihre Bedeutung für die höfische Kunst des frühen Hellenismus* [Marburg, 1987], 47–72) and an ideological dimension as well as being part of a "system of refined semiotics . . . which was open to any kind of sophisticated nuances in order to express meaningful variations of the political atmosphere" (Tinnefeld, "Ceremonies for Foreign Ambassadors," 213).

45 Corippus, *In Praise of Emperor Justin* 3.245–54.

also surrounded at all times by court officials and dignitaries, who appeared in full court regalia. How could they not be impressed? Even if the caustic judgment of the sixth-century historian Agathias, who derides the palace guards as civilians in splendid uniforms, is perhaps exaggerated, the representative aspect of these bodyguards would have been as important on such occasions as the physical protection of the emperor. The guards served to heighten the splendor of the ceremony and the strength of Roman arms, "to emphasize the pomp and imperial majesty when performed in public," as Agathias wrote, and to demonstrate the sheer number of servants to which the emperor had recourse.[46] Corippus described the scene as follows:

> By the command of the ruler all the leaders were summoned, every troop [*schola*] of the palace was ordered to take up its position. And now in fixed order the throng of *decani, cursores, agentes in rebus* and with them the white band [*candidate*] with the palatine *tribuni* and the troop of protectors under the control of their *magister*, and all the strength of the holy officials was there, in different uniforms, clothing, dress and appearance.[47]

Corippus's account further emphasizes this show of strength when sketching the preparations for the audience, emphasizing the physical appearance of the participants, especially the bodyguards. In the fourth century, the military writer Vegetius had recommended that attention be paid to the appearance of soldiers and had maintained that the pageantry of arms could serve to inspire great fear (*terror*) in enemies, a commonplace reiterated in the sixth/seventh-century *Strategikon* of Maurice.[48] Indeed, glittering bodyguards, resplendent in

arms and armor, are a frequent trope in late antique literature that touches upon the figure of the emperor. One finds them in Ammianus's description of Constantius's *adventus* into Rome in 357, in Claudian's panegyrics on Rufinus and Honorius, and in the speeches of Themistius and Synesius.[49] Their massed appearance during the audience ceremony itself is terrifying in Corippus's account: the guards posted at the entrance to the Great Consistory are both numerous and standing closely pressed (*condensi numeris*) and "terrible" (*tremendus*) in their contempt and in their gestures (*fastu nutuque*).[50] The interaction of envoys and bodyguards was not limited to the audience itself. According to Corippus, different units of the bodyguards were stationed as espaliers through which the envoys had to pass throughout their progress in the palace:

> The great excubitors who guard the sacred palace were gathered close together in the long porticoes from the very gate and protected right hand and left like a wall, linking their golden shields with their upright javelins. Their sides girded with swords, their legs gripped by boots, they stood, of equal height and glittering equally . . . as leafy oaks. . . . On the left and the right, you could see lines of soldiers standing and glittering in the double light of their double-headed axes, matched in terrible ferocity.[51]

46 Agathias, *History* 5.15.2 (B. G. Niebuhr, ed., *Agathiae Myrinaei Historiarum libri quinque*, CSHB 3 [Bonn, 1828]): ὄγκου τοῦ βασιλείου ἕνεκα καὶ τῆς ἐν ταῖς προόδοις μεγαλαυχίας ἐξευρημένοι.

47 Corippus, *In Praise of Emperor Justin* 3.157–64: *iussuque regentis / acciti proceres omnes, schola quaeque palati est / iussa suis astare locis. Iamque ordine certo / turba decanorum, cursorum, in rebus agentum, / cumque palatinis stans candida turba tribunis / et protectorum numerus mandante magistro; / omnis sacrorum vis affuit officiorum / ornatu vario cultuque habituque modoque* (trans. Cameron, *In laudem*).

48 Veg., *Mil.* 2.14.68: *plurrimum enim terroris hostibus armorum splendor importat.* Cf. Maurice, *Strategikon* 1.2.52 (G. T. Dennis, ed., *Das Strategikon des Maurikios*, CFHB 17 [Vienna, 1981]), on the

equipment of cavalrymen: οὐκ ἄτοπον δὲ καὶ χειρομάνικα σιδηρᾶ τοὺς βουκελλαρίους ἐπινοῆσαι καὶ μικρὰ τουφία κατὰ τῶν ὀπισθελίνων καὶ ἀντελίνων τῶν ἵππων, καὶ φλάμουλα μικρὰ ἐπάνω τῶν ζαβῶν κατὰ τῶν ὤμων. Ὅσον γὰρ εὔσχημος ἐν τῇ ὁπλίσει ὁ στρατιώτης ἐστίν, τοσοῦτον καὶ αὐτῷ προθυμία προσγίνεται καὶ τοῖς ἐχτροῖς δειλία. G. T. Dennis, trans., *Maurice's Strategikon: Handbook of Byzantine Military Strategy* (Philadelphia, 1984), 12: "It is not a bad idea for the bucellary troops to make use of iron gauntlets and small tassels hanging from the back straps and the breast straps of the horses, as well as small pennons hanging from their own shoulders over the coats of mail. For the more handsome the soldier is in his armament, the more confidence he gains in himself and the more fear he inspired in the enemy."

49 Amm. Marc. 16.10.6–8; Claudian, *In Ruf.* 2.355–65; and *III Cons. Hon.* 134–42; Them. *Or.* 1.1–2. Synesius, *On Royalty* 16.6 (J. Lamoureux, ed., *Synésios de Cyrène*, vol. 5, *Opuscules II*, trans. N. Aujoulat [Paris, 2008]).

50 Corippus, *In Praise of Emperor Justin* 3.207–9: *custodes ardua servant / limina et indignis intrare volentibus obstant / condense numeris, fastu nutuque tremendi.*

51 Corippus, *In Praise of Emperor Justin* 3.165–79: *Ingens excubitus divina palatia servans / porticibus longis porta condensus ab ipsa, / murorum in morem laevam dextramque tegebat, / scuta sub erectis*

In the Consistory, the envoys were surrounded by members of a different guard, the candidati.[52] The description of the bodyguards during the ceremony itself then takes up these same elements: "They saw the tall men standing there, the golden shields, and looked up at their gold javelins as they glittered with their long iron tips and at the gilded helmet tops and red crests. They shuddered at the sight of the lances and cruel axes."[53]

The suitably cowed steppe emissaries, Corippus goes on to say, with their outlandish dress and long hair plaited and tied with ribbons—the very model of the warlike and uncultured "barbarian" having arrived in the glittering imperial city—saw the splendid buildings of the palace and the courtiers in their fineries and also took in "the other wonders of the brilliant ceremony and believed that the Roman palace was another heaven."[54]

Empire as Performance Art

In 2004 Liz James argued that an important part of Byzantine art, ritual, and aesthetics—the synesthetic interplay of senses, particularly in religious contexts—had been overlooked by the Western philosophical view emphasizing sight (with hearing a distant second) over the other senses, which were relegated to "base and corporeal" body functions.[55] It must be added that ceremonial contexts have suffered the same type of neglect. Like religious worship, imperial ceremonial was not exclusively experienced through sight; it was also heard, smelled, felt, touched, tasted, and otherwise experienced on many different levels. Ceremony, to paraphrase James, badgered all the senses of the participants into engaging with it and its underlying ideas. The interplay of sensory experience and ideological framework transformed political ritual into an imperial "liturgy" and turned imperial representational buildings into quasi-religious places of worship.[56] To understand this overwhelming sensory and aesthetic impression requires reconstructing and analyzing ceremonies from a holistic point of view, incorporating visual, auditory, tactile, and olfactory elements as well as their interplay in the thoughts and minds of the participants with the ideological framework in which such ceremonies were developed and performed. This synesthetic composition, together with the physical experience and performance of ceremonies, is what makes them such a distinct category, differentiating them from imperial monumental art and portraiture. They are not a static representation of an ideology, or even a "living image of the imperial idea," as they have recently been described, but its enactment, its performance.[57] This distinction sounds trivial, though it is anything but.

Studies in ritual practices have shown that participation in physical performances of power, in ceremonies, has a noticeable effect on the participants: it can lead them to internalize the ideology expressed in the ceremony and to acquiesce in the ideas of order and hierarchy that they present. "Doing is believing," as Barbara Myerhoff put it in her discussion of secular ritual.[58] To illustrate this point, kneeling before another

coniungens aurea pilis. / Ense latus cincti, praestricti crura cothurnis, / astabant celsi pariter pariterque nitebant / extantes latis umeris durisque lacertis: / coniferae . . . quercus . . . / Et laeva dextraque acies astare videres / multaque ancipites splendescere luce bipennes, / terribili feritate pares (trans. Cameron, *In laudem*, modified). The text is uncertain at lines 178–79, and the connection between *anceps* (sing.) and *bipennum* (pl.) is not evident. Both Antès, *Éloge,* and Ramírez de Verger, ed., *Flavio Cresconio Coripo: El Panegírico de Justino II* (Sevilla, 1985), have *bipennes*; Cameron emends to *bipennum* (p. 106) and translates lines 178–79 as "standing and glittering in the glancing light of their axes."

52 On the various corps of late antique and Byzantine bodyguards, see R. I. Frank, *Scholae Palatinae: The Palace Guards of the Later Roman Empire* (Rome, 1969); J. F. Haldon, *Byzantine Praetorians: An Administrative, Institutional and Social Survey of the Opsikion and Tagmata, c. 580–900* (Bonn, 1984). Christina de Rentiis, at the University of Rostock, is preparing a new and systematic analysis.

53 Corippus, *In Praise of Emperor Justin* 3.239–42: *ingentes astare viros. Scuta aurea cernunt, / pilaque suspiciunt alto splendentia ferro / aurea et auratos conos cristasque rubentes. / Horrescunt lanceas saevasque instare secures* (trans. Cameron, *In laudem*).

54 Corippus, *In Praise of Emperor Justin* 3.243–44: *ceteraque egregiae spectant miracula pompae / et credunt aliud Romana palatia caelum* (trans. Cameron, *In laudem*). On the appearance of Avar delegates, see Theophanes, *Chronicle* AM 6050 (ed. De Boor 232), and *Anth. Graec.* 16.72.

55 L. James, "Senses and Sensibility in Byzantium," *AH* 27 (2004): 522–37, at 525.

56 Bauer, "Potentieller Besitz," 147: "Ereignisraum einer Liturgie." Cf. H. Hunger, *Das Reich der Neuen Mitte: Der christliche Geist der byzantinischen Kultur* (Vienna, 1965), 80–81, on the subject of hymns extolling the emperor sung during ceremonies: "Für den Durchschnittsbyzantiner . . . waren die Kaiserhymnen nicht ein bloßer Bestandteil des Zeremoniells, sondern ein Stück Religion."

57 Kaldellis, *Byzantine Republic*, 168.

58 B. Meyerhoff, "We Don't Wrap Herring in a Printed Page: Fusions, Fictions and Continuity in Secular Ritual," in *Secular Ritual: A Working Definition of Ritual*, ed. S. Falk Moore and B. Meyerhoff (Assen, 1977), 199–226, esp. 223.

person to acknowledge their relative hierarchy is an alien thought to the modern reader, but it was an accepted and universal practice in premodern societies. It is thus important to correctly gauge the subliminal and subtle effect that physical gestures of submission had on those who performed (and observed) them. Modern royal protocol can serve only as a very temperate analogue; for example, the sharply executed nod of the head and curtsy of the British court seem negligible in contrast to the full body prostration expected of late Roman and Byzantine courtiers. Nevertheless, the ritual practice approach to ceremonial and ritual shows that physical practices of ritual reify ideological elements and cultural hierarchies.[59] In other words, kneeling or prostrating oneself in front of a person deemed (or accepted as) one's superior not only expresses subordination, but in a sense produces it.[60] Ceremonial thus served to buttress imperial authority by performing a late antique *consensus omnium* in a way that a painted or sculpted representation of an emperor could never do. Rituals, as Clifford Geertz observed, are stories that participants tell themselves about themselves, about their place in the order of things, a "narrative ordering of the world and . . . an agent of change."[61] In political contexts, rituals and ceremonies fulfilled a role similar to *Selbstvergewisserung*, that is, of assertation and acceptance of one's own place in an ordered world. It was "an argument, made over and over again in the insistent vocabulary of ritual, that worldly status has a cosmic base, that hierarchy is the governing principle of the universe."[62]

Given this particular facet of political ceremonies and the differences between artistic representation and performative enactment, the analysis of imperial ceremonial calls for a different tool set than analyses of, for example, imperial art and iconography. This is particularly important as ceremonies are, by their very nature, transient performances. Regardless of whether they follow a strict form or are adapted to the specific moment, they are constantly evolving, moving, and,

above all, ephemeral. We cannot observe them directly but are dependent on more or less detailed normative texts, written *ekphrases* and historiographic accounts, and rare iconographic representations, each of which includes its own biases. In that sense, too, ceremonies move before one's very eyes, as their descriptions are a function of individual authors' knowledge and experience of them as well as their own auctorial intentions.[63] Moreover, any "experience" of ceremonies through text or image has inherent fundamental limits. In some ways, it is simply a case of having to be there, as one cannot fully reproduce the overall sensory impression, which includes olfactory, acoustic, or tactile aspects, though the ancient authors tried. With almost no exceptions, Corippus's effort being one, it was not. How then should one proceed?

It is proposed here to take inspiration from methodological advances in other academic fields. In a series of articles, edited volumes, and books released over the last two decades, the Byzantine art historian Alexei Lidov pioneered a collection of concepts and theoretical frameworks that can provide historians with a methodological approach to better understand ceremonial, "focusing on the different strategies by which the divine, supernatural dimension is spatially, visually, and materially evoked in specific ritual contexts."[64] His approach is the concept of hierotopy, a term that he prefers to "sacred spaces."[65] It takes its inspiration terminologically from Foucault's concept of heterotopy—spaces like museums or ships that operate according to different sets of rules than other, regular spaces—but Lidov gives it an aesthetic meaning: hierotopies are conceived as a form of human creativity that produces a communicative space between the profane and the

59 Cf., e.g., C. Bell, *Ritual Theory, Ritual Practice* (Oxford, 1992), 197.

60 Bell, *Ritual Theory*, 100; C. Bell, *Ritual: Perspectives and Dimensions* (Oxford, 1997), 160–62.

61 Lindholmer, "Rituals of Power," 11. C. Geertz, "Deep Play: Notes on the Balinese Cockfight," *Daedalus* 101 (1972): 1–37, at 26.

62 C. Geertz, *Negara: The Theatre State in Nineteenth-Century Bali* (Princeton, 1980), 102.

63 On the methodological problems of studying historic ceremonies, see McCormick, "Analyzing Imperial Ceremonies."

64 See the summary of M. Bacci, "Sacred Spaces Versus Holy Sites: On the Limits and Advantages of a Hierotopic Approach," in *Icons of Space: Advances in Hierotopy*, ed. J. Bogdanovic (London, 2021), 16.

65 A. Lidov, "The Flying Hodegetria: The Miraculous Icons as Bearer of Sacred Space," in *The Miraculous Image in the Late Middle Ages and Renaissance,* ed. E. Thunoe and G. Wolf (Rome, 2004), 291–321; A. Lidov, "Hierotopy: The Creation of Sacred Spaces as a Form of Creativity and Subject of Cultural History," in *Hierotopy: Creation of Sacred Spaces in Byzantium and Medieval Russia,* ed. A. Lidov (Moscow, 2006), 32–58; A. Lidov, "Creating the Sacred Space: Hierotopy as a New Field of Cultural History," in *Spazi e percorsi sacri: I santuari, le vie, i corpi,* ed. L. Carnevale and C. Cremonesi (Rome, 2014), 61–89.

sacred through the synesthetic interaction of a range of material and immaterial elements, a "creative fusion of elements often centered around a relic or icon."[66] Lidov originally conceived of hierotopies primarily as a means to better understand the performative aspects of sacred milieus and especially the Orthodox Christian practice of icon veneration. By their very nature, the spiritual and even mystic elements inherent in veneration lie somewhat beyond the ken of historians, but in several case studies, Lidov has to good effect demonstrated the historical uses of his methodology, which consists of identifying and studying both material and immaterial elements of religious rituals on the same ontological plane. The material comprises, for example, the individual icon, specific topography or architectural framing, permanent and temporary decorations, participants' attire and jewelry, and sacred or otherwise important objects, while the immaterial encompasses such elements as smells, noises, tactile impressions, sights, light effects, feelings and affect, religious sentiment, and ideological background. The ensemble of all the individual elements Lidov calls a "spatial icon," that is a three-dimensional performance encompassing some or all of the elements and thus the result of a specific process of meaning creation.[67] From the point of view of the art historian, these spatial icons are rather similar in nature and conception to modern performance art.[68] Like performance art, ceremonies are performed for specific occasions (or only once), often follow a specific

set of rules and conventions, and are thus, in a sense, repetitive, but nevertheless unique in each iteration.[69]

To facilitate and understand spatial icons, Lidov assumes the existence of culture-specific ideological templates that he terms "image ideas" or "image paradigms."[70] These may be (and often are) influenced by iconographic or ideological concepts, but they are not necessarily connected to specific illustrations or texts; according to Lidov, they are instead to be understood as part of "a continuum of literary and symbolic meanings and associations." The image paradigm thus belongs to visual culture but is distinct from "iconographic devices." Of importance, although it is "visible and recognizable," it is not "formalized in any fixed state" but rather is similar to "the metaphor that loses its sense in re-telling, or in its de-construction into parts."[71] Image paradigms are thus a necessary prerequisite for a cultural understanding of rituals and ceremonies by onlookers, and as such Lidov operates in terms of *Rezeptionsästhetik*, the contention that the meaning—for instance, of a work of art, a religious ritual, or a political ceremony—is realized at the point of reception.[72] There is also the possibility of a creator—such as a master of ceremonies at court—utilizing image paradigms to create a specific spatial icon. Lidov compares such creators to film directors, manipulating and interweaving efforts to create a certain effect.[73]

Lidov illustrates his approach in a number of case studies centered on specific image paradigms, such as the

66 R. Stearn, *Historiography and Hierotopy: Palestinian Hagiography in the Sixth Century* (Piscataway, NJ, 2020), 16. Cf. N. Dennis, "Bodies in Motion: Visualizing Trinitarian Space in the Albenga Baptistery," in *Perceptions of the Body and Sacred Space in Late Antiquity and Byzantium*, ed. J. Bogdanovic (London, 2018), 124–48, at 142: "Heavenly visions can be created or divine presence projected through the material and immaterial elements of spatial design, whether physical icons of divine or saintly figures . . . or more ephemeral, sensory agents such as light, sound, scent, taste, or the effects of haptic interactions with material forms within the space."

67 A. Lidov, "Spatial Icons: A Hierotopic Approach to Byzantine Art History," in *Toward Rewriting? New Approaches to Byzantine Archaeology and Art: Proceedings of the Symposium on Byzantine Art and Archaeology, Cracow, September 8–10, 2008*, ed. P. Grotowski and S. Skrzyniarz (Warsaw, 2010), 85–100. Cf. A. Simsky, "Image-Paradigms: The Aesthetics of the Invisible," in Bogdanovic, *Icons of Space*, 29–45, at 29: "a kind of icon, which is not depicted on a flat surface in a usual way but is represented by a number of elements distributed in space."

68 This point has previously been made by James, "Senses," 524, who sees in installation art an "odd but effective parallel" to Byzantine art.

69 Lidov, "Creating the Sacred Space," 78: "[T]he imagery is created in space by dynamically changing forms and the beholder actively participates in the re-creation of the spatial imagery."

70 A. Lidov, "'Image-Paradigms' as a Category of Mediterranean Visual Culture: A Hierotopic Approach to Art History," in *Crossing Cultures: Papers of the 32nd International Congress in the History of Art* (Melbourne, 2009), 148–53. Cf. Simsky, "Image-Paradigms," 32: "If we were dealing with music, we would be talking about the theme of a musical piece. When it comes to sacred spaces, we can say that such an overall design theme is its image-paradigm."

71 Lidov, "Image-Paradigms," 149.

72 C. Martindale, *Redeeming the Text* (Cambridge, 1993), 3. Cf. H. R. Jauss, *Ästhetische Erfahrung und literarische Hermeneutik* (Frankfurt am Main, 1982); R. Warning, ed., *Rezeptionsästhetik*, 4th ed. (Munich, 1994).

73 Stearn, *Historiography and Hierotopy*, 16: "Like the film director, the hierotopic creator was a creative artist in his own right. It was his task to direct and meld not only architecture and art, but also the many visual, audio, and tactile elements that went into the differentiation of sacred space."

Heavenly Jerusalem, and their role in shaping a variety of ritual, ceremonial, and aesthetic expressions, or on individual, well-known rituals.[74] In his perhaps most poignant take, Lidov interprets the annual Byzantine rite of the Flying Hodegetria as a hierotopy. The ritual, performed every Tuesday in front of the Hodegon monastery in Constantinople, consists of the Hodegetria icon being carried in a procession until the icon seizes control of its bearers and, in turn, carries them along, flying, as it were. The image paradigm behind this ritual, according to Lidov, is the display of the Theotokos icon on the walls of Constantinople during the joint Persian-Avar siege of 626. Just as the patriarch had led a procession that included the Hodegetria around the city walls during the siege, so did the icon—miraculously carried by a single man despite its very heavy weight—lead its bearer around the marketplace in front of the Hodegon, thereby creating a sacred place in an analogy of the city space.[75] His holistic approach, designed to identify and analyze the constitutive elements of what, in the case of the Hodegetria, is at its core a religious enactment, and to integrate the interplay of these elements into an analytical framework, allows one to grasp not only the overall ideological-religious meaning of the ritual, but also its effects. In Lidov's view, the mysticism of religious rituals centered on icons is an irruption of the sacred into the profane realm made possible by the synesthetic experiences of ritual actions and interactions channeled through the icon itself. In several subsequent case studies, Lidov further showed that this framework could function as a heuristic and analytical tool to better grasp those elements of ritual that elude modern rational preconceptions.

This framework can also be applied as a useful *instrumentum studiorum* to imperial, political ritual, which has so far been studied only from more

circumspect points of view—as pure representations of ideology, as farcical political theater, or, in the case of audiences for foreign envoys, as enactments of diplomatic antagonism. The nature, ideological background, and religious and spiritual connotations of ceremonial, moreover, have long been subject to rationalist reservations. By contrast, as Averil Cameron pointed out a long time ago, one consequence of official Roman imperial ideology as propagated by the court in a variety of media was to see the ruler as the visible image of God on earth, as an *omnipotentis imago*. This necessarily implied communication, or "movement," between the sacred and the profane; this movement is a core element of late Roman and Byzantine ceremonial.[76] In fact, to aid this "movement," imperial audience ceremonial consists of a complex interplay of material conditions, synesthetic effects, and performative acts aimed at reproducing a specific image paradigm in the shape of a spatial icon that is visible, audible, smellable, experienceable, and centered on the emperor.

Ceremonial as Hierotopy: A Second Reading

Returning to Corippus's striking turn of phrase about the imperial palace, it is impossible to know whether "another heaven" was indeed the impression that formed in the minds of the Avar envoys. Of course, it is Corippus speaking, not them, but his choice of words is hardly accidental. In his clipped formulation, one can identify the main image paradigm that informed the audience ceremony—that of the Heavenly Jerusalem and, specifically, the Heavenly Court. That a close relationship existed between earthly and heavenly courts in the late Roman and Byzantine *imaginaire* is hardly a novel idea.[77] For the late Roman and Byzantine court in particular, the sources going back to the Christian political theory of Eusebius of Caesarea are replete with

74 A. Lidov, ed., *New Jerusalems: Hierotopy and Iconography of Sacred Spaces* (Moscow, 2009). For similar approaches, see M. C. Carile, "Imperial Palaces and Heavenly Jerusalem: Real and Ideal Palaces in Late Antiquity," in Lidov, *New Jerusalems*, 78–102; M. C. Carile, *The Vision of the Palace of the Byzantine Emperors as a Heavenly Jerusalem* (Spoleto, 2012); M. Savage, "Building Heavenly Jerusalem: Thoughts on Imperial and Aristocratic Construction in Constantinople in the 9th and 10th Centuries," in *Byzantium in Dialogue with the Mediterranean: History and Heritage*, ed. D. Slootjes and M. Verhoeven (Leiden, 2019), 67–90.

75 Lidov "Flying Hodegetria"; A. Lidov, "Spatial Icons: The Miraculous Performance of the Hodegetria of Constantinople," in Lidov, *Hierotopy*, 349–72.

76 Av. Cameron, "The Construction of Court Ritual: The Byzantine Book of Ceremonies," in *Rituals of Royalty: Power and Ceremonial in Traditional Societies*, ed. D. Cannadine and S. Price (Cambridge, 1987), 106–36, esp. at 112: a "movement, whether real or symbolic, between sacred and profane contexts." Cf. Corippus, *In Praise of Emperor Justin* 2.428, on the relationship between God and the emperor: *ille est Omnipotens, hic Omnipotentis imago.*

77 See, for instance, Treitinger, *Reichsidee*, passim, but esp. 124–28, for *christomimesis*, and 214–15; Hunger, *Neuen Mitte*, chap. 2; and H. Maguire, "The Heavenly Court," in *Byzantine Court Culture from 829 to 1204*, ed. H. Maguire (Washington, DC, 1997), 247–58.

analogies or similes drawing on that very connection.[78] For instance, writing in the first half of the sixth century, Agapetus explained the following in *Advice to the Emperor Justinian*:

> [Y]ou have a dignity beyond all other, honour, Emperor—beyond all others—God, who dignified you. For it was in the likeness of the Heavenly Kingdom that He [God] gave you the sceptre of earthly rule that you might teach men the protection of justice and drive away the howling of those who rave against it, just as you are ruled by the laws of justice and rule lawfully those subject to you.[79]

Scholarship, particularly in the realm of Romano-Byzantine art, literature, and panegyrics, has long emphasized the importance of the idea of an emperor as the functional equivalent of the Christian God, who "dignified" and appointed the earthly ruler.[80] The same idea could also be heard among the acclamations shouted by the crowd and factions in the Hippodrome after the death of Leo I (r. 457–474): "Oh, Heavenly Emperor! Give us an earthly one!"[81] In addition, none other than Constantine VII himself expresses the clear idea of the connection between earthly ceremonial and heavenly order in his preface to the *Book of Ceremonies*:

> Perhaps this undertaking seems superfluous to others who do not have as great a concern for what is necessary, but it is particularly dear to us and highly desirable and more relevant than anything else because through praiseworthy ceremonies [ἐπαινετῆς τάξεως][82] the imperial

78 See also the paired texts by Ps.-Dionysios on *The Celestial Hierarchies* and *The Ecclesiastical Hierarchies* (G. Heil and A. M. Ritter, ed., *Pseudo-Dionysius Areopagita: De Coelesti Hierarchia, De Ecclesiastica Hierarchia, De Mystica Theologia, Epistula 2*, rev. ed., PTS 67 [Berlin, 2012]) for a similar model in the church establishment and cf. W. T. Woodfin, *The Embodied Icon: Liturgical Vestments and Sacramental Power in Byzantium* (Oxford, 2012), 178–200; R. Cormack, "The Emperor at St. Sophia: Viewer and Viewed," in *Byzance et les images: Cycle de conférences organisé au musée du Louvre par le service culturel du 5 octobre au 7 décembre 1992*, ed. A. Guillou and J. Durand (Paris, 1994), 223–53; esp. 234; Maguire, "Heavenly Court"; A. Eastmond, "The Heavenly Court, Courtly Ceremony, and the Great Byzantine Ivory Triptychs of the Tenth Century," *DOP* 69 (2015): 71–114. Kaldellis, *Byzantine Republic*, 167–98, has rightly criticized scholars' dependence on the theocratic conception of Byzantium, based allegedly on Eusebius, as a model for explaining politics and administration. In interpreting ceremonies, which are a performance of ideology, however, ideas first expressed by Eusebius about Christian emperors and held on to by scholars since Norman Baynes's 1934 article remain relevant explanatory factors.

79 Agapetus, *Advice* (R. Riedinger, ed., *Agapetos Diakonos: Der Fürstenspiegel des Kaisers Justinianos* [Athens, 1995], 26): τιμῆς ἁπάσης ὑπέρετερον ἔχων ἀξίωνα, βασιλεῦ, τιμᾷς ὑπὲρ ἅπαντας τὸν τούτον σε ἀξιώσαντα θεόν, ὅτι καὶ καθ᾽ ὁμοίωσιν τῆς ἐπουρανίου βασιλείας ἐδωκέ σοι τὸ σκῆπτρον τῆς ἐπιγείου δυναστείας, ἵνα τοὺς ἀνθρώπους διδάξῃς τὴν τοῦ δικαίου φυλακὴν καὶ τῶν κατ᾽ αὐτοῦλυσσώντων ἐκδιώξῃς τὴν ὑλακὴν ὑπὸ τῶν αὐτοῦ βασιλευόμενος νόμων καὶ τῶν ὑπὸ σὲ βασιλεύων ἐννόμως; for the English, P. N. Bell, trans., *Three Political Voices from the Age of Justinian*, TTH 52 [Liverpool, 2009], 99). Perhaps the most unequivocal statement of this imperial idea of Byzantium can be found in Michael Psellos's oration to Constantine IX Monomachos: "What the Creator is in relation to you, this you may be in relation to us." Quoted in Maguire, "Heavenly Court," 247 n. 2. For a modern translation and commentary of the panegyric, see S. Lüthi, "Michael Psellos, Panégyrique 1: Traduction princeps et commentaire," *Byzantion* 77 (2007): 501–65.

80 A. Grabar, *Christian Iconography: A Study of Its Origins* (Princeton, 1968), 79, held that depictions of the heavenly court were based on similar images of the imperial family, and C. Mango, *Byzantium: The Empire of New Rome* (New York, 1980), 151–58, likewise agreed that the heavenly court was conceived as a mirror of the Byzantine court. For the imperial image itself, see A. Grabar, *L'empereur dans l'art byzantine* (Paris, 1936); A. Walker, *The Emperor and the World: Exotic Elements and the Imaging of Middle Byzantine Imperial Power, Ninth to Thirteenth Centuries C.E.* (Cambridge, 2012); M. C. Carile, "Imperial Icons in Late Antiquity and Byzantium: The Iconic Image of the Emperor between Representation and Presence," *Ikon* 9 (2016): 75–98; M. Studer-Karlen, "The Emperor's Image in Byzantium: Perceptions and Functions," in *Meanings and Functions of the Ruler's Image in the Mediterranean World (11th–15th Centuries)*, ed. M. Bacci and M. Studer-Karlen (Leiden, 2022), 134–71. Contra, T. Mathews, *The Clash of Gods: A Reinterpretation of Early Christian Art* (Princeton, 1999). More recently, K. Ringrose, *The Perfect Servant: Eunuchs and the Social Construction of Gender in Byzantium* (Chicago, 2003), 143, emphasized the bidirectional quality of this mirroring, asserting that "in a reciprocal way, patterns of visualizing heaven became the model for the Byzantine imperial court, and that each image reinforced the other." Similarly, Maguire, "Heavenly Court," 248, argued, "One court was an image of the other, but the mirror that did the reflecting was permeable; as in the case of Alice's mirror, it was possible for characters to pass through and come out on the other side."

81 *Book of Ceremonies* 1.92 (ed. Reiske, 419): βασιλεῦ οὐράνιε, δὸς ἡμῖν ἐπίγειον.

82 One may quibble with the translation of τάξις as "ceremony." It has been argued that there is no specific Byzantine word used for "ceremony"/"ceremonial," but I tend to disagree. Τάξις appears in the *Book of Ceremonies* in two subtly different ways. It is frequently employed in the primary sense of "arrangement" or "order,"

rule appears more beautiful and acquires more nobility and so is a cause of wonder to both foreigners and our own people. . . . The imperial power thus being conducted in measure and order, we shall depict the harmony and movement of the creator in relation to the whole, and it will appear to those subject to it to be more dignified and for this reason both sweeter and more wonderful.[83]

Imperial ceremonial in general was thus religiously charged, reflecting the official, court-propagated ideology of the emperor as the vice regent of God. There are a number of distinct elements to the particular ceremony examined here, the audience ceremonial, that are

closely connected to the idea of an imperial Heavenly Jerusalem or the Heavenly Court and that allow one to understand the spectacle of the enthroned emperor as a spatial icon in his "other heaven." They consist of the architectural setting of the audience and its décor; the synesthetic and symbolical elements of the appearance of the emperor himself; the dramatis personae of the bodyguards and courtiers. Each is examined taking into consideration the material and synesthetic, immaterial elements of the scene that constitute the imperial spatial icon—including specific sights and their visual effects, as well as the olfactory and acoustic impressions connected to the ceremony—and the most famous description of the Heavenly Jerusalem in the book of Revelation, a passage that served as inspiration for various literary approaches to the earthly/heavenly palace:[84]

And he carried me away in the spirit to a great and high mountain, and shewed me that great city, the holy Jerusalem, descending out of heaven from God, having the glory of God: and her light was like unto a stone most precious, even like a jasper stone, clear as crystal; and had a wall great and high, and had twelve gates. . . . And the building of the wall of it was of jasper: and the city was pure gold, like unto clear glass. And the foundations of the walls of the city were garnished with all manner of precious stones. The first foundation was jasper; the second, sapphire; the third, a chalcedony; the fourth, an emerald; the fifth, sardonyx; the sixth, sardius; the seventh, chrysolite; the eighth, beryl; the ninth, a topaz; the tenth, a chrysoprasus; the eleventh, a jacinth; the twelfth, an amethyst. And the twelve gates were twelve pearls; every several gate was of one pearl: and the street of the city was pure gold, as it were transparent glass. . . . And the city had no need of the sun, neither of the moon, to shine in it: for the glory of God did lighten it, and the Lamb is the light thereof.[85]

often in the context of describing the position of persons in their hierarchical ranks and topographical placement. It is also used, however, in a broader sense, akin to "ceremony"/"ceremonial" throughout the work (e.g., in conjunction with the liturgical "following"/"arrangement" (ἀκολουθία) in the heading at 1.1: Τάξις καὶ ἀκολουθία τῶν . . . προελεύσεων). Though this expanded meaning has received little comment, translating τάξις as "ceremony" follows the humanist tradition, the source of the commonly used Latin title of the work, De cerimoniis aulae byzantinae, as well as Reiske's proposed title, Περὶ βασιλείου τάξεως. Cf. the extended commentary on the term in Dagron and Flusin, De cerimoniis, 4.1:6–13. One may add that the middle Byzantine palace official in charge of ceremonial held the title of ὁ ἐπὶ τῆς καταστάσεως, and Dagron and Flusin, De cerimoniis, 4.1:476–79, convincingly argue that the lost treatise of Peter the Patrician was not entitled Περὶ πολιτικῆς, as the Suda entry (A. Adler, ed., Suidae lexicon, 5 vols. [Leipzig, 1928–38], 4.117) would have one believe, but rather Σύνταγμα τῆς τοῦ παλατίου καταστάσεως, based on a scholion to the Basilika (see Basilicorum libri LX, ed. H. J. Scheltema, N. van der Wal, and D. Holwerda [Groningen, 1988], B.VIII 2.1, no. 6). The formulation πολιτείας κατάστασις, found in Theophanes the Confessor, Chronicle AM 6024 (ed. De Boor, 181–83) in his account of the debate between the imperial herald and the Greens (Akta dia Kalopodion) under Justinian, is best translated as "the ceremonies of the state" (hesitantly by Av. Cameron, Circus Factions: Blues and Greens at Rome and Byzantium [Oxford, 1976], 252 and 320 n. 7, and without comment in C. Mango and R. Scott, trans., The Chronicle of Theophanes Confessor: Byzantine and Near Eastern History, AD 284–813 [Oxford, 1997], 278).

83 Book of Ceremonies 1, preface (ed. Reiske, 3, 5): Ἄλλοις μέν τισιν ἴσιος ἔδοξεν ἂν τουτὶ τὸ ἐγχείρημα περιττόν, οἷς οὐ τοσαύτη τῶν ἀναγκαίων φροντίς, ἡμῖν δὲ καὶ λίαν φίλον καὶ περισπούδαστον καὶ τῶν ἄλλων ἁπάντων οἰκειότερον, ἅτε διὰ τῆς ἐπαινετῆς τάξεως τῆς βασιλείου ἀρχῆς δεικνυμένης κοσμιωτέρας καί πρὸς τὸ εὐσχημονέστερον ἀνατρεχούσης καὶ διὰ τοῦτο θαυμαστῆς οὔσης ἔθνεσί τε καὶ ἡμετέροις. . . . ὑφ᾽ ὧν τοῦ βασιλείου κράτους ῥυθμῷ καὶ τάξει φερομένου, εἰκονίζοιμεν τοῦ δημιουργὸν τὴν περὶ τόδε τὸ πᾶν ἁρμονίαν καὶ κίνησιν, καθορῷτο δὲ καὶ τοῖς ὑπὸ χεῖρα σεμνοπρεπέστερον, καὶ διὰ τοῦτο ἡδύτερόν τε καὶ θαυμαστότερον (trans. Moffatt and Tall, Book of Ceremonies, modified).

84 Carile, The Vision, 173 n. 133.

85 Rev. 21:10–23: καὶ ἀπήνεγκέν με ἐν πνεύματι ἐπὶ ὄρος μέγα καὶ ὑψηλόν, καὶ ἔδειξέν μοι τὴν πόλιν τὴν ἁγίαν Ἰερουσαλὴμ καταβαίνουσαν ἐκ τοῦ οὐρανοῦ ἀπὸ τοῦ θεοῦ ἔχουσαν τὴν δόξαν τοῦ θεοῦ, ὁ φωστὴρ αὐτῆς ὅμοιος λίθῳ τιμιωτάτῳ ὡς λίθῳ ἰάσπιδι κρυσταλλίζοντι. ἔχουσα τεῖχος μέγα καὶ ὑψηλόν, ἔχουσα πυλῶνας δώδεκα . . . καὶ ἡ ἐνδώμησις τοῦ τείχους αὐτῆς ἴασπις καὶ ἡ πόλις χρυσίον καθαρὸν ὅμοιον ὑάλῳ

The Good Place

While it is true that the notion of an intrinsic link between the imperial and the divine spheres is part and parcel of late antique and Byzantine political ideology, pervading almost all forms of public display of imperial power, a qualification must be added. This link focused on a specific location, the emperor's abode, the Great Palace—the most obvious place for it to be made visible and, indeed, where it could be experienced by means other than sight—the special topographical and symbolic focus of the connection between the earthly and the divine. The emperor, enthroned in majesty, awaited those to whom he had granted an audience in his "high seat" in the palace, just as God awaited the souls of the deceased in the Heavenly Jerusalem in order to judge them. As Maria Cristina Carile has argued, based on both written sources and iconographic material, the palace was intentionally conceptualized from an early stage as the equivalent of the Heavenly Jerusalem on earth.[86] Analyzing literary concepts of the palace in works such as the *Dionysiaca* of Nonnus of Panopolis and the same author's *Paraphrasis* of the Apocalypse of John, among others, she argues persuasively in favor of such a concept having general currency in late antiquity.[87] In quasi-official ideology, the palace "represented the bridge between the earthly and the heavenly realm" and was "conceived as an epitome of the heavenly kingdom,"[88] a sentiment echoed, among others, by John Chrysostom: "Yes, for the city [the Heavenly Jerusalem] is most kingly and glorious; not as the cities with us, divided into a marketplace, and the royal courts; for there all is the court of the King."[89]

Carile's argument cannot be reproduced in detail here, but there can be little doubt of an increasing hieratization of the palace and the emperor in the centuries after Justinian, including both an increasing discursive parallelization of the emperor and Christ himself and ritual emphasis on this idea in ceremonial.[90] Carile notes,

> Therefore, the palace, as the privileged setting for the manifestation of the emperor with his court, ultimately reproduced on earth the heavenly model for the imperial court, the kingdom of God. In this representative system, as the

καθαρῷ. οἱ θεμέλιοι τοῦ τείχους τῆς πόλεως παντὶ λίθῳ τιμίῳ κεκοσμημένοι· ὁ θεμέλιος ὁ πρῶτος ἴασπις, ὁ δεύτερος σάπφιρος, ὁ τρίτος χαλκηδών, ὁ τέταρτος σμάραγδος, ὁ πέμπτος σαρδόνυξ, ὁ ἕκτος σάρδιον, ὁ ἕβδομος χρυσόλιθος, ὁ ὄγδοος βήρυλλος, ὁ ἔνατος τοπάζιον, ὁ δέκατος χρυσόπρασος, ὁ ἑνδέκατος ὑάκινθος, ὁ δωδέκατος ἀμέθυστος, καὶ οἱ δώδεκα πυλῶνες δώδεκα μαργαρῖται, ἀνὰ εἷς ἕκαστος τῶν πυλώνων ἦν ἐξ ἑνὸς μαργαρίτου. καὶ ἡ πλατεῖα τῆς πόλεως χρυσίον καθαρὸν ὡς ὕαλος διαυγής. . . . καὶ ἡ πόλις οὐ χρείαν ἔχει τοῦ ἡλίου οὐδὲ τῆς σελήνης ἵνα φαίνωσιν αὐτῇ, ἡ γὰρ δόξα τοῦ θεοῦ ἐφώτισεν αὐτήν, καὶ ὁ λύχνος αὐτῆς τὸ ἀρνίον (trans. King James Version, hereafter KJV). The canonicity of the book of Revelation was disputed in late antiquity (e.g., Eusebius, *Ecclesiastical History* 3.25), particularly in the Greek-speaking East, and its canonical status in the Chalcedonian (modern Orthodox) Church was only finally cemented in the middle and late Byzantine eras. Particularly problematic in ideological terms was the strong anti-imperial slant of the text, written during a time of Christian persecution in the first century CE. As stated in S. J. Shoemaker, "The Afterlife of the Apocalypse of John in Byzantium," in *The New Testament in Byzantium*, ed. D. Krueger and R. S. Nelson (Washington, DC, 2016), 301–16, esp. at 306, "[S]uch ideas would be difficult to reconcile with the drastically changed political circumstances of the Byzantine period, when Rome and its emperors were no longer enemies of the church but instead had become (theoretically, at least) its pious and divinely appointed protectors." In terms of Lidov's image paradigm theory, however, the specific text of Revelation and the question of its acceptance or popularity need not be of concern here; image paradigms are not based on single, specific texts or archetypes, but on part of a continuum of ideas (Lidov, "Image-Paradigms"). Revelation may be the most well-known expression of the image paradigm of the Heavenly Jerusalem, but it was not the only one.

86 Carile, *The Vision*; Carile, "Imperial Palaces"; and for shorter elaborations on the same theme, Carile, "The Imperial Palace Glittering with Light: The Material and Immaterial in the Sacrum Palatium," in *Hierotopy of Light and Fire in the Culture of the Byzantine World*, ed. A. Lidov (Moscow, 2013), 105–35.

87 Carile, *The Vision*, 27–48. Conversely, in the seventh century *Life of Martha*, mother of Symeon the Stylite the Younger, the Heavenly Jerusalem is a "succession of ever more luxurious palaces at ever higher levels of Paradise" (Savage, "Building Heavenly Jerusalem," 72, and also see passim; cf. *La Vie de sainte Marthe mère de S. Syméon stylite le Jeune* 16–18, in P. van den Ven, ed., *La vie ancienne de S. Syméon Stylite le Jeune [521–592]* [Brussels, 1970], 2:265–67). In the fourth century Coptic *Life of Apa Matthaeus the Poor*, Heavenly Jerusalem appears as a palace with gates and halls (cf. Carile, *The Vision*, 43, with n. 101; for the text, see W. C. Till, ed., *Koptische Heiligen- und Märtyrerlegenden*, vol. 2 [Rome, 1936], 5–27). In Byzantine tradition, the Kingdom of Heaven, imagined as a Heavenly Jerusalem, was an "improved, purified, and infinitely successful version of the Basileus's earthly kingdom": P. Alexander, "The Strength of Empire and Capital as Seen through Byzantine Eyes," *Speculum* 37 (1962): 339–57, at 344.

88 Carile, *The Vision*, 24; 25.

89 John Chrysostom, *Homily in Matthew* 1.71 (PG 57:23): Καὶ γὰρ ἔστι βασιλικωτάτη ἥ πόλις καὶ περιφανής· οὐχ ὥσπερ αἱ παρ᾽ ἡμῖν, εἰς ἀγορὰν καὶ βασίλεια διῃρημένη· ἀλλὰ πάντα βασίλεια τὰ ἔχει.

90 Carile, *The Vision*, 171–75.

earthly order reproduced the heavenly order, so too did the palace with its architecture and decoration reproduce the heavenly kingdom of God, the Heavenly Jerusalem, on earth.[91]

While the parallelization reached its logical extremes only in later centuries, the essential elements, both architectural and decorative as well as ceremonial, were already in place in the sixth century.[92] Mischa Meier, following on a remark by Averil Cameron, called this process "liturgification."[93] The sacralization of the emperor, he argued, was an epiphenomenon of this process, a "heightened religious charging and semantization of all socially relevant spheres" that was particularly actively pursued under Justinian but also played a role as early as the fifth century, such as in the emphasized ceremonial piety of emperors, among them Arcadius and Thedosius II.[94] In the seventh-century *Tales* of Anastasius of Sinai, a dead emperor's ascension to heaven is imagined as a procession into an imperial palace.[95] It is thus hardly surprising that the emperor's house also had to undergo a corresponding sacralization, which, moreover, it had already had *in nuce* since the beginning of the emperorship. This included infusing the architecture of the palace with religious motifs, the construction of chapels and churches, inter alia, to house the ever-growing collection of precious relics on the palace grounds.[96]

Carile contends that parts of the architecture and decoration of Constantinople's Great Palace may have been consciously modeled to evoke a heavenly image based on her analysis of visual depictions of imperial and heavenly palaces in places such as the Thessaloniki Rotunda, the apse mosaic of Santa Pudenziana in Rome, and the mosaics of Sant'Apollinare Nuovo in Ravenna and also on her readings of descriptions of the palace in Constantinople. She asserts that the glittering, shining quality of palace architecture, a ubiquitous trope in the sources, was a material reality rather than a mere literary convention.[97] Some buildings, including the Chalkê, the Consistory, and later the Chrysotriklinos, were all furnished with polished roof tiles of gold or gilded bronze in a conscious effort to make the palace appear in an almost supernatural light.[98] The roofs reflected a bright, golden light to transform the palace into a highly visible beacon during the day and, possibly, during the night as well, when moonlight or the light from the nearby lighthouse would be reflected.[99] Pervasive mosaic decorations, burnished marble revetments, and exterior water pools and fountains would have lent daylight in the palace courts that glittering or rippling quality of which so many of our sources speak. The same effect was pursued with interior decoration schemes. We know for instance that the Hall of Nineteen Couches had a gilded ceiling after the renovations of Constantine VII and there is reason to

91 Carile, *The Vision*, 176.

92 For instance, a new iconographic program in the audience hall of the Chrysotriklinos, executed under Michael III (r. 842–867), made the parallelization of the earthy and heavenly courts explicit: a mosaic of Christ hovered directly over the imperial throne, "visually conveying the power of the earthly *basileia* as derived from God and his protection of the Christian emperor": Carile, "Glittering with Light," 175.

93 M. Meier, "Liturgification and Hyper-Sacralization: The Declining Importance of Imperial Piety in Constantinople between the 6th and 7th Centuries A.D.," in *The Body of the King: The Staging of the Body of the Institutional Leader from Antiquity to Middle Ages in East and West. Proceedings of the Meeting Held in Padova, July 6th–9th, 2011*, ed. G. B. Lanfranchi and R. Rollinger (Padova, 2016), 227–46.

94 C. Kelly, "Stooping to Conquer: The Power of Imperial Humility," in *Theodosius II: Rethinking the Roman Empire in Late Antiquity*, ed. C. Kelly (Cambridge, 2013), 221–43.

95 Anastasius of Sinai, *Tales* 2.24 (A. Binggeli, ed., "Anastase le Sinaïte: 'Récits sur le Sinaï' et 'Récits utiles à l'âme': édition, traduction, commentaire" [PhD diss., Paris IV, 2001], 1:255); see P. Booth, "The Ghost of Maurice at the Court of Heraclius," *BZ* 112 (2019): 781–826, esp. 817–18.

96 Cf. Carile, *The Vision*, 171–73.

97 Carile, "Glittering with Light"; M. C. Carile, "Metafore di luce nelle architetture e nel decoro da Costantino a Costanzo II," in *L'impero costantiniano e i luoghi sacri*, ed. T. Canella (Bologna, 2016), 461–90.

98 Cf. Carile, "Glittering with Light," esp. 106–15. For the Chalkê Gate, see C. Mango, *The Brazen House: A Study of the Vestibule of the Imperial Palace of Constantinople* (Copenhagen, 1959), and cf. *Anth. Graec.* 9.656: αὐτὸς ἐμὸς σκηπτοῦχος Ἰσαυροφόνον μετὰ νίκην / χρυσοφαές μ᾽ ἐτέλεσσεν ἐδέθλιον Ἡριγενείης, / πάντη τετραπόρων ἀνέμων πεπετασμένον αὔραις, and W. R. Paton, trans., *The Greek Anthology*, vol. 3 (London, 1917), 365: "My Prince [sc. the emperor Anastasius] himself, after his victory over the Saurians, completed me, the House of the Dawn [sc. the Chalkê], shining with gold, on all sides exposed to the breezes of the four winds."

99 It is unclear when the lighthouse, the Pharos of Constantinople, was built. What is known is that a church of the Pharos was renovated after the iconoclastic period, which indicates that it existed at the least at the beginning of the eighth century.

think that this was the case earlier as well.[100] Similar gilded ceiling decorations are attested in Eusebius's *Life of Constantine* and in Claudius Mamertinus's *Speech of Thanks to Julian*.[101] Flavius Merobaudes, in his fifth-century *Carmina*, composed under Valentinian III and surviving only in a fragmentary state, describes a glittering image of the imperial couple executed in mosaics on the ceiling of the Ravenna palace, combining the ideologeme of the luminescent emperor with the sensual impression of an extant artwork:

Harmony of the table portrayed hovers over the doors, as does the sacred pair of the imperial house, where festive guests carry on eternal banquets and the royal couches are resplendent with purple coverlets. The Emperor himself in full splendor occupies with his wife the center of the ceiling, as if they were the bright stars of the heavens on high. . . . The court flourishes, after obtaining its master's beautiful offspring, and the ceiling itself, set on fire by the chariot of Phoebus and the purple of the Emperor, shines with youthful light and holds united the stars of heaven and earth.[102]

The notion of the architecture of the Great Palace expressing "the idea of a heavenly palace on earth" is also found throughout Corippus's panegyric, whether by the analogy of the palace as "another heaven," as already noted, or as "Olympus."[103] Beyond describing the pure architecture of the palace itself, Corippus dwells on its lavish decorations to make his point. He highlights the effects of lighting and reflections throughout the palace with a particular intensity; the Consistory itself "shines

with sunlight reflected by the surfaces" (*sole metallorum splendentia*).[104] It is this light symbolism that turns the palace into a supernatural place: "The imperial palace with its officials is like Olympus. Everything is as bright, everything as well ordered in its numbers, as shining with light."[105]

The most obvious parallel with the Heavenly Jerusalem, however, is that the palace shines of its own accord, by its own brilliance, without the need for an actual light source: "There is a hall deep inside the higher part of the building, shining with its own light as though exposed to the open sky, brilliant with the bright shine of glassy metal. If one can say so, it does not need the yellow sun, or else it should be called the room of the sun."[106]

This idea of a place that does not need sunlight because it is illuminated by the divine is appropriated straight from the book of Revelation: the Heavenly Jerusalem needs neither sun nor moon, as the light of God illuminates it.[107] In Constantinople, however, it is not God himself who provides supernatural light, but his representative and functional equivalent on earth: the emperor. This is a well-worn theme in later Byzantine imperial discourse, but already quite developed in late antiquity.[108]

100 Theophanes Continuatus, *Chronographia* 6.20 (I. Bekker, ed., *Theophanes Continuatus, Chronographia*, CSHB [Bonn, 1838], 449).

101 Eusebius, *Vita Constantini* 3.49; *Pan. Lat.* III (11) 11.4.

102 F. Merobaudes, *Carmina* 1.1–6: *incumbit foribus pictae Concordia mensae, / purpureique sacer sexus uterque laris, / aeternas ubi festa dapes convivia gestant, / purpureisque nitent regia fulcra toris. / ipse micans tecti medium cum coniuge princeps / lucida ceu summi possidet astra poli*; 2.1–4: *silva viret, pulchram domini sortita iuventam, / ipsaque primaevo lumine tecta nitent, / quae Foebi flammata rotis et principis ostro / aetheris ac terrae sidera mixta tenant* (F. Clover, ed. and trans., "Flavius Merobaudes: A Translation and Historical Commentary," *TAPA*, n.s., 61 [1971]: 1–78, at 11). On Merobaudes, perhaps a descendant of the fourth-century *magister militum* of the same name, see *PLRE* 1.598–99 (Merobaudes 2).

103 Carile, *The Vision*, 173.

104 Corippus, *In Praise of Emperor Justin* 3.191–93: *Atria praelargis extant altissima tectis, / sole metallorum splendentia, mira paratu, / et facie plus mira loci, cultuque superba.*

105 Corippus, *In Praise of Emperor Justin* 3.179–81: *Imitatur Olympum / officiis augusta domus: sic omnia clara, / sic numeris bene compta suis, ita luce corusca* (trans. Cameron, *In laudem*). Cf. E. Dimitriadou, "From the Great Palace to the Great Church: Art and Light in the Context of Court Ritual in Tenth-Century Constantinople," in Lidov, *Hierotopy of Light and Fire*, 147–58. See also Carile, "Glittering with Light," 174: "Everything from the wall decoration to the guards' apparel shines of gold in the throne room, the light being one of the greatest and pervasive features of the whole scene."

106 Corippus, *In Praise of Emperor Justin* 1.97–101: *Est domus interior, tectorum in parte superna, / luce sua radians, ut aperto libera caelo, / conspicuo vitrei splendens fulgore metalli. / Dicere si fas est, rutili non indiga solis / vel solis dicenda domus* (trans. Cameron, *In laudem*).

107 This is a common idea associated with divinity, as shown, for example, by the inscription of Pope Felix IV below the apse mosaic of the church of Cosma and Damian in Rome: *aula dei claris radiato speciosa metallis / in qua plus fidei lux pretiosa micat* (*ILCV* 1784.1).

108 Cf. H. P. L'Orange, *Studies on the Iconography of Cosmic Kingship in the Ancient World* (Oslo, 1953); Treitinger, *Reichsidee*, 67–71; E. H. Kantorowicz, "Oriens Augusti: Lever du Roi," *DOP* 17 (1963): 117–77; H. Hunger, *Prooimion: Elemente der byzantinischen Kaiseridee in den Arengen der Urkunden* (Vienna, 1964), 75–80;

Here Comes the Sun

Corippus describes the person of the emperor, as well as his clothes and the objects associated with him, as imbued with a supernatural luminance. Consider, for instance, the passage describing Justin changing into the imperial costume shortly before his formal accession:

> The emperor himself took off his former clothing and stood dressed only in one garment and increased the light with his royal limbs. Like when the dense cloud begins to part and the pure air shows the clear sky, the sun sends out blazing rays and all the elements rejoice together at the sight of the day. . . . He stepped out and clothed his pious limbs in a tunic, covering himself with a gilded robe in which he shone out, white all over, and gave off light and dispersed the dusky shadows though the light from the heavens had not yet fully appeared. His calves resound with the shining purple boot. . . . A shining girdle, bright with noble gems and worked gold, encircled the royal loins. . . . The *chlamys*, which was adorned with tawny gold and outdid the sun as the emperor stretched out his right hand, covered the imperial shoulders in glowing purple.[109]

Similar light references always accompany the appearance of the emperor. For instance, when Justin entered the Consistory for his audience with the Avars, Corippus prefaces his physical appearance with "a glorious light [that] shone from the inner chamber and filled all the meeting place."[110] When he appears in the Hippodrome, he is depicted as stepping out "with his own light" (*cum luce sua*).[111] The inner light of the divinely legitimized emperor is even transferred to his seat in the description of his consular procession, namely, to the magnificent *sella curulis*, decorated with gold and precious stones, which even without the sun had a "light of its own."[112] Finally, during Justin's subsequent elevation on a shield, the emperor appears to Corippus as another sun rising in the palace; an imperial light now shone from the city and in one day two suns had risen.[113] The simile of the emperor as imperial sun is also found in Merobaudes' *Carmina*; here, too, the imperial couple occupy the place of the "bright stars of the heavens." Pointedly, however, whereas the emperor is the sun, resplendent with his own light, his relatives only mirror that luminescence: "When his sister stands nearby, you would think that the shining luminary of the bright moon is glittering with her brother's light."[114] Both the ideological conceit and literary device of equating the emperor with light and the sun (or a solar deity), going back to earlier imperial and Hellenistic antecedents, were well established by the sixth century

M. Parani, "'Rise Like the Sun, the God-Inspired Kingship': Light-Symbolism and the Uses of Light in Middle and Late Byzantine Imperial Ceremonials," in Lidov, *Hierotopy of Light and Fire*, 159–84, esp. 159: "The metaphor of the Byzantine emperor as the sun, bringing warmth and light to his subjects and destructive fire to the empire's enemies, was a constant in the rhetoric of the Byzantine imperial idea."

109 Corippus, *In Praise of Emperor Justin* 2.89–120: *Cultu ipse priore / exuitur, tantumque uno vestitus amictu / constitit et lumen membris regalibus auxit. / Haud secus ut, nubes cum se rescindere densa / coeperit et caelum monstraverit aethra serenum, / ardentes radios mittit iubar. . . . / Egreditur tunicaque pios inducitur artus, / aurata se veste tegens, qua candidus omnis / enituit lumenque dedit fuscasque removit / aetherea nondum prolata luce tenebras. / Purpureo surae resonant fulgente cothurno, / . . . Nobilibus gemmis et cocto lucidus auro / balteus effulgens lumbos praecinxit heriles, / . . . Caesareos umeros ardenti murice texit / circumfusa chlamys, rutilo quae ornata metallo / principis exerta vincebat lumina dextra* (trans. Cameron, *In laudem*).

110 Corippus, *In Praise of Emperor Justin* 3.211–12: *adytis radiavit ab imis / inclita lux et consistoria tota replevit* (trans. Cameron, *In laudem*).

111 Corippus, *In Praise of Emperor Justin* 2.299 (trans. Cameron, *In laudem*).

112 Corippus, *In Praise of Emperor Justin* 4.115–16: *extabat sedes, auro gemmisque superba, / lumen habens sine sole suum* (trans. Cameron, *In laudem*).

113 Corippus, *In Praise of Emperor Justin* 2.148–50: *Astitit in clipeo princeps fortissimus illo / solis habens speciem: lux altera fulsit ab urbe. / Mirata est pariter geminos consurgere soles.* The trope of the emperor as a new sun is already well established in late antiquity: Eusebius, *De laudibus Constantini* 3.4; *Pan. Lat.* II (12) 21.5; Synesius, *On Royalty* 16.6, 26.1 (ed. Lamoureux); and Corippus, *In Praise of Emperor Justin* 2.137–58 and passim (esp. 2:149: *solis habens speciem*). Solar ideology had already begun to play an increasingly large role in imperial ideology by the third century, with Sol first appearing as a companion on coinage of the emperor Probus; e.g., *RIC* V Probus 138: SOLI INVICTO COMITI, a slogan later also adopted by Constantine (cf. *RIC* VII Sirmium 31). For later examples of imperial sun ideology in Byzantine literature, see Hunger, *Proiomion*, 75–80.

114 Merobaudes, *Carmina* 1.12–14 (ed. Clover): *cum soror adsistis, nitidae candentiae Lunae / sidera fraterna luce micare putes.* The sibling in question is Honoria, sister to Valentinian III and daughter to Galla Placidia.

and would see their ultimate apogee in later centuries.[115] Although Merobaudes and Corippus's verses are thoroughly ideologized texts, which must be read with the necessary critical distance, there is no reason to think that the light symbolism described was a purely stylistic device of the panegyrist, rather than a reflection of actual ceremonial practices. It is doubtful, certainly, whether the imperial limbs really shone with the grace and power of the sun. It is safe, however, to assume that the masters of the imperial ceremonial and of the architecture and furnishings of the imperial palace made efforts to adapt visual and tactile elements of the palace in such a way as to evoke precisely that symbolism of light. This is well established for individual imperial ceremonies in late antiquity as well as in Byzantine times. The appearance of the emperor during the chariot races in the Hippodrome, for instance, was requested and

accompanied by a prescribed set of acclamations that revolved around the exhortation Ἀνάτειλον! ("Rise up!"), an expression as closely connected to sunrise or the rise of stars as the Hippodrome was to solar cosmography.[116] Similarly, the palace was situated in a symbolic urban topography and closely associated with the imperial sun and the heavenly realm. Both the literary light symbolism *and* the actual lighting design and gold mosaics of imperial representational spaces are meant to evoke religious associations with the celestial realm, as Corippus explicitly states: "There are two wonderful things imitating the glorious sky, founded by the advice of God, the venerable temple and the glorious building of the new Sophianae. This is the hall of the emperor and this is of God."[117]

This parallelization of imperial palace and great church is all the more striking for two reasons. First, Hagia Sophia was commonly understood and described

115 Earlier examples include Caligula and Nero adopting the title or being called New Helios (Νέος Ἥλιος): for Caligula, *IGRRP²* IV 145 = *SIG* II 798; Nero, *IG* VII 2713, line 35, *IGRRP²* III 345; cf. Alföldi, *Monarchische Repräsentation*, 60, 225–26, 257–63, on the officially propagated solar cult of late third-century emperors, including Aurelian, and J. Bardill, *Constantine, Divine Emperor of the Christian Golden Age* (Cambridge, 2012), 42–125, on the attribution of a salvific luminosity of tetrarchic and Constantinian rulers in paneygrics. On solar elements in Constantinian ideology, see also I. Tantillo, "Attributi solari della figura imperial in Eusebio di Cesarea," *Mediterraneo antico* 6 (2003): 41–59; I. Tantillo, "L'impero dela luce: Riflessioni su Costantino e il sole," *MÉFRA* 115 (2003): 985–1048. Cf. Kantorowicz, "Oriens Augusti," 151: "The sun-kingship of the Byzantine emperors, therefore, was not only a residuum of Hellenistic-Roman tradition but also a reflection of the sun-kingship as represented by the Christian God." In middle Byzantine imperial ideology, the parallelism between emperor and sun was even more pronounced; e.g., Michael Psellos's panegyric to Constantine Monomachos (*Oration to Constantine Monomachos* 1.1, E. Kurtz and F. Drexl, eds., *Michaelis Pselli scripta minora*, vol. 1 [Milan, 1936], 31), opens with the striking (and multifaceted) appellation "Sun-King!" (Ὦ βασιλεῦ ἥλιε). The sun metaphor is the dominant element of the entire speech: see, e.g., lines 21, 56–57, 60–62, 99, 179, and the commentary by Lüthi, "Panégyrique," 517–24, who notes (p. 519) that the term is steeped in neo-Platonic philosophical implications as it is also the name for the highest divinity (Βασιλεὺς Ἥλιος or Ἥλιος Βασιλεὺς) in neo-Platonic thought (as, e.g., in Julian's *Hymn to King Helios*). To name but two of a plethora of possible examples, similar appellations are later used in addressing John Komnenos, such as those by Theodoros Prodromos, *Poemata* 1.1, 4.32–33, 9.21, 10.1 (W. Hörandner, ed., *Theodoros Prodromos: Historische Gedichte, Text und Kommentar*, Wiener Byzantinische Studien 11 [Vienna, 1974]), and those used by by Eustathius of Thessalonica in orations for Manuel Komnenos (E. Regel, ed., *Fontes rerum byzantinarum* I/1 [St. Petersburg, 1892], or. 1, p. 14, lines 8–18; or. 6, p. 121, lines 19–122); cf. Hunger, *Neuen Mitte*, 97–103.

116 *Book of Ceremonies* 1.68 (ed. Reiske, 316). See Rollinger, *Zeremoniell und Herrschaft*, chap. 9, and G. Dagron, "L'organisation et le déroulement des courses d'après le Livre des Cérémonies," *TM* 13 (2000): 3–200, for the ceremonies and preparations associated with the chariot races. On the cosmic symbolism of the Hippodrome, see also G. Vespignani, *Simbolismo magia e sacralità dello spazio circo* (Bologna, 1994); G. Vespignani, *ΙΠΠΟΔΡΟΜΟΣ: Il circo di Costantinopoli nuova Roma. Dalla realtà alla storiografia* (Spoleto, 2010), 67–136, and 189–248, for circus ceremonies. There is reason to think that after the disappearance of chariot races, the later Komnenian ceremony of *prokypsis* developed at least in part to replace this important element of imperial ceremonial. On the *prokypsis*, designed around light symbolism and practical lighting effects, see Pseudo-Kodinos, *On the Offices* 7.97 (J. Macrides, J. A. Munitiz, and D. Angelov, eds., *Pseudo-Kodinos and the Constantinopolitan Court: Offices and Ceremonies* [Farnham, 2013], 234–37). Cf. L'Orange, *Studies*, 110–14; Treitinger, *Reichsidee*, 67–70, 112–23; M. Jeffreys, "The Comnenian Prokypsis," *Parergon* 5 (1987): 38–53.

117 Corippus, *In Praise of Emperor Justin* 4.285–88: *inclita praeclarum duo sunt imitantia caelum, consilio fundata Dei, venerabile templum / et Sophianarum splendentia tecta novarum. / Principis haec, haec aula Dei* (trans. Cameron, *In laudem*). In later centuries, the complex interplay of solar political ideology and imperial christomimesis would be strikingly expressed in a poem by Theodoros Prodromos (*Poemata* 10.c.1–6, ed. W. Hörandner): Φωτίζου, πόλις Ῥωμαῖς, πάλιν ἐρῶ· φωτίζου, / διπλαῖς αὐγάζου ταῖς αὐγαῖς ἐκ δύο τῶν ἡλίων. / ἔχεις ἐκεῖθεν ἥλιον τὸν τῆς δικαιοσύνης, / τό τοῦ πατρὸς ἀπαύγασμα γυμνὸν ἐν Ἰορδάνῃ, / ἔχεις ἐντεῦθεν ἥλιον τὸν τῆς μονοκρατίας, / τὸν τοῦ πατρὸς διάδοχον λαμπρὸν ἐν ἀνακτόροις (Shine, Roman city, again I say: shine! Shine in the double brilliance of both suns! From thence you have the Sun of Justice, the Father's naked reflection in the Jordan; and from thence you have the Sun of Monarchy, the successor of the father, brilliant in the palace!). On the "Sun of Justice" as a common circumscription of Christ, see Lüthi, "Panégyrique," 521.

as mimicking the heavenly spheres in its architecture and aesthetics. For instance, in a contemporary kontakion, "On the earthquake and arson," composed after the Nika riots and to celebrate the construction of Justinian's Hagia Sophia, Romanos Melodos expresses this in no uncertain terms: "The building of the church itself was built with such artfulness that it imitates heaven, the Divine Throne, which offers eternal life."[118] Second, the palace that Corippus refers to as Sophianae is not the Great Palace, but an imperial resort on the Asian side of the Bosporus built by Justin II and occupied by him and his consort, Sophia, before their accession.[119] The passage thus suggests that the quasi-divine luminosity was not only associated with the Great Palace, but also with imperial palaces in general, or rather, with any building or place housing the emperor. After all, it was he who illuminated the house and not the other way around.

How was this light symbolism and solar ideology aided and furthered by actual ceremonial elements? For one, the imperial costume and insignia of late antiquity would have lent themselves to comparisons with bright stars and suns; emperors were after all clad in striking dress. When Corippus describes the imperial chlamys as "adorned with tawny gold" and that it "outdid the sun," it was no literary trope but a fairly accurate description.[120]

According to all extant late antique sources, Diocletian had been the first emperor to introduce bejeweled costume and footwear, in the late third century, and subsequent emperors only added to this imperial costume.[121] The expensive silken tunics and chlamydes of the emperor teemed with golden thread, the chlamys held fast at the right shoulder by a precious fibula with pearl *pendilia*. The diadem, probably introduced as a decorated purple band by Constantine, had developed into a jewel-encrusted, pearl-studded crown with double pendilia hanging on both sides of the face, as famously illustrated by the Justinian mosaics in Ravenna (Fig. 1).[122] The luxurious, almost decadent splendor of the imperial costume is mostly glossed over by scholars—or, alternatively, criticized as an aberration from earlier models of emperorship during the Principate—but it is worth dwelling on. Jennifer Ball has rightly pointed out the heaviness and impracticality of such dress—yards of fabric, bejeweled, and impearled from head to foot in addition to jeweled footwear and a heavy diadem more crown than headband—but the trade-off held great symbolic and ideological value.[123] The bright purple dye, prohibitively expensive and legally restricted to the emperor and his family, screamed "Imperial!"; the silks, gemstones, and pearls represented *emolumenta imperii*, originating from every corner of the Roman world (and beyond); the jewels themselves possessed an ideological charge and were imbued in the Roman and Byzantine imaginaire with apotropaic powers, medical properties, and divine-imperial connotations.[124] Closer to the point

118 Romanos Melodos, *Hymns* 54.23.7–10 (J. Grosdidier de Matons, ed., *Romanos le Mélode: Hymnes,* SC 283, vol. 5 [Paris, 1981]): ὁ οἶκος δὲ αὐτὸς ὁ τῆς ἐκκλησίας / ἐν τοσαύτῃ ἀρετῇ οἰκοδομεῖται, / ὡς τὸν οὐρανὸν μιμεῖσθαι, τὸν θεῖον θρόνον, / ὃς καὶ παρέχει ζωὴν τὴν αἰώνιον. On the kontakion (and the question of which earthquake is alluded to in the title), see the commentary in Grosdidier de Matons, *Romanos le Mélode,* 455–59. Note that the "heavenly" aspects of Hagia Sophia are (e.g., in Procopius or Paul the Silentiary) always connected with the subtle choreography of lighting effects, which again recalls the description of the Heavenly Jerusalem as a place of transcendent brightness. Cf. inter alia N. Isar, "'Χορός of Light': Vision of the Sacred in Paulus the Silentiary's Poem *Descriptio S. Sophia,*" *ByzF* 28 (2004): 215–42, and N. Schibille, *Hagia Sophia and the Byzantine Aesthetic Experience* (Farnham, 2014). For the importance of the church's aural characteristics in creating an otherworldly impression, see B. Pentcheva, "Hagia Sophia and Multisensory Aesthetics," *Gesta* 50 (2011): 93–111, and B. Pentcheva, *Hagia Sophia: Sound, Space, and Spirit in Byzantium* (University Park, PA, 2017).

119 It was there that they were informed of Justinian's passing. On the identification of the Sophianae, see Av. Cameron, "Notes on the Sophiae, the Sophianae and the Harbour of Sophia," *Byzantion* 37 (1967): 11–20.

120 Corippus, *In Praise of Emperor Justin* 2.119–20: *chlamys, rutilo quae ornata metallo / principis exerta vincebat lumina dextra.*

121 Eutr. 9.26; Aur. Vict. *Caes.* 39.2; Zonar. 12.31. See Rollinger, "These Boots," for a recent study of Diocletian's role and purpose in such ceremonial innovations and for earlier literature. For later costumes, see, e.g., Symm. *Or.* 2.1.

122 Later centuries would see the culmination of these trends in the ever-richer, ever-heavier garments of the middle Byzantine court. Cf. J. L. Ball, *Byzantine Dress: Representations of Secular Dress in Eighth- to Twelfth-Century Painting* (New York, 2005), 11–36.

123 Ball, *Byzantine Dress,* on the late antique, early Byzantine *loros,* the triumphal dress of the emperor: "Typically, the gemstones on a *loros* formed a grid of, on average, twelve rows of two large, square gemstones bordered with pearls. In one instance, representations attest to a *loros* with sixteen rows of four gemstones per row" (pp. 14–15), and "Between the *loros, stemma,* and *tzangia* the imperial couple not only carried all the empire's wealth on their shoulders but they also radiated the healthy blessings that these gems offered" (p. 15).

124 Cf. Michael Psellos, *Power of Stones* (J. M. Duffy, ed., *Michael Pselli Philosophica Minora: Concerning the Power of Stones,* vol. 1 [Leipzig, 1992]).

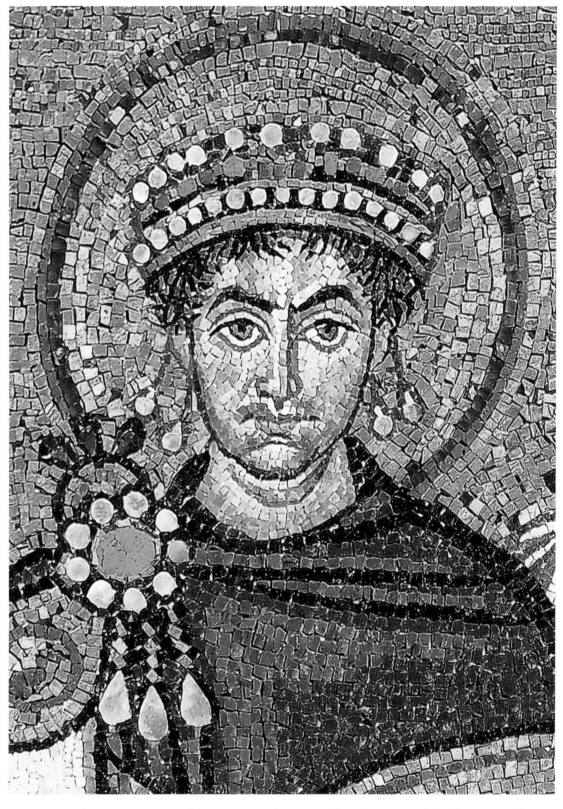

Fig. 1. Detail, Justinian, San Vitale, Ravenna, sixth century. Photo by Petar Milošević; courtesy of Wikimedia Commons.

of Corippus's sun allegory, the effect produced by these garments would have been a glittering, sparkling, almost otherworldly figure, the imperial person rippling with reflected light at every movement, both in sunlight and in the more ethereal light of candles and lamps.

During ceremonies in the Great Palace, this effect would have been reinforced by the choreography of light design and the decorative program of the ceremonial rooms. Maria Parani has studied the use of physical lighting fixtures and their effect on ceremonial for the middle Byzantine period, but unfortunately, less is known about the interior of the Great Palace in late antiquity.[125] From a chapter in the *Book of Ceremonies* describing the preparations and procedures for tenth-century audiences, for instance, one learns that much care was taken in the maintenance and use of *polykandela* and other multi-light devices.[126] Furthermore, the ninth-century *Kletorologion* of Philotheos, which provides a list of palace offices and titles as well as rules of precedence, mentions a special corps of lamplighters (κανδηλάπται) assigned to the throne room (at the time the Chrysotriklinos).[127] These are likely connected with the earlier *lampadarii*, who accompanied the emperor and other high officials during public appearances and surrounded him with various light sources, as there seems to have been a special category of "imperial lights."[128] There are scant equivalent sources for late antiquity, but it is hard to see that things would have changed fundamentally between the fourth and ninth centuries. The light fixtures used would have been more or less the same—silver and gold polykandela and oil lamps—and thus a need for a corps of lamplighters then as well.

Corippus also states, albeit without details, that the Great Palace was specially decorated on ceremonial occasions.[129] The splendor of the Constantinopolitan palace is richly attested, however, in the other sources and reflected in surviving evidence from aristocratic domus and other palatial residences: the walls, floors, and roofs were decorated with such precious metals as silver and gold, but also burnished bronze, glass tesserae, and a variety of different marbles, each with their own hue and assembled in intricate geometric patterns or floral elements. Columns were adorned with pearls, jewels, or glass paste, everything "as bright . . . as shining with light" (*sic omnia clara . . . ita luca corusca*), replicating the heavenly equivalent.[130] As for the rest of the furnishings, one is unfortunately left with conjecture and educated guesses. Not only is Corippus mostly silent on this, so are the chapters ascribed to Peter the Patrician in the *Book of Ceremonies*. That reduces the available options to mining later chapters written about audiences in the Magnaura of the tenth century but again while being mindful that these later circumstances cannot be unreservedly applied to the sixth century. It is fair, however, to assume some general parallels in terms of structural similarities. If the later chapters list carpets, embroidered and unembroidered silk curtains, special robes, chandeliers, and other ornaments of gold, silver, enamel, bronze among the necessary objects and decorations for the audiences, there would appear to be no reason to consider it much different from in earlier

125 M. Parani, "Look Like an Angel: The Attire of Eunuchs and Its Significance within the Context of Middle Byzantine Court Ceremonial," in *Court Ceremonies and Rituals of Power in Byzantium and the Medieval Mediterranean*, ed. A. Beihammer, S. Constantinou, and M. Parani (Leiden, 2013), 433–63.

126 *Book of Ceremonies* 2.15 (ed. Reiske, 570–73).

127 Philotheos, *Kleterologion* 131 (ed. Oikonomidés). Cf. Parani, *Look Like an Angel*, 161.

128 A. Hug, "Lampadarius," *RE* 12.1:569, and cf. Alföldi, *Monarchische Repräsentation*, 111–18. *Chron. Pasch.* ad a. 363 (ed. Dindorf, 551), recounts that the cubicularii of Emperor Julian hastened to the emperor's side "with the imperial lamps" (μετὰ λαμπάδων βασιλικῶν) when he was awakened by an ominous vision during his Persian campaign. Cf. John Malalas, *Chronicle* 13.23 (ed. Thurn, 256).

129 Corippus, *In Praise of Emperor Justin* 3.157: *ornata est augusta domus.*

130 See the studies collected in V. Ruppiené, ed., *Stone and Splendor: Interior Decorations in Late-Antique Palaces and Villas. Proceedings of a Workshop, Trier, 25–26 April 2019* (Wiesbaden, 2021). Echoes of such splendor survived from late antiquity into the thirteenth century, when the Frankish despoilers of Byzantium broke into its palaces, specifically the already much-reduced and smaller (compared to the Great Palace) Palace of Boukoleon, and found no better mode to describe them than one that again recalls the biblical archetype: "Within this palace . . . there were fully five hundred halls, all connected with one another and all made with gold mosaic. And in it there was one of them which was called the Holy Chapel, which was so rich and noble that there was not a hinge nor a band nor any other part such as usually made of iron that was not all of silver, and there was no column that was not of jasper or porphyry or some other rich precious stone. And the pavement of this chapel was of a white marble so smooth and clear that it seemed to be of crystal" (E. H. McNeal, ed. and trans., *The Conquest of Constantinople: Robert of Clari* [New York, 2005], chap. 82). On the Palace of Boukoleon, see C. Mango, "The Palace of Boukoleon," *CahArch* 45 (1997): 41–50.

times. Similarly, there is no a priori reason to doubt the likelihood of wall decorations (flower garlands and laurel wreaths) or the sprinkling of floors with ivy and laurel, myrtle, and rosemary or rose water as attested in the *Book of Ceremonies*.[131] The text is precise on these points in its contemporary context, down to prescribing exactly what shape the laurel wreaths and flower garlands must take, which floors should be sprinkled with laurel, which with rosemary, what kind and color of curtains should be hung in which corridors and rooms. Although it is unlikely that the precise arrangements remained unchanged after four centuries, it cannot be doubted that sixth-century ceremonial would have also involved a clean, sweet-smelling, heavily decorated and brightly lit palace.

Next to nothing is known about the architectural decoration of the Consistory. Corippus does mention in passing that the floor was richly decorated with mosaics (*pavimentum*), though more likely with multicolored marble slabs, as *pavimentum* may mean both, and covered with luxurious carpets, into which precious stones were woven. The walls were adorned, too, and one may imagine either decorative assemblages of polychromatic marble, as in the Trier Aula, or, again, mosaics, though there is no hint of any specific iconographic program.[132] Curtains—some embroidered, some unembroidered, some purple, some not—hung between door arches and columned arcades; sumptuous benches draped with fabrics ran along the walls.[133] For an approximation of the intended effects of such architectural decorations, the modern observer could do worse than look to the golden mosaics of the Rotunda at Thessaloniki: here one finds all the individual elements attested in the literary depictions of the Great Palace visualized and can experience the dazzling ensemble. The Rotunda mosaics, to be sure, are not meant to depict a

specific building or even an imperial one, but they are extrusions of the same image paradigm that also influenced the iconography of the Great Palace, namely, the Heavenly Jerusalem. Its golden columns and mosaics, the arches and walls set with emeralds and sapphires, the purple-colored curtains spanning between fixtures recall not only the Heavenly Court, but the earthly one as well. Such shimmering and glittering surroundings are a trope of sixth century and later literature, particularly of ekphrasis, but we should take them seriously: they were also a reflection of actual practice. The imperial audience, as Carile has put it, happened in just such an "amazement of bright light."[134]

There is, however, one specific and highly symbolic object within the Consistory about which there is reliable information: Justin's throne, the *sedes Augusta*, was positioned in the center of the room, surrounded by four columns that supported an orthogonal canopy that, as Corippus explicitly states, was supposed to represent the vault of heaven:

> The imperial throne ennobles the middle of the sanctum, girded with four marvelous columns, over which rests a canopy shining with abundant liquid gold, like the vault of the curving sky, and shades over the immortal head and throne of the emperor as he sits there, the throne adorned with jewels and proud with purple and gold. It had curved four bending arches into itself. A similar Victory held the right side and the left side, hanging high into the air on extended wings, stretching out in her shining right hand a crown of laurel.[135]

131 See, below, note 202.

132 For the wall decoration of the Trier aula, see V. Ruppiené, "Pavements and Revetments in the Audience Hall (Basilika) and Its Vestibule of the Late-Antique Imperial Palace in Trier (Germany)," in Ruppiené, *Stone and Splendor*, 37–54. A monograph detailing Ruppiené's striking reconstruction of the marble revetments is in preparation. As for mosaics, the only surviving archaeological evidence within the palace are those of bucolic scenes wholly unfitting for the context of the Consistory. Cf. S. Bassett, "The Great Palace Mosaic and the Image of Imperial Power," in *Mosaics of Anatolia*, ed. G. Sözen (Istanbul, 2011), 89–100.

133 Corippus, *In Praise of Emperor Justin* 3.205–7.

134 Carile, *The Vision*, 174. For the Rotunda as Heavenly Jerusalem, see Carile, *The Vision*, 49–100, and for its decorations and architecture, see H. Torp, *La Rotonde Palatine à Thessalonique: Architecture et mosaïques*, 2 vols. (Athens, 2018).

135 Corippus, *In Praise of Emperor Justin* 3.194–203: *Nobilitat medios sedes augusta penates, / quattuor eximiis circumvallata columnis, / quas super ex solido praefulgens cymbius auro / immodico, simulans convexi climata caeli, / inmortale caput soliumque sedentis obumbrat, / ornatum gemmis, auroque ostroque superbum. / Quattuor in sese nexos curvaverat arcus. / Par laevam dextramque tenens Victoria partem / altius erectis pendebat in aera pennis, / laurigeram gestans dextra fulgente coronam* (trans. Cameron, *In laudem*, modified). Here, again, the text is uncertain, and Cameron follows two conjectures: one by M. Petschenig, ed., *Flavii Cresconii Corippi Africani Grammatici quae supersunt* (Berlin, 1886), who prints *in medio* instead of *immodico* (line 197), as the Matritensis codex has it. I agree with Petschenig's

The canopy itself has an obvious cosmic connotation, representing the heavens bending over the ecumene.[136] This detailed description—the only one of the late Roman imperial throne—can be supplemented with some well-known examples of imperial and ecclesiastical art. For instance, a (roughly) contemporary depiction of the imperial throne on a famous ivory diptych now in the Kunsthistorisches Museum Wien shows either the empress Ariadne or, perhaps, Justin's wife, Sophia, seated on an imperial, canopied throne (Fig. 2).[137] The iconography matches Corippus's description: the empress is clad in an imperial chlamys, whose borders are set with pearls and jewels and that includes a *segmentum/tablion* with the portrait of the emperor, as does a sister piece of the diptych (Fig. 3), held by the

Bargello Museum, Florence.[138] An imperial diadem/ crown rests on her elaborately coiffed head, with pearl pendilia falling from it on each side. She sits on a high-backed throne decorated with jewels and pearls (*ornatum gemmis*, as Corippus described it), her feet resting on an equally ornate suppedaneum. The back of the throne rises to more than shoulder height behind her and is also decorated with precious stones. Her back is supported by a tubular pillow made from heavily decorated cloth, very likely of purple and with gold thread. Two pillars (out of four, according to Corippus) are visible, each decorated with three jeweled bands; curtains hang from a transverse curtain rod and are pulled aside, the textile wrapping around the columns.

The only difference between this visual representation in ivory and Corippus's ekphrasis are the two Victoriae holding laurel wreaths; on the ivory, they are replaced by two eagles with spread wings perching on the front columns.[139] The ivory gives no indication as to the decoration or material of the canopy, but there is a striking iconographic parallel in an illumination in the Codex Purpureus Rossanensis, a sixth- or seventh- century manuscript incorporating the gospels of Matthew and Mark. The folio in question contains two miniatures (Fig. 4): at the top, the trial of Christ before Pontius Pilate, with the Roman procurator adorned with late antique symbols of imperial authority, inter alia the throne with tubular pillow, flanked by standards with imperial portraits; and at the bottom, a scene depicting Judas's remorse and his attempt to give his 30 pieces of silver back to the Sanhedrin. The latter scene depicts the chief priest sitting in a Roman official's seat, surrounded by four columns supporting a heavily decorated segmented canopy with a golden interior and insets of colored glass or precious stones.[140]

emendation, but take *in medio* not to mean the literal center of the hall, but rather the middle of the apse, in which the throne was likely placed. The second conjecture goes back to D. R. Shackleton Bailey, "Notes on Corippus," *CPh* 50 (1955): 119–24, esp. 120, who emends *solido . . . auro* for the manuscript reading of *liquido . . . auro* (Matritensis: *lido*, corrected in a second hand to *liquido*; cf. Cameron, *In laudem*, 20). Shackleton Bailey nevertheless selects "shining with liquid gold." To Shackleton Bailey ("Notes," 120), "*liquidus* is an unusual if not unexampled epithet for solid gold," but Corippus does not mean solid gold—referring not to its materiality, but to the glittering, shining quality. Ramírez de Verger, *Flavio Cresconio Coripo*, 159, complicates the matter unnecessarily when he follows the original Matritensis writing of *lido* but emends to *Lydo auro . . . inmodico* ("abundante oro de Lidia"). On the imperial throne, see L'Orange, *Studies*, 134–35, and Treitinger, *Reichsidee*, 56–57.

136 On the symbolism and history of throne canopies, see A. Alföldi, "Die Geschichte des Throntabernakels," *La nouvelle Clio* 1–2 (1949–50): 537–66, esp. at 537: "In Wahrheit ist er ein wesentliches Kennzeichen der Bestrebung aller monarchischen Regime der Welt, den Machthaber von der übrigen Menschheit zu isolieren und ihn weit über die träge Masse der Beherrschten zu erheben"; Alföldi, *Monarchische Repräsentation*, 242–52; H. Michaelis, "Der Thronbaldachin (Zum Verständnis eines Herrschersymbols)," in *Aus der byzantinistischen Arbeit der Deutschen Demokratischen Republik II*, ed. J. Irmscher (Berlin, 1957), 110–19. For a systematic analysis of the role and form of canopies in late antique and Byzantine churches, see P. Bogdanović, *The Framing of Sacred Space: The Canopy of the Byzantine Church* (Oxford, 2017), esp. 10–45, for the literary evidence (e.g., the description of the canopy in Hagia Sophia by Paul the Silentiary, *Description of St. Sophia*, 2147–48).

137 On the Vienna ivory (Vienna, Kunsthistorisches Museum Wien, Antikensammlung, X 39), dating to the sixth century, see D. Angelova, "The Ivories of Ariadne and Ideas about Female Imperial Authority in Rome and Early Byzantium," *Gesta* 43 (2004): 1–15. For a possible identification of the empress as Sophia, rather than Ariadne, cf. A. McClanan, *Representations of Early Byzantine Empresses* (New York, 2002), 149–78.

138 The imperial portrait is difficult to make out on the Vienna ivory, but clearly visible on its sister piece in Italy (Florence, Museo Nazionale del Bargello, Collezione Riccardi, inv. no. 24 C; see also below, n. 139).

139 The Bargello diptych reproduces all of the elements of the Vienna piece, but with additional details that are not pertinent here. In both pieces, the empress holds a scepter in her hand in addition to the *globus cruciger*. The perching eagles of the Vienna ivory hold a laurel wreath in their beaks that spans the canopy.

140 Rossano, Museo Diocesano e del Codex, Codex Purpureus Rossanensis Σ (042), fol. 8r; see W. Loerke, "The Miniatures of the Trial in the Rossano Gospels," *ArtB* 43 (1961): 171–95.

Fig. 2. Diptych of Ariadne (or Sophia?).
Kunsthistorisches Museum Wien / Antikensammlung
X 39, ca. 500 CE. Photo © KHM-Museumsverband,
Vienna.

Fig. 3. Diptych of Ariadne (or Sophia?). Museo
Nazionale del Bargello / Collezioni Riccardi, Florence,
inv. 24C, ca. 500 CE. Photo by Praxinoa; courtesy of
Wikimedia Commons.

Fig. 4. (top) Illumination of Pilate's judgment of Christ; (bottom) Judas's repentance. Codex Purpureus Rossanensis Σ 043, fol. 8r, sixth century. Photo © Museo Diocesano e del Codex Rossano, Rossano / Arcidiocese di Rossano-Cariati, Italy.

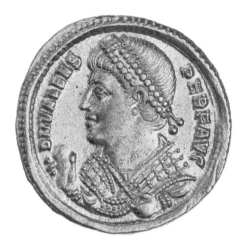 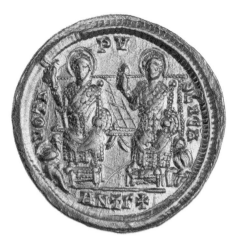

Fig. 5. Gold solidus of Valens, *RIC* IX Antioch 23B: obv.: D N VALENS – PER F AVG, with an imperial bust and pearl diadem as well as a trabea and holding a mappa and scepter; rev.: VOTA – PV-BLICA, with two emperors, Valens and Valentinian, diademed and nimbate, seated on a high-backed throne and holding a mappa and scepter, with kneeling captives at their feet. American Numismatic Society 1944.100.25294. Photo courtesy of the American Numismatic Society.

Other iconographic evidence provides additional details about the appearance of the throne. On a multitude of late antique coins from all the imperial mints, the bejeweled *sedes Augusta* often appears as a double-width throne, seating two augusti.[141] One such example is a solidus minted by Valens circa 367–375 (Fig. 5), showing the diademed bust of Valens on the obverse.[142] The reverse depicts both Valens and his brother Valentinian I, both nimbed, wearing a trabea and holding a scepter and mappa while seated on a throne set with pearls or jewels, their feet resting on ornate suppedanea. Apart from the general nature of the thrones as high-backed seats, however, there is little one can tell from these depictions; the hints of pearl encrustations and textile decorations may merely be iconographic conventions. Further evidence of gold-plated and bejeweled thrones and footrests for Roman

emperors are rare in secular iconography, but a strikingly early example is located in the so-called imperial cult chamber at Luxor, where a tetrarchic fresco depicts an imperial audience. The fresco is badly damaged, unfortunately, but one section clearly shows a purple-shod imperial foot resting on a golden and bejeweled suppedaneum (Fig. 6).[143]

The clearest visual parallels of how imperial thrones might have looked, however, come from ecclesiastical art. The motif of the empty or prepared throne, *hetoimasia* (after the Greek for "preparation"), as a symbol of the Trinity and, later, the impeding Second Coming of Christ, has led to a variety of different thrones obviously inspired by imperial models. Among the most well-known examples, the one in the Arian baptistery, in Ravenna, has a jeweled cross standing atop an empty throne with a suppedaneum, purple-and-gold

141 E.g., for Valentinian and Valens, *RIC* IX Antioch no. 23a (two emperors on one throne); for Gratian, *RIC* IX Antioch no. 20g (two single thrones for two emperors); for Valentinian II, *RIC* IX Mediolanum no. 5d (double throne); for Theodosius I, *RIC* IX (Valentinian I–Theodosius I) no. 40b. Under Justin, a copper half-follis (*MIBEC* 95, no. 44c, now at Dumbarton Oaks, BZC.1967.17.9) was struck, showing the emperor and his wife Sophia sitting side by side on two lyre-backed thrones. The shared-thrones motif survived until at least into the seventh century, as a silver hexagram struck under Heraclius shows (*MIB* 3:222, no. 135, now at Dumbarton Oaks, BZC.2015.015).

142 *RIC* IX Antioch, no. 23b.

143 On the frescoes and their preservation, see J. Deckers, "Die Wandmalerei im Kaiserkulturaum von Luxor," *JDAI* 96 (1979): 600–52; M. Jones and S. McFadden, ed., *Art of Empire: The Roman Frescoes and Imperial Cult Chamber in Luxor Temple* (New Haven, CT, 2015); N. Barbagli, "The Emperors in the Province: A Study of the Tetrarchic Images from the Imperial Cult Chamber in Luxor," in *A Globalised Visual Culture? Towards a Geography of Late Antique Art*, ed. F. Guidetti and K. Meinecke (Oxford, 2020), 91–131. On this fresco and the debate about Diocletian as innovator in ceremonial, see also Rollinger, "These Boots." The suppedaneum in the famous drawing of Constantius II as consul in the *Chronograph of 354* is undecorated.

Fig. 6. At upper right, suppedaneum with imperial foot, tetrarchic fresco in the imperial cult chamber at Luxor, ca. 300 CE. Photo by Yarko Kobylecki, 2008; courtesy of the American Research Center in Egypt (ARCE).

tubular pillow, and jeweled, high-rising backrest; no less than 711 pearls and 123 precious stones of various hues cover the throne itself (Fig. 7).[144] In Santa Maria Maggiore in Rome, the fifth-century mosaics on the apex of the arch include a hetoimasia commissioned by Pope Sixtus III (432–440), of similar shape and splendor.[145] Finally, a miniature in a ninth-century edition of homilies by Gregory Nazianzus shows the empty throne (and suppedaneum) set up by Theodosius I (r. 379–395) during the sessions of the First Council of Constantinople in 381: all-golden, beset with pearls and jewels, and covered in purple textiles (Fig. 8).[146]

Why is the appearance of throne and canopy so important? Because of the cumulative effect of gleaming gold and gold-threaded purple, shimmering pearls, and glittering jewels. In poetic language, it is "the chariot of Phoebus and the purple of the Emperor" that "shines with youthful light" and by which the ceiling is "set on fire" (*flammatus*); the emperor himself is "purple gleaming" (πορφυραυγὲς) and a "purple glittering sun" (ἥλιε πορφυρακτινε).[147] In reality, the combination of the soft light from large numbers of candles and oil lamps as well as the clear and bright sunlight streaming through the windows, illuminating the purple chlamys and reflected in the rippling and iridescent surfaces of tens of thousands of golden-glass tesserae, must have produced a striking, ethereal image. The impression would have been comparable to the effect of the light in Hagia Sophia as recorded by Paul the Silentiary in *Description of Hagia Sophia*: "The roof is compacted of gilded tesserae from which a stream of golden rays pours abundantly and strikes men's eyes with irresistible

force. It is as if one were gazing at the midday sun in spring when it gilds each mountain top."[148]

Bathed in a billowing gold luminescence, the audience hall at the Great Palace would have awakened associations of the imperial "sun" and the court of the Heavenly Father. At the center of it all, surrounded by reflecting and glittering surfaces, at first hidden behind curtains, then revealed to all, was the emperor, enthroned in light and majesty, surrounded by a host of courtiers also dressed in splendor, red-robed dignitaries, and bodyguards in startling white, "so that it seemed as though stars were shining on the earth."[149] Compare this, again, with scriptural references to God enthroned, sitting in judgment, surrounded by angels, thrones, and powers dressed in white and gold and shining with his reflected light.[150]

The book of Revelation has a striking description of John beholding the vision of God: "Immediately I was in the spirit: and, behold, a throne was set in heaven, and one sat on the throne. And he that sat was to look upon like a jasper and a sardine stone: and there was a rainbow around the throne, in sight like unto an emerald."[151] Corippus's description of Justin during the Avar audience is reminiscent of its biblical image paradigm: the emperor, on his brilliant throne and under a resplendent (*praefulgens*) canopy, appeared also "like a jasper and a sardine stone"; he was clad in the purple and jeweled imperial chlamys, not too far off from the dark-to-dullish red hues of sardius (or carnelian), jacinth, or jasper stones, which are found in a variety of different colors.[152] A figurative "rainbow" had formed around

144 I counted them.

145 For further examples of the hetoimasia, see A. Bergmeier, "Volatile Images: The Empty Throne and Its Place in the Byzantine Last Judgment Iconography," in *Cultures of Eschatology*, ed. V. Wieder, V. Eltschinger, and J. Heiss, vol. 1 (Berlin, 2020), 84–122, with appendix.

146 Paris, Bibliothèque nationale de France, gr. 510, fol. 355r. The emperor, diademed and clad in a purple chlamys with golden *tablion*, is seated to the right of the throne, slightly elevated among the bishops.

147 Merobaudes, *Carmina* 2.2–3 (ed. Clover), and Theodoros Prodromos, *Poemata* 12.4 and 7 (ed. Hörandner). The radiant and shining imperial purple had become a well-worn trope by the fourth century. Cf., e.g., Amm. Marc. 15.8.15: *imperatoris muricis fulgore flagrantem*, and 20.4.22: *fulgentem eum augusto habitu conspexissent*.

148 Paul the Silentiary, *Description of St. Sophia* 668–72 (C. de Stefani, ed., *Descriptio Sanctae Sophiae: Descriptio Ambonis* [Berlin, 2011]): Χρυσοκολλήτους δὲ τέγος ψηφῖδας ἔεργει, / ὧν ἄπο μαρμαίρουσα χύδην χρυσόρρυτος ἀκτὶς / ἀνδρομέοις ἄτλητος ἐπεσκίρτησε προσώποις. / φαίη τις Φαέθοντα μεσημβρινὸν εἴαρος ὥρῃ / εἰσοράαν, ὅτε πᾶσαν ἐπεχρύσωσεν ἐρίπνην (trans. James, "Senses," 527–28).

149 Mark the Deacon, *Life of Porphyry* 47 (H. Grégoire and M.-A. Krugener, ed., *Marc le Diacre: Vie de Porphyre, évêque de Gaza* [Paris, 1930]; G. F. Hill, trans., *The Life of Porpyhry, Bishop of Gaza* [Oxford, 1913]).

150 Dan. 7:9–10; Is. 6:1–3; Rev. 4:1–11, 7:9–11.

151 Rev. 4:2–3: Εὐθέως ἐγενόμην ἐν πνεύματι, καὶ ἰδοὺ θρόνος ἔκειτο ἐν τῷ οὐρανῷ, καὶ ἐπὶ τὸν θρόνον καθήμενος, καὶ ὁ καθήμενος ὅμοιος ὁράσει λίθῳ ἰάσπιδι καὶ σαρδίῳ, καὶ ἶρις κυκλόθεν τοῦ θρόνου ὅμοιος ὁράσει σμαραγδίνῳ (trans. KJV).

152 It should be noted, however, that the precise color value associated with the ancient terminology is not completely clear, and it may be that the ancient and modern names do not match.

Fig. 7. Detail, *hetoimasia* mosaic in the cupola of the Arian baptistery, Ravenna, fifth century. Photo by Georges Jansoone; courtesy of Wikimedia Commons.

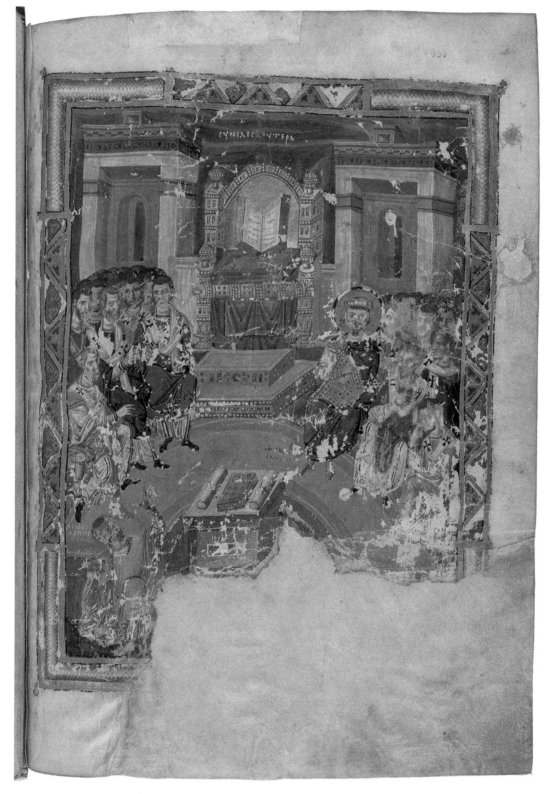

Fig. 8.　A *hetoimasia* during the First Council of Constantinople (381); illumination from a collection of the *Homilies* of Gregory Nazianzus. Paris, Bibliothèque nationale de France, gr. 510, fol. 355r, ninth century. Photo courtesy of the Bibliothèque nationale de France.

the emperor composed of light reflected in different hues by gold and purple, rubies, emeralds and sapphires, by glass tesserae, armor, weapons, shining golden and purple cloth.[153] Tellingly, the use of such divinely connotated precious stones—emeralds and sapphire count among the twelve foundational stones of the Heavenly Jerusalem in the Apocalypse of John, and its gates were fashioned of pearls—was regulated by law, as with purple-dyed textiles. An edict issued by Emperor Leo I decreed, "No one at all shall be allowed to fasten or insert pearls, emeralds, and sapphires on their bridles, saddles, and belts. . . . They should use these kinds of clasps on robes that are precious only because of gold and the skill (in making them). . . . No private individual shall be allowed to make anything from gold and gems that belongs to imperial dress and decoration."[154] These gemstones were associated with imperial dignity and office, as were specific hues of purple, whose manufacture and possession the law also regulated.[155] The gems enumerated in Leo's law were reserved for "royal use" (*usibus regiis*), especially for objects associated with emperorship (*ornamenta regia*), and in particular the emperor's jewel-studded pearl fibula and diadem. The imperial diadem as famously illustrated in the mosaic of Justinian in San Vitale in Ravenna (see Fig. 1) included

rubies (or jacinths or amethysts?) and emeralds, a double row of pearls set in a golden circlet, and two pearl pendilia framing his face. They collectively added to the "godly" effect of the emperor sparkling like a rainbow.

The Apocalypse mentions a further element of light symbolism: "And before the throne there was a sea of glass like unto crystal."[156] Depending on how much of the floors and walls of the audience hall was decorated, one can imagine the effect of a "sea of glass" produced architecturally by means of different kinds of marble slabs and revetments. Similar choreographies of material and lights, as well as their effect on viewers, have been observed and analyzed in various buildings.[157] In Hagia Sophia, the use of Proconnesian and other marbles, combined with the sunlight reflecting off a multitude of different surfaces, produces a rippling and shape-shifting appearance reminiscent of the one pervasive in Corippus's description of the palace. In *Description of Hagia Sophia*, Paul the Silentiary likens the interplay of material and lighting to molten metal, describes the shining marble of the ambo inter alia as "silver-shining" and "golden," and associates the marble surfaces with the waters of the Bosporus.[158] One may imagine a similar choreography of marble and light in the Consistory. The sum total of these elements created an effect that would not have been far from the panegyrical and quasi-religious description in the sources of a divinely sanctioned monarch who shone of his own accord.

153 Compare this with the description of rainbow colors in Amm. Marc. 20.11.27–28, which matches the colors of the imperial costume: *cuius species, quantum mortalis oculus contuetur prima lutea visitor, secunda flavescens vel fulua, punicea tertia, quarta purpurea, postrema caerulo concreta et viridi.*

154 *Cod. Iust.* 11.12.1: pr. *Nulli prorsus liceat in frenis et equestribus sellis vel in balteis suis margaritas et smaragdos et hyacinthos aptare posthac vel inserere. . . . Fibulis quoque in chlamydibus his utantur, quae solo auro et arte pretiosae sunt. . . . 1. Nulli praeterea privatorum liceat . . . aliquid ex auro et gemmis quod ad cultum et ornatum imperatorium pertinet facere* (B. W. Frier et al., trans., *The Codex of Justinian: A New Annotated Translation, with Parallel Latin and Greek Text* [Cambridge, 2016]). Bejeweled imperial bridles are also attested by a striking passage in Claudian's panegyric on the occasion of Honorius's fourth consulate (Claudian, IV *Cons. Hon.* 549–50), describing the imperial horse: *turpantur phalerae, spumosis morsibus aurum / fumat, anhelantes exundant sanguine gemmae* (His harness rattles and the golden bit steams from the foaming bite, the breathed-on jewels flow with blood). The famous Barberini Diptych of Justinian in the Louvre gives a good impression of what an imperial bridle and *phalerae* may have looked like, as does the so-called Kersch *missorium,* now in the Hermitage Museum, likely depicting Constantius II on horseback.

155 M. Reinhold, *History of Purple as a Status Symbol in Antiquity* (Brussels, 1970), 62–70; cf. Hunger, *Neuen Mitte,* 84–96 for imperial monopolies in general.

156 Rev. 4:6: καὶ ἐνώπιον τοῦ θρόνου ὡς θάλασσα ὑαλίνη ὁμοία κρυστάλλῳ (trans. KJV).

157 F. Barry, "Walking on Water: Cosmic Floors in Antiquity and the Middle Ages," *ArtB* 89 (2007): 627–56; F. Barry, "The House of the Rising Sun: Luminosity and Sacrality from Domus to Ecclesia," in Lidov, *Hierotopy of Light and Fire,* 82–104; Pentcheva, "Multisensory Aesthetics"; B. Pentcheva, "The Power of Glittering Materiality: Mirror Reflections between Poetry and Architecture in Greek and Arabic Medieval Culture," in *Istanbul and Water,* ed. P. Magdalino and N. Ergin (Leuven, 2015), 241–74; Pentcheva, *Hagia Sophia.* I would also again point out the characterization of the golden canopy of the throne as "shining with liquid gold" in Corippus, *In Praise of Emperor Justin* 3.196; see above, note 135.

158 Paul the Silentiary, *Description of St. Sophia* 91–92 (ed. de Stefani): ὃς δὲ μεταΐσσει μὲν ἐς ἄργυφον, εἰσέτι δ' οὔπω / τρέψεν ὅλην χροιὴν ἔτι λείψανα χρύσεα φαίνων; 664–67: πᾶν δὲ πέδον στορέσασα Προκοννήσοιο κολώνη / ἀσπασίως ὑπέθηκε βιαρκέϊ νῶτον ἀνάσσῃ· / ἠρέμα δὲ φρίσσουσα διέπρεπε Βοσπορὶς αἴγλη / ἀκροκελαινιόωντος ἐπ' ἀργεννοῖο μετάλλου. Pentcheva, "Multisensory Aesthetics," 96, acknowledges the intertextuality of such descriptions but rightly surmises that it "also integrates a direct response to the sensual materiality of the space and uncovers in it a metaphysical dimension."

Powers and Thrones

Just as the heavenly ruler was surrounded by attendants—in John's vision by twenty-four white-clad elders and six-winged, myriad-eyed seraphim—so too was the emperor of the Romans.[159] The sources provide a relatively full accounting of which courtiers and officials took part in audiences. Some receive explicit mention, with their duties detailed in the chapters from the *Book of Ceremonies* attributed to Peter the Patrician: the magister officiorum and his assistants; the officials of the *scrinia*, the different administrative bureaus; the *tertiocerius*, the third most senior court notary; the comes admissionum and a number of his staff, tasked with executing the audiences; the chamberlain (*praepositus sacri cubiculi*); the *silentiaries*, whose role was to ensure ritual silence; the candidati and their decurion and other bodyguards; the bearers of the imperial labara; the noble pages; and the gatekeepers and porters (*ostiarii*).[160] The *proceres*/ἄρχοντες, a collective term denoting the highest officials of the palace, are also mentioned, and although it is nowhere explained who exactly belonged to this group, it is almost certainly included the *comites consistoriani*—i.e., the magister, the *quaestor sacri palatii*, the *comes sacrarum largitionum,* and the *comes rerum privatarum*—the praepositus sacri cubiculi, as well as the *magistri militum* in presence and perhaps some of the higher-ranking *decuriones* and *comites* of the various scholae. Others in attendance belonged to the wider court.

According to the *Book of Ceremonies*, diplomatic receptions explicitly took the form of an assembly called the *silention*, the later name for the emperor's *consistorium*, that is, his official council.[161] The role of the emperor's council had changed in late antiquity. While it had originally functioned as a decision-making body and a court of justice, by the sixth century, it was no longer a setting for discussion or exchange of opinion, but

instead had become a ceremonial framework in which the emperor's decisions were ritually proclaimed and received with acclamations by the grandees present.[162] This was also the case with diplomatic audiences; contrary to the accounts of Corippus and Menander the Guardsman, which include differently stylized verbal confrontations between the serene but war-like Justin and the impudent "barbarians," "only the *honneurs* were made and gifts exchanged," at least during the initial audience.[163] A novel of Justinian describes the composition of the full silention: in addition to the court officials enumerated above, the highest civil officials (that is, the praetorian and urban prefects, who did not belong to the inner court), the magistri militum, and, importantly, the Constantinopolitan senate itself (i.e., assorted patricians, consuls, consulars, honorary consuls, and other *illustri*).[164] The patriarch was only occasionally invited and thus in attendance.[165] There are strong indications that palace officials and servants from the ranks of the *cubicularii*, the private attendants of the emperor and palace, were also present: the chamberlain, whose office was close to the emperor, attended as a matter of course, but Corippus also mentions "a throng of eunuchs" who served the emperor, likely referring to the cubicularii.[166] In total, then, participants in this ceremony may have easily numbered in the dozens or even hundreds, especially if one includes the armed bodyguards.

Among all those, however, Corippus highlighted one person: Narses, the imperial sword-bearer (*spatharius*), who was either a eunuch bodyguard or commander of a eunuch bodyguard.[167] In Corippus's

159 Rev. 4:1–11.

160 *Book of Ceremonies* 1.87–89 (ed. Reiske, 393–408).

161 The term *silention* derives from the ceremonial silence that had to be observed in the presence of the emperor. Cf. Treitinger, *Reichsidee*, 52–55; A. Christophilopulu, "ΣΙΛΕΝΤΟΝ," *BZ* 44 (1951): 79–85; A. H. M. Jones, *The Later Roman Empire, 284–602: A Social, Economic and Administrative Survey*, 3 vols. (Oxford, 1964), 333–41; R. Smith, "The Imperial Court of the Late Roman Empire, c. AD 300–c. AD 450," in *The Court and Court Society in Ancient Monarchies*, ed. A. Spawforth (Cambridge, 2007), 157–232, esp. 198–202, also 215–20.

162 D. Graves, "*Consistorium domini*: Imperial Councils of State in the Later Roman Empire" (PhD diss., City University of New York, 1973).

163 Christophilopulu, "ΣΙΛΕΝΤΙΟΝ," 84.

164 *CIC Nov* 62.2. Cf. Christophilopulu, "ΣΙΛΕΝΤΙΟΝ." Cf. Corippus, *In Praise of Emperor Justin* 3.213: *egreditur princeps magno comitante senatu.*

165 Christophilopulu, "ΣΙΛΕΝΤΙΟΝ," 81 n. 1–2.

166 Corippus, *In Praise of Emperor Justin* 3.214.

167 *PLRE* 3b 930–31 (Narses 4). This is not Justinian's famous military commander, who was also spatharius at some point in his career. Corippus refers to Narses as *armiger* throughout his text, but there is much uncertainty surrounding both titles. E. Stein, *Histoire du Bas-Empire*, 2 vols. (Paris, 1949), 1:297, identified the *spatharius* as commander of the *spatharo-cubicularii*; for the eunuch bodyguards of late antiquity, see M. E. Stewart, "Protectors and Assassins: Armed Eunuch-*Cubicularii* and -*Spatharii*, 400–532," in *Brill's Companion to*

description, he surpassed all others' physical appearance, with the exception of the emperor, of course:

> In the meantime came Narses, the emperor's sword-bearer, following on in the steps of his master, towering a head over all the lines, and made the imperial hall shine with his beauty, his hair well arranged, handsome in form and face. He was in gold all over [*aureus omnis erat*], yet modest in dress and appearance, and pleasing for his upright ways, venerable for his virtue, brilliant [*fulmineus*], careful, watchful night and day for the rulers of the world, shining with glorious light [*honora luce coruscus*]: as the morning star, glittering in the clear sky outdoes the silvery constellations with its golden rays and announces the coming of day with its clear flame.[168]

Narses make a second appearance in the fourth book, there accompanying the emperor during his consular procession:

> There too stood the sword-bearer Narses, firm in his bodily strength and kindly in mien and white-haired gravity, and adorned the imperial throne as he held his glorious standards. Like precious agate or the Parian stone shining out in the midst of yellow gold as the hand of the artist shapes it: he was as bright with light, as calm in mind, as handsome with his gentle expressions, as he protected the back of the emperor

and shone in his bright armour [*claris fulgebat in armis*].[169]

The physical beauty of eunuchs is a well-established trope in late antique and Byzantine literature,[170] but, strikingly, Corippus expresses this physical beauty in terms of a golden light emanating from the eunuch's figure as it does from the emperor. This is, again, a symbolic connection between the earthly and heavenly courts as, in the later Byzantine *imaginaire*, eunuchs were closely associated with angels. Corippus's depiction, together with the so-called *Vision of Dorotheus*, discussed below, is one of the earliest indications of this notion with respect to the imperial court.[171]

Angels were the messengers of God, whereas eunuch cubicularii could be, and frequently were, employed as palace messengers. As Cyril Mango explained, "The angels, being sexless and acting as God's attendants, had their closest earthly analogy in the eunuchs of the imperial palace."[172] This parallel makes perfect sense and was emphasized in late antique and Byzantine texts, among them the *Life of John of Cyprus* (the Almsgiver) by Leontios of Neapolis.[173] More subtly, eunuchs themselves, by virtue of their physical appearance, also served to announce the impending imperial presence, like the morning star "announcing the coming of the day," to use Corippus's turn of phrase. This close identification is, again, easy to explain. Court eunuchs were employed in a variety of tasks in the

Bodyguards in the Ancient Mediterranean, ed. M. Hebblewhite and C. Whately (Leiden, 2022), 272–91, and cf. J. B. Bury, *The Imperial Administrative System in the Ninth Century, with a Revised Text of the Kletorologion of Philotheos* (Oxford, 1911), 112–13: "The earliest Imperial spatharioi were perhaps cubicularii who had a military character and bore a sword." By the eighth century, the office had become a title.

168 Corippus, *In Praise of Emperor Justin* 3.220–30: *Armiger interea, domini vestigia lustrans, / eminet excelsus super omnia vertice Narses / agmina, et augustam cultu praefulgurat aulam, / comptus caesarie formaque insignis et ore. / Aureus omnis erat, cultuque habituque modestus / et morum probitate placens, virtute verendus, / fulmineus, cautus, vigilans noctesque diesque / pro rerum dominis, et honora luce coruscus, / matutina micans ut caelo stella sereno / auratis radiis argentea sidera vincit / vicinumque diem claro praenuntiat igne* (trans. Cameron, *In laudem*).

169 Corippus, *In Praise of Emperor Justin* 4.366–73: *Nec non ensipotens, membrorum robore constans, / adspectu mentis non a gravitate, benignus, / astabat Narses sedemque ornabat herilem / splendida signa gerens, qualis pretiosus achates / aut medius fulvo Parius lapis enitet auro / artificis formante manu: sic luce coruscus, / sic animo placidus, miti sic gratior ore, / terga tegens domini claris fulgebat in armis* (trans. Cameron, *In laudem*).

170 G. Sidéris, "'Eunuchs of Light': Power, Imperial Ceremonial and Positive Representations of Eunuchs in Byzantium (4th–12th Centuries AD)," in *Eunuchs in Antiquity and Beyond*, ed. S. Tougher (London, 2002), 161–75; Ringrose, *Perfect Servant*, 78, 90, 148; cf. S. Tougher, "Bearding Byzantium: Masculinity, Eunuchs and the Byzantine Life Course," in *Questions of Gender in Byzantine Society*, ed. B. Neil and L. Garland (Farnham, 2013), 153–66.

171 Ringrose, *Perfect Servant*, 163–83. For a very brief overview of Byzantine angelology, see Mango, *Byzantium*, 154.

172 Mango, *Byzantium*, 155.

173 Leontios, *Life of John of Cyprus* 52.39–46, 53.34–39, 60.1–10 (A. J. Festugière and L. Rydén, ed., *Léontios de Néapolis: Vie de Syméon le Fou et Vie de Jean de Chypre* [Paris, 1974]). Cf. Sidéris, "Eunuchs of Light."

palace, all of which led to and necessitated their being in close physical proximity to the ruler. Where there were eunuchs, there was an emperor (or a member of the imperial family). As Maria Parani has argued, however, there was also a metaphysical or quasi-religious component to this proximity, a statement on the imperial *basileia* itself, "a power so awe-inspiring and fearsome that it could not be directly approached by ordinary human beings, but needed to be mediated by the eunuchs, angel-like and pure."[174]

In late antique, and particularly in Byzantine Constantinople, this parallelization between the earthly and heavenly court was incorporated into court ceremonial and religious art.[175] At court, eunuchs dressed in splendid court costume were distinguished by insignia conveying their rank of dignity. Costumes and insignia—the scabbard and torques of the *spatharii*, for instance—were of gilt or of silver inlay, studded with jewels and pearls. Visual depictions of angels and archangels in religious contexts, on the other hand, made use of court costumes, including imperial ones, for their representation, just as angels appearing in literary visions always dressed in court costume, the details of which allowed some recipients of such visions to identify the angel-eunuch's celestial "rank."[176] Thus, the beautiful and incandescent Narses, bearing the imperial arms, dressed in pure white and gold, "adorning" the imperial throne, evokes the image of an angel or archangel attending the throne of God, both as a literary topos and during ceremonies themselves, where Narses would have stood close by the emperor.

That Narses radiates light himself, not merely reflecting the imperial light as the emperor's sister does in Merobaudes' *Carmen*,[177] is an important detail. It distinguishes him from other courtiers and officials present, even from members of the imperial family, and especially from the various other bodyguards. As shown above, monarchy in late antiquity and in the Byzantine

period became closely associated with light and brilliance as well as with physical beauty. The very same physical qualities were ascribed, somewhat naturally, to the ruler's closest companions. Among them were the court eunuchs and the imperial bodyguards, who had regular and mostly unimpeded access to him. The physiognomy of guard soldiers was such that it attracted attention. Procopius informs the reader that Justin I, upon his first arrival in Constantinople and enlisting as a soldier, was enrolled among the *excubitores* guard because of his attractive physique.[178] Their demeanor and appearance was seen as a reflection of the *basileia*, all the more so given the potential overlap between eunuchs and (typically non-eunuch) bodyguards—as in the case of spatharii like Narses, who might have numbered among the select bodyguard, the forty candidati.[179] It comes as no surprise that Synesius of Cyrene describes the bodyguards in his *Oration on Royalty* as "a sort of picked force detached from the army itself, of men all young, tall, fair-haired and superb, 'their heads ever anointed and their faces fair'[Hom. *Od.* 15.332], equipped with golden shields and golden lances. At the sight of these we are made aware beforehand of the king's approach, much as, I imagine, we recognize the sun by the rays that rise above the horizon."[180]

Where Corippus's Narses is the morning star, Synesius's bodyguards are a protuberance of the imperial sun, a source of light, and they the product of it. This, again, is not merely a literary trope. Guards, as Synesius alludes to, were luxuriously equipped, with belts, shields, spears, and even horse bridles made of gold or gilt and silver-inlaid materials.[181] Though the

174 Parani, "Look Like an Angel," 437.

175 Parani, "Look Like an Angel," passim.

176 Parani, "Look Like an Angel," 436, with sources in note 16. Cf. G. Peers, *Subtle Bodies: Representing Angels in Byzantium* (Berkeley, 2001), 1–11; M. Hatzaki, *Beauty and the Male Body in Byzantium: Perceptions and Representations in Art and Text* (Basingstoke, 2009), 86–115. See C. Jolivet-Lévy, "Notes sur la représentation des archanges en costume impérial dans l'iconographie byzantine," *CahArch* 46 (1998): 121–28, for depictions of angels in religious art.

177 See above, note 114.

178 Procopius, *Secret History* 6.2–3.

179 Stewart, "Protectors and Assassins," 289: "By the close of the sixth century, one could be both a *candidatus* and a *spatharius* simultaneously, and these individuals could either be eunuchs or non-eunuchs."

180 Synesius, *On Royalty* 16.6 (ed. Lamoureux: ἀπὸ τῆς στρατιᾶς στρατιά τις ἔκκριτος, νέοι πάντες, πάντες εὐμήκεις, τὰς κόμας ξανθοί τε καὶ περιττοί, αἰεὶ δὲ λιπαροὶ κεφαλὰς καὶ καλὰ πρόσωπα, χρυσάσπιδες καὶ χρυσεολόγχαι, οἷς, ὅταν ποτὲ ὀφθῶσι, τὸν βασιλέα σημαινόμεθα, καθάπερ, οἶμαι, ταῖς προανισχούσαις ἀκτῖς τὸν ἥλιον (A. Fitzgerald, trans., *The Essays and Hymns of Synesius of Cyrene, Including the Address to the Emperor Arcadius and the Political Speeches* [London, 1930]). Cf. Them. *Or.* I 1–2.

181 R. Delmaire, "Les soldats de la garde impériale à l'époque théodosienne: Le témoignage des sources religieuses," *AntTard* 16 (2008): 37–42. Cf. Amm. Marc. 16.10.7; 31.10.9; Synesius, *On Royalty* 16.6 (ed. Lamoureux); John Chrysostom, *Quod reg.* 6 (PG 47:527); *In ep. ad Eph.* 9.1 (PG 42:70); *In ep. ad Phil.* 13.4 (PG 42:281); and *In ep. ad*

guards were usually uniformly dressed, the tunics and costumes of the main guard units—the scholae palatinae and the excubitores—could also be polychromatic, as in the case of Justinian's guard on the famous Ravenna mosaic.[182] The candidati, as their name indicated, wore white (linen) tunics; they are Corippus's *candida turba*.[183] A variety of descriptions of imperial ceremonies, not least in Corippus, state that the guards' superiors carefully arranged the spatial positioning of guards and other participants to evoke wonder and awe.[184] This was not a late antique invention; earlier emperors had done the same. The fragments of the third-century historian Dexippus perhaps provide the most detailed description of the thought that went into such displays, in the context of the emperor Aurelian's reception of ambassadors from the Juthungi in the early 270s.[185]

The attractive appearance and lavish equipment of the guards, clad in distinct colors, fine silks, and golden armor and carrying golden arms, were not idle ostentation, but an expression of imperial ideology and power. Within the palace, the heavily gilded and jewel-encrusted military paraphernalia played a role in an intricate choreography of light involving the guards, palace officials, the emperor, and the architecture and decoration of the buildings. By their physical appearance and their splendid apparel, guards served to invoke both awe and terror, to borrow from Liudprand, to visualize the formidable power of Roman superiority and to remind onlookers of the continued success and triumph enjoyed by their ruler.

During ceremonies, guards stood shoulder to shoulder in ordered ranks as if "leafy oaks amid sacred rivers" and "of equal height and glittering equally."[186] The planning and desired effect of impressing observers find further confirmation in that specific units, particularly mounted ones—the scholae palatinae were technically cavalry units—were specially equipped to reinforce the notion of impersonal and implacable masses of soldiers in serried ranks and of awesome appearance in all senses. The description of armored cavalry as found in the works of Claudian and the emperor Julian himself is particularly telling in this regard, as it emphasizes the guards almost inhuman appearance. Claudian says of the movement of armored cavalry that it was "as though iron statues moved," and Julian notes the metal masks "which makes the wearer look like a glittering statue."[187] The deportment of a statue—calm,

Rom. 14.10 (PG 40:537). Lib. *Or.* 12.82; Prudent., *Apotheosis* 495–97. It is not immediately clear if the prohibition of jeweled bridles in *Cod. Iust.* 11.12.1 also applies to the imperial guards; the bridles, in any case, were certainly made of gold (Theophylact Simocatta, *History* 6.2).

182 Compare the intriguing, though almost certainly garbled, account of John Lydus, *Mag.* 12, who states that the uniform of the excubitores derived directly from Roman dress of the time of Aeneas and Romulus.

183 Corippus, *In Praise of Emperor Justin* 3.156–64. They are called *protectores* here because by the sixth century the *protectores/domestici*, a corps of staff officers grown from what had originally been informal bodyguards, had been amalgamated into the scholae; cf. M. Emion, "Les *protectores Augusti*," in *Corps du chef et gardes du corps dans l'armee romaine*, ed. C. Wolff and P. Faure (Paris, 2020), 473–96; M. Emion, *Les protectores augusti (IIIᵉ–VIᵉ s. a.C.)* (Bordeaux, 2023).

184 Corippus, *In Praise of Emperor Justin* 3.156–64. Cf. the *Anonymus Valesianus* (II 76f.) and Procopius, *History of the Wars* 2.21.2–3 for an audience that Belisarius held in the field, in which the carefully ordered and arranged lines of his soldiers figure prominently.

185 Dexippus, *Brill's New Jacoby:* 100 F 6.2–3 (= C. de Boor, ed., *Excerpta de legationibus Romanorum ad gentes* [Berlin, 1903], 20): ἐπεὶ δὲ καλῶς εἶχεν αὐτῶι ἡ διακόσμησις, ἐπὶ ὑψηλοῦ βήματος μετέωρος βέβηκε καὶ ἁλουργίδα ἀμπέχων τὴν πᾶσαν τάξιν ἐποίει ἀμφ' αὐτὸν μηνοειδῆ. Παρεστήσατο δὲ καὶ τῶν ἐν τέλει, ὅσοι ἀρχάς τινας ἐπιτετραμμένοι, σύμπαντας ἐφ' ἵππων. Κατόπιν δὲ βασιλέως τὰ σημεῖα ἦν τῆς ἐπιλέκτου στρατιᾶς – τὰ δέ εἰσιν ἀετοὶ χρυσοῖ καὶ εἰκόνες βασίλειοι καὶ στρατοπέδων κατάλογοι γράμμασι χρυσοῖς δηλούμενοι – ἃ δὴ σύμπαντα ἀνατεταμένα προυφαίνετο ἐπὶ ξυστῶν ἠργυρωμένων. ἐπὶ δὲ τούτοις ὧδε διακοσμηθεῖσιν Ἰουθούγγους ἠξίου <παρελθεῖν>. τοὺς δὲ συνέβη θαμβήσασθαι ἰδόντας καὶ ἐπὶ πολὺ σιγῆι ἔχειν ("When he found the units arranged to his satisfaction, he mounted a high speaker's platform and, donning a purple robe, he arranged the entire force around him in a crescent. He also placed beside him any officers who had been in any command, all of them on horseback. Behind the emperor were the standards of the élite units—golden eagles, images of the emperor, and plaques showing the names of the units picked out in

gold letters—all held aloft and displayed on poles sheathed in silver. With everything so arranged he ordered the Juthungi to enter. The ambassadors, when they beheld his spectacle, were struck dumb with astonishment," trans. *Brill's New Jacoby*). Cf. C. Rollinger, "Changing the Guard: Guard Units and Roman State Ceremonial in the First to Fourth Century," in *The Roman Imperial Court in the Principate and Late Antiquity*, ed. C. Davenport and M. McEvoy (Oxford, 2023), 56–74, and C. Rollinger, "*Specie Dominationis*: The 'Ceremonial' Uses of Imperial Bodyguards under the Principate," in *Brill's Companion to Bodyguards in the Ancient Mediterranean*, ed. M. Hebblewhite and C. Whately (Leiden, 2022), 223–48 for similar, earlier examples of the ceremonial employ of guards.

186 Corippus, *In Praise of Emperor Justin* 3.165–79 (trans. Cameron, *In laudem*).

187 Claudian, *In Ruf.* lines 355–65, esp. 359–60: *horribiles visu: credas simulacra moveri / ferrea.* Julian, *Or.* I 37c–d: τὸ κράνος αὐτῷ προσώπῳ σιδηροῦν ἐπικείμενον ἀνδριάντος λαμπροῦ. Cf. Julian, *Or.* 2.57: αὐτοὶ δὲ ἀτεχνῶς ὥσπερ ἀνδριάντες ἐπὶ τῶν ἵππων φερόμενοι.

immobile, serene, but terrible in its majesty—is exactly the behavior Constantius II adopted and thought appropriate for his public appearances, as evident from Ammianus's famous description of the adventus into Rome in 357.[188] Here, as in other things, the guards emulated the emperor.

The well-dressed, sparkling, angelic, and intimidating figures surrounding the ruler served a "diplomatic" purpose within the context of audience ceremonials, in that they were intended to project an image of power and majesty in the envoys' minds. At the same time, they also played a role in the complex choreography of the spatial icon of the emperor enthroned in majesty. They are mirror images of the dramatis personae of the Heavenly Court, with the courtiers in the role of the elders of John's Apocalypse, and bodyguards and court eunuchs as the angelic messengers, protectors, and worshipers of God.[189] The *Vision of Dorotheus* (Papyrus Bodmer 29), a fascinating literary text surviving on a single papyrus and presumably dating to the fourth century, shows how intimately connected the two courts were thought to be and, tellingly, is written from the perspective of a heavenly (and earthly?) guard soldier.[190] In 343 verses of dactylic hexameter, the eponymous Dorotheus narrates a vision that came to him while alone in the imperial palace in the middle of the day, a remarkable circumstance in itself. In the vision, he comes face to face with God and part of the Heavenly Court, which he is only able to describe in terms and concepts borrowed from

the context of the imperial bodyguards and thus the Constantinopolitan court:

> I was sitting as a doorkeeper in the middle of the *praepositi* / and there also was a *domesticus* of the Lord ... [...] / Being changed I received a privilege as before: / the *praepositi* of the palace had me as their *tiro* near the *biarchoi* ... [...] / and on the other hand in front of the Lord's *primicerius* / Gabriel was standing [...]. ... and the elder jumped forth / and they ordered me to take my position at the porch and by no means / to enter the house nor to be driven out of the palace, / but that I should be guarding the very porch and the fence of the courtyard.[191]

Praipositi here refers not to members of the *cubiculum* or the praepositus sacri cubiculi, but to the chief of the various administrative scholae, of which the narrator was made a member as *ostiarius*.[192] As he is negligent in his duties and attempts to deceive Christ himself, Dorotheus is punished, sentenced to flagellation in the *signa* (a place of imprisonment in a military camp) for leaving his post while on duty.[193] After his atonement, Christ and the archangel Gabriel again confront him, and when brought before God the Father, he declines to take Dorotheus back into his service, saying, "Surely that is not a man who will be able to stand close to / the gate of the ante-chamber; send him back to where he came from: / another man you must bring and give him strength in addition / to stand guard over the palace as a guardian of the courtyard."[194]

188 Amm. Marc. 16.10.9–10. Cf. Xen., *Cyr.* 8.40; 42, but also see R. Flower, "*Tamquam figmentum hominis*: Ammianus, Constantius II and the Portrayal of Imperial Ritual," *CQ* 65 (2015): 822–35, for a reading *à rebours*.

189 Rev. 4:4–11.

190 P. Bodmer 29 (A. Kessels and P. van der Horst, ed. and trans., "The Vision of Dorotheus [Pap. Bodmer 29]: Edited with Introduction, Translation and Notes," *VChr* 41 [1987]: 313–59). All translations are from this original publication. Cf. D. Van Berchem, "Des soldats chrétiens dans la garde impériale: Observations sur le texte de la *Vision de Dorothéos* (Papyrus Bodmer XXIX)," *Studii Clasica* 24 (1986): 156–63; T. Gelzer, "Zur Visio Dorothei: Pap. Bodmer 29," *MusHelv* 45 (1988): 248–50; D. Van Berchem, "Zur Frage des Verfassers der Visio Dorothei," in *Le Codex des Visions*, ed. A. Hurst and J. Rudhardt (Geneva, 2002), 139–54; J. Bremmer, "The Vision of Dorotheus," in *Early Christian Poetry: A Collection of Essays*, ed. J. den Boeft and A. Hilhorst (Leiden, 1993), 253–62; J. Bremmer, "An Imperial Palace Guard in Heaven: The Date of the Vision of Dorotheus," *ZPapEpig* 75 (1988): 82–88.

191 Bracketed ellipses added. P. Bodmer 29 Kessels and van der Horst, lines 17–18, 42–43, 49–50, 55–58: ἤμην πραιποίτοισιν ἐνὶ μ[έσσοισ]ι θυ[ρωρός / καί τε δομέστικος ἦεν ἄνα[κτος ... ἀλλοῖος] δὲ ἐὼν γέρας ἔλλαχον ὡς τὸ πάρος περ· / π[ραιπο]σίτοισι δόμοισιν ἔην τίρων ἄγχι βιάρχων ... / οιο[....]γίοισι καὶ δ᾽ αὖ πριμικῆρος ἄνακτος / πρ[όσθεν Γ] αβριὴλ ἦεν γέρας αἰνὸν ὑπή{ε}ιξαν δὲ γέροντες / κ]αί με κέ<λε>ον προθύροισιν ἐφεστάμεν οὔτι μάλ᾽ ἔνδον / ἐ]λθέμεν [οὔ τι καὶ ἐτκὸς ἀπὸ μεγάροιο δίεσθαι / ἀ]λλ᾽ αὐτὰ[ς θυρέας] τε φυλαξέμεν ἔρκεα τ᾽ αὐλῆς.

192 P. Bodmer 29 Kessels and van der Horst, line 131.

193 P. Bodmer 29 Kessels and van der Horst, lines 131–312. On signa, see M. Letteney and M. Larsen, "A Roman Military Prison at Lambaesis," *Studies in Late Antiquity* 5 (2021): 65–102.

194 P. Bodmer 29 Kessels and van der Horst, lines 184–87: ἦ ῥ᾽ οὐκχ οὗτος ἀνήρ γε δυνήσεται ἄγ[χι] θυρά[ων / ἑστάμεναι προδόμοιο· ἀφήτέ μιν [ἔ]νθεν [ὑπ]ῆλθ[εν· ... παρφυλακήν ποιέειν μεγάροι[᾽ ἄτ᾽ ἐπίτρο]πον αὐ[λῆς.

Dorotheus is saved by the intercession of Christ and Gabriel and reinstated among the bodyguards. After a ritual washing, baptism, he appears for service as a man changed in appearance and name. Now called Andreas, he shines "brilliant as the sun" (ὡς ἠέλιος καταλάμπων), a "great and untouchable giant in the ante-chamber":[195]

> and I came marching again to take my stand at the / high gate, and with my head I stood out high above the doors / of his palace. From afar the men looked at me in astonishment, / seeing how big I was and that I did not have simple clothing, / but a cloak, when I was standing at the gate as before, / was I wearing, made for me from two different sots of linen.... For I also wore a glittering belt.[196]

As Jan Bremmer has rightly noted, this dress is reminiscent of the uniform of the white-clad candidati.[197] In fact, imperial references saturate the *Vision of Dorotheus*, making the author's familiarity with imperial appearances obvious. The washing and rebirth of Dorotheus/Andreas through baptism, which is only at first glance purely spiritual, also testifies to this. Dorotheus/Andreas is in a bad state after his scourging and covered with blood.[198] Through the act of baptism, he acquires a new, more beautiful physical form. The other attendants are astounded at Dorotheus's appearance and look at him in astonishment as he stands guard.[199] In Corippus's depiction, too, the Avar ambassadors are impressed by the *candida turba* of the *protectores* and taken aback by the magnificent appearance of these imperial guards.[200]

195 P. Bodmer 29 Kessels and van der Horst, line 298: μέγα[ς ἠδ]ὲ πέλωρος ἀκήριος ἐν προδόμοιο.

196 P. Bodmer 29 Kessels and van der Horst, lines 326–34: καὶ ἐπέσ-ʼτι ʼχον αὖτις ἐν ὑψηλαῖς θυρ[έη]σιν / ἱστάμενος, κεφαλῇ δ᾽ ὑπερίσχανον ὕψ[ι θυρ]άων / οἷο δόμοιο. ἔκηθεν ἐθάμβεον εἰς ἐμὲ [φῶτε]ς / οἷος μακρὸς ἔην καὶ ρʼ οὐκ ἔχον ἔνδυμ[α λιτόν, / χλαῖναν δʼ ὡς τὸ πάρος περ ἐφεσταμέ-νο[ς θυρ]έησιν / εἶχον, ἐμοὶ ἀλλοίοις ἐνί λινέεσσι δυοῖσ[ι / καὶ γὰρ ἔχον ζωστῆρα παναίολον.

197 Bremmer, "Imperial Palace Guard," 86. Cf. Amm. Marc. 25.3.6, 31.13.14.

198 P. Bodmer 29 Kessels and van der Horst, lines 145, 150–52, 160, 199, 206, 212.

199 P. Bodmer 29, lines 299–304, 328–35.

200 Corippus, *In Praise of Emperor Justin* 3.239–43: *ingentes astare viros. Scuta aurea cernunt / pilaque suspiciunt alto splendentia ferro*

Power Smells

Within the logic of ceremonial audiences, the presence of the divinely sanctioned ruler together with that of eunuchs-cum-angels transforms a secular ceremony into a quasi-religious ritual. The *Vision of Dorotheus* is a striking text that illustrates the close association of the heavenly and earthly courts and demonstrates the permeability of the barrier between them. The emperor himself played a decisive role in breaking the membrane separating the earthly from the heavenly realm. He stood at the center of every ceremony as the fulcrum, and the splendor of his guards, courtiers, servants, eunuchs, soldiers, thrones, halls, and palaces existed to further highlight his position of exaltedness. As John Chrysostom explained, "But when we see the king we immediately lose sight of all these. For he alone turns our eyes to him, and to the purple robe, and the diadem, and the throne, and the clasp, and the shoes, all that splendor of his appearance."[201]

In this show, the emperor was aided by the choreography of light as well as other sensate elements elements—that is, sounds and smells, which though more sparsely attested in the sources warrant brief discussion. Though middle Byzantine ceremonies are richly attested, one cannot state with certainty whether music—be it the chanting and singing of hymns or organ playing—was a part of late antique audiences. To be sure, all three were important elements of other ceremonies: church choirs performed during imperial rituals in Hagia Sophia and the palace, for instance, during formal banquets; the organ was associated with the Hippodrome and imperial appearances there. Nowhere in the sources, however, is there a hint of music in the context of audiences.

There is some circumstantial evidence for the use of perfumed oils, incense, balms, and fragrant flowers during some ceremonies, including the audience. From the *Book of Ceremonies*, for instance, one learns that in the tenth century, the passageways and halls of the Great Palace were decorated with wreaths and garlands of

/ aurea et auratos conos cristasque rubentes. / Horrescunt lanceas saevasque instare secures / ceteraque egregia spectant miracula pompae. See Corippus, *In Praise of Emperor Justin* 3.156–64, for the appearance of the *protectorum numerus*.

201 John Chrysostom, *Hom. in ep. Rom.* 14.10 (PG 60:537): ἐκεῖνος γὰρ ἡμᾶς ἐπιστρέφει μόνος, καὶ τὰ πορφυρᾶ ἱμάτια, καὶ τὸ διάδημα, καὶ ἡ καθέδρα, καὶ ἡ περόνη, καὶ τὰ ὑποδήματα, ἡ πολλὴ τῆς ὄψεως λαμπηδών.

various shapes made of laurels and seasonal flowers; the pavement and floors of passageways were strewn with ivy and laurel and those and the ceremonial halls and rooms with myrtle and rosemary.[202] This may be what Corippus had witnessed when he wrote of the palace being exceptionally decorated; there is ample evidence from the earlier imperial period of fragrant liquids, flowers, and blossoms being strewn during aristocratic and imperial banquets or used for cleaning.[203] The criticism of Elagabalus in the *Historia Augusta*, written around 400, was likely a reflection of contemporary, late antique practices, rather than a faithful account of that much-maligned emperor's antics in the early third century. Thus, one reads that Elagabalus "would have perfumes from India burned without any coals, in order that the fumes might fill his apartments" and "he used to strew roses and all manner of flowers, such as lilies, and narcissi, over his banqueting-rooms, his couches and his porticoes, and then stroll about in them."[204] For imperial weddings, there is more direct evidence, as in the *Epithalamium* of Claudian on the occasion of the marriage of Honorius to Maria, daughter of Stilicho and Verena. In the poem, Venus herself oversees the arrangements for the festivities and orders: "Let these haste to entwine the gleaming door-posts with my sacred myrtle. Do sprinkle the palace with drops of nectar and kindle a whole grove of Sabaean incense."[205]

Since the sources omit any mention of specific olfactory components of audience ceremonies in the sixth century, one should be mindful of hypothesizing too carelessly. Yet, despite the lack of direct evidence, for example of special braziers or *thymateria* in which incense or saffron were burned, it is probably correct to assume that these fragrances were used as a matter of course. Of note, the twenty-four elders surrounding God in John's Apocalypse are in fact described as carrying "golden censers full of incense, which are the prayers of the saints,"[206] a simile that both alludes to the connection between certain smells and the divine and recalls the use of incense burners in religious and imperial rituals such as (and very likely) audiences. Scents, balms, oils, and wines and foods (during banquets, to which diplomats were also invited as a matter of course) arrived from all corners of the Roman ecumene as *emolumenta imperii* (as did expensive textiles, such as silk, and gemstones and pearls) to showcase the unlimited reach of the empire.[207] Candles could be scented, and it was common practice to mix the oil burned in lamps with perfumes or unguents, which would have diffused a sweet smell in every room of the palace.[208] Again, there is indirect evidence in the sources: in Claudian's poems, palaces of both gods or emperors are associated with sweet scents.[209] The *Book of Ceremonies* attests that even during imperial travels, the retinue carried along fragrances and balms in large quantities.[210] Incense, particularly associated with funerals in antiquity, was by no means the only fragrance used, and neither was it only used during the ceremony.[211] Corippus mentions the burning of an abundance of incense (*pia tura*) on the occasion of Justinian's funeral in 565.[212] His precise

202 *Book of Ceremonies* 2.15 (ed. Reiske, 566–98).

203 See for example, Plin. *HN* 25.59.105–107, 109, 216–17; Petron. *Sat.* 68. For further examples, see B. Caseau, "Incense and Fragrances: From House to Church," in *Material Culture and Well-Being in Byzantium (400–1453)*, ed. M. Grünbart, E. Kislinger, A. Muthesius, and D. Stathakopoulos (Vienna, 2007), 75–92.

204 Scriptores Historiae Augustae (hereafter SHA), *Heliogabalus* 31.4: *odores Indicos sine carbonibus ad vaporandas diaetas iubebat incendi* and 19.7: *stravit et triclinia de rosa et lectos et porticus ac sic deambulavit, idque omniflorum genere, liliis, violis, hyacinthis et narcissis* (D. Magie, trans., *Historia Augusta*, vol. 2 [Cambridge, MA, 1924]). In later centuries, Michael Psellos, *Chronographia* 6.64 (D. R. Reinsch, ed., *Michaelis Pselli Chronographia*, Millennium Studies 51, vol. 1 [Berlin, 2014]), recounts that the empress Zoe had a private workshop for manufacturing perfumes in her palace quarters.

205 Claudian, *Epithal.* 208–10: *hi nostra nitidos postes obducere myrto contendat; pars nectareis adspergite tecta fontibus et flamma lucos adolete Sabaeos* (trans. B. Caseau, "Εὐωδία: The Use and Meaning of Fragrances in the Ancient World and Their Christianization [100–900 AD]" [PhD diss., Princeton University, 1994], 122).

206 Rev. 5:8: ἔχοντες ἕκαστος . . . φιάλας χρυσᾶς γεμούσας θυμιαμάτων, αἵ εἰσιν αἱ προσευχαὶ τῶν ἁγίων.

207 Cf. Ball, *Byzantine Dress*, 15.

208 Cf., again, SHA *Elagab.* 24.1, and cf. Petron. *Sat.* 70.9. Tert., *De cor. mil.* 10.5.

209 Claudian, *Epithal.* 92–96; 154–55.

210 *Book of Ceremonies*, app. I (ed. Reiske, 468): ἀλειπτά, καπνίσματα διάφορα, θυμίαμα, μαστίχην, λίβανον, σάχαρ, κρόκον, μόσχον, ἄμπαρ, ξυλαλόην ὑγρὰν καὶ ξηράν, κιννάμωμον ἀληθινὸν πρῶτον καὶ δεύτερον, καὶ ξυλοκιννάμωμον, μυρίσματα λοιπά.

211 Myrrh, saffron, cinnamon, nard, and hyacinths were also frequently used (Stat., *Silv.* 2.6.85–89; Prop. 4.7.32; Claudian, *II Cons. Stil.* 420). Plutarch recounts that the women of Rome gathered such quantities of spices and incense for Sulla's funeral that they had to be transported to the funeral pyre in no less than 210 separate litters (Plut., *Sull.* 38). Cf. D. Clancy, "The Smell of Grief: Odour and Olfaction at the Roman Funeral," *thersites* 9 (2019): 89–116.

212 Corippus, *In Praise of Emperor Justin* 3.55.

wording is instructive here: it was burnt *transitus ob causa*, which can mean "on the occasion of his passing," but could also be translated as "to facilitate his passing," that is, to heaven. This is no accident. Sweet and pleasant smells were always closely associated with the divine sphere by both Christians and non-Christians. Saints and other martyrs as well as their relics emitted a fragrant smell, and God himself needed the scent of neither flowers nor incense, as he himself was the "final fragrance."[213] Sweet smells filled the Heavenly Jerusalem, and whatever "was near to God, whatever was sent or given by God—these were known by their wondrous smells."[214]

By filling the palace with similar smells, the organizers of ceremonial thus not only assured the well-being and olfactory satisfaction of the residents, but also connected the earthly palace to the divine realm. These fragrances conveyed an allegorical meaning, but were also thought to physically and spiritually interact with the bodies of those who came into contact with them; they had the power to break the thin membrane between the earthly and the supernatural and to allow humans to encounter and interact with the divine.[215] Thus, fragrances were not only an attribute of the holy, but also a means of communication, a way in which "human and divine could meet—not face to face as distinct realities, but intermingled in a communion of being.... To smell God was to know God as a transcendent yet transforming presence, a presence actively known through bodily experience."[216] Their use in palace ceremonial would have further facilitated the sensory, aesthetic, and ideological association of the imperial court with the heavenly archetype. In fact, this seems to have been the explicit intention, as indicated by a fascinating entry in the *Book of the Eparch*, usually ascribed to Leo VI but likely an evolving compendium of rules and guidelines for city guilds. It provides the following instruction for the guild of perfumers: "Let their counters stand in a

line comprised between the miliarion and the revered eikon of Christ, our divine Lord, which stands above the bronze portico, so that the sweet perfume may waft upwards to the eikon and at the same time permeate the vestibule of the imperial palace."[217]

Conclusion: Audiences in Another Heaven

Throughout, this lengthy analysis has attempted to show that the concepts of image paradigms and spatial icons à la Lidov are a useful heuristic tool for better understanding the symbolic meanings and communicative intentions of imperial ceremonies. For the purposes of these ceremonies, the emperor should be understood as being part of a spatial icon. This approach has two significant implications. The first implication concerns the ideological import of the ceremony itself—in short, understanding that ceremonial literally embodied the imperial idea. The image paradigm of the Heavenly Jerusalem was the basis of the most formal of audience ceremonies in the silention, and those responsible for organizing and putting on those ceremonies took specific measures to drive home this impression, to connect the lived ceremony with the imagined paradigm. They used choreography, lighting, decoration, costumes, smells, sounds, and visuals to reify the notion that the earthly court mirrored the heavenly one. The second implication is that to really understand the semiotics of the audience ceremony itself, its "grammar" and ideological implications, it is necessary to incorporate into one's analysis all the material and immaterial elements of late antique ceremonial that informed the rich symbolic meaning of the ritual. In other words, one needs to look at the ceremonies not as images, but as performance (or installation) art. It is not enough to only take into account the figure of the emperor and the gestures made by him and the other participants of the ceremony. In this, Lidov's methodology is helpful.

213 Athenagoras, *Leg.* 13.2 (M. Marcovich, ed., *Athenagoras, Legatio Pro Christianis*, PTS 31 [Berlin, 1990]): ἡ τελεία εὐωδία. Cf. Eccles. (Jesus Sirach) 24:20–21: *et quasi balsamum non mixtum odor meus*. See Caseau, "Εὐωδία," 218–20; S. Ashbrook Harvey, *Scenting Salvation: Ancient Christianity and the Olfactory Imagination* (Berkeley, 2006), 11–21; 46–56; James, "Senses." It was also thought that authentic relics could be identified by the sweet smell they gave off.

214 Harvey, *Scenting Salvation*, 54. Cf. Caseau, "Εὐωδία," 252–60.

215 James, "Senses," 525–26; Harvey, *Scenting Salvation*, 64.

216 Harvey, *Scenting Salvation*, 65.

217 *Book of the Eparch* 10.1 (J. Koder, ed., *Das Eparchenbuch Leons des Weisen*, CFHB 33 [Vienna, 1991]: Ἔστωσαν δὲ τὰ τούτων ἀββάκια μετὰ καὶ τῶν καβιῶν ἀπὸ τῆς πανσέπτου εἰκόνος Χριστοῦ τοῦ Θεοῦ ἡμῶν τῆς ἐπὶ τῇ Χαλκῇ στοιχηδὸν ἱστάμενα μέχρι τοῦ Μιλίου, ὡς ἄν εἰς εὐωδίαν ἁρμοζόντως τῆς εἰκόνος καὶ τέρψιν τῶν βασιλικῶν προαυλίων εἴησαν. For the English, E. H. Freshfield, trans., *Roman Law in the Later Roman Empire: The Isaurian Period, Eighth Century, the Ecloga* [Cambridge, 1938], repr. in *ΤΟ ΕΠΑΡΧΙΚΟΝ ΒΙΒΛΙΟΝ / The Book of the Eparch / Le Livre du Préfet, with an introduction by Professor Ivan Dujcev* [London, 1970], chap. 5).

When conceptualizing the emperor as a spatial icon in Lidov's interpretation, however, one must fully grasp the term. In Byzantine and Orthodox understanding, an icon is not simply a two- (or three-)dimensional image, but a pathway to an otherworldly sphere—a "channel" to the divine. This applies to the spatial imperial icon as well. An audience with the emperor, in terms of ideology, was also meant to be an "otherworldly" experience in that the emperor was not a mere ruler, but God's directly appointed viceroy. To adapt Lidov's term, the formal imperial audience was a "hierotopy" of power, an irruption of the divine into the politic. Through the performative presentation of the ideological foundation of the ceremonial, the court's active participation, and the ubiquity of the image paradigm at its root, the audience at the court of the emperor became a ceremony at the heavenly court of God. Understanding it as such explains in part the importance of ceremonial to late Roman and Byzantine emperors.

The emperor was not alone in ceremonies, however, and the officially sanctioned, top–down projection of symbolic meaning was (and is) not the only way in which to make sense of ceremonies. Participants in ceremonies brought their own perspectives and interpretations to the table. Individual or group receptions of ceremonial, its understanding or interpretation, depended on a number of factors: the participants, familiarity with ceremonies, their erudition or attentiveness to ceremonial details, their status and rank, their relationship with the emperor or elites, and, not least, the degree of their integration into the Roman world and thus their understanding of it. The effect and received message of individual elements of the ceremony and of the ceremony as a whole depended on these factors.

For instance, there is no knowing whether foreign envoys picked up on the deeper symbolism of most of the ceremonial elements discussed here. On the whole, it would seem rather unlikely in the case of envoys from non-Christian nations. The reason Corippus could believably claim that the Avar envoys thought themselves in "another heaven" had nothing to do with the envoys themselves, who would not necessarily have had any notion of the Heavenly Jerusalem or, indeed, the Christian vision of the Heavenly Court of God. In their eyes, the actual displaying of material wealth, military power, and civilizational advances—which over the centuries the court in Constantinople had learned to present in elaborate and refined ceremonies—would have been the main point. After all, their own rulers would have attempted similar displays, meant to impress and cow, during audiences at their courts, to which Roman envoys regularly traveled. External groups had always been quick to pick up on the advantages of Roman wealth and a Roman lifestyle and keenly attuned to the importance of displayed wealth in diplomacy, as illustrated, for example, by the description of Attila's court in the fragments of accounts by Priskos and Menander the Guardsman's about a Roman embassy to the Turks.[218] Persian ambassadors were perhaps another case. Conceivably, they may have had a better understanding of political ideology due to the centuries-long history of diplomacy between Rome and Persia, which would have bred a certain familiarity at the least, and given the existence within the Sāsānian Empire of a significant Christian (albeit, from a Constantinopolitan point of view, heterodox) community, whose head, the catholicos of Seleucia-Babylon, was a salaried official of the state.

There was certainly an element of one-upmanship to ancient diplomacy, particularly in Romano-Persian relations, and there is at least circumstantial evidence of mutual influencing, particularly between the Roman and Persian courts, the "Two Eyes of the World."[219] This begs an important, but ultimately impossible to answer, question: Quite apart from the cosmological implications of the ceremonies that a Persian noble

218 Priskos, *History*, frag. 11 and 12.1 (R. C. Blockley, ed., *The Fragmentary Classicising Historians of the Later Roman Empire*, vol. 2 [Liverpool, 1983]); Menander the Guardsman, *History*, frag. 10.3 (ed. Blockley).

219 Theophylact Simocatta, *History* 4.11.2–3. On the cultural exchanges and the cold war–like ritual competition between the two courts, see M. Canepa, *The Two Eyes of the Earth: Art and Ritual of Kingship between Rome and Sasanian Iran* (Berkeley, 2009). There are hints in seventh-century sources that Khusro II in fact choreographed a Roman accession ceremony in Edessa in 603 when he proclaimed the alleged son of Maurice as emperor in his war against Phocas: *Khuzistan Chronicle* 14 (G. Greatrex and S. N. C. Lieu, trans. and eds., *The Roman Eastern Frontier and the Persian Wars: Part II, AD 363–630* [London, 2002], 229–37), the *Seert Chronicle* 199, 223–24 (A. Scher, ed., *Histoire Nestorienne [Chronique de Séert]*, PO 13.4.65 [Paris, 1918]), and the *History of Khosrow* (Ps.-Seb. 107, 110–11, R. W. Thomson, ed., *The Armenian History Attributed to Sebeos*, trans. R. W. Thomson, comm. J. Howard-Johnston, TTH 31 [Liverpool, 1999]). On the implications of this, see C. Rollinger, "#notmyemperor: Theodosios, Son of Maurice, Revisited," in *Fake News in Antiquity*, ed. D. de Brasi, T. Tsiampokalos, and A. Papathomas (forthcoming).

witnessed, just how impressed would he have been with the pomp of the Roman court when already accustomed to the different, but surely no less impressive rituals at the court of Ctesiphon? Roman ceremonial would have doubtlessly impressed and, perhaps, terrified envoys from "barbarian" peoples more than courtiers from a similarly advanced and centrally organized state such as that of the Sāsānians.

Awing foreigners certainly constituted an important part of diplomatic ceremonial. It even played a role, albeit a more subtle one, when the envoys hailed from friendly or, indeed, very friendly states. Two chapters in the *Book of Ceremonies* describe the protocol for admissions involving envoys from the Western Empire, which obviously must date to no later than the fifth century.[220] The ceremony itself was not much different from the general model described above, but the instructions in the *Book of Ceremonies* are a striking proof of both the flexibility of Roman ceremonial and its inherent ability to impart even minuscule nuances, immediately understandable by the target audience. Concessions were made to the envoys being Roman (albeit from a potentially rival court); the envoys themselves, as well as their staff, were ceremonially integrated into the hierarchy of the Constantinopolitan court according to their rank, to which appropriate deference was shown.[221] For instance, when being admitted into the imperial presence, Roman envoys were not preceded by a special section of guards, as other envoys were, "because the ambassadors are not barbarians."[222] These Romans would naturally have been attuned to the symbolic and ideological implications of individual elements of the ceremony—which is not to say that there would not have been an element of one-upmanship here, too—with which they would

likely have been familiar, although the sources are silent on this; much less is known about the ceremonies of the Western court than that of the East, and there is no telling to what extent sixth-century ceremonies precisely mirrored earlier ones.[223]

As previously mentioned, however, it is mostly the inherent nature of the extant sources, which describe the elaborate ceremonial of diplomatic audiences, rather than those of "normal" admissions, that creates the impression of there being a focus on the diplomatic. Not all audiences involved diplomats; indeed, most did not. Regardless of who was being admitted, every audience of the emperor was imbued with concurrent symbolisms and complex and highly ideologized webs of references, allusions, and metaphors. They were aimed at all participants, but each would have received them differently. From the standpoint of foreign envoys, for instance, the palace and court elites were certainly perceived as part of the late Roman state and its display of splendor; glorified extras in a theatrical show of power, or to quote T.S. Eliot, each an "attendant lord, one that will do / To swell a progress, start a scene or two."[224] Byzantine court officials, though they would likely have taken pride in lording it over steppe "barbarians," themselves viewed the ceremony differently. Thus, what to the envoys was an agonistic display of soft and hard power, and what was to the emperor and his top officials an opportunity to reify a divinely ordained hierarchy of power (not least to the court), could also be, to the middle and lower hierarchies of the court, a means of ascertaining and navigating relative status or power configurations in court circles, which were easily observable. Ceremonies visualized power structures and hierarchies. Courtiers and all participants in ceremonial were spatially placed and organized as a reflection of their relative rank within the court and broader imperial hierarchy. This is clear from the detailed descriptions of such ceremonial in the *Book of Ceremonies*,

220 *Book of Ceremonies* 1.87–88 (ed. Reiske, 393–98).

221 *Book of Ceremonies* 1.87 (ed. Reiske, 394): It is explicitly stated that "nothing is done otherwise than is customary for [bearers of these] titles here" (οὔτε ἄλλο τί ποτε τῶν εἰωθότων ἐπὶ ταῖς ἐνταῦθα ἀρχαῖς γίνεται).

222 *Book of Ceremonies* 1.87 (ed. Reiske, 394): ἁρμάτοι δὲ ἐπὶ τοῦ βασιλεώς οὐκ εἰσέρχονται διὰ τὸ μὴ εἶναι βαρβάρους τοὺς πρεσβευτάς. There is also no "summons" (*citatio*, rendered in Greek as κιτατίων) by the magister, as there is for foreign envoys (κιτατίονος μὴ γινομένης ὡς ἐπὶ ἄλλων πρεσβεύων). This refers to the official, written summons of the envoys to court that an assistant of the magister (σουβαδίουβα, *sub-adiuva*) or a *decurio* delivers to the diplomats on the eve of the audience (*Book of Ceremonies* 1.89, ed. Reiske 403). These are presented to the *admissionalis* before the envoys are admitted in front of the enthroned emperor.

223 I would argue for a significant degree of overlap or consistency, as ceremonies are by their very nature conservative and traditional. The same applies to them in later centuries, though in this case the role of iconoclasm in transforming both ideology and expressions of the ideology is almost unfathomable. The ideological foundations, in any case, remained the same, and most ideologemes of the divinely appointed Christian ruler can be traced back to the political theology of Eusebius.

224 T. S. Eliot, "The Love Song of J. Alfred Prufrock." Cf. Luchterhandt, "Bilder ohne Worte," 347.

which reflect an obsession with τάξις (order) and rank. Each dignitary had his own place, behind or below those of higher status, in front of or above those of lower status, closer to or more distant from the imperial figure himself. To the trained observer, the social hierarchy of the court was thus obvious from this spatial disposition alone. From the perspective of the courtier, all audience ceremonies and all ceremonial presented (among other things) a means of ascertaining their own position in the political cosmos and then competing against their peers. Furthermore, the acquiescence in the very framework of spatial ordering implied the courtier's consent and acceptance of the position of the monarch as ultimate arbitrator of status and rank.[225] Such gestures of submission needed to be legitimized, to make sense within an ideological framework, and to be performed physically and spatially. The vehicle for that was ceremony. In the case of imperial audiences, it was not only Rome's superiority over other peoples being staged performatively, nor even a simple visualization of social and court order, but rather the courtiers' and elite's own assent to imperial ideology.

Neither these dynamics of relative power and status between heterogenous groups of participants, nor the ideological accretion of legitimacy through performance took place only in audiences, though they make for an especially striking case study. In almost every appearance of the emperor, the court was also involved. Officials and palace elites accompanied him during urban perambulations, surrounded him in church, attended him in the Hippodrome. In this regard, the emperor was seldom without his court, just as God was never without his seraphim and cherubim. Courtiers and officials—through their participation in the ceremonial exaltation of the emperor, by the veneration of the spatial icon of the emperor, by their acquiescence to being moved about on the playing field of ceremonial like so many rooks and knights and bishops—inserted themselves into the ceremonially constructed image of the divinely appointed ruler propagated by the court and assumed the subordinate positions assigned to them by the divine Creator and his earthly viceregent. As in heaven, so on earth.

University of Trier
Department of History (FB III)
54286 Trier
Germany
rolling@uni-trier.de

225 Rollinger, "Being Splendid." Cf. S. Schmidt-Hofner, "Ehrensachen: Ranggesetzgebung, Elitenkonkurrenz und die Funktion des Rechts in der Spätantike," *Chiron* 40 (2010): 209–44.

THIS ARTICLE HAS BEEN LONG IN THE making. From inception, it was part of a larger work on late antique imperial ceremonial in general, currently being prepared for publication as C. Rollinger, *Zeremoniell und Herrschaft in der Spätantike: Die Rituale des Kaiserhofs in Konstantinopel (4.–7. Jh.)* (Stuttgart, forthcoming 2024). While that monograph presents a systematic overview of the evolution and political import of Byzantine ceremonies as a multifaceted means of communication in the context of urban emperorship, the article here is a case study more focused on Byzantine ritual aesthetics and symbolism in a specific ceremony—the diplomatic exchange—and seeks to introduce a new approach to the study of ceremonies.

The analysis presented here is based on papers I delivered at the Danish Institute in Rome and at the Universities of Regensburg, Stuttgart, Heidelberg, and Tübingen. I would like to thank the convenors of the respective seminars and the participants for their insights and helpful discussions. I am also obliged to Amy Russell and Monica Hellström for inviting me to *Social Dynamics of Roman Imperial Imagery*, a workshop held in 2017 at Durham University. This allowed me to pursue my interest in Alexei Lidov's concept of hierotopy, and the participants provided valuable input during the discussions. Two anonymous reviewers made a number of insightful comments that improved the text considerably, and Colin Whiting has been an exemplary editor, both helpful and efficient. To all, I extend my sincere gratitude.

Reconstructing the Wine Industry of Byzantine Amorium

Production and Consumption of Wine in Central Asia Minor, Seventh to Ninth Centuries

NIKOS TSIVIKIS, THANASIS SOTIRIOU,
OLGA KARAGIORGOU, AND ILIAS ANAGNOSTAKIS

The production and consumption of wine in late antique and medieval Asia Minor is a subject that has recently attracted significant attention, despite the fact that Byzantine historical accounts on wine in the region are limited and have been extensively discussed.[1] The study of archaeological evidence has been dynamically evolving and largely setting the pace in the study of the field.[2] At the same time, the history and archaeology of the region have been enriched by the rapidly developing study of the paleoenvironment, offering new insights in our understanding of the interplay between climate and agricultural production.[3]

The archaeological evidence connected with wine production unearthed in the systematic excavation of Amorium in central Asia Minor is of special importance in this discussion, as it offers a unique window into the relatively unknown conditions of wine making in Byzantine cities. The main aim of this paper is to combine archaeological material with historical information and environmental data and offer answers to questions on why Amorium developed into a wine-production center, how wine was produced in the city,

1 I. Anagnostakis, Βυζαντινός οινικός πολιτισμός: Τὸ παράδειγμα τῆς Βιθυνίας/Wine Culture in Byzantium: The Bithynian Example (Athens, 2008); I. Anagnostakis, "Noms de vignes et de raisins et techniques de vinification à Byzance: Continuité et rupture avec la viticulture de l'antiquité tardive," Food and History 11 (2013): 35–59; M. Kaplan, "La viticulture byzantine (VIIᵉ–XIᵉ siècles)," in Olio e vino nell'alto Medioevo: Atti delle LIV settimane di studio della Fondazione Centro italiano di studi sull'alto Medioevo, Spoleto, 20–26 aprile 2006 (Spoleto, 2007), 163–207, esp. 163–82; and I. Anagnostakis and T. Boulay, "Les grands vignobles bithyniens aux époques romaine et protobyzantine," in Propriétaires et citoyens dans l'Orient romain, ed. F. Lerouxel and A.-V. Pont (Bordeaux, 2016), 25–49. For the continuing use of wine in Seljuk and Ottoman Anatolia, see B. Kitapçı Bayrı, Warriors, Martyrs, and Dervishes: Moving Frontiers, Shifting Identities in the Land of Rome (13th–15th Centuries) (Leiden, 2020), 85–88.

2 E. Dodd, "The Archaeology of Wine Production in Roman and Pre-Roman Italy," AJA 126.3 (2022): 443–80; R. Frankel, Wine and Oil Production in Antiquity in Israel and Other Mediterranean Countries (Sheffield, 1999); J.-P. Brun, Le vin et l'huile dans la Méditerranée antique: Viticulture, oléiculture et procédés de transformation (Paris, 2003); Ü. Aydınoğlu and A. K. Şenol, eds., Antik çağda Anadolu'da zeytinyağı ve şarap üretimi: Sempozyum bildirileri, 06–08 Kasım 2008, Mersin, Türkiye/Olive Oil and Wine Production in Anatolia during Antiquity: Symposium Proceedings, 06–08 November 2008, Mersin, Turkey (Istanbul, 2010); A. Diler, A. K. Şenol, and Ü. Aydınoğlu,

eds., Olive Oil and Wine Production in Eastern Mediterranean during Antiquity: International Symposium Proceedings 17–19 November 2011 Urla - Turkey/Antikçağ'da Doğu Akdeniz'de zeytinyağı ve şarap üretimi: Uluslararası sempozyum bildirileri 17–19 Kasım 2011 Urla - İzmir (Izmir, 2015); and E. K. Dodd, Roman and Late Antique Wine Production in the Eastern Mediterranean: A Comparative Archaeological Study at Antiochia ad Cragum (Turkey) and Delos (Greece) (Oxford, 2020).

3 A. Izdebski, A Rural Economy in Transition: Asia Minor from Late Antiquity into the Early Middle Ages (Warsaw, 2013); J. Haldon et al., "The Climate and Environment of Byzantine Anatolia: Integrating Science, History, and Archaeology," Journal of Interdisciplinary History 45.2 (2014): 113–61; and J. Haldon, "Remarks on History, Environment, and Climate in Byzantine Anatolia: Comments on a Complex Landscape," in Space and Communities in Byzantine Anatolia: Papers from the Fifth International Sevgi Gönül Byzantine Studies Symposium, ed. N. D. Kontogiannis and B. T. Uyar (Istanbul, 2021), 3–17.

and who were its consumers. Hence, through a multidisciplinary approach, we attempt to set the phenomenon in its historical setting and offer a basic outline of wine production and consumption in central Asia Minor between the seventh and ninth centuries.

State of Research

Inland Asia Minor has been traditionally portrayed as suitable mainly for animal husbandry, cereal agriculture, and stock raising, in contrast to the coastal zones, featuring cereal crops, vineyards, and olive groves, the basis for the Mediterranean triad.[4] Therefore, the central parts of Anatolia were not considered in relevant traditional scholarship among the places where wine was systematically produced.[5] Up to a point, this picture relies on the difficulties that the local landscape poses to viticulture, but mostly on Byzantine textual sources reproducing the perception of a *wineless plateau*. Among the most often quoted ones are the letters sent out by Leo, the tenth-century metropolitan of Synada, who noted that "our land does not yield wine because of the high altitude and the short growing season," and John Mauropous, the eleventh-century metropolitan of Euchaita, who lamented that "with regard to wine . . . the land is unfortunate owing to its utter poverty and want."[6] It is worth noting, however, that the underlying context is that both these two ecclesiastic intellectuals had left

Constantinople for their appointment to provincial Anatolian towns and, next to other troubles of country life, they also complained about the lack of wine in their dioceses.[7] Such complaints, obviously meant to convey the strong nostalgia of the two prelates for the "civilized" way of life in Constantinople, must contain elements of exaggeration.[8] This view is contrasted by the compelling Roman and Early Byzantine epigraphic and archaeological evidence indicating that parts of the plateau had been rich in viticulture and wine making already in earlier times.[9] This evidence, which has not been systematically studied so far, needs to be revisited and added to a wealth of newly acquired data.[10] These include numerous archaeological finds that have been published over the last two decades in connection with a renewed interest in wine making, especially during the early medieval and Middle Byzantine periods.[11] At the same time, new

4 M. F. Hendy, *Studies in the Byzantine Monetary Economy, c. 300–1450* (Cambridge, 1985), 138–45, 70, map 13.

5 J. Lefort, "The Rural Economy, Seventh–Twelfth Centuries," in *The Economic History of Byzantium: From the Seventh through the Fifteenth Century*, ed. A. E. Laiou (Washington, DC, 2002), 234, 249. The opposite view has already been expressed in C. S. Lightfoot, "Excavations at Amorium: Results from the Last Ten Years (1998–2008)," in *Archaeology of the Countryside in Medieval Anatolia*, ed. T. Vorderstrasse and J. Roodenberg (Leiden, 2009), 142; C. S. Lightfoot, "Business as Usual? Archaeological Evidence for Byzantine Commercial Enterprise at Amorium in the Seventh to Eleventh Centuries," in *Trade and Markets in Byzantium*, ed. C. Morrisson (Washington, DC, 2012), 177–91, at 182, n. 22; and C. S. Lightfoot, "City and Countryside in Byzantine Anatolia: Amorium," in *Byzantium in Transition: The Byzantine Early Middle Ages, 7th–8th c. AD*, ed. A. K. Vionis (Nicosia, forthcoming).

6 Leo of Synada, *Correspondence*, no. 43 (M. P. Vinson, ed. and trans., *The Correspondence of Leo, Metropolitan of Synada and Syncellus*, CFHB 23 [Washington, DC, 1985], 68–71), and Ioannes Mauropous, *Letters*, no. 64 (A. Karpozilos, ed. and trans., *The Letters of Ioannes Mauropous, Metropolitan of Euchaita*, CFHB 34 [Thessaloniki, 1990], 173).

7 For Synada (modern Şuhut), see K. Belke, "Synada," *TIB* 7:393–95. For Euchaita (modern Avkat), see J. Haldon, "Euchaïta: From Late Roman and Byzantine Town to Ottoman Village," in *Archaeology and Urban Settlement in Late Roman and Byzantine Anatolia: Euchaïta-Avkat-Beyözü and Its Environment*, ed. J. Haldon, H. Elton, and J. Newhard (Cambridge, 2018), 210–54. See also Lightfoot, "Business as Usual?," 184, n. 40.

8 John Mauropous considered his appointment to Euchaita an exile (Karpozilos, *The Letters of Ioannes Mauropous*, 17). Leo's testimony is part of an epistle through which he protested to the emperor about the poverty of his metropolis (A. Kazhdan, *A History of Byzantine Literature [850–1000]*, ed. C. Angelidi [Athens, 2006], 293).

9 S. Mitchell, *Anatolia: Land, Men, and Gods in Asia Minor*, vol. 1, *The Celts in Anatolia and the Impact of Roman Rule* (Oxford, 1993), 146–47. For archaeological evidence of the region of Phrygia, which is the main focus of this article, see M. Waelkens, "Phrygian Votive and Tombstones as Sources of the Social and Economic Life in Roman Antiquity," *Ancient Society* 8 (1977): 277–315, and T. T. Sivas, "Wine Presses of Western Phrygia," *Ancient West & East* 2.1 (2003): 1–18.

10 In the seminal works of Frankel in the late 1990s on winepresses and wine production in antiquity, when offering an overview of the Mediterranean, the inland area of Asia Minor is shown as completely barren of relevant archaeological evidence; see Frankel, *Wine and Oil Production*, 170–74. In Andrea Zerbini's 2015 bibliographical overview of late antique wine and olive oil production and its economy in Asia Minor, only a single study by Stephen Mitchell on olive oil is presented: A. Zerbini, "The Late Antique Economy: Primary and Secondary Production," in *Local Economies? Production and Exchange of Inland Regions in Late Antiquities*, ed. L. Lavan (Leiden, 2015), 64.

11 S. Mitchell et al., "Church Building and Wine Making East of Ankara: Regional Aspects of Central Anatolia in the Early Byzantine Period," *Gephyra* 21 (2021): 199–229; N. Peker, "Agricultural Production and Installations in Byzantine Cappadocia: A Case Study Focusing on Mavrucandere," *BMGS* 44.1 (2020): 40–61; P. Niewöhner, "The Riddle of the Anatolian Cross Stones: Press Weights for Church or Monastic

environmental data allows us to gain a more trustworthy picture of the agricultural potential of this area.[12]

Amorium has been one of the few sites steadily providing us with significant new archaeological information on the subject with the discovery of considerable evidence on extensive wine production taking place inside the city between the seventh and ninth centuries.[13] More specifically, a series of wine-making installations has been unearthed, whose number and size imply extensive viticulture locally and the processing of large quantities of grapes for the making of wine.[14]

The Site and the City of Amorium

Amorium is situated 970 m above sea level in the highlands of Phrygia. It lies on the southern side of a large plain that is well irrigated by rivers and streams belonging to the broader Sangarius riverine system. The plain is delimited by the Emirdağ Mountains to the south, the Phrygian highlands to the northwest, and the Sivrihisar range to the northeast. To the west via Dorylaeum, it opens onto the road leading to Constantinople and on the east to the road to Iconium, traversing the Konya plain and reaching as far as the Cilician Gates and Syria (Fig. 1).[15]

The excavation has revealed a small but indicative portion of the Byzantine city that stood on top of the previous Hellenistic and Roman settlement. Byzantine Amorium can be divided into the walled Lower City that received its curtain wall probably in the late fifth or early sixth century and the fortified Upper City, which was fortified separately for the first time probably in the seventh century and refortified once again in the ninth or tenth century (Fig. 2).[16] These fortifications marked the cityscape of Amorium and remained in use with several phases of reconstruction and abandonment until the second half of the eleventh century and the coming of the Seljuks into the area.[17]

Inside the walled Lower City, which would have been the main hub of life and work for the inhabitants of Amorium, archaeological investigation in different areas has brought to light an unusually high number of industrial installations connected to wine making.[18]

Estates?," in *Archaeology of a World of Changes: Late Roman and Early Byzantine Architecture, Sculpture and Landscapes; Selected Papers from the 23rd International Congress of Byzantine Studies (Belgrade, 22–27 August 2016) in Memoriam Claudiae Barsanti*, ed. D. Moreau et al. (Oxford, 2020), 327–36; and G. Varinlioğlu, "Trades, Crafts, and Agricultural Production in Town and Countryside in Southeastern Isauria," in *Archaeology and the Cities of Asia Minor in Late Antiquity*, ed. O. Dally and C. Ratté (Ann Arbor, MI, 2011), 173–87.

12 A recent overview of the discussion can be found in Haldon, "Remarks on History, Environment, and Climate in Byzantine Anatolia," and J. Newhard, H. Elton, and J. Haldon, "Assessing Continuity and Change in the Sixth to Ninth Century Landscape of North-Central Anatolia," in *Winds of Change: Environment and Society in Anatolia*, ed. C. H. Roosevelt and J. Haldon (Istanbul, 2022), 141–60.

13 For earlier works on Amorium wines, see C. S. Lightfoot, "Stone Screw Press Weights," in *Amorium Reports II: Research Papers and Technical Reports*, ed. C. S. Lightfoot (Oxford, 2003), 73–79; C. Lightfoot and O. Koçyiğit, "Antik Kent/Amorium: Şarap ve Felaket," *Aktüel Arkeoloji* 11 (2009): 42–43; O. Koçyiğit, "Amorium'da bulunan yeni veriler ışığında bizans dünyası'nda şarap üretimi," in *XIII. Ortaçağ ve Türk Dönemi Kazıları ve Sanat Tarihi Araştırmaları Sempozyumu bildirileri: 14–16 Ekim 2009/Proceedings of the XIIIth Symposium of Medieval and Turkish Period Excavations and Art Historical Researches: 14–16 October 2009*, ed. K. Pektaş, S. Cirtil, and S. Özgün Cirtil (Denizli, 2010), 393–402. There is no solid evidence of wine making in pre-Byzantine Amorium, as the Roman city either still lies buried or has been almost completely destroyed by later occupation.

14 Detailed discussion on the installations excavated inside the Enclosure trench appears in E. A. Ivison, "Excavations at the Lower City Enclosure, 1996–2008," in *Amorium Reports 3: The Lower City Enclosure; Finds Reports and Technical Studies*, ed. C. S. Lightfoot and E. A. Ivison (Istanbul, 2012), 47–50.

15 J. Howard-Johnston, "Authority and Control in the Interior of Asia Minor, Seventh–Ninth Centuries," in *Authority and Control in the Countryside: From Antiquity to Islam in the Mediterranean and Near East (6th–10th Century)*, ed. A. Delattre, M. Legendre, and P. Sijpesteijn (Leiden, 2019), 132–35, and K. Roussos, "Tracing Landscape Dynamics in the Vicinity of Amorium," in *Byzantine Medieval Cities: Amorium and the Middle Byzantine Provincial Capitals*, ed. N. Tsivikis (Berlin, forthcoming).

16 C. S. Lightfoot, "Survival of Cities in Byzantine Anatolia: The Case of Amorium," *Byzantion* 68.1 (1998): 64–65; E. A. Ivison, "*Amorium* in the Byzantine Dark Ages (Seventh to Ninth Centuries)," in *Post-Roman Towns, Trade and Settlement in Europe and Byzantium*, vol. 2, *Byzantium, Pliska, and the Balkans*, ed. J. Henning (Berlin, 2007), 41–43; and N. Tsivikis, "Amorium and the Ever-Changing Urban Space: From Early Byzantine Provincial City to Middle Byzantine Provincial Capital," in Kontogiannis and Uyar, *Space and Communities in Byzantine Anatolia*, 200–202.

17 Lightfoot, "Survival of Cities in Byzantine Anatolia," 66; E. A. Ivison, "Urban Renewal and Imperial Revival in Byzantium (730–1025)," *ByzF* 26 (2000): 13–18; H. Yılmazyaşar and Z. Demirel Gökalp, "Amorium'da yukarı şehir iç sur kazıları (2014–2018)," *Anadolu Üniversitesi sosyal bilimler dergisi* 21.4 (2021): 521–54; and Tsivikis, "Amorium and the Ever-Changing Urban Space," 202–5.

18 The main areas of the Lower City of Amorium that have been excavated are the Enclosure trench in the city center, named after a Middle Byzantine fortification installed after the destruction of 838; the Church A trench, also in the center; the Triangular Tower trench,

Fig. 1.
Map of Asia
Minor showing
places referred to
in the text. Map
by J. C. Donati.

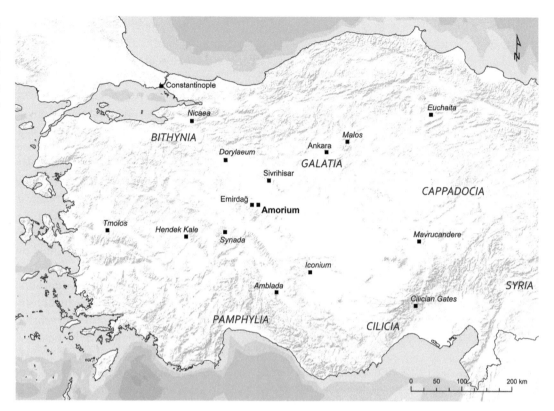

Fig. 2.
Topographical plan of
Amorium indicating the
location of wine-making
installations. Designed by
J. C. Donati, based on plan
courtesy of the Amorium
Excavations Project.

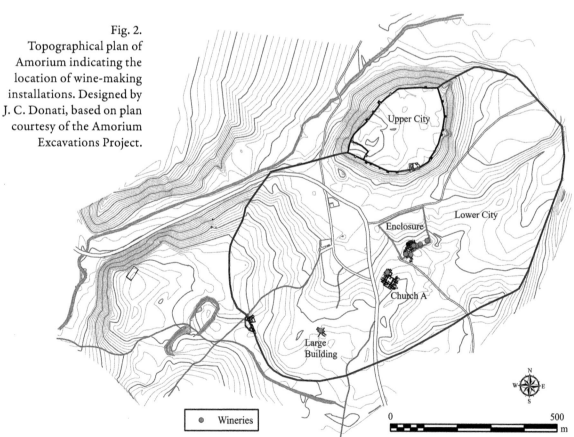

Wine-Producing Installations at Amorium

Eleven wine-making installations have been excavated in Amorium up to this point, and there is circumstantial evidence for the existence of more. A detailed account of this material, presented so far either in interim excavation reports or in more generic essays, is offered here in the accompanying catalogue (Table 1).

Wineries have been unearthed at the Lower City of Amorium in three different locations (Fig. 2). The largest number of these—nine—has been discovered clustered in the center of the city, forming an industrial neighborhood, which was explored from 1996 until 2008.[19] A single winery was unearthed in 2009 in a side room on the north end of Church A, attached to the wider ecclesiastical complex.[20] Finally, one more winery was discovered during the 2018 and 2019 excavation seasons at a considerable distance from the other installations in a trench near the western gate of the Lower City fortifications.[21] The distribution of wineries in the Lower City of Amorium is remarkable, as they are found in three out of the four large trench areas explored so far.[22]

Despite their diverse state of conservation, the Amorium wineries preserve many of their original characteristics, allowing us to reconstruct their operation and the processes that took place inside them (Fig. 3). There are two distinct types of wine-producing installations found at Amorium: treading floors and winepresses.

The most common type are winepresses, represented by eight fully investigated examples. They all occupied a large ground or semibasement rectangular room of larger structures, and they all shared the same basic construction characteristics that classify them as the lever-and-screw press type.[23]

This type of installation worked by the lever principle, squeezing the pulp under a wooden pressboard that fitted inside a large, mortared tank, probably inside a wooden crate set within the tank. The lever was a long, solid, wooden beam, attached at one end inside the narrow wall of the room. The other end of the lever was attached through a wooden screw mechanism to a massive stone counterweight. By turning the screw mechanism, this far end of the wooden lever would lower, exercising a substantial force to the other end near the wall where the pressboard would have been attached.

A crucial element of the winery was two masonry-built orthogonal tanks (varying from rectangular to square) lined with fine waterproof mortar (Figs. 4, 5, and 6). The larger one was situated near the narrow wall of the room where the wooden lever was fixed. This was the pressing vat, or *lenos*, inside which the grapes or grape skins were pressed. Following the central axis of the pressing tank, a second and much smaller tank was constructed at a lower level; this was the collection vat, or *hypolenion*. A stone spout led the liquids from the larger, higher tank into the smaller, lower one.

No identifiable remains of the wooden parts of the press mechanisms were discovered, but other parts made of stone, built elements, mortar, and metal were found in situ or nearby.[24] The most commonly surviving elements are the pivot stones that were set inside a narrow wall of the winepresses for the fixing of the lever beam, as found in installations A, C, D, G, H, I, and J.[25] These were pairs of ashlar-doweled stone posts set vertically inside a built rubble wall and parallel to each other, allowing a narrow slit between them (Figs. 4, 7–9). They were set inside the wall masonry, and in some cases, as in installation J, the two pivot

where the western gate of the city and parts of its Early Byzantine fortifications have been uncovered; and the Large Building trench in the southwest quadrant, where a huge late Roman/Early Byzantine building complex, parts of which were reused in the seventh to ninth centuries, has been explored.

19 The excavation trenches and related finds are discussed in detail in Lightfoot and Ivison, *Amorium Reports 3*.

20 C. Lightfoot, N. Tsivikis, and J. Foley, "Amorium kazıları, 2009," in *32. Kazı sonuçları toplantısı* (Ankara, 2011), 1:48–49, figs. 4–5.

21 Z. Demirel Gökalp et al., "2018 yılı Amorium kazıları," in *41. Kazı sonuçları toplantısı* (Ankara, 2020), 4:570–71.

22 It is only in the large trench of the Triangular Tower and the West City Gate that no winery remains have been discerned so far, a logical result as this concerns a liminal area focused on military defensive constructions. See C. S. Lightfoot and E. A. Ivison, introduction to *Amorium Reports, Finds I: The Glass (1987–1997)*, ed. M. A. V. Gill (Oxford, 2002), 12–13, and C. S. Lightfoot and E. A. Ivison, "Amorium Excavations 1994: The Seventh Preliminary Report," *AnatSt* 45 (1995): 110–11.

23 Frankel, *Wine and Oil Production*, 76–85, 107–21.

24 A heap of large iron fittings has been interpreted as possibly coming from the dismantled remains of press-beam machinery in installation G: Ivison, "Excavations at the Lower City Enclosure," 55.

25 Pivot stones are referred to as "niches" elsewhere in the bibliography (see, most commonly, Frankel, *Wine and Oil Production*). In Amorium publications, we emphasize the role of this element for the lever principle, and thus we prefer the term "pivot stones."

Table 1. Catalogue of Wine-Making Installations Excavated at Amorium

Inst.	Trench Location	Type	Surviving Elements	Bibliography
A	Enclosure: XC-98 (XC-01), XD-00	Winepress	Large part of the room Pivot stones Pressing vat (partially) Press weight (orthogonal) Figs. 3 and 11	C. S. Lightfoot et al., "The Amorium Project: Research and Excavation in 2000," *DOP* 57 (2003): 289–290, and Ivison, "Excavations at the Lower City Enclosure," 13, 32–33, 55
B	Enclosure: XC-05	Winepress	Large part of the room Pressing vat Collection vat (partially) Stone spout Figs. 3 and 14	C. S. Lightfoot, "Trade and Industry in Byzantine Anatolia: The Evidence from Amorium," *DOP* 61 (2007): 273, and Ivison, "Excavations at the Lower City Enclosure," 16–17, 33, 55
C	Enclosure: XE-04	Winepress	Entire room Pivot stones Pressing vat (partially) Stone spout Press weight (drum) Figs. 3, 13, 16, and 20	C. Lightfoot, O. Koçyiğit, and H. Yaman, "Amorium kazısı, 2005," in *28. Kazı sonuçları toplantısı*, vol. 1 (Ankara, 2007), 275–76, 291–92, pls. 4–5; Lightfoot, "Trade and Industry in Byzantine Anatolia," 272–73, fig. 2; Lightfoot, "Excavations at Amorium," fig. 6; C. S. Lightfoot, "Die byzantinische Stadt Amorium: Grabungsergebnisse der Jahre 1988 bis 2008," *Byzanz–das Römerreich im Mittelalter / Byzantium–the Roman Empire in the Middle Ages / Byzance–l'Empire Romain au moyen age*, ed. F. Daim and J. Drauschke (Mainz, 2010), 299–300, fig. 9; O. Koçyiğit, "Amorium'da bulunan yeni veriler işığında bizans dünyası'nda şarap üretimi," *13. Ortaçağ ve türk dönemi kazıları ve sanat tarihi araştırmaları sempozyumu bildirileri: 14–16 Ekim 2009*, ed. K. Pektaş et al. (Istanbul, 2010) 395, pl. 4; and Ivison, "Excavations at the Lower City Enclosure," 16–17, 39–41, 54
D	Enclosure: XB-03, XB-08	Winepress	Entire room Pivot stones Pressing vat (partially) Figs. 3, 7, and 16	Lightfoot, "Die byzantinische Stadt Amorium," 303–4, and Ivison, "Excavations at the Lower City Enclosure," 16–17, 35–36, 55
E	Enclosure: XE-05, XE-06/XE-08	Treading floor	Entire space Treading floor Collection vat Stone spout Figs. 3, 16, 17, and 18	C. Lightfoot, "Amorium 2005," *AnatArch* 11 (2005): 31–32; C. Lightfoot, O. Koçyiğit, and H. Yaman, "Amorium kazısı, 2006," in *29. Kazı sonuçları toplantısı*, vol. 1 (Ankara, 2008), 450, pl. 9; Lightfoot, "Excavations at Amorium," fig. 10; Koçyiğit, "Şarap üretimi," 395, figs. 1–2; and Ivison, "Excavations at the Lower City Enclosure," 17, 42–43
F	Enclosure: XE-05, XE-06/XE-08	Treading floor	Parts of the space Treading floor (partially) Collection vat Stone spout Figs. 3, 16, 17, and 18	Lightfoot, "Amorium 2005," 31–32; Lightfoot, Koçyiğit, and Yaman, "Amorium kazısı, 2006," 450, pl. 9; Lightfoot, "Excavations at Amorium," fig. 10; Koçyiğit, "Şarap üretimi," 395, figs. 1–2; and Ivison, "Excavations at the Lower City Enclosure," 17, 42–43
G	Enclosure: XC-06/XC-08	Winepress	Entire room Pivot stones Pressing vat Collection vat Stone spout Figs. 3, 4, 5, and 6	C. Lightfoot et al., "Amorium kazıları, 2008," *31. Kazı sonuçları toplantısı*, vol. 1 (Ankara, 2010), 137–42, pls. 8–11; C. Lightfoot and E. Ivison, "Amorium 2008," *AnatArch* 14 (2008): 25–26; C. Lightfoot, "Amorium 2009," *AnatArch* 15 (2009): 24; Lightfoot, "Die byzantinische Stadt Amorium," 298–99, figs. 8–9; and Ivison, "Excavations at the Lower City Enclosure," 17–18, 44

Table 1. *continued*

Inst.	Trench Location	Type	Surviving Elements	Bibliography
H	Enclosure: XA-01	Winepress	Room (partially) Pivot stones Figs. 3 and 19	C. Lightfoot and Y. Arbel, "Amorium kazısı 2001," *24. Kazı sonuçları toplantısı,* vol. 1. (Ankara, 2003), 524, figs. 2, 6, and Ivison, "Excavations at the Lower City Enclosure," 14, 33
I	Church A: A19	Winepress	Room (partially) Pivot stones Pressing vat (partially) Press weight (orthogonal) Figs. 3, 8, and 12	Lightfoot, "Amorium 2009," 24–25; C. S. Lightfoot, N. Tsivikis, and J. Foley, "Amorium kazıları 2009," in *32. Kazı sonuçları toplantısı,* vol. 1 (Ankara, 2011), 48–49, figs. 4–5, and Ivison, "Excavations at the Lower City Enclosure," 49–50
J	Large Building: Area 18	Winepress	Room (partially) Pivot stones Metal beam attachment mechanism Figs. 3, 9, 10, 21, and 23	Z. Demirel Gökalp et al., "2019 ve 2020 yılları Amorium kazıları," in *2019–2020 yılı kazı çalişmaları,* vol. 4 (Ankara, 2022), 507, fig. 4, and Tsivikis, "A Byzantine Neighborhood in Flux"
K	Enclosure: XE-05 and XE-06/ XE-08, continues under MB Enclosure wall	Treading floor	Space (partially) Treading floor (partially) Figs. 3, 16, 17, and 18	Lightfoot, "Amorium 2005," 31–32; Lightfoot, Koçyiğit, and Yaman, "Amorium kazısı, 2006," 450, pl. 9; Lightfoot, "Excavations at Amorium," fig. 10; Koçyiğit, "Şarap üretimi," 395, figs. 1–2; and Ivison, "Excavations at the Lower City Enclosure," 17, 42–43

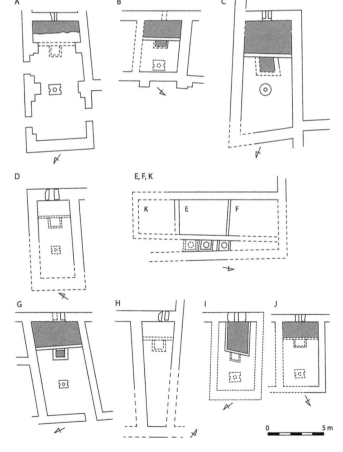

Fig. 3.
Reconstructed ground plans of the wineries found in Amorium. Drawing by Y. Nakas, based on plans provided by the Amorium Excavations Project.

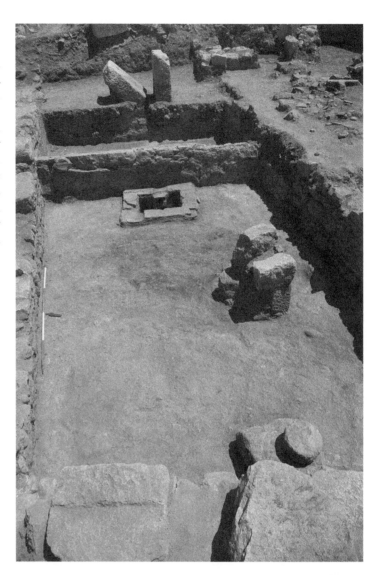

Fig. 4.
Winepress (installation G) in the Enclosure trench, with well-preserved pressing and collection vats, drain with stone spout connecting them, and pivot stones (view from the west). Photograph courtesy of the Amorium Excavations Project, 2008, after Ivison, "Excavations at the Lower City Enclosure," pl. 1/20.

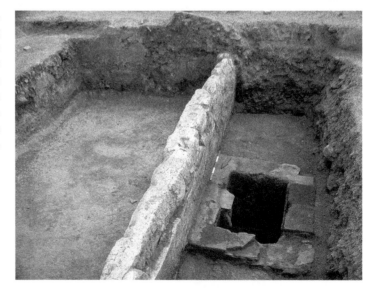

Fig. 5.
Detailed view of the pressing and collection vats with the stone spout of the winepress and solid stone barrier above (installation G) (view from the north). Photograph courtesy of the Amorium Excavations Project, 2008.

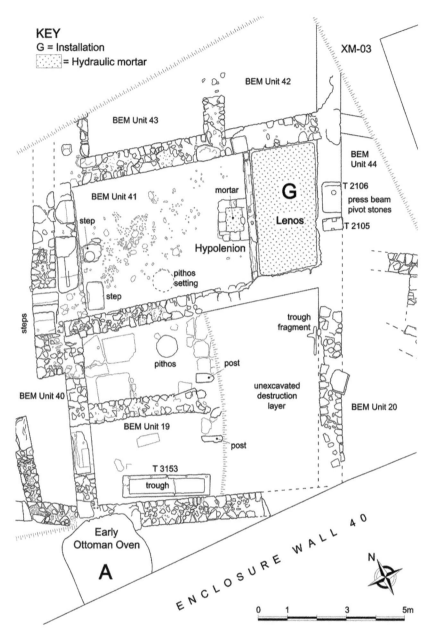

KEY
G = Installation
∴ = Hydraulic mortar

XM-03

BEM Unit 42

BEM Unit 43

BEM Unit 41

BEM Unit 44

mortar

G

Lenos

T 2106
press beam
pivot stones

T 2105

Hypolenion

step

pithos
setting

step

steps

trough
fragment

pithos

post

BEM Unit 40

unexcavated
destruction
layer

BEM Unit 20

BEM Unit 19

post

T 3153

trough

Early
Ottoman Oven

A

ENCLOSURE WALL 40

N

0 1 3 5m

Fig. 6.
Winepress (installation G) in the Enclosure trench; detailed ground plan of the entire complex that housed the winery. Drawing by T. Papadogkonas; courtesy of the Amorium Excavations Project, after Ivison, "Excavations at the Lower City Enclosure," fig. 1/16.

stones were standing on larger ones lying flat inside the wall and set as a base for the two standing stones. The base had a worked upper surface marking the areas where the two vertical stones should be placed and defining the gap between them. In other cases, as in installation G, the stones were decorated with crosses in relief on the narrow surface looking into the room. In all cases, both the standing pivot stones had on their interior faces circular, shallow dowel holes approximately 0.10 m in diameter. These holes were intended to receive the mechanism fixing the end of the wooden lever inside the wall. The long wooden lever must have been perforated or bifurcated at its culmination inside the wall. At that point, some type of an axle set in the round dowel holes would have secured the lever. Large iron fragments of such a massive rotating mechanism or pin were found in installation J inside the slot and near the dowel holes of the pivot stones (Fig. 10). This arrangement is universal in all winepresses in Amorium and quite rare elsewhere, making them stand out from

Fig. 7. Winepress (installation D) in the Enclosure trench with the pivot stones at extreme right (view of the eastern wall from the east). Photograph courtesy of the Amorium Excavations Project, 2004.

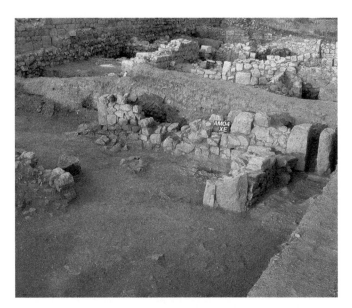

Fig. 8. Winepress (installation I) in Church A built inside an annex north of the baptistery, showing the mortared pressing vat and the pivot stones (view from the north). Photograph courtesy of the Amorium Excavations Project, 2009.

Fig. 9. Winepress (installation J) in the Large Building trench, with the surviving pivot stones of the press on a large stone base (view from the east). Photograph courtesy of the Amorium Excavations Project, 2019.

Fig. 10.
Winepress (installation J)
in the Large Building trench:
large fragments of the iron
mechanism securing the
wooden lever beam to the
doweled pivot stones.
Photograph courtesy of the
Amorium Excavations
Project, 2019.

other known examples, where the fulcrum of the lever has been generally imagined to be adjustable.[26]

At the other end of the lever, a massive stone served as the counterweight for the press machinery. Counterweights were found still in their original position or near it only in three winepresses of Amorium (installations A, C, and I). The surviving stone weights were either orthogonal (installation A, Fig. 11, and installation I, Fig. 12) or cylindrical (installation C, Fig. 13). The weights of installations A and C were also decorated with Christian crosses in relief, a characteristic that is not uncommon on Middle Byzantine winery screw weights from Anatolia.[27] The upper surface of these weights had square and circular dowel holes and dovetail cuts for the slotting and attaching of the wood and metal mechanism of the screw; for the same

reason, the two orthogonal weights had cut mortises on the sides.[28]

In addition to the three weights found in situ or near the excavated wineries, another ten large stone screw weights have been recorded in Amorium, lying in the fields or in the houses of the modern village of Hisar.[29] In total, thirteen large stone weights have been recorded, and among them, only three are securely associated with the eight winepress installations excavated so far. The excessive number of screw press weights clearly indicates that the number of operating winepresses inside the walled city of Amorium was considerably higher than the eight already excavated.[30]

These stone pieces were made-to-order for the presses and must have been highly valued elements, as evidenced by the workmanship invested in them and their occasional decoration. Eventually, when the winepresses fell out of use, they would be the pieces of

26 We would like to thank one of the anonymous reviewers for bringing this fact to our attention.

27 Niewöhner, "Riddle of the Anatolian Cross Stones." Counterweight stones with Christian inscriptions and crosses were also found in late antique Delos (Dodd, *Roman and Late Antique Wine Production*, 108–10, pls. 20–21). There are also examples that trace the tradition for inscribing such production equipment with inscriptions and symbols of protection or ownership in Roman times, as with a third-century *mortarium* from a *trapetum* olive press found in Attica; see S. Katakis, V. Nikolopoulos, and P. Fotiadi, "Νέες έρευνες στον αρχαιολογικό χώρο του λεγόμενου Ρωμαϊκού βαλανείου στην Ραφήνα: Ιδιωτικός ή δημόσιος χώρος," in *What's New in Roman Greece? Recent Work on the Greek Mainland and the Islands in the Roman Period*, ed. V. Di Napoli et al. (Athens, 2018), 322–23.

28 A detailed typology of dovetail cuts and mortises on oil- and winepress weights appears in R. Frankel, "Presses for Oil and Wine in the Southern Levant in the Byzantine Period," *DOP* 51 (1997): 73–84, and Frankel, *Wine and Oil Production*.

29 Six weights, all belonging to the type with a socket and two mortises, were published in 2003 by Lightfoot, "Stone Screw Press Weights." Four more (Amorium inventory nos. T1925, T2016, T3259, and T3363) were later mentioned in passing by Ivison, "Excavations at the Lower City Enclosure," 49. Three more screw press weights from Amorium have been recorded since by Lightfoot in a yet unpublished additional catalogue that was kindly made available to the authors.

30 Lightfoot, "Business as Usual?," 184–87.

Fig. 11. Winepress (installation A) in the Enclosure trench with the stone press weight close to its original position (view from the south). Photograph courtesy of the Amorium Excavations Project, 2001.

Fig. 12. Winepress (installation I) in Church A with the orthogonal stone press weight found in situ (view from the east). Photograph courtesy of the Amorium Excavations Project, 2009.

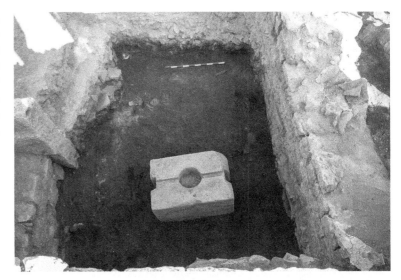

Fig. 13. Winepress (installation C) in the Enclosure trench, with remains of the pressing vat, the collection vat, and the cylindrical stone press weight in situ (view from the north). Photograph courtesy of the Amorium Excavations Project, 2005, after Lightfoot, "Business as Usual?," 185, fig. 7.5.

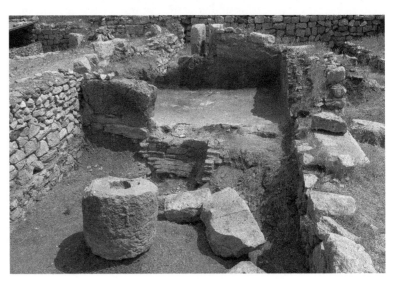

the mechanism that could be easily reutilized in other constructions. Stone screw weights have been discussed lately as a secure indicator for the existence of winepresses in other instances across Anatolia.[31] In our case, the weights complement the picture of extensive wine production inside the walls of the Lower City of Byzantine Amorium.

Characteristic of the Amorium winepresses are also the two tanks found in each installation: the pressing vat and the collection vat. The pressing vat, or large parts of it, is preserved in seven of the eight winepresses (A, B, C, D, G, H, and I). It usually covered an orthogonal area along the narrow end wall of the room in front of the wall where the lever was fitted. The best preserved and larger pressing vats in installations C and G measured approximately 4 × 2.5 m and were more than 1 m deep (see above, Figs. 4, 5, and 13).

The collection vats were placed next to the pressing basins and along their longitudinal axis. Since these vats were smaller and less massive, their archaeological remains were preserved only in three of the eight winepresses (B, C, and G), but it is certain that all of the installations would have collection vats in approximately the same location (Fig. 14; see above, Figs. 5 and 13).[32] The surviving collection vats are less than a quarter the size of the pressing vats, with the best-preserved one, found in Installation G, measuring approximately 1.50 × 1 m and 0.75 m deep. The collection vats were set at a lower level, as they were intended to receive and collect the juice flowing from the higher pressing basins.

Flow between the pressing and the collection vats was facilitated by gravity and siphoned through limestone conduits attached to the elevated tank that projected over the lower tank channeling the juice. Such stone spouts were found in situ or nearby in three of the winepresses (B, C, and G) (see above, Figs. 5 and 14). They were made-to-order elements of local limestone,

like the weights, the pivot stones, and some elements of the pressing tanks.

Both pressing and collection vats were carefully built of mortared masonry with frequent use of recycled Roman bricks; their interior was covered with strong hydraulic mortar suitable for pressing grapes or grape skins, but not hard enough for crushing olives, a fact that excludes olive-oil production in these presses.[33] In order to better understand the use of these constructions, mortar samples from the pressing basin of installation G underwent residue analysis at the Department of Scientific Research of the Metropolitan Museum of Art in New York. According to the report, residues of syringic acid and lactic acid were detected on the pink mortar lining the tank, suggesting the presence of juice or wine from red grapes (Fig. 15).[34]

Regarding their technology, the winepresses of Amorium were sophisticated devices. Their identical technical characteristics possibly point to a common episode or a centrally orchestrated program for their creation. Indeed, as we shall see, they were all built and functioned within a limited period between the mid-seventh and the late eighth or early ninth centuries. The importance of this investment is underlined by the special treatment of certain stone parts of the pressing mechanism that were decorated with Christian apotropaic symbols, probably to safeguard these devices and ensure their smooth operation.[35]

In most cases, the winepresses of Amorium occupied the ground floor or semibasement of two-story buildings, whose upper floor had a domestic use as evidenced by the contextual (or accompanying)

31 Mitchell et al., "Church Building and Wine Making"; Niewöhner, "Riddle of the Anatolian Cross Stones"; and E. Laflı, "Archäologische Evidenzen zum Weinanbau im südwestlichen Paphlagonien in römischer und frühbyzantinischer Zeit," in *Die Schätze der Erde: Natürliche Ressourcen in der antiken Welt; Stuttgarter Kolloquium zur Historischen Geographie des Altertums 10, 2008*, ed. E. Olshausen and V. Sauer (Stuttgart, 2012), 261–79.

32 Collecting vats are a characteristic element of winepresses and in the lever and screw presses are almost always put along the central axis of the installations, allowing the applied pressure to be maximized.

33 For arguments rejecting the use of Amorian presses for olive oil production, see Lightfoot, "Stone Screw Press Weights," 74–75. Additionally, there is no other evidence for any olive-pressing activity in Amorium (i.e., no stone mortars or pressing basins were found). After all, Amorium—at an elevation of approximately 1000 m above sea level and more than 400 km away from any coast—lies firmly outside the olive-tree production zone.

34 The examination was commissioned by C. S. Lightfoot and performed by Adriana Rizzo and Meghan Schwab of the Department of Scientific Research of the Metropolitan Museum of Art in New York (Amorium archive, residue analysis report, 18.02.2016).

35 For stone press weights with decoration, usually Christian, see: Dodd, *Roman and Late Antique Wine Production*, 108–10; Niewöhner, "Riddle of the Anatolian Cross Stones." For rock-cut wineries in Cappadocia with fresco decoration, see Peker, "Agricultural Production," 49–50. For analogous pagan practices in a Roman context, see Dodd, "Archaeology of Wine Production," 454.

Fig. 14.
Winepress (installation B) in the Enclosure trench, with remains of the pressing vat, the collection vat, and the drain connecting them (view from the south). Photograph courtesy of the Amorium Excavations Project, after Ivison, "Excavations at the Lower City Enclosure," pl. 1/10.

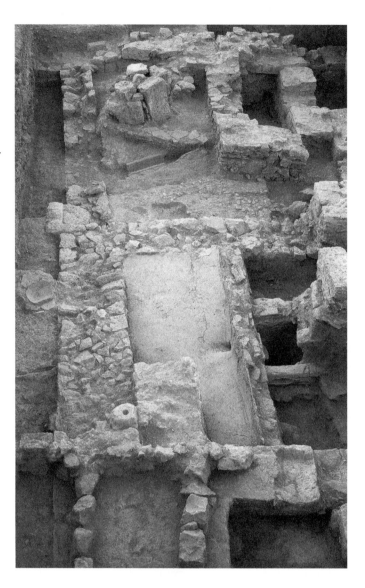

archaeological finds.[36] In the *Geoponika*, we read that the wine-making installations should be constructed in well-aired areas with plenty of light, since they need to be thoroughly cleaned and dried after use.[37] However, the practice often seems to contradict this advice.[38] In the dry climate of Central Anatolia, drying the grape

basins and airing the rooms would have been relatively easy, as we can see in the numerous underground wine-treading installations of medieval and early modern Cappadocia.[39] The practice of the well-protected, almost subterranean, wine-pressing installations would additionally have resolved the constant problem of dust blowing in, especially in an urban setting.

Specific installations were needed, as we will see below in detail, during the second stage of the wine-

36 The metal finds, among which is a substantial number of tools and weapons, from the Enclosure trench are in the process of publication: Ivison, "Excavations at the Lower City Enclosure," 7, 56.

37 *Geoponika* 6.1, 6.10, 6.13 (H. Beckh, ed., *Geoponica sive Cassiani Bassi scholastici de re rustica eclogae* [Leipzig, 1895], 170–71, 179, 182–83).

38 Dodd, *Roman and Late Antique Wine Production*, 38–39, provides a short comparison of pros and cons between open-air and covered or in-house treading rooms.

39 Peker, "Agricultural Production"; E. Balta, "The Underground Rock-Cut Winepresses of Cappadocia," *Journal of Turkish Studies* 32.1 (2008): 61–88; and E. Balta, "Τα υπόσκαφα λαξευτά πατητήρια της Καππαδοκίας," in *Οἶνον ἱστορῶ IV: Θλιπτήρια καὶ πιεστήρια; Ἀπό τοὺς ληνοὺς στὰ προβιομηχανικὰ τσιπουρομάγγανα*, ed. G. A. Pikoulas (Athens, 2005), 226–67.

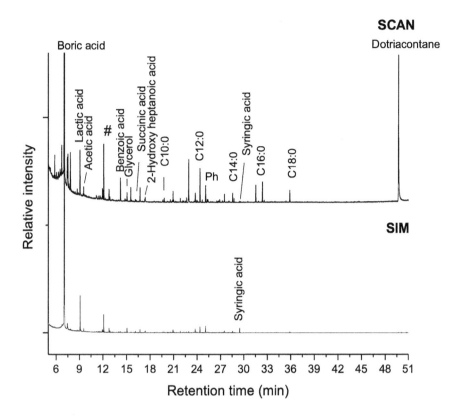

SCAN

Fig. 15.
Residue analysis results of mortar samples from the pressing tank of a winepress (installation G). Analysis by the Department of Scientific Research, the Metropolitan Museum of Art, New York. Chart courtesy of C. S. Lightfoot.

making process, when the pulp and the skins of the first treading were pressed to extract the remaining must.[40]

The first stage traditionally involved treading the grapes by feet in large tanks. Three such simpler treading floors (installations E, F, and K) were discovered in Amorium.[41] These were shallow, broad troughs surrounded by low walls not higher than 0.30 m, looking more like enclosed floors lined with strong, waterproof, pink mortar. All three treading floors found were part of a single complex. The best-preserved one is installation E, which stood in the middle of the three with installation F to its north and installation K to its south (Figs. 16 and 17). The treading floor F was a rectangular

tank, measuring 2.65 × 1.90 m. Its east side was defined by a higher wall rising to 0.80 m and made of large limestone slabs. The wall had stone spouts at a lower point on its outside, similar to the ones in the winepresses, that led the drained liquid to deep collection vats coated with hydraulic mortar (Fig. 18). The treading-floor complex seems to have been a semi-open-air installation with a shed-like roof, supported by wooden posts and neighboring side walls.[42] This is quite distinctive to the winepress rooms, which were all enclosed ground or semibasement rooms.

Wine making seems to have been an important aspect of the much broader economic activity taking place in the houses and larger complexes of Amorium. The domestic units that contained the wine-producing installations hosted several other productive activities, as indicated by contextual finds in adjacent rooms and open spaces, such as stone troughs for animal feeding, storage pithoi, and iron tools for various industrial or agricultural purposes (see, e.g., the courtyard south of installation G, Fig. 6, and the rooms around installation H, Fig. 19).[43]

40 The poor-quality wine produced by the pressing of the pulp was called θάμνα(-ας) (*Geoponika* 6.13 [Beckh, *Geoponica*, 182]). This kind of wine was also named οἶνος δευτέριος or δευτερίας (second wine) (I. Anagnostakis, "Περί θλίψεων καὶ εκθλίψεων," in Pikoulas, *Οἶνον ἱστορῶ IV*, 77–167, at 119–20, 127). In Roman Egypt, it was named οἶνος ἀπὸ στεμφύλων (wine made from grape skins) (D. Dzierzbicka, *ΟΙΝΟΣ: Production and Import of Wine in Graeco-Roman Egypt* [Warsaw, 2018], 223).

41 Ivison, "Excavations at the Lower City Enclosure," 43, based on the discovery of another collection vat, suggests that there must have been one more treading floor to the south under the thick Middle Byzantine Enclosure wall.

42 Ivison, "Excavations at the Lower City Enclosure," 42.

43 Lightfoot, "Excavations at Amorium," 141–43; Ivison, "Excavations at the Lower City Enclosure," 35, 56; and N. Tsivikis, "A

Fig. 16. Ground plan of part of an early medieval Byzantine neighborhood excavated in the Enclosure trench with two winepresses (installations C and D) west of a cobbled street and a complex of three treading floors (installations E, F, and K; installation K lies in the plan under Middle Byzantine Enclosure wall 40.) on the east side. Drawing courtesy of the Amorium Excavations Project, after Ivison, "Excavations at the Lower City Enclosure," fig. 1/14.

Fig. 17.
Treading floors (installations E, F, and K) in the Enclosure trench: at center, the mortared surface of installation E; at top, partially excavated mortared surface of installation F (view from the south). Photograph courtesy of the Amorium Excavations Project, 2005.

Fig. 18.
Collection vats with stone spouts running from the treading floors of installations F and E. Photograph courtesy of the Amorium Excavations Project, 2005, after Ivison, "Excavations at the Lower City Enclosure," pl. 1/18.

Fig. 19.
Winepress (installation H) outside the Enclosure trench, with remains of the pivot stones (view from the east). Photograph courtesy of the Amorium Excavations Project, 2001.

The Creation and Abandonment of Amorium's Wine-Making Industries

The wine-making installations found across Amorium share many common features in their overall construction (building techniques, composition of the strong hydraulic mortar) and the technological solutions adopted. All these suggest that the wineries were created within a short period of time, and the time span of their use could hardly have been more than a century or two. The detailed published accounts on the stratigraphy of the ongoing excavation have determined this time span with relative accuracy.[44]

The wineries were first introduced inside the city walls most probably around the middle of the seventh century.[45] This was a time when the established urban fabric of the city began to lose its late Roman and Early Byzantine character, and the form and function of entire neighborhoods of the city underwent a dramatic change.[46]

Byzantine Neighborhood in Flux: 2013–2019 Excavation of the Large Building in the Lower City at Amorium," in Tsivikis, *Byzantine Medieval Cities.*

44 See Table 1 for detailed references to each installation with bibliographical and archaeological data.

45 Ivison, "Excavations at the Lower City Enclosure," 47–50.

46 Ivison, *"Amorium* in the Byzantine Dark Ages"; Lightfoot, "Survival of Cities in Byzantine Anatolia"; Tsivikis, "Amorium and

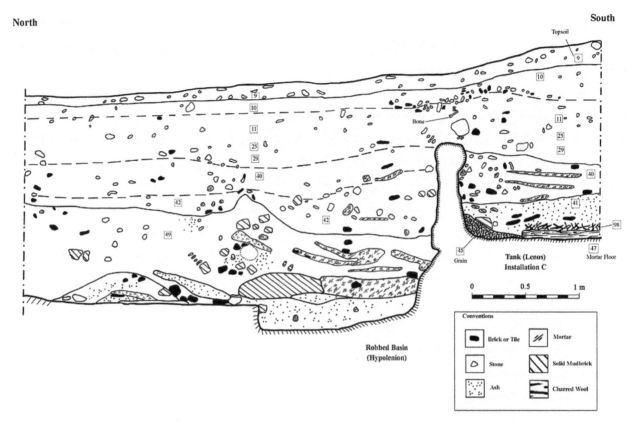

Fig. 20. Stratigraphical section of the fill inside winepress installation C, with remains of grain stored inside the pressing vat at right. Drawing courtesy of the Amorium Excavations Project, after Ivison, "Excavations at the Lower City Enclosure," fig. 1/22.

Based on the excavation data, the end of the wineries can also be dated with certainty at some point before the sack of the city by the Arabs in 838.[47] Most of them were already no longer in use before the destruction of the city, as revealed by their archaeological picture. Winepress installations A, B, D, G, and J were found largely dismantled by the time they were trapped inside the destruction layer. Some of their built components had been removed and likely their wooden mechanisms as well, although this cannot be verified. Their pressing vats, wherever they have survived, were repurposed as storage depots for grain or barley, as evidenced in the stratigraphy of installations

C and G (Fig. 20).[48] In other cases, the pressing and collection basins were completely dismantled, and new storage facilities had been built in their place (Fig. 21). This is one of the main reasons that very few contextual small finds can be attributed to the period of use of the wineries, as intensive wine-making activity inside the city had ceased before the final destruction of these spaces.

Some archaeological evidence in installation I, belonging to the complex of Church A, suggests that this might have been the only winepress that was still intact at the time of the destruction of 838 and perhaps

the Ever-Changing Urban Space"; and Z. Demirel-Gökalp and N. Tsivikis, "Understanding Urban Transformation in Amorium from Late Antiquity to the Middle Ages," in *Proceedings of the Plenary Sessions: The 24th International Congress of Byzantine Studies, Venice and Padua, 22–27 August 2022*, ed. E. Fiori and M. Trizio (Venice, 2022), 324–44.

47 Ivison, "Excavations at the Lower City Enclosure," 54–56.

48 Some of the old wine-pressing basins were found burnt and full of carbonized grain as a result of the destruction (Ivison, "Excavations at the Lower City Enclosure," 54–56). This means that by the early ninth century some of these spaces would have been converted into silos for storage or that other processes could be taking place inside them, like wheat thrashing (Anagnostakis, "Περί θλίψεων και εκθλίψεων," 83–84).

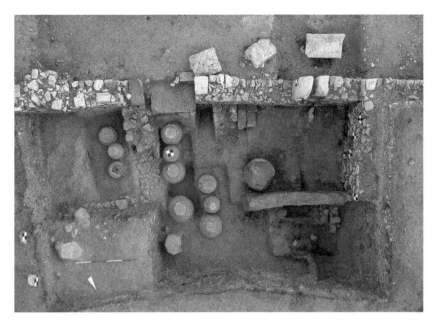

Fig. 21.
Aerial view of the large storage room filled with numerous sealed pithoi created out of installation J in the Large Building trench after the dismantlement of the winepress. Photograph courtesy of the Amorium Excavations Project, 2019.

still functioning (see above, Figs. 8 and 12).[49] We cannot determine the exact time of abandonment for each winery. Since they were only partially dismantled and their spaces were still in use, albeit in a different context, we can plausibly suggest that their abandonment must have happened only a few decades before 838.[50]

Summing up the evidence, the creation and exploitation of the wine-producing facilities of Amorium can be placed between the middle of the seventh century and the beginning of the ninth century. Thus, their function seems to represent a boom episode in the economic life cycle of early medieval Byzantine Amorium.[51]

Reconstructing Wine Making in Early Medieval Byzantine Amorium

Vineyards around Amorium, the Grape Harvest, and Its Transportation

In order for the numerous wine-producing installations found at Amorium to function, they demanded

a massive quantity of grapes. In premodern societies, vineyards were preferably situated not far away from these installations, since the transport of grapes over long distances entailed great risks like losing the prized first grape juice or initiating primary fermentation.[52] There is no archaeological evidence so far of vineyards planted inside the walled area of the city, which was highly developed until at least the ninth century.[53] Consequently, we need to assume that extensive viticulture must have been taking place in the city's immediate hinterland.

The soil in the vicinity of Amorium was and still is appropriate for vine cultivation. The settlement is surrounded by a well-watered fertile plain, today engaged

49 C. Lightfoot, "Amorium 2009," *AnatArch* 15 (2009): 24–25, and Lightfoot, Tsivikis, and Foley, "Amorium kazilari, 2009," 48–49, figs. 4–5.

50 Ivison, "Excavations at the Lower City Enclosure," 59–60.

51 Emlyn Dodd describes a similar boom episode event, in an earlier timeframe, by analyzing the introduction of wine making installations in Early Byzantine Delos in the Aegean (Dodd, *Roman and Late Antique Wine Production*, 108–12).

52 Dodd, *Roman and Late Antique Wine Production*, 113.

53 Amorium does not seem to follow the rule of other post-seventh-century Byzantine cities with the insertion of cultivated fields inside the urban space as part of a phenomenon of "ruralization." For relevant recent discussion, see N. Tsivikis, "Messene and the Changing Urban Life and Material Culture of an Early Byzantine City in the Western Peloponnese (4th–7th Century)," in *Transformations of City and Countryside in the Byzantine Period*, ed. B. Böhlendorf-Arslan and R. Schick (Mainz, 2020), 39–53, and A. Vionis, "Abandonment and Revival between Late Antiquity and the Early Middle Ages: Facts and Fiction," in *Before/After: Transformation, Change, and Abandonment in the Roman and Late Antique Mediterranean*, ed. P. Cimadomo et al. (Oxford, 2020), 85. Vines were cultivated inside the urban fabric of Roman cities, as we know from Pompeii; see lately E. Dodd, "Pressing Issues: A New Discovery in the Vineyard of Region I.20, Pompeii," *ArchCl* 68 (2017): 577–88.

mostly in the cultivation of cereals, that historically could have been used for viticulture.[54] At the same time, about 10 km to the south, the rolling foothills of the mountain range of Emirdağ offer a gentle inclination appropriate for vineyards.[55] Thus, in an easily walkable distance around the city, there is ample land, both flat and sloping, that could have hosted vineyards.[56]

The climate of the area is also adequate for wine production with wet, cold winters and dry, hot summers. Modern reconstructions of the historical climate show significant long-term changes from the fourth to the eleventh centuries in the curve of temperature and moisture, but we cannot be sure about their implications for viticulture.[57] Viticulture remains extremely difficult to trace using environmental proxies since vine pollen travels very short distances from the plant and is seldom found in the lake beds where the well-dated sample cores have been drilled; thus, vines are heavily underrepresented in such samples.[58]

Interestingly enough, there might be some information on the organization of historical, possibly Byzantine, vineyards in the analysis of field systems surrounding the city. According to a historic landscape characterization (HLC) model developed specially for the agricultural landscape of Amorium, visible land divisions southwest of the city and other long-abandoned land divisions further south in the low hills toward the Emirdağ Mountains could reflect historical agricultural divisions and plots (Fig. 22).[59] These are medium to small plots of two different types: strip fields, probably intended for grain cultivation as their form was suitable for the back and forth movement of the oxen and the plow, and more regular coaxial orthogonal plots, better candidates for vineyards, especially as we come close to the Emirdağ foothills.[60]

54 Even today there are some traces of abandoned vineyards, probably modern, in the immediate hinterland of Amorium or even inside the village; see R. M. Harrison and N. Christie, "Excavations at Amorium: 1992 Interim Report," *AnatSt* 43 (1993): 153; Ivison, "Excavations at the Lower City Enclosure," 48; and R. M. Harrison, *Mountain and Plain: From the Lycian Coast to the Phrygian Plateau in the Late Roman and Early Byzantine Period*, ed. W. Young (Ann Arbor, MI, 2001), 74. According to *Geoponica* 7.1 (Beckh, *Geoponica*, 188), τὰ κοῖλα χωρία πολὺν τὸν οἶνον ποιεῖ καὶ φαῦλον (valley land produces abundant, poor-quality wine). For the translation, see A. Dalby, *Geoponika: Farm Work; A Modern Translation of the Roman and Byzantine Farming Handbook* (Totnes, 2011), 159.

55 In *Geoponika*, 5.2, it is recognized that "the finest wine is that made from vines grown on dry and sloping terrain facing East and South" (Dalby, *Geoponika* 124); instead, the foothills of the Emirdağlar face mostly north on the side toward Amorium.

56 Roussos, "Tracing Landscape Dynamics." These favorable conditions are not the rule in Central Anatolia, as the plateau is mainly covered by shallow and poor soil coming from the erosion of limestone ranges. On the soils allowing cultivation of vines in Central Anatolia, see Mitchell, *Anatolia*, 1:145–47, and R. L. Gorny, "Viniculture and Ancient Anatolia," in *The Origins and Ancient History of Wine*, ed. P. E. McGovern, S. J. Fleming, and S. H. Katz (London, 1996), 137–47.

57 Haldon, "Remarks on History, Environment, and Climate in Byzantine Anatolia."

58 S. D. Turner and A. G. Brown, "*Vitis* Pollen Dispersal in and from Organic Vineyards: I. Pollen Trap and Soil Pollen Data," *Review of Palaeobotany and Palynology* 129 (2004): 117–32; this assumption was further verified by D. Fuks et al., "The Rise and Fall of Viticulture in the Late Antique Negev Highlands Reconstructed from Archaeobotanical and Ceramic Data," *Proceedings of the National Academy of Sciences* 117.33 (2020): 19785. For pollen from

Lake Nar used to comment on Byzantine Cappadocia cultivations, see A. England et al., "Historical Landscape Change in Cappadocia (Central Turkey): A Palaeoecological Investigation of Annually Laminated Sediments from Nar Lake," *The Holocene* 18.8 (2008): 1229–45.

59 The distribution of farming land around Amorium and the evolution of Byzantine field systems are being studied as part of the research project "Byzantine Agricultural Landscape Across the Aegean–BALAA" hosted at the Institute for Mediterranean Studies/FORTH and funded by the Hellenic Foundation for Research and Innovation. Preliminary presentation on the project can be found in N. Tsivikis and J. C. Donati, "The *Byzantine Agricultural Landscape across the Aegean* Project and the Byzantine Field Systems: Is There a Distinct Type of Byzantine Field?," in *Abstracts of the Free Communications, Thematic Sessions, Round Tables and Posters: The 24th International Congress of Byzantine Studies; Venice and Padua, 22–27 August 2022*, ed. L. Farina and E. Despotakis (Venice, 2022), 294.

60 Our knowledge of the archaeology of Roman vineyards is mostly limited to the earlier Roman period and the West. Some of the best documented examples are the vineyards excavated in and around Pompeii. For an overview, see Dodd, "Archaeology of Wine Production," 451–54; W. Jashemski, "Produce Gardens," in *Gardens of the Roman Empire*, ed. W. F. Jashemski et al. (Cambridge, 2018), 125–34; in Britain, A. G. Brown et al., "Roman Vineyards in Britain: Stratigraphic and Palynological Data from Wollaston in the Nene Valley, England," *Antiquity* 75.290 (2001): 745–57; and elsewhere. On the actual form and archaeology of Byzantine vineyards (of which we know very little) with a focus on the Early period, see A. Zerbini, "Landscapes of Production in Late Antiquity: Wineries in the Jebel al-'Arab and Limestone Massif," in *Territoires, architecture et matériel au Levant: Doctoriales d'archéologie syrienne; Paris-Nanterre, 8–9 décembre 2011*, ed. A. Le Bihan et al. (Beyrouth, 2012), 41, https://books.openedition.org/ifpo/2886. Abundant documented information comes from sixth- and seventh-century Egypt; see N. Litinas, ed., *Greek Ostraca from Abu Mina (O.AbuMina)* (Berlin, 2008), 68–69,

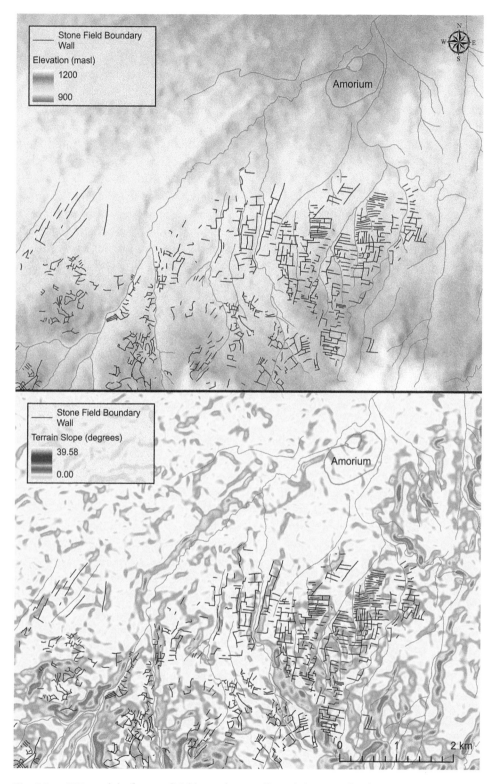

Fig. 22. GIS model of stone field boundary walls with historical information south of Amorium, elevation (upper image) and terrain-slope (lower image) modeling. GIS and analysis by J. C. Donati, courtesy of the Byzantine Agricultural Landscape Across the Aegean (BALAA) Project, Institute for Mediterranean Studies/FORTH.

These fields also had access to the city through country roads that lead to the west and southwest gates of the Lower City fortifications.[61] In this way, grapes could have been transferred quickly and securely from the nearby vineyards to the wineries. Inside the city itself, the wineries were situated on major (broad) streets accessible to carts that were still in use and well-maintained until the mid-ninth century (see above, Fig. 16).[62]

Treading and Pressing the Grapes

The wine installations found at Amorium were used both for treading and for pressing grapes. The very first stage of the whole procedure, preceding the treading and pressing of the fruit, took place immediately after the transportation of the grapes into the city, when these were placed inside the vats, where the natural pressure of their own weight would extract the first and best-quality must (πρότροπον). Then followed the main stage of wine production, the treading by foot, during which the grapes lose approximately 80 percent of their juice.[63] In the third stage, the already trodden grapes were usually moved to the winepresses for further extraction of their fluids.[64]

The material put in the winepress would have been mostly remains of grapes already trodden, offering an inferior quality product. However, we cannot exclude the possibility that grapes coming directly from the harvest with no previous treading also could have been pressed in order to expedite the process, resulting in a

better-quality must, close to the one produced by grape treading. There is no way of establishing which one of the aforementioned qualities of must was extracted in the Amorium presses, and probably any or various combinations could have occurred.

An important aspect of grape pressing was containing the grape skins, pulp, and stalks during the process to filter the must and keep the conduit unblocked. The usual containers in this process were thread and rope frails (gr. σχοινίον, ὄρος; lat. *fiscus*) and in fewer cases specially made wooden press frames (gr. γαλεάγρα; lat. *regula, galeagra*).[65] In Amorium, no archaeological evidence is preserved for either, but it would have been in any case difficult to find such remains given their organic nature. In earlier studies of Amorium winepresses, it has been assumed that the press boards would have been set freely on the lever and that, when lowered, they would have exercised pressure along their surface.[66] Detailed analysis of the possible operation mode of the winepresses has shown that more likely a wooden frame or frails containing the grapes must have been set inside the pressing vat and the press board would have followed guided movement inside the wooden frame.[67] Additionally, as already mentioned, the wineries in their final use had been dismantled, and most of their mobile parts had been removed, along with perishable items like rope frails or wooden frames.

It is interesting to note the distinction between facilities with just treading areas and ones with presses. In the examples from Amorium presented here, it seems that these processes were separate and the installations possibly owned by different wine makers.[68] The small number of treading floors discovered in Amorium, only

and T. M. Hickey, *Wine, Wealth, and the State in Late Antique Egypt: The House of Apion at Oxyrhynchus* (Ann Arbor, MI, 2012), 39–61.

61 Grapes would have been transferred in baskets carried by mules and/or carts, as numerous sources and depictions attest; see Dodd, *Roman and Late Antique Wine Production*, 54; M. Decker, *Tilling the Hateful Earth: Agricultural Production and Trade in the Late Antique East* (Oxford, 2009), 128–29; and P. Asemakopoulou-Atzaka, "Τρύγος καὶ ληνός στα ψηφιδωτά της ύστερης αρχαιότητας. Μαρτυρίες παραστάσεων καὶ πηγών," in Pikoulas, *Οἶνον ἱστορῶ IV*, 47–76.

62 The winery installations in the Enclosure trench flanked a wide cobbled street (Ivison, "Excavations at the Lower City Enclosure," 28), and the Large Building installation was also located next to a wide main street (Tsivikis, "A Byzantine Neighborhood in Flux").

63 Dodd, "Archaeology of Wine Production," 457.

64 The treading of grapes in theory could have also taken place inside the winepress basins as a first phase of extraction, but we should probably dismiss this possibility, since it would be difficult to tread grapes under the fixed beam; moreover, it would have been a waste of the winepress's valuable time.

65 Frankel, "Presses for Oil and Wine," 82–83; Frankel, *Wine and Oil Production*, 147–48; and Anagnostakis, "Περί θλίψεων καὶ εκθλίψεων," 91–92, 116–117.

66 In an older artistic reconstruction of winepress installation G, the pressing basin was depicted as filled with grapes being directly pressed by a pressing board suspended from the beam (Ivison, "Excavations at the Lower City Enclosure," 116, fig. 1/20).

67 This process would have functioned much like known late Roman winepresses from the Rhine area: K.-J. Gilles, ed., *Neue Forschungen zum römischen Weinbau am Mosel und Rhein* (Trier, 1995), fig. 18, and J.-P. Brun and K.-J. Gilles, "La viticulture antique en Rhénanie," *Gallia* 58 (2001): 171–72.

68 In Roman times, it was not unusual to encounter wineries with only treading floors. See the examples in Dodd, "Archaeology of Wine Production," 457–58.

three—all of them part of a single, unified complex—compared to eight winepresses, needs an explanation. Treading floors are much more fragile constructions, so the few existing remains might be an accident of survival, as many more might have been lost. The pressing vats of the winepresses also could have been used for treading the grapes at a first stage, thus balancing the numbers. Finally, we cannot exclude that treading of the grapes also occurred in other areas, inside or outside the city, and that only at a later time were grape remains transferred to the presses.

Fermentation and Storage

After the treading and pressing of the grapes, the next stage was the fermentation of the grape juice into wine. Wine fermentation in Roman and Byzantine practice occurred usually in two stages. Initially, the grape juice was collected in open vessels, where it was left to ferment and naturally "boil" for a few days, usually four to seven. After that, the must was siphoned off into closed vessels for the secondary and longer fermentation, up to four months.[69]

In studies on late antique winepresses, it is often the collection vats themselves (gr. ὑπολήνια) that are identified as the open containers hosting the juice during the first fermentation.[70] In those cases, the collection vats were rather large, permanent constructions where the must flowed directly from the pressing basins. The unfermented juice was kept there for the first few days, thus obstructing any use of the winepress and extending the operational time of the entire process.[71]

In the wineries of Amorium, the rather limited size of the collection vats makes it highly improbable that they received large quantities of grape must to ferment.[72] According to advice offered in the *Geoponika*, the collection vats and the fermentation vessels should be rather small for better-quality wine.[73] Thus, the grape juice must have been quickly transferred into other fermentation vessels.[74] We know from medieval sources that initial and secondary fermentation could happen in various containers: clay pots, wooden barrels, pithoi, or even animal skins.[75] Logistically speaking, it would not have been profitable to limit the use of the entire winepress complex to only three or four times each per grape harvest season.[76] An operation scheme where the grape must was immediately removed from the collection vats into separate first-stage fermentation vessels could multiply the productivity of the winepresses, as they could be in almost continuous use throughout the harvest season.[77]

If the collection vats at Amorium were not used for the initial fermentation of grape juice, we need to

69 Decker, *Tilling the Hateful Earth*, 133–36; Frankel, *Wine and Oil Production*, 43; and Brun, *Le vin et l'huile dans la Méditerranée antique*, 63–70.

70 Decker, *Tilling the Hateful Earth*, 144; Brun, *Le vin et l'huile dans la Méditerranée antique*, 63–64; D. Van Limbergen, "Figuring Out the Balance between Intra-regional Consumption and Extra-regional Export of Wine and Olive Oil in Late Antique Northern Syria," in Diler, Şenol, and Aydınoğlu, *Olive Oil and Wine Production in Eastern Mediterranean*, 175; and Zerbini, "Landscapes of Production in Late Antiquity." For the ethnographic, literary, and artistic evidence of how these presses operated and for the technical terms *lenos* and *hypolenion*, their origin, and use in ancient literature and Byzantine sources, see the exhaustive volume Pikoulas, Οἶνον Ἱστορῶ IV. For literary evidence of the terms *lenos* and *hypolenion* in particular, see Anagnostakis, "Περὶ θλίψεων καὶ ἐκθλίψεων," 82–86, 135–37 (papyri), 162–63 (literary texts), and P. Mayerson, "The Meaning and Function of ληνός and Related Features in the Production of Wine," *ZPapEpig* 131 (2000): 161–65. For artistic evidence, see Asemakopoulou-Atzaka, "Τρύγος καὶ ληνός," 47–76.

71 Dodd, *Roman and Late Antique Wine Production*, 58, and Frankel, *Wine and Oil Production*, 138–58.

72 Similar-size collection vats to those at the Amorian wineries can be seen in many of the Middle Byzantine wineries in Mavrucandere and elsewhere in Cappadocia (Peker, "Agricultural Production," 46–47). Of the Mavrucandere examples, we single out the Ağaçlık 2 winepress that technically adopts identical solutions to the Amorium winepresses.

73 *Geoponika* 6.3 (Beckh, *Geoponica*, 173–74).

74 A similar process is discussed by Dodd when dealing with the late antique wineries of Delos and Antiocheia ad Cragum (Dodd, *Roman and Late Antique Wine Production*, 56–59, 115–16).

75 Greek and Arabic sources from Egypt as well as archaeological finds attest to the use of wine jars with drilled holes for the fermentation of must; see N. Hansen, "Sunshine Wine on the Nile," in *Documents and the History of the Early Islamic World*, ed. A. T. Schubert and P. M. Sijpesteijn (Leiden, 2015), 294–96. Skins were used also in the process of wine production for emptying the collection vats (P. Mayerson, "A Note on *O. Mich.* I 249: λόγος οἴνου σακ()," *BASP* 35.3/4 [1998]: 211–13).

76 Zerbini, "Landscapes of Production in Late Antiquity," §12–21.

77 This practice was common in cases of large producers needing great output, like in the monastery of Abu Mina in seventh-century Egypt. This offers an interesting scale, as archival documents on ostraca from a winery with five winepresses in Abu Mina suggest that the installation could produce up to 60,000 liters of wine (Litinas, *Greek Ostraca from Abu Mina*, 70–72).

think of other suitable containers serving this role. No substantial archaeological evidence is preserved regarding this crucial phase of wine making. Some of the unearthed installations have ancillary spaces that could have been used for storing open pots or casks with the fermenting juice. Another possibility is the existence of larger communally or centrally organized storage areas or depots, but to date, no such building has been identified in the process of archaeological exploration.[78]

Equally, we have little archaeological information on the final stages of the wine's life cycle in Amorium. The storage of matured wine, its circulation and distribution, possibly through transporting, and its consumption are difficult to trace in general. Amphoras have been traditionally treated as indicators par excellence for wine circulation and consumption in the Roman and Byzantine world.[79] It has long been noted that, although rich in sherds and entire pots of other types of Byzantine pottery, the excavation layers at Amorium dated in the transitional and Middle Byzantine period are devoid of significant quantities of amphora finds.[80] If not an accident of discovery, this absence shows that in Amorium amphoras were probably not the preferred vessel for storing or moving around foodstuff and wine in particular.[81]

A recent discovery in Amorium, in the area of the Large Building at the west part of the Lower City, a warehouse with more than eleven sealed large and medium-sized pithoi, is quite tempting to identify as a wine depot with specialized wine containers (see above, Fig. 21).[82] The pithoi were set halfway into the ground, and they were all sealed with clay or stone lids secured airtight with limey mortar. Many of their characteristics and their arrangement resemble *dolia* vessels that would store wine in known Roman wineries, although they lack the careful and organized arrangement in the ground. The area that these pithoi occupy coincides with the position of an older and dismantled winery, that of winepress J, when the room was transformed (with the creation of dividing mudbrick walls) into a storage place for wheat (Fig. 23). So, most of these sealed pithoi were positioned in the depot in the early ninth century and after the cessation of function of the winery. Thus, it is almost impossible, with a lack of any scientific analysis, to positively connect them with storing and fermenting wine, as they are a common find in houses of Amorium and could equally have been used for storing cereal surplus or other dry goods.[83]

Thus, we need to think of other types of storage vessels that probably left little or no archaeological traces, animal skins or wooden barrels being the best candidates.[84] A military treatise of the tenth

78 *Geoponika* 6.2 (Beckh, *Geoponica*, 171), instructs that ὁ οἶκος ὁ ὑποδεχόμενος τοὺς πίθους... πόρρω δὲ ἔστω τῆς ληνοῦ, καὶ ἀπηλλάχθω πάσης δυσωδίας (Dalby, *Geoponica*, 150: "the building housing the vats should... be a long way from the treading room and free of any bad smells").

79 Although scholarship has recently attempted to nuance wine commerce and transportation beyond the amphora question, an overview of the discussion is offered by J.-P. Brun, "From Oil to Wine? A Balanced View on the Production of the Most Representative Agricultural Products of Antiquity," in *Archaeology and Economy in the Ancient World: Proceedings of the 19th International Congress of Classical Archaeology; Cologne/Bonn, 22–26 May 2018*, vol. 9, *A. Making Wine in Western-Mediterranean; B. Production and the Trade of Amphorae: Some New Data from Italy; Panel. 3.5*, ed. J.-P. Brun, N. Garnier, and G. Olcese (Heidelberg, 2020), 11–12; for a ceramological overview, see A. G. Yangaki, "Quelques réflexions sur le contenu (vin et huile) des amphores proto-byzantines: Données et perspectives de la recherche," in *Identità euromediterranea e paesaggi culturali del vino e dell'olio*, ed. A. Pellettieri (Foggia, 2014), 89–103.

80 Lightfoot, "Excavations at Amorium," 143, and B. Böhlendorf-Arslan, "Die mittelbyzantinische Keramik aus Amorium," in *Byzanz–das Römerreich im Mittelalter*, vol. 2.1, *Schauplätze*, ed. F. Daim and J. Drauschke (Mainz, 2010), 368.

81 Lightfoot, "Business as Usual?," 186–87. Given the expanded excavation trenches at Amorium from 1989 until 2021, it would be

highly improbable that significant quantities of amphoras will be found in the future.

82 Demirel-Gökalp and Tsivikis, "Understanding Urban Transformation in Amorium" 338–40, and Tsivikis, "A Byzantine Neighborhood in Flux."

83 For pithoi found in the Upper City of Amorium, see C. S. Lightfoot, "Amorium Excavations 1993: The Sixth Preliminary Report," *AnatSt* 44 (1994): 112. For pithoi in the Enclosure trench, see C. Lightfoot, "Trade and Industry in Byzantine Anatolia," *DOP* 61 (2007): 278, and Ivison, "Excavations at the Lower City Enclosure," 55–58.

84 On barrels, see M. McCormick, "Movements and Markets in the First Millennium: Information, Containers, and Shipwrecks," in Morisson, *Trade and Markets in Byzantium*, 91–94. On wine barrels in Byzantine sources, see I. Anagnostakis, "Βυζαντινά οινοβούτια, βουτζία και οι Βουτζαράδες του Αράκλοβου στην Φραγκοκρατούμενη Ηλεία," in *Οἶνον ἱστορῶ: Ἀμπελοοινική ιστορία και αρχαιολογία της ΒΔ Πελοποννήσου*, ed. G. A. Pikoulas (Korakochori, 2001), 89–108. Traditionally, wooden barrels are regarded as taking over the prominence of amphoras as containers in Late Byzantine times: A. G. Yangaki, "Τὰ δὲ σκεύη πάντα μὴ ὁμοειδῶς ἀλλήλοις διεσχηματίσθω, ἀλλὰ τὸ μὲν πίθος, τὸ δὲ ἀμφορεύς, ἕτερον δὲ πινάκιον...: Κεραμικά και οι χρήσεις τους," in *Τὸ Βυζάντιο χωρὶς λάμψη: Τὰ ταπεινὰ ἀντικείμενα καὶ

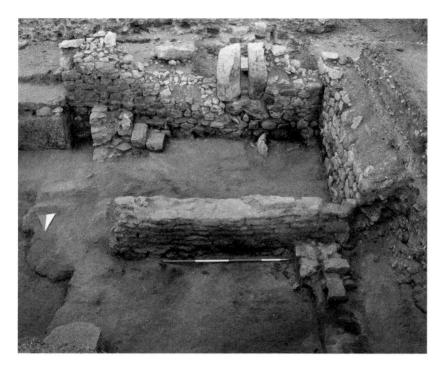

Fig. 23.
Winepress (installation J) in the Large Building trench, showing the pivot stones in situ; the other elements were remodeled in the early ninth century (view from the north). Photograph courtesy of the Amorium Excavations Project, 2019.

century mentions that during overland expeditions the Byzantine army used leather skins for carrying wine on pack animals.[85] These containers could have been produced locally in considerable quantities for use in the wine industry, more or less like how wine amphoras in other areas were produced centrally and even distributed by the large estate holders to wine producers.[86]

As for wooden barrels, the possibility of using them for early medieval Byzantine wine commerce and distribution, especially overland, has been little assessed so far.[87] In the post-Roman West, barrels become the preferred vessel, and their use has been related to the

disruption of the great coastal networks after the late third century or even earlier and the heightened importance of inland and river routes, where wooden barrels were a more suitable vessel.[88] Similar processes might have occurred in later times in the East with the collapse of Egyptian and Levantine commerce after the rise of Islam and the rise of the importance of land routes, especially in Anatolia.[89] In Byzantine sources, the earlier references to wine barrels date from the early Middle Byzantine era, whereas in the eleventh century, Byzantine barrels already appear as a standard reference, indicating that they had been in use for a long time.[90]

η χρήση τους στον καθημερινό βίο των Βυζαντινών/*Byzantium without Glamour: The Humble Objects and Their Use in the Everyday Life of the Byzantines*, ed. A. G. Yangaki and A. Panopoulou (Athens, 2018), 123.

85 Constantine VII Porphyrogenitus, *Treatise (C)*, lines 137–54, 599–604 (J. F. Haldon, ed. and trans., *Constantine Porphyrogenitus: Three Treatises on Imperial Military Expeditions*, CFHB 28 [Vienna, 1990], 102–4 [commentary, 254], 132 [commentary, 254]).

86 Hickey, *Wine, Wealth, and the State in Late Antique Egypt*, 72–73.

87 In the West there is a growing discussion that "by the early medieval period the amphora had been largely replaced . . . by the barrel," and thus the archaeological visibility of wine commerce in shipwrecks is significantly altered compared to Roman times (A. Wilson, "Approaches to Quantifying Roman Trade," in *Quantifying the Roman Economy: Methods and Problems*, ed. A. Bowman and A. Wilson [Oxford, 2009], 219–21).

88 A. Tchernia, "La crise de l'Italie impériale et la concurrence des provinces," *Les Cahiers du Centre de recherches historiques* 37 (2006): 137–56. Generally, on barrels in the Western Roman world, see E. Marlière, *L'outre et le tonneau dans l'Occident romain* (Montagnac, 2002), and Brun, "From Oil to Wine?," 10–14.

89 Barrels can actually be much more efficient as liquid containers than amphoras, as they are much lighter and durable; see J. H. Pryor, "Types of Ships and Their Performance Capabilities," in *Travel in the Byzantine World: Papers from the Thirty-Fourth Spring Symposium of Byzantine Studies, Birmingham, April 2000*, ed. R. Macrides (Aldershot, 2002), 54.

90 Anagnostakis, "Βυζαντινά οινοβούτια." The Genizah archive refers to vessels that contained "half a Byzantine barrel"; see S. D. Goitein, *A Mediterranean Society: The Jewish Communities of the Arab World as Portrayed in the Documents of the Cairo Geniza*, vol. 1,

Quantifying Amorium Wine Production

An accurate calculation of the production capability of the Amorium wine industry is almost impossible because of the multiple variables and the limited archaeological sources. However, we can still attempt to quantify the production based on methodologies applied on similar material elsewhere, since it is only through quantification that we can get a rough idea of the scale of the phenomenon. Generally, for the quantification of Byzantine wine production, scholars have used two different methods. The first one presupposes that the collection basins were used as fermentation vats and calculates the quantity of the produced wine through the volume of the must that these basins could hold.[91] The second is based on projecting the few figures known from documentary sources, mostly from Early Byzantine Egypt, and combining them with actual winepress vat volumes.[92] It is obvious that both these approaches have pros and cons, and none can actually offer a definite estimate, although they are still useful tools.

In the case of Amorium, initially we must consider the approximate number of wineries in operation during the period between the seventh and ninth centuries. We have archaeological evidence for eleven such installations (eight winepresses and three treading floors) scattered in three different locations of the Lower City. Along with those, several screw press weights have been documented around the site, probably coming from other, still unexcavated winepresses. The Lower City trenches excavated so far represent less than 10 percent of the total fortified urban area, but still wineries were found everywhere. Such a density makes it highly probable that more wineries existed inside the city walls, still waiting to be explored. We cannot establish an exact number, but by projection, we can postulate that at least a few dozen more wineries could have existed inside the walled city, making the total number considerably greater.

Clustering of winepresses is not an uncommon phenomenon. It has been studied in late antique Syria, where small or medium-sized villages with ten or fifteen installations each were involved in industrial-scale production of wine.[93] Also in Middle Byzantine Cappadocia, in two sites at Mavrucandere, a total of fourteen installations have been located and have been connected with the needs of the Byzantine army.[94] At another site in Phrygia, that of Hendek Kale, nine setting stones for the wooden levers and fourteen rectangular counterweight stones have been documented on the surface, all of them belonging to presses, probably winepresses.[95] However, most known examples of wineries clustering seem to be connected to rural areas and village settlements. The situation in Amorium, therefore, is unique, since the concentration of wineries is observed inside a fortified urban settlement.

In the Syrian wineries studied by Andrea Zerbini, it was estimated that three (probably post-sixth century) winepresses of the lever-and-screw type had an annual average production of approximately 4,000 liters of wine; the estimate was based on the size of their collection vats, under the supposition that these operated for only three fillings per harvest.[96] Another well-documented example, both textually and archaeologically, is the seventh-century winepress at the monastery complex of Abu Mina in Egypt. According to the *ostraka* dossier, this winepress received the grape harvest of four to five hundred different vine growers in a period of two weeks, and its annual yield is estimated as between 30,000 and 60,000 liters of wine.[97] The Abu Mina winery has been also excavated, offering a concise idea of its

Economic Foundations (Berkeley, CA, 1967), 321. This reference is discussed also in Pryor, "Types of Ships," 53.

91 Dodd, *Roman and Late Antique Wine Production*, 64–67, 117–22; Brun, *Le vin et l'huile dans la Méditerranée antique*, 63; Decker, *Tilling the Hateful Earth*, 144; Van Limbergen, "Figuring Out the Balance," 175; and Zerbini, "Landscapes of Production in Late Antiquity," §12–21.

92 Litinas, *Greek Ostraca from Abu Mina*, 70–72; Hickey, *Wine, Wealth, and the State in Late Antique Egypt*; L. A. Schachner, "Economic Production in the Monasteries of Egypt and Oriens, AD 320–800" (PhD diss., University of Oxford, 2006), 188–89.

93 Zerbini, "Landscapes of Production in Late Antiquity," and Van Limbergen, "Figuring Out the Balance," 175. For Antioch as a market for wine and its relationship to the surrounding region with respect to wine production, see A. U. De Giorgi, *Ancient Antioch: From the Seleucid Era to the Islamic Conquest* (Cambridge, 2016), 119–31.

94 Peker, "Agricultural Production."

95 J. Bennett and B. Claasz Coockson, "Hendek Kale: A Late Roman Multiple Lever Press Site in Western Asia Minor," *Antiquity* Project Gallery 83.319 (2009), http://www.antiquity.ac.uk/projgall/bennett319/.

96 These are wineries P9, P12, and P27 in Dehes and Si'a (Zerbini, "Landscapes of Production in Late Antiquity," table 1).

97 Schachner, "Economic Production in the Monasteries of Egypt and Oriens," 70–72.

form and productive capabilities; it included five wine-presses of various sizes with spacious collecting vats.[98]

Based on the aforementioned examples, we may attempt to assess the possible magnitude of wine production at Amorium. The Amorian winepresses resemble in technology and form those on the Syrian plateau with a possible average output of about 1,500 liters per use each. Since at Amorium the first stage of fermentation probably did not take place in the collection vats, the continuous operation of the presses was unobstructed. Thus, the estimated output of about 1,500 liters per use can be multiplied considerably, reaching up to the number of harvest days or even more, if the winery were used more than once daily.[99] We cannot know if a systematic wine-production operation like in the Abu Mina monastery was also taking place in Amorium, but this could offer a satisfactory explanation for not using collection vats as initial fermentation vessels, thus safeguarding the continuous use of the winery.[100]

If it was the case that the Amorium winepresses were in operation for a considerable number of days, if not daily, during the four weeks of the harvest season, they could have been producing something between 10,500 liters of wine (if operating daily over a period of seven days of the harvest season) to 42,000 liters of wine (if operating daily for the twenty-eight days of harvest), or even more. By projecting this figure to each Amorium winepress, we see that the annual production of the eight excavated winepresses alone (excluding the three treading floors) could rise to a total of between 84,000 and 336,000 liters.

This number represents only the excavated wineries and is quite substantial in itself. If the wineries of Amorium were as numerous and widespread as the excavated sample shows, the total amount could rise considerably, two or even three times more. These numbers, of course, cannot be proven in any way and remain suggestive, providing us with a possible order of magnitude for local wine production.

To sum up, the volume of the wine produced in Amorium cannot be easily estimated with accuracy, but it was certainly quite substantial. Such large-scale production must have exceeded local population needs and was probably intended for a wider market; furthermore, in a period like the seventh and eighth centuries when most of the economy was controlled or stimulated by the state, it may be safely assumed that this kind of production was intended to satisfy, directly or indirectly, state commissions.

Winepresses and the Investment in Money and Material

As discussed earlier, wineries in Amorium were part of newly built constructions, especially created in the seventh century. These units were erected over the Early Byzantine urban fabric, mostly replacing and partly reusing preexisting structures. The agrarization of urban life and the establishment of manufacturing installations inside the urban environment were some of the developments signaling the transition from late antique to medieval cities all across the Byzantine Empire.[101] Yet a careful look at the evidence shows that the building of winepresses in Amorium must have been a particularly demanding and expensive investment, dictated

98 On the excavation of Abu Mina's main winery, see P. Grossmann, F. Arnold, and J. Kościuk, "Report on the Excavations at Abu Mina in Spring 1995," *BSAC* 36 (1997): 87–90; P. Grossmann and J. Kościuk, "Report on the Excavations at Abū Mīnā in April 2014," *BSAC* 53 (2014): 56–61; and P. Grossmann, *Abū Mīnā*, vol. 4, *Das Ostraka-Haus und die Weinpresse* (Wiesbaden, 2019), 31–52. It is not uncommon for wineries to have more than one winepress, which is explicitly mentioned (e.g., the second or third ληνός) in papyri from late Roman Egypt; see Mayerson, "Meaning and Function of ληνός," 165, and Anagnostakis, "Περί θλίψεων και εκθλίψεων," 85, 135–37.

99 The papyri describing production in the seventh-century winepress of Abu Mina (Litinas, *Greek Ostraca from Abu Mina*, 70–72) or that of the wineries at the estate of Apion in Aphrodito (Hickey, *Wine, Wealth, and the State in Late Antique Egypt*, 90–98) imply that wine pressing probably happened more than once per day during harvest days.

100 We see the same arrangement in one of the Byzantine winepresses (Ağaçlık 2) in Mavrucandere in Cappadocia, where the collection vat is small and a number of larger fermentation vats were cut on the sides of the room to accept the freshy pressed grape juice (Peker, "Agricultural Production," 45, fig. 5).

101 For some recent views on the ruralization of Byzantine urban settlements, see L. Brubaker and J. F. Haldon, *Byzantium in the Iconoclast Era, c. 680–850: A History* (Cambridge, 2011), 531–72; P. Niewöhner, "Urbanism," in *The Archaeology of Byzantine Anatolia: From the End of Late Antiquity until the Coming of the Turks*, ed. P. Niewöhner (New York, 2017), 46–48; F. Curta, "Postcards from Maurilia, or the Historiography of the Dark-Age Cities of Byzantium," *Post-Classical Archaeologies* 6 (2016): 93–95; and Tsivikis, "Messene and the Changing Urban Life," 40–49. For the city of Amorium in particular, see Lightfoot, "Survival of Cities in Byzantine Anatolia"; C. S. Lightfoot, "Amorium," in Niewöhner, *Archaeology of Byzantine Anatolia*, 333–41; Ivison, "*Amorium* in the Byzantine Dark Ages"; and Tsivikis, "Amorium and the Ever-Changing Urban Space."

most probably by specific, newly occurring needs. If this were not the case, it would have been much easier for Amorians to use simpler winepress solutions, like the rock-cut winepresses that are so popular in the area, rather than investing in newly built, freestanding constructions.[102] Furthermore, wine-producing installations were usually built in rural areas, in close proximity to the vineyards, in order to limit the cost and risks of transporting the grapes.[103] Additionally, the construction and constant maintenance of elaborate machines like winepresses demanded specialized knowledge and the presence of trained craftsmen to guarantee their proper operation.[104] The same applies for the carving of the screw weights, the cutting and installation of the huge stone slabs used in various vats, and the creation of the specialized hydraulic mortars.[105] At the same time,

intensive wine production requires considerable investment of time and labor in the vineyards, since the vine needs five to seven years to produce its first fruit and, after that, it requires a series of tasks annually in order to be kept productive.[106]

All the above indicate that wine making in Amorium was a considerable, long-term investment of surplus, entailing the conscious decision to sacrifice valuable urban space and undertake a great financial commitment for the creation and especially the maintenance of both wineries and vineyards. It also means that a substantial part of the arable land around the city was dedicated to viticulture, limiting the productive cultivation of other crops such as wheat and barley. This choice entailed a great risk, since cereals can easily be resown and ripen within a seasonal cycle, whereas vine needs a considerably longer period to be fruitful again in case of destruction either by man or by inclement weather. The seventh and eighth centuries were times of insecurity for much of Anatolia because of the Byzantine–Arab wars.[107] Moreover, literary sources mention that as part of the warfare, vineyards were often intentionally destroyed.[108] In other historical contexts, political insecurity has been regarded as one of the reasons that small

102 On rock-cut installations, see Frankel, *Wine and Oil Production*, 51–60. On Asia Minor, see E. Dodd, "Late Roman Viticulture in Rough Cilicia: An Unusual Wine-Press at Antiochia ad Cragum," *JRA* 33 (2020): 471–72, n. 26, with extensive literature on the subject, and Sivas, "Wine Presses of Western Phrygia." On wooden and portable presses, see A. Diler, "Olive Oil and Wine Production of the Halikarnassos Peninsula in Karia," in Aydınoğlu and Şenol, *Olive Oil and Wine Production in Anatolia*, 160. In Phrygia, a winepress inside the settlement of Hierapolis has been dated to the eleventh to twelfth centuries (P. Arthur, *Byzantine and Turkish Hierapolis [Pamukkale]: An Archaeological Guide* [Istanbul, 2006], 134–36).

103 Dodd, *Roman and Late Antique Wine Production*, 33–34, 113; Zerbini, "Landscapes of Production in Late Antiquity," §15–19; and Van Limbergen, "Figuring Out the Balance," 170–73.

104 T. Lewit, "Invention, Tinkering, or Transfer? Innovation in Oil and Wine Presses in the Roman Empire," in *Capital, Investment, and Innovation in the Roman World*, ed. P. Erdkamp, K. Verboven, and A. Zuiderhoek (Oxford, 2020), 324–27, and Varinlioğlu, "Trades, Crafts, and Agricultural Production," 186–87. Documents from Roman Egypt mention specialized workers who operated the mechanical presses (στεμφυλουργοί) and craftsmen hired to maintain the devices (Dzierzbicka, *ΟΙΝΟΣ*, 186–88); for related terms, see also Anagnostakis, "Περὶ θλίψεων καὶ ἐκθλίψεων," 85, 156. A press weight found at Kalecik/Malos carries an inscription with the name of the craftsman (τεχνίτης) who constructed the press to which the weight belonged (Mitchell et al., "Church Building and Wine Making," 214–15).

105 A Greek cross cut on a circular limestone press weight (Am. Inv. T2016) probably indicates that the press was considered a highly prized investment; see Lightfoot, "Excavations at Amorium," 141–42, figs. 6–7. Mitchell et al., "Church Building and Wine Making," 205, based on dozens of examples from Central Anatolia, suggest that Christian decoration of press weights was a local custom and a distinctive regional feature of Central Anatolia. Early Byzantine press weights with Christian decoration can also be found elsewhere, like in the Aegean (Dodd, *Roman and Late Antique Wine Production*,

108–10), but Middle Byzantine ones seem to be mostly represented in Anatolian examples.

106 T. Lewit, "'*Terris, vineis, olivetis...*': Wine and Oil Production after the Villas," *European Journal of Postclassical Archaeologies* 10 (2020): 195–96; G. C. Maniatis, "The Byzantine Winemaking Industry," *Byzantion* 83 (2013): 232–33; and Gorny, "Viniculture and Ancient Anatolia," 146.

107 R.-J. Lilie, *Die byzantinische Reaktion auf die Ausbreitung der Araber: Studien zur Strukturwandlung des byzantinischen Staates im 7. und 8. Jahrhundert* (Munich, 1976), 183–200, and J. Haldon, *The Empire That Would Not Die: The Paradox of Eastern Roman Survival, 640–740* (Cambridge, MA, 2016), 26–78.

108 According to Middle Byzantine military treatises, the destruction of the vineyards was a common tactic in the wars of the period: "If it should happen that out in front of the city there are parks, vineyards, and trees, they should be cut down, uprooted, and set on fire" (*Book on Tactics*, §21 [G. T. Dennis, ed. and trans., *Three Byzantine Military Treatises*, CFHB 25 (Washington, DC, 1985), 304–5]). One characteristic case is the destruction of the vineyards and trees around the besieged Adana by Nikephoros Phokas: "He set up camp there near the town [i.e., Adana in Cilicia], chopped down vines, trees, and everything that bore fruit, and razed the elegant and beautiful suburbs" (Nikephoros II Phokas, *Skirmishing*, §20 [Dennis, *Three Byzantine Military Treatises*, 218]). See also G. Dagron and H. Mihaescu, eds. and trans., *Le traité sur la guérilla (De velitatione) de l'empereur Nicéphore Phocas (963–969)* (Paris, 1986), 113, and Anagnostakis, *Βυζαντινός οινικός πολιτισμός*, 44, 114, nn. 153–54.

vine cultivators ceded their "prerogative of production to a central administration or the large landowners."[109] Accordingly, in a period when war was endemic in Anatolia and the vineyards around Amorium faced constant threat, it is possible that such high-risk and demanding investments in agrarian production, like the winepresses, were either part of state-oriented projects or funded by powerful agents capable of taking the risk in order to extract a profit.[110] Unfortunately, it is still unclear who exactly was responsible for the investment, but we can say without a doubt that it could have only been viable in connection to a steady and broad-based demand for wine.[111]

The Historical Framework of Amorium in the Seventh to Ninth Centuries

In order to understand the circumstances under which Amorium became a wine-production center, we need to examine the evolution of the settlement, principally in the period between the seventh and ninth centuries. By the end of the sixth century, Amorium conveyed the basic features of a typical Early Byzantine inland Anatolian town: it was a fortified local administrative and ecclesiastical center, supported by a community which was characterized by social stratification and economic differentiation based on the exploitation of land.[112] However, the rapid expansion of Islam in the first half of the seventh century set in motion conditions that transformed Amorium into a major military hub. The turning point was 636, when the Byzantine army suffered a serious defeat by the Arabs at the Yarmuk River. This failure led to significant territorial losses for Byzantium encompassing areas broadly corresponding to modern Syria, Lebanon, Israel, Palestine, and

northern Egypt.[113] After this great loss, the Byzantine field armies that had been active against the Arabs in these regions were forced to withdraw behind the natural barrier of the Taurus and Anti-Taurus Mountains. As part of this relocation, the army of the East (the *Anatolikoi*) was stationed in southern and central Asia Minor, and Amorium was gradually converted to the base of the commander of the army (*strategos*).[114]

The concentration of officials and soldiers in the area after the middle of the seventh century made Amorium a military stronghold in Byzantium's external and internal struggles.[115] Moreover, in 820, a local military man, Michael II, became emperor of Byzantium, and his dynasty, the Amorian, was named after the city. However, less than twenty years later, Caliph al-Muʿtaṣim launched a campaign against Byzantium which ended with the sack of Amorium and the capture of many of its inhabitants.[116] After this destruction, the city was partially rebuilt, but following wider transformations, it lost its significance as one of the most important military and administrative centers in Anatolia.[117]

The Role of Amorium in the Provisioning of the Byzantine Army: The Sigillographic Evidence

The choice of the Byzantine government to transform Amorium into a major military base has been attributed among other factors to its strategic location, astride the main highway connecting Constantinople with the new

109 Gorny, "Viniculture and Ancient Anatolia," 149.

110 The installations could have been a community enterprise, possibly owned by an individual or collective and rented out to independent users to process their produce. Lewit, "Invention, Tinkering, or Transfer?," 339–41, provides examples of varying social constructs in which presses existed, including extensive ethnographic evidence for the shared use of press installations by multiple farmers or those owned by wealthy villagers and leased out. See also Anagnostakis, "Noms de vignes et de raisins," 35–60.

111 On the economics of viticulture and wine making, see Maniatis, "Byzantine Winemaking Industry," 239–43.

112 Lightfoot, "Amorium"; Ivison, "*Amorium* in the Byzantine Dark Ages"; and Tsivikis, "Amorium and the Ever-Changing Urban Space."

113 For a detailed analysis of the period, see W. E. Kaegi, *Byzantium and the Early Islamic Conquests* (Cambridge, 1992).

114 J. F. Haldon, *Warfare, State, and Society in the Byzantine World, 565–1204* (London, 1999), 73–77; Haldon, *The Empire That Would Not Die*, 266–71; and Ivison, "*Amorium* in the Byzantine Dark Ages," 25–34.

115 The army of the Anatolikoi also participated in the civil wars of the period. Together with the neighboring army of the Thrakesioi, the Anatolikoi supported Constantine V (741–775), who had settled in Amorium when his brother-in-law, Artabasdos, occupied Constantinople for more than a year (between 741 or 742 up to November 743) (Nikephoros, *Short History*, §64 [C. A. Mango, ed. and trans., *Nikephoros Patriarch of Constantinople: Short History*, CFHB 13 (Washington, DC, 1990), 134], and Theophanes, *Chronographia*, AM 6233 [C. de Boor, ed., *Theophanis Chronographia* (Leipzig, 1883), 1:414–15]).

116 J. Signes Codoñer, *The Emperor Theophilos and the East, 829–842: Court and Frontier in Byzantium during the Last Phase of Iconoclasm* (Farnham, 2014), 279–312.

117 C. S. Lightfoot, "Doukas and Amorium: A Note," *JÖB* 46 (1996): 337–40.

frontier.[118] In addition, John Haldon, who has studied the process of the relocation of the Byzantine army in Anatolia after the Battle of Yarmuk, has proposed that we should comprehend it as part of a "well-thought-out plan through which the empire could continue to maintain and support substantial numbers of troops."[119] In other words, one of the main reasons that transformed Amorium into a major military base was the ability of the city and its hinterland to provide for the army.

Given the importance of wine in the provisioning of the army, not just for nutritional but also for medical and recreational purposes, as we shall see in the next section of our study, it looks, indeed, very attractive to connect the increased wine production at Amorium with the provisioning of the army stationed in and around the city. Such a theory, however, must be examined in connection with the economic institutions of the empire during the very demanding seventh and eighth centuries, when a deep administrative reform, from the model of the late Roman provinces to the medieval thematic system, occurred. The available contemporary literary sources are almost silent concerning these crucial changes, and this gap can be filled by sigillography.

Valuable hints relating to the economy of the Byzantine state during these centuries are provided by the seals issued by (a) the *genikoi kommerkiarioi* of the *apothekai* (these are attested between ca. 654–659 and ca. 730/1) and (b) the "impersonal" state institution of the imperial kommerkia (attested between ca. 730/1 and ca. 832/3).[120] These lead seals that authenticated and secured the correspondence of state officials with the capital are coin-like cartes de visite bearing the portrait(s) of the ruling emperor(s) and a legend that offers the area of jurisdiction of the specific bureau and the indictional year during which the seal was valid.

The genikoi kommerkiarioi were centrally appointed fiscal officials of high rank and status (often holding consecutive appointments), responsible for the collection and redistribution of resources managed from Constantinople. They have been characterized as the financial crisis managers of the period, responsible for the provisioning of military campaigns, supplying the capital, and controlling the movement of all commodities (precious and non precious) in and out of the empire.[121] The first seals of the kommerkiarioi, which appear under Justinian I (after 538), mention the names, dignities, and functions of one or two officials, sometimes accompanied by the area(s) of their jurisdiction. Between 654–659 and until 729/30, the kommerkiarioi are associated with the apothekai of a specific late Roman province or groups of late Roman provinces, while from 673/4 onward, their seals bear an indiction.[122] In the absence of relevant literary sources, any theories on the role, function, and purpose of the apothekai during the seventh and eighth centuries rely solely on the seals issued by the kommerkiarioi in charge of them. Various hypotheses have been proposed on the interpretation of this material, but the theory that has provoked the most lively scholarly debate is the one first put forward by Michael Hendy and subsequently supported by Haldon, who believe that the introduction of the institution of the apothekai to the provinces aimed at equipping the soldiers and/or supplying them with provisions.[123] This theory seems to

118 Ivison, "*Amorium* in the Byzantine Dark Ages," 33–34, and C. S. Lightfoot, "Amorium: Facts, Myths, and Misconceptions," in Lightfoot and Ivison, *Amorium Reports 3*, 478–79.

119 Haldon, *The Empire That Would Not Die*, 269.

120 On the first kommerkiarioi and their role, see the valuable study of F. Montinaro, "Les premiers commerciaires byzantins," *Travaux et mémoires du Centre de recherche d'histoire et civilisation de Byzance* 17 (2013): 351–538. A very important discussion on the economic institutions of the apothekai and the imperial kommerkia with all the previous references can be found in W. Brandes, *Finanzverwaltung in Krisenzeiten: Untersuchungen zur byzantinischen Administration im 6.–9. Jahrhundert* (Frankfurt, 2002), 291–309 (on the apothekai), 365–94 (on the imperial kommerkia). See also Brubaker and Haldon, *Byzantium in the Iconoclast Era*, 684–95 (on the apothekai), 695–705 (on the imperial kommerkia). For Asia Minor in particular, see E. Ragia, "The Geography of the Provincial Administration of the Byzantine Empire (ca. 600–1200): I.1. The Apothekai of Asia Minor (7th–8th c.)," *Byzantina Symmeikta* 19 (2009): 195–245.

121 Brubaker and Haldon, *Byzantium in the Iconoclast Era*, 695.

122 Montinaro, "Les premiers commerciaires byzantins," 365.

123 Hendy, *Studies in the Byzantine Monetary Economy*, 626–40, 654–62. Brubaker and Haldon, *Byzantium in the Iconoclast Era*, 687–88, note that although the priority of the apothekai had been Constantinople itself, their association in date, place, and event with various military undertakings "remains quite striking." See also more recently, Haldon, *The Empire That Would Not Die*, 259–66, where it is argued that the kommerkiarioi were state officials in charge of feeding the Byzantine army. On a summary of the main theories concerning the kommerkiarioi and the apothekai, see Montinaro, "Les premiers commerciaires byzantins," 354–64. Federico Montinaro expresses great skepticism about Haldon's theory on the role of the kommerkiarioi as state agents responsible for the provisioning of the army; see F. Montinaro, "Killing 'Empire': Goldilocks and the Three

be supported also by the geographical distribution of the apothekai, since some of them are directly associated with specific military operations, while the earliest among them are located in eastern Asia Minor, which suffered the results of the massive attacks by the Persians and then by the Arabs; in contrast, apothekai in western Asia Minor appear after the late seventh century.[124] What remains unclear is how this objective was achieved and what the exact binding relations were among (a) the local producer/artisan, (b) the warehouse (*apotheke*), and (c) the soldier. Warren Treadgold, taking for granted that the distribution of landholdings to soldiers had started already in the mid-seventh century (thus, soldiers were recruited among the landowners), has argued that the soldier-farmers were able to exchange their agricultural produce at the apothekai located in their districts and thus obtain their weapons.[125] According to Wolfram Brandes, the apothekai were a state service subject to the *genikon logothesion* (finance ministry), and their objective was to collect taxes in kind, which were then used to supply the army.[126]

On this basis, can we assume that the archaeological evidence on wine production at Amorium suggests the existence of an apotheke in the city? First of all, as already noted, all the known seals of the genikoi kommerkiarioi in charge of an apotheke are associated in their overwhelming majority with one or more late Roman provinces, very rarely with specific cities.[127] Still, if we take into account that an apotheke was "probably a building or part of a building, a room where various things could be (safely, we would add)

deposited,"[128] then such a building should have been erected in a walled and well-guarded area, located on or near an important communication network that would facilitate both the collection and the redistribution of the collected goods. The favorable position of Amorium on the crossing of important highways leading to Constantinople (to the west) and the Cilician Gates (to the east) has already been discussed above. The Lower City acquired its first circuit wall under Zeno (r. 474–491) or Anastasios (r. 491–518), and, as noted already, the sophisticated and consistent building techniques employed in the Lower City walls and towers "certainly point to a state initiative . . . [indicating] that the Amorium fortifications are certainly part of a new push in state-sponsored fortifications in Anatolia as part of an evolving strategy."[129] Thus, Amorium had all the credentials to house an apotheke, although its physical remains have not been traced as of now.

The geographical distribution of the seals issued by kommerkiarioi of the apothekai in Asia Minor indicates that eastern Asia Minor, "which suffered the results of the massive attacks by the Persians and later the yearly invasions of the Arabs, was the ground where the new institution of the warehouses was first put into effect" and that "a good number of seals concern the eastern war zones," an observation that "points with surprising clarity to a possible military orientation of the apothekai."[130] Among the known lead seals issued by kommerkiarioi of the apothekai, the ones that could be connected to Amorium are those concerning the neighboring late Roman provinces of Phrygia Salutaria (Amorion was always regarded as part of Greater Phrygia in the Roman and Early Byzantine periods), Galatia II (Amorion was added to this province upon its creation in 396–399), and Lycaonia (which was fully incorporated in the Anatolikon theme), issued by the following officials (in chronological order): Theodoros, hypatos and genikos kommerkiarios of the apotheke of Galatia (654–659); Stephan, patrikios (and genikos kommerkiarios?) of the apotheke of Galatia I and II (659–668),

Byzantine *Kommerkiarioi*," *The Journal of European Economic History* 46.2 (2017): 165–72.

124 Ragia, "Geography of the Provincial Administration," 200–201. Cf. also Brubaker and Haldon, *Byzantium in the Iconoclast Era*, 685: "the seals of this institution seem in several cases to follow the warfare."

125 W. Treadgold, *Byzantium and Its Army, 284–1081* (Stanford, CA, 1995), 179–86.

126 Brandes, *Finanzverwaltung in Krisenzeiten*, 291–309. In documents from seventh-century Egypt, wine also "served as a commodity to meet the obligations imposed by the state (taxes)" (Schachner, "Economic Production in the Monasteries of Egypt and Oriens," 186).

127 Among the 165 entries concerning seals of kommerkiarioi in charge of apothekai compiled by Montinaro ("Les premiers commerciaires byzantins," 443–515), only 38 refer to apothekai associated with a city, either on its own or combined with one or more provinces; 22 of these entries refer to the apotheke of Constantinople.

128 Brandes, *Finanzverwaltung in Krisenzeiten*, 291: "wahrscheinlich ein Gebäude oder einen Gebäuteteil, einen Raum . . . , wo die verschiedensten Dinge deponiert worden konnten" (trans. authors).

129 Tsivikis, "Amorium and the Ever-Changing Urban Space," 199–201. This is also discussed in Ivison, "*Amorium* in the Byzantine Dark Ages," 35.

130 Ragia, "Geography of the Provincial Administration," 200–201.

Kosmas, apo hypaton and genikos kommerkiarios of the apotheke of Lycaonia (690/1); Georgios, apo hypaton of the *andrapoda* (slaves) of Galatia II (694/5), who may be the same as Georgios, apo hypaton of the apotheke of the andrapoda of Phrygia Salutaria (694/5); Georgios, patrikios, and Theophylaktos, general kommerkiarioi of the apotheke of Galatia II (706–708); and Theophanes, patrikios, imperial protospatharios, general logothetes, and kommerkiarios of the apotheke of Bithynia, (Phrygia) Salutaria, and (Phrygia) Pakatiane (727/8 and 728/9). It is worth noting the presence of andrapoda in Galatia II and Phrygia Salutaria in 694/5. Are these slaves the workforce that carried out the necessary agricultural and construction works connected to the implementation of a new central policy in the provisioning of the army? If so, they could have participated also in the construction and operation of the wine installations at Amorium.[131]

After these seals, the wider area where Amorium is situated reappears on the seals issued by the impersonal state financial institution of the βασιλικά κομμέρκια (imperial kommerkia) from the 730s onward. These seals continue to bear the imperial portrait and an indictional year, but they no longer feature the names of high-ranking genikoi kommerkiarioi in charge of apothekai; instead, they are issued in the name of the (impersonal) imperial kommerkia of (in the majority of cases) a province or a group of provinces, or military commands.[132]

Table 2, which brings together, in chronological order, a list of forty seals issued by imperial kommerkia specifically related to Asia Minor, offers several interesting observations.[133] It is worth noting that this list begins with four specimens all issued in 695–697 by (still) an apotheke of the imperial kommerkia (of Helenopontos and of Asia, Karia, and Lykia), marking thus the final passage from the system of apothekai/warehouses under the supervision of specific kommerkiarioi to the system of the impersonal imperial kommerkia. More importantly, however, we see that the three old Roman provinces of Phrygia Salutaria, Galatia II, and Lycaonia could be connected to Amorium under the system of the apothekai supervised by kommerkiarioi (as discussed above); now, in the new system of the impersonal imperial kommerkia, it is only the province of Phrygia Salutaria (in combination with Bithynia and Phrygia Pakatiane) that reappears, and this happens only for two consecutive years, in 731/2 and 733/4, but never again thereafter. In fact, immediately afterward, in 734/5, we encounter for the first time the Anatolikoi on the two seals of the imperial kommerkia "of the eparchiae of the Anatolikoi," obviously referring to the old late Roman provinces where this army was stationed (note that the same expression is also used for Opsikion in 745/6; see Table 2). Ten years later (in 744/5), we encounter the seal of the imperial kommerkia of (this time) "the strategia of the Anatolikoi" (in Table 2, compare the similar expression used for the Thrakesioi in 741/2, 744/5, and 745/6), while from 747/8 onward (as indicated currently by the available material), the seals are issued by the imperial kommerkia of (simply) "the Anatolikoi." This gradual change in the nomenclature employed by the official Byzantine administration is indicative, in our view, of the gradual transformation to yet another new system, that of the themes. The simple term "Anatolikoi" that appears on the seals of the imperial kommerkia from 747/8 onward should be understood, in our view, as a well-known geographical entity identified by this military command; in fact, we would be very tempted to regard the year 747/8 as the terminus ante quem for the creation of the theme of the Anatolikoi.

131 On the fluctuating borders of these provinces, especially during the Early Byzantine period, and the administrative status of Amorium, see *TIB* 4:40, 42, n. 1, 59, and 123. On the seals enumerated here, see Montinaro, "Les premiers commerciaires byzantins," nos. 4, 8, 78, and 112 (Galatia), 57 (Lycaonia), and 76, 160, and 164 (Phrygia Salutaria).

132 Important discussions on the imperial kommerkia with all previous references are included in Brubaker and Haldon, *Byzantium in the Iconoclast era*, 696–97; Ragia, "Geography of the Provincial Administration," 218–25; and Brandes, *Finanzverwaltung in Krisenzeiten*, 365–94, 511–64 (Appendix I), 594–95 (Appendix VII), which should take into account the remarks by Montinaro, "Les premiers commerciaires byzantins," 370, n. 45. On a recently updated list of the seals issued by the imperial kommerkia, see O. Karagiorgou, "Sigillographische Spuren der Hexapolis von Hellespontos," in *Anekdota Byzantina: Studien zur byzantinischen Geschichte und Kultur; Festschrift für Albrecht Berger anlässlich seines 65. Geburtstags,* ed. I. Grimm-Stadelmann, A. Riehle, R. Tocci, and M. M. Vučetić, Byzantinisches Archiv 41 (Berlin, 2023), 245–76.

133 Table 2 is an excerpt of a catalogue including 119 (currently known to us) seals of imperial kommerkia, published in Karagiorgou, "Sigillographische Spuren," 258–76. Specimens with the prefix "BZS" in the column "Present location" are kept in the sigillographic collection of Dumbarton Oaks in Washington, DC. In the column "References," we render in bold those references (if more than one) or comments that propose and/or further explain the date that appears in the column "Date"; "n/a" stands for "not available."

Table 2. Catalogue of the Known Seals of Imperial Kommerkia in Asia Minor

Note: Underlined entries are directly relevant to Amorium and its hinterland.

Date (ind.)	Imperial Kommerkia of . . .	Present Location	References
695–697 (9 and 10)	Helenopontos (the apotheke of)	BZS.1955.1.4402	Montinaro, "Les premiers commerciaires byzantins," no. 89
695–697 (9 and 10)	Asia, Karia, and Lykia (the apotheke of)	Paris, Bibliothèque nationale de France (Zacos) 730	J.-C. Cheynet, "Quelques nouveaux sceaux de commerciaires," in *Trade in Byzantium: Papers from the Third International Sevgi Gönül Byzantine Studies Symposium*, ed. P. Magdalino and N. Necipoğlu (Istanbul, 2016), no. 10
		Berlin, Münzkabinett	Montinaro, "Les premiers commerciaires byzantins," no. 90
		Private coll. Savvas Kofopoulos 2518 (Lesbos)	J.-C. Cheynet, *Les sceaux byzantins de la collection Savvas Kofopoulos*, vol. 1 (Paris, 2022), no. 3.56
730/1 (14)	Asia and Karia	Private coll. Yavuz Tatış 2563 (Izmir)	J.-C. Cheynet, *Les sceaux byzantins de la collection Yavuz Tatış* (Izmir, 2019), no. 3.11
730–741? (n/a)	Amastris up to the (Cimmerian?) Bosporus	Paris, Bibliothèque nationale de France, Thierry 174	Cheynet, "Quelques nouveaux sceaux de commerciaires," no. 14
731/2 (15)	Bithynia, (Phrygia) Salutaria, (Phrygia) Pakatiane	n/a (ex-Zacos coll.)	G. Zacos and A. Veglery, *Byzantine Lead Seals* (Basel, 1972), no. 243. See also Brandes, *Finanzverwaltung in Krisenzeiten*, 553, no. 213
731/2 (15)	Hexapolis (Kato) von Hellespontos	Private coll. Dr. D. Theodoridis 789 (Munich)	Karagiorgou, "Sigillographische Spuren"
731/2 (15)	Lydia	Private coll.	See Brandes, *Finanzverwaltung in Krisenzeiten*, no. 213B
732/3 (1)	Asia	n/a (ex-Zacos coll.)	Zacos and Veglery, *Byzantine Lead Seals*, no. 246; *Byzantine Seals from the Collection of G. Zacos*, part 1, Spink, Auction 127 (London, 1998), no. 14; see also Brandes, *Finanzverwaltung in Krisenzeiten*, 554, no. 216
733/4 (2)	Bithynia, (Phrygia) Salutaria, (Phrygia) Pakatiane, and Lydia	BZS.1951.31.5.1738 (ex-Zacos coll.)	Zacos and Veglery, *Byzantine Lead Seals*, no. 248a, and *DOSeals* 3, no. 24.4. See also Brandes, *Finanzverwaltung in Krisenzeiten*, 554, no. 218
		n/a (ex-Zacos coll.)	Zacos and Veglery, *Byzantine Lead Seals*, no. 248b
		Hannover, Museum August Kestner L7.2005 (=ex-Zarnitz coll. 1063)	W. Seibt, *Ein Blick in die byzantinische Gesellschaft: Die Bleisiegel im Museum August Kestner* (Rahden, 2011), no. 8
734/5 (3)	Anatolikoi (ἐπαρχιῶν)	BZS.1958.106.682	Zacos and Veglery, *Byzantine Lead Seals*, no. 245, and Corrigenda et Addenda, 1955 (see no. 245, giving the correct date), and *DOSeals* 3, no. 86.37. See also Brandes, *Finanzverwaltung in Krisenzeiten*, 554, no. 215, and C. Malatras, "The Thema of the Anatolikoi: Prosopography and Administrative Structure," in Karagiorgou, Charalampakis, and Malatras, *TAKTIKON*, 277–401, 372, 375 (TAKTIKON_ANAT_46)
		Paris, Bibliothèque nationale de France (Zacos) 740	Cheynet, "Quelques nouveaux sceaux de commerciaires," no. 12; Malatras, "Anatolikoi" 372, 388 (TAKTIKON_ANAT_241)

Table 2. *continued*

Date (ind.)	Imperial Kommerkia of . . .	Present Location	References
734/5 (3)	Krateia, Prousias, and Herakleia	St. Petersburg, Hermitage M-8024	N. P. Lihačev, "Datirovannye vizantijskie pechati," *Izvestija Rossijskoj akademii material'noj kul'tury* 3 (1924): 153–224, 198–99, no. 9, table XII.6; N. P. Lihačev, *Molivdovuly grecheskogo Vostoka*, ed. V. S. Šandrovskaja, Naučnoe nasledie 19 (Moscow, 1991), 240–41, table LXXV.4; and Zacos and Veglery, *Byzantine Lead Seals*, 192 (table 34, n. 3). See also Brandes, *Finanzverwaltung in Krisenzeiten*, 554, no. 219
735/6 (4)	Kerassous	BZS.1955.1.4397	Zacos and Veglery, *Byzantine Lead Seals*, no. 250, and *DOSeals* 4, no. 34.2. See also Brandes, *Finanzverwaltung in Krisenzeiten*, 555, no. 223
736/7 (5)	Lydia	Paris, Bibliothèque nationale de France (Zacos) 741	Zacos and Veglery, *Byzantine Lead Seals*, Corrigenda et Addenda, 1955 (see no. 251). See also Brandes, *Finanzverwaltung in Krisenzeiten*, 555, no. 227, and Cheynet, "Quelques nouveaux sceaux de commerciaires," no. 13
737/8 (6)	Asia and Karia	Private coll. Savvas Kofopoulos 1742 (Lesbos)	Montinaro, "Les premiers commerciaires byzantins," 371, n. 45.10, and Cheynet, *Collection Savvas Kofopoulos,* no. 3.57
738/9 (7)	Asia and Karia	n/a (ex-Zacos coll.)	Spink, *Zacos*, no. 15. See also Brandes, *Finanzverwaltung in Krisenzeiten*, 556, no. 233a; (auction) Hirsch 237 (November 2004), no. 1017 = *SBS* 10 (2010): 169, no. 1017
		Gaziantep, Museum of Archaeology 18.5.76	J.-C. Cheynet, E. Erdoğan, and V. Prigent, "Les sceaux byzantins du Musée de Gaziantep," *REB* 78 (2020): 5–69, 17
738/9 (7)	Kerassous	St. Petersburg, Hermitage M-7973	Lihačev, "Datirovannye," 199, no. 10, table XII.7; Lihačev, *Molivdovuly*, 241–42, table LXXV.5; and Zacos and Veglery, *Byzantine Lead Seals*, 194 (table 34, n. 10), no. 250 (simple mention). See also Brandes, *Finanzverwaltung in Krisenzeiten*, 556, no. 230
739/40 (8)	Kibyrraiotai (στρατηγία)	Paris, Bibliothèque nationale de France (Zacos) 739	Zacos and Veglery, *Byzantine Lead Seals*, Corrigenda et Addenda, 1955 (see no. 261), and Cheynet, "La mise en place," 1–14, 9, no. 5. See also Brandes, *Finanzverwaltung in Krisenzeiten*, 557, no. 234a; P. Charalampakis, "Towards a New Prosopographic *Corpus* of the Kibyrraiotai: Sources, Methods, Benefits," in Karagiorgou, Charalampakis, and Malatras, *TAKTIKON*, 515–600, 591 (TAKTIKON_KIB_125)
741/2 (10)	Thrakesioi (στρατηγία)	BZS.1951.31.5.1737	Zacos and Veglery, *Byzantine Lead Seals*, no. 261, and *DOSeals* 3, no. 2.31. See also Brandes, *Finanzverwaltung in Krisenzeiten*, 557, no. 237
741/2 (10)	Hexapolis (Kato)	Brussels, Cabinet des médailles de la Bibliothèque royale	V. Tourneur, "L'Hexapolis arménienne au VIIᵉ siècle et au VIIIᵉ," in *Mélanges Bidez: Annuaire de l'Institut de philologie et d'histoire orientales*, vol. 2 (Brussels, 1934), 947–52, and Zacos and Veglery, *Byzantine Lead Seals*, no. 260a. See also Brandes, *Finanzverwaltung in Krisenzeiten*, 557, no. 236, and Karagiorgou, "Sigillographische Spuren"
741/2? (n/a)	Hexapolis (Kato)	n/a (ex-Zacos coll.)	Zacos and Veglery, *Byzantine Lead Seals*, no. 260b, and Spink, *Zacos*, no. 16. See also Brandes, *Finanzverwaltung in Krisenzeiten*, 557, no. 236, and Karagiorgou, "Sigillographische Spuren"
742/3 (11)	Hellespontos, Asia, and Karia	Athens, Numismatic Museum BE 656/1996 (found on the islet of Arkadia, north of Melos, in the Cyclades)	I. Koltsida-Makre, "New Acquisitions of Byzantine Lead Seals in the Athens Numismatic Museum Collections," *SBS* 9 (2006): 11–22, 15–16, no. 5; Montinaro, "Les premiers commerciaires byzantins," 370, n. 45.1, 437, n. 225

Table 2. *continued*

Date (ind.)	Imperial Kommerkia of . . .	Present Location	References
744/5 (13)	Anatolikoi (στρατηγία)	Hierapolis, Hierapolis Archaeology Museum E 4203	N. Elam, "Thematic Molybdoboulla from the Collections of Eleven Archaeological Museums in Turkey," in Karagiorgou, Charalampakis, and Malatras, *TAKTIKON*, 716–44, 718, no. 1. See also Malatras, "Anatolikoi," 389 (TAKTIKON_ANAT_253)
744/5 (13)	Thrakesioi (στρατηγία)	Paris, Bibliothèque nationale de France (Zacos) 735	Cheynet, "La mise en place," 9, no. 4
745/6 (14)	Opsikion (ἐπαρχιῶν)	BZS.1951.31.5.1741	Zacos and Veglery, *Byzantine Lead Seals*, no. 263, and *DOSeals* 3, no. 39.41. See also Brandes, *Finanzverwaltung in Krisenzeiten*, 557, no. 239; C. Malatras, "At the Service of the Imperial Opsikion: The *Corpus* of the Officials," in Karagiorgou, Charalampakis, and Malatras, *TAKTIKON,* 401–512, 488, 493 (TAKTIKON_OPS_51)
		St. Petersburg, Hermitage M-12456 (found in Sougdaia/ Sudak)	V. Šandrovskaja, "Die Funde der byzantinischen Bleisiegel in Sudak," *SBS* 3 (1993): 85–98, 89, and Malatras, "Opsikion," 488, 496 (TAKTIKON_OPS_91)
		n/a (auction)	Classical Numismatic Group, E-auction 436, no. 742; Malatras, "Opsikion," 488 and 508 (TAKTIKON_OPS_238)
745/6 (14)	Thrakesioi (στρατηγία)	Munich, Staatliche Münzsammlung 499	W. Seibt and M.-L. Zarnitz, *Das byzantinische Bleisiegel als Kunstwerk* (Vienna, 1997), 66–67, no. 1.3.8, and Cheynet, "La mise en place," 8, no. 3. See also Brandes, *Finanzverwaltung in Krisenzeiten*, 558, no. 240
747/8 (or 732/3) (1)	Anatolikoi	Geneva, Musée d'art et d'histoire CdN 44665 (acquired at Amorium, Fig. 24)	M. Campagnolo-Pothitou and J.-C. Cheynet, *Sceaux de la collection Georges Zacos au musée d'art et d'histoire de Genève* (Milan, 2016), no. 103, and Malatras, "Anatolikoi," 372, 377 (TAKTIKON_ANAT_82)
748/9 (2)	Anatolikoi	Paris, Bibliothèque nationale de France (Zacos) 744	Cheynet, "Quelques nouveaux sceaux de commerciaires," no. 11, and Malatras, "Anatolikoi," 372, n. 128, 388 (TAKTIKON_ANAT_240)
755/6? or 770/1? (9?)	Asia	Sofia, National Institute of Archaeology with Museum 12	G. Schlumberger, "Sceaux byzantins inédits (Quatrième série) (1)," *REG* 13, fasc. 55 (1900): 467–92, 469, no. 149; N. A. Mušmov, "Vizantijski olovni pechati ot sbirkata na Narodnija Muzej," *Izvestija na Bălgarskija arheologičeski Institut* 8 (1934–1935): 331–91, 335, no. 5, fig. 190.8; Lihačev, "Datirovannye," 203; and Zacos and Veglery, *Byzantine Lead Seals*, 166 (table 19, n. 8), 196 (table 34, n. 17). See also Brandes, *Finanzverwaltung in Krisenzeiten*, 559, no. 252, and I. Jordanov, *Corpus of Byzantine Seals from Bulgaria*, vol. 1, *Byzantine Seals with Geographical Names* (Sofia, 2003), no. 12.2
756/7 or 771/2 (10)	Nicaea, Christoupolis (?) and . . .	Paris, Bibliothèque nationale de France (Zacos) 729	Cheynet, "Quelques nouveaux sceaux de commerciaires," no. 18

Table 2. *continued*

Date (ind.)	Imperial Kommerkia of . . .	Present Location	References
758/9 (12)	Anatolikoi	Munich, Staatliche Münzsammlung 23	Seibt and Zarnitz, *Kunstwerk,* no. 1.3.9. See also Brandes, *Finanzverwaltung in Krisenzeiten*, 560, no. 254, Karagiorgou, "Yet Another *TAKTIKON*," 76, and Malatras, "Anatolikoi," 372, 383 (TAKTIKON_ANAT_167)
760/1 (14)	Anatolikoi	n/a (auction)	Auction Gorny, München 82 (29.4.1997), no. 423, and Peter Schreiner and Cordula Scholz, "Bibliographische Notizen und Mitteilungen: Nachträge zu den Jahrgängen 89 (1996) und 90 (1997)," *BZ* 89–90, Supplementum Bibliographicum 3 (1998): 135, no. 1375 (Seibt). See also Brandes, *Finanzverwaltung in Krisenzeiten*, 560, no. 255; Karagiorgou, "Yet Another *TAKTIKON*," 76; and Malatras, "Anatolikoi," 372, 381 (TAKTIKON_ANAT_138)
776 (14)	Anatolikoi	Munich, Staatliche Münzsammlung 618	Seibt and Zarnitz, *Kunstwerk,* no. 1.3.10, and Malatras, "Anatolikoi," 372, 383 (TAKTIKON_ANAT_168)

Table 2 also shows that within the catalogue of attested seals of imperial kommerkia associated with Asia Minor (forty specimens in total), the Anatolikoi (in contrast to other areas) have not only a prominent position but also the most lasting presence (from 734/5 up to 776). This is not surprising if we bear in mind that the Anatolikoi was one of the largest and most important armies of the empire. The recently published results of the *TAKTIKON* Research Project on the prosopography and administrative structure of three of the earliest (and largest) themes in Asia Minor (the Opsikion, the Anatolikoi, and the Kibyrraiotai) have offered further tangible support to the prominence of the Anatolikoi in comparison to the other two Asia Minor themes: the Anatolikoi have the highest recorded number of officials (227) and molybdoboulla (360), as well as the highest number and variety of recorded offices (twenty-six) in the military and civil sectors.[134] Thus, it is of no surprise that the office of the strategos of the

Anatolikoi was often a stepping stone to higher offices, such as (in the tenth century) the domesticate of the scholai (the highest military command of the empire) and, above all, that of the emperor itself.[135]

More specific data on the exact numbers of the army of the Anatolikoi would have been a very welcome addition to our discussion here, since the pressure that any army corps exercises on the local resources for their provisioning is directly proportional to their size. The question, however, of the exact numbers of the Byzantine army in any given period remains one of the most debated issues.[136] The number of soldiers in the Anatolikoi could have even risen to 25,000 in the seventh century, according to a recent assessment by Haldon.[137]

Apart from the size of the army of the Anatolikoi, it is worth considering another serious possibility that would have almost certainly doubled the amount of the military presence in Central Anatolia in the seventh and eighth centuries and subsequently the requirements for

134 For a comparison of the attested officials, molybdoboulla, and offices in the Opsikion, Anatolikoi, and Kibyrraiotai, see O. Karagiorgou, "Yet Another *TAKTIKON*," in *TAKTIKON: Studies on the Prosopography and Administration of the Byzantine Themata*, ed. O. Karagiorgou, P. Charalampakis, and C. Malatras (Athens, 2021), 83, fig. 4, 100–101, fig. 13. For a detailed study on the prosopography and administrative structure of the Anatolikoi under the principles of the *TAKTIKON* Research Project, see C. Malatras, "The Thema of the Anatolikoi: Prosopography and Administrative Structure," in *TAKTIKON,* 277–401, esp. appendix 2 (a chronological list of the officials active in the various administrative sectors in the Anatolikoi).

135 Among the eighty-two strategoi of the Anatolikoi recorded in *TAKTIKON*, six ascended the imperial throne (in chronological order): Leontios (695–698), Leo III the Isaurian (717–741), Leon V the Armenian (813–820), Nikephoros Phokas (963–969), Ioannes Tzimiskes (969–976), and Nikephoros Botaneiates (1071–1078).

136 Haldon, *Warfare, State, and Society in the Byzantine World*, 101–3, 107–15.

137 Haldon, *The Empire That Would Not Die*, 266–75, map 7.1; see also J. F. Haldon, *Byzantium in the Seventh Century: The Transformation of a Culture*, rev. ed. (Cambridge, 1997), 251–53.

its subsistence (including provisions in wine). Ralph-Johannes Lilie has argued that the military command of Thrakesion had been established before 680 and that the reference to the *tracisianus* army in the royal *iussio* that Justinian II addressed to Pope Ioannes V in February 687 in confirmation of the acts of the council of 680–681 refers in fact to this division.[138] This thesis raised several objections, but in one of his latest studies, Haldon addresses this question again, offering further arguments in support of Lilie's theory.[139] According to Haldon, the Thracian field army (the *magister militum per Thracias*) had been in Anatolia since the 630s/early 640s, certainly fighting the Arabs in the eastern theater where extra military force must have been much needed after the disaster at Yarmuk in 636. Thereafter, the Thracian field army was permanently allocated across Anatolia, retaining its formal name (tracisianus) and its ranking in the hierarchy. The main reason for this development (apart from the crucially defensive role of these troops) was the requirement to supply and quarter the soldiers. Before the 630s, the magister militum per Thracias was located behind the Danube frontier (in Moesia II and Scythia). However, after the 640s, the areas south of the Danube were no longer under safe imperial control and, above all, they were unable to sustain such a large field army.

At this point, it is worth remembering that armies, along with their officers, played a key role not only against the foreign threat of the Arabs but also in the internal strife of the mid-eighth century. Next to the imperial kommerkia of the Anatolikoi, it is the imperial kommerkia of the (*strategia* of the) Thrakesioi that feature quite prominently in the eighth century (see Table 2, in 741/2, 744/5 and 745/6). The Thrakesians and the Anatolikoi provided the main support to Constantine V against his brother-in-law, Artabasdos, who usurped the throne of Constantinople from June 742 to November 744. Indiction 741/2 would then correspond to the

preparations for the civil war and that of 744/5 to the siege of Constantinople by Constantine.[140] It is only reasonable to assume that, while Artabasdos occupied Constantinople, Constantine V must have sought refuge in one of the important urban centers in the areas that supported him (and most probably at Amorium).[141] Thus, Amorium may very well have acted (even if occasionally) as the headquarters for his counteroffensive. Under these circumstances, the imperial concern for the sufficient provisioning of its armed forces would have been constant. Furthermore, if Amorium had become the temporary base of exiled emperors or claimants to the imperial throne, then the pressure on local resources (including the production of good wine needed for the imperial retinue) must have been far more intense.

It is under these contemporary realities, therefore, that we could explain the construction of intra muros wine-making installations at Amorium and the much-needed increase in the production of wine. Consequently, we may reasonably assume that the process of "conscious decision to sacrifice valuable urban space and undertake a great financial commitment for the creation and especially the maintenance of both wineries and vineyards," as described above, mirrors a centrally orchestrated act of "compulsory purchase" as part of an overall devised plan on behalf of the Byzantine government to support the exceptionally large forces that were settled in Central Anatolia from 650 onward. Consequently, it became necessary to maximize local produce, especially the kind that was directly necessary for the well-being of these troops and the sustainability of their fighting force (and wine was certainly among them).[142]

A final point needs to be discussed. If the institution of the imperial kommerkia was primarily destined to cover the needs of the armed forces, why do seals of the imperial kommerkia associated with the Kibyrraiotai (last attested in 739/40), the Opsikion (last attested in 745/6), and the Anatolikoi (last attested in 776; Fig. 24) gradually cease to exist after the 740s? We believe that this fact does not relate to the volume of evidence that has survived to our days but rather to a slow, but deep,

138 R.-J. Lilie, "'Thrakien' und 'Thrakesion': Zur byzantinischen Provinzorganisation am Ende des 7. Jahrhunderts," *JÖB* 26 (1977): 7–47. Recently, Efi Ragia argued that the tracisianus army in the royal iussio of Justinian II refers in fact to the theme of Thrakesion, whose creation she places under Justinian II, in 687 or a little later; see Ragia, "Geography of the Provincial Administration," 213.

139 J. Haldon, "Thrace, Thrakesion and Hellas," in *Constantinople: Queen of Cities; Papers Dedicated to Paul Magdalino*, ed. D. Smythe and S. Tougher (Leiden, forthcoming). We are grateful to John Haldon for sharing with us his unpublished manuscript.

140 J.-C. Cheynet, "La mise en place des thèmes d'après les sceaux: Les stratèges," *SBS* 10 (2010): 10.

141 K. Belke, *Tabula Imperii Byzantini*, vol. 4, *Galatien und Lykaonien* (Vienna, 1984; repr. Vienna, 2004), 123.

142 Haldon, *The Empire That Would Not Die*, 275–82.

Fig. 24.
Lead seal of the imperial kommerkia of the Anatolikoi, ind. 1 (732/3 or 747/8), acquired at Amorium. Obverse: half-length portraits of Emperor Leo III (left) and his son Constantine V (right); reverse: inscription in seven lines with an indiction date in the last line: Τῶν βασιλικῶν κομμερκίων τῶν Ἀνατολικῶν. Ind. Aʹ ([Seal of] the imperial kommerkia of the Anatolikoi. Indiction 1). Geneva, Musée d'art et d'histoire, inv. no. CdN 44665. Donated by Jean Romieux, 1942; photographed by B. Jacot-Descombes.

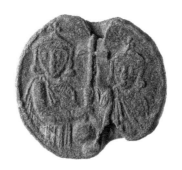
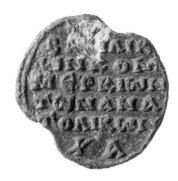

institutional change. As Brandes has rightly noted, around 730/1, when the institution of the imperial kommerkia was introduced, "the geographical distribution of the *apothekai* changed in favour of the European areas."[143] This observation is confirmed by the sigillographic corpus of the imperial kommerkia that we have recently compiled, where only twenty-four of the 119 relevant seals (20.16 percent) are associated with areas far from the western Asia Minor littoral, the Black Sea coast, and Europe, while after 773/4, the imperial kommerkia of Thessaloniki and Thrace dominate.[144] The fact that after about the 760s the imperial kommerkia are not associated anymore with the old late Roman provinces (Asia, Karia, Lydia, etc.) or large military units (e.g., Opsikion, Anatolikoi, etc.), but with coastal areas and important port cities (Mesembria, Thessaloniki, Debeltos) clearly indicates, in our view, their detachment from the management of products exclusively (or also) for the supply of the army and their gradual link to the general import and export trade of the empire. This change occurred probably in parallel to the gradual introduction of the thematic system (hence the gradual abandonment of the nomenclature of the old late Roman provinces) and the providence in it of other (now thematic) mechanisms and officials responsible for the provisioning of the army. In other words, although the institution of imperial kommerkia maintained the same name during its centennial life, its role and activities (and possibly also its structure) changed as they adapted to contemporary economic and fiscal requirements.

143 Brandes, *Finanzverwaltung in Krisenzeiten*, 305.

144 Karagiorgou, "Sigillographische Spuren."

Amorian Wines and the Army

The connection between wine and its rationing and consumption in the Roman army has long been established.[145] Wine was also a staple drink for the soldiers of the Early Byzantine military, and it was provided regularly to them as rations. We can observe this process in numerous documents dating up to the seventh century from Egypt, where a daily ration of approximately 1 to 2 *sextarii*/ξέστες was the rule.[146] A sextarius equals 0.546 liters, according to the most common metrological calculations; thus, the daily ration of wine to Early Byzantine soldiers would have been between 0.5 and 1 liter (thus approximately equivalent to a modern bottle of wine per day).[147] It is not clear if this is a quantity to be consumed or whether part of it could be sold for income, as the figures seem quite high. In the Middle Byzantine period, rationing of wine to soldiers most probably continued as is indicated in different military manuals.[148] In these sources, we can observe that before or during the military operations special arrangements were made in order for wine to be

145 R. W. Davies, "The Roman Military Diet," *Britannia* 2 (1971): 124–25, and J. P. Roth, *The Logistics of the Roman Army at War (264 B.C.–A.D. 235)* (Leiden, 1999), 14–16, 53–55.

146 Hickey, *Wine, Wealth, and the State in Late Antique Egypt*, 111–29, with further discussion and full bibliography.

147 Hickey, *Wine, Wealth, and the State in Late Antique Egypt*, 194.

148 For information contained in Leo VI's *Sylloge Tacticorum* and *Taktika*, see S. Wierzbiński, "The Burden, the Craving, the Tool: The Provisioning of the 10th Century Byzantine Army in the Light of Leo's *Tactica* and *Sylloge Tacticorum*," *Studia Ceranea* 10 (2020): 477.

procured for the use of the army on campaign.[149] Based on such texts, Lucas McMahon recently calculated a much lower daily wine ration for the soldiers of the tenth-century Byzantine army that reconquered Crete, amounting to 0.27 liters every third day (or half a bottle of wine every three days).[150]

By proxy, we can use this low Middle Byzantine ration to calculate the possible needs in wine of the thematic army of the Anatolikoi based in and around Amorium. To do this, we estimate the power of the army of the Anatolikoi at any given time in the seventh to ninth centuries at approximately 20,000 troops. This equals to an annual quantity around 660,000 liters of wine needed solely for the army of the Anatolikoi according to this moderate estimate.[151]

Of course, this modeling is highly hypothetical, and a great number of variants could affect it (e.g., the true quantity rationed, the number of soldiers, their actual base of operation, and the projected period of time of their expedition), and thus it should be regarded only as indicative of the magnitudes of wine needed. Since moving supplies for the army was an onerous task, especially overland, as in the case of landlocked Amorium, it would have been logical for the state to ensure that much of the needed foodstuff

was produced locally.[152] In this way, investing in the creation and upkeep of a robust local wine industry in seventh- and eighth-century Amorium at a scale unseen ever before in order to serve the needs of the army of the Anatolikoi newly stationed there seems to be a plausible explanation for the archaeological finds from the city. After all, focused wine production in Amorium was an investment materialized exactly at the moment when wine production in the Levant spirals down and wine from these areas almost disappears for the Byzantines with the expansion of Islam.[153]

More detailed information concerning wine provision for the army during campaigns and possible connections to the situation at Amorium can be found in a treatise on imperial military expeditions, which reflects realities of the eighth and ninth centuries.[154] According to this text, when the emperor was on a campaign in Syria, the *domestikos* of the household service had to transport with him "one hundred measures of vintage Nicaean wine in skins (εἰς ἀσκοὺς οἶνον Νικαινὸν παλαιὸν)." Moreover, the imperial wine server had to secure "sufficient imperial wine (οἰνάριν δεσποτικὸν)," while all the rest "ought to be drawn from the supplies of the *protonotarioi*."[155] In another part of the *Treatise*, it is also mentioned that the emperor and his army, when marching overland from Constantinople to Syria, were expected to consume local wines (ἐγχώριος οἶνος) provided by the protonotarioi.[156] These wines were obtained in two distinct qualities: the good wine (καλὸς οἶνος), which was served to the emperor and his courtiers, and the ordinary common wine, which was destined for the main bulk of the army. The good wine

149 On Early Byzantine and possibly Middle Byzantine rations, see J. Haldon, "The Organisation and Support of an Expeditionary Force: Manpower and Logistics in the Middle Byzantine Period," *Τὸ ἐμπόλεμο Βυζάντιο (9ος–12ος αι.)/Byzantium at War (9th–12th c.)*, ed. K. Tsiknakis (Athens, 1997), 124; J. Haldon, "Feeding the Army: Food and Transport in Byzantium, ca 600–1100," in *Feast, Fast or Famine: Food and Drink in Byzantium*, ed. W. Mayer and S. Trzcionka (Brisbane, 2005), 86; J. Haldon, "Roads and Communications in the Byzantine Empire: Wagons, Horses, and Supplies," in *Logistics of Warfare in the Age of the Crusades: Proceedings of a Workshop Held at the Centre for Medieval Studies, University of Sydney, 30 September to 4 October 2002*, ed. J. H. Pryor (Aldershot, 2006), 147–48; Wierzbiński, "The Burden, the Craving, the Tool"; and L. McMahon, "Logistical Modelling of a Sea-Borne Expedition in the Mediterranean: The Case of the Byzantine Invasion of Crete in AD 960," *Mediterranean Historical Review* 36.1 (2021): 74–76. For a table that gathers examples of regulation rations including wine, see C. Morrisson and J.-C. Cheynet, "Prices and Wages in the Byzantine World," in Laiou, *The Economic History of Byzantium*, 870–71, table 20.

150 McMahon, "Logistical Modelling," 77.

151 A similar effort of quantification of the needs of the 20,000 Roman legionaries and auxiliaries serving in second-century Galatia established that their monthly need in wine would be around 327,000 liters; see J. Bennett, "Agricultural Strategies and the Roman Military in Central Anatolia during the Early Imperial Period," *Olba* 21 (2013): 325.

152 On the cost of transporting and "packaging" goods, see McCormick, "Movements and Markets."

153 Fuks et al., "Rise and Fall of Viticulture," 19780–91.

154 Constantine VII Porphyrogenitus, *Treatise (C)*, lines 1–884 (Haldon, *Three Treatises*, 94–151), and Anagnostakis, *Βυζαντινός οινικός πολιτισμός*, 51–57. Generally on the organization of army logistics, see Haldon, "Organisation and Support," 118–19.

155 Constantine VII Porphyrogenitus, *Treatise (C)*, lines 599–604 (Haldon, *Three Treatises*, 132–33): "the head of the table and the domestikos of the household service ought to transport the imperial table-service; and when the emperor is in Syria, of course, 100 measures of vintage Nicaean wine in skins; and 30 measures of Nicaean oil; and the imperial wine-server (should bring) sufficient imperial wine. All the rest of the provisions ought to be drawn from the supplies of the prōtonotarioi, that is from Romania."

156 Constantine VII Porphyrogenitus, *Treatise (C)*, lines 136–54 (Haldon, *Three Treatises*, 102–4, and commentary, 200–203).

was also to be supplemented locally during the army's march wherever it could be found, since the original supplies were rapidly depleted.[157]

How could local Amorian wine production and the presence of the thematic army of the Anatolikoi fit in this picture? We can make the reasonable assumption that the Amorian wine was one of the local wines (ἐγχώριος οἶνος) prepared for the army or mustered in the process of the campaign. In this way, local production could both cover (or supplement) the needs of the permanently stationed garrisons and the much greater needs for expeditionary forces.

As a provincial center, Amorium had a constant presence of military and administrative dignitaries of some status, while also occasionally being visited by individuals directly connected to the imperial throne. So, it is worth examining the possibility that, besides lower-quality local wine (ἐγχώριος οἶνος), the city could have also produced high-quality wine (καλὸς οἶνος) that was reserved for the military elite, the imperial court, or even the campaigning emperor himself. In Middle Byzantine sources, this good wine is synonymous with the wine of Bithynia (or of Nicaea), a special red vintage probably made from sun-dried grapes being also "flower-scented."[158]

Army officials, aristocrats, and occasionally members of the court might not have been the only ones interested in sweet wine from sun-dried grapes in Amorium. According to the *Chronicles* of both Theophanes Continuatus and Genesios, the city was the homeplace of a sizable Jewish community in the eighth and ninth centuries.[159] Jewish communities made extensive use of this type of sweet wine for everyday and religious practices, thus making them a possible additional clientele, and one with special rules for both production and consumption.[160]

Discussion about the quality of wine produced in the Amorium wineries remains largely speculative, but it is still worth attempting a synthesis based on the little evidence and comparable information. Residue analysis of Amorium winery tank samples suggests the possibility that part of the wine produced at Amorium could have been red, based on chemical signature, although this approach to identifying wine color can be far from certain.[161] There is no known tradition, though, of eponymous wines connected with the region of Amorium, such as we know for Bithynia and other areas of Asia Minor.[162] Pliny in his *Naturalis historia* mentions that Galatia produced a sweet wine called *Scybelites*.[163] This reference has been broadly reproduced in modern literature, but it should be treated with caution since all Greek textual sources up to the ninth century consider Scybelites a "Pamphylian wine."[164] Thus, ancient Scybela should be placed in

157 Constantine VII Porphyrogenitus, *Treatise (C)*, lines 150–51 (Haldon, *Three Treatises*, 102–4).

158 Anagnostakis, Βυζαντινός οινικός πολιτισμός, 59–65, and I. Anagnostakis, "The Sweet Wine of Bithynia in the Byzantine Era," in *Of Vines and Wines: The Production and Consumption of Wine in Anatolian Civilizations through the Ages*, ed. L. Thys-Şenocak (Leuven, 2017), 93–117; for *anthosmias*, a floral wine scented by the *anthos*, i.e., the froth or scum produced on the surface of the wine in the vats or wine jars, see Anagnostakis, "Noms de vignes et de raisins," 56, n. 66.

159 *Theophanes Continuatus*, II.3 (M. Featherstone and J. Signes Codoñer, eds., *Chronographiae quae Theophanis Continuati nominee fertur Libri I–IV*, CFHB 53 [Berlin, 2015], 66); Joseph Genesios, *Basileion*, III.13 (A. Lesmueller-Werner and H. Thurn, *Iosephi Genesii regum libri quattuor*, CFHB 14 [Berlin, 1978], 46); J. Starr, "An Eastern Christian Sect: The Athinganoi," *HTR* 29.2 (1936): 93–106; J. Starr, *The Jews in the Byzantine Empire, 641–1204*, 2nd ed. (New York, 1970), 98–99, 109; A. Sharf, *Jews and Other Minorities in Byzantium*

(Ramat Gan, 1995), 61–62; E. Ivison, "Kirche und religiöses Leben im byzantinischen Amorium," in Daim and Drauschke, *Byzanz – das Römerreich im Mittelalter*, 325–26; and P. Gardette, "The Judaizing Christians of Byzantium: An Objectionable Form of Spirituality," *Jews in Byzantium: Dialectics of Minority and Majority Cultures*, ed. R. Bonfil et al. (Leiden, 2012), 591–95.

160 Dodd, *Roman and Late Antique Wine Production*, 62–63. For more on the kosher wine used by Jewish communities in the Middle Ages, see B. Arbel, "The 'Jewish Wine' of Crete," in Μονεμβάσιος οίνος–Μονοβασ(ί)α–Malvasis/Monemvasian Wine–Monovas(i)a–Malvasia, ed. I. Anagnostakis, Οἶνον ἱστορῶ 5 (Athens, 2008), 82.

161 L. Drieu et al., "Is It Possible to Identify Ancient Wine Production Using Biomolecular Approaches?," *STAR: Science & Technology of Archaeological Research* 6.1 (2020): 16–29.

162 For the tradition of the sweet wines of Bithynia, see Anagnostakis, "Sweet Wine of Bithynia," and Anagnostakis and Boulay, "Les grands vignobles bithyniens," 25–49.

163 Pliny the Elder, *Naturalis historia* 14.80 (H. Rackham, ed. and trans., *Pliny: Natural History*, vol. 4, *Libri XII–XVI*, Loeb 370 [Cambridge, MA, 1945], 238–40).

164 Pliny's comment is reproduced in Gorny, "Viniculture and Ancient Anatolia," 134, and A. Dalby, *Food in the Ancient World, from A to Z* (London, 2003), 296. For the Pamphylian origin of Scybelites, see Galen, *De victu attenuante* 98.2 (K. Kalbfleisch, ed., *Galeni de victu attenuante*, Corpus medicorum Graecorum 5.4.2 [Leipzig, 1923]): ὁ ἀπὸ τῆς Παμφυλίας οἶνος ὁ καὶ Σκυβελίτης ὀνομαζόμενος (the wine from Pamphylia that is also named Scybelites).

Pamphylia and not in Central Anatolia.[165] Other areas in the interior of Asia Minor were known in antiquity for their wines, some of which were also used for therapeutic purposes.[166] For instance, Maeonia, in inland Lydia, produced the highly valued *Katakekaumenites* wine, and the region of Tmolos was famous for a wine extensively used in medical recipes together with other ingredients such as hellebore, saffron, and *akoron*.[167] The region of Kalecik/Malos at the eastern vicinity of Ankara in Galatia was well-known for its high-quality red wine that had a reputation for healing and well-being.[168] Moreover, the area around the city of Amblada, which Strabo places near the boundaries of Phrygia and Karia, produced wine that was exported and used for medicinal purposes.[169]

Still, we can extract some indirect evidence that could be connected with special wine making in the area of Amorium during the Middle Ages. According to Arabic sources, one of the important substances obtained at Amorium by traveling Arab merchants was a plant called *al-vaj*.[170] This can be identified as sweet flag (*Acorus calamus*, akoron, or aromatic reed), whose root was used for various medical and other purposes, or alternatively, but less possibly, as yellow flag (*Iris pseudacorus*).[171] Dioscorides, a physician and writer from the first century CE, describes a plant similar to *Acorus* collected in Galatia and includes it in a formula for a therapeutic wine.[172] Sweet flag was an expensive product that was used widely as an additive in wine during antiquity due to its therapeutic properties.[173] The same plant still grows in swampy areas next to lakes in Central Anatolia and is collected for various medicinal purposes.[174] Perhaps the sweet flag reportedly acquired by the Arabs at Amorium offers evidence for its continued collection and use in the early Middle Ages.[175]

165 Hesychius, *Lexicon*, s.v. Κέσκος (Ian Cunningham, ed., *Hesychii Alexandrini lexicon*, vol. 2, *E–O*, rev. ed. [Copenhagen, 2020]): . . . καὶ Σκυβελίτης οἶνος, ἀπὸ Σκυβέλων, τόπου Παμφυλίας (. . . and the Scybelites wine, [that comes] from Scybela, a place in Pamphylia). According to Mitchell, *Anatolia*, 1:146–47, "[T]here need be no contradiction if Pliny was using a source which dated from the time when Pamphylia was in the province of Galatia."

166 Dalby, *Food in the Ancient World*, 30–31 (on Asian wines); S. Mitchell, "Food, Culture and Environment in Ancient Asia Minor," in *A Companion to Food in the Ancient World*, ed. J. Wilkins and R. Nadeau (Chichester, 2015), 285–95; and P. Komar, *Eastern Wines on Western Tables: Consumption, Trade and Economy in Ancient Italy* (Leiden, 2020), 16, 102–4. See also J. Jouanna, *Greek Medicine from Hippocrates to Galen: Selected Papers*, ed. P. van der Eijk, trans. N. Allies (Leiden, 2012), 173–94, and P. Komar, "In vino sanitas: Medical Qualities of Greek Wines," *Mélanges de l'École française de Rome – Antiquité* 132.2 (2020): 429–47.

167 A. Dalby, *Food in the Ancient World*, 30–31, 134, and Komar, *Eastern Wines on Western Tables*, 102. For the use of ingredients in the wine, see Z. Rzeźnicka and M. Kokoszko, "Wine and Myrrh as Medicaments or a Commentary on Some Aspects of Ancient and Byzantine Mediterranean Society," *Studia Ceranea* 9 (2019): 615–55.

168 Mitchell et al., "Church Building and Wine Making."

169 Strabo, *Geographica* 12.7.2 (A. Meineke, ed., *Strabonis geographica* [Leipzig, 1853], 2:800–801). On Dionysus's cult and the viticulture, vintage, and wines in Mysia, Pisidia, and Cappadocia, see Mitchell, "Food, Culture and Environment," 285–95, and especially on Amblada, 288–89.

170 K. Durak, "Commerce and Networks of Exchange between the Byzantine Empire and the Islamic Near East from the Early

Ninth Century to the Arrival of the Crusaders" (PhD diss., Harvard University, 2008), 188–91.

171 It is mentioned as yellow flag by Durak, "Commerce and Networks of Exchange," 188, and as sweet flag by Lightfoot, "Business as Usual?," 188. Indeed, *haj* is one of the common Arabic names for sweet flag (*Acorus calamus*): T. J. Motley, "The Ethnobotany of Sweet Flag, *Acorus calamus* (Araceae)," *Economic Botany* 48.4 (1994): 397–412; S. Tibi, *The Medicinal Use of Opium in Ninth-Century Baghdad* (Leiden, 2006), 208 (where it is transcribed as *wajj*); N. Serikoff, "'Syriac' Plant Names in a Fifteenth Century Greek Glossary (From the Wellcome Library Books and Manuscripts)," in *Medical Books in the Byzantine World*, ed. B. Zipser (Bologna, 2013), 103 (the published catalogue suggests ἄκορον: ὀυέτζ), 110, n. 34.

172 Dioscorides, *De materia medica* 1.2 (M. Wellmann, ed., *Pedanii Dioscuridis Anazarbei de materia medica libri quinque* [Berlin, 1907]), 1:1–7: ἄκορον τὰ μὲν φύλλα ἔχει ἐμφερῆ ἴριδι, . . . πλῆρες εὐωδίας. τοιοῦτο δέ ἐστι τὸ ἐν Κολχίδι καὶ τὸ ἐκ τῆς Γαλατίας (akoron has leaves that resemble the leaves of iris . . . full of scent. Such is the one in Colchis and that from Galatia [translation based on L. Y. Beck, trans., *Pedanius Dioscorides of Anazarbus: De materia medica* (Hildesheim, 2005), 7]). For the formula, see Rzeźnicka and Kokoszko, "Wine and Myrrh," 627, 638.

173 Rzeźnicka and Kokoszko, "Wine and Myrrh," 627, 632–33, 638. The authors note that the sweet flag used by Early Byzantine physicians and mentioned by Dioscorides was "the type imported from India" and not "today's ubiquitous European variety, since it was not brought to the region until sometime between the Middle Ages and the 16th century" (633).

174 A. Baytop, "Türkiye'de *Acorus calamus*/*Acorus calamus* in Turkey," *Journal of Faculty of Pharmacy or Ankara University* 9 (1979): 12–17, and Motley, "Ethnobotany of Sweet Flag," 403.

175 The study of archaeobotanical material from Amorium by John Giorgi revealed no presence of *Acorus calamus*: Lightfoot, "Business as Usual?," 188, and J. Giorgi, "The Plant Remains," in Lightfoot and Ivison, *Amorium Reports 3*, 395–418. However, we need to take into account that the plant grew some distance from the settlement, probably in the marshy areas of the Sangarius riverine system to the north of Amorium, and the plant material of interest is the rhizome that

Thus, it is possible that local wine production also could have carried on the ancient tradition of seasoning wine with aromatic herbs.

If so, this good wine (καλὸς οἶνος) would probably have been produced following the Bithynian method of making sweet straw wine, a technique dictating that the grapes should be dried in the sun before being trodden, and resulting in a heavy, deep red wine later aromatized by herbs like sweet flag.[176] Perhaps the parallel existence of treading floors and winepresses inside the city of Amorium could relate to the production of two different quality categories of wine. Certainly, Middle Byzantine wine tasters still held in high esteem the production of sophisticated and therapeutical wines, as shown by the tenth-century compilation of the *Geoponika*, which contains a large number of recipes and mentions the addition of spices and fragrances to the wine after its fermentation in order to enhance its taste and scent.[177]

Wine (and wine vinegar) intended for army use must have also played an important role as a therapeutic medium for its mildly antiseptic, analgesic, and soporific qualities.[178] In a skirmish near Samarra in AD 363, the emperor Julian was wounded by a spear that pierced the lower lobe of his liver. He was treated by his personal physician, Oribasius of Pergamum, who, according to recent research, followed Hippocratic medical practice and treated Julian by irrigating his wound with dark wine, applying a procedure known as *gastrorrhaphy*.[179]

Advice on using wine for its anesthetic and other qualities in military context is also provided in the tenth-century *Sylloge tacticorum*.[180] Sometimes wine could have offered an invigorating and hydrating boost to the army, as during the Battle of Dorostolon in midsummer of 971, when the soldiers were provided with flasks of wine and water by John Tzimiskes.[181]

The consumption of wine by the Byzantine military could also be a concern occasionally, especially when this became excessive and had negative effects on the discipline of the soldiers. Textual sources make references both to the care taken by the military officers to provide a constant supply of wine during the campaigns and to the disastrous consequences of drunkenness. Libanius mentions that, during Julian's Persian wars, when the emperor Julian saw "a large camel train, with one animal tied behind another and all loaded with supplies, this being composed of the finest wines from all over the world and all the devices people have discovered for the increased pleasure of wine drinking," he ordered his men to leave the supplies behind, saying, "Good soldiers . . . should drink the wine they won at sword point."[182]

In another event in 533, the Byzantine fleet under Belisarios set sail from Constantinople to fight the Vandals. Five days later, the fleet anchored at Abydos, a fees station (*commercium*) with large warehouses

would have left no easily discernible traces, while the rest of the plant along with the seeds would have been discarded at the harvesting location. See Motley, "Ethnobotany of Sweet Flag," 397–99; H. Fazal, N. Ahmad, and B. Haider Abbasi, "Identification, Characterization, and Palynology of High-Valued Medicinal Plants," *Scientific World Journal* (2013), https://doi.org/10.1155/2013/283484.

176 Anagnostakis, Βυζαντινός οινικός πολιτισμός, 59–63; Anagnostakis, "Sweet Wine of Bithynia"; and Anagnostakis and Boulay, "Les grands vignobles bithyniens." It was difficult to get all the juice from dried grapes only by treading; the use of heavy rollers or winepresses would have also been needed (D. Van Limbergen, "Changing Perspectives on Roller Presses in Late Antique Northern Syria," *Syria: Archéologie, art et histoire* 94 [2017]: 314–15).

177 See references to *Geoponika* by Rzeźnicka and Kokoszko, "Wine and Myrrh," 615–55, and Decker, *Tilling the Hateful Earth*, 136.

178 C. F. Salazar, *The Treatment of War Wounds in Graeco-Roman Antiquity* (Leiden, 2000), 63 (anesthetic), 66 (antiseptic).

179 J. Lascaratos and D. Voros, "Fatal Wounding of the Byzantine Emperor Julian the Apostate (361–363 A.D.): Approach to the Contribution of Ancient Surgery," *World Journal of Surgery* 24

(2000): 615–19, and D. Potter, *Rome in the Ancient World: From Romulus to Justinian* (London, 2009), 288.

180 Wierzbiński, "The Burden, the Craving, the Tool," 493.

181 John Skylitzes, *Synopsis*, Ioannes Tzimiskes 15 (H. Thurn, ed., *Ioannis Scylitzae Synopsis Historiarum*, CFHB 5 [Berlin, 1973], 306.49–50); G. Dennis, "The Byzantines in Battle," in Tsiknakis, Το εμπόλεμο Βυζάντιο, 168; and S. McGrath, "The Battles of Dorostolon (971): Rhetoric and Reality," in *Peace and War in Byzantium: Essays in Honor of George T. Dennis, S.J.,* ed. T. S. Miller and J. Nesbitt (Washington, DC, 1995), 159.

182 Libanius, *Funeral Oration over Julian*, §216 (R. Foerster, ed., *Libanii opera*, vol. 4, *Orationes LI–LXIV* [Leipzig, 1908], oration XVIII, 330–31). For the English translation, see A. F. Norman, trans., *Libanius, Selected Works*, vol. 1, *Julianic Orations*, Loeb 451 (London, 1969), p. 425. It should be noted that Julian owned vineyards in Bithynia, producing a unique sweet wine similar to the imperial *despotikos* wine taken by the emperors in their campaigns. On Julian's vineyards in Bithynia, see J. Bidez, ed., *L'empereur Julien: Oeuvres complètes*, vol. 1.2, *Lettres et fragments* (Paris, 1924), epistle no. 4; Anagnostakis, Βυζαντινός οινικός πολιτισμός, 62; and Anagnostakis and Boulay, "Les grands vignobles bithyniens," 36–39.

(apothekai) of wine and oil.[183] During their stay there, the Massagetae, who, according to Procopius, were the most intemperate *akratopotes* (drinkers of unmixed wine) among all the soldiers, got drunk and killed one of their comrades. Belisarios punished them with impalement and gave a speech to the army, in which he made it clear that drunkenness "itself . . . is worthy of punishment" and that it would not be accepted.[184]

Three centuries later, the Byzantine army faced more serious problems caused by alcohol abuse, according to a legendary interpretation by chronographs of a great disaster considered a divine punishment. This time it was during a campaign against the Bulgarians in the Balkans. Emperor Nikephoros I, who was leading the Byzantine army, succeeded in defeating Tsar Krum and sacked his capital.[185] In order to celebrate his victory, the emperor opened the cellars of the seized palace and distributed wine to his soldiers, who got drunk. After some days of feasting, the Byzantines burned the palace of the tsar to the ground and left the city, only to be attacked by the Bulgarians, who seized the opportunity to retaliate. The imperial army, perhaps also because of its inebriety all those days, was annihilated by the Bulgarians, and Nikephoros was killed, his skull, according to the legend, becoming the drinking cup of Krum.[186]

Maybe it was this kind of experience that caused Leo VI in his *Taktika* to counsel military officers that wine consumption by soldiers should be avoided during the hot summer months, along with other precautions for alleviating the possibility of heatstroke.[187]

Conclusions

The typology and function of the wine-producing installations at Amorium fall neatly into the existing discussion and relevant typology, vastly expanding our understanding of the use of screw weight presses in the Transitional Period. The archaeological remains are highlighted even more by the precise dating offered by the systematic excavation, information that is usually missing for similar constructions in a Byzantine setting. Large parts of the urban settlement of the newly established thematic capital were repurposed and dedicated to the production of wine at an almost industrial scale. The wineries of Amorium were created during the seventh century and remained functioning until the early ninth century. They had been partially or entirely dismantled some years before the Arab destruction of the city in 838. No wine-producing installations have been discovered in the subsequent phase during the rebuilding of Amorium in the late ninth and early tenth century until its final abandonment by the Byzantines in the late eleventh century.

The relocation of large military units to the region of Amorium from the East and the creation of the thematic army of the Anatolikoi in the seventh century also signaled new realities for the settlement. One of these would be the need to sustain a large number of soldiers, administrative officers, skilled workmen, and professionals connected to the army.[188] It has been shown before, especially in Roman times, that the presence of large military units in certain marginal or

183 On the Abydos tariff and wine, see V. Iacomi, "Some Notes on Late-Antique Oil and Wine Production in Rough Cilicia (Isauria) on the Light of Epigraphic Sources: Funerary Inscriptions from Korykos, LR 1 Amphorae Production in Elaiussa Sebaste and the Abydos Tariff," in Aydınoğlu and Şenol, *Olive Oil and Wine Production in Anatolia*, 19–32; more generally, see G. A. Leveniotis, Η Άβυδος του Ελλησπόντου και η περιοχή της (Thessaloniki, 2017).

184 Procopius, *History of the Wars* III.12.6–22 (H. B. Dewing, trans., *Procopius*, vol. 2, *History of the Wars, Books 3–4*, Loeb 81 [London, 1916], 112–17), and I. Anagnostakis, "Wine, Water, Bread, and Love Affairs on a Sixth-Century Military Campaign: Narrative Strategies, Politics and Historicity," in *Homage to Tibor Živković*, ed. I. R. Cvijanović (Belgrade, 2016), 23–38.

185 I. S. Dujcev, "La chronique byzantine de l'an 811," *TM* 1 (1965): 210–16, and Theophanes, *Chronographia*, AM 6303 (de Boor, *Theophanis Chronographia*, 1:489–91).

186 For an interpretation of the story in the light of the use of wine by the Byzantine army and the Byzantine legends of vines' destruction and interdiction of wine, see I. Anagnostakis, "Η παροινία των Βαλκανίων: Η μέθη του πολέμου και το ποτήρι του Κρούμου," in Τέχνη και τεχνική στα αμπέλια και στους οινώνες της Β. Ελλάδος: Θ´ Τριήμερο Εργασίας Αδριανή Δράμας, 25–27 Ιουνίου 1999 (Athens, 2002), 138–67; see also P. Stephenson, "'About the Emperor Nikephoros and How He Leaves His Bones in Bulgaria': A Context for the Controversial 'Chronicle of 811,'" *DOP* 60 (2006): 88.

187 Leo VI, *Taktika*, §83 (G. T. Dennis, ed. and trans., *The Taktika of Leo VI*, CFHB 49 [Washington, DC, 2010], 336–37), and Wierzbiński, "The Burden, the Craving, the Tool," 494.

188 Useful analogies emerge from the study of the Apion estate in sixth-century Aphrodito in Egypt, where the usual allowance for military wine grows to an unforeseen measure when a new military unit, the *Scythae Iustiniani*, appears in the general area and needs to be provided for (Hickey, *Wine, Wealth, and the State in Late Antique Egypt*, 120–23).

noncentral areas could greatly affect the local economy.[189] Additionally, providing for the military in a landlocked base of operations like Amorium meant that there could only be limited reliability for imports for reasons of time and cost. Thus, an economy of scale regarding wine production must have developed locally, based partially on preexisting viticulture traditions but mainly due to large investment in the form of new mechanical wineries and the development of the respective vineyards.[190] The material remains of this new economic reality can be seen in the unearthed wine-producing installations of Amorium.

But, if the presence of the army can be associated with the construction of the winepresses in the middle of the seventh century, their abandonment some years before the destruction of 838, in a period when Amorium was still an important military hub and the base of the strategos of the Anatolikoi, remains an unanswered question. We can enumerate a number of reasons that could have contributed to this decline in wine production inside the walled city of Amorium from the ninth century on.

Firstly, we do not have palynological data from the broader area to investigate if there was any total reduction in viticulture at this time. However, paleoenvironmental evidence from all around Anatolia shows that in the middle of the eighth century the climatic conditions changed, creating increased dryness.[191] This relatively drier and colder period, which lasted until the beginning of the tenth century, could have influenced the agricultural regime of the area. The vine in particular is sensitive to both drought and frost. Spring frosts can destroy the annual grape harvest, whereas drought conditions affect the volume and quality of the wine production.[192]

Moreover, apart from the change in the climate, during the eighth century, Amorium suffered multiple Arab raids, as we saw earlier. These attacks, which occurred mainly in the spring and summer, made the rural population abandon their villages. During this type of warfare, both the invaders and the defenders used to burn or uproot the crops. A vineyard destroyed either by the weather or by man takes five to seven years to bear fruit again.[193] Hard times or bad harvests mean instability in the supply chain and problems in the production of wine. This insecurity might have already played a role in the introduction of the high-value wineries inside the walled area in the seventh century.

The new realities of the ninth- and tenth-century Byzantine state with the expansion to both the east and west meant that the needs for wine could again be served by the traditional networks of production and distribution. The apotheke of Amorium was not a functioning institution anymore, so much of the logistic arrangements designed for the armies of the seventh and eighth centuries were not valid anymore. Also, Arab raids gradually diminished or entirely stopped after 838, and the Byzantines were on the offensive by that point. It would be logical in this phase for wine making to return to the countryside with no special care for it being conducted inside the safety offered by fortifications. It may also be that the consolidation of the frontier line further to the east meant that other areas closer to the frontier army,

189 "The presence of the Rhine armies sparked a demand that ultimately pushed wine production as far north as the Moselle banks" (K. S. Verboven, "Good for Business: The Roman Army and the Emergence of a 'Business Class' in the Northwestern Provinces of the Roman Empire [1st Century BCE–3rd Century CE]," in *The Impact of the Roman Army [200 BC–AD 476]: Economic, Social, Political, Religious, and Cultural Aspects: Proceedings of the Sixth Workshop of the International Network Impact of Empire [Roman Empire, 200 B.C.–A.D. 476], Capri, March 29–April 2, 2005*, ed. L. de Blois and E. Lo Cascio [Leiden, 2007], 295–313, at 307). At Roman Gordion, see C. Çakırlar and J. M. Marston, "Rural Agricultural Economies and Military Provisioning at Roman Gordion (Central Turkey)," *Environmental Archaeology* 24.1 (2019): 91–105, and Bennett, "Agricultural Strategies and the Roman Military," 324–37.

190 It has been proposed that the Phrygian site of Hendek Kale near modern Uşak had been developed in late antiquity into a wine- or oil-producing center connected with the needs of locally stationed troops: Bennett and Claasz Coockson, "Hendek Kale," and Bennett, "Agricultural Strategies and the Roman Military," 327.

191 Haldon, "Remarks on History, Environment, and Climate in Byzantine Anatolia," 9, and A. Izdebski et al., "The Environmental, Archaeological and Historical Evidence for Regional Climatic Changes and Their Societal Impacts in the Eastern Mediterranean in Late Antiquity," *Quaternary Science Reviews* 136 (2016): 192–98.

192 E. Xoplaki et al., "The Medieval Climate Anomaly and Byzantium: A Review of the Evidence on Climatic Fluctuations, Economic Performance and Societal Change," *Quaternary Science Reviews* 136 (2016): 233, and D. Van Limbergen and W. De Clercq, "Viticulture as a Climate Proxy for the Roman World? Global Warming as a Comparative Framework for Interpreting the Ancient Source Material in Italy and the West (ca. 200 BC–200 AD)," in *Climate Change and Ancient Societies in Europe and the Near East: Diversity in Collapse and Resilience*, ed. P. Erdkamp, J. G. Manning, and K. Verboven (Cham, 2021), 468.

193 Gorny, "Viniculture and Ancient Anatolia," 146, and Maniatis, "Byzantine Winemaking Industry," 232.

such as Cappadocia, undertook a considerable portion of the production of wine for the military.[194]

While viticulture and wine production marked the fortune and prosperity of early medieval Amorium, it is again a wine story that marks the city's destruction in 838. The famous Arabic long poem by Abū Tammām (d. 846) celebrating the triumph of Caliph al-Muʿtaṣim records that the fall of the city happened just "before the ripening of figs and grapes" (verse 59).[195] Abū Tammām's verse responded to an astrological prediction prophesizing that the capture of Amorium would come only at the time when grapes and figs ripen, probably an allusion to the city being ripe for the taking.[196]

194 Peker, "Agricultural Production."
195 M. M. Badawi, "The Function of Rhetoric in Medieval Arabic Poetry: Abū Tammām's Ode on Amorium," *Journal of Arabic Literature* 9.1 (1978): 50, and H. M. Hassan, "Το ποίημα του Αμπού Ταμμάμ και η άλωση του Αμορίου το 838 μ.Χ," *Journal of Oriental and African Studies* 13 (2004): 45, 66.
196 Abū Bakr al-Ṣūlī, *The Life and Times of Abū Tammām*, ed. and trans. B. Gruendler (New York, 2015), 33, and Hassan, "Το ποίημα του Αμπού Ταμμάμ," 66.

Nikos Tsivikis
Institute for Mediterranean Studies, FORTH
130 Nikiforou Foka Str. & Melissinou
74100 Rethymno
Crete
Greece
ntsivikis@ims.forth.gr

Thanasis Sotiriou
Institute for Mediterranean Studies, FORTH
130 Nikiforou Foka Str. & Melissinou
74100 Rethymno
Crete
Greece
sotiriouthan@gmail.com

Olga Karagiorgou
Research Centre for Byzantine and Postbyzantine Art
Academy of Athens
14 Anagnostopoulou Str.
10673 Athens
Greece
karagiorgou@academyofathens.gr

Ilias Anagnostakis
National Hellenic Research Foundation
48 Vassileos Constantinou Ave.
11635 Athens
Greece
eanagno@eie.gr

❧ THIS RESEARCH HAS BEEN COFINANCED BY Greece and the European Union (European Social Fund [ESF]) through the operational program "Human Resources Development, Education and Lifelong Learning 2014–2020" in the context of the project "Wine-Producing Installations in Byzantine Asia Minor, 7th–9th c.: The Case of Amorion" (MIS 5050161) hosted by the Academy of Athens. Also important for the successful conclusion of our project was the support of Chrysa Maltezou, a member of the academy, and the personnel of the institution.

We would like to express our sincere appreciation to the Amorium Excavations Project and its director, Dr. Zeliha Demirel-Gökalp of Anadolu University, for her continuous support of our project and international collaborations in general. The Amorium excavations are supported by the Ministry of Culture and Tourism of the Republic of Türkiye, the Anadolu University Scientific Research Projects Commission, and the Turkish Historical Society. We are grateful to Christopher Lightfoot, former director of the Amorium Excavations Project, for providing access

to the archival and photographic material of the older excavation, for allowing us to consult his own personal notes on stone press weights and the residue analysis of the winepress mortar, both as yet unpublished, and for his careful and time-consuming revisions to this text. The assistance of Dr. Jamieson Donati with his research of the landscape around Amorium was paramount, as was his editing of some of the maps presented here. A special thanks is owed to the anonymous reviewers, who offered ideas for crucial improvements of the text, and to the editor of *Dumbarton Oaks Papers*, who treated our text and its production with special care. All remaining errors are those of the authors themselves.

Byzantine Cultural Entomology (Fourth to Fifteenth Centuries)

A Microhistory of Byzantine Insects

PRZEMYSŁAW MARCINIAK

Of Insects and Humans

As Michael Psellos aptly remarked, "We rule over other animals, but the louse is our ruler."[1] Inspired by this remark, this article hopes to offer a new perspective onto an unstudied subfield of animal studies by looking at Byzantine insects.

One of the pioneers of ecocriticism, Donna Haraway, names insects ("creepy crawlies," in her words) as one of the principal Others to humans.[2] And yet in the Byzantine cultural tradition, where every single being was believed to have been created by God and to ultimately possess some purpose, even if it remains unclear, such creatures should be construed rather as the "other within." They both belong and do not belong; they are everywhere in the material sphere, while simultaneously existing on the margins of the human–animal world. At the same time, their omnipresence makes them ideal vehicles for metaphorical meanings.

This contribution aims to show how insects functioned in the Byzantine imagination. By analyzing changes in metaphorical meanings attributed to insects, I trace a transformative process: a dialogue between old (pagan) and new (Christian) metaphors and symbols.[3] Certain ideas, which had been fairly popular in antiquity, were phased out in the Byzantine period. A good example is the idea of *bougonia*—the spontaneous generation of bees from cow carcasses.[4] Unlike in antiquity, when this theory was widely debated, in the Byzantine period there were no scientific discussions regarding bougonia and other zoogonic theories.[5] The only Byzantine text where it is described in detail and the

1 Michael Psellos, *Minor Orations* 28.113 (A. R. Littlewood, ed., *Michaelis Pselli oratoria minora* [Leipzig, 1985], 106): Τῶν μὲν οὖν ἄλλων ἡμεῖς ἄρχομεν ζῴων, ἡμῶν δὲ κατάρχει ἡ φθείρ.

2 D. Haraway, *When Species Meet* (Minneapolis, 2008), 9.

3 See the remark of Elisabeth Wimmer: "Die frühchristlichen Schriftsteller haben das in der heidnischen Literatur vorgebildete Erbe der Bildersprache übernommen, umgeformt und aus seiner ursprünglichen Bedeutung gelöst, um es einer geistlich religiösen Idee dienlich zu machen" (E. Wimmer, *Biene und Honig in der Bildersprache der lateinischen Kirchenschriftsteller* [Vienna, 1998], 93).

4 See the most recent and very thorough treatment of this subject in D. Berrens, *Soziale Insekten in der Antike: Ein Beitrag zur Naturkonzepten in der griechisch-römischen Kultur* (Göttingen, 2018), 187–217.

5 Bougonia had been discussed in many ancient sources, starting probably with the work Ἑρμηνεία of Philetas of Kos; the birth of wasps and bees from the carcasses of horses and of bulls, respectively, is mentioned in the *Theriaka* by Nikander. Zoogonic theories are discussed in Plutarch (*Cleom.* 60.5) and Pliny (*Historia naturalis* 11.70). On Ovid's description of bougonia and its sources, see M. Garani, "Lucretius and Ovid on Empedoclean Cows and Sheep," in *Lucretius: Poetry, Philosophy, Science*, ed. D. Lexoux, A. D. Morrison, and A. Sharrock (Oxford, 2013), 244–48; on bougonia in Vergil and beyond, see H. V. Harissis, "Aristaeus, Eurydice and the Ox-Born Bee: An Ancient Educational Beekeeping Myth," in *Apiculture in the Prehistoric Aegean: Minoan and Mycenaean Symbols Revisited*, ed. H. V. Harissis and A. V. Harissis (Oxford, 2009).

term itself is mentioned (as βουγονή) is the *Geoponika* (15.2).[6] Several later authors briefly referred to this bizarre process.[7] In his commentaries on Aristotle's *Physics*, Michael Psellos includes the following remark on the origin of insects: Γίνεται καὶ ἐκ τοῦ ἐγκεφάλου τοῦ βοὸς μέλισσα, ὡς ἐξ ἵππου σφὴξ (A bee is born from a cow's brain and similarly a wasp from a horse).[8]

John Kinnamos alludes somewhat cryptically to bougonia in his *Ethopoiia on a Painter Trying to Paint Apollo on an Uncooperative Panel of Laurel Wood*, where he states: "And Zeus bellowed like a bull, so it be known that not only was honey contrived out of the bull, but inversely the bull out of Zeus and honey."[9] These references reflect an inherited literary topos rather than any zoological interest. It would be tempting to assume that this lack of further interest in zoogonic theories is indicative of the general approach to insects in the Byzantine period. Unlike ancient writers, Byzantines did not show much interest in zoological explorations. But even in antiquity, insects attracted far less scientific attention than other species.[10] Perhaps one of the few, largely unstudied, attempts at discussing insects in the Byzantine period was by Michael of Ephesus (twelfth century) in his commentaries on Aristotle's works. However, a more detailed study would be required to see if Michael contributed anything beyond Aristotle's work.

Studies on insects are a part of animal studies—or human–animal studies—that has recently become a flourishing area of research. While the "animal turn" has not been overlooked in Byzantine studies, it has certainly not attracted the same level of attention there as it has in the fields of classics and Western medieval studies. So far, only isolated investigations into particular topics have been produced. For example, the *Ζώα και περιβάλλον στο Βυζάντιο (7ος–12ος αι.)* offers interesting contributions and provides Byzantine scholars with a good starting point in animal studies, but has ultimately failed to stir further interest.[11] Nancy Ševčenko's contribution to a valuable volume on gardens gives an overview of animal parks and menageries in the middle Byzantine period, while a 2012 edition of the online periodical *RursuSpicae* is devoted to *Excerpts on the Nature of Animals (Sylloge)* by Constantine Porphyrogennetos, and a companion to Byzantine science published this year includes a survey of Byzantine zoological knowledge.[12] Moreover, individual species, such as cats and dogs, have attracted the attention of scholars.[13] Recent studies have tackled the issue of political zoology—that is, the use of animal imagery in political discourse—in Byzantine literature.[14] Stavros Lazaris, one of the most prominent researchers in the field of ancient and Byzantine animal studies, has written extensively on the *Physiologos*, veterinary knowledge, and scientific manuscripts.[15]

6 See the title of *Geoponika* 15.2: Περὶ μελισσῶν, καὶ πῶς ἂν ἐκ βοὸς γένοιτο, ὃ καλεῖται βουγονή (About bees, and how what is called bougonia is born from a cow) (H. Beckh, *Geoponica* [Leipzig, 1895], 437–443).

7 See, e.g., *Suda* β 453 (and also ι 577 and τ 158), where the process is alluded to (A. Adler, ed., *Suidae lexicon*, 4 vols. [Leipzig, 1928–35]).

8 Michael Psellos, *Commentary on Physics* 1.33.38–9 (L. G. Benakis, *Michael Psellos Kommentar zur Physik des Aristoteles*, Corpus philosophorum Medii Aevi, Commentaria in Aristotelem Byzantina 5 [Athens, 2008], 58). Psellos alludes most likely to Nikander's *Theriaka* 741: ἵπποι γὰρ σφηκῶν γένεσις, ταῦροι δὲ μελισσῶν (For horses are the origin of wasps, but bulls of bees); this line was used three times in the *Suda* (see above, n. 7) and in the *Anthologia Graeca*. If not stated otherwise, all translations are my own.

9 Translation after K. Warcaba, "Ethopoiia on a Painter Trying to Paint Apollo on an Uncooperative Panel of Laurel Wood," in *Sources for Byzantine Art History*, vol. 3, *The Visual Culture of Later Byzantium (c. 1081–c. 1350)*, ed. F. Spingou (Cambridge, 2022), 142–56, at 145.

10 O. Keller, *Die Antike Tierwelt*, vol. 2 (Leipzig, 1913), 395.

11 I. Anagnostakis, T. Kolias, and E. Papadopoulou, eds., *Ζώα και περιβάλλον στο Βυζάντιο (7ος–12ος αι.)* (Athens, 2011).

12 N. Ševčenko, "Wild Animals in the Byzantine Park," in *Byzantine Garden Culture*, ed. A. Littlewood, H. Maguire, and J. Wolschke-Bulmahn (Washington, DC, 2002), 69–86; *L'encyclopédie zoologique de Constantin VII*, issue of *Rursus: Poïétique, réception et réécriture text textes antiques*, no. 7 (2012), https://journals.openedition.org/rursus/617; A. Zucker, "Zoology," in *A Companion to Byzantine Science*, ed. S. Lazaris (Leiden, 2019), 262–301.

13 O. Keller, "Zur Geschichte der Katze im Altertum," *MDAIRA* 23 (1908): 40–70; E. Kislinger, "Byzantine Cats," in Anagnostakis et al., *Ζώα και περιβάλλον*, 137–64; A. Rhoby, "Hunde in Byzanz," in *Lebenswelten zwischen Archäologie und Geschichte: Festschrift für Falko Daim zu seinem 65. Geburtstag*, ed. J. Drauschke, E. Kislinger, and K. Kühtreiber (Mainz, 2018), 807–20; T. Schmidt, "Noble Hounds for Aristocrats, Stray Dogs for Heretics: Connotation and Evaluation of Literary Dogs in Byzantium," in *Impious Dogs, Haughty Foxes and Exquisite Fish: Evaluative Perception and Interpretation of Animals in Ancient and Medieval Mediterranean Thought*, ed. T. Schmidt and J. Pahlitzsch (Berlin, 2019), 103–31.

14 T. Schmidt, *Politische Tierbildlichkeit in Byzanz: Spätes 11. bis frühes 13. Jahrhundert* (Wiesbaden, 2020).

15 See, e.g., S. Lazaris, *Le Physiologus grec*, vol. 1, *La réécriture de l'histoire naturelle antique* (Florence, 2016) and more recently *Le Physiologus grec*, vol. 2, *Donner à voir la nature* (Florence, 2021), and

A recent book on ecocriticism offers some insights into animal metaphors in *Digenis Akritas*, and important works by Henriette Kroll engage with the zooarchaeological material.[16] Finally, literary animals of the later Byzantine period have also attracted attention.[17] A single group of living creatures remains unstudied and neglected by scholars: insects.[18] Only one article exists on this topic, which discusses the few Byzantine texts where insects are referenced.[19]

I will thus here present two main ideas. First, that the Byzantines subsumed the ancient entomological legacy and mapped their Christian worldview on it. And second, that insects and related arthropods in Byzantine culture are predominantly *literary animals*: that is, cultural constructs. In exploring the role of insects in the Byzantine cultural fabric, this article adopts the approach of cultural *entomology*. Cultural entomology, which is more a perspective than a set of clearly defined methodological tools, focuses on the presence and influence of insects and other terrestrial arthropods in literature, language, music, the arts, history, religion, and recreation.[20] In other words, it deals with "recorded sources in literate societies."[21] Cultural entomology can be seen as a subfield of ethnoentomology.[22] As Darrel Posey has argued, "The native (folk) view of insects—their naming, classification, and use—is surely the ultimate goal of ethnoentomology."[23] *Ethnoentomology* studies the zoological and practical knowledge of insects, such as their pharmacological or nutritional use, in a given society (past or present). Charles L. Hogue offers an alternative approach, viewing ethnoentomology as part of cultural entomology.[24]

The division between ethnoentomology and cultural entomology may seem artificial or blurred at best in Byzantine culture.[25] All the accounts at our disposal are "recorded sources," whether literary or visual. However, because of the popular nature of premodern zoological knowledge—Byzantine authors often fused zoological knowledge inherited from ancient authors with what would today be described as "folk" knowledge—this article also incorporates zoological writings on insects as well as technical and practical uses of insects as food or medicine within its understanding of cultural entomology.[26] Cultural entomology typically shows little concern with the identification and reconstruction of zoological knowledge on insects, instead emphasizing ways to integrate such knowledge into the cultural fabric of a society.

When compared to the use of insect imagery in Western literature, Byzantine cultural entomology shows its own peculiarities. For instance, the comparison of Jesus Christ to the scarab (dung beetle) that appears in the texts of Ambrose (and is rooted in biblical tradition) apparently was not embraced in

Art et science vétérinaire à Byzance: Formes et fonctions de l'image hippiatrique (Turnhout, 2010).

16 A. Goldwyn, *Byzantine Ecocriticism: Women, Nature and Power in the Medieval Greek Romance* (London, 2018); see also, for instance, H. Kroll, *Tiere im Byzantinischen Reich: Archäozoologische Forschungen im Überblick* (Mainz, 2010).

17 See, e.g., F. Leonte, "'. . . For I have brought to you the fugitive animals of the desert': Animals and Representations of the Constantinopolitan Imperial Authority in Two Poems by Manuel Philes," in *Animaltown: Beasts in Medieval Urban Space*, ed. A. Choyke and G. Jaritz (Oxford, 2017), 179–87.

18 To the best of my knowledge, this topic has been completely neglected, except for Byzantine apiculture (see below). Günter Morge, in his history of entomology in medieval times, unsurprisingly ignores Byzantium. See G. Morge, "Entomology in the Western World in Antiquity and in Medieval Times," in *History of Entomology*, ed. R. F. Smith, T. E. Mittler, and C. N. Smith (Palo Alto, 1973), 37–80.

19 J. de la Fuente, "El insecto como tema retórico y poético," *Minerva: Rivista del Filologia Clasica* 17 (2004): 85–102.

20 The terms of the discipline of cultural entomology were set out by Charles L. Hogue in his paper "Cultural Entomology," *Annual Review of Entomology* 32 (1987): 181–99.

21 D. Posey, "Topics and Issues in Ethnoentomology with Some Suggestions for the Development of Hypothesis-Generation," *Journal of Ethnobiology* 6.1 (1986): 99–120, at 100.

22 J. N. Hogue, "Cultural Entomology," in *Encyclopedia of Insects*, ed. V. H. Resh and R. T. Cardé (New York, 2009), 239–45.

23 Posey, "Topics and Issues in Ethnoentomology," 100.

24 C. L. Hogue, "Cultural Entomology," 191: "Ethnoentomology, i.e., applications of insect life in so-called primitive (traditional, aboriginal, or nonindustrialized) societies, may be regarded as a special branch of cultural entomology."

25 The question of if and to what extent the label *ethnos/ethnie* can be applied to the Byzantine Empire is far beyond the scope of this article.

26 See R. Kutalek, "Ethnoentomology: A Neglected Theme in Ethnopharmacology?," *Curare* 34.1–2 (2011): 128–36, at 128: "Ethnoentomology is concerned not only with mankind's *use of insects* in medicine, as food, poison and aphrodisiac, in divination, recreation, myths or sayings; but also with the *knowledge on insects*, specifically focusing on their perceived relationship as causes or vectors of diseases (human, animal, plant pests), on the biology and emic taxonomy of insects, and on collection techniques."

Byzantium, where the dung beetle's connotations were unequivocally negative.[27] This, among other things, shows that insect imagery in Byzantium was not just a simple blend of ancient and biblical/Christian ideas but something much more complex.

The presentation of arguments in this article is organized around four focal concepts: terminology, perceptions, texts, and transformation. Accordingly, it surveys the terminological issues; discusses the perception of insects as recorded by Byzantine writers, briefly mentioning the diverse emotional and cognitive responses provoked by insects and related arthropods; analyzes texts in which insects played a principal role; and finally demonstrates how their metaphorical meaning evolved as the Greek world shifted from having a classical to a Christian outlook.

The wealth of extant material, both in the range of available sources and the number of insects mentioned in them, does not allow for a complete and in-depth presentation of the Byzantine world of insects, and therefore this contribution focuses on select examples (for instance, the section devoted to the transformation of meaning focuses on the cicada). This study is limited mainly to those insects and related arthropods that occupied a prominent role in the literary imagination of the Byzantines. It encompasses the fourth through the fifteenth century, drawing examples from different periods, but since insect imagery and knowledge do not appear to have developed over a protracted time in the Byzantine period, no fixed chronology will be traced. I focus largely on literature; the rare visual representations of insects from the Byzantine period are mostly, if not exclusively, preserved in manuscripts.[28]

Terminology

Ancient, late antique, and medieval entomology entails studying "insects," but ancient and medieval taxonomies are not consistent with a Linnaean classification.[29]

Aristotle's definition of insects includes worms, spiders, scorpions, and myriapods[30]—in other words, creatures excluded from the Linnean class Insecta. As Posey notes, "Even though the concept 'insect' is clearly defined by Western science, entomologists also frequently study 'related arthropods.'"[31] Thus, instead of imposing our modern concepts, we should rather look for emic categories and terminology.[32]

The Bible offers a somewhat puzzling characterization of insects in Leviticus 11:20, which declares, "All flying creatures that walk on all fours are to be regarded as unclean to you" (τὰ ἑρπετὰ τῶν πετεινῶν ἃ πορεύεται ἐπὶ τέσσαρα, in the Septuagint). It remains unclear why the writer claimed that insects have four legs.[33] The first and most basic "zoological" definition of insects comes from Aristotle, who used the term *entoma* for "animals which have insections either on their under or their upper surface, or in both places" and classifies them among bloodless animals.[34] This term does not seem to

27 M. P. Ciccarese, "Scarabaeus clamans: La construzione di una simbologia," *Vetera Christianorum* 53 (2016): 77–98. Truth be told, this comparison was not unanimously well received in the West.

28 Images of insects in Byzantine manuscripts were collected by Z. Kadar, *Survivals of Greek Zoological Illuminations in Byzantine Manuscripts* (Budapest, 1978).

29 R. Egan, "Insects," in *The Oxford Handbook of Animals in Classical Thought and Life*, ed. G. L. Campbell (Oxford, 2014), 180–91, at 180.

30 M. Davies and J. Kathirithamby, *Greek Insects* (London, 1986), 19; for a full list see S. Byl, *Recherches sur les grands traités biologiques d'Aristote: Sources écrites et préjugés* (Brussels, 1980), 325–30.

31 Posey, "Topics and Issues in Ethnoentomology," 99. Similarly, see Kutalek, "Ethnoentomology: A Neglected Theme," 128.

32 Medieval taxonomies, especially those found in nonzoological works, can be structured on completely different principles. For instance, Michael Psellos, in his poem on the creation of the world, divides mammals into three categories: animals created for work (horses, oxen), animals created for pleasure (elephants, unicorns [rhinoceroses?]), and bloodthirsty (dangerous) animals (bears, crocodiles, hyenas, wolves); see Michael Psellos, *Poems* 55, ll. 79–83 (L. G. Westerink, ed., *Michaelis Pselli poemata* [Stuttgart, 1992], 391). On similar "folk" taxonomies, see S. Lewis and L. Llewellyn-Jones, *The Culture of Animals in Antiquity: A Sourcebook with Commentaries* (New York, 2018), 8–31. For an example of the non-Western definition of "insects," see E. M. Costa-Neto and H. Magalhães, "The Ethnocategory 'Insect' in the Conception of the Inhabitants of Tapera County, São Gonçalo dos Campos, Bahia, Brazil," *Anais da Academia Brasileira de Ciências* 79.2 (2007): 239–49.

33 G. Kritsky and R. Cherry, "The Insect and Other Arthropods of the Bible, the New Revised Version," in their *Insect Mythology* (San Jose, 2000), 67.

34 Aristotle, *HA* 4.523b13–15 (A. L. Peck, trans., *Aristotle: Historia Animalium*, 2 vols. [Cambridge, MA, 1965–70], 2:4–5): Ἔστι δ' ἔντομα ὅσα κατὰ τοὔνομά ἐστιν ἐντομὰς ἔχοντα ἢ ἐν τοῖς ὑπτίοις ἢ ἐν τοῖς πρανέσιν ἢ ἐν ἀμφοῖν. On Aristotle as entomologist, see L. Bodson, "The Beginnings of Entomology in Ancient Greece," *Classical Outlook* 61.1 (October–November 1983): 3–6. This term was translated by Pliny as *insecta*; see also H. B. Weiss, "The Entomology of Pliny the Elder," *Journal of the New York Entomological Society* 34.4 (1926): 355–59. Interestingly, Isidore of Sevilla, who draws extensively

have gained particular traction in the Byzantine period, however.[35] It would thus be misleading to assume that Byzantine writers all accepted one clear definition of insects. Gil Fernandez, in his seminal work on the etymology of insects, remarked that the notion of "insect" is highly imprecise and for the most part reflects one of the most important characteristics of these creatures, namely their smallness.[36]

But Byzantine writers did not seem to be particularly interested in providing a taxonomical classification of their own. Like their ancient predecessors, they used diminutive forms such as ζῴδιον, ζῴφιον, θηρίδιον, and θηράφιον.[37] The type of literary genre makes no difference, as these descriptors are to be found in both scientific and poetic works.[38] Interestingly enough, one such form—ζῳύλλιον—appears only in the texts penned by John Tzetzes.[39] It is be tempting to assume that this noun was coined by the twelfth-century writer.

Available sources do not provide any clear explanations for these terms, which they instead define by using examples. For instance, πυραύστης (a moth whose self-destructive nature was proverbial) is described as ζῴφιον πτηνὸν ἐναλλόμενον τῷ φωτὶ καὶ ῥᾷον κατακαιόμενον (a winged insect attracted to light and quickly destroyed).[40] The lexicon of Pseudo-Zonaras

includes spiders among ζῴφια.[41] Furthermore, certain terms capture a distinguishing feature of a given creature. For instance, several insects are more precisely described as βομβύκια (buzzing), while others could be referred to as those that bite (δάκετον).[42]

Individual names of insects were mostly inherited from previous periods. At first blush, Byzantine writers do not seem to have invented new insect-related terminology, but there might be some exceptions. For example, the prayer of Saint Tryphon for the deliverance of gardens, vineyards, and small farms includes a precise list of insects destroying the saint's garden: caterpillar (κάμπη), worm (σκώληξ), wingless locust (βροῦχος), locust (ἀκρίς), ant (μύρμηξ), and so on.[43] This is well-established, ancient terminology. Some terms in the prayer, however, are names of insects not recorded elsewhere, such as σκωληκοκάμπη, καλιγάρις μακρόπους, and καυσοκόπος.[44] In a learned scientific treatise, the use of *hapax legomena* would be a way of showing off the author's familiarity with unusual and forgotten terminology. This text, in contrast, was a prayer, not intended for recipients well-versed in zoological matters or expecting refined terminology. Therefore, an educated

on Pliny, does not use the term *insecta* for bees, moths, and flies; see F. Wallis, "Isidore of Seville and Science," in *A Companion to Isidore of Seville*, ed. A. Fear and J. Wood (Leiden, 2020), 182–221, at 209. On the classification of animals in Aristotle's work, see P. Pellegrin, *Aristotle's Classification of Animals: Biology and the Conceptual Unity of the Aristotelian Corpus*, trans. A. Preus (Berkeley, 1986), 147, 152.

35 The term appears sporadically in the writings of Byzantine authors, but most often in texts commenting on Aristotle.

36 L. G. Fernández, *Nombres de insectos en griego antiguo* (Madrid, 1959), 10; and see more recently A. Zucker, *Les classes zoologiques en Grèce ancienne: D'Homère (VIIIᵉ av. J.-C.) à Élien (IIIᵉ ap. J.-C.)* (Aix-en-Provence, 2005), 38.

37 Fernández, *Nombres de insectos*, 10.

38 For instance, Eugenios of Palermo, *Psogos of the Fly* 15.6 (M. Gigante, ed., *Versus Iambici*, Testi e Monumenti 10 [Palermo, 1964], 99).

39 See, e.g., John Tzetzes, *Comm. in Plutum*, ad 253d, l. 26: ψύχη ζῳύλλιόν ἐστι πετόμενον (the butterfly is a winged insect) (L. Massa Positano, ed., *Scholia in Aristophanem, Pars 4, Jo. Tzetzae commentarii in Aristophanem*, fasc. 1, *Prolegomena et Commentarium in Plutum* [Groningen, 1960], 73).

40 See, e.g., Eustathios of Thessaloniki, *Commentaries in the Odyssey* 1.ad v. 490 (G. Stallbaum, ed., *Eustathii archiepiscopi Thessalonicensis commentarii ad Homeri Odysseam* [1825–26; repr. Hildesheim, 1970], 233).

41 *Lexicon of Ps.-Zonaras*, α, p. 286: Ἀράχνης. τὸ ζῴφιον (J. A. H. Tittmann, ed., *Iohannis Zonarae lexicon ex tribus codicibus manuscriptis*, 2 vols. [1808; repr. Amsterdam, 1967]).

42 See, e.g., the discussion on βομβύκια in the scholia on *The Clouds*. In Aristophanes' play, a disciple discusses with Strepsiades whether gnats buzz through the mouth or the rump. This provides scholiasts, including Byzantine ones, with the opportunity to include a short discussion on insects. For instance, Tzetzes, following older commentators, takes this opportunity to note, ἔντομα μὲν διὰ τὴν ἐν τῇ ῥάχει αὐτῶν ἐντομὴν καὶ ὀπήν, δι' ἧς φθέγγονται, βομβύκια δὲ διὰ τὸ βομβεῖν. μᾶλλον δὲ βομβύκια κυρίως καλεῖται κώνωψ καὶ μυῖα καὶ μέλισσα, σφὴξ καὶ ὅσα βομβεῖ, ἔντομον δὲ ὁ τέττιξ (*In Nubes*, ad 156a, 10–13 [Massa Positano, *Jo. Tzetzae commentarii in Aristophanem*, 422]): "[Some are called] insects because of the section in their lower part and the hole through which they make sounds and *bombykia* because they buzz. The gnat is called more properly a *bombykion*, as well as a fly and a bee, a wasp, and everything that buzzes. The cicada, on the other hand, is an insect (*entomon*)."

43 *The Prayer of Saint Trychon*, chap. 31, section 2, l. 28 (R. P. J. Goar, ed., *Εὐχολόγιον sive rituale graecorum complectens ritus et ordines divinae liturgiae* [Venice, 1760; repr. Graz, 1960], 555).

44 *The Prayer of Saint Trychon*, chap. 31, section 2, l. 28. In the seventeenth-century dictionary authored by Johannes Meursius, σκωληκοκάμπη is defined simply as *vermis genus*; see J. Meursius, *Glossarium Graeco-Barbarum: In quo, praeter vocabula 5400, officia atque dignitatis imperii Constantinopoli, tam in palatio quam ecclesia aut militia, explicantur, et illustrantur* (Leiden, 1614), 512. At this point, identifying these insects does not seem possible.

guess would be that here we probably have common names not recorded in more stylistically elevated texts.

John Tzetzes uses the term πυραυστούμορος (dying by fire) to describe the moth.[45] Chiara Bianco, in her work on butterflies in antiquity, calls this term a mistake for πυραύστης.[46] Such a dismissal might be too hasty. Tzetzes explains that the word φάλαινα may mean "moth" and gives three synonyms: πυραυστούμορος, ψυχή (butterfly), and ψώρα (itch). The first term is quite unusual, and it is attested only in the works by Tzetzes. Indeed, according to Panagiotis Agapitos, this word may be Tzetzes' own invention, created from an Aeschylean fragment.[47] Interestingly enough, at the end of this scholion, Tzetzes states that there is yet another word for the moth, κανδηλοσβέστρα (extinguisher of the oil lamp), which is used in colloquial language (ἰδιωτικῶς). A variation of this word appears in the scholia to Nikander (*Theriaka* 763a, "κανδηλοσβέστου") and Oppian (*Halieutika* 1.404, "κανδηλοσβέστρια").[48] Although no decisive conclusion can be drawn, it is not excluded that κανδηλοσβέστρα entered the language only in the later (Byzantine?) period.

This preliminary survey of Byzantine terminology concerning insects demonstrates that although it was heavily dependent on the ancient tradition, there was room, however small, for some innovativeness. Moreover, since the basic defining feature was the smallness of such creatures, Byzantine writers, like their ancient predecessors, included in the category of "small animals" a wide range of arthropods and, more generally, various invertebrates.

Perception: Insects as Creatures

In the eye of the human beholder, an animal is a blend of its biological properties and behavioral characteristics. Texts whose focus is not on studying animals tend to refer to such features rather freely. Usually an animal (and consequently its metaphorical meaning) is captured in one such defining feature. For example, leeches came to be viewed as symbols of greediness because of their biological properties.[49] John Chrysostom, commenting on Proverbs 30:15, likens the Devil to leeches "because he squeezes out the blood of the souls that is their vital force."[50] Similarly, bees' and ants' eusocial behavior made them excellent models for metaphors of state and governance from ancient times onward.[51]

Perhaps the most widespread detail concerning the biological properties of insects was the information regarding their respiratory system. Various sources throughout the Byzantine period such as the *Suda*, the lexicon of Pseudo-Zonaras, and others, including Gennadios, note that insects, such as wasps, ants, and bees, do not respire and do not have lungs.[52] This

45 John Tzetzes, *Scholia in Lycophron*, ad v. 84 (E. Scheer, ed., *Lycophronis Alexandra*, vol. 2, *Scholia continens* [Berlin, 1908], 46).

46 C. Bianco, "Metamorphoses of the Butterfly in Classical Antiquity: From the Female Body to the Soul of the Dead" (PhD diss., Cambridge, 2018), 21.

47 P. Agapitos, "John Tzetzes and the Blemish Examiners: A Byzantine Teacher on Schedography, Everyday Language and Writerly Disposition," *Medioevo Greco* 17 (2017): 28, and esp. n. 144: "The word 'πυραυστούμορος' is attested only in Tzetzes (*LBG* s.v.). It is probable that he created it from an Aeschylean fragment (288 Radt δέδοικα μῶρον κάρτα πυραύστου μόρον) quoted by Ael. *NatAnim.* XII 8 and explained in the Zenobian proverb epitome."

48 For the scholion to Nikander, see A. Crugnola, ed., *Scholia to Nicandri Theriaka* (Milan, 1971), 325; for that to Oppian, see U. C. Bussemaker, ed., *Scholia et paraphrases in Nicandrum et Oppianum*, in *Scholia in Theocritum*, ed. F. Dübner (Paris, 1849), 283. The context and general wording shows, in my opinion, that there was a common source of the passage, including the explanation of κανδηλοσβέστρα. Whether that source was Tzetzes or not is impossible to tell.

49 For leeches used metaphorically, see I. C. Beavis, *Insects and Other Invertebrates in Classical Antiquity* (Devon, 1988), 6. I am referring here to concepts proposed by Donna Haraway (material-semiotic nodes) and Roland Borgards (material-semiotic hybrids). Insects can be encountered in the material world as well as in textual and literary imaginaries. The combination of both real and imagined relations to objects creates cultural units or, in the words of Roland Borgards, "material-semiotic hybrids" defined both by their material presence and by the semiotic meanings that they accrue for human observers; see also R. Borgards, "Tiere und Literatur," in *Tiere: Kulturwissenschaftliches Handbuch*, ed. R. Borgards (Stuttgart, 2016), 225b–244b.

50 Proverbs 30:15: "The leech has two daughters: Give and Give. Three things are never satisfied; four never say 'enough.'" See Chrysostom's commentary in PG 64.733. Interestingly, the Suda refers to the same passage but notes that "sin [is called] a leech" (*Suda* β 197).

51 For the use of such metaphors see, e.g., P. Dietmar, *Untersuchungen zur Staats- und Herrschaftmetaphorik in literarischen Zeugnissen von der Antike bis zur Gegenwart* (Munich, 1983), 166–301. On these metaphors in the Byzantine period see Schmidt, *Politische Tierbildlichkeit* (n. 14 above), 187–92.

52 See, e.g., the *Suda* ε 147: ... οἷον σφήξ, μύρμηξ, μέλιτται: ἃ οὔτε ἀναπνεῖ οὔτε πνεύμονα ἔχει (... such as the wasp, ant, and bee: they neither breathe nor have lungs); *Lexicon of Ps.-Zonaras* ε, p. 738; Gennadios, *Annotations on Different Works of Aristotle*, vol. 3.3, *De*

definition ultimately goes back to ancient naturalists: Aristotle, Aristophanes of Byzantium, and Aelian (Aristotle elaborates on the issue in his treatise *On Respiration*,[53] while Aelian states in the *Characteristics of Animals* that insects do not have lungs[54]). It is unsurprisingly included in the *Sylloge* (also called the *Excerpta de historia animalium*) by Constantine Porphyrogennetos,[55] whose source was Aristophanes of Byzantium's *Epitome* (itself a summary of Aristotle's works on animals), which is not extant. A similar definition, though differently worded, is included in the highly influential *Homilies in Hexaemeron* by Basil the Great.[56] It is also interesting to note that the issue of insects' breathing was taken up by Clement of Alexandria, who attacked the idea that God literally inhales the smoke of sacrifices.[57]

What relatively little the Byzantines noted about the behavioral patterns of insects was how limited and simple they were. The treatise *On Demons*, ascribed to Michael Psellos, contains a passage that discusses insects' intellectual faculties:

ἵππος δὲ καὶ βοῦς καὶ τὰ τούτοις ὁμόστοιχα, μερικωτέραν καὶ πρὸς ἔνια τῶν φανταστῶν ἐνεργοῦσαν, τὰ σύννομα καὶ τὴν φάτην καὶ τοὺς κτησαμένους γινώσκουσαν. ἐμπίδες δὲ καὶ μυῖαι καὶ σκώληκες ἀπεστενωμένην ἔχουσι ταύτην καὶ ἀδιάρθρωτον, μήτε ὀπὴν εἰδότος ἑκάστου τούτων ἧς ἐξελήλυθεν, μήτε τόπον οἷ πορεύεται καὶ οὗ δεῖ προσάγειν, μίαν δὲ μόνον ἔχοντος φαντασίαν τῆς τροφῆς.[58]

Horses, oxen, and animals of that sort have a more confined kind of imagination, which extends but to some things, and exercise their imaginative faculty to recognize their companions at pasture or in their stall, or their owners. This faculty in gnats, flies, and worms is exceedingly restricted, not knowing where they come from, where they are, and where they should go but using their imagination for the single purpose of alimentation.[59]

Insects such as flies and gnats exist here simply to eat; they have no direct value to humans, and no intellectual capacity. Demetrios Chrysoloras, in his *Praise of the Flea*, describes fleas as "unreasoning animals far from exhibiting any trace of intellect (or logical thinking)."[60]

However, the Byzantines, following ancient examples, were able to distinguish between "useful"

An. 2, 428–29 (M. Jugie, L. Petit, and X. A. Siderides, eds., *Oeuvres complètes de Georges [Gennadios] Scholarios* [Paris, 1936], 446): Ὅτι τὰ πλείω τῶν ζῴων ὀσφραίνεται ἀναπνέοντα· τὰ δὲ ἔντομα μὴ ἀναπνέοντα (That the majority of animals, which can smell, breathe, but insects do not breathe).

53 Aristotle, *Parva Naturalia: On Respiration* 10.475a 30 (W. S. Hett, trans., *Aristotle: On Soul, Parva Naturalia, On Breath* [Cambridge, MA, 1935], 455): "We have stated before that among living creatures insects do not respire, and this is evident in the case of the small ones, such as flies and bees; for they can swim in liquid for a long time." On the respiration of insects as understood by Aristotle and later scholars, see G. H. Müller, "The Development of Thought on the Respiration of Insects," *History and Philosophy of the Life Sciences* 7.2 (1985): 301–14.

54 Aelian, *Characteristics of Animals* 11.37 (M. García Valdés, L. A. Llera Fueyo, and L. Rodríguez-Noriega Guillén, eds., *Claudius Aelianus de natura animalium*, Teubner [Berlin, 2009], 278).

55 Constantine Porphyrogennetos, *Sylloge* 1.10 (S. Lampros, ed., *Excerptorum Constantini de natura animalium libri duo: Aristophanis historiae animalium epitome* [Berlin, 1885], 3): ἔντομα δὲ καλεῖται ὅσα τῶν ζῴων ἐντομὴν μεταξὺ ἑαυτῶν κέκτηται, καθάπερ ὅ τε σφὴξ καὶ μύρμηξ μέλιττα καὶ εἴ τι ἄλλο. ταῦτα δὲ τὰ ζῷα λέγεται μήτε ἀναπνεῖν μήτε πνεύμονα ἔχειν (These among animals are called insects, which have insections within themselves, such as the wasp and ant, bee and some other. It is said that these animals neither breathe nor have lungs).

56 Basil the Great, *Hexaemeron* 8.7, 67–71 (S. Giet, ed., *Basile de Césarée: Homélies sur l'hexaéméron*, SC 26 [Paris, 1949], 468: Ὅταν ἴδῃς τὰ ἔντομα λεγόμενα τῶν πτηνῶν, οἷον μελίσσας καὶ σφῆκας [οὕτω γὰρ αὐτὰ προσείρηκασι διὰ τὸ πανταχόθεν ἐντομάς τινας φαίνειν], ἐνθυμοῦ, ὅτι τούτοις ἀναπνοὴ οὐκ ἔστιν, οὐδὲ πνεύμων, ἀλλ' ὅλα δι' ὅλων τρέφεται τῷ ἀέρι (When you see bees, wasps, in short all those flying creatures called insects, because they have an incision all around, reflect that they have neither respiration nor lungs, and that they are supported by air through all parts of their bodies; trans. B. Jackson and K. Knight, "Hexaemeron [Homily 8]," *New Advent*, 2021, https://www.newadvent.org /fathers/32018.htm).

57 See R. M. Grant, *Early Christians and Animals* (London, 1999), 47.

58 Michael Psellos, *On Demons* (J. F. Boissonade, ed., *De operatione Daemonum cum notis Gaulmini* [Nurnberg, 1838], 29–30).

59 Translation follows M. Collisson, *Psellus' Dialogue on the Operation of Daemons* (Sydney, 1843), 44, with alterations.

60 Demetrios Chrysoloras, *Praise of the Flea* 7.3–4 (G. de Andrés, ed., "Demetrio Crisoloras el Palaciego, Encomio de la pulga," *Helmantica* 35 [1984]: 51–69, at 62). However, as Chrysoloras remarks, fleas never condemn anybody to death. On this text, see also F. Leonte, *Ethos, Logos, and Perspective: Studies in Late Byzantine Rhetoric* (Abingdon, 2023).

and "useless" insects.[61] This distinction may have been more nuanced. Some insects and other arthropods were considered to be outright valuable, such as bees and silkworms.[62] Others were deemed useful for medicinal purposes.[63] The insect most commonly used in medical recipes was the κανθαρίς (a kind of beetle, most probably the blister beetle), a creature with septic and warming properties that could be used to treat skin diseases such as sores, scurvy, and lichen-like eruptions.[64] On the other hand, some recorded instances involving insects and medicine are clearly fictitious, such as the healing of the patient who accidentally swallowed a leech, as described in the *Miracles of St. Eugenios*.[65] Finally, Manuel Philes gives secret advice (ἀπόκρυφον γὰρ ἐκκαλύπτω νῦν λόγον) on how to cure a wound by placing a flea on it.[66] Philes seems to rationalize (or mock) Aelian's story about the Libyan race called the Psylli whose members were able to cure a bite of the cerastes "by simply spitting on the wound."[67]

Yet some insects possessed abilities that were not only appreciated but even favorably compared to human skills. Since antiquity, the abilities of ants and spiders had been praised by writers. Plutarch in his treatise *On the Intelligence of Animals* (*Moralia* 967D–968B) applauds spiders and the hard work of ants. The Byzantines were clearly able to recognize, *pace* their ancient ancestors, that some insects and related arthropods were capable of performing complex tasks. Insects such as spiders and ants possessed outstanding skills, although they had no direct value to humankind.[68] Their extraordinary abilities were praised extensively by church fathers such as Gregory of Nazianzus.[69] Byzantine writers repeatedly underscored the industriousness of ants.[70] In his short poem on the ant (no. 125), Christopher of Mytilene emphasizes, following the ancient tradition, "the ant's great mind" compared to its "tiny body" (τὸν νοῦν ὁ μύρμηξ, τὸ βραχὺ ζῷον, μέγας).[71] In his commentary on Synesios's *De insomniis*, Nikephoros Gregoras states that οἷον ὁ ἀράχνης, ἡ μέλιττα, ὁ μύρμηξ φυσικῶς ἐνεργοῦσιν ἔργα, οἷα οὐδὲ τῶν ἀνθρώπων οἱ φρονιμώτατοι (as the spider, the bee, the ant naturally create works, which the cleverest of people [cannot]).[72] And although positive imagery of ants is widespread, there were some exceptions.[73] For instance, in Byzantine dream-interpretation books, the entrance of ants into someone's house indicates death and disease.[74] Likewise, John Kantakuzenos compares accursed people to ants from holes and dung beetles.[75]

61 Yet even the useless insects can perform useful tasks if needed: there is a Syriac story of a holy woman named Anahid who was protected by a swarm of wasps that prevented anybody from hurting her. See P. S. Brock, *Holy Women of the Syrian Orient* (Berkeley, 1998), 96.

62 On Byzantine apiculture see S. Germanidou, Βυζαντινός μελίρρυτος πολιτισμός (Athens, 2016).

63 J. Stannard, "Aspects of Byzantine Materia Medica," *DOP* 38 (1984): 205–211, at 209.

64 See, e.g., Aetios of Amida's *Tetrabiblos* 2.174. I owe this information to Petros Bouras-Vallianatos.

65 In miracle no. 7, the patient, one Barbara, swallowed the leech, which "penetrated from her chest and wandered as far as her right nostril and her temples and forehead"; see J. O. Rosenqvist, "Miracles and Medical Learning: The Case of St. Eugenios of Trebizond," *BSl* 56 (1995): 461–70, at 464–65.

66 Manuel Philes, *On the Nature of Animals* 1381–85 (F. Dübner and F. S. Lehrs, eds., *Poetae bucolici et didactici Manuelis Philae versus iambici de proprietate animalium* [Paris, 1862], 3–68 at 33).

67 Aelian, *Characteristics of Animals* 16.28 (García Valdés et al., *Claudius Aelianus de natura animalium* [n. 54 above], 397). See also J. F. Kindstrand, "Manuel Philes' Use of Aelian's *De natura animalium* in his *De animalium proprietate*," *StItalFCl* 4 (1986): 119–39, at 130.

68 The spider and its webs were used for medicinal purposes in antiquity, however; see Beavis, *Insects and Other Invertebrates* (n. 49 above), 33–34.

69 "Insects, especially bees and ants, are frequently referred to and treated as models for humans." I. S. Gilhus, *Animals, Gods and Humans: Changing Attitudes to Animals in Greek, Roman and Early Christian Ideas* (New York, 2006), 73. See also Berrens, *Soziale Insekten* (n. 4 above), and H. Maguire, *Earth and Ocean: The Terrestrial World in Early Byzantine Art* (University Park, PA, 1987), 19 (on Gregory). See also M. P. Ciccarese, *Animali simbolici: Alle origini del Bestiario cristiano*, vol. 1 (Bologna, 2002), 393–406 (on ants).

70 See, e.g., Gemisthos Pletho, *Book of Laws*, book 2, chap. 26.3.

71 Christopher of Mytilene, *Poems* 125.1 (M. De Groote, *Christophori Mytilenaii Versuum uariorum Collectio Cryptensis*, CCSG 74 [Turnhout, 2012], 122).

72 P. Pietrosanti, ed., *Nicephori Gregorae explicatio in librum Synesii 'De insomniis,'* Πίνακες 4 (Bari, 1999), 137 B 155.17.

73 For instance, the Pueblo peoples of North America believe that ants may cause diseases and are perceived as vindictive.

74 S. M. Oberhelman, *Dreambooks in Byzantium: Six Oneirocritica in Translation, with Commentary and Introduction* (Aldershot, 2008), 180. Achmet's dreambook makes a distinction between winged and nonwinged ants; the former are a sign of death. That this information comes from the Arabic sources may explain this unflattering imagery; M. Mavroudi, *A Byzantine Book on Dream Interpretation: The Oneirocriticon of Achmet and Its Arabic Sources* (Leiden, 2002), 443–44.

75 John Kantakuzenos, *Two Refutations of Prochorus Kydones* 1.21.13–14 (F. Tinnefeld and E. Voordeckers, eds., *Iohannis Cantacuzeni*

Be that as it may, bees and ants were also the only insects included in the *Physiologos* and they became paradigmatic ones, even serving as mirrors and guides for humans.[76] The Christian-Byzantine reinterpretation saw their skills as proof of the ingenuity of God's creation plan.

Yet the reason for the existence of certain insects remained unclear at best. Fleas, bedbugs, and lice were "paradigmatic annoying vermin," omnipresent but hardly welcome.[77] The fourth-century emperor Julian states in the *Misopogon* that he puts up "with the lice that scamper about in it [his beard] as though it were a thicket for wild beasts."[78] In the *Ptochoprodromos III*, line 64, the father who advises his son to study in order to be professionally successful says of an accomplished rhetor that "his bosom used to be full of lice the size of almonds (φθείρας ἀμυγδαλάτας)."[79]

The above-mentioned prayer of Saint Tryphon is testimony to a somewhat paradoxical situation: God created insects, but he should also protect humankind from their undesirable activities. It is thus small wonder that both ancient and late antique writers wondered why God created bedbugs, fleas, and other insects in the first place.[80] This was a universal question, transcending languages, cultures, and confessions. The pagan Porphyry, in *On Abstinence from Animal Food*, asks, "But if God fashioned animals for the use of men, in what do we use flies, lice, bats, beetles, scorpions, and vipers? Of which some are odious to the sight, defile the touch, are intolerable to the smell, and in their voice dire and unpleasant; and others, on the contrary, are destructive to those that meet with them."[81] A similar statement might also be found in the ancient Jewish rabbinic material, such as the commentary to Genesis Rabbah 10:7: "Our rabbis said: 'Even things that you see them [*sic*] as superfluous to the creation of the world, like mosquitos and fleas and flies, are included in the creation of the world and through all the Holy One blessed be He who carries out his mission, even by snake, scorpion, mosquito and frog.'"[82] Likewise, the Christian Augustine, while replying to a Manichean question about why God created so many hostile and terrifying creatures offers, "I must confess that I have not the slightest idea why mice and frogs were created, and flies, and worms; yet I can still see that they are all beautiful in their own specific kind."[83] Similarly, Jerome

Refutationes Duae Prochori Cydonii et Disputatio cum Paulo Patriarcha Latino Epistulis Septem Tradit [Brepols, 1987], 29).

76 Several Byzantine authors (e.g., John Chrysostom, Eustratios of Constantinople) referred to the passages from the book of Proverbs (6.6, 6.8a) that praise ants and bees. On the bee image in Plutarch (also in connection with his educational ideas), see S. A. Xenophontos, "Imagery and Education in Plutarch," *CPh* 108.2 (2013): 126–38.

77 J. E. Spittler, *Animals in the Apocryphal Acts of the Apostles: The Wild Kingdom of Early Christianity* (Tübingen, 2008), 102. See also Keller, *Antike Tierwelt* (n. 10 above), 2:395–401.

78 Julian Apostate, *Misopogon* 338C (W. C. Wright, ed. and trans., *Works of the Emperor Julian*, vol. 2 [Cambridge, MA, 1913], 422–23).

79 *Ptochoprodromos III* 64 (H. Eideneier, ed., *Ptochoprodromos: Einführung, kritische Ausgabe, deutsche Übersetzung, Glossar* [Cologne, 1991], 119). This is probably a case of *pediculosis pubis* (pubic louse infestation). The dangers of pediculosis in ancient Greece were discussed in H. Keil, "The Louse in Greek Antiquity," *Bulletin of the History of Medicine* 24.5 (1951): 305–23; see also H. Heimerzheim, "Insekten, Ungeziefer, Würmer in ihrer hygienischen Bedeutung bei Plinius" (Univ. diss., Köln, 1940). There is no similar study for the Byzantine period, but the hygienic challenges must have been the same. Nicholas Myrepsus (thirteenth century) advises one to wash the head with a special concoction made of lupine in order to get rid of lice: see his *Dynameron* 45, 1.1 (I. Valiakos, ed., *Das Dynameron des Nikolaos Myrepsos* [Heidelberg, 2019], 1085).

80 See, e.g., Arnobius in *Adversus Nationes* 2.59: "For what purpose have so infinite and innumerable kinds of monsters and serpents been either formed or brought forth? . . . what the *different* kinds of ants and worms springing up to be a bane and pest in various ways? what fleas, obtrusive flies, spiders, shrew, and other mice, leeches, water-spinners?" (trans. Philipp Schaff, in *Ante-Nicene Fathers*, vol. 6, *Fathers of the Third Century: Gregory Thaumaturgus, Dionysius the Great, Julius Africanus, Anatolius, and Minor Writers, Methodius, Arnobius*, Christian Classics Ethereal Library, https://ccel.org/ccel /schaff/anf06.xii.iii.ii.lix.html). See also a discussion of this issue in Grant, *Early Christians and Animals* (n. 57 above), 29–33.

81 Porphyry, *On Abstinence from Animal Food* 3.20.1–3: καὶ μὴν εἰ πρὸς ἀνθρώπων χρῆσιν ὁ θεὸς μεμηχάνηται τὰ ζῷα, τί χρησόμεθα μυίαις, ἐμπίσι, νυκτερίσιν, κανθάροις, σκορπίοις, ἐχίδναις; (25).ὧν τὰ μὲν ὁρᾶν εἰδεχθῆ καὶ θιγγάνειν μιαρὰ καὶ κατ᾽ ὀδμὰς δυσανάσχετα καὶ φθέγγεται δεινὸν καὶ ἀτερπές, τὰ δ᾽ ἄντικρυς ὀλέθρια τοῖς ἐντυγχάνουσι (J. Bouffartigue, M. Patillon, and A. P. Segonds, *Porphyre: De l'abstinence*, 3 vols. [Paris, 1977–95], 2:265). English translation after T. Taylor, *Selected Works of Porphyry* (London: Thomas Rodd, 1832), at https://www.tertullian.org/fathers/porphyry_abstinence_03_book3 .htm. In fact, Porphyry took this passage from Plutarch, fr. 193.79–84.

82 English translation after Y. Wilfand, "Genesis Rabbah 10:7," *Judaism and Rome*, 9 January 2017, at https://www.judaism-and -rome.org/genesis-rabbah-107. See also E. J. Schochet, *Animal Life in Jewish Tradition: Attitudes and Relationships* (New York, 1984), 186.

83 Augustine, *De Genesi adversus Manicheos* 1.26.1–3 (PL 34.185): *Ego vero fateor me nescire mures et ranae quare creatae sint, aut muscae aut vermiculi; video tamen omnia in suo genere pulchra esse.* Translation

claimed that insects, which people might find useless and annoying, exist to remind people about their weaknesses and unimportance.[84]

Byzantine writers addressed the same doubts. As Basil of Caesarea noted in his discussion of insects, "Our God has created nothing unnecessarily and has omitted nothing that is necessary."[85] George of Pisidia, in his *Hexaemeron*, hints at the same idea when he declares that one should marvel with fear at the tiniest of God's creations, such as the ant, gnat, and locust.[86]

The line of argumentation provided by both Christian and non-Christian writers appeared to be similar: if such creatures exist, then they exist for a reason, whatever that might be. Robert Grant even speaks of "apologetic entomology"—that is, a way of perceiving insects as a part of the created world.[87] In fact, contempt for creepy-crawlies might have been theologically dangerous, as it could imply contempt for the Creator and his plan.[88]

Finally, our records reveal various emotional responses provoked by human–insect interactions. In his discussion of insects in antiquity, Rory Egan has suggested that "[t]he record also reveals a wide range of human perceptions and reactions: fear, revulsion, affection, bemusement, mystification, scientific curiosity, aesthetic appreciation, and utilitarianism."[89] Fear and revulsion were likely the most common emotions provoked by insects and related arthropods (for instance, John Mauropous speaks about the fearsome scorpion, δεινὸς σκορπίος).[90] In a similar tone, Alexios

Makrembolites in the *Dialogue of the Rich and the Poor* speaks about hateful dung beetles and flies.[91] However, fear and hatred felt toward insects may best be encapsulated in the gruesome torture method known as scaphism. John Zonaras, following Plutarch, describes this Persian torture, which entails a victim being trapped between two boats that are nailed together so that his head, hands, and feet are left outside; after his face, arms and feet are covered with milk and honey, flies, wasps, and bees sting him.[92] Insects perform here the role of an executioner and are the embodiment of human fears. On the other hand, sources also show other reactions that are less extreme. In a perhaps rhetorically exaggerated tone, the fifth-century bishop Theodoret of Cyrrhus instructs his listeners not to be annoyed upon seeing a spider weaving a small web.[93] The late Byzantine historian Dukas speaks about the pleasure that can be felt while squeezing a flea (which only confirms how hated these creatures were).[94]

An Insect in the Text

The textual world of insects in Byzantium was very heterogeneous: they could feature in texts as mentions, metaphors, or similes.[95] Animal metaphors, since antiquity, were a widespread literary tool that could be used to extol or denigrate a human being by attributing to them characteristics associated with an animal.[96]

after P. C. Miller, *In the Eye of the Animal: Zoological Imagination in Ancient Christianity* (Philadelphia, 2018), 158.

84 G. J. M. Bartelnik, "Hieronymus über die minuta animalia," *VChr* 32 (1978): 289–300, at 291.

85 Basil the Great, *Hexaemeron* 8.7, 77–78 (Giet, *Basile de Césaré*, 470; n. 56 above).

86 George of Pisidia, *Poems* ll. 1240–43 (F. Gonelli, ed., *Giorgio di Pisidia. Esamerone. Introduzione, testo critico, traduzione e indici* [Pisa, 1998], 200).

87 Grant, *Early Christians and Animals* (n. 57 above), 30.

88 Spittler, *Animals in the Apocryphal Acts*, 35. A similar understanding of insects as creatures of God can be found in a hymn to Amun-Re, dating back to the Eighteenth Dynasty (ca. 1550–1352 BCE); see H. Levinson and A. Levinson, "Venerated Beetles and Their Cultural-Historical Background in Ancient Egypt," *Spixiana*, suppl. 27 (2001): 35.

89 Egan, "Insects" (n. 29 above), 180.

90 John Mauropous, *Poems* 53.2 (P. de Lagarde, ed., *Joannis Euchaitorum Metropolitae quae in codice Vaticano Graeco 676 supersunt*, AbhGött, Philol.-hist.Kl. 28 [Göttingen, 1882], 28).

91 Alexios Makrembolites, *Dialogue of the Rich and the Poor* 25 (I. Ševčenko, ed., "Alexios Makrembolites and His 'Dialogue between the Rich and the Poor,'" *ZRVI* 6 [1960]: 203–15, at 205).

92 John Zonaras, *Epitome historiarum* 3.6 (L. Dindorf, ed., *Ioannis Zonarae epitome historiarum*, 3 vols. [Leipzig, 1868–70], 1:190–91).

93 Theodoret of Cyrrhus, "On Providence: Ten Orations," PG 83:632.32–36. Gillian Clark interprets this passage slightly differently, noting that "Theodoret tells his audience not to envy spiders"; see G. Clark, "The Fathers and the Animals: The Rule of Reason?" in her *Body and Gender, Soul and Reason in Late Antiquity* (Farnham, 2011), III.71.

94 Dukas, *History* 34.4 (D. R. Reinsch, ed., *Dukas. Chronographia. Byzantiner und Osmanen im Kampf um die Macht und das Überleben* [Berlin, 2020], 440).

95 See, e.g., J. P. Harris, "Flies, Wasps, and Gadflies: The Role of Insect Similes in Homer, Aristophanes, and Plato," *Museion: Journal of the Classical Association of Canada* 15.2 (2018): 475–500.

96 See, e.g., M. Roux, "Animalizing the Romans: The Use of Animal Metaphors by Ancient Authors to Criticize Roman Power or Its Agents," in *Reconsidering Roman Power: Roman, Greek, Jewish and Christian Perceptions and Reactions*, ed. K. Berthelot (Rome, 2020),

The process of dehumanizing a person by animalizing them was adopted by Christians authors, who used animal imagery to describe pagans and their fellow Christian heretics.[97] Insects, related arthropods, and snakes, because of their *otherness*, were especially well suited for such a use. I would even tentatively suggest that insect-related invectives were more widespread in the Byzantine period than before.[98] Epiphanios of Constantia (fourth century), writing in the *Panarion*—a very large compendium of the heresies up to his own time—refers to scorpions nineteen times and to various vipers and snakes more than eighty times. Epiphanios's work is intertextually dependent on, among others, Nikander's *Theriaka*, and he maps the terrifying creatures from Nikander's work onto pagans and Christian heretics.[99] In a somewhat similar vein, John Mauropus (eleventh century) penned a poem in which he likened people who slandered emperors and patriarchs to scorpions. Mauropus uses a generic term for a scorpion, turning the slanderer into a human–animal hybrid who expresses his hatred by "raising his stinger."[100] Such metaphors (both positive and negative) could also be employed in a secular context. A person could be compared favorably to the cicada (see below) or unfavorably to the leech and the beetle.[101]

And yet insects and related arthropods, since antiquity, can also perform the role of full-fledged protagonists of texts such as fables, parables, poems, epigrams, and paradoxical encomia. They feature in the Aesopic fables and even more notably in the epigrams of the *Greek Anthology*.[102] Perhaps the best-known of such texts remains Lucian's *Praise of the Fly*, a paradoxical encomium of the insect (that is, a rhetorical display piece in which an unworthy object is presented as excellent and desirable).[103]

Byzantine literature offers a selection of works in which insects performed a more central role. Christopher of Mytilene authored not only a poem, mentioned above, on the ant but also a much longer poem that eulogizes the spider (no. 122). Both these texts use small and lowly creatures to ponder God's might. In the epigram on the ant, Christopher offers, "How ample is God's knowledge, / with power so great even in things so small."[104] The poem on the spider is a direct reworking of the fragment from the *Hexaemeron* by George of Pisidia.[105] Centuries later, Theodore I Laskaris employed the allegorical story of the dung beetle and the rose in order to comment on envy and friendship.[106]

https://books.openedition.org/efr/5097. For the Byzantine period see P. Eliopoulos, "Τα ζώα στον προσβλητικό λόγο των Βυζαντινών," *Byzantina Symmeikta* 31 (2021): 51–120.

97 M. Kahlos, "The Shadow of the Shadow: Examining Fourth-and Fifth-Century Christian Depictions of Pagans," in *The Faces of the Other: Religious Rivalry and Ethnic Encounters in the Later Roman World*, ed. M. Kahlos (Turnhout, 2011), 179–80.

98 Severin Koster in his work on ancient invectives does not record any use of insects; S. Koster, *Die Invektive in der griechischen und römischen Literatur* (Meisenheim am Glan, 1980).

99 For a very thorough analysis of Epiphanios's work, see Gilhus, *Animals, Gods and Humans* (n. 69 above), 238–43.

100 John Mauropous, *Poems* 53. It is my assumption that Mauropous makes here an allusion to Demosthenes' *Against Aristogeiton* 25.52, σκορπίος ἡρκὼς τὸ κέντρον. References to scorpion imagery were by no means limited to Byzantine writers of the period. William of Tyre compares Alexios I Komnenos to the scorpion: *vicem scorpionis agens, cui cum non si in facie quod formides, prudenter feceris si caude posterioris declinare poteris maleficium*; *Chronicle* 10.13 (R. B. C. Huygens, ed., *Guillaume de Tyr Chronique* [Turnhout, 1986], 432). William uses animal metaphors abundantly, including comparisons to the locust (*locustarum more*, Huygens, 6.11).

101 See, e.g., Psellos's poem *Against Sabbaitam* 21.181: ὦ κανθαρίς, βδέλλιον ἢ χαμαιλέον (O dung beetle, fly, or the chameleon) (Westerink, *Michaelis Pselli Poemata*, 265; n. 32 above). Similarly, Arethas claims

that when compared with Gregory of Nazianzus, Leo Choirosphaktes is a beetle; see C. Simelidis, "Aeschylus in Byzantium," in *Brill's Companion to the Reception of Aeschylus*, ed. R. F. Kennedy (Leiden, 2018), 190, n. 49. Simelidis translates κάνθαρος as "beetle," which is one option, but Arethas is more specific and means the dung beetle.

102 Norman Douglas lists more than thirty various insects that make an appearance in the epigrams; see N. Douglas, *Birds and Beasts of the Greek Anthology* (London, 1928), 72–83. By no means are "insect-texts" limited to the Greco-Roman tradition; see, e.g., W. L. Idema, *Insects in Chinese Literature* (Amherst, 2019).

103 It is perhaps worth noting that "insect literature" flourished in the medieval period beyond Byzantium in the form of the so-called flea poems. See M. Françon, "Un motif de la poésie amoureuse au XVIᵉ siècle," *PMLA* 56.2 (1941): 307–36. See also the twelfth-century agon between the flea and the fly by William of Blois: A. Boutemy, "Pulicis et musce iurgia: Une oeuvre retrouvée de Guillaume de Blois," *Latomus* 6.2 (1947): 133–46.

104 F. Bernard and C. Livanos, eds. and trans., *The Poems of Christopher of Mytilene and John Mauropous*, DOML 50 (Washington, DC, 2018), 125.3–4.

105 M. D. Lauxtermann, *Byzantine Poetry from Pisides to Geometres: Texts and Contexts*, 2 vols. (Vienna, 2019), 2:221–22.

106 The dung beetle was viewed as a symbol of envy and was supposed to perish at the smell of a rose. This story is analyzed by D. Angelov, *The Byzantine Hellene: The Life of Emperor Theodore Laskaris and Byzantium in the Thirteenth Century* (Cambridge, 2019), 123, 191.

However, there existed even more complex texts whose focus was on insects. Michael Psellos, for example, penned a funny oration addressed to one of his students, a certain Sergios, who supposedly boasted that no flea had ever bitten him (no. 26 in the *Oratoria Minora*). Psellos counters that perhaps this is nothing to be proud of—fleas, lice, and other species that our body nourishes are attracted to those whose four bodily humors are excellently blended.[107] Psellos's oration is by no means a zoological work; rather, it was perhaps meant as a witty reminder that we are all equal as members of the animal world and as a demonstration of Psellos's medical knowledge (not to mention that the oration clearly demonstrates the hygienic challenges of daily Byzantine life). But this entertaining work foreshadows another three orations authored by Psellos (and it is tempting to see them as compositions akin to sequels to the oration to Sergios). These texts are paradoxical encomia of fleas, bedbugs, and lice. Debra Hawhee rightly interprets these pieces as the "preservation of Lucianic heritage," although the name of the author of the *Praise of Fly* never appears in them.[108] The similarity to the Lucianic model lies in these treatises' purporting to be serious and scientific, while more often being humorous and playful: the flea is compared to a panther and the gnat to an elephant.[109] These three texts are perhaps the most brilliant Byzantine examples of the paradoxical encomium.[110]

Psellos blends Aristotelian zoology with entertaining beliefs and fantastical statements.[111] He seemed to have found only one imitator. Demetrios Chrysoloras, sometime in the fifteenth century, penned the already-mentioned *Praise of the Flea*.[112] It is unclear whether he

was familiar with Psellos's text, but in any case his composition is very different. Unlike Lucian and Psellos, Chrysoloras apparently has very little interest in describing the physicality of the flea. He states, for instance, that its having more than four legs is a sign that nature esteemed it more than other animals.[113] Chrysoloras's text contains references to ancient poets, as well as to historical and mythological figures. Although this text is primarily funny and subversive, among various witty remarks one can find serious and surprising observations regarding the natural world.[114] Perhaps even more important, Chrysoloras's encomium, unlike Psellos's works, has a Christian dimension, beginning with a witty remark that the flea was not created by God at the beginning but was born or formed later from earth just like man.[115]

There is one more text that was directly inspired by Lucian's *Praise of the Fly*. In the twelfth century, Eugenios of Palermo (ca. 1130–1203) authored a refutation of the ancient satirist's text, thereby turning the paradoxical encomium into a *psogos*, an insult written in verse. Eugenios is not interested in the fly as an animal. He focuses instead on refuting all virtues of the fly, "falsely" ascribed to it by Lucian.

Although insects stood front and center in these pieces, they were mostly a pretext. It was never Psellos's aim to write a scientific treatise on these insects. Instead, he engages with both Lucian and the paradoxical encomium by writing pseudo-scholarly treatises to demonstrate to his students the power of logos, as he himself states at *Oration* 28.121: his goal is "to show what the word is capable of." Psellos's three treatises are perhaps the best illustration of the intersection of the real and the fantastic in Byzantine discussions of the animal world. But at the end of the day, insects for him are just a (rhetorical) means to a very serious end—to demonstrate that a rhetor can craft language and bend the common perceptions of reality to serve his needs. Eugenius

107 Michael Psellos, *Minor Orations* 26.12–22.

108 D. Hawhee, *Rhetoric in Tooth and Claw: Animals, Language, Sensation* (Chicago, 2017), 101. Hawhee's analysis of these three pieces unfortunately does not take into account their Byzantine context. For a short introduction and German translation, see M. Billerbeck and C. Zubler, *Das Lob der Fliege von Lukian bis L. B. Alberti: Gattungsgeschichte, Texte, Übersetzung und Kommentar* (Bern, 2000).

109 Michael Psellos, *Minor Orations* 27.1.

110 See P. Marciniak, "The Paradoxical Enkomion and the Byzantine Reception of Lucian's *Praise of the Fly*," *Medioevo Greco* 19 (2019): 141–50.

111 Psellos's oration explicitly refers to Aristotle as the authority: see Michael Psellos, *Minor Orations* 29.35.

112 Some initial remarks on the text are offered in Fuente, "El insecto como tema retórico y poético" (n. 19 above), 93–95.

113 Demetrios Chrysoloras, *Praise of the Flea* 2.6–8 (de Andrés, "Demetrio Crisoloras el Palaciego" [n. 60 above], 58).

114 Demetrios Chrysoloras, *Praise of the Flea* 17.6–7: οὐδενὶ γὰρ τῶν ζῴων ἔνεστι πώποτε κακία, ἀλλ' ἄνθρωπός ἐστι βλάβης καὶ κακίας αἴτιος (For there is never any evil in animals, but man is the reason of evil and harm) (de Andrés, "Demetrio Crisoloras el Palaciego," 68).

115 Demetrios Chrysoloras, *Praise of the Flea* 1 (in the de Andrés translation, 57: "Pues no fue creado por Dios al principio, según mi parecer, sino que, al final, fue formado de la tierra como su señor el hombre").

of Palermo chooses to challenge the authority of Lucian in order to glorify himself and show his own skills as a rhetor/poet. Similarly, Chrysoloras's piece is an exercise in praise displaying his rhetorical skills, philosophical ideas, and finally his knowledge of the ancient tradition. Nevertheless, when Chrysoloras notes that the flea does not respect status or age, he allows us a glimpse into the Byzantine reality of human–insect coexistence.

A praise (or a psogos, in Eugenios's case) of annoying insects, the paradigmatic others, underscores the rhetorical prowess of its author. And yet, at the same time it also helps tame their *otherness* and turn insects into something more familiar, less dangerous—the "other within."

The Transformation and the Case Study of the Cicada

Rhetors and writers throughout the centuries have used bees, cicadas, and scorpions to strengthen their arguments, terrify listeners, or make some ideas more understandable. While the Byzantines inherited many of their ideas about the symbolic nature of insects from their ancient ancestors and retained the zoological legacy of antiquity, at the same time they creatively transformed it.

Insects as vehicles for metaphorical meanings were used in Christian writings from a very early period. For example, the apocryphal *Acts of John* relate an encounter between the apostle, his traveling companions, and the insects that infested a tavern where the group had intended to rest. When John and his companions arrive at a deserted inn, they find the place full of bedbugs. John exclaims, "I say to you, O bugs, behave yourselves, one and all, and leave your abode for this night and *remain quiet in one place* [emphasis mine], and keep your distance from the servants of God."[116] The creatures obey John's command. In the morning, John's companions see numerous bugs in front of the door. John lets them back in and says that these creatures had listened the voice of a man (i.e., John) and obeyed, while human beings can hear to the voice of God and still disobey his commandments. This story may be interpreted in multiple ways. It demonstrates the

apostle's ability to communicate with and command animals, and it points out the shameful conduct of people by comparing them with useless insects. Finally, it uses bedbugs for illustrative purposes: they are ordered to remain quiet since "the point is first and foremost to prescribe to Christians a specific behavior, that is 'to be at rest.'"[117] This episode is clearly not without literary (pagan) antecedents, as scholars have found some possible ancient models for the parable, such as the miraculous removal of flies from the sacrificial altar at Pisa.[118] The ancient tradition was transformed and used to convey a Christian message.

However, we can also trace the Christian transformation of specific kinds of insects. In what follows, I focus on one significant example—the cicada.

The cicada—a symbol of both song and immortality—was perhaps the most frequently mentioned insect in ancient literature.[119] Notably, at a certain point there came into existence the expression ἀκάνθιος τέττιξ, which was used to describe a person unable to sing and hence perhaps to suggest that they were uncultured and unsophisticated.[120] This insect was also widely represented visually.[121] However, when the Greek world

116 Translation after "Acts of John," *New World Encyclopedia*, 28 April 2021, https://www.newworldencyclopedia.org/entry /Acts_of_John.

117 Spittler, *Animals in the Apocryphal Acts* (n. 77 above), 104–5. See also Grant, *Early Christians and Animals* (n. 57 above), 27–28.

118 Aelian, *Characteristics of Animals* 3.37. For a more detailed commentary see E. Junod and J.-D. Kaestli, eds., *Acta Iohannis: Textus alii—Commentarius—Indices* (Turnhout, 1983), 535–38. More general comparisons to insects in theology are rather rare but they do exist. In the works of Ps.-Athanasios disembodied souls are likened to the swarm of bees since they are undistinguishable from one another; see Ps.-Athanasios, "Questiones ad Antiochum ducem," PG 28.612a3–5.

119 On cicadas, see *RE*, 5A.1, s.v. *tettix*.

120 This proverb seems to be a relatively late invention, as it is attested only from the second century onward (cf. Aelius Herodianus, *De prosodia catholica* 3.1, p. 119; Diogenianus, *Paroemiae*, 1.49). There were, it seems, two different interpretations of the adjective ἀκάνθιος. The *Suda* (α 796) links it with ἄκανθα (thorn). According to other sources (mostly later ones), this adjective is derived from the city of Akanthos, because the cicadas there did not sing; see Michael Apostolios, *Collectio paroemiarum* 16.33: ἐπὶ τῶν ἀφώνων καὶ ἀμούσων· οὐκ ᾄδουσι γὰρ οἱ ἐκεῖσε τέττιγες (about those unable to sing and unrefined: because the cicadas do not sing there) (E. L. Leutsch and F. W. Schneidewin, *Corpus paroemiographorum Graecorum*, vol. 2 [Göttingen 1851, repr. Hildesheim, 1958], 666). See also *Diccionario Griego–Español*, s.v. ἀκάνθιος: "prov. Ἀ. τέττιξ de la que se dice que carece de voz, ref. a los que no hablan" (http://dge.cchs.csic.es/xdge /Ἀκάνθιος), and Davies and Kathirithamby, *Greek Insects* (n. 30 above), 130.

121 See Keller, *Die Antike Tierwelt* (n. 10 above), 406.

Fig. 1.
Cicada. Fifteenth century.
Vatican City, Biblioteca
Apostolica Vaticana, Chig. F.
VII.159, fol. 223v. Photo
courtesy of the Biblioteca
Apostolica Vaticana.

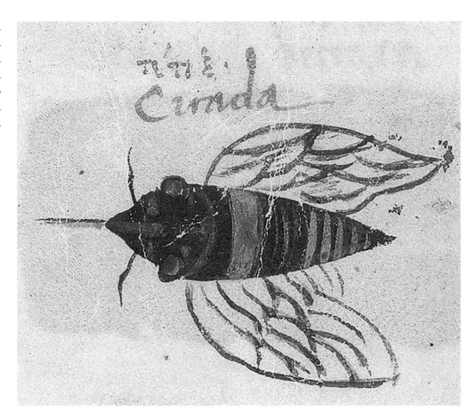

shifted from the pagan to the Christian worldview, the visual representations of this insect dwindled; to the best of my knowledge there exists only one illustration of the cicada from the Byzantine period, a drawing included in the fifteenth-century manuscript Vatican City, Biblioteca Apostolica Vaticana, Chig. F. VII.159, fol. 223v (Fig. 1).[122]

In later periods, the cicada remained a symbol of beautiful singing but also gained a new, Christian meaning and was mapped onto the Christian tradition. In describing the artful performance of one monk, John Kroustoulas, Michael Psellos both calls him the "cicada of the Muses" and recounts that the audience thought that the monk's voice outperformed the songs of cicadas.[123] Manuel II Palaiologos compares King David to a musical cicada, while Bishop Symeon of

Thessaloniki refers to the "everlasting, godly cicada" in his hymn on John of Damaskos.[124] As Emilie van Opstall has recently shown, John Stylianos, in his poetic exchange of insults with Theodore the Paphlagonian, likens himself to a cicada. He does so not only to portray himself as an excellent poet but also to allude to Archilochus, who "when provoked by somebody, uttered the words τέττιγα τοῦ πτεροῦ συνείληφας ('you

122 Kadar, *Survivals of Greek Zoological Illuminations* (n. 28 above), 60. On the cicada in art, see I. Sekal, "Die Biene und die Zikade in der antiken Kunst" (PhD diss., Vienna, 1980).

123 Michael Psellos, "Encomium for the Monk Ioannes Kroustoulas Who Read Aloud at the Holy Soros," in *Michael Psellos on Literature and Art: A Byzantine Perspective on Aesthetics*, ed. C. Barber and S. Papaioannou (Notre Dame, IN, 2017), 238, 244.

124 Manuel II Palaiologos, *Dialogi cum mahometano* 14: Καὶ οὗτος τοίνυν ὁ ἐν βασιλεῦσι προφήτης, τέττιξ ὁ μουσικός (And this prophet among kings, the musical cicada) (E. Trapp, *Manuel II. Palaiologos: Dialoge mit einem "Perser,"* WbyzSt 2 [Vienna, 1966], 198; the editors of the text suggest Plato, *Phaidros* 259 C as a source); Symeon of Thessaloniki, *Hymns* 32.10: ὁ ἄπαυστος θεῖος τέττιξ (everlasting divine cicada) (I. Phountoules, ed., Συμεὼν ἀρχιεπισκόπου Θεσσαλονίκης, τὰ Λειτουργικὰ Συγγράμματα, Εὐχαὶ καὶ Ὕμνοι [Thessaloniki, 1968], 109). Such comparisons could be employed outside the religious context as a compliment. John Apokaukos calls his friend Nikephoros Gorianites ὁ τέττιξ οὗτος ὁ μουσικώτατος (this most musical cicada): John Apokaukos, *Letters* 11 (S. Pétridès, "Jean Apokaukos, Lettres et autres documents inédits," *Izviestiia Russkago arkheologicheskago instituta v Konstantinopolie* 14 [1909]: 69–100, at 85).

have caught a cicada by the wing').”[125] In other words, his reaction was very loud and intense.

Asterios the Sophist (or Asterios the Homilist, fourth century) employs perhaps the most sophisticated web of Christianized allusions to the cicada.[126] In his *Homily* (no. 14) on Psalm 8, “O Lord, our Lord, how excellent is thy name in all the earth!,” he compares cicadas to newly baptized Christians who “are bedewed from the baptismal font, who rest on the cross as if on the tree, who are comforted in the sun of righteousness, and who say and chirp heavenly things.”[127] The traditional simile of a singing cicada is reworked in such a way as to give it a completely original Christian meaning. In describing freshly baptized Christians as “bedewed from the baptismal font” (οἱ ἐκ τῆς κολυμβήθρας δροσιζόμενοι), Asterios is referring to the common belief that cicadas do not eat food but subsist on dew alone (δρόσος). This supposition is confirmed later in the text when the author explicitly notes that just as cicadas feed on dew, so the newly baptized Christians are nourished by the heavenly word (Οἱ τέττιγες τῇ δρόσῳ σιτίζονται καὶ οἱ νεοφώτιστοι τῷ λόγῳ στηρίζονται).[128] In Asterios's homily, the cicada and its customs form not just a simile but a point of reference, which shows that ancient (pagan) material and tradition had been subsumed and reinterpreted.

There are two Byzantine pieces on cicadas embedded in longer narratives; one written by John Tzetzes and the other one by Manuel Philes. Tzetzes devotes an entire story in the *Historiai* to them.[129] Tzetzes is cognizant of both zoological facts taken from ancient writers (for instance, he mentions that female cicadas are mute)[130] and certain common beliefs regarding these insects, such as that the shedding of the cicada's skin signals its immortality. At the same time, to describe their behavior he invokes literary passages, such as Homer's comparison of the Trojan elders with cicadas to represent their talkativeness.[131] He also points out that the myth of Tithonus, who was turned into a cicada, should be interpreted allegorically:

Τὸν Τιθωνὸν ἐρώμενον Ἡμέρας οὕτω νόει·
τῷ εἶναι μακροχρόνιον καὶ τάχα δὴ φιλεῖσθαι
ταῖς τῆς ζωῆς ἡμέραις τε καὶ τῷ μακρῷ δὲ χρόνῳ.
Ἐπεὶ δ' ὑπερεγήρασε καὶ δίκην βρεφυλλίων
ἐν λίκνῳ συνεστρέφετο χάριν τοῦ καθευδῆσαι,
πάλιν νεάσαι θέλοντες τοῦτον ὡς βρέφος λέγειν,
ἐπεὶ καὶ τέττιγες αὐτοὶ νεάζουσιν ὡς ὄφεις·
λαλῶν γὰρ τέττιξ ῥήγνυται, ἄλλος δ' ἐκτρέχει
νέος.[132]

That Tithonus was Hemera's beloved you
 should understand in this way—
Namely, that he was long-lived and was treated
 well
By the days of his life and the long passage of
 time.
But when he grew very old, like a newborn baby
He was put in the cradle so he could sleep,
Because they wished him to become young
 again and babble like a child,
Just like cicadas renew themselves, as serpents do.
For the cicada bursts open while chattering,
 and another young emerges.

125 E. van Opstall, “The Cicada and the Dung-Beetle,” in *Satire in the Middle Byzantine Period: The Golden Age of Laughter?*, ed. P. Marciniak and I. Nilsson (Leiden, 2021), 152–76, at 163.

126 On the identification of the author see W. Kinzig, *In Search of Asterius: Studies on the Authorship of the Homilies on the Psalms* (Göttingen, 1990).

127 Asterios the Sophist, *Commentaries on Psalms* 14.2.3–6 (M. Richard, ed., *Asterii sophistae commentariorum in Psalmos quae supersunt* [Oslo, 1956], 106): Τίνες δὲ οἱ τέττιγες; Οἱ νεοφώτιστοι, οἱ ἐκ τῆς κολυμβήθρας δροσιζόμενοι καὶ ὡς ἐπὶ δένδρον τὸν σταυρὸν ἀναπαυόμενοι καὶ τῷ ἡλίῳ τῆς δικαιοσύνης θαλπόμενοι καὶ πνεύματι περιλαμπόμενοι καὶ πνευματικὰ τερετίζοντες καὶ λέγοντες.

128 Asterios the Sophist, *Commentaries on Psalms* 14.3.4 (Richard, *Asterii sophistae commentariorum in Psalmos*, 106).

129 John Tzetzes, *Histories* 8.166 (Leone, *Ioannis Tzetzae historiae* [n. 45 above], 298). On cicadas in antiquity, see *cicada* in K. F. Kitchell Jr., *Animals in the Ancient World from A to Z* (Abingdon, 2014), 30–32; Davies and Kathirithamby, *Greek Insects*, 113–34 (n. 30 above); Beavis, *Insects and Other Invertebrates* (n. 49 above), 91–103.

130 John Tzetzes, *Histories* 8.166.63 (Leone, *Ioannis Tzetzae historiae*, 298). See Aristotle, *HA* 556b12–13, although Tzetzes' knowledge seems to come instead from Aelian's work; see Aelian, *Characteristics of Animals* 1.19 (García Valdés et al., *Claudius Aelianus de natura animalium* [n. 54 above], 11): τέττιξ δὲ θήλεια ἄφωνός ἐστι (the female cicada is mute).

131 Homer, *Iliad* 3.150–53; on this passage and simile see H. M. Roisman, “Old Men and Chirping Cicadas in the Teichoskopia,” in *Approaches to Homer: Ancient & Modern*, ed. R. J. Rabel (Swansea, 2005), 105–18.

132 John Tzetzes, *Histories* 8.166.73–80 (Leone, *Ioannis Tzetzae historiae*, 298).

This entire story mixes zoological knowledge, folk beliefs, and references to ancient literature. To put it in modern terms, Tzetzes combines ethnoentomology with cultural entomology.

The second text was authored by Manuel Philes and is part of his work *On the Nature of Animals* (498–506):

> Τοὺς ἄρρενας δὲ τῆς γονῆς τῶν τεττίγων
> ποιεῖ φιλῳδοὺς ἡ μαγὰς τῆς ἰξύος.
> Οἳ νυκτερινῆς ἐμφορούμενοι δρόσου,
> τὸν ῥυθμὸν ἐντείνουσιν εἰς μεσημβρίαν,
> ὅταν τὸ θερμὸν τὰς νοτίδας ἁρπάσῃ,
> καὶ τοὺς ἀγωγοὺς τῶν μελῶν ἐξικμάσῃ.
> Θῆλυς δὲ σιγῶν εὐπρεποῦς νύμφης τρόπον,
> καὶ τῶν γυναικῶν σωφρονίζει τὰς λάλους,
> αἰδοῦς νόμων ἄρρητον ὠδίνων μέλος.[133]

> Among the family of cicadas,
> The bridge of their waist makes the male ones
> song-loving.[134]
> They, filling themselves with dew during the
> night,
> Carry on the rhythm until midday,
> When the heat takes over the humidity
> And dries up the canals of the limbs.
> The female, on the other hand, is silent in the
> manner of a decent maiden
> And chastens talkative women
> By giving birth to the mute song of the rules of
> modesty.

Unlike Tzetzes, who in his usual way combines various traditions and sources, Philes mainly reworks a single passage from Aelian's work (1.20).[135] However, Aelian simply states that the female cicada is mute and appears "silent in the manner of a maiden." Philes not only presents a version that is much more refined but also transforms this comparison into an admonition against overly talkative women.

The Byzantine image of the cicada is a blend of the zoological facts observed by ancient naturalists, ancient cultural tradition, and finally a Christian (re)interpretation of this tradition. Like other elements of pagan culture, insect imagery was subsumed and adopted to serve the new religious paradigm. Not all insects and invertebrates underwent a similarly profound transformation. Their treatment must have been dependent at least to some extent on how charged and how widespread the symbolism of a given creature was.

Insects inhabit the entire spectrum of human activities, experiences, and imaginative capabilities, from their practical (ethnoentomological) uses to the world of pure fantasy. As Egan recently noted, "Human interaction with insects occupies two general and interlocking areas of interest: the realm of biophysical reality and the abstract world of aesthetics, fantasy, and metaphysical speculation."[136]

With some exceptions, such as bees, insects and people in Byzantium lived in a continuous, though hardly welcome, symbiosis.[137] This interaction existed in the material sphere: various anti-insect treatments—included, for instance, in the thirteenth book of the *Geoponika* (a tenth-century manual of agriscience)—prove that insects and other vermin posed everyday agricultural problems.[138] They also featured abundantly in literature and imagination.

In texts that stood in between the real and the imaginary, insects are often depicted as hybrids of material beings, possessing certain observable or imaginary features, and regarded as avatars of symbolic meanings and values. They appear in similes, comparisons, and quotations. I would argue that there is very little interest in insects as living and breathing (or not) creatures, but paradoxically there is much interest in using them as metaphors and vehicles for symbolic

133 Dübner and Lehrs, *Poetae bucolici et didactici Manuelis Philae* (n. 66 above), 14.

134 Anna Caramico translates ἡ μαγὰς τῆς ἰξύος as "ponticello." A. Caramico, ed. and trans., *Manuele File: Le proprietà degli animalii* (Naples, 2006), 63.

135 On Philes as more than just a simple imitator of Aelian, see, e.g., F. Capponi, "Eliano fonte di Phile," *RCCM* 34.2 (1992): 223–61.

136 Egan, "Insects" (n. 29 above), 180.

137 See Psellos's playful, though insightful, remark in his oration on bedbugs: οὕτω δὴ καὶ τοῦτο ἡμῖν τὸ ζῷον συμβιοτεύει ὡς ἥδιστα; Michael Psellos, *Minor Orations* 29.61 (Littlewood, *Michaelis Pselli oratoria minora* [n. 1 above], 107).

138 See, e.g., A. E. Smith and D. M. Secoy, "Forerunners of Pesticides in Classical Greece and Rome," *Journal of Agricultural and Food Chemistry* 23.6 (1975): 1050–55 (this article focuses on ancient sources but also discusses the treatment of insects in the *Geoponika*).

meanings. Moreover, it seems that the Byzantines were more inventive in this area than they were in recounting zoological observations. Among the fragments of Constantine Manasses's *Aristandros and Kallithea* is a story about false friends embodied by two animals: the dolphin and the louse. Such a comparison between these two animals, as Otto Mazal notes in his edition, is probably rooted in the tradition of the paradoxographical literature, but these two exemplary animals were added by the Byzantine writer.[139]

Byzantine zoological knowledge did not advance significantly beyond what the ancient authorities had already noted and observed. And yet, there was no need for much advance: Christian beliefs about animals—that is, the establishment of a clear hierarchy in which humans are undeniably superior to them—coupled with (mostly) Aristotelian beliefs, set the stage for understanding animals in the Byzantine period.[140] At the same time, most Byzantine readers did not look for information that is authentic, however we want to define this term, but instead sought what was interesting and perhaps unusual. Byzantine knowledge of insects was textual, not empirical. It was mainly based on the works of the ancient authorities such as Aristotle, Theophrastus, and Aelian. Insect imagery in Byzantium is a complex blend of ancient ideas,

Christian reinterpretation, and, occasionally, Byzantine innovativeness.

As Hal Herzog has rightly remarked, culture plays a major role in constructing how we perceive animals and their place on our sociozoological scale.[141] In Western culture, invertebrates are typically met with aversion (although such an attitude is not necessarily shared by other cultures). Except for bees and silkworms, they were hardly useful. But insects as *literary animals* provoked more nuanced responses and proved to be fairly useful for the Byzantines.

The line from Psellos's work quoted at the beginning of this article was obviously meant as a joke. And yet, in my opinion, the Byzantines noticed the potential of insects and other invertebrates, which was perhaps best encapsulated centuries later in a sentence from Ulysse Aldovrandi's encyclopedia: *insecta animalia esse perfecta . . . puto* (I think that insects are perfect animals).[142]

Faculty of Humanities
University of Silesia in
Katowice
Uniwersytecka 4
40-007 Katowice
Poland
przemyslaw.marciniak
@us.edu.pl

139 O. Mazal, *Der Roman des Konstantinos Manasses: Überlieferung, Rekonstruktion, Textausgabe der Fragmente*, WbyzSt 4 (Vienna, 1967), 111.

140 As noted, "There was no single Christian view of animals in antiquity" (Gilhus, *Animals, Gods, and Humans* [n. 69 above], 161). Nevertheless, this one principle—the inferiority of animals—was the most basic and defining one.

141 H. Herzog, *Some We Love, Some We Hate, Some We Eat: Why It's So Hard to Think Straight about Animals* (New York, 2010), 24.

142 Ulisse Aldovrandi, *De animalibus insectis libri septem, cum singulorum iconibus ad vivum expressis* (Bologna, 1602), 3.

✥ THIS ARTICLE IS PART OF RESEARCH FUNDED by the National Science Center (Poland) UMO-2019/35/B/HS2/02779. My sincerest thanks go to Anthony Kaldellis, Tristan Schmidt, and Janek Kucharski, who read and commented on earlier drafts. I am indebted to the anonymous readers of this essay for their perceptive and critical remarks, which helped me improve it and avoid blatant errors. I am also grateful to Colin Whiting for his help and advice and to Alice Falk for her careful reading of my text. All remaining errors are mine.

The Elephant Mosaic Panel of Huqoq

"Write on the Horn of a Bull"

MEIR BEN SHAHAR

Over the past decade, excavations on the western slopes of the Lower Galilee overlooking the Sea of Galilee have revealed a Byzantine-era synagogue that once stood at the center of the ancient village of Huqoq. Jewish literature of that era and later provides evidence of Huqoq's existence, the latest of which is attributed to Ishtori Haparchi, a fourteenth-century rabbi, as he writes of his visit to Huqoq: "And there we saw a synagogue with an ancient floor."[1] In 2011, a joint excavation team led by Professor Jodi Magness from the University of North Carolina at Chapel Hill with the assistance of Assistant Director Shua Kisilevitz of the Israel Antiquities Authority began excavating at the site,[2] revealing a spectacular mosaic floor dated to the fifth century.[3] It is possible that this is the same

floor that caught Ishtori Haparchi's attention.[4] This paper deals with one panel from this floor, known as the Elephant Mosaic panel.

I posit that the panel represents a complex dialogue with several sources and suggest that the panel is a visual portrayal of a rabbinic midrash dealing with the struggle between the Seleucid Empire and the Hasmoneans. Deciphering the visual language of the mosaic indicates that the panel presents a unique conception of the Hasmoneans and their struggle as not merely following rabbinic values.

The mosaic spans the entire synagogue floor including the nave and the aisles flanking it. The structure measures 20 × 16.5 m, and the floor of the nave is

1 Ishtori Haparchi, *Sefer Kaftor va-Ferach*, ed. A. Y. Havatzelet and Y. Dobrovitzer, 3 vols. (Jerusalem, 1994), 2:63. Unless otherwise noted, translations are the author's.

2 Kisilevitz finished her activity with the excavation team in 2019. Over the last hundred years, there have been few archaeological surveys at Huqoq; see Z. Ilan, *Synagogues in the Galilee and the Golan* (Jerusalem, 1987), 42.

3 On the excavation's progress and its findings, see J. Magness, S. Kisilevitz, M. Grey, D. Mizzi, D. Schindler, M. Wells, K. Britt, R. Boustan, S. O'Connell, E. Hubbard, J. George, J. Ramsay, E. Boaretto, and M. Chazan, "The Huqoq Excavation Project: 2014–2017 Interim Report," *BASOR* 380 (2018): 61–131; J. Magness, S. Kisilevitz, M. Grey, D. Mizzi, J. Burney, K. Britt, and R. Boustan, "Huqoq—2018," *Hadashot Arkheologiyot* 131 (2019), http://www.hadashot-esi.org.il/Report_Detail_Eng.aspx?id=25653&mag_id=127; and J. Magness, S. Kisilevitz, D. Mizzi, J. Burney, K. Britt, and R. Boustan,

"Huqoq—2019," *Hadashot Arkheologiyot* 132 (2020), http://www.hadashot-esi.org.il/report_detail_eng.aspx?id=25880&mag_id=128. For a detailed iconographic interpretation of the north aisle, see K. Britt and R. Boustan, "Scenes in Stone: Newly Discovered Mosaics from the North Aisle in the Huqoq Synagogue," *Studies in Late Antiquity* 5.4 (2021): 509–79. The late David Amit was supposed to be part of the excavation team; however, he was unable to join due to an illness that led to his untimely death. He did manage to help read one of the inscriptions revealed at the site: see D. Amit, "Mosaic Inscription from a Synagogue at Horvat Huqoq," Bible History Daily, 2 January 2013, https://www.biblicalarchaeology.org/daily/biblical-artifacts/inscriptions/mosaic-inscription-from-a-synagogue-at-horvat-huqoq/. David Amit was a neighbor and friend. Regrettably, I did not have the opportunity to discuss this with him. This paper is dedicated to his memory.

4 Magness et al., "Huqoq—2019."

20 cm lower than that of the aisles.[5] Most of the mosaic, approximately 60 percent, is well-preserved and rich in scenes depicting biblical narratives.[6] In the nave are representations of the construction of the Tower of Babel, the Ark of Noah, Jonah being swallowed by a fish, and the parting of the Red Sea, with the zodiac at the center. Unfortunately, since this part of the mosaic was damaged, it is impossible to know whether the center contained a depiction of the figure of the sun god as it was found in the Hammath Tiberias and Beit Alfa synagogues or only a depiction of the sun similar to that seen in the Sepphoris Synagogue.[7] The floors of the colonnades contain depictions of Samson and the foxes, the table of showbread, the spies, and Yael and Deborah (Judges 4–5) as well as two scenes from the Book of Daniel—the three children and the four beasts, among other biblical narratives. The only scene lacking clear interpretative consensus is the Elephant Mosaic panel.

The Elephant Mosaic Panel: A General Description

Uncovered during the third and fourth excavation seasons, the Elephant Mosaic panel (Fig. 1) has drawn much international attention and become the subject of heated academic debates.[8] Located at the east aisle adjacent to the synagogue's entryway,[9] it measures 111.7 × 196.5 cm and is divided into three horizontal registers

of differing widths. The upper, westernmost register occupies some 50 percent of the panel's total space. The width of the second, middle register is approximately one-third of the first panel's width, and the third, lower, easternmost register is narrowest, some 17 percent of the overall width.

The upper register depicts two groups facing one another. The top right corner contains a phalanx of seven soldiers garbed in typical Hellenistic military insignia, wearing helmets and armed with spears (δόρυ) and round shields (ἀσπίς). Beneath the phalanx are two elephants armored in battle gear. Standing just to the right of the center of the register is the figure of the apparent leader of the group. Nearly twice the size of the soldiers, his height spans the width of the register. He is bearded, wearing the diadem (διάδημα) and purple cloak (χλαμύς) traditionally worn by Hellenistic kings.[10] His left hand grasps the horn of a large bull standing slightly behind him and near the soldiers. Due to their distinctly Hellenistic attire, I will refer to this group as the Hellenistic group.

The left side of the register depicts seven youthful figures clothed in white tunics and mantles marked with a sign in the shape of the Greek letter H, each holding a sword, some unsheathed, others not. In the center, adjacent to and opposite the Greek leader, stands a white-haired, bearded figure, depicted, like his counterpart, as twice as large as the men he leads. His right arm is raised with his finger pointing upward. Despite the seeming lack of any distinct visual religious or ethnic identity in this group, I will refer to it as the Jewish group. This is supported simply by the fact that the mosaic was crafted for a Jewish synagogue. However, we shall see several other artistic elements that support this assertion.

The middle register depicts nine figures resembling those in the group to the left of the top register. Each is framed by one of nine arches crowned with a lit oil lamp. At the center, an elderly male, visibly a leader of the group, is seated on a throne and holding an object resembling a scroll.[11] Only the left half of the easternmost [lower] mosaic register has been preserved. At its center lies a bull resembling the one in the top register, prostrate on the ground with blood gushing from the gaping wounds caused by three javelins piercing its belly. To its left on the ground lies an elephant (in all

5 Magness et al., "Huqoq Excavation," 67.

6 This overview is based on Magness et al., "Huqoq Excavation"; Magness et al., "Huqoq—2018"; Magness et al., "Huqoq—2019"; and Britt and Boustan, "Scenes."

7 Magness et al., "Huqoq Excavation," 106.

8 Two years after the panel was discovered, it was published with a comprehensive interpretation by K. Britt and R. Boustan in *The Elephant Mosaic Panel in the Synagogue at Huqoq: Official Publication and Initial Interpretations, JRA* Supplement 106 (Portsmouth, RI, 2017). However, prior to this publication, there were researchers who relied on preliminary photographs and reports and published several papers (see below, n. 98). These publications generated grievances and raised questions regarding scientific ethics. See the pointed words of J. H. Humphrey in his editorial preface to Britt and Boustan's publication: J. H. Humphrey, "JRA's Editorial Preface," in Britt and Boustan, *Elephant*, 7–8. Additional aspects of the Elephant Mosaic were discussed by Britt and Boustan in another article: R. Boustan and K. Britt, "Historical Scenes in Mosaics from Late Roman Syria and Palestine: Building on the Seleucid Past in Late Antiquity," *JLA* 14.2 (2021): 335–74.

9 The following description draws on Britt and Boustan, *Elephant*, 23–26.

10 For a detailed description of the clothing, see Britt and Boustan, *Elephant*, 37.

11 Britt and Boustan, *Elephant*, 29.

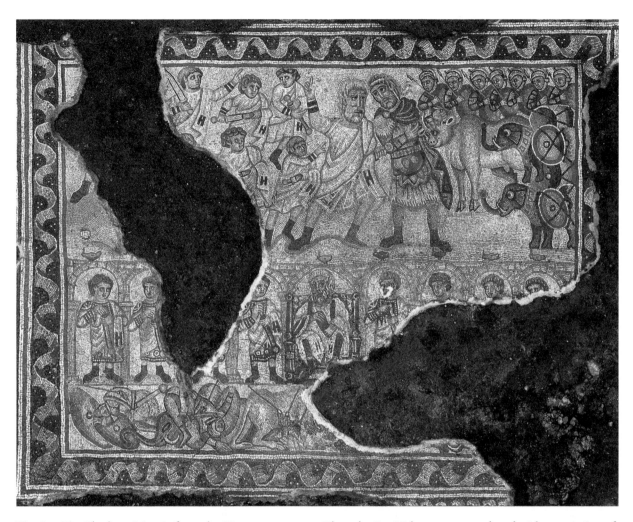

Fig. 1. The Elephant Mosaic from the Huqoq synagogue. Photo by Jim Haberman; reproduced with permission of Jodi Magness.

probability, there is another to the right of the bull, identifiable only by its tusk). A slain soldier lies facedown across the elephant with a javelin protruding from his back, while on the far left lies another soldier, also facedown, his back pierced by an arrow and his body strewn over shields, a sword, and a helmet on the ground.

The Top Register: A Military and Theological Confrontation

"Write on the Horn of a Bull": *Midrash, Image, and Midrashic Image Interpretation*

What is the relationship between the two camps depicted in the upper register of the panel? The depictions of swords, phalanx, and war elephants indicate

a military confrontation, but the two leaders facing each other appear to be in dialogue. Moreover, if this is a military conflict, what is the function of the bull? These questions have led some researchers (see below, pp. 217–18) to claim that the mosaic is an expression of closeness and peace rather than conflict, and that the bull is a sacrifice, expressing the covenant and brotherhood between the two camps. However, this irenic interpretation ignores the militant nature of the scene and provides no reasonable explanation for the defeated Hellenistic camp in the lower register.[12] I will

12 Britt and Boustan, *Elephant*, 25–27, 78–79, are aware of this, so they read the mosaic from the bottom up (see below, pp. 216–17). However, this reading is unreasonable; see A. Erlich, "The Patriarch and the Emperor: The Elephant Mosaic Panel in the Huqoq

argue that the mosaic presents a dual-natured dispute, in which the military conflict is parallel to a religious struggle between Greece and Israel.

The many interpretations proposed for the mosaic (see below, pp. 216–18) show that, at least for us, it is impossible to reach an unequivocal interpretation derived solely from the mosaic. This necessitates seeking texts and traditions that were probably known to the Huqoq congregation[13] and were reflected in multiple motifs, especially those that are unusual and prominently featured in the mosaic. The most enigmatic detail in the mosaic is the bull, without which it is likely most would agree that the mosaic depicts a military conflict. The bull poses a problem for the confrontational approach because it is allegedly brought as a gift. On the other hand, the irenic approach seems to be negated by the many military elements. Since the mosaic dates to the fifth century, it is natural to seek the relevant traditions in rabbinic literature. Indeed, the connections between literature and art in general and between rabbinic literature and Jewish art in particular

are not at all simple. Still, it seems that if there exists a midrash that contains most of the prominent elements of the mosaic, it makes room to examine the possibility of a connection between them. Below, I argue, with the necessary caution, that such a midrash exists. However, I am not claiming that the mosaic is a visual representation of the midrash, but rather that the midrash and the mosaic share common themes and motifs, each offering a slightly different interpretation.

Among the multiple exegeses in Genesis Rabbah (a fifth-century Palestinian midrash) on the second verse in the Bible, "The earth being unformed and void, with darkness over the surface of the deep and a wind from God sweeping over the water" (Genesis 1:2), Rabbi Shimon ben Lakish, a third-century Palestinian rabbi, interprets the verse as an allusion to the four kingdoms:

> "The earth being unformed": this is [a reference to the empire of] Babylon [as it says] "I look at the earth, It is unformed" (Jeremiah 4:23);
>
> "and void": this is [a reference to the empire of the] Medes [as it says] "and hurriedly [in Hebrew, the same root as "void"] brought Haman" (Esther 6:14);
>
> "with darkness": this is [a reference to the empire of] Greece, who darkened the eyes of Israel with their decrees. They would say to them, write upon the horn of a bull that you have no part in the God of Israel;
>
> "over the surface of the deep": this is [a reference to] the evil kingdom, which is innumerable like the deep; just as the deep has no end, just so this evil kingdom.[14]

The exegesis for the Greek empire comprises two parts: the first asserts that the decrees of Greece darkened the eyes of Israel; the second refers to the content of a particular decree: "They would say to them, write upon the horn of a bull that you have no part in the God of Israel." The end of this sentence describes a theological conflict between Israel and the Greek empire. The

Synagogue Reconsidered," *JRA* 31 (2018): 542–58, at 542–43. In addition, in Greco-Roman art, depictions of sacrifice differ greatly from the Huqoq mosaic. Some well-known examples of sacrificial processions such as Trajan's Column, the Decennalia Base, and others were accessible to all visitors to Rome in late antiquity (V. Huet, "Roman Sacrificial Reliefs in Rome, Italy, and Gaul: Reconstructing Archaeological Evidence?" in *Ritual Matters: Material Remains and Ancient Religion*, ed. C. Moser and J. Knust [Ann Arbor, MI, 2017], 11–32). In all of these, the sacrifice is led and offered by the *victimarii*, who were presented as low-class people (J. J. Lennon, "*Victimarii* in Roman Religion and Society," *BSR* 83 [2015]: 65–89). In these descriptions, the emperor or ruler pours sacrificial liquids on the altar but does not approach the sacrificed animals. In addition, even the victimarii rarely hold the bull's horn but only accompany the animal and at most hold the halter. Further, Jaś Elsner points to the fact that beginning in the third century, with no actual connection to the rise of Christianity, depictions of animal sacrifice are rarely found (J. Elsner, "Sacrifice in Late Roman Art," in *Greek and Roman Animal Sacrifice: Ancient Victims, Modern Observers*, ed. C. A. Faraone and F. S. Naiden [Cambridge, 2012], 120–63). Of course, this conclusion does not rule out the possibility of sacrifices being depicted in artworks of late antiquity. However, some unequivocal indication is necessary to contend that this is a sacrificial scene (such as holding the knife over an animal or its slaughter) and that the artist deviated from the accepted artistic conventions of his time, of not depicting animal sacrifice.

13 Indeed, some researchers believe that this is the only possible way to fully decipher Jewish works of art from late antiquity. See C. Hezser and U. Leibner, "Jewish Art in Its Late Antique Context: An Introductory Essay," in *Jewish Art in Its Late Antique Context*, ed. U. Leibner and C. Hezser (Tübingen, 2016), 1–23, at 1.

14 Genesis Rabbah 2:4; see J. Theodor and C. Albeck, eds., *Midrash Bereshit Rabba*, 3 vols. (Berlin, 1912–1936; repr. Jerusalem, 1965), 1:16–17. The translation is based on "Bereishit Rabbah," Sefaria, https://www.sefaria.org.il/Bereishit_Rabbah.2.4?lang=en&with=Jewish%20Thought&lang2=en. All biblical translations follow the JPS Tanakh translation on https://www.sefaria.org/texts/Tanakh.

people of Israel must deny their belief in the God of Israel by writing "upon the horn of a bull that [they] have no part in the God of Israel."

A conflict and a bull are also significant motifs in the upper register. The bull is a central motif which, together with the leaders, stands in stark contrast to the other, less distinctive figures. On the Hellenistic side, there are seven soldiers who appear essentially identical and two battle elephants that also appear quite similar to one another. Against this rather homogeneous background, the bull stands out as a unique iconographic element, made more distinct by the purposeful use of color and shadow. The Hellenistic warriors are depicted in shades of dark red and the war elephants in dark browns. The black contours outlining the soldiers and elephants and their gear contribute to the dark, shadowy appearance of this section of the mosaic. The bull, on the other hand, is dominated by atypical, bright tones of light gray brown.[15] This color scheme forges the two focal points of the register. The first is the conflict between the two leaders who fill its entire height and are positioned at its center, and the second is the bull, which, although positioned at the heart of the Hellenistic camp, is clearly separate from it by virtue of the artist's use of color. The relationship of the Hellenistic leader to the bull is highlighted by his grasping of its horn.

Although obscure and elusive, the reference to the decree of the bull horn does have a continual traditional presence in late ancient Jewish literature.[16] The most

developed source for the decree is in a Jewish interpretation from late antiquity of a first-century essay called *Megillat Taanit* (the Scroll of Fasting). *Megillat Taanit* is a compilation of thirty-five dates on which the Jews experienced fortunate events, most related to Hasmonaean military and political victories. The scroll marks the date and succinctly describes each event. The scholion, a commentary added later to the scroll, features different traditions, some of which were probably related to a particular event mentioned in the scroll, though others seem quite unrelated and even dubious, as in the following:[17]

> On the twenty-seventh of it [the month of Iyar], the coronation tax (*kelilah*) was removed from Jerusalem and from Judea, and one is not to eulogize.[18]

> That is, in the days of the Greek kingdom, crowns were made [and hung] at the entrances of shops and courtyards, and they sang songs to idols and wrote on bull horns and asses' foreheads that their masters had no portion in the Supreme [the God of Israel], just as the Philistines did, as it is written, "No smith was to be found. . . . The charge for sharpening was a *pim* for plowshares and mattocks" (1 Samuel 13:19–21). And when the Hasmonean house overcame them, they were abolished.[19]

15 In most instances in Christian art, and certainly in Roman art, there was a tendency toward realism and the realistic representation of human figures. This was done by using colors both to achieve natural body tones and for shadowing and highlighting figures and body parts (J. Gage, *Color and Culture: Practice and Meaning from Antiquity to Abstraction* [Berkeley, 1999], 47–48). In the current context, it should be noted that in the zodiac cycle at Hammath Tiberias, as in the Sepphoris synagogue, the dominant color of the bull is black gray. The artist's willingness to deviate from the bull's natural colors in order to highlight its image certainly indicates that his purpose was to give it special meaning.

16 This decree appears in the following sources: Palestinian Talmud, Hagigah 2:2, 77d; Genesis Rabbah 16:4 (Theodor and Albeck, *Midrash*, 1:147–48); Leviticus Rabbah 13:5, 15:9 (M. Margulies, ed., *Midrash Wayyikra Rabbah: A Critical Edition Based on Manuscripts and Genizah Fragments with Variants and Notes*, 2 vols. [Jerusalem, 1953], 1:282, 339); Exodus Rabbah, Bo 15:17 (*Midrash Rabbah Shemot* [Lviv, 1874], 21b); Pesiqta Rabbati 33 (R. Ulmer, ed., *Pesiqta Rabbati: A Synoptic Edition of Pesiqta Rabbati Based Upon All Extant Manuscripts and the Editio Princeps*, 3 vols. [Atlanta, 1997–2002], 2:788); Midrash

Aggadah, Genesis 15 (S. Buber, ed., *Midrasch Tanchuma: Ein agadischer Commentar zum Pentateuch* [Vienna, 1894], 33); Midrash Tanhuma, Genesis, va-Yechi 13 (S. Buber, ed., *Midrash Tanhuma* [Vilna, 1885], 219); Midrash Tanhuma, Leviticus, Tazria 12 (*Midrash Tanhuma* [Warsaw, 1875], Leviticus 22a); Bereshit Rabbati, va-Yechi 49:27 (H. Albeck, ed., *Midras Bereshit Rabbati* [Jerusalem, 1940], 253); and V. Noam, *Megilat Taanit: Ha-nusaḥim, pishram, toldotehem; Be-tseruf mehadurah biḳortit* (Jerusalem, 2003), 67–68.

17 On the scroll and its scholion, see V. Noam, "Megillat Taanit—The Scroll of Fasting," in *The Literature of the Jewish People in the Period of the Second Temple and the Talmud*, vol. 3, *The Literature of the Sages*, part 2, *Midrash and Targum; Liturgy, Poetry, Mysticism; Contracts, Inscriptions, Ancient Science; and the Languages of Rabbinic Literature*, ed. S. Safrai, Z. Safrai, J. Schwartz, and P. J. Tomson (Assen, 2006), 339–62; for the edition and interpretation, see Noam, *Megilat Taanit*.

18 Translation of this sentence by Noam, "Megillat Taanit," 343.

19 Translation according to the reconstruction of the original text by Noam, *Megilat Taanit*, 67–68.

The event noted most likely refers to the abolition of the royal taxation (*aurum coronarium*) imposed by the Seleucid Empire, a clear indication of subjugation.[20] Events such as this are mentioned at various times in 1 Maccabees, twice during the reign of Jonathan Apphus (1 Maccabees 10:29, 11:35) and three times during the reign of Simon Thassi (1 Maccabees 13:39, 15:2–9).[21] The first section of the scholion contains a creative, though erroneous interpretation of the term "coronation" (*kelilah* in Aramaic), which may also be translated as "crown," thereby pointing to the crown-like embellishments at the "entrances of shops and courtyards" in the scholion tradition. The second section features an elaborately stylized version of the bull horn tradition, with the addition of donkeys' foreheads. Although the wording in the scholion—"their masters had no portion in the Supreme"—differs somewhat from the wording in the midrash—"[they] have no part in the God of Israel"—the meaning, requiring Jews to publicly state that they do not believe in the God of Israel, is equivalent. Indeed, 1 Maccabees and 2 Maccabees provide evidence of the Seleucids' attempts to force the Jews of Judaea to denounce their faith in their God. Along with the decrees of Antiochus IV in 1 Maccabees 1:44–59 prohibiting the keeping of the laws of the Torah, there is also an obligation to participate in the imperial religious rites. 2 Maccabees comprehensively addresses this issue of renouncement of faith, summarizing the meaning of the decrees: "Thus there was no way to keep the Sabbath or to observe the ancestral festivals, nor even simply to admit to being a Jew" (2 Maccabees 6:6).[22] The decrees were meant to create a situation in which the individual denies his Jewish identity.

The bull's horn midrash explains that the focus of the Jewish–Greek conflict was the belief in the God of Israel. But what linked the bull's horn to the theological conflict? Based on previous studies, Ra'anan Boustan and Karen Britt point out that the bull was a central symbol among the Seleucid kings.[23] The most valuable and recognizable symbol on the body of the bull was its horn, as seen on coins minted in Susa in 305–301 BCE depicting Seleucus I wearing a helmet adorned with a bull's horn. A colossal statue of Seleucus I with bull's horns on his head stood near Antioch.[24]

The bull also symbolized the divine right to rule in Babylonian and Iranian cultures.[25] Kyle Erickson has shown that the images of bull horns on coins and sculptures were intended to spread the royal propaganda that the Seleucid kings were already recognized as living gods, similar to the prevalent practice in the Ptolemaic Kingdom.[26] The bull's horn midrash resonates powerfully and precisely with the deployment of the bull in the Seleucid world as a symbol of the king's royalty and divinity. The writing on the bull's horn, "you have no part in the God of Israel," is simultaneously a denial by the people of Israel of their God through the content of the writing and—by using the bull's horn, a symbol

20 On this tax, see V. Baesens, "Royal Taxation and Religious Tribute in Hellenistic Palestine," in *Ancient Economies, Modern Methodologies: Archaeology, Comparative History, Models and Institutions*, ed. P. F. Bang, M. Ikeguchi, and H. G. Ziche (Bari, 2006), 179–99, at 181.

21 This is the dispatch sent by Antiochus Sidetes to Simeon in 140 BCE. It does not mention the term "aurum coronarium" (cf. τοὺς ἀνήκοντας ἡμῖν στεφάνους [1 Maccabees 11:35]). However, there is a reference to abolition from any tax paid to the Seleucid Empire.

22 D. R. Schwartz, trans., *2 Maccabees* (Berlin, 2008), 270.

23 Britt and Boustan, *Elephant*, 64–66, and Boustan and Britt, "Historical Scenes," 350–54. They also note that the description of the Seleucus statue in pseudo-Callisthenes 2.28 includes a horn as a symbol of Seleucus's kingdom. But the Seleucus statue appears only in recension gamma (H. Engelmann, *Der griechische Alexanderroman: Rezension Gamma*, book 2 [Meisenheim am Glan, 1963], 230). This recension is steeped in Jewish motifs, including Alexander's visit to Jerusalem, but it was created in the tenth century (R. Stoneman, *The Greek Alexander Romance* [London, 1991], 14). Although Gerhard Delling claims that recension gamma's traditions were already prevalent among Alexandrian Jewry in the Hellenistic period ("Alexander der Grosse als Bekenner des Jüdischen Gottesglaubens," *Journal for the Study of Judaism in the Persian, Hellenistic, and Roman Period* 12.1 [1981]: 1–51), there is no evidence of the existence of recension gamma until the tenth century. It seems that this tradition should be seen as evidence of the prevalence of the bull's horn as a symbol of the Seleucid Empire in late antique Jewish culture.

24 On Seleucus's coins, see D. Ogden, *The Legend of Seleucus: Kingship, Narrative and Mythmaking in the Ancient World* (Cambridge, 2017), 61–63. On Seleucus's statue, see A. Houghton, "A Colossal Head in Antakya and the Portraits of Seleucus I," *Antike Kunst* 29.1 (1986): 52–62.

25 O. D. Hoover, "Never Mind the Bullocks: Taurine Imagery as a Multicultural Expression of Royal and Divine Power under Seleukos I Nikator," in *More Than Men, Less Than Gods: Studies on Royal Cult and Imperial Worship; Proceedings of the International Colloquium Organized by the Belgian School at Athens (November 1–2, 2007)*, ed. P. P. Iossif, A. S. Chankowski, and C. C. Lorber (Leuven, 2011), 197–228.

26 K. Erickson, "Another Century of Gods? A Re-evaluation of Seleucid Ruler Cult," *CQ* 68.1 (2018): 97–111.

of the Seleucid king's divinity—an acknowledgment of his divinity.

Finally, it is important to note that the bull's horn midrash was probably common and well-known, as it appears in a variety of formulations in multiple Talmudic texts, including the Palestinian Talmud, Genesis Rabbah, Leviticus Rabbah, and others.[27] The best evidence for the presence of the midrash in late ancient Judaism is in the liturgical literature. In late ancient synagogues, those who prayed recited hymns referred to in Hebrew as *piyyutim*, composed especially by *payytanim* for each festival or holiday. In one of his Hanukkah poems, the great paytan Eleazar ha-Kalir (sixth–seventh century) described the religious persecutions that led to the rebellion. Among the decrees of the Greeks, there is a decree of "blasphemies [against God] engraved on the bull's horn."[28]

Neither the midrash nor the piyyut describes how the Jews responded to the demand to "write upon the horn of a bull that you have no part in the God of Israel." It appears to me that the mosaic articulates what is absent from the text. In response to the Hellenistic decree, the Jewish leader raises his right hand and points his index finger upward, expressing his faith in the one God. As my student Hilla Cohen has suggested, the finger raised towards the sky expresses both the faith of the Jewish leader in the God of Israel who resides in the heavens and his utter rejection of the Greek leader's sacrificial offering. This interpretation is supported by Talmudic sources and Jewish art. The thrusting of arms upward as an expression of faith and confidence in God appears already in the Mishnah, the fundamental Jewish text from the third century:

> "And it came to pass, when Moses held up his hand, that Israel prevailed; and when he let down his hand, Amalek prevailed" (Exodus 17:11). Did the hands of Moses make war when he raised them or break war when he lowered them? Rather, the verse comes to tell you that as long as the Jewish people turned their eyes upward and subjected their hearts to their

Father in Heaven, they prevailed, but if not, they fell.[29]

Thus, the upward-pointed hand signifies the recognition by the people of Israel in the existence of the Lord in heaven and their willingness to obey him. According to the Mishnah, by looking at objects directed upward toward heaven (Moses's hands), the people of Israel were symbolically recognizing their acceptance of and belief in God. An effective rendering of this notion appears in the following late midrash:

> "A Jewish man" (Esther 2:5)—What makes a man Jewish? That he sanctifies the name of the Almighty to all the world's inhabitants. When? When he did not bow to Haman. Did Mordechai ignore the King's order? No, because when King Achashverosh [Xerxes] ordained that all must bow to Haman the wicked Haman inscribed on his chest "we worship idols" saying let the Jews bow to idol worship and they will be annihilated by their own God; when he rode past Mordechai, Haman was boasting about his horse, so Mordechai lifted his hand to heaven and told Haman, "We have a master who prides himself above all the proud in the world, so how can we discard a master that lives and exists forever and forever, and why will we bow to an idol worshipper (as is inscribed on your heart) to flesh and blood that is here today and gone tomorrow to his grave." Haman immediately became furious.[30]

This midrash contains many motifs that are reflected in the Huqoq mosaic. Both share a religious conflict— Haman wants the Jews to bow before idols and presents a tangible object, a medallion engraved with the picture of an idol. Mordechai raises his hand upward to signal his denial and refusal to obey Haman. Mordechai explains that the supremacy of God is not just as residing in heaven, but rather, God is supreme, infinitely

27 For the various rabbinic sources, see above, n. 16.

28 The piyyut was printed and interpreted by E. Fleischer, *Hebrew Poetry in Spain and Communities under Its Influence*, 3 vols. (Jerusalem, 2010), 1:168–75, at 173.

29 Mishnah Rosh Hashanah 3:8; for the translation, see "Mishnah Rosh Hashanah," Sefaria, https://www.sefaria.org.il/Mishnah _Rosh_Hashanah?lang=en.

30 Midrash Panim Acherim, version B, paragraph 6; see S. Buber, ed., *Sammlung Agadischer Commentare zum Buche Ester: Enthält; Midrasch Abba Gorion; Midrasch Ponim Acherim; Midrasch Lekach Tob* (Vilna, 1894), 82.

superior to all creatures and indeed to the idol worshiped by Haman. The upraised hand has the double meaning of belief in God in heaven and faith that God is supreme and superior to all creatures.

It is worth mentioning that the prayer '*Aleinu l'shabeḥ* ([It is] our duty to praise), which was said in late antiquity, presents a poignant contrast between the Jewish belief in one God and gentile belief in idols: "It is our duty to praise the Lord of all. . . . For they [gentiles] bow to vanity and emptiness and pray to a god who cannot save. But we prostrate [ourselves] [before] the king of kings, the holy one, blessed is he. He stretches out the heavens and establishes the earth. His seat of glory is in the heavens above, and his powerful presence is in the highest heights. He is our God, there is no other."[31] In this prayer, the worshiper declares loyalty to God, the world's Creator, whose place "is in the highest heights." To clarify, my claim is not that the prayer '*Aleinu l'shabeḥ* is a basis for the mosaic in Huqoq, but rather that the existence of a polemical concept in both midrashic and contemporary liturgy positing God in heaven makes it reasonable to attribute this meaning to this motif in Jewish art from both.

A similar iconographic representation that utilizes an index finger pointing heavenward to indicate a connection to God can be seen in the fresco depicting the vision of the valley of dry bones at the Dura-Europos synagogue. The image of Ezekiel appears three times on the left side of the fresco with the hand of God depicted above each figure.[32] The faces of all three "Ezekiels" are turned toward the sky with one hand raised towards the firmament with the index figure pointing upward. It is likely that each of these renderings of Ezekiel and the hand of God hints at one of the instances in which God summons the prophet. The hand of God above the

far-left figure is probably a figurative attempt to express the verse, "The hand of the Lord came upon me. He took me out by the spirit of the Lord and set me down in the valley" (Ezekiel 37:1). Thus, the other two figures represent two other instances in which God reveals himself to the prophet (Ezekiel 37:4, 9).[33] It is also conceivable that this motif carries the same polemic connotation elsewhere in the Huqoq mosaic. While this article was being written, a panel was discovered at the eastern corner of the north aisle. The panel appears to depict Hananiah, Mishael, and Azariah, the three children who were thrust into a fiery furnace by Nebuchadnezzar (Daniel 3). The boys' right hands are raised with their index fingers pointing skyward. It seems that the finger pointing upward to the heavens simultaneously indicates the boys' faith in God and their refusal to bow down to an image of Nebuchadnezzar.[34] It appears, therefore, that in the Huqoq mosaic, the index finger pointing imports both absolute faith in and commitment to the one Jewish God and the refusal to believe in or worship other gods.[35]

Vestis virum facit *(I)*: *Dress and Identity—Warriors and Rabbis*

If indeed the mosaic depicts the military and religious confrontation between the Hasmoneans and the Seleucids, the question arises as to whether we can identify the displayed figures. The garb of a high-ranking military commander worn by the Hellenistic leader, including a diadem tied around his head (διάδημα), a purple cloak (χλαμύς), and a cuirass (*lorica*), has led many scholars to the conclusion that this is a Hellenistic king embarking on a military campaign. Since the scene depicts a conflict between a Hellenistic kingdom and the Jews, the Hellenistic leader might be identified as Antiochus IV, who imposed religious decrees and

31 The text is according to the Genizah fragment (Cambridge, Cambridge University Library, T-S H8, 40). Translation is based on J. Hoffman, "The Image of the Other in Jewish Interpretations of *Alenu*," *Studies in Christian–Jewish Relations* 10.1 (2015): 1–41, at 2. There is an ongoing debate concerning the time the prayer was composed. The earliest suggested date is the Second Temple period, and the latest is the third century (see M. Katz, "*Aleinu*—A Prayer Common to Jews and Gentile God-Fearers," in *Judaism's Challenge: Election, Divine Love, and Human Enmity*, ed. A. Goshen-Gottstein [Boston, 2020], 83–97, at 86–90). However, scholars agree that in the fifth century the prayer was already included in the Jewish liturgy.

32 It is customary to mark this section as section A of panel NC; see C. H. Kraeling, *The Synagogue Excavations at Dura-Europos, Final Report VIII*, part 1, 2nd ed. (New Haven, CT, 1979), 178–80.

33 I have adopted the connection to these verses suggested by E. G. Kraeling, "The Meaning of the Ezekiel Panel in the Synagogue at Dura," *BASOR* 78 (1940): 12–18, at 12–13. Others have proposed other, slightly different verses (see Kraeling, *Dura-Europos*, 190, n. 742, and Kraeling's own suggestion, ibid., 191–92).

34 Britt and Boustan, "Scenes," 553–61, depict the scene as a refusal-to-worship scene, but they don't deal with the positive meaning embedded in the index finger pointing upward.

35 Obviously, the meaning of the upward-pointing index finger is contingent on the precise position of the finger and the direction in which it is pointed, as well as the broader context of the scene. I am grateful to Shulamit Lederman for her assistance on this topic.

sent his marshals and troops to crush the Hasmonean rebels.[36] Naturally, this conclusion points in a particular direction regarding the identity of the Jewish figure with different possible options: Mattathias Hasmonean, Judas Maccabee, Eleazar, or someone else.[37] Yet it is doubtful whether the Jews of late antiquity knew any of these names. Although the Jewish sources mention the name Antiochus several times as a moniker for a foreign king, there is no specific detail that links this king to the Hasmoneans.[38] Furthermore, beards were unpopular among the Hellenistic kings and most Roman emperors, so it is unlikely that a late antique artist would add a beard to a Hellenistic king.[39] As for the Hasmoneans, the findings are not much better. The term "Hasmonean house" appears numerous times in rabbinic literature, and all those mentions revolve around military campaigns against the Seleucids and the non-Jewish population in the Land of Israel. As Vered Noam has noted, these victories are rarely attributed to any single figure; even Judah Maccabee is not mentioned by name.[40]

If, however, the mosaic is a visual depiction of the decree "Write on the horn of a bull," then the Hellenistic figure would not represent a particular king but rather the Greek kingdom that "darkened the eyes of Israel with [its] decrees," with the bearded leader of the right-hand group personifying the Hellenistic culture and regime. In this case, it is likely that the Jewish leader would personify the Jewish leadership. This approach might also provide an answer to the question of the beard. Although beards were not popular among Hellenistic kings and most Roman emperors, Zeus was depicted with a magnificent beard.[41]

This insight demands closer scrutiny of the garb worn by the group on the left, representing Israel and perhaps even Judaism. If we were dealing with the historical conflict between the Maccabees and the Seleucid Empire, the Jewish leader could have been represented in one of two ways: as a high priest or a king. But this leader wears nothing that would identify him as either.[42] The white tunics worn by the Jewish figures in the upper and middle registers[43] are distinctively Roman and were worn by all social classes, apparently contributing little to their identification. Closer examination, however, indicates that the garments of both the leader and his followers comprise two parts: a close-fitting tunic with long sleeves adorned with two dark stripes around the wrist and a *pallium*, a version of the

36 Indeed, Janine Balty suggests the same; see J. Balty, "La 'mosaïque à l'éléphant' de Huqoq: Un document très convoité et d'interprétation controversée," *JRA* 31 (2018): 509–12, at 511.

37 All these suggestions were proposed by scholars (see below, nn. 40–43).

38 These are the sources in which Antiochus is mentioned: Seder Olam Rabbah 30 (C. Milikowsky, ed., *Seder Olam: Critical Edition, Commentary and Introduction*, 2 vols. [Jerusalem, 2013], 1:323), in a list of a number of kings without historical context; Genesis Rabbah 23:1 (Theodor and Albeck, *Midrash*, 1:221) with Antiochus as the founder of Antioch; and in *Megillat Taanit*, where it is relayed that a holiday was instituted in commemoration of the elimination of Antiochus's siege (*Megillat Taanit*, 28th Shevat [Noam, *Megilat Taanit*, 115]). Indeed, Antiochus IV visited Jerusalem (1 Maccabees 1:21–23; 2 Maccabees 5:11–16), but neither source states that he laid siege upon the city. According to most scholars, *Megillat Taanit* refers to Antiochus V who laid siege to Jerusalem in 162 BC (1 Maccabees 6:51–60 [Noam, *Megilat Taanit*, 298–300]).

39 See the detailed discussion in C. Oldstone-Moore, *Of Beards and Men: The Revealing History of Facial Hair* (Chicago, 2015), 38–62.

40 This is how the Palestinian Talmud brings the tradition on the Day of Nicanor: "[A] ruler of the kingdom of Greece" wanted to destroy Jerusalem but "one of the Hasmonean dynasty went forth toward him and killed members of his troops" (Palestinian Talmud, Ta'anit 2:13, 66a; translation according to V. Noam, *Shifting Images of the Hasmoneans: Second Temple Legends and Their Reception in Josephus and Rabbinic Literature* [Oxford, 2018], 35). Noam, *Shifting Images*, 202–3, has convincingly shown that rabbis systematically removed the name of Judah Maccabee from the text, replacing it with the general appellation "one of the Hasmonean house."

Indeed, "Mattathias the high priest, son of Yohanan," is mentioned just once in Babylonian Talmud, Megillah 11a as one of the leaders who saved Israel from the "Greeks"; other leaders are Simon the Just and Hasmonai and his sons. The reader gets the impression that Mattathias is not part of the Hasmonean family.

41 On Zeus's beard, see Oldstone-Moore, *Of Beards*, 43.

42 There are indeed very few iconographic representations of Aaron in synagogue art; however, the depiction in Dura-Europos teaches us that the painter painted an image quite similar in terms of the clothing mentioned in the Bible, as Kraeling has noted (Kraeling, *Dura-Europos*, 127–28). Regarding depictions of kings, assuming that the Meroth mosaic represents the image of King David, it is noteworthy that this figure is wearing some kind of ornament (perhaps a diadem) around its head, as well as a purple cloak (χλαμύς). David as Orpheus in Gaza is dressed in a large purple robe over a white tunic, whereas Samuel the prophet is wearing a tunic with a clavus and a white pallium with an H-shaped appendage. For the iconography of David in synagogue art, see G. G. Xeravits, "The Reception of the Figure of David in Late Antique Synagogue Art," in *Figures Who Shape Scriptures, Scriptures that Shape Figures: Essays in Honour of Benjamin G. Wright III*, ed. G. G. Xeravits and G. S. Goering (Berlin, 2018): 71–92.

43 Britt and Boustan, *Elephant*, 31.

Fig. 2.　Hypogeum of the Aurelii, cubiculum B, south wall. Photo courtesy of the Pontificia Commissione di Archeologia Sacra.

Greek cloak known as ἱμάτιον or τρίβων,[44] which hangs over the left shoulder and passes under the right armpit. These pallia are decorated with the Greek letter *eta* (H), which I will discuss below.

It is more than likely that the decision to dress the Judean figures in pallia was deliberate, as in contrast to the Hellenistic camp's typically militaristic uniform, the pallium was a garment customarily worn by philosophers and scholars rather than by those associated with the military or warfare in late antiquity. Evidence of this is prevalent in both the literary imagery and iconography of late antiquity,[45] including frescoes and sarcophagi.

The fresco of the Hypogeum Aurelii (Fig. 2) contains a row of figures dressed in tunics and pallia with some holding scrolls, indicating that they are scholars.[46] In

scholars who differentiate between the Roman pallium and the Greek himation; see C. Baroin and E. Valette-Cagnac, "S'habiller et se déshabiller en Grèce et à Rome (III): Quand les Romains s'habillaient à la grecque ou les divers usages du *pallium*," *RH* 643.3 (2007): 517–51.

46　The religious identity of the figures is debatable. Recently, John Bradley convincingly argued that the twelve figures are members of a *collegium*. This particular collegium emphasized learning and literacy (J. W. Bradley, *The Hypogeum of the Aurelii: A New Interpretation as the Collegiate Tomb of Professional Scribae* [Oxford, 2018], 102–11). According to Arthur Urbano, there is a consensus as to their being scholars (A. P. Urbano Jr., "The Philosopher Type in Late Roman Art: Problematizing Cultural Appropriation in Light of Cultural Competition," in *Religious Competition in the Greco-Roman World*, ed. N. P. DesRosiers and L. C. Vuong [Atlanta, 2016], 27–40, at 27). The image of the scholar or philosopher on sarcophagi of late antiquity is discussed broadly in P. Zanker, *The Mask of Socrates: The Image of the Intellectual in Antiquity*, trans. A. Shapiro (Berkeley, 1995), 267–84. On the centrality of the pallium in the iconography of the scholar, see Urbano, "Philosopher," 29–30, who argues that the pallium was the most distinctive motif in this iconography; see also A. P. Urbano,

44　The most distinctive feature of the pallium is its rectangular shape and the fact that it is draped over one shoulder. See M. Bieber, "Roman Men in Greek Himation (Romani Palliati): A Contribution to the History of Copying," *PAPS* 103 (1959): 374–417, at 398.

45　In the literature of antiquity, the appearance of the philosopher was established, and one of the most prominent characteristics of this look was the *himation*. This aspect also remained during late antiquity; see R. R. R. Smith, "Late Roman Philosopher Portraits from Aphrodisias," *JRS* 80 (1990): 127–55, at 149–50. However, there are

the late third century, the pallium was adopted by the Christians to replace the toga as a distinguishing mark of their disengagement from the opulent and corrupt Roman world. As in Roman culture, the pallium symbolized scholarship for the Christians, but it also signified an ethical way of life and Christian piety.[47]

It is more than likely that the Jews, like the Christians, appropriated the pallium from the Roman world to symbolize a life of religious learning and pedagogy. Thus, for example, the frescoes at the Dura-Europos synagogue have depictions of the leading biblical figures, Abraham, Moses, and Elijah, wearing pallia. Arthur Urbano notes that in several scenes in which a biblical figure appears alongside other Israelites, only the important personality is depicted wearing a pallium. For example, in the scene showing the miracle of the well, Moses is draped in a pallium, whereas the people of Israel wear only tunics (Fig. 3).[48] Some scholars argued that the figure depicted wearing a pallium in the four panels on the Western Wall above the Holy Ark (Fig. 4) is Moses symbolized as a teacher and/or a rabbi.[49] In rabbinic literature, the pallium is referred to as a *tallith* (prayer shawl),[50] and according to scholars, the rabbis wrapping themselves in tallithot while studying

and teaching Torah[51] are parallel to the association between learning and the pallium in Greco-Roman culture.

It appears that in our mosaic, "Israel" from the midrash is represented by a leader who is primarily a scholar. Though the military nature of the conflict depicted in the upper and lower registers does not enable him to carry scrolls into the battlefield, he carries one in the middle register. In the conflict portrayed in the upper register, the leader's religious affiliation is expressed by raising his right hand heavenward. His other hand seems to be holding some object apparently on or embedded in the Greek leader's arm, though the object and the meaning of the gesture are difficult to identify.[52]

Like their leader, the youths are dressed in white pallia. Clearly cumbersome, they are not suited for battle, although their presence complements the image of the Jewish cohort as a group of young students led by a rabbinic leader. Indeed, the leader's superiority is only indicated by his size and position in the register. The entire Jewish group is clothed in identical pallia, in contrast to the Hellenistic group, in which the hierarchy between the leader and the soldiers is clearly delineated by their garb, with the leader's clothing adorned with a royal insignia while the soldiers wear helmets, have a different type of armor, and are armed with spears and shields. Thus, the difference between the groups is marked both ethnically—Greeks against Israelites—and in terms of sociocultural imagery. On one side, the orderly and well-equipped Hellenistic army, and on the other, a cohort of students led by their rabbi.

"Literary and Visual Images of Teachers in Late Antiquity," in *Teachers in Late Antique Christianity*, ed. P. Gemeinhardt, O. Lorgeaux, and M. Munkholt Christensen (Tübingen, 2018), 1–31, at 15–20.

47 For the Christians' appropriation of the pallium, see A. P. Urbano, "'Dressing a Christian': The Philosopher's Mantle as Signifier of Pedagogical and Moral Authority," *StP* 62 (2013): 213–29, at 218–21, and A. P. Urbano, "Sizing Up the Philosopher's Cloak: Christian Verbal and Visual Representations of the *Tribōn*," in *Dressing Judeans and Christians in Antiquity*, ed. K. Upson-Saia, C. Daniel-Hughes, and A. J. Batten (Farnham, 2014), 175–94, at 182–86.

48 A. P. Urbano, "Fashioning Witnesses: 'Hebrews' and 'Jews' in Early Christian Art," in *A Most Reliable Witness: Essays in Honor of Ross Shepard Kraemer*, ed. S. Ashbrook Harvey, N. DesRosiers, S. L. Lander, J. Z. Pastis, and D. Ullucci (Providence, RI, 2015), 89–100, at 94.

49 S. Fine, *Art and Judaism in the Greco-Roman World: Toward a New Jewish Archaeology* (Cambridge, 2005), 179, and R. Hachlili, *Ancient Jewish Art and Archaeology in the Diaspora* (Leiden, 1998), 111–13. For other identifications (e.g., Ezra the scribe), see Hachlili, *Ancient Jewish Art*, 113.

50 On the similarity between the pallium and the tallith, see D. Sperber, *Material Culture in Eretz Israel during the Talmudic Period*, 2 vols. (Jerusalem, 1993), 1:132–35, and D. Shlezinger-Katsman, "Clothing," in *The Oxford Handbook of Jewish Daily Life in Roman Palestine*, ed. C. Hezser (Oxford, 2010), 362–81, at 367–70.

51 Tosefta Hagigah 2:1; Leviticus Rabbah 37:3. See also C. Hezser, *Rabbinic Body Language: Non-Verbal Communication in Palestinian Rabbinic Literature of Late Antiquity* (Leiden, 2017), 41–51.

52 The identity of the object is unclear, and each scholar has interpreted it according to his general interpretation of the mosaic. Some claim that it is a coin, which in turn supports the tendency to interpret the scene as an exchange of gifts (Britt and Boustan, *Elephant*, 31–33, 80). Balty, "Mosaïque," 511, in keeping with her military interpretation, argues that it is a sword. A. Yoskovich, "The 'Elephant Mosaic' Panel from the Huqoq Synagogue: Ehud Ben Gera in Jewish-Galilean Traditions," *Journal for the Study of Judaism in the Persian, Hellenistic, and Roman Period* 52.2 (2021): 257–78, at 262 and n. 18, suggests the same. Erlich, "Patriarch," 553, n. 70, does not offer a definitive answer but tends to identify it as a clod of earth symbolic of the fertile lands that Caracalla gifted to Rabbi Judah the Patriarch. B. D. Gordon and Z. Weiss, "Samuel and Saul at Gilgal: A New Interpretation of the Elephant Mosaic Panel in the Huqoq Synagogue," *JRA* 31 (2018): 524–41, at 525–26, suggest that this is merely a decorative ornament.

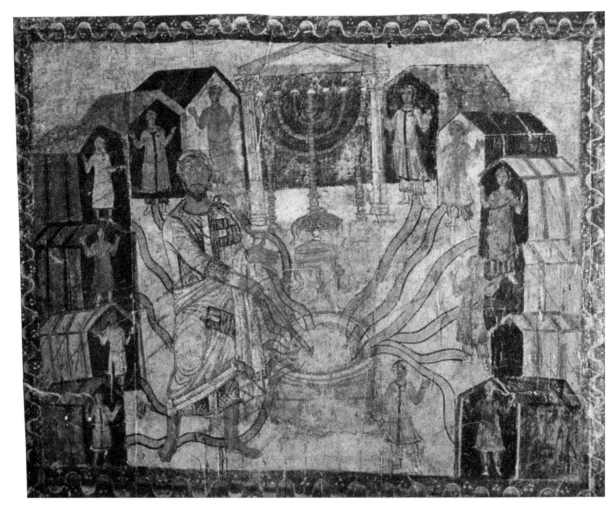

Fig. 3. Well of Miriam, Dura-Europos synagogue, 250 CE. Note the symbol "H" on the hems. Photo courtesy of the Center for Jewish Art, the Hebrew University of Jerusalem.

A midrash that has been given little attention so far contains a similar contrast:

> Levi is juxtaposed to the Greek kingdom. The former being the third tribe and the latter the third kingdom. The name of the former consists of three letters, and that of the latter consists of three letters. The former blow horns and the latter blow *solpirim*. The former wear turbans and the latter wear *qisim*. The former wear breeches and the latter wear *femamalia*.[53] Now the latter are many while the former are but few in number, yet the many came and fell by the hands of the few. For whose sake was that? It was for the blessing of Moses: "Smite the loins of his foes" (Deuteronomy 33:11)—by whose hand will the Greek kingdom fall? By the hand of the Hasmoneans, descended from Levi.[54]

The midrash compares the Levites to the Greek soldiers.[55] The Greeks wear helmets, whereas in Exodus

53 There are numerous versions of this word, but all point to *feminalia* (φεμινάλια), which means "tight-fitting trousers"; see Sperber, *Culture*, 1:151–54.

54 Genesis Rabbah 99:2; see Theodor and Albeck, *Midrash*, 3:1274; translation based on H. Freedman and M. Simon, trans., *Midrash Rabbah*, vol. 2, *Genesis* (London, 1939), 974.

55 Although the exegesis opens with "Levites," in light of the articles of clothing noted later, it appears that the exegete is referring to *kohanim* (priests), which corresponds to the exegesis that mentions the Hasmoneans.

 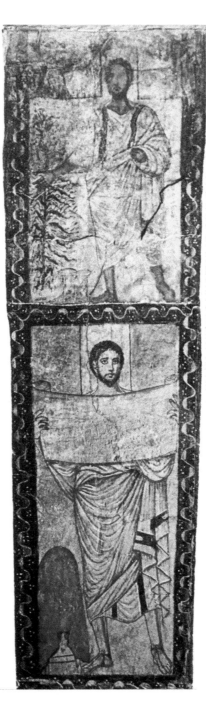

Fig. 4.
Moses, Dura-Europos synagogue. Photo courtesy of the Center for Jewish Art, the Hebrew University of Jerusalem.

28:40, the Levites wear turbans; the Greeks wear *feminalia* (tight-fitting trousers), whereas the Levites wear loose trousers; and the Greeks blow trumpets, whereas the Levites blow horns—that is, *shofarot*. Following this juxtaposition, the exegete arrives at the crucial distinction that "the latter are many while the former are but few," and still "the many fell by the hands of the few." Although the description of the attire in the midrash differs from that depicted in the mosaic, they both highlight the presence of differences between the groups in terms of their garb.

The most enigmatic visual symbol in the mosaic is the geometric sign H appended to the hems of the pallia worn by the Jewish group. This shape is part of a repertoire of geometric adornments called *gammadia* (from the Greek letter Γ [gamma]), which were very common

in the material culture of late antique Palestine.[56] Two types of gammadia are known from ancient Jewish clothing culture, a jagged-edged Γ and a jagged-edged rectangle. Both were discovered on pieces of textile found and identified by Yigael Yadin as tallithot, which he excavated at the Bar Kochba caves and Masada. They were also found on the himatia of many figures in the Dura-Europos synagogue (Figs. 3 and 4).[57]

The few scholars who have addressed this issue have stressed the obscurity of the geometrical appendage. Yadin was of the opinion that these were simply ornaments, which over time evolved into markings of gender.[58] Some scholars endowed them with religious meaning,[59] while others viewed them as social status symbols, similar to the *clavi*, the colorful bands which will be discussed below.[60] Whatever the exact meaning and roots of the symbol H, by the third century it had become part of the visual language and an accepted decoration of the pallia and tallithot of Jewish leaders, as seen in Dura-Europos. Thus, it is probable that this symbol plays the same role in Huqoq.

The differences between the groups are not only in the dress and appearance but also in the composition and the relationships visible between the individuals within each group. The Hellenistic leader's superiority is apparent in his full set of royal attire. In contrast, the other Greek figures are soldiers wearing helmets and equipped with spears and shields. They stand shoulder to shoulder in a straight line with their lower bodies concealed by the bull. The absolute uniformity in the Greek camp, the soldiers' "frozen" posture, and partial exposure of their bodies are contrasted with the leader's full-bodied image, movement, and vitality. These differences clearly denote the social and cultural gap between the leader and the soldiers, while their fixed and uniform images strip them of their individuality and position them as mere cogs in the Hellenistic war machine.

In contrast, all the members of the Jewish group are depicted as relative equals with their figures fully articulated and their differing gestures indicating their unique identities. While these details underscore the individuality of each member of the Jewish group, there is also a significant measure of equality between the leader and the soldiers. All the Jewish figures, without exception, are dressed in identical tunics with two stripes on the arms and in white pallia with the H sign adorning their hems. The status of the Jewish leader is distinguished from the others by his physical size (approximately double compared to the others), beard, and white hair rather than in terms of his dress. These may indicate that the older man's leadership is based on his personal qualities, old age (which symbolizes life experience), wisdom, and guidance. It is only fitting to mention here the words of fourth-century Roman historian Ammianus Marcellinus: [*E*]*t ubique patrum reverenda cum auctoritate canities* (Everywhere

56 See O. Peleg-Barkat, "Interpreting the Uninterpreted: Art as a Means of Expressing Identity in Early Roman Judaea," in *Jewish Art in Its Late Antique Context*, ed. U. Leibner and C. Hezser (Tübingen, 2016), 27–48, at 32.

57 In Christian-Byzantine art, the ancient geometrical adornment was transformed into the Greek letter gamma to which it bears a close resemblance. This led the way for the use of other Greek letters, including Z, N, and, of course, H, as appendages added to pallia. In recent years, Cristina and Fabio Cumbo have been engaged in an effort to categorize all of the varieties of the gammadia symbols; see C. Cumbo and F. Cumbo, "GMS—Gammadiae Management System: Cataloguing and Interpretation Project of the So-Called *Gammadiae* Starting from the Iconographic Evidences [*sic*] in the Roman Catacombs," *Conservar Património* 31 (2019): 145–54. The topic has been discussed in numerous papers by Maciej Szymaszek. For a designated discussion on the symbol H, see M. Szymaszek, "On the Interpretation of Textile Finds with Right-Angled or H-Shaped Tapestry Bands," in *Textiles, Tools and Techniques of the 1st Millennium AD from Egypt and Neighbouring Countries: Proceedings of the 8th Conference of the Research Group "Textiles from the Nile Valley" Antwerp, 4–6 October 2013*, ed. A. De Moor, C. Fluck, and P. Linscheid (Tielt, 2015), 169–97. I thank Maciej Szymaszek for making his publications available to me.

58 Y. Yadin, *Bar Kokhba: The Rediscovery of the Legendary Hero of the Last Jewish Revolt against Imperial Rome* (London, 1971), 124–33. This assumption was refuted by discoveries made in Egypt; see A. Sheffer and H. Granger-Taylor, "Textiles from Masada: A Preliminary Selection," in *Masada IV: The Yigael Yadin Excavations 1963–1965, Final Reports*, ed. J. Aviram, G. Foerster, and E. Netzer (Jerusalem, 1994), 153–282, at 240.

59 This is Goodenough's suggestion (E. R. Goodenough, *Jewish Symbols in the Greco-Roman Period*, vol. 9, *Symbolism in the Dura Synagogue* [New York, 1964], 162–64). See the literature noted in Peleg-Barkat, "Interpreting," 32, n. 23, and C. Cumbo's detailed overview, "La questione delle 'gammadiae': Rassegna degli studi," *Augustinianum* 57.2 (2017): 515–39. According to Antonio Quacquarelli, the letter H, which symbolizes the number 8 in Greek gematria, is related to Christian symbolism associated with the resurrection of Christ; see A. Quacquarelli, "Il monogramma cristologico (gammadia) H," *VetChr* 16.1 (1979): 5–20. For an extensive yet critical survey of Quacquarelli, see C. Cumbo, "L'ogdoade cristiana: Riflessioni e ipotesi a partire dagli studi di Antonio Quacquarelli," *De medio aevo* 7.1 (2018): 259–76.

60 Gordon and Weiss, "Samuel," 525.

the white hair of the senators and their authority are revered).[61] The composition and attire of the two groups create the impression that the confrontation is not between two camps of warriors but between two cultural worlds. The Hellenistic world is represented through the warriors, war elephants, and the king-general, whereas Judaism is represented by the partnership of Torah study and the war for Torah, as depicted by a group of students led by their rabbi.

The Middle Register: Warriors and a Rabbi

The upper register represents a snapshot of a moment in the conflict. There is a particularly strong sense of movement on the left side, where the figures appear to maintain an active stance in the face of the opposing camp. The Hellenistic leader on the right appears to be in motion with the soldiers apparently alert and ready for action. In contrast, the figures in the middle and lower registers are stationary, primarily indicating outcomes of the upper register. Indeed, while the upper register denotes a sense of a power balance between the camps, the outcomes of the conflict, as depicted in the middle and lower registers, are different between the two groups. While in the top register they stood facing one another, the other two depict the Hellenistic group lying defeated at the feet of the Jewish group.

Vestis virum facit (II):
Dress and Social Status in the Huqoq Mosaic

Then as now, *vestis virum facit,* and the color and style of clothing as well as the embellishments indicated an individual's membership in a particular group and a certain social stratum.[62] At first sight, the figures in the middle register appear to be the same as those on the left in the upper one, but meticulous comparison of the composition and the clothing reveals important differences. The upper register depicts a group of individuals wearing the same garb, whereas in the middle register, there is a distinct hierarchy between the old man and the young men in both composition and dress. The most conspicuous difference between the leader and the other members of the group is that the former is now seated on a chair while the others stand at his sides. Roman and Byzantine art show well-documented distinctions between figures depicted as sitting or standing, with the senior personage seated on a lavish chair flanked by standing figures.[63] This also appears in rabbinic literature, in which the obligation to stand in honor of an elder and the duty of a student to stand when engaging with his rabbi are discussed widely.[64] Relative size is often another indicator of seniority, with the authoritative figure occupying more space than the others, and indeed in the middle register the seated figure is positioned under an arch that is approximately 20 percent wider than those above the others. An additional noted distinction between the younger men and their leader is visible in the objects they hold. As in the upper register, the soldiers are portrayed as carrying swords, while the elder grasps an open scroll, already a distinctive symbol of erudition and literacy in the Hellenistic age.[65] Ornamentation of Roman sarcophagi of scholars from the third century usually features a central figure holding a scroll, indicating the status of the deceased as teacher and pedagogue with surrounding figures depicting their students. This iconographic image was also well-integrated into early Christian art.[66]

Two other areas of distinction merit discussion: comparison between the upper and middle registers and comparison of the seated elder with the standing soldiers. As mentioned above, the similar clothing worn by the leader and soldiers in the upper register conveys a sense of equality and uniformity, in contrast to the middle register, in which trimmings appearing on the attire of the elder differ from those on the garments of the soldier-students. Here, the old man's tunic is adorned by two dark stripes descending from the neckline of his tunic—each a common appendage called a *clavus*. Two clavi have also been added to the

61 Amm. Marc. 14.6.6; text and translation according to J. C. Rolfe, ed. and trans., *Ammianus Marcellinus, History,* vol. 1, Loeb 300 (Cambridge, MA, 1950), 38–39. See also T. G. Parkin, *Old Age in the Roman World: A Cultural and Social History* (Baltimore, 2003), 105. The connection between white hair, old age, and wisdom is recognized also in Jewish sources (e.g., Babylonian Talmud, Berakhot 28a).

62 Valuable studies on the meaning of dress in the Roman world can be found in J. Edmondson and A. Keith, eds., *Roman Dress and the Fabrics of Roman Culture* (Toronto, 2008).

63 G. Davies, "On Being Seated: Gender and Body Language in Hellenistic and Roman Art," in *Body Language in the Greek and Roman Worlds,* ed. D. L. Cairns (Swansea, 2005), 215–38, at 217.

64 Palestinian Talmud, Bikkurim 3:3, 65c–65d; Babylonian Talmud, Qiddushin 32b–33a; and Hezser, *Rabbinic Body Language,* 75–83.

65 Zanker, *Socrates,* 193–97.

66 Zanker, *Socrates,* 268–97, followed by Urbano, "Literary," 15–18.

robes of the young men, yet unlike those of their senior, these ribbons, as well as the two stripes on their arms, are adorned with white buttons. Moreover, *segmenta* (ornate patches) have been added on their right shoulders, as have *orbiculi* (circular appendages) at the bottom of the tunics.

These appendages grant social status to the wearer in a way that is similar to the status conveyed by the type of garment (i.e., pallium). The width of the clavus was an indicator of one's social status during the republican and early imperial periods.[67] It is likely that at a certain stage, other adornments were for decorative purposes and also bore social significance.[68] In any case, from the evidence in mosaics, frescoes, and even the material relics of clothing, it has become clear that these different types of appendages were worn by members of all social circles and classes[69] and that they may not carry any particular meaning. However, assuming their appearance in the middle register was a conscious choice on the part of the artist, the distinct gap between the ornamented and non-ornamented dress begs an explanation.

It is probable that even after the clavi and other appendages became more common, their earlier significance as illustrations of prestige and high social status remained familiar and well-known. Thus, the transition in the mosaic from the representation of an egalitarian social order—void of status-designating emblems—in the upper register to the use of dress and composition as a means of indicating and defining social hierarchy in the middle register is conscious and deliberate. The

Jewish group, led by the elder, triumphed over the "Greek Empire" and is therefore granted the emblems of prestige.

Here it is worthwhile to point to other distinguishing indicators between the older man and the younger ones. The elder's pallium is adorned with only two clavi and two H symbols; by contrast, the young men's clothes are further decorated with their orbiculi, clavi, and segmenta and are embedded with white buttons. In late antiquity, these additional decorations were largely associated with royal attire, such as when the emperor Constantine appropriated the traditional Hellenistic diadem and enhanced the earlier simple ribbon by decorating it with pearls and precious stones.[70] Later, other articles of Byzantine royal dress were inlaid with gems and pearls.[71] The adornment of clothing and objects with gems and expensive jewelry, in both reality and Christian mosaics, originated in imperial iconography, which in late antiquity became part of the triumphant Church's visual culture.[72] In Huqoq, the addition of royal insignia on the clothing of the Jews signifies that their victory granted them a form of royal status.

The composition of the middle register is similar to those found primarily on Roman sarcophagi of late antiquity. The sarcophagus of L. Pullius Peregrinus, a public figure among the social class of *equites* (cavalrymen in Rome in the mid-third century), is decorated with a rich relief (Fig. 5). Pullius himself is depicted as seated in the center, holding an open scroll with both hands. He is flanked on each side by two rows of pallium-garbed figures with some facing Pullius while others appear to be conversing with one another. This composition implies that the deceased was a learned man and emphasizes his commitment to teaching his disciples.[73] Like the pallium, Christian art in late antiquity adopted this composition style, and many sarcophagi and mosaics depict Jesus holding a scroll while surrounded by his apostles.[74]

67 On the widths of the band and the social division associated with them, see K. Olson, *Masculinity and Dress in Roman Antiquity* (Abingdon, 2017), 18–20. However, scholars have shown that the reality reflected in the literary sources is more complex; see B. Levick, "A Note on the Latus Clavus," *Athenaeum* 79 (1991): 239–44, and L. Bender Jørgensen, "Clavi and Non-Clavi: Definitions of Various Bands on Roman Textiles," in *Textiles y tintes en la ciudad antigua*, ed. C. Alfaro, J.-P. Brun, P. Borgard, and R. Pierobon Benoit (Valencia, 2011), 75–81.

68 The shape and size of the segmenta were probably related to social and class aspects; see R. MacMullen, "Some Pictures in Ammianus Marcellinus," *ArtB* 46.4 (1964): 435–55, at 445–51 (reprinted in R. MacMullen, *Changes in the Roman Empire: Essays in the Ordinary* [Princeton, 1990], 78–106). On the origin of the orbiculi, see F. Pennick Morgan, *Dress and Personal Appearance in Late Antiquity: The Clothing of the Middle and Lower Classes* (Leiden, 2018), 39.

69 M. Harlow, "Clothes Maketh the Man: Power Dressing and Elite Masculinity in the Later Roman World," in *Gender in the Early Medieval World: East and West, 300–900*, ed. L. Brubaker and J. M. H. Smith (Cambridge, 2004), 45–61, at 55–58.

70 M. P. Canepa, *The Two Eyes of the Earth: Art and Ritual of Kingship between Rome and Sasanian Iran* (Berkeley, 2009), 201–4.

71 H. Maguire, "Personal Adornment: Glory, Vainglory, and Insecurity," in *Transition to Christianity: Art of Late Antiquity, 3rd–7th Century AD*, ed. A. Lazaridou and V. Mouseio (Athens, 2011), 43–47.

72 D. Janes, *God and Gold in Late Antiquity* (Cambridge, 1998), 119–33.

73 Zanker, *Socrates*, 268–79.

74 Urbano, "Literary," 15–26.

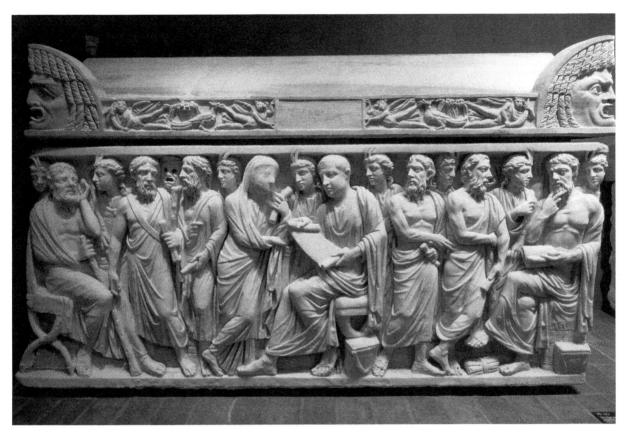

Fig. 5. Lucius Pullius Peregrinus Sarcophagus, Palazzo Caffarelli-Clementino (formerly at the Museo Torlonia). Photo by Damien Marcellin Tournay; courtesy of Flickr (CC BY-NC 2.0).

For our purposes, it is particularly valuable to observe the columnar sarcophagi found in Roman art from the mid-second century, in which the different figures are positioned within arched niches separated by decorated columns.[75] This style was adopted during the Byzantine era by Christian art. For instance, the Ariosti-Fontana sarcophagus has seven shell-patterned arched niches (Fig. 6) with Jesus seated in the center niche holding an open book in one hand. His apostles stand in the remaining niches with their faces looking in various directions. Some of the apostles are facing Jesus, although the second figure on the left faces leftward, similar to the leftmost figures in the middle register of the Huqoq mosaic.

In Huqoq, there appears to be a more pronounced disparity between the seated older figure and the standing youths. The senior figure clearly represents the values of learning and literacy, in contrast to the younger figures, who continue to hold swords and wear more conspicuously adorned clothing when compared to both their simple dress in the upper register and the older man's less decorated attire. Perhaps this complex composition is designed to portray the tension between the different values associated with the Hasmoneans. The ornately stylized clothing suited for royalty may perhaps indicate a change in the soldiers' status as new rulers, while the substitution of a scroll for the sword in the hands of the old man portrays him as a quintessential scholar. This implies perhaps that according to the Huqoq congregation (or the artists), the Hasmonean state was led and governed (or at the very least should have been led and governed)

75 E. Thomas, "'Houses of the Dead'? Columnar Sarcophagi as 'Micro-Architecture,'" in *Life, Death and Representation: Some New Work on Roman Sarcophagi*, ed. J. Elsner and J. Huskinson (Berlin, 2011), 387–435. There is disagreement as to whether the sarcophagus of Bishop Liberius, which today functions as the altar in the Church of St. Francis in Ravenna, indeed dates from the fourth century or whether it is a later forgery; see E. M. Schoolman, "Reassessing the Sarcophagi of Ravenna," *DOP* 67 (2013): 49–74, at 60–61.

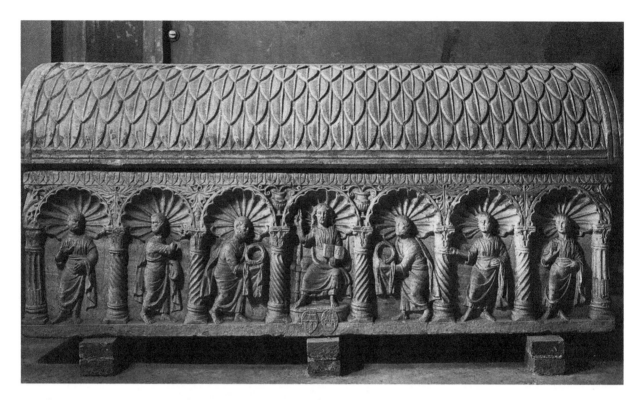

Fig. 6. Ariosti-Fontana Sarcophagus, Ferrara, Church of San Francesco. Photo courtesy of the Istituzione Biblioteca Classense di Ravenna.

by Torah scholars, not by a class of soldiers that rose to greatness.

The different images of the Hasmoneans as kings, priests, or clergy also appear in rabbinic literature. Vered Noam has recently demonstrated that the Hasmoneans' status and iconography in rabbinic literature are not homogeneous.[76] The appreciation for the Hasmoneans' military valor is quite substantial in both *Megillat Taʿanit* and other rabbinic sources, but the Hasmonean commanders are not mentioned by name. In contrast, when the rabbis dealt with the image of John Hyrcanus, they set aside the military and political motifs highlighted by Josephus, instead referring to him as "Yohanan the high priest" and "an early sage who issues regulations."[77] Of course, these are insufficient grounds for the identification of the elderly man in the mosaic as John Hyrcanus, but as I will propose in the last section, the complex and multifaceted memory of the Hasmonean dynasty in rabbinic literature is echoed in a different way in Huqoq.

76 Noam, *Shifting Images*, 202–13.

77 Noam, *Shifting Images*, 206.

Hanukkah Menorah in Huqoq?

The final element to discuss regarding the middle register is the presence of nine lit oil lamps at the crown of each of the nine arches. To the best of my knowledge, this artistic motif is unknown from the art of this period, so it may have an iconographic meaning connected with the unique motifs of the midrash. I argue, with necessary caution, that the oil lamps are related to a particular motif in the midrash, while also representing its principal theme. I tend to agree with those who link the nine lamps to Hanukkah and the Hasmoneans.[78] The use of the motifs of light and oil lamps in a Jewish mosaic is not surprising, as the menorah is an exemplar of Jewish symbolism in late antiquity. Appearing in many variations in mosaic floors, stone

78 A. Ovadiah and R. Pierri, "The Mosaic Panel with the Warlike Scenes and Figurative Arcade in the Ancient Synagogue at Huqoq: Context and Meaning," *Judaica: Beiträge zum verstehen des Judentums* 73 (2017): 284–98, at 292; Balty, "Mosaïque," 511–12; and even Britt and Boustan (*Elephant*, 78, n. 233) hint at the affinity between the oil lamps and Hanukkah.

engravings, metal medallions, and reliefs, it is almost always depicted as the seven-branched menorah.[79] The nine oil lamps, as they appear in the Huqoq mosaic, certainly recall the nine-branched Hanukkah menorah while also suggesting something else. Although lighting candles for Hanukkah was a well-established tradition in late antiquity, it was only during the Middle Ages that special candelabra were designed for this purpose.[80] It seems that in ancient times regular oil lamps were aggregated in accordance with a particular day of the eight days.[81] The nine oil lamps in the mosaic are explained by the religious laws of Hanukkah.

According to Rabbi Yohanan (a third-century Palestinian rabbi), one is forbidden to read, count, or perform any activity by the light of the Hanukkah candles (Babylonian Talmud, Shabbat 21b). Since the halakha determines that eight candles are to be lit during Hanukkah, a halakhic ordinance based on Rabbi Yohanan's words was introduced to prevent their forbidden use by directing the placement of a ninth candle adjacent to the sanctified lights, so that the Hanukkah lamps are never the only source of light in the house.[82] Thus, on the last day of Hanukkah, there would be nine candles arranged in a single construct, as depicted in Huqoq.

However, considering the bull's horn midrash, the oil lamps in the mosaic are subject to deeper interpretation. The midrash in Genesis Rabbah begins with a reference to the Greek empire, which "darkened the eyes of Israel with [its] decrees." The lamps appear at the dividing line between the upper and middle registers. Against the darkness depicted in the upper register, symbolizing the Greek kingdom and its decrees, the illuminating oil lamps in the mosaic are Hanukkah lamps, symbolizing religious victory.

To conclude, the middle register describes an additional stage in the struggle against "the Greeks." Following their victory, the soldiers' more elaborate clothing as opposed to their simple attire in the upper register indicates their having attained higher levels of authority and respect. The complex images of the Hasmoneans in late antiquity are evident in the differences between the seated figure and the standing younger men. The seated elder wearing relatively simple clothing and holding a scroll in his hand symbolizes not only an acceptance of but also the centrality of the Torah. The Hanukkah candles symbolize the commemoration of the Jewish spiritual and militaristic victory in the holiday of Hanukkah. The middle register illustrates that although the Hasmonean triumph involved military elements, it was primarily a victory of the Torah and its students.

Victory and Defeat in the Lower Register

The lower register stands in contrast to the middle register and completes the picture of the relationship between the Jews and the Hellenistic army following the conflict. It occupies approximately 17 percent of the panel, creating a distinct hierarchy, since the Jewish group in the middle register occupies twice the space as do the defeated Greeks in the register below. Visual signs of downfall are unmistakable: three javelins piercing a bull and battle gear strewn in disarray; war elephants lying lifeless on the ground; and dead soldiers with sprawled limbs and javelins wedged in their backs. Based on other examples from Byzantine art, in which the upper register depicts a leader and his unit and the lower depicts their inferior subjects, Britt and Boustan have noted that the compositions of these two registers are not unique. Indeed, they noted two examples—Theodosius's famous missorium and the Lampadii ivory diptych—that demonstrate this hierarchical relationship.[83] However, these artworks do not

79 Much has been written about the menorah and its significance. For our discussion, R. Hachlili's book *The Menorah, the Ancient Seven-Armed Candelabrum: Origin, Form, and Significance* (Leiden, 2001) is particularly important. In this monograph, Hachlili catalogues some 1,000 menorahs discovered in different contexts. The few with nine branches do not symbolize Hanukkah, but rather belong to a limited category of menorahs which have five, nine, or even more branches. Each of these anomalous menorahs results from negligent work by the artists and the differing numbers of branches has no halakhic or ritual significance (Hachlili, *Menorah*, 202).

80 S. L. Braunstein, *Five Centuries of Hanukkah Lamps from the Jewish Museum: A Catalogue Raisonné* (New Haven, CT, 2005), 14–15, and B. Yaniv, "The Influence of Halakhah and Custom on the Design of Hanukkah Lamps," in D. Sperber, *Minhagei Yisrael: Mekorot ve-Toldot*, vol. 5 (Jerusalem, 1995), 121–61. Mordechai Narkiss's study is still the most detailed research on the Hanukkah lamp (*The Hanukkah Lamp* [Jerusalem, 1939]).

81 Narkiss, *Hanukkah Lamp*, 1–2, and Yaniv, "The Influence," 122.

82 This halakha appears in the Babylonian Talmud, Shabbat 21b. Given that the Palestinian Talmud, which was composed in the Land of Israel, mentions a similar prohibition (Palestinian Talmud, Shabbat 2:1, 4c), one assumes that the solution was the same—adding a ninth candle.

83 Britt and Boustan, *Elephant*, 40.

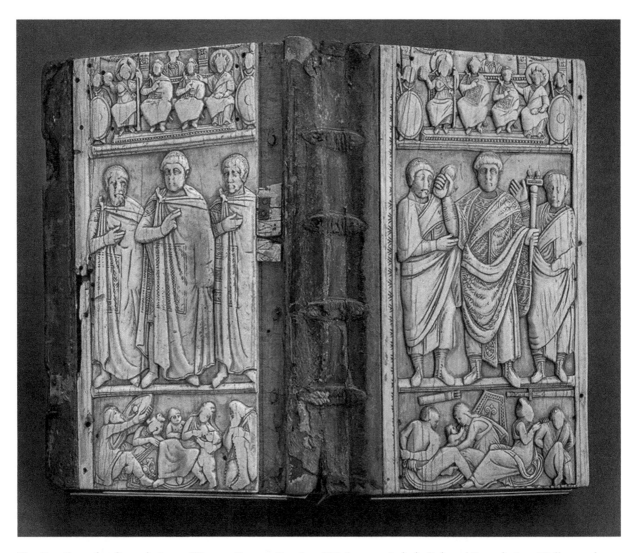

Fig. 7. Consular diptych, ivory, Western Roman Empire, 417, Saxony-Anhalt Cultural Foundation, Halberstadt cathedral treasure, inv. no. DS045. Photo by Falk Wenzel / the Kulturstiftung Sachsen-Anhalt Domschatz Halberstadt; courtesy of Wikimedia Commons.

describe defeat and victory, but rather ruler and ruled. Comparable portrayals to the composition at Huqoq can be found in two other artistic objects from the first half of the fifth century: the Halberstadt diptych and the missorium of Aspar. The Halberstadt diptych has two leaves, each divided into three registers (Fig. 7). Each middle register depicts a consul with two figures, one on either side of him. On the right leaf, the consul is dressed in a *chlamys*, a royal garment, and holds a piece of cloth, or *mappa*, in his right hand, indicating his exclusive authority, while in his left, he holds the consular staff. The lower register depicts barbarian prisoners of war, whose hands are tied behind their

backs and whose battle gear is scattered on the ground in a definitive description of military triumph. Alan Cameron identifies the consul as Constance, who served between 412 and 414, claiming in his detailed analysis that the diptych most probably depicts a military victory over an Eastern army.[84] We find a similar composition on the missorium of Aspar. A silver plate depicts Roman consul Flavius Ardabur Aspar, who served in the year 434 (Fig. 8). At the center of the plate sits Aspar on a *sella curulis* with his young son at his

84 A. Cameron, "City Personifications and Consular Diptychs," *JRS* 105 (2015): 250–87.

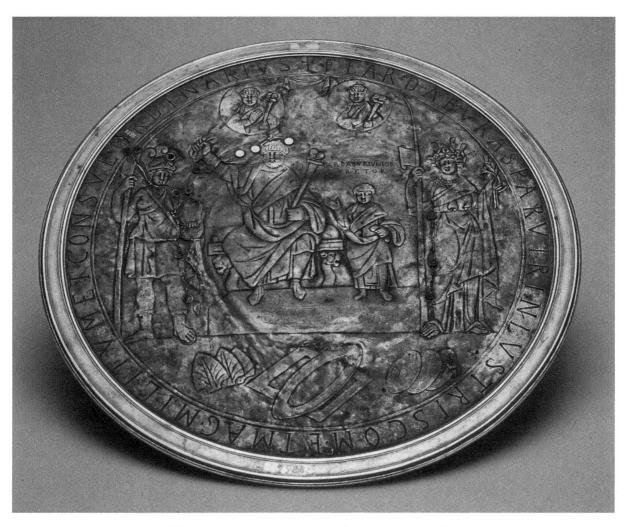

Fig. 8. Missorium of Aspar, fifth century CE. Photo courtesy of the Museo Archeologico Nazionale di Firenze, Direzione regionale Musei della Toscana.

side. A female figure stands on each side, personifications representing Roman cities, probably Rome and Constantinople. The lower register contains symbols related to Aspar's authority and deeds. On the left are three palm branches symbolizing the consular games for which he was responsible, while on the other side three round shields suggest military triumph.[85] The resemblance to Huqoq is in the double structures in both registers, which is designed to express the authority and superiority of the figures in the middle register

by way of literally (visually) casting remnants of the defeated at the feet of the victor.

Old Questions, New Questions

Any new discovery of a Jewish work of art from late antiquity enriches and can even rejuvenate the discourse on the nature of the work and the cultural identity of the individuals associated with it. There is no doubt that the rich and unique findings from Huqoq will deepen the discourse, blaze new trails, and raise new questions.

The scholarly literature usually links two key issues regarding synagogues and synagogue art: (a) who controlled the ancient synagogue—were the norms

85 C. Zaccagnino, G. Bevan, and A. Gabov, "The *Missorium* of Ardabur Aspar: New Considerations on Its Archaeological and Historical Contexts," *ArchCl* 63 (2012): 419–54, at 421–30. For historical-artistic contexts, see Cameron, "City," 275–80.

and values of rabbinic authorities dominant in the synagogues of late antiquity, or were other religious concepts and social elites represented there, and (b) what sources of inspiration underlie synagogue art—do the themes and ideas appearing in works of Jewish art reflect only biblical stories, or might they echo rabbinic literature and/or other sources?[86] Steven Fine, tending to decipher Jewish art in relation to rabbinic literature, claims that the institutional functions of the synagogue, including its liturgical practices, patrons, and builders, were committed to rabbinic norms.[87] In contrast, Lee Levine contends that the rabbis constituted a marginal group with little influence and did not rule the local congregations, positing that there is no connecting line between rabbinic literature and works of art.[88] Uzi Leibner recently argued for many cases of distinct linkages between artistic representations and rabbinic literature, contending that although one cannot conclude that rabbis influenced or dominated the synagogues, there is indeed evidence of a shared cultural fabric.[89] According to Leibner, the primary issue is the very existence of these kinds of parallels rather than their direction of influence.[90]

Where does the Huqoq mosaic fit in this framework, and how does it contribute to the ongoing discourse? Most of the studies that have dealt with the Elephant Mosaic panel have focused on iconographic decryption according to various sources. One group of scholars argues that, to date, all the mosaics and frescoes (other than Helios and zodiac) discovered in synagogues have presented only biblical scenes. Led by this argument, Ze'ev Weiss and Benjamin Gordon propose

that this scene describes Samuel's message to Saul at Gilgal, according to which God rejects Saul as king (1 Samuel 15).[91] Reading the mosaic from the bottom up, Weiss and Gordon posit the lower register as depicting the defeat of the Amalekites and the middle showing Samuel and the sons of the prophets accompanying him, while the upper register depicts Samuel and his entourage facing Saul's men outfitted as Greek soldiers. Though this interpretation raises many difficulties, suffice to say that in the Book of Samuel, neither does Saul bring a bull to his meeting with the prophet nor is there a hint of Samuel's companions. Avraham Yoskovich argues for an alternative biblical interpretation, suggesting that the mosaic portrays the assassination of Eglon, king of Moab (Judges 3:12–30),[92] by Ehud ben Gera. Indeed, in this biblical story there is no mention of youths, an army, or a bull, but Yoskovich shows that some details do appear in a rabbinic midrash and admits that many others, particularly the bull, do not.

Despite the logic in claiming that the mosaic presents a biblical story, no Bible-based story or midrash has yet been found that can convincingly explain the mosaic panel,[93] making it easily understandable why most scholars turn to post-biblical texts and contexts to explain it. The various interpretations by this group differ regarding the question of whether any ancient text (providing it offers a convincing interpretation) could be a source for the mosaic or whether these texts must have been plausibly available to or have shaped the cultural world of the Huqoq community.

Britt and Boustan, two members of Magness's research group, represent the first approach, claiming that it depicts the alliance between Antiochus VII Sidetes and the Hasmonean leader John Hyrcanus in 134 BCE.[94] Based primarily on Josephus's writing that Antiochus "sent in a magnificent sacrifice, oxen with their horns gilded" (Josephus, *Antiquities* 13:242), they read the panel upwards from the lowest register, in which the lowest depicts the military power of

86 The literature on the topic is extensive; see U. Leibner, "Rabbinic Traditions and Synagogue Art," in *Jewish Art in Its Late Antique Context*, ed. U. Leibner and C. Hezser (Tübingen, 2016), 139–54.

87 Fine, *Art*, 183.

88 L. I. Levine, "Synagogue Art and the Rabbis in Late Antiquity," *Journal of Ancient Judaism* 2.1 (2011): 79–114, and L. I. Levine, *Visual Judaism in Late Antiquity: Historical Contexts of Jewish Art* (New Haven, CT, 2012), 403–42. Even when there are connections and similarities between rabbinical texts and the artistic representations, Levine rejects it; see, for example, *Visual Judaism*, 421.

89 Leibner, "Rabbinic Traditions," 151–52.

90 Boustan has made a similar suggestion; see R. Boustan, "Afterword: Rabbinization and the Persistence of Diversity in Jewish Culture in Late Antiquity," in *Diversity and Rabbinization: Jewish Texts and Societies between 400 and 1000 CE*, ed. G. McDowell, R. Naiweld, and D. Stökl Ben Ezra (Cambridge, 2021), 427–49, at 433–34.

91 Gordon and Weiss, "Samuel."

92 Yoskovich, "Elephant."

93 Steven Fine also argues for a biblical interpretation; see S. Fine, review of *The Elephant Mosaic Panel in the Synagogue at Huqoq: Official Publication and Initial Interpretations*, by Britt and Boustan, *Images: A Journal of Jewish Art and Visual Culture* 11.1 (2018): 259–61, at 261.

94 Britt and Boustan, *Elephant*, 79–80, and Boustan and Britt, "Historical Scenes," 347–50.

John Hyrcanus and the losses of Antiochus VII Sidetes during the siege of Jerusalem, while the upper follows Antiochus acknowledging his downfall and seeking an alliance with Hyrcanus.[95] Josephus, however, tells a very different story, and still more problematic is whether Galilean Jews knew this story at all.[96]

Other scholars agree that the mosaic depicts a Hellenistic episode but were impressed by its warlike and conflicting nature. They searched the literary works of the period looking for the most suitable story. Rina Talgam proposes 3 Maccabees 1:1–2:24 as the textual background for the mosaic, claiming the panel is a rendering of the conflict between Ptolemy IV Philopator (222–204 BCE) and Simeon, the Jewish high priest.[97] Nina Braginskaya identifies the Greek leader as Antiochus Epiphanes and his opponent as Eleazar based on 1 Maccabees 6:28–47.[98] Asher Ovadiah, who

also suggested that the mosaic depicts scenes from the Maccabean Revolt, argues that the leader on the left is Mattathias Hasmonean facing the Seleucid commander who attempted to force him to offer a sacrifice to the Greek gods (1 Maccabees 2),[99] and Janine Balty identifies the Jewish figure as either Mattathias or Judah Maccabee and their opponent as Antiochus Epiphanes. Balty, however, prefers to view the mosaic as a schematic representation rather than a depiction of a particular historical scene.[100] Although the reasons for interpretations based on the Maccabean–Hellenistic conflict are easily understood, these suggestions are problematic. Despite the Jews' familiarity of the Hasmoneans and their wars in late antiquity, as well as the Jewish celebrations of their success, there is no evidence of a contemporaneous (i.e., late antique) Jewish source that indicates they were acquainted with the names of the Maccabean brothers. To the best of our knowledge, the Jews of the Land of Israel in late antiquity knew neither Josephus nor the Books of the Maccabees.[101]

It was this gap between the proposed sources and the date of the mosaic that led Adi Erlich to turn instead to rabbinic literature. Erlich suggests that the mosaic is a depiction of the friendship between Rabbi Judah the Patriarch and the Roman emperor, asserting the centrality of Rabbi Judah the Patriarch in the

95 Britt and Boustan, *Elephant*, 78–79.

96 Britt and Boustan are aware of this question. Their first publication (Britt and Boustan, *Elephant*, 75–76) claimed that Josephus's books were accessible to the societal elites who knew Greek or Latin. However, it should be noted that no Greek inscriptions have been found in the synagogue so far, and it is difficult to assess whether the people of Huqoq did indeed know Greek and whether books in Greek and Latin were accessible to any of them. In their second publication (Boustan and Britt, "Historical Scenes," 347–48), they proposed a different argument, according to which we have very little information about the ancient traditions that were known to the people of Huqoq. As evidence, they bring up the description of the prophet Jonah being swallowed up by three fish. According to them, the fact that this description is known only from later Jewish and Muslim traditions shows that in the Jewish Galilee of late antiquity, there were many traditions, of which only some found expression in midrashic literature. However, the example of Jonah may teach the opposite, that only a tradition that has gained literary expression has also received artistic expression. The fact that the tradition is in a late midrash does not, of course, indicate the time of its formation.

97 R. Talgam, "An Illustration of the Third Book of Maccabees in a Late-Antique Galilean Synagogue?," review of *The Elephant Mosaic Panel in the Synagogue at Huqoq: Official Publication and Initial Interpretations*, by Britt and Boustan, *JRA* 31 (2018): 518–23.

98 N. V. Braginskaya, "Novootkrytaya mozaika iz Khukkoka," in *Knigi Makkaveev: Perevod s Drevnegrecheskogo, vvedenie i kommentarii*, ed. N. V. Braginskaya, A. N. Koval, and A. I. Shmaina-Velikanov (Jerusalem, 2014), 543–48. Later, when the entire panel was excavated, she published a more detailed paper: N. V. Braginskaya, "Proiskhozhdenie khanukkalnoy lampy v svete noveyshikh otkrytiy v Galilee," in *Obraz i simvol v iudeyskoy, khristianskoy i musulmanskoy traditsii*, ed. U. Gershovitch and A. B. Kovelman (Moscow, 2015), 41–62. For a review of Braginskaya's publications in English, see K. Bolonnikova, "JRA's Editorial Preface," in Britt and Boustan, *Elephant*, 11–15.

99 Ovadiah and Pierri, "Mosaic," 292–93.

100 Balty, "Mosaïque." Matthew Grey, who participated in the excavation, is also of the opinion that the mosaic depicts the Hasmoneans' victory over the Greeks, but he emphasizes the martyrdom traditions (Magness et al., "Huqoq Excavation," 95). When this article was already approved for printing, another paper on the Elephant Mosaic panel was published: D. Cielontko, "The Elephant Mosaic Panel in the Huqoq Synagogue: A Reappraisal of the Maccabean Interpretation," in *Hellenism, Early Judaism, and Early Christianity: Transmission and Transformation of Ideas*, ed. R. Fialová, J. Hoblík, and P. Kitzler (Berlin, 2022), 179–204. Cielontko claims that the mosaic depicts the deeds of the martyrs described in 2 Maccabees, Eleazar the scribe (2 Maccabees 6:18–31), and the mother and her seven sons (2 Maccabees 7). This proposal is also problematic because we have no evidence that the Jews of the Land of Israel in late antiquity were familiar with 2 Maccabees (see below, n. 101). The story of the mother and her seven sons does appear in rabbinical literature, but not the story of Eleazar.

101 Jerome, the fourth-century church father, mentioned a Hebrew version of 1 Maccabees (R. Weber, ed., *Biblia sacra: Iuxta Vulgatam versionem*, part 1 [Stuttgart, 1983], 365), but he probably means that 1 Maccabees was written in Hebrew. See G. Darshan, "The Original Language of 1 Maccabees: A Reexamination," *Biblische Notizen* 182 (2019): 91–110, at 93–94.

collective memory of fifth-century Jewish Galilee, thus anchoring the mosaic in the sociocultural reality of its time. Yoskovich also highlights the importance of connecting the mosaic to sources and traditions that can be considered with certainty to have been present in the cultural world of the Huqoq community, suggesting that the mosaic presents a midrashic interpretation of the story of Ehud ben Gera.[102] Finally, the site's excavator Jodi Magness suggests that the mosaic depicts an encounter between Alexander the Great and the high priest, found in both ancient (Josephus, *Antiquities* 11:302–47) and rabbinic sources.[103] However, as many scholars have already noted, many motifs in the mosaic are inconsistent with this narrative.[104]

Each of these proposals has its own advantages and disadvantages,[105] but all assume the mosaic is a visual expression of some text. Scholars have argued that significant considerations in identifying the text underlying the mosaic are the definition of the community's cultural identity and the degree to which the text was likely to be familiar to community members. Erlich's and Yoskovich's assumption that the community was committed to rabbinic norms led to their conclusion that the mosaic depicts a rabbinic text. In contrast, for Britt and Boustan, to find support for their position they needed to argue for a significant Greco-Roman element in the cultural identity of the Huqoq community that enabled them to become acquainted with the story of Josephus. The current proposal is not without flaws. Nevertheless, one of its merits is that

it is not bound to the midrash or rabbinic attitude towards the Hasmoneans. The mosaic recognizes and uses motifs in rabbinic literature while organizing and interpreting them differently. I interpret the panel as a unique representation of the story of the Hasmoneans in dialogue with other, particularly rabbinic, concepts.

In rabbinic literature, the phrases "Hasmonean" and "Hasmonean house" appear only in the context of military confrontations with foreign forces, while the religious dimensions of the Hasmoneans merge into the figure of John the high priest. The rabbis attribute various religious regulations and even prophetic abilities to him. Scholars have striven to link "John the high priest" of the rabbis with "Hyrcanus," the military and political leader. Although this identification is well supported, it must be emphasized that the rabbinic literature does not identify John the high priest as a descendant of the Hasmonean house, and a reader would have no way of doing so.

Indeed, the Hasmonean ethos as expressed by Hasmonean propaganda was committed on the one hand to the Torah and its commandments and to political and military skills on the other,[106] although rabbinic culture held no place for such unification.[107] Noam claims that the rabbis were reluctant to portray military figures as objects for admiration or imitation and therefore attributed the military successes to a collective body called "Hasmonean house." On the other hand, due to his religious adherence, "John the high priest" was considered a worthy role model for future generations.[108]

A fairly different approach emerges from the Hanukkah piyyutim describing the historical Hasmoneans. These chronicle the religious decrees and portray the Hasmoneans as military warriors loyal to the Torah. Although the piyyutim use motifs found in rabbinic

102 Erlich, "Patriarch"; Yoskovich, "Elephant," 3, 18.

103 Babylonian Talmud, Yoma 69a; *Megillat Taanit*, Kislev 21 (Noam, *Megilat Taanit*, 100–103); Leviticus Rabbah 13:5 (Margulies, *Midrash Wayyikra Rabbah*, 1:296–94); and Pesiqta of Rab Kahana 4:9 (B. Mendelbaum, ed., *Pesiqta de Rav Kahana According to an Oxford Manuscript*, 2 vols. [New York, 1962], 1:75).

104 Magness did not publish a clear account of her interpretation of the mosaic. A comprehensive account of her ideas appears in Britt and Boustan, *Elephant*, 48–61. The highlights appeared in an announcement published on 2 July 2014 by the University of North Carolina at Chapel Hill and were published in various reports. One of the earliest reports is an article that was published in *National Geographic* (A. R. Williams, "Explore This Mysterious Mosaic—It May Portray Alexander the Great," *National Geographic*, 9 September 2016, https://www.nationalgeographic.com/history/article/mysterious-mosaic-alexander-the-great-israel). Britt and Boustan, *Elephant*, 55–61, point out the problems with this proposal.

105 A detailed critical overview of the various proposals can be found in Erlich, "Patriarch," 543–46, and Yoskovich, "Elephant," 2–5.

106 E. Regev, *The Hasmoneans: Ideology, Archaeology, Identity* (Göttingen, 2013), 266–96.

107 In contrast to the Hasmoneans, biblical figures, chief among them King David, have been described by the rabbis as both "rabbis" and military leaders. For example, King David is called in the Talmud "Adino ha-Etzni" (2 Samuel 23:8). The Talmud explains: "[T]his alludes to the fact that when David would sit and occupy himself with Torah, he would make himself soft [*me'aden*] as a worm, and when he would go out to war, he would make himself hard and strong as a tree [*etz*]" (Babylonian Talmud, Mo'ed Qatan 16b:26).

108 Noam, *Shifting Images*, 221.

literature, they do not criticize the Hasmoneans,[109] a similar attitude characterizing the Elephant Mosaic panel. The plot depicted in the mosaic is based on the tradition of the Greek demand: "write upon the horn of a bull that you have no part in the God of Israel." This tradition was interpreted differently in rabbinic literature than in the mosaic. The rabbis simply describe the religious conflict, but in Huqoq the Greek requirement is conflated in the story into a joint conflict with both military and religious aspects. To this end, the artist used the accepted artistic language of the period, dressing the Hellenistic group in military uniform, while the Jewish group was robed in tunics and pallia, like scholars and rabbis used to dress.

The innovative approach of the mosaic is more pronounced in its two lower parts. First, the two registers both emphasize the military nature of the conflict, which is not reflected in the midrash. Indeed, the rabbinic literature mentions victories of the Hasmoneans, but they are not connected to the religious conflict. Second, the Hasmonean leadership as depicted in the middle register emphasizes, in the image of the elder holding the scroll, the commitment to Torah, while also recognizing the contribution of military power and leadership, portrayed by the images of eight youths with drawn swords and in garments signifying their political authority. The mosaic delineates the participation of rural community members of Huqoq alongside the rabbis in shaping the collective memory by using ancient traditions and depicting them in contemporary artistic language.

Sha'anan College
Department of History
7 ha-Yam ha-Tikhon
Haifa
Israel

The Open University
Department of History,
	Philosophy and Judaic
	Studies
1 Derekh ha-Universita
Ra'anana, 4353701
Israel

meir.bsr@gmail.com

109 O. Münz-Manor, "The Memory of the Hasmoneans in Piyyutim from Byzantine Palestine," *Oqimta* 5 (2019): 101–24 at 118–20. The poem that describes the bull's horn decree (see above, n. 28) later describes the military victory with the words "until the hand of Hashemites prevailed" (Fleischer, *Hebrew Poetry*, 175).

✈ I WISH TO THANK PROF. MARC Z. BRETTLER, Dr. Shulamit Laderman, Prof. Sarit Shalev-Eyni, and Dr. Noa Yuval-Hacham for reading previous versions of this paper. Their invaluable questions and suggestions considerably improved the article. Nevertheless, "If indeed I have erred, my error remains with me" (Job 19:4).

The Authorship of the Early Greek Translation of the Quran (Vat. gr. 681)

The text of the Quran has been largely commented on since its composition. Hapax legomena, ellipses, and metaphors make the holy book difficult to understand, and it is partially incomprehensible without exegetical aids even for Arabic-speaking Muslims today. For this reason, quranic exegesis (*tafsīr*) and explanations of the Prophet Muḥammad's acts (*ḥadīth*), as well as lexicographical and grammatical works, rapidly gained importance after the composition of the Quran in order to ensure a canonical (i.e., "correct") reading of the holy text. Quranic translations reveal additional interpretations because they are valuable sources of sometimes very early hermeneutical understandings of the Quran.

The Byzantines were the first who fully translated the Quran into another language.[1] This Greek translation of the Quran is only fragmentarily preserved, mainly in an anti-Islamic polemic of the ninth century by Nicetas of Byzantium.[2] The quranic text in Greek preserved therein, called the *Coranus Graecus*, sometimes bears exceptional and rare interpretations of quranic terms that are not or only rarely transmitted in Muslim exegetical works. For example, the quranic technical term *furqān* in verse Q 3:4[3] was translated into Greek as σωτηρία (salvation),[4] while quranic exegesis often understands *furqān* as what "separates good from evil."[5] It is usually interpreted as one of the synonyms for the word *Qurʾān*, but in several quranic commentaries, the meaning of *furqān* is explained in the sense of *najāh* (salvation, redemption; e.g., Q 8:29).[6]

others, in the so-called *Abjuration* and in the anti-Islamic verses of Theodore the Stoudite: see below, p. 223 and nn. 19–21.

3 It is also mentioned elsewhere in the Quran at Q 2:53, 2:185, 3:4, 8:29, 8:41, 21:48, 25:1.

4 See fragment Conf. II, 3–6, here line 6. In the following, if not indicated otherwise, I am referring to Karl Förstel's edition by quoting the passage according to the author's system (see Förstel, *Niketas von Byzanz*, 1:XXV): i.e., the number of the *confutatio* (Conf.), followed by the line(s) after the comma.

5 From the root *f-r-q* (separate, divide, distinguish); see, e.g., the exegesis (*tafsīr*) in Fakhr al-Dīn al-Rāzī, *al-Tafsīr al-kabīr* (Tehran, n.d.), part 7, 161, and Ibn Kathīr, *Tafsīr al-Qurʾān al-ʿazīm* (Riyadh, 1999), part 2, 5–6; part 4, 42–43, 65–66; part 5, 347. On this point, cf. M. Ulbricht, "Die Verwendungsweise der griechischen Koranübersetzung durch Niketas von Byzanz," *Byzantion* 92 (2022): 502–5, incl. n. 57.

6 E.g., the quranic commentary (*tafsīr*) by Ibn Kathīr, *Tafsīr al-Qurʾān*, part 4, 42–43, esp. 43. See also K. Ahrens, "Christliches im Qoran: Eine Nachlese," *ZDMG* 84.3 (1930): 31–32, and U. Rubin, "On the Arabian Origins of the Qurʾān: The Case of *al-Furqān*," *Journal of Semitic Studies* 54.2 (2009): 421–33.

1 See M. Ulbricht, "Nachweis der Existenz einer vollständigen und schriftlichen Vorlage der griechischen Koranübersetzung: Eine philologische Untersuchung des Codex Vaticanus graecus 681," *JÖB* 72 (2022): 533–50.

2 Vatican City, Biblioteca Apostolica Vaticana, gr. 681 (henceforth Vat. gr. 681), fols. 1r–165v (*codex unicus*) (editions: K. Förstel, ed., *Niketas von Byzanz: Schriften zum Islam*, vol. 1, Corpus Islamo-Christianum, Series Graeca 5 [Würzburg, 2000], 1–153, and PG 105:665–806; *editio princeps*: A. Mai, ed., *Nova patrum bibliotheca*, vol. 4 [Rome, 1847], 321–408). There are also some fragments, among

DUMBARTON OAKS PAPERS | 77

221

The Greek translation reflects this meaning by interpreting *furqān* of verse Q 3:4 as σωτηρία (Conf. II, 6).[7] It is, therefore, an invaluable witness of alternative, sometimes very early hermeneutics of the quranic text itself that reflect the "pre-classical" period of Muslim quranic understanding.

Nicetas of Byzantium is the very first Byzantine to extensively refer to the Quran as a written text (ninth/tenth century).[8] Earlier Christian writers, such as Anastasius of Sinai (ca. 630–700),[9] John of Damascus (ca. 650–754),[10] Theodore Abū Qurra (ca. 740–820),[11]

and Theophanes the Confessor (ca. 760–818),[12] did indeed also refer to quranic contents in their polemics against Islam.[13] Nevertheless, they apparently did not use a quranic text in a strict sense as their source; rather, they display a more general knowledge of Islamic teachings. Nicetas, by contrast, undoubtedly had at his disposal a Greek translation of the Quran. This was not his own but is of unknown authorship.[14] The Greek original of the translation he used for refuting the Quran in his Ἀνατροπὴ τοῦ Κορανίου (*Refutation of the Quran*) must have been complete and in written form.[15] In his polemic, Nicetas extracts a significant number of quranic passages from the Greek translation and uses them for his argumentation against the Quran and the Muslim faith.[16]

These quranic fragments are preserved in the codex unicus Vat. gr. 681 of Nicetas's polemic.[17] As the quranic fragments are only indirectly handed down to us, I refer to them as the *Coranus Graecus*.[18] In addition

7 The term *furqān* is a loan word from the Syriac word *purqānā* (ܦܘܪܩܢܐ) meaning "salvation" (see F. M. Donner, "Quranic *Furqān*," *Journal of Semitic Studies* 52.2 [2007]: 279–300; A. Jeffery, *The Foreign Vocabulary of the Qurʾān* [repr. Leiden, 2007], 225–29, esp. 227–28; and *EI²*, s.v. Furḳān). The Greek rendering seems to reflect a Syrian influence of the translation, which might have been done by somebody acquainted with both Syriac and Arabic. Trilingualism was not uncommon in the *Oriens Christianus*, as the multilingual oeuvres of Theodore Abū Qurra and Ḥunayn ibn Isḥāq show us. The Greek translator was evidently aware of this, unlike some Muslim Quran commentators who devised theological explanations for the term based on an ad hoc Arabic etymology from the Arabic *faraqa* (فرق; see above, n. 5).

8 On the life, work, and context of Nicetas of Byzantium, see below, pp. 223–26. For his topics and argumentation in the *Refutation* and his perception of Islam, see M. Ulbricht, "Der Islam-Diskurs bei Niketas von Byzanz: Themen und Argumentation in seinem Hauptwerk 'Widerlegung des Korans' (Ἀνατροπὴ τοῦ Κορανίου)," *BZ* 114.3 (2021): 1351–94 (with further bibliographical references on Nicetas at n. 13), and M. Ulbricht, "Die philosophisch-dialektische Arbeitsweise und das theologische Selbstverständnis des Niketas von Byzanz: Das *Programma*, die *Apologia* und der 'Methodenteil' in seiner Islampolemik 'Widerlegung des Korans' (Ἀνατροπὴ τοῦ Κορανίου)," *BSl* 80.1–2 (2022): 30–58.

9 See A. Binggeli, "Anastasius of Sinai," in *Christian–Muslim Relations: A Bibliographical History*, vol. 1, *600–900*, ed. D. Thomas and B. Roggema (Leiden, 2009), 193–202, with further references to editions and studies. For manuscripts, see K.-H. Uthemann, *Anastasii Sinaitae Viae dux*, CCSG 8 (Turnhout, 1981), and K.-H. Uthemann, "Eine Ergänzung zur Edition von Anastasii Sinaitae 'Viae Dux': Das Verzeichnis benutzter und zitierter Handschriften," *Scriptorium* 36.1 (1982): 130–33.

10 R. F. Glei, "John of Damascus," in Thomas and Roggema, *Christian–Muslim Relations*, 1:295–301, with further references to editions and studies. For the complete list of manuscripts, see P. B. Kotter, *Die Schriften des Johannes von Damaskos*, vol. 4, *Liber de haeresibus: Opera polemica* (Berlin, 1981), 60–67.

11 J. C. Lamoreaux, "Theodore Abū Qurra," in Thomas and Roggema, *Christian–Muslim Relations*, 1:439–91, with further references to editions, studies, and manuscripts.

12 M. Vaiou, "Theophanes the Confessor," in Thomas and Roggema, *Christian–Muslim Relations*, 1:426–36, with further references to editions, studies, and manuscripts.

13 Anastasius, *Hodēgos*, 1.1.37.44–49, 7.2.117–19 (for the context, see until line 135), 10.2.8–12 (for the context, see lines 1–16), in Uthemann, *Anastasii Sinaitae*, 9, 113, 190; John of Damascus, *De haeresibus*, chapter 100, in Kotter, *Johannes von Damaskos*, 4:60–67; R. Glei and A. T. Khoury, eds., *Johannes Damaskenos und Theodor Abū Qurra: Schriften zum Islam*, Corpus Islamo-Christianum, Series Graeca 3 (Würzburg, 1995); Theophanes, *Chronographia*, PG 108:684–88 (AM 6122).

14 E. Trapp, "Gab es eine byzantinische Koranübersetzung?," *Diptycha* 2 (1980/1981): 7–17.

15 Ulbricht, "Nachweis der Existenz," and for the editions, see above, n. 2.

16 For his method of using the quranic text, see Ulbricht, "Verwendungsweise."

17 Vat. gr. 681, fols. 1r–165v (around 900); I refer to this manuscript by folio and then line numbers. Catalogues: R. Devreesse, *Codices Vaticani graeci*, vol. 3, *Codices 604–866* (Vatican City, 1950), 143–44, and A. Rigo, "Niceta Byzantios, la sua opera e il monaco Evodio," in *"In partibus Clius": Scritti in onore di Giovanni Pugliese Carratelli*, ed. G. Fiaccadori (Naples, 2006), 149–50. Editions: see above, n. 2.

18 The term *Coranus Graecus* (*CG*) is based on the overall study by the author: M. Ulbricht, "*Coranus Graecus*: Die älteste überlieferte Koranübersetzung in der 'Ἀνατροπὴ τοῦ Κορανίου' des Niketas von Byzanz; Einleitung–Text–Übersetzung–Kommentar," 3 vols. (PhD diss., Freie Universität Berlin, 2015). *CG* is a retrospective designation and comprises the various textual witnesses of quranic fragments as we find them in Nicetas's work *Refutation of the Quran*. Thus, the *CG* has to be distinguished from the original Greek translation of the Quran, whose exact form and wording we do not know anymore. The Latin

to Nicetas's, other documents independently preserving quranic fragments in Greek include the so-called *Abjuration*[19] and some anti-Islamic verses by Theodore the Stoudite.[20] But the latter consists only of some seventy-seven verses,[21] while the former formula of the Orthodox Church (to be read by proselytes during the rite of rejection of the Muslim faith in order to become Christian) similarly preserves a very small number of fragments;[22] additionally, its manuscript tradition goes back only to the thirteenth/fourteenth century CE. Since the other Byzantine polemics by Evodius the Monk,[23] Euthymius Zigabenus,[24] and Nicetas Choniates,[25] which make use of quranic quotations, exclusively depend on Nicetas of Byzantium's work, Nicetas should be considered the main source for reconstructing the Greek translation of the Quran.[26]

In this article, I will examine some of the fragments of the *Coranus Graecus* in terms of their philological rendering into Greek and compare them synoptically with the Arabic quranic readings. Through this analysis, I will elaborate on the early Christian understanding of the quranic text as documented in the *Coranus Graecus*. I will therefore focus on quranic verses that are theologically relevant to Christian–Muslim interfaith dialogue. In the final part, I will present my conclusions about the cultural and religious background of the translator(s) of the Greek translation of the Quran based on philological analysis and its interpretation. But first, I will give an overview about the life and work of Nicetas of Byzantium as well as the historical-intellectual context in which he flourished.

Nicetas of Byzantium: His Life, Writings, and Historical-Intellectual Context

Information about the life of Nicetas of Byzantium is scarce.[27] Given his epithet, *byzantios* (βυζάντιος), Nicetas might originally be from the city of Constantinople. Further concrete biographical details can be reconstructed exclusively from his own works. We know that Nicetas lived in the shadow of the empire of Michael III (r. 842–867), son of Theophilus, until the reign of Leo VI the Wise (r. 886–912).[28] This means that he was a contemporary of the patriarch of Constantinople, Photius (793–810, r. 858–867, 877–886 CE). Nicetas might have been a monk,[29] and it is clear from his writings that he had deep knowledge of Orthodox theology and dogmatics. His erudite language and scholarly way of writing indicate his profound education, while his

terminology *Coranus Graecus* is intended to express the hypothetical nature of the version of this translation as preserved today.

19 Editions: E. Montet, "Un rituel d'abjuration des Musulmans dans l'église grecque," *RHR* 53 (1906): 145–63 (partial edition containing only the anathemas); PG 140:124–36; and F. Sylburg, *Saracenica siue Moamethica* [...] (Heidelberg, 1595), 74–91. A critical edition of the *Abjuration* is still a desideratum. Studies: A. Rigo, "Ritual of Abjuration," in Thomas and Roggema, *Christian–Muslim Relations*, 1:821–24; D. M. Freidenreich, "Muslims in Canon Law, 650–1000," in Thomas and Roggema, *Christian–Muslim Relations*, 1:95–96; and P. Eleuteri and A. Rigo, *Eretici, dissidenti, musulmani ed ebrei a Bisanzio: Una raccolta eresiologica del XII secolo* (Venice, 1993), 53–59.

20 A. Rigo, "La sezione sui musulmani dell'opera di Teodoro Studita contro le eresie," *REB* 56 (1998): 213–30.

21 Athos, Great Lavra, ms. Ω 44 (1854), fols. 149v–151r (cf. Rigo, "Ritual of Abjuration," 821–24, esp. 823).

22 Trapp, "Koranübersetzung?," 14–17.

23 Madrid, El Escorial, ms. gr. Υ.III.8 (463), fols. 232r–242r (thirteenth century), and Athos, Great Lavra, ms. Ω 44 (1854), fols. 113r–120v, 123r–128v, 129r–149v (seventeenth century).

24 Euthymius Zigabenus, *Πανοπλία δογματική* (*Armor of Doctrines*), chap. 28 (editions: K. Förstel, *Arethas und Euthymios Zigabenos: Schriften zum Islam. Fragmente der griechischen Koranübersetzung*, Corpus Islamo-Christianum, Series Graeca 7 [Wiesbaden, 2009], 43–83, and PG 130:1331–60).

25 Nicetas Choniates, *Thesaurus orthodoxae fidei*, book 20 (edition: PG 140:105–22).

26 For an overview of the importance of Nicetas's work for much of the later history of Byzantine polemics against Islam, see Ulbricht, "Islam-Diskurs," 1351–94, esp. 1352–53, and for possible traces even in twentieth-century anti-Islamic writings, 1388–94.

27 Summarized in A. Rigo, "Nicetas of Byzantium," in Thomas and Roggema, *Christian–Muslim Relations*, 1:751–56, and Förstel, *Niketas von Byzanz*, 1:IX.

28 J. Hergenröther, *Monumenta graeca ad Photium ejusque historiam pertinentia* (Regensburg, 1869), 84: Ἦν δὲ οὗτος ὁ συγγραφεὺς Βυζάντιος ἐπὶ τῶν χρόνων τοῦ βασιλέως Μιχαὴλ υἱοῦ Θεοφίλου διαρκέσας μέχρι καὶ τῆς βασιλείας αὐτῆς τοῦ βασιλέως κυρίου Λέοντος τοῦ σοφοῦ (And the author was Byzantine [i.e., from the city of Constantinople], in the years of the emperor Michael, son of Theophilus, up to the reign of the emperor lord [*kyrios*] Leo the Wise). See also Förstel, *Niketas von Byzanz*, 1:156, line 5, 176, line 3 (cf. 1:IX).

29 This suggestion is based on Nicetas's statement: Τί γὰρ πλέον τοῦ ὑπὲρ ἐντολῆς Θεοῦ κόσμον μισῆσαι καὶ σῶμα, ἔτι δὲ καὶ τὴν ἑαυτοῦ ψυχὴν ἀριδήλως πρὸς τὰ ὑπερφυῆ μεταθεῖναι (Conf. I, 232–34). Therein, Nicetas rhetorically wonders what would be better than to "hate the world and body" in order to "form the own soul toward the supernatural"; cf. M. Ulbricht, "At-Tarğamah al-ūlā li-l-Qurʾān al-karīm min al-qarn 8/9 al-mīlādī fī siğāl Nikītās al-Bīzanṭī (al-qarn 9 al-mīlādī) maʿa l-Islām bi-smi ›Tafnīd al-Qurʾān‹," *Chronos: Revue d'histoire de l'Université de Balamand* 25 (2012): 33–58, at 37.

strict, logical way of argumentation suggests that he was trained in philosophy and dialectics.[30] Considering that he is referred to as φιλόσοφος, διδάσκαλος, and πατρίκιος (philosopher, teacher, patrikios) in the titles of his writings,[31] we can infer that he was teaching and may have occupied a high administrative and social position in the imperial capital in the ninth century.[32]

Nicetas's text corpus comprises a total of five writings: a treatise against the Latin *filioque*,[33] a letter to the Armenian emir against miaphysite Christology,[34] and three writings against Muslims. The latter are two letters in response to a Muslim emir[35] and Nicetas's magnum opus, the Ἀνατροπὴ τοῦ Κορανίου (*Refutation of the Quran*).[36] It might not be accidental that Nicetas's treatise against the Latins' *filioque* (866–870)[37] has obvious parallels with Photius's *Epistle* 2.[38] In addition, it is remarkable that Nicetas was commissioned to redact the letter against Armenian miaphysitism (around 877/78) "instead of the Patriarch."[39] While the latter's

identity is not specified, it seems that this was Patriarch Photius himself, as the life and working period of both coincide. Additionally, we find many congruences between Nicetas's letter against the Miaphysites and Photius's *Epistle* 298.[40] Furthermore, Nicetas's two letters to a Muslim ruler were commissioned by Emperor Michael III[41] and his *Refutation of the Quran* has a clear official character.[42] All this suggests that Nicetas had good connections to the empire's court and that he was surely part of the inner ecclesiastical-political elite of Byzantium, perhaps one of the patriarchate's clerics in the capital.

Looking to the chronology of his works,[43] we notice a certain development over time. On the one hand, Nicetas is generally dealing with heterodoxies, represented by his letters against the Latins and the Miaphysites. These works were written in the shadow of the outstanding theological and political personality of Photius,[44] so we can perhaps suggest that Nicetas may have been in collaboration with him. On the other, with Nicetas's engagement with Islam, we do see a clear, genuine independence in his works. Beyond that, he seems to have grown into the role of an "Islam expert" over the years: while his first two letters to a Muslim ruler deal with Islamic teachings in a very general manner, his *Refutation of the Quran* constitutes a much more detailed and text-immanent engagement with Islam, and is also the longest of his oeuvre. It is probably his final anti-Islamic work, dating to sometime after 856–63.[45]

For some centuries, the fragments of the *Coranus Graecus* seem to have been the only source providing direct access in Greek to the Quran in written form. They had a long reception in later Byzantine sources, thus enduringly shaping the Byzantine-Greek hermeneutics of the Quran. Besides Nicetas of Byzantium's

30 See Förstel, *Niketas von Byzanz*, 1:IX.

31 Hergenröther, *Monumenta graeca*, 84: Νικήτα Βυζαντίου πατρικίου καὶ φιλοσόφου καὶ διδασκάλου κεφάλαια συλλογιστικά (The syllogistic chapters of Nicetas Byzantius the patrikios, philosopher, and teacher); and Förstel, *Niketas von Byzanz*, 1:2, line 1: Νικήτα Βυζαντίου φιλοσόφου πρόγραμμα [. . .] (Foreword of the philosopher Nicetas Byzantius's [. . .]). For the meaning of the title patrikios, see A. P. Kazhdan, "Patrikios," *ODB* 3:1600.

32 For possible interrelations between Nicetas of Byzantium and Patriarch Photius, see Ulbricht, "Islam-Diskurs," 1351–94, 1354–56.

33 Hergenröther, *Monumenta graeca*, 84–138. For the dating, see Förstel, *Niketas von Byzanz*, 1:X–XI; for an evaluative overview of this work, see P. Gemeinhardt, *Die Filioque-Kontroverse zwischen Ost- und Westkirche im Frühmittelalter*, Arbeiten zur Kirchengeschichte 82 (Berlin, 2002), 302–6.

34 L. Allatius, *Graecia orthodoxa* (Rome, 1652), 663–754, and PG 105:587–666. For the dating, see Förstel, *Niketas von Byzanz*, 1:X.

35 Förstel, *Niketas von Byzanz*, 1:155–99; PG 105:807–42; and Mai, *Nova patrum bibliotheca*, 4:409–31.

36 See above, n. 2. For an overview of this work, see Ulbricht, "Arbeitsweise," and Ulbricht, "Islam-Diskurs."

37 For an overview, see Förstel, *Niketas von Byzanz*, 1:XIX–XXII.

38 B. Laourdas and L. G. Westerink, eds., *Photii Patriarchae Constantinopolitanae: Epistulae et Amphilochia*, vol. 1, *Epistularum pars prima* (Stuttgart, 1983), 39–53. Cf. Förstel, *Niketas von Byzanz*, 1:XX, n. 69.

39 Ἐξ ἐπιτροπῆς τοῦ φιλοχρίστου καὶ εὐσεβεστάτου βασιλέως ἡμῶν. Ἐγράφη δέ πρὸς τὸν ἄρχοντα ἐκ προσώπου τοῦ Πατριάρχου (With the guardianship of our Christ-loving and most pious emperor, it was written to the ruler by a representative of the Patriarch) (PG 105:587–88; cf. Förstel, *Niketas von Byzanz*, 1:XI).

40 See Förstel, *Niketas von Byzanz*, 1:XXII–XXIV.

41 Förstel, *Niketas von Byzanz*, 1:156, line 5, 1:176, line 3.

42 Ulbricht, "Arbeitsweise," 37–40.

43 See the up-to-date discussion in J. M. Demetriades, "Nicetas of Byzantium and His Encounter with Islam: A Study of the 'Anatropē' and the Two 'Epistles' to Islam" (PhD diss., The Hartford Seminary Foundation, 1972), 1–18. See also Förstel, *Niketas von Byzanz*, 1:IX–X.

44 Concerning the works of Photius, see Laourdas and Westerink, *Photii Patriarchae Constantinopolitanae*.

45 A. T. Khoury, *Les théologiens byzantins et l'Islam: Textes et auteurs (VIIIᵉ–XIIIᵉ s.)* (Louvain, 1969), 111, 117–18, and Förstel, *Niketas von Byzanz*, 1:IX–XI.

Refutation, the *Abjuration* and Theodore the Stoudite's anti-Islamic verses are sources that independently transmit material of the *Coranus Graecus*.[46] The former short work belongs to the genre of canonical texts of the Orthodox Church and was used for official purpose for the act (*taxis*) of renouncing Islam and embracing Christianity. The *Abjuration* condenses the main anti-Islamic points perceived by Byzantine Christians. Within its anathemas of Islamic teachings and beliefs,[47] the *Abjuration* contains some material from the Greek translation of the Quran.[48] The *Abjuration* is transmitted, in contrast to Nicetas of Byzantium's polemic, in a large number of manuscripts.[49] This points to its intense liturgical use over centuries. Evodius the Monk, probably a monk in Constantinople in the ninth century in the monastery of Joseph the Hymnographer,[50] seemingly relied on Nicetas's *Refutation* for two of his works: the hagiographic report on *The Martyrdom of the Forty-Two Martyrs of Christ of Amorion* (after 855/56, or between the ninth and tenth centuries)[51] and his anti-Islamic *Chapters from the Forged Book of the Unbelieving Muḥammad and of Destitution* (last quarter of the ninth century),[52] both of which contain some fragments of the Greek translation of the Quran (the former only occasionally). In addition, Evodius's *Chapters* sum up the structure and argumentation of

Nicetas's work in a more approachable way.[53] Later Byzantine polemicists apparently relied on Evodius's work. He therefore played an important role in the transmission of Nicetas's anti-Islamic thoughts and the fragments of the translation of the Quran. For example, Euthymius Zigabenus's *Armor of Doctrines*[54] (tenth/eleventh century) is based on Evodius's *Chapters*.[55] Thus reproducing Nicetas's anti-Islamic argumentation, Euthymius also integrates a significant number of fragments of the *Coranus Graecus* into his work. The interesting point here is that Euthymius emends the rather colloquial Greek of the quranic fragments into a more classical style by polishing its language.[56] Nicetas Choniates (ca. 1155–1217) is the last important witness of Nicetas of Byzantium's *Refutation*, thereby preserving fragments of the *Coranus Graecus*.[57] His polemical work, called *Thesaurus orthodoxae fidei*, is an anti-heretical composition based on older sources. The first paragraphs of the anti-Islamic book twenty[58] consist of a literal rewriting of John of Damascus's *De haeresibus* (chap. 100) and a reuse of George Monachus's *Chronikon* (chapter nine) and Euthymius Zigabenus's *Armor of Doctrines* (chapter ten to the beginning of chapter thirteen).[59] In the latter parts, we find, among others, a rewriting of quranic fragments preserved in Nicetas of Byzantium's work.

The *Refutation of the Quran* starts with the introduction, the so-called *Programma*, which highlights the symbiosis between state power and ecclesiastical

46 See above, pp. 222–23, incl. nn. 19–22.

47 Montet, "Un rituel d'abjuration."

48 The quranic quotations and paraphrases deal with the refutation of the prophet Muḥammad and a number of other Muslim personages; the conception of quranic paradise; Islamic teachings and laws, such as the pilgrimage and its rites; and the image of God within the Quran.

49 For a provisional overview, see Eleuteri and Rigo, *Eretici, dissidenti, musulmani ed ebrei*, 19–36; see also Rigo, "Ritual of Abjuration," 823.

50 See R.-L. Lilie, C. Ludwig, B. Zielke, and T. Pratsch, *Prosopographie der mittelbyzantinischen Zeit Online*, no. 1682, https://db.degruyter.com/view/PMBZ/PMBZ12786?rskey=N7inxV&result=1&dbq_o=1682&dbf_o=pmbz-code-number&dbt_o=keynumber&o_o=AND, and A. Kolia-Dermitzaki, "Euodius the Monk," in Thomas and Roggema, *Christian–Muslim Relations*, 1:844–47. For the several manuscripts, as well as editions and translations of Evodius, see Kolia-Dermitzaki, "Euodius the Monk," 1:846–47, and A. Rigo, "Euodius the Monk," in Thomas and Roggema, *Christian–Muslim Relations*, 1:848.

51 Kolia-Dermitzaki, "Euodius the Monk," 1:845–47.

52 Rigo, "Euodius the Monk," 1:848.

53 E. Trapp, ed., *Manuel II. Palaiologos, Dialoge mit einem "Perser"* (Vienna, 1966), 27, and Rigo, "Euodius the Monk," 1:848.

54 Förstel, *Arethas und Euthymios Zigabenos*, 43–83; PG 130:1331–60; and Gerhard Podskalsky, "Euthymios Zigabenos (Zigadenos, 11./12. Jh.)," *Theologische Realenzyklopädie (TRE) Online*, 2010, https://db.degruyter.com/view/TRE/TRE.10_557_13?pi=0&moduleId=common-word-wheel&dbJumpTo=euthymios.

55 This is apart from whole passages copied from John of Damascus, *De haeresibus*, chap. 100. See Trapp, *Manuel II. Palaiologos*, 20*–21*, and Rigo, "Niceta Byzantios," 163–64; cf. J. Darrouzès, "Bulletin critique," *REB* 22 (1964): 255–86, at 282.

56 Trapp, "Koranübersetzung?," 14.

57 N. Zorzi, "Nicetas Choniates," in *Christian–Muslim Relations: A Bibliographical History*, vol. 4, *1200–1350*, ed. D. Thomas and A. Mallett (Leiden, 2012), 132–44, at 135.

58 PG 140:124–36.

59 Khoury, *Les théologiens byzantins et l'Islam*, 249–58, and Trapp, *Manuel II. Palaiologos*, 22*. See also Zorzi, "Nicetas Choniates," 140–41.

hierarchy in fighting against Islam.[60] After the table of contents, the *Argumentum*, Nicetas explains the Orthodox faith in an apologetic part.[61] The polemic as such is divided into two sections: In *Confutationes* I–XVIII, Nicetas refutes quranic sayings that he quotes literally or freely, or paraphrases or alludes to,[62] while *Confutationes* XIX–XXX are dedicated to different Islamic teachings that Nicetas argues against.[63]

Nicetas's polemic is especially important because it preserves a significant number of quranic verses and narrations from several quranic suras in Greek. The single manuscript that preserves the *Refutation of the Quran* is dated to around 900 CE.[64] The translation itself, which is fragmentarily embedded in Nicetas's polemic, seems to be the oldest complete translation of the Quran ever, dating back to the ninth century CE (second/third century *hijrī*) or potentially even before. This is extraordinarily close to the time of the composition of the quranic text and dates even prior to Ibn Mujāhid's (859–935/36) canonization of the seven readings (sing.: *qirāʾa*; pl.: *qirāʾāt*) in 934.[65] The *Coranus Graecus* is, therefore, an important source for early hermeneutics of the Quran.

Methodology

In order to evaluate differences between the *Coranus Graecus* and the Arabic text of the Quran, we first have to distinguish the different textual layers within the *Refutation of the Quran*. The first step is to extract from Nicetas's text those passages that are not his own polemic but reveal quranic material. The second step is to distinguish between the different philological approaches of his excerpts of quranic contents, which range from verbatim and free quotations to paraphrases and simple allusions.[66] In the present article, I only rely on the first of the four philological categories: those passages of the *Coranus Graecus* that are characterized as verbatim or literal quotations.[67] These passages are relatively easy to detect within the overall corpus of Nicetas's work, as they follow a word-by-word technique regarding their translation from Arabic into Greek.[68] In the following, I will give a short characterization of the philological category of literal quotations before explaining in the next section why Nicetas's transmission of literal quotations is a reliable basis for further philological analysis.

The translation is a very precise work that in most cases translates the Quran into Greek literally and stays very close to the Arabic text both in terms of syntax and semantics.[69] The translation was made in such a way that it is sometimes difficult to understand the Greek version without the Arabic text beside it because the Arabic is usually translated word for word into Greek without always adapting it to Greek grammar.[70] For example, one characteristic of the translation is that it often uses prepositions in Greek that are literal translations of the

60 Förstel, *Niketas von Byzanz*, 1:30, and Ulbricht, "Arbeitsweise," 37–40.

61 Förstel, *Niketas von Byzanz*, 1:6–39. For the exact interrelations between the *Apology* and the respective passages from Nicetas's two epistles, see Förstel, *Niketas von Byzanz*, 1:XI–XV. See also Förstel, *Niketas von Byzanz*, 1:XXV, and Ulbricht, "Arbeitsweise," 33–34.

62 Förstel, *Niketas von Byzanz*, 1:XXX. For how Nicetas uses this quranic material in his polemic, see Ulbricht, "Verwendungsweise." For the classification into the four so-called philological categories (verbatim quotations, free quotations, paraphrases, and allusions), see M. Ulbricht, "Die Klassifizierung in 'Philologische Kategorien' der im *Coranus Graecus* überlieferten Koranfragmente: Eine Einteilung in *Wörtliches Zitat, Freies Zitat, Paraphrase* und *Anspielung*," *De Medio Aevo* 12.1 (2023): 125–45.

63 For an overview of the structure and content of the *Refutation of the Quran*, see Ulbricht, "Arbeitsweise," 32–37. For an analysis of the introductory parts of the polemic (i.e., the so-called *Programma*, the *Apology of the Christian Faith*, and the *Explanation of His Methodological Approach*), see Ulbricht, "Arbeitsweise," 37–40, 41–48, 48–55, respectively.

64 Vat. gr. 681; see Devreesse, *Codices Vaticani graeci*, 3:143–44, and Rigo, "Niceta Byzantios," 149–50.

65 See below, n. 96.

66 For the classification into the so-called philological categories, see Ulbricht, "Klassifizierung."

67 For text editions of the literal quotations, see Förstel, *Arethas und Euthymios Zigabenos*, and C. Høgel, "An Early Anonymous Greek Translation of the Qurʾān: The Fragments from Niketas Byzantios' *Refutatio* and the Anonymous *Abjuratio*," *Collectanea Christiana Orientalia* 7 (2010): 65–119; cf. Trapp, "Koranübersetzung?"

68 See, for example, the Greek fragments in comparison with the Arabic Quran: Conf. I, 93 = Q 2:223; Conf. I, 301–2 = Q 2:125–27; Conf. I, 328–30 = Q 2:168; Conf. I, 362–65 = Q 2:230; Conf. I, 376–77 = Q 2:256; Conf. IV, 45–47 = Q 5:51; Conf. VI, 36 = Q 7:158; Conf. XII, 22–23 = Q 13:30; Conf. XII, 38–40 = Q 13:43; Conf. XIII, 11–12 = Q 14:50; Conf. XVIII, 20–26 = Q 37:1–9; Conf. XVIII, 38–45 = Q 53:1–14; Conf. XVIII, 70–72 = Q 68:1–4; Conf. XVIII, 79–80 = Q 75:1–2; Conf. XVIII, 81 = Q 77; and Conf. XVIII, 85–87 = Q 79:1–6. See also Høgel, "Early Anonymous Greek Translation," 69.

69 Cf. Høgel, "Early Anonymous Greek Translation," 68–72.

70 Cf. K. Versteegh, "Greek Translations of the Qurʾān in Christian Polemics (9th Century A.D.)," *ZDMG* 141 (1991): 64–65.

respective Arabic prepositions, although they do not match the Greek verb they are referring to. So a number of Arabic verbs in combination with the *ḥarf jarr* (preposition) *'alā* is literally translated into Greek as ἐπάνω (upon), despite the fact that the corresponding Greek verb may be constructed with another preposition.[71] One also notes some tendencies to translate certain Arabic grammatical constructions more or less in the same way in Greek.[72] Also noteworthy is that the

translator(s) had a sense for translating the same Arabic word differently correspondent with its respective quranic context. For example, the letter *wāw* is translated as μά when it is grammatically a *ḥarf qasam* (adjuration particle) in Arabic and as a simple conjunction καί in the immediately following verses.[73]

Once we detect the literal quotations of quranic fragments within Nicetas's polemic, we then must discuss the extent to which the text of the *Coranus Graecus*, i.e., the version given by Nicetas in his work, also depicts the wording of the original Greek translation of the Quran and is, thus, reliable for further philological and comparative studies. It seems that once Nicetas quotes the translation of the Quran, he just copies the text without modifying the actual wording.[74] The only modification he apparently does within the literal quotations of the translation is distortion by omission:[75] in several quotations, Nicetas omits textual passages ranging from whole verses to just a single word. This is, in a narrow sense, not a real modification of the text as such, but it may imply a modification of its meaning. We can infer this from passages where the text of the *Coranus Graecus* does not make any syntactical sense anymore in the way that Nicetas integrated it into his work. For example, the translation of verse

71 M. Ulbricht, "Graeco-Arabica am Beispiel der ältesten Koranübersetzung: Die Übersetzungstechnik im *Coranus Graecus* samt Glossar und Konkordanz der wörtlichen Koranzitate (griechisch-arabisch, arabisch–griechisch)" (printed version of vol. 3 of PhD diss., Freie Universität Berlin, 2015; see above, n. 18), 90–92. See, for example, ἐπάνω: ἔχθρανεν ~ ὑμῶν (Conf. I, 357 = Q 2:194), τοῦ κατενέγκαι ~ αὐτῶν γραφὴν (Conf. III, 54 = Q 4:153), ἐκωλύσαμεν ~ αὐτῶν ἄπερ {ἐξὸν} αὐτοῖς {ἦσαν} (Conf. III, 70 = Q 4:160), τοῦ ἐντυγχάνειν ~ αὐτῶν τὰ δηλοποιηθέντα πρὸς σέ (Conf. XII, 23 = Q 13:30), τοῦ βλασφημεῖν ~ τοῦ θεοῦ ψεῦσμα (Conf. XV, 11 = Q 16:116), ἐδικαιώθη ~ αὐτοῦ λόγος (Conf. XVI, 21 = Q 17:16), ~ τοῦ πράγματος αὐτῶν (Conf. XVII, 16 = Q 18:21), ἀκουμβίζοντες ἐν αὐτῷ ~ ἀνακλητορίων (Conf. XVII, 25 = Q 18:31), διηγούμεθα ~ σου τὴν ἐξήγησιν ἐν ἀληθείᾳ (Conf. XVII, 32 = Q 18:13), ἀδικώτερος τοῦ βλασφημοῦντος ~ τοῦ θεοῦ ψεῦσμα (Conf. XVIII, 60 = Q 61:7), {εἶσαι} ~ πλάσματος μεγάλου (Conf. XVIII, 72 = Q 68:4), πᾶσα ψυχὴ τῶν ὄντων ~ αὐτῆς {φύλαξ} (Conf. XVIII, 93 = Q 86:4), and τοῦ δεσπόζειν αὐτὸν ~ πάσης πίστεως (Conf. XVIII, 95, 97 = Q 9:33); cf. Høgel, "Early Anonymous Greek Translation," 70–71.

72 For example, the translation equates the Arabic *an al-maṣdariyya* (i.e., the conjunction *an* in the syntactical function of the verbal noun [*maṣdar*]) with the Greek infinitive form of the verb, which is the corresponding form for the Arabic *maṣdar*; in order to express the final aspect of an action, it is placed in the genitive case in Greek. See, for example, sura Q 3:64 (Āl 'Imrān): *ta 'ālaw ilā kalimatin sawā'in baynanā wa-baynakum allā na 'buda illā llāha wa-lā nushrika bihī shay'an* – δεῦτε εἰς τὸν λόγον τὸν στοιχοῦντα μέσα ἡμῶν καὶ ὑμῶν, τοῦ μὴ δουλεύειν εἰ μὴ τὸν Θεόν καὶ τοῦ μὴ θεῖναι αὐτῷ κοινωνὸν τίποτε (join together in the word that is in agreement among us and you, that we shall worship none but God and that we shall not make anything like him) (Conf. II, 67–69). The Greek also sometimes uses the *genitivus absolutus* for the status clause *ḥāl* (static accusative) in Arabic: e.g., ὑμῶν συχναζόντων (while you are gathered) (Conf. I, 349 = cf. Q 2:187), ἀμφιβάλλοντος δὲ αὐτοῦ (while he was doubting) (Conf. II, 20–21 = cf. Q 3:40), σοῦ μὴ ὄντος ἐκεῖσε (while you were not there) (Conf. II, 26 = cf. Q 3:44), καὶ σοῦ ὄντος ἐν ταύτῃ τῇ χώρᾳ (and while you are in that country) (Conf. XVIII = cf. Q 90:2), and τῆς αὐτοῦ γυναικὸς ὑποκαιούσης κάμινον (while his wife was setting the fire alight) (Conf. XVIII, 144 = cf. Q 111:4); see also an example in this context from sura Q 2:187 (al-Baqara): *thumma atimmū l-ṣiyāma ilā l-layli wa-lā tubāshirūhunna wa-antum 'ākifūna fī l-masājidi tilka ḥudūdu llāhi fa-lā taqrabūhā ka-dhālika yubayyinu llāhu āyātihī li-l-nāsi la 'allahum yattaqūna* – Καὶ πάλιν πληρώσατε τὴν νηστείαν ἕως τῆς ἑσπέρας καὶ <μὴ> μίχθητε αὐταῖς ὑμῶν συχναζόντων ἐν τῷ προσκυνητηρίῳ· αὕτη ἐστὶν νομοθεσία Θεοῦ καὶ μὴ ἐγγίσητε αὐτάς (And fulfill again

the fast until evening. And do not have intercourse with them while gathered in the prayerhouse. This is the commandment of God, and do not come near them) (Conf. I, 348–50). Note: There is a significant difference between the Arabic quranic text and the Greek translation as transmitted in Vat. gr. 681: the elimination of the negating *lā* in the translation of *lā tubāshirūhunna* reverses the meaning exactly (see Ulbricht, "Verwendungsweise," 500). Förstel adds in his edition the Greek negation μή, in καὶ <μὴ> μίχθητε αὐταῖς (Conf. I, 349). The English translations of the quranic verses are based on Høgel, "Early Anonymous Greek Translation," if there are any; if not, translations are my own.

73 For example, sura Q 52:1–4 (al-Ṭūr): *wa-l-ṭūri, wa-kitābin masṭūrin, fī raqqin manshūrin, wa-l-bayti l-ma 'mūri* – Μὰ τὸ ὄρος καὶ γραφὴν στιχιζομένην ἐν μεμβράνῳ λιτῷ καὶ τὸ ὀσπίτιν τὸ ᾠκονομημένον (By the mountain and by the writing that is given in lines on simple parchment) (Conf. XVIII, 33–35); the diplomatic transcription of the Vat. gr. 681, fol. 124r, 12–14, is: μὰ τὸ ὄρος· καὶ γραφὴν στιχιζομένην ἐν βεμβράνωι λιτῶι· καὶ τὸ ὀσπίτιν τὸ ᾠκοδομημενον·. For some aspects mentioned in this paragraph, see also the introduction of Høgel, "Early Anonymous Greek Translation," 68–72.

74 For the evidence, see Ulbricht, "Verwendungsweise," 507–8, passim. See also Høgel, "Early Anonymous Greek Translation," 69–70.

75 For a detailed study on this, see Ulbricht, "Verwendungsweise," 497–505.

Q 4:161 says in the *Coranus Graecus*: Διὰ τὴν ἀδικίαν τῶν Ἰουδαϊσάντων ἐκωλύσαμεν ἐπάνω αὐτῶν, ἅπερ ἐξὸν αὐτοῖς ἦσαν, καὶ ἡτοιμάσαμεν ἐξ αὐτῶν κόλασιν σφοδρὰν καὶ διὰ τὸ φονεῦσαι αὐτοὺς τοὺς προφήτας ἄνευ δικαίου.[76] The question here is what ἐξ αὐτῶν (from them) refers to, as it does not make any sense syntactically. But if we compare the wording of the Greek text with the Arabic Quran, we see that it renders the Arabic *minhum* (from them), which refers to *li-l-kāfirīna* (for the unbelievers) before it. As the translation has clear characteristics of a word-by-word translation, we may suppose that the syntagma *li-l-kāfirīna* had also been present in the original Greek translation, but Nicetas omitted it when quoting this verse.[77]

This makes sense in this specific context because the ἐξ in ἐξ αὐτῶν (from them) depends on the restrictive syntagma *li-l-kāfirīna* (for the unbelievers). The sentence is syntactically illogical in Greek without that syntagma. The Greek translation of the Quran tends to reproduce syntactical constructions literally and so ought to have included this passage in its entirety as well. The omission of it, however, complements Nicetas's polemical purposes, as it now appears that punishment is delivered to everyone without restriction, that is, not only "for the unbelievers." One increasingly finds these kinds of omissions in connection with terms positively connoted for Islam[78] or when the Quran formulates a certain claim to universality as "a scripture for the whole of humanity."[79] As this regularly occurs in relation to soteriological-theological debates concerning the "right" faith, we may postulate that this pattern of omissions was made by Nicetas in order to strengthen his polemical argumentation against the Quran by leaving out positive connotations of the Quran.

Another example is the discussion on the quranic hapax legomenon *al-ṣamad*.[80] Nicetas discusses the term in the introductory part of his work and refers to it as ὁλόσφαιρος (completely round) (Conf. I, 82).[81] Later, however, in the final part of his quotations of quranic verses (Conf. XVIII), he literally cites from the Greek translation and retains the form as ὁλόσφυρος (Conf. XVIII, 146).[82] This version is apparently taken from his source, the original translation of the Quran. Nicetas is aware of the difference in terminology, as he tries to harmonize the meaning of both terms (Conf. I, 81–83; Conf. XVIII, 147–48).[83] Nevertheless, he is a reliable transmitter, as he does not change the wording of the quranic quotation as such.[84] This is,

80 For a full discussion of this term, see C. Simelidis, "The Byzantine Understanding of the Qurʾanic Term *al-Ṣamad* and the Greek Translation of the Qurʾan," *Speculum* 86.4 (2011): 887–913.

81 See Ulbricht, "Islam-Diskurs," 1365–68.

82 For the meaning and translation of this term, see Simelidis, "Byzantine Understanding."

83 So it is arguable that Nicetas really "misread" the word ὁλόσφυρος as ὁλόσφαιρος, as Høgel states ("Early Anonymous Greek Translation," 117, n. 78). By contrast, Nicetas seems to have been aware of the different ways of translating *ṣamad* into Greek (see below, n. 84). In addition, it is not "his [sc. Nicetas's] translation of sura 112," as Josef van Ess states ("The Youthful God: Anthropomorphism in Early Islam," in *Kleine Schriften by Josef van Ess*, ed. H. Biesterfeldt [Leiden, 2018], 2:606–30, at 614, n. 32), as the translation of the Quran does not go back to Nicetas (see Trapp, "Koranübersetzung?," 7–17), as mentioned above, but is of unknown authorship.

84 Nicetas's remarks on the quranic hapax legomenon *al-ṣamad* (Q 112:2) are relevant for the early understanding of the Quran in Arabic (see also van Ess, "Youthful God," 613–14). Nicetas takes this lexeme as a starting point for reflections on the nature of God in the Quran, i.e., his nature in the narrower sense (Conf. I, 81–86; Conf. XVIII, 144–48). A corresponding discussion about the anthropomorphism of God in the Quran also arises among Muslim scholars at the time. In the introductory part of his refutation, Nicetas contradicts the supposed quranic statement "that spherical is the divine" (ὅτι σφαιρικόν ἐστι τὸ θεῖον)—rather, he writes, "as he [sc. Muḥammad] himself said that God is a full sphere" (ὡς αὐτὸς εἶπεν, ὁλόσφαιρός ἐστιν ὁ Θεός) (quotations: Conf. I, 81–82, and Conf. I, 82, respectively). For a spherical form presupposes materiality (Conf. I, 83: οὐ γὰρ ἂν ἄλλως τὸ τῆς σφαίρας ἐδέχεται σχῆμα [for otherwise he could not have assumed the spherical form]; Conf. I, 84: σφαῖρα δὲ ὑλικὴ κατ' αὐτὸν τυγχάνων [according to him being a material sphere]). Accordingly, Nicetas's objection at this point (Conf. I, 81–86) is directed against a "spherical form" of God, since this would make Muḥammad "imagine him [sc. God] as a body entirely" (σῶμα πάντως αὐτὸν οἰόμενος [Conf. I, 82–83]). At the end of his quranic polemic, Nicetas quotes sura Q 112 verbatim from the translation available to him, where the word *ṣamad* is translated as ὁλόσφυρος (impenetrable; see above, and

76 Conf. III, 69–72: "Due to the transgression of the Jews, we have made forbidden to them what was formerly possible for them. And we prepared [for] them a heavy punishment because they unrightfully killed the prophets" (Høgel, "An Early Anonymous Greek Translation," 85).

77 See Ulbricht, "Verwendungsweise," 497–98.

78 E.g., *hudan* (guidance) in Q 2:185 (Conf. I, 342) and Q 3:96 (Conf. II, 99) or *ṭayyibāt* (good things) in Q 4:160 (Conf. III, 70); see Ulbricht, "Verwendungsweise," 501–4.

79 E.g., Conf. I, 296–301; Conf. II, 40–44; Conf. IV, 10–15; and Conf. XVII, 3–4 (cf. Ulbricht, "Verwendungsweise," 502–5).

therefore, an additional indication that Nicetas stuck quite faithfully to the text of the Greek translation of the Quran.

Actually, his reluctance to alter the quranic text makes sense because there is no reason to suppose that Nicetas possessed any mastery of Arabic. Consequently, he was unable to double-check the Greek translations of quranic verses by himself. Moreover, as a meticulous writer and scholar,[85] he might not have changed the terminology of his source. The latter point becomes even clearer in other contexts: Nicetas also does not interfere when the same Arabic constructions[86] or transliterations[87] are rendered in different manners in different parts of the Greek translation of the Quran.

We may thus conclude that once he quotes or paraphrases a quranic passage, Nicetas apparently quite faithfully retains the wording, syntax, and spelling of the Greek original that he had at his disposal. The only alterations are the omission of isolated phrases or words while the rest of the text is kept as it is.[88]

Having discussed (1) the different source layers within Nicetas's *Refutation* and (2) how to detect the literal quotations from the quranic fragments as such, we will have to face (3) the question of the possible origins of modifications within the quranic passages that have been classified as literal quotations with respect to the Arabic text. Even though the translation was, in general, carefully made, there are nevertheless some instances where its text differs from the Arabic text of the Quran. Furthermore, when I refer to the Arabic text of the Quran in the following, I do not only mean the quranic reading of Ḥafṣ ʿan ʿĀṣim (short for *qirāʾat* Ḥafṣ ʿan ʿĀṣim),[89] which today is the most popular in the Muslim world, not least because of the widespread Cairo edition of 1924. I also checked all the other remaining readings of the Quran as they are documented in the most recent major *qirāʾāt* works.[90] The latter comprise all fourteen canonical readings—i.e., *al-qirāʾāt al-thalātha al-mukammila li-l-ʿashr*,[91] *al-qirāʾāt al-ʿashr*,[92] and, finally, *al-qirāʾāt al-arbaʿ al-zāʾida ʿalā al-ʿashr*[93]—as well as the non-canonical,

n. 82) (Conf. XVIII, 146). Nicetas in turn interprets this term as follows: Εἰ μὴ τὸ σχῆμα τῆς σφαίρας δηλοῖ τὸ ὁλόσφυρον, ἀλλά γε τὸ πυκνὸν καὶ πεπιλημένον (If the word "impenetrable" does not denote sphericity, it does denote density and solidity [Conf. XVIII, 147–48]). This, too, implies materiality, since "also that [density and solidity is] a property of the body" (καὶ αὐτὸ τοῦ σώματος ἴδιον [Conf. XVIII, 148]). Nicetas aims to interpret the Muslim image of God as a material one of the actually metaphysical, transcendent God. From a source-critical point of view, it is noteworthy that the word *ṣamad*, which is the starting point of discussion in the two different passages in Nicetas's work (Conf. I, 81–86 and Conf. XVIII, 144–48, respectively), is rendered differently in Greek in each case; for an overview, see Ulbricht, "Islam-Diskurs," 1365–68, esp. 1366 (with the table of comparison) and 1367–68 (concerning the reception of the term *al-ṣamad* by later anti-Islamic writers); cf. Simelidis, "Byzantine Understanding."

85 Cf. Förstel, *Niketas von Byzanz*, 1:IX.

86 E.g., the Arabic expression *tubāshirūhunna/bāshirūhunna* (they have intercourse with them) (Q 2:187) is constructed once with a *praepositio cum accusativo* (μίχθητε εἰς αὐτὰς [Conf. I, 346]) and some lines later, on the same folio, with a *praepositio cum dativo* (μίχθητε αὐταῖς [Conf. I, 349]). See also Conf. I, 333–34, where *ikhtalafū fī* (doubt about) (Q 2:176) is constructed with ἐν as ἀμφιβάλλονται ἐν, while the same Arabic expression of Q 16:124 is translated in Conf. XV, 13–14, with εἰς as τῶν ἀμφιβαλλόντων εἰς. Here, I only quote passages whose differences are easy to recognize, as they appear close to each other within the manuscript.

87 E.g., the prophet Thamūd is transliterated in four different ways (I give here the diplomatic transcriptions of the manuscript Vat. gr. 681): Θαμὼθ (fol. 90v, 2; cf. Conf. VI, 25 = Q 7:73); Θαμούτ (fol. 102r, 14; cf. Conf. VIII, 112 = Q 9:70); Θαιμοὺδ (fol. 113v, 14; cf. Conf. XIII, 7 [Förstel reads Θαμοὺδ] = Q 14:9); and Θαμοὺθ (fol. 126v, 4–5; cf. Conf. XVIII, 75 = Q 69:4). The prophet Shuʿayb is rendered in two different ways: Σαῖκ (fol. 90v, 13; cf. Conf. VI, 30 [Förstel reads Σαὶκ] = Q 7:85) and Σωαὴπ (fol. 108v, 8; cf. Conf. X, 31 = Q 11:84). The prophet Ṣāliḥ is transliterated in two different ways: Τζάλετ (fol. 90r, 17; Conf. VI, 24–28 [Förstel reads Ζάλετ] = Q 7:73) and Ζάλεθ (fol. 108r, 7; cf. Conf. X, 23–27 = Q 11:61).

88 See above, pp. 227–28, and Ulbricht, "Verwendungsweise," 497–505.

89 This means the text of the Quran as it was read in the way (*riwāya*) of Ḥafṣ ibn Sulaymān (d. 796), who recited the Quran according to the reading (*qirāʾa*) of Abū Bakr ʿĀṣim (d. 745).

90 The following major studies (*muʿjam al-qirāʾāt*) on the quranic readings were consulted for the Muslim tradition: ʿA. S. Makram and A. M. ʿUmar, *Muʿjam al-qirāʾāt al-qurʾāniyya*, 8 vols. (Kuwait, 1988), and ʿA. L. al-Khaṭīb, *Muʿjam al-qirāʾāt*, 11 vols. (Damascus, n.d.), as well as the information given in the commentary to the Quran by A. T. Khoury, *Der Koran: Arabisch–Deutsch; Übersetzung und wissenschaftlicher Kommentar*, 12 vols. (Gütersloh, 1990–2001). I also checked the information of printed books with the most recent version of the online database of the project *Corpus Coranicum* (https://corpuscoranicum.de/) at the Berlin-Brandenburg Academy of Sciences and Humanities.

91 The seven readings; for an introduction, see Makram and ʿUmar, *Muʿjam*, 91–99.

92 The ten readings; for an introduction, see Makram and ʿUmar, *Muʿjam*, 73–91.

93 The fourteen readings; for an introduction, see Makram and ʿUmar, *Muʿjam*, 95–98.

i.e., *al-qirāʾāt al-shādhdha*.[94] From a methodological point of view, it is crucial to consider all these quranic variants because Nicetas's polemic, into which the quranic fragments are embedded, dates back, as a *terminus ante quem*, to as early as the ninth century CE (second/third century *hijrī*). This means that the historical origins of the translation of the Quran are close to the codification of the Arabic Quran as a written text in the seventh/eighth century CE (first century *hijrī*).[95] The Greek translation was, additionally, written even prior to the canonization of the seven readings by the Muslim scholar Ibn Mujāhid in 934.[96] This makes the translation of the Quran not only an extraordinary source of early quranic hermeneutics but also a very precious witness of the quranic text as such, because its translation may reflect alternative readings other than those documented in Ḥafṣ *ʿan* ʿĀṣim.

When detecting a discrepancy between the literal quotations in the *Coranus Graecus* and the Arabic text of the Quran, I first excluded the possibility that the Greek refers back to an alternative quranic reading.[97] We then have to think about other intermediate steps within the transmission chain as possible origins

for textual modifications.[98] Although the copyist(s) accurately worked on the manuscript, we also have to consider palaeographical lapsus that were apparently committed during the process of copying. For example, the proper noun *al-ḥijr* in the title of sura 15 is transliterated as τὸν νογερ [*sic*].[99] The letter nu at the beginning of the word is presumably a diplography because of the nu of the preceding article τόν, resulting in its doubling. In contrast to that, when *ḥijr* is not preceded by a word ending with nu, it is transliterated as ὄγερ.[100]

However, this is not always as easy as it appears. Sometimes, we may be persuaded to think that an emendation is obviously necessary. However, after a closer look, things appear differently. For example, in Conf. XVIII, 132–33 (according to the manuscript Vat. gr. 681, fol. 129v, 15–16), the Greek text translates Q 100:6 as ὁ γὰρ ἄνθρωπος τοῦ κυρίου ἀχώριστος (the human is inseparable from the lord). Erich Trapp, Karl Förstel, and Christian Høgel correct ἀχώριστος (inseparable) to ἀχάριστος (ungrateful), as this fits the Arabic sense of verse Q 100:6.[101] However, ἀχάριστος is constructed with πρός or τινί.[102] This means that the genitive τοῦ κυρίου (of the Lord) (Conf. XVIII, 133) in the Greek text would have been grammatically incorrect if ἀχάριστος had been the original reading of the Greek text; in the case of ἀχάριστος, the genitive should rather have been a dative τῷ κυρίῳ. If ἀχώριστος is indeed the original reading of the Greek translation, τοῦ κυρίου would be correct by understanding it as *partitivus*.[103]

94 The non-canonical readings; for an introduction, see Makram and ʿUmar, *Muʿjam*, 111–18.

95 This happened when the third caliph ʿUthmān gathered the different written fragments of the quranic text and had them consolidated into the so-called *al-muṣḥaf al-ʿUthmānī*, i.e., the Quran codex of the third caliph ʿUthmān ibn ʿAffān (579/83–656, r. from 644).

96 The seven readings as classified by Ibn Mujāhid are the first group of the canonical fourteen readings of the Quran. The three readings after the seven (i.e., the ten readings), notably supported (and added to the canonical seven) by Ibn al-Jazarī (d. 1429), and the four after the ten (i.e., the fourteen readings) were grouped later. See also Aḥmad ʿAlī al-Imām, *Variant Readings of the Qurʾan: A Critical Study of Their Historical and Linguistic Origins* (Herndon, VA, 1998), 128–31; C. Melchert, "The Relation of the Ten Readings to One Another," *Journal of Qurʾanic Studies* 10.2 (2008): 73–87; and Y. Dutton, "Orality, Literacy and the 'Seven Aḥruf' Ḥadīth," *Journal of Islamic Studies* 23.1 (2012): 1–49. Cf. also the more recent studies by S. H. Nasser, *The Transmission of the Variant Readings of the Qurʾān: The Problem of Tawātur and the Emergence of Shawādhdh* (Brill, 2013) and *The Second Canonization of the Qurʾān (324/936): Ibn Mujāhid and the Founding of the Seven Readings* (Brill, 2020).

97 The alternative readings for the examples given below are stated in the apparatus. For some cases where the Greek translation, indeed, reflects another quranic reading than Ḥafṣ *ʿan* ʿĀṣim, see Ulbricht, "Nachweis der Existenz," 547–48; see also Versteegh, "Greek Translations of the Qurʾān," 62–63.

98 I do not agree with the characterization as "errors" when the Greek text does not match the Arabic because this presumes that all the other intermediate steps have been excluded as origins; see R. F. Glei, "Der Mistkäfer und andere Missverständnisse: Zur frühbyzantinischen Koranübersetzung," in *Frühe Koranübersetzungen: Europäische und außereuropäische Fallstudien*, ed. R. F. Glei (Trier, 2012), 9–24, at 13, and Høgel, "Early Anonymous Greek Translation," 69–70.

99 Vat. gr. 681, fol. 114v, 6 (Conf. XIV, 2).

100 Vat. gr. 681, fol. 127v, 12 (Conf. XVIII, 96): τοῖς ὄγερ [*sic*].

101 Trapp, "Koranübersetzung?," 10; Förstel, *Niketas von Byzanz*, 1:116; and Høgel, "Early Anonymous Greek Translation," 115.

102 LSJ, s.v. ἀχάριστος. See also W. Bauer, *Griechisch–deutsches Wörterbuch zu den Schriften des Neuen Testaments und der übrigen urchristlichen Literatur* (Berlin, 1958), s.v. ἀχάριστος, but nothing about πρός or τινί; G. W. H. Lampe, *A Patristic Greek Lexicon* (Oxford, 1961), s.v. ἀχαριστέω; and E. Kriaras, *Λεξικό τῆς Μεσαιωνικῆς Ἑλληνικῆς Δημώδους Γραμματείας*, vol. 3 (Thessaloniki, 1973), s.v. ἀχάριστος.

103 Cf. LSJ, s.v. ἀχώριστος; Bauer, *Wörterbuch zum Neuen Testament*, s.v. ἀχώριστος; Lampe, *Patristic Greek Lexicon*, s.v. ἀχώριστος; Kriaras, *Λεξικό*, s.v. ἀχώριστος.

As such, an error by the copyist appears rather unlikely, and the emendations by Trapp, Förstel, and Høgel seem wrong. It is noteworthy that the editio princeps by Angelo Mai preserves the original ἀχώριστος but with a footnote.[104] This is a term of great Christological relevance,[105] and we will come back to this context and especially this example later.

Once we exclude these differences between the Arabic and Greek texts that might result from another quranic reading or from palaeographic error, the next possible step in the transmission chain is Nicetas himself. I already showed that he apparently did not intervene in the text of the literal quotations except by omitting passages or words. It is here where we find certain patterns that give us the possibility of differentiating the different kinds of omissions in the quotations of the *Coranus Graecus*.[106] First, we find some differences between the Arabic and Greek versions that recur in connection with two specific key topics of anti-Islamic polemics: sexuality and the quranic image of God. For example, there are several verses that lack the negative[107] or interrogative particles[108] found in the Arabic text. In their respective contexts, these omissions lead to diametrically opposed, sometimes even salacious, statements within the Greek translation, and the description of the quranic God is pejoratively connoted. We may attribute these kinds of modifications (i.e., omissions) to Nicetas because the modified statements now fit his polemical agenda. Second, the same seems to occur with omissions of subordinate clauses that relativize quranic sayings.[109] This leads to statements that are formulated much harsher than intended in the Quran. In addition, distorted separations of verses[110] or the inappropriate collation of two independent verses of

the Quran[111] also permit Nicetas to polemically attack the quoted holy book. The relative regularity in which these phenomena occur suggests that these modifications were made by Nicetas for two reasons: First, it is easy to omit textual passages without actually intervening in the text (of the translation as such), that is, the original of which Nicetas was not able to check because of his lack of Arabic. Second, these kinds of modifications serve Nicetas's polemical aims.

There is, however, also a third kind of modification within the *Coranus Graecus* that cannot be convincingly attributed to Nicetas. It repeatedly occurs in quranic verses dealing with theological issues with respect to Muslim and Christian dogmas. Here, instead of omissions, we repeatedly find additions to the quranic text and/or a certain interpretation of its content. The result of these additions and specific interpretations might be characterized as a Christian hermeneutical reading of the Quran.

In the following, I will philologically analyze these alterations to contextualize them historically in the conclusion. I will first give some examples where quotations related to Jesus Christ and his soteriological role in the Quran and Christianity are given in a modified manner in the *Coranus Graecus*. I will then focus on translations of technical terms of the Christian liturgical tradition that demonstrate the sensibility of the translator(s) for transporting the religious connotations into a Christian context. Lastly, I will discuss sample passages that depict the ability of the translator(s) to deeply understand Muslim worship practices. Based on this philological examination, I will finally formulate my conclusions on the cultural-religious background of the translator(s) of the Quran and try to sketch a composite picture of his/their historical environment.

The examples will be given in a Greek–Arabic synoptical way with English translations. The Greek text of the following examples is taken from Förstel's edition but was, however, also checked against the manuscript.[112] The Arabic text is according to the quranic reading of Ḥafṣ ʿan ʿĀṣim with all the remaining readings (fourteen

104 Mai, *Nova patrum bibliotheca*, 4:388, n. 4, and PG 105:776, n. 74.

105 See the *horos* (definition) of Chalcedon (451): ἀσυγχύτως, ἀτρέπτως, ἀδιαιρέτως, ἀχωρίστως (H. Denzinger, *Enchiridion symbolorum definitionum et declarationum de rebus fidei et morum*, 27th ed. [Freiburg, 1999], 71).

106 For the following, see Ulbricht, "Verwendungsweise," 497–505.

107 See, for example, Conf. I, 255–62 (Q 2:102); Conf. I, 349 (Q 2:187); and Conf. IV, 36 (Q 5:46–47).

108 See, for example, Conf. II, 105–6 (Q 3:144), and Conf. XVI, 53–54 (Q 17:40).

109 See, for example, Conf. I, 362–65 (Q 2:230).

110 See Ulbricht, "Verwendungsweise," 495–97.

111 γυναιξί, φησι, λελευκασμέναις τε καὶ εὐοφθάλμοις συγγινομένων, . . . καὶ, τὸ φρικτότερον, Θεοῦ κατενώπιον· (Conf. I, 141–43 [Q 2:25–26]); cf. PG 105:711, n. 26, and Mai, *Nova patrum bibliotheca*, 4:349, n. 2. See also Ulbricht, "Verwendungsweise," 492–93.

112 If there are significant differences between Förstel's edition and the manuscript, both readings are given.

canonical and non-canonical) in the apparatus. The English translations, which are to be seen only as a support for the reader and not as a basis for the examination of the texts, aim to stress the main points of my argumentation.[113]

The *Coranus Graecus*: A Christian Hermeneutical Reading of the Quran?

We have already stated that the *Coranus Graecus* follows an interlinear method of translating from Arabic into Greek. This also extends to the use of the definite article, meaning that the definite article is usually translated into Greek where it is also written in Arabic and vice versa.[114] Most cases in which there is no definite article *al-* in the Arabic (while there is one in the Greek) are genitive constructions in Arabic.[115] That means that the article is correctly written in Greek while not present in a written form in Arabic because the Arabic word is semantically defined by the following word (*majrūr bi-l-iḍāfa* [genitive construction]). Very few cases are found in the *Coranus Graecus* where the rendering of the article in Greek does not correspond to the grammar of the Arabic text. These alterations occur in passages related to theological terms and expressions, including Christological statements and dogmatic differences between Christianity and Islam.

Examples of omitting the definite article are linked to proper nouns present in the Greek text but not in the Arabic.[116] Here, we find word-for-word translations that refer to frequently used expressions and denominations of persons of the scripture, such as *rasūl Allāh* (<u>the</u> messenger of God) and *ibn Maryam* (<u>the</u> son of Mary). They are consistently rendered word-for-word into Greek (i.e., without the article) as ἀπόστολος Θεοῦ

(God's messenger)[117] and υἱὸς Μαρίας (Mary's son),[118] respectively. The reason for this deviation from the rule might be that these expressions are frequently used in theological contexts and are therefore common in religious language in Greek.[119]

But we also find examples where the definite article is added in Greek where it is not intended in the Arabic text. This disproportionally high percentage of anomalies with respect to the word-for-word translation in the rest of the *Coranus Graecus* is linked to contexts of theologically relevant terms like λόγος (word), εὐαγγελίζω (evangelize), and υἱός (son). Of course, it is indeed important to consider that the use of articles particularly differs from one language to another. However, the text of the *Coranus Graecus* is very accurate in rendering articles and even particles from Arabic into Greek,[120] and these expressions all refer to Jesus Christ himself in the respective quranic contexts. Furthermore, through the addition of the article, the text in Greek takes on a theological-dogmatical cast that not only was not intended in the Arabic quranic text but moreover implicates Christian associations of these quranic passages that contrast with Islamic teachings. One may wonder if these alterations are only by chance or if we may distinguish a certain pattern related to the translated quranic contents.

Looking at sura Q 3:45 (Āl ʿImrān), which deals with the relation of Christ with the term "Word of God" (λόγος), we read the following:[121]

113 The English translations were originally based on Sahih International for the quranic text, quoted after https://quran.com/, and Høgel, "Early Anonymous Greek Translation," 65–119; however, I modified both of them, when necessary, in order to point out the differences.

114 For a full list of the corresponding uses of the articles, see Ulbricht, "Graeco-Arabica," 139–71 (for the words that have the definite article in Greek), 235–49 (for the syntagmata translating the Arabic article *al-* into Greek).

115 For a full list of these cases, see Ulbricht, "Graeco-Arabica," 389–98.

116 See all the entries where the definite article ὁ, ἡ, τό (the) and its derivates are used within the translation: Ulbricht, "Graeco-Arabica," 139–71. See also above, n. 115.

117 For example: Conf. III, 80, 102–3, and Conf. IV, 15. See Ulbricht, "Graeco-Arabica," 36–37 (for a full list and glossary of ἀπόστολος), 103–6 (for Θεός).

118 For example: Conf. I, 220; Conf. II, 29; Conf. III, 79, 102; and Conf. XVIII, 56. See Ulbricht, "Graeco-Arabica," 127–28 (for a full list and glossary of Μαρία), 208–9 (for υἱός).

119 The exact phrases ἀπόστολος Θεοῦ and υἱὸς Μαρίας are not attested in the New Testament, but the recurring phrases ἀπόστολος Χριστοῦ Ἰησοῦ and ἀπόστολος Ἰησοῦ Χριστοῦ also lack the article (see Englishman's Greek Concordance, https://biblehub.com/greek/, and Abarim Publications, "Greek New Testament Concordance—with Strong Index Numbers," https://www.abarim-publications.com/Concordance/index.html). See also Bauer, *Wörterbuch zum Neuen Testament*, s.v. ἀπόστολος, and s.v. υἱός, (esp. under υἱὸς Θεοῦ).

120 For a detailed concordance and Arabic-Greek synopsis of all lexemes used in the *Coranus Graecus* in relation to the quranic text, see Ulbricht, "Graeco-Arabica," 26–399.

121 Cf. Ulbricht, "At-Tarǧamah," 46–47. In the tables, the following abbreviations are used: MQQ = Makram and ʿUmar, *Muʿjam*; MQ = al-Khaṭib, *Muʿjam*; and KK = Khoury, *Der Koran*; see above, n. 90.

Sura Q 3:45 (Āl ʿImrān)	Vat. gr. 681, fol. 69v, 12–16 (Conf. II, 28–30)
[...] *inna llāha yubashshiruki* **bi-kalimatin minhu** *smuhu l-masīḥu ʿĪsā bnu Maryama wajīhan fī l-dunyā wa-l-ākhirati* [*wa-mina l-muqarrabīna*]	Ὁ Θεός [...]¹²² εὐαγγελίζεταί σε **τὸν λόγον αὐτοῦ·** Χριστὸς Ἰησοῦς υἱὸς Μαρίας ἐπιτυγχάνων ἐν τῷ βίῳ τούτῳ καὶ ἐν τῷ μέλλοντι ὑπάρχων·
[...] Indeed, God brings you good news of **a word from him,** his name is the Messiah, Jesus, the son of Mary, distinguished in this world and the hereafter. [and from those who are near.]	God brings you [...] good news of **his word,** Christ, Jesus, son of Mary, meeting in this life and existing in the coming life.¹²³
inna : *anna* (MQQ 2:30 = 1030; MQ 1:494); *inna llāha yubash-shiruki* : *inna llāha la-yubshiruki, inna llāha la-yubshiruki* (MQ 1:494; KK 4:104); *yubashshiruki* : *yabshuruki, yubshiruki* (MQQ 2:30 = 1031, 2:28 = 1015; MQ 1:494, 488); *bi-kalimatin* : *bi-kilmatin* (MQQ 2:30 = 1032, 2:28 = 1017; MQ 1:494, 489); phon. (*imāla*) (MQQ 2:31 = 1033; MQ 1:494); *wajīhan* : *wijīhan, wajhiyyan* (MQ 1:494); phon. (*imāla*) (MQQ 2:31 = 1034; MQ 1:494); phon. (*imāla* et al.) (MQ 1:494)	

The translation construes the expression *bi-kalima-tin minhu* (a word from him) as τὸν λόγον αὐτοῦ (his word). We thus have a definite article in Greek where the Arabic text does not have one. In order to evaluate this addition, it is necessary to first ask if the Greek syntax allows for the construction of a (possessive) genitive added to an indefinite noun and if the translation also translates elsewhere compounds like *minhu* into the genitive alone. Other examples within the *Coranus Graecus* indeed show that the Arabic *minhu* is translated with a literal construction, such as ἐκ/ἐξ plus the genitive.¹²⁴ In this specific context, it is clear that the intended referent of the quranic verse is Jesus Christ. Therefore, the modification of the Arabic text means

that Jesus Christ becomes, in the Greek text, "the Word of God" (literally "his Word," τὸν λόγον αὐτοῦ), while in the Quran, he is just "a Word of God" (*kalimatin minhu*). On the one hand, the term λόγος is one of the most important epithets of God's second hypostasis, the Son Jesus Christ; on the other, we do not find any other example within the *Coranus Graecus* of a translation of *minhu* as a definite construction in Greek.¹²⁵ Therefore, I suggest not considering this modification as a simple lapsus or haphazard faulty reading—be it by Nicetas or a possible copyist—but to take it as one puzzle piece of the whole picture, as we will see in the following.

I say this because introducing the formulation λόγος τοῦ Θεοῦ (Word of God) to a Greek version of the Quran reminds us of the genuine Christian concept of Christ's sonship of God¹²⁶ and that Christ is

122 Square brackets [...] mark omitted passages or words.

123 Here, Høgel's translation "who succeeds ... and will live ..." ("Early Anonymous Greek Translation," 81) has been modified. The translator seems to understand the Arabic verb based on the root *w-j-h* in the sense of "being face to face" and, subsequently, as in *wājaha*, "to meet." The Greek verb ἐπιτυγχάνω has the connotation of "something happening unexpectedly," which is also used for "meeting with" (see LSJ, s.v. ἐπιτυγχάνω). My thanks to an anonymous reviewer for encouraging me to clarify this passage.

124 See, e.g., Ulbricht, "Graeco-Arabica," 79–83. For the combination of *min* plus *ḍamīr* (pronoun), like *minhu, minkum*, etc., and its translations into Greek, see, e.g., Conf. III, 81, 104; Conf. IV, 47 (twice); Conf. VI, 61, 71; and Conf. IX, 5.

125 See above, n. 124, especially the passages concerning Conf. III, 81 (Ulbricht, "Graeco-Arabica," 356); Conf. III, 104 (Ulbricht, "Graeco-Arabica," 357); and Conf. VI, 61 (Ulbricht, "Graeco-Arabica," 355); cf. Conf. III, 71; Conf. IV, 47; and Conf. IX, 5 (constructions in plural).

126 To give proof for this self-evident quotation seems redundant in this context. As an example, we may refer to the hymn "Ὁ μονογενὴς υἱὸς καὶ λόγος τοῦ θεοῦ" (The Only-Begotten Son and Word of God), whose authorship has been attributed to the emperor Justinian I (482–565 CE, r. from 527 CE) (H. G. Beck, *Kirche und theologische Literatur im Byzantinischen Reich* [Munich, 1959], 378) and which is

"[his] only-begotten son, born of the Father before all ages . . . and one with the Father in essence."[127] So we may think that the *Coranus Graecus* indirectly reflects these meanings in the quranic content as if the concepts of Christ's filiality and divinity were also present in Islam. In contrast, these Christian dogmas par excellence are categorically rejected by the Quran itself.[128]

We find the addition of the definite article in Greek in the same context (i.e., in combination with the word *kalima/λόγος*) a little further on in the *Coranus Graecus* in the very same sura: the expression *kalimatin sawā'in* (a word that is equitable) in sura Q 3:64 (Āl 'Imrān) is translated as "<u>the</u> word that is equitable." Here again, a definite article was added (<u>τὸν</u> λόγον <u>τὸν</u> στοιχοῦντα), while the Arabic text has the indefinite form.[129]

Sura Q 3:64 (Āl ʿImrān)	Vat. gr. 681, fol. 72r, 6–10 (Conf. II, 67–69)
[. . .] *taʿālaw ʾilā **kalimatin sawāʾin*** *baynanā wa-baynakum* *allā naʿbuda illā llāha* *wa-lā nushrika bihī shayʾan* [. . .]	δεῦτε εἰς **τὸν λόγον τὸν στοιχοῦντα** μέσα ἡμῶν καὶ ὑμῶν, τοῦ μὴ δουλεύειν εἰ μὴ τὸν Θεὸν καὶ τοῦ μὴ θεῖναι αὐτῷ κοινωνὸν τίποτε.
[. . .] Come to **a word that is equitable** between us and you, that we shall worship none but God and not associate anything with him. [. . .]	Come to **the word that is equitable** between us and you, that we shall worship none but God and that we shall not put any associate with him whatsoever.
taʿālaw : taʿālū (MQ 1:512); *kalimatin : kilmatin, kalmatin* (MQQ 2:38–39 = 1075; MQ 1:512); *sawāʾin : sawāʾan, ʿadlin* (MQQ 2:39 = 1076; MQ 1:513; KK 4:132)	

This is especially interesting because the term λόγος appears within the literal quotations of the *Coranus Graecus* only in seven passages. Four of them are a translation of the Arabic *maṣdar* (verbal noun/infinitive) *qawl* (root *q-w-l*),[130] and the remaining three all translate the Arabic term *kalima* (word).[131]

As in Christian-Arabic terminology, the respective word for λόγος is *kalima*; what interests us in this context are the three latter cases (Q 3:45, 3:64; Q 4:171). All of them are related to Christological passages in the Quran,[132] in contrast to the former four. In the *Coranus Graecus*, the word *kalima* is defined both times where it is indefinite in the Arabic Quran (Q 3:45, 3:64).[133] The third case (Q 4:171) is already definite in Arabic through a genitive construction that is rendered word by word into Greek (without the written article).[134] Therefore, I contend that there is a tendency within the *Coranus Graecus* to make the word *kalima* definite when mentioned in the Quran. We may suppose that the goal was to make the quranic concept of "God's Word" accessible or more familiar

sung in the Holy Mass between the second and third ἀντίφωνον, thus being part of the Byzantine Orthodox liturgical practice.

127 As in the Nicene-Constantinopolitan Creed: τὸν υἱὸν τοῦ θεοῦ τὸν μονογενῆ, τὸν ἐκ τοῦ πατρὸς γεννηθέντα πρὸ πάντων τῶν αἰώνων, . . . ὁμοούσιον τῷ πατρί (G. L. Dossetti, *Il simbolo di Nicea e di Costantinopoli: Edizione critica* [Rome, 1967], 244).

128 See suras Q 5:72–75, 5:116–117 (al-Māʾida), and Q 4:171–172 (al-Nisāʾ), passim.

129 See Ulbricht, "*At-Tarǧamah*," 47.

130 See Ulbricht, "Graeco-Arabica," 124: Conf. VIII, 16–17 = Q 9:30 (twice) (ὁ λόγος αὐτῶν διὰ τῶν στομάτων αὐτῶν· ἰσοφωνοῦσι τοῖς λόγοις τῶν ἀρνησαμένων) (This is their speech through their mouths. They liken their speech to the deniers of old); Conf. XVI, 21 = Q 17:16 (ἐδικαιώθη ἐπάνω αὐτοῦ λόγος) (And the saying about it is done right); and Conf. XVI, 37 and 54 = Q 17:40 (ὑμεῖς δὲ λέγετε λόγους μεγάλους) (But you utter frightful speech).

131 See Ulbricht, "Graeco-Arabica," 325: Conf. II, 29 = Q 3:45 (ὁ θεὸς εὐαγγελίζεταί σε τὸν λόγον αὐτοῦ); Conf. II, 67 = Q 3:64 (δεῦτε εἰς τὸν λόγον τὸν στοιχοῦντα μέσα ἡμῶν); and Conf. III, 103 = Q 4:171 (ὁ Χριστὸς . . . λόγος αὐτοῦ ὃν ἔρριψεν πρὸς τὴν Μαρίαν).

132 Q 3:64 is preceded by the Christological passage about his birth, childhood, miracles, and ascension (Q 3:45–57) and a soteriological-eschatological narrative (Q 3:58–63) where reference is made to Christ (Q 3:59).

133 With τὸν λόγον in both passages.

134 Q 4:171: *innamā l-masīḥu ʿĪsā bnu Maryama rasūlu llāhi wa-kalimatuhū alqāhā ilā Maryama wa-rūḥun minhu* = Ὁ Χριστὸς Ἰησοῦς υἱὸς Μαρίας ἀπόστολος Θεοῦ ἐστι καὶ Λόγος αὐτοῦ, ὃν ἔρριψεν πρὸς τὴν Μαρίαν, καὶ Πνεῦμα ἐξ αὐτοῦ (The Messiah, Jesus, son of Mary, is God's messenger and his word, which he hurled to Mary, and spirit of him) (Conf. III, 102–4).

to non-Muslim readers. By defining the term λόγος, a Christian reader would associatively understand the quranic passage in relation to Jesus Christ as "the Word of God." Independent from this is the question of whether the modification was done intentionally or unintentionally.

We find a similar case of modification concerning the definite article in the *Coranus Graecus* that again occurs in the context of a Christological passage. Sura Q 9:30 (al-Tawba) refers to the expression "Son of God" and its meaning for Jews and Christians. The same Arabic construction is rendered in two different ways grammatically:[135]

Sura Q 9:30 (al-Tawba)	Vat. gr. 681, fol. 96v, 1–5 (Conf. VIII, 15–17)
wa-qālati l-yahūdu **ʿUzayruni bnu llāhi** *wa-qālati l-naṣārā* ***l-masīḥu bnu llāhi*** *dhālika qawluhum* *bi-afwāhihim* […]	Λέγουσιν Ἰουδαῖοι, ὅτι **Ἰσραήλ ἐστιν υἱὸς Θεοῦ.** καὶ λέγουσιν οἱ Χριστιανοί, ὅτι **ὁ Χριστός ἐστιν ὁ Υἱὸς τοῦ Θεοῦ** Τοῦτό ἐστιν ὁ λόγος αὐτῶν διὰ τῶν στομάτων αὐτῶν·
The Jews say **ʿUzayr** [i.e., Ezra] **is the son of God** [lit. "the God"], and the Christians say **the Messiah is the son of God** [lit. "the God"]. That is their speech through their mouths. […]	The Jews say that **Israel is a son of God** [lit. "a God"], and the Christians say that **the Messiah is the son of God** [lit. "the God"]. This is their speech through their mouths.
ʿuzayruni : phon. (MQQ 3:14 = 3032; MQ 3:368); *ʿuzayruni bnu llāhi* : *ʿuzayru bnu llāhi* (MQQ 3:14–15 = 3033; MQ 3:368–70; KK 7:310); *al-naṣārā* : phon. (*imāla*) (MQQ 3:15 = 3034; MQ 3:370); phon. (*idghām* et al.) (MQQ 3:15 = 3035; MQ 3:370); *bi-afwāhihim* : *bi-yafwāhihim* (in pausa) (MQ 3:370)	

If both syntagmata were seen to be isolated in their respective languages, there would be no need to perceive a difference. The meaning in Greek does not necessarily deviate from the Arabic text because the role of definite and indefinite articles in Greek allows for some flexibility. However, what is striking here is that, first, there is a difference between both passages in Greek, though the Arabic construction is completely the same. Second, the definite article is added in the analogous expression only some lines later, so a lapsus or a different translator (and thus translating technique) may be excluded. Third, and most important, the modification again occurs in a Christological context, that is, the sonship of God. So at first glance, this purely grammatical difference seems worthy of examination under a different (i.e., dogmatical) prism. Let us look at this in detail.

The Quran states in Arabic in both syntagmata that Ezra (*ʿUzayr*)/Israel[136] and Christ, respectively, are "the Son of God" (lit. the God), as the Arabic *ibn* (son) is defined by its genitive construction with *Allāh*. However, when referring to the Jews, the translation of *ʿUzayruni bnu llāhi* becomes Ἰσραήλ ἐστιν υἱὸς Θεοῦ in Greek, without the definite article before υἱός. If taken literally, this would mean "Israel is a son of a God." In contrast, the expression *al-masīḥu bnu llāhi* appears in Greek as in the Arabic text where "son" is definite: ὁ Χριστός ἐστιν ὁ Υἱὸς τοῦ Θεοῦ.

136 To understand this translation is a major challenge. To my knowledge, there is no indication why the Arabic *ʿUzayr* has been rendered as Israel. It is also noteworthy that Muslim exegesis is not quite clear about who or what might be *ʿUzayr*. Of course, one might always suspect that the Greek translation has been made from a different *rasm* (i.e., text body in defective scripture), although in this instance this does not seem to be the case (see "44 Manuscripts for Q 9:30," *Corpus Coranicum*, accessed 15 August 2023, https://corpuscoranicum.de/en/verse-navigator/sura/9/verse/30/manuscripts).

135 See Ulbricht, *at-Tarǧamah*, 48.

Comparing both syntagmata, the expression "a son of a God" (concerning the Jews) would allow the existence of another son (υἱός) because the word is indefinite. By contrast, Christ would be the only son (of God) because the word is grammatically defined by the definite article (ὁ υἱός). So we see a tendency within the *Coranus Graecus* to point to the uniqueness of Christ's sonship in comparison to other (non-Christian) traditions.

In principle, we might argue that the addition or lack of an article might be either a copyist's lapsus or Nicetas's own modification. That this modification originated with a copyist is very unlikely because the manuscript has been copied extremely carefully, and I have already demonstrated that this kind of modification primarily occurs in theologically relevant contexts. It seems similarly unlikely that this specific modification of the quranic text goes back to Nicetas. If in this specific case Nicetas changed the wording of the original Greek translation of the Quran, he surely did this with a specific aim (i.e., with a polemical target). But by contrast, Nicetas does not discuss the grammatical status of the word υἱός in this context. He only refers to the different concepts of the sonship of God in Judaism and Christianity (Conf. VIII, 20–89).

However, that the use of the definite article is indeed not marginal but rather a central point of argumentation for Nicetas becomes clear in his own explanations some lines later. Toward the end of the very same *Confutatio* VIII, he quotes verse Q 9:61 (Conf. VIII, 106–7) and discusses in this context the use of the definite versus indefinite status in combination with the word υἱός. In his interpretation of verse Q 9:61, Nicetas states:

Μετ' ὀλίγον δέ, ὅποι φέρεται αὐτῷ ὁ σύμπας τῆς θεομαχίας σκοπός, ἔκδηλος γίνεται. Ὁ γάρ τοι ἕως τοῦ νῦν διισχυριζόμενος, ὅτι Θεὸς Υἱὸν οὐκ ἔχει, οὐ θαρρῶν ἑαυτῷ ταῦτα φιλονεικοῦντι, ἀλλὰ διαλογισάμενος, ὅτι τυχὸν καὶ ἔχει, οὐκ ἀναδύεται ἑαυτῷ τοῦτο προσάψαι τὸ πρόσωπον, εἰ καὶ ἐκ πλαγίου τοῦτο ἐπήγαγεν καὶ προσποιεῖται οἱονεὶ σχηματίζεσθαι βλακίαν [102r] πάνυ αἰσχράν, καί φησιν· «Τινὲς σιαίνουσιν τὸν προφήτην καὶ λέγουσιν, ὅτι + αὐτὸς Υἱὸς Θεοῦ ἐστιν.» + Καὶ οὐκ εἶπεν, ὅτι ὁ Υἱός ἐστιν, λογιζόμενος, ὃν ἀνελεῖν ἀγωνίζεται, ἵνα μὴ γυμνὸς παντελῶς τοῦ δόλου καταλειφθεὶς συσκελισθῇ, ἀλλ', ὅτι αὐτὸς Υἱός

ἐστιν· ὡς ἂν εἰ ἔλεγεν, ὅτι 'Εἰ θέλετε Υἱὸν Θεοῦ ὁμολογεῖν, ἐγὼ τοῦ λαλουμένου ἐγγύτερον.[137]

Nicetas seems not to pay any attention to this grammatical difference in Q 9:30 with respect to the Arabic Quran (which he might not have even been aware of because he did not know Arabic). Therefore, if it was Nicetas who added or omitted the definite article in Conf. VIII, 15–17 (Q 9:30), then it is hard to explain why he does not refer to this grammatical difference there but does so when discussing the later quranic verse, Q 9:61 (Conf. VIII, 101–9). Therefore, we may suppose that he did not make this modification; instead, we may assume that it goes back to an earlier step within the transmission process of the Greek translation, that is, back to the translator himself. If the difference in the use of the article in this passage does not originate with Nicetas, then there is no reason to suppose him to also be behind the additions of articles in the other cases mentioned above (Q 3:45, 3:64).

A modification analogous to the abovementioned also occurs with the term "God" (θεός) within the translation of Q 9:30. In the first case (of the Jews, when "son" is indefinite), "God" has also no article in Greek; in the latter case (of Christ, when "son" is grammatically defined), "God" gets the definite article, too. This may be explained best with an attempt to harmonize both cases (of the Jews with their Son and God, and of the Christians, respectively) and to stress the exclusiveness of the relation between the specific God and his Son in the Christian understanding.

Of course, we must keep in mind the loose use of the article in Greek, not least in the case of θεός. Nevertheless, it is not the single observation that makes the argument—it is the sum of the parts that allows us to draw a picture of possibilities, and those consist of the following points. First, the Greek translation of the

137 Conf. VIII, 101–10: "Shortly thereafter it becomes quite obvious what his [sc. Muḥammad's] whole intention in the fight against God aims at. For he, who up to now has asserted that God has no son, does not trust himself to claim that, but in setting forth that he may have <one> after all, he does not hesitate to ascribe to himself this role, while he also introduces it covertly and presumes to display a quite shameful simplicity, as it were. He says, 'Some cause trouble to the prophet and say + that he is son of God + [cf. Q 9:61].' In saying this, he did not say that he is *the* Son because he was thinking of the one he was striving to eliminate, lest he be left utterly exposed by his cunning and brought down, but only that he is Son. This is as if he said, 'If you will confess that there is a Son of God, I am closer to <him> than the one named'" (translation my own).

Quran follows a method of interlinear translation, closely following Arabic grammar and syntax. That means that even small aberrations from this concept might be of importance. Second, the divergences in the use of the article largely occur in the context of the word *kalima/λόγος*, and this term has special importance to Greek readers, as it associatively refers to Christological issues.

A further example in this context relates to another theologically relevant term. The word *bashīr* ("bringer of good news," translated as εὐαγγελιζόμενος) in sura Q 5:19 (al-Māʾida) is indefinite in the Quran. In the *Coranus Graecus*, however, it is again given a definite article.[138] The respective verse is as follows:

Sura Q 5:19 (al-Māʾida)	Vat. gr. 681, fol. 83v, 12–13 (Conf. IV, 17)
yā ahla l-kitābi qad jāʾakum rasūlunā yubayyinu lakum ʿalā fatratin mina l-rusuli *an taqūlū* *mā jāʾanā **min bashīrin*** *wa-lā nadhīrin fa-qad jāʾakum bashīrun wa-nadhīrun* *wa-llāhu ʿalā kulli shayʾin qadīrun*	<...>[139] τοῦ μὴ λέγειν ὑμᾶς ... οὐκ ἦλθεν ἡμῖν **ὁ εὐαγγελιζόμενος** <...>
O people of the Scripture, there has come to you our Messenger to make clear to you after a period of messengers, lest you say, there came not to us **any bringer of good news**, or one who warns. But there has come to you a bringer of good news and one who warns. And God is over all things competent.	<...> so that you will not say, [...] there came not to us **the bringer of good news** <...>
jāʾanā : phon. (*imāla*) [MQQ 2:200 = 1824; MQ 2:248]	

Once again, a definite article is added to a word of theological-soteriological significance, in this case the predication of God's messenger. The expression "any bringer of good news" (*min bashīrin*) is translated into Greek as "<u>the</u> bringer of good news" (ὁ εὐαγγελιζόμενος). The Greek rendering of the Arabic word *bashīr* with εὐαγγελίζομαι is obvious and shows the linguistic sensibility of the translator. However, for a Christian reader of the Quran in Greek, the word εὐαγγελίζομαι/εὐαγγέλιον is connoted with a certain theological understanding: it evokes an association not only to the Christian Holy Scripture, the εὐαγγέλιον, but also to Jesus Christ himself as "the [one and only] bringer of good news" (ὁ εὐαγγελιζόμενος), who was identified by John the Baptist when he "bore witness about him and cried out, 'This was he of whom I said, he ... comes after me'" (John 1:15).

So far, we have observed a number of differences between the quranic text in Arabic and Greek.

Though they are all arguable from a linguistic standpoint when seen separated one from the other, the sum of these observations within their specific source (i.e., the *Coranus Graecus*), which has specific characteristics (i.e., of a word-by-word translation), and in their respective contexts (i.e., of theologically relevant terms) allows us to postulate the following: these modifications may have a certain significance for the understanding of the quranic text in Greek, and they were not made by lapsus. This could be explained by the fact that certain associations, maybe originating from the cultural-religious background of the translator(s), impacted the interpretation of certain quranic contents in Greek.

An example for the latter suggestion might be sura Q 3:44 (Āl ʿImrān), which contains information not found in the Quran. It is again related to a theologically relevant person in Christianity, as it deals with the story of the Virgin Mary:[140]

138 See Ulbricht, *at-Tarǧamah*, 48.

139 Angle brackets <...> mean that these quranic passages are not transmitted in the *Coranus Graecus*.

140 See Ulbricht, *at-Tarǧamah*, 49–50.

Sura Q 3:44 (Āl ʿImrān)	Vat. gr. 681, fol. 69v, 7–11 (Conf. II, 26–28)
[. . .] wa-mā kunta ladayhim **idh yulqūna aqlāmahum** ayyuhum yakfulu Maryama wa-mā kunta ladayhim idh yakhtaṣimūna	σοῦ μὴ ὄντος ἐκεῖσε, **ὅταν ἥπλωσαν αὐτῶν τὰς ἀγκάλας ἄγγελοι,** ποῖος ἐξ αὐτῶν προσδέξεται τὴν Μαρίαν, καὶ οὐκ ᾗς ἐκεῖσε. <. . .>
[. . .] And you were not with them **when they cast [lots with] their pens [as to]** who among them should be responsible for Mary, nor were you with them when they disputed.	You were not there **when the angels spread out their arms,** who among them should receive Mary, and you were not there. <. . .>
ladayhim : ladayhum, ladayhumū (MQQ 2:30 = 1028; MQ 1:493)	

In this Mariological passage (Q 3:42–47), the quranic wording "they cast their pens" (*idh yulqūna aqlāmahum*) is rendered in Greek as "the angels spread out their arms" (ὅταν ἥπλωσαν αὐτῶν τὰς ἀγκάλας ἄγγελοι). The modification is not understandable in the context of the quranic verse, although the syntax is continued congruently and logically despite this modification. One possibility would be that the word *aqlāmahum* (pens) was translated as ἀγκάλας (arms) for the phonetic proximity between / aqlā- / (*aqlāmahum*) and / aŋkalá- / (ἀγκάλας). Moreover, "the angels" are an addition to the Greek text with no equivalence in the Quran in this particular verse. However, the logical subject implicit in Arabic is not "the angels" but the men who are throwing the pens of the oracle.[141] The word ἄγγελοι might have been included because otherwise the subject of ἥπλωσαν would have been unknown. If so, the one who inserted the angels into the Greek text might have referred to Q 3:42, a verse Nicetas quotes as a paraphrase shortly before,[142] where the angels are mentioned as those who are speaking to Mary.[143]

We cannot know who the author of this modification of the quranic text is. However, the person who inserted ἄγγελοι did not insert the right subject according to the quranic context, namely, "they" who "cast their pens." The quranic story (and therefore "they") is unknown in the canonical Christian tradition.

However, we indeed know this story from the Christian apocryphal tradition that has its liturgical manifestation as the feast of Mary's Presentation in the Temple (21 November).[144] The Gospel of Pseudo-Matthew mentions angels in relation to "pens,"[145] to which Q 3:44 refers intertextually.[146] So the combination of both elements, the "pens" and "angels" (as the subjects casting the pens), and the substitution of the quranic subject of ἥπλωσαν/*yulqūna* (i.e., the men) by "the angels" in the Greek text, could be seen as a result of an unconscious association with Christian intertexts that led to the misinterpretation of the quranic text.

We also find textual alterations subconsciously evoking Christian associations among Greek readers in the rendering of other passages. For example, the title of sura Q 3 (Āl ʿImrān) refers to the quranic figure ʿImrān. However, his name is not transliterated according to the Arabic text, in contrast to many other cases of quranic

141 Khoury, *Der Koran*, 106–7.

142 Ἐφεξῆς δὲ τοὺς ἀγγέλους εἰσ(69v)άγει πρὸς Μαρίαν εἰρηκότας, ὅτι . . . (And in the following, he [sc. Muḥammad] introduces the angels, saying to Mary that . . .) (Conf. II, 23).

143 *wa-idh qālati l-malāʾikatu yā maryamu . . .* (And when the angels said, "O Mary . . .") (Q 3:42).

144 For the liturgical texts concerning this feast, see B. Koutloumousianos Imbrios, *Μηναῖον τοῦ Νοεμβρίου* (Athens, 1993), 386–418.

145 See C. Markschies and J. Schröter, *Antike christliche Apokryphen in deutscher Übersetzung*, 7th ed. (Tübingen, 2012), 993. The liturgical texts about Mary in the *Mēnaion* at her religious feasts (in particular 25 March, 15 August, and 31 August), in contrast, do not mention pens (see the respective volumes above, n. 144), while a majority of the apocryphal Mariological literature does. Besides, there seems to be no Syriac rendering of that Quran verse (my thanks for this information from Bert Jacobs, 8 May 2020, personal communication) that might shed light on the Syriac tradition of this passage.

146 See also D. Kiltz, Y. Kouriyhe, and S. Teber, "Lebensgeschichte der Gottesmutter Maria - TUK_0035," *Corpus Corsicanum*, beta version, 15 August 2023, https://corpuscoranicum.de/de/verse-navigator/sura/19/verse/28/intertexts/37.

proper names.[147] The name ʿImrān has rather been interpreted as the biblical figure Abraham, rendering the sura's title as "εἰς τοὺς τοῦ Ἀβραὰμ" (to those of Abraham).[148] It is noteworthy that, due to this modification, we now have two suras in the *Coranus Graecus* referring to the same figure (Abraham), because the title of sura 14 is written (in agreement with the Arabic version) as "εἰς [...] τὸν Ἀβραὰμ" (To Abraham).[149]

Of course, there is always the possibility of attributing this modification to the copyist[150] or to claim that Nicetas himself changed the text he copied from the Greek translation of the Quran. However, with respect to the former, the orthographical difference between Ἀβραάμ and Ἰμβράν in Greek minuscule would be a rather significant change, and more than one error in copying has to be assumed. This seems unlikely.[151] As for the latter, we already tried to illustrate that Nicetas did indeed pick out different passages from the Greek translation, but, once he quoted them, he actually did not change the original text as far as we can tell.[152] However, the main argument here again is to evaluate the overall picture of small variances that occur within the *Coranus Graecus*. The alteration from ʿImrān to Abraham again demonstrates a shift from a Muslim conceptualization toward a Christian reading of the Quran. The translator(s) apparently transferred the quranic figure ʿImrān, unknown to the Christian tradition, into his/their own Christian frame by understanding the former name as one known in the Bible.

The last aspect we shall examine is the skill of the translator(s) for finding adequate and equivalent translations, especially of theological terms. I will give two examples that might open new venues for discussions of the cultural-religious background of the translator(s).[153] First, sura Q 2:23 (al-Baqara) refers to the linguistic characteristics of the revelation. Therein, God in the Quran

asks, "And if you are in doubt about what we [sc. God] have sent down upon our Servant [sc. Muḥammad], then produce a sura the like thereof."[154] The term *sūra* has been translated into Greek as ᾠδή (ode),[155] which at first glance is not such an obvious translation. However, the translation shows in this way a remarkable understanding of the liturgical-performative character of both Muslim and Christian worship practices and very accurately renders the Arabic meaning into Greek, for "ode" is a *terminus technicus* par excellence of Byzantine liturgy, indicating a certain genre of hymn.[156] The ode was ever-present in liturgical life—whether as the nine Biblical Odes[157] or as part of the canon.[158] Odes were loudly recited in a melodical way during religious rites in both the synagogue and the church.[159] That is what the translator must have associated the term *sūra* with while translating it into Greek; the sura—that is, a part of the Muslim liturgical text used for worship (i.e., the Quran)[160]—is recited during Muslim prayer in a similarly melodical way (*tajwīd*/*qirāʾa*). That is the reason the translator interpreted the word *sūra* with a term

147 See above, n. 87, and Høgel, "Early Anonymous Greek Translation," 71.

148 Vat. gr. 681, fol. 68r, 10–11. Förstel corrects the manuscript to Ἀμβρὰμ (Conf. II, 2–3) and Mai to Ἀμρὰν (PG 105:724). Both emendations obliterate the essential point of the transcription of the manuscript.

149 Vat. gr. 681, fol. 113v, 4 (Conf. XIII, 2).

150 In Greek minuscule, there are indeed some similarities between mu (μ) and beta (β) as well as mu (μ) and nu (ν).

151 See above, p. 230.

152 See above, pp. 227–29, 231.

153 See Ulbricht, *at-Tarǧamah*, 52.

154 *wa-in kuntum fī raybin mimmā nazzalnā ʿalā ʿabdinā fa-ʾtū bi-sūratin min mithlihī* (Q 2:23).

155 Conf. I, 184.

156 K. Onasch, *Lexikon Liturgie und Kunst der Ostkirche unter Berücksichtigung der alten Kirche* (Berlin, 1993), s.v. Oden.

157 Like the Magnificat, Μεγαλύνει ἡ ψυχή μου... (My soul doth magnify...) or Benedictus, Εὐλογητὸς κύριος ὁ θεός (Blessed be the Lord...) (edition: R. Hanhart, ed., *Septuaginta: Id est Vetus Testamentum graece iuxta LXX interpretes*, rev. ed. [Stuttgart, 2006], 164–83).

158 Nine odes form a canon (κανών), the poetical masterpiece of Byzantine hymnology (Onasch, *Lexikon Liturgie und Kunst*, s.v. Kanon; Kanon, Goldener; and Kanon, Großer). One of the canon's most famous authors is John of Damascus himself with his well-known "Golden Canon" of the Easter Feast (see Onasch, *Lexikon Liturgie und Kunst*, s.v. Kanon, Goldener). The Byzantine odes originally derive from the nine Biblical Odes and their later performance in the Jewish synagogue liturgical practice that found its way into Orthodox rites.

159 The Greek terms are *psallein* and *psalmōdia*, from which arose the English term "psalm."

160 The word *sūra* originally did not necessarily mean the whole of a "chapter" of the Quran, as we understand it today (e.g., sura al-Baqara, sura Āl ʿImrān, etc.), but it referred to any kind of section of the Quran of non-defined length in general (A. Neuwirth, "Structural, Linguistic and Literary Features," in *The Cambridge Companion to the Qurʾān*, ed. J. D. McAuliffe [Cambridge, 2006], 97)—like how an ode is also just a section of a larger text, the canon.

related to religious chants in Greek.[161] This can only mean that he did not merely know the meaning of the technical term within Christian liturgical understanding but that he also was acquainted with the Muslim analogous function of a sura, that is, its liturgical use through its recitation during Muslim prayer.

In addition, the term ᾠδή in Greek is a highly technical term, the general meaning of which is profane singing;[162] it is used only within a very restricted framework for religious songs.[163] Using this specific term in a Greek translation of a religious text (like the Quran) implies a Christian background for the translator because in Byzantine-Greek culture, the word ᾠδή mainly appears in liturgical and hymnological contexts. A general knowledge of religious parlance or the use of Greek as the mother tongue would not be enough to reasonably argue that somebody who was not deeply acquainted with the technical language of Byzantine-Orthodox worship would have used this specific term.

These observations also shed light on another translation of an equally liturgically relevant term: the quranic term *al-Qur'ān* is translated as τὸ ἀνάγνωσμα (the reading) in the verse *shahru ramaḍāna lladhī unzila fīhi al-Qur'ānu hudan li-l-nāsi* (Q 2:185; cf. Conf. I, 342).[164] The Greek meaning fully reflects the semantics of the Arabic root *q-r-'* of the word *Qur'ān*, both implying reading/recitation.[165] Therefore, it is indeed an obvious and simultaneously sensitive choice to translate the name of the Muslim holy book. It moreover fits into the interlinear character of the translation, which renders the Arabic text not only in

terms of syntax but also semantics.[166] However, this translation is nevertheless noteworthy because of two reasons: First, other (albeit later) polemical works, like the *Abjuration* and the *Elenchus* (the latter written by Bartholomew of Edessa), do not use this term but refer to the Quran as τὸν [...] Κουρὰν[167] and κουράνιον,[168] respectively. Second, the translator would have had the possibility of using a lexical alternative, such as the synonym ἀνάγνωσις. This term was also used in liturgical contexts;[169] nevertheless, the translator decided to use the term ἀνάγνωσμα. There also might be a reason: analogous to the translation of *sūra*/ᾠδή, the term ἀνάγνωσμα bears in its meaning a liturgical-performative dimension, too. This is the technical term used within the Christian liturgy (and not ἀνάγνωσις) that is written in liturgical books over the respective pericope to be read during service, describing the "reading" of the scripture (Lat. *lectio*).[170] So having in mind both translations of *sūra* and *al-Qur'ān*, it indeed seems that the translator(s) consciously chose these options in Greek. This points to a performative understanding of both terms and their respective liturgical use in Islamic rites, giving us some hints as to the cultural-religious background of the translator(s).

Conclusion: A Christian Background of the Translator(s)

We do not know who commissioned and/or authored the translation, nor do we know what the motivation or historical background was behind this undertaking. Different opinions on the authorship have been expressed,[171] though without an overall and systematic

161 It is noteworthy that oral and aural transmission play a highly important role in learning quranic sciences (such as for Byzantine hymnology [ὑμνολογία] and the intonation of the psalms [ψαλμῳδία]), especially when it comes to the sound pronunciation (*tajwīd*) and recitation (*qirā'a*) of the Quran.

162 LSJ, s.v. ᾠδή, and Lampe, *Patristic Greek Lexicon*, s.v. ᾠδή, no. 2.

163 See Lampe, *Patristic Greek Lexicon*, s.v. ᾠδή, no. 1.

164 "The month of Ramadan [is that] in which was revealed the Quran, a guidance for the people" (Q 2:185). For the interpretation of this verse, see also Ulbricht, "Klassifizierung," 133–35, and Ulbricht "Verwendungsweise," 500–502.

165 Muḥammad b. Jarīr al-Ṭabarī, *Tafsīr al-Ṭabarī: Jāmiʿ al-bayān ʿan taʾwīl al-Qurʾān*, ed. M. M. Shākir and A. M. Shākir (Cairo, 1954), 1:94, quoted in W. A. Graham, "The Earliest Meaning of 'Qurʾān,'" *Die Welt des Islams* 23–24 (1984): 361–77, at 364, n. 14 (see also 365), and Jeffery, *Foreign Vocabulary*, 233–34; cf. also the Latin *legere*, like the German "lesen."

166 See above, pp. 226–27, and Høgel, "Early Anonymous Greek Translation," 68–72.

167 Montet, *Un rituel d'abjuration*, 149, lines 12–13; see also PG 140:128, where it is written as Κουρᾶν.

168 ἐν αὐτοῦ Κουρανίου σου (K.-P. Todt, *Bartholomaios von Edessa: Confutatio Agareni. Kommentierte griechisch–deutsche Textausgabe* [Würzburg, 1988], 6, line 13, and PG 104:1385).

169 For the identical meaning of both terms, see Lampe, *Patristic Greek Lexicon*, s.v. ἀνάγνωσις and ἀνάγνωσμα. See also LSJ, s.v. ἀνάγνωσις and ἀνάγνωσμα. For the liturgical use of ἀνάγνωσις, see especially Lampe, *Patristic Greek Lexicon*, s.v. ἀνάγνωσις, nos. A.2.b., d., e., and B.2.

170 E.g., Πρὸς... ἐπιστολῆς Παύλου τὸ ἀνάγνωσμα.

171 Glei, "Der Mistkäfer und andere Missverständnisse," 24; Høgel, "Early Anonymous Greek Translation," 67, 73; C. Høgel, "The Greek

philological-theological analysis of the remaining fragments in the *Coranus Graecus*. Sidney Griffith has proposed, without giving textual evidence, "that the *Qur'ān* translations were supplied by some one of the numerous refugees from Palestine in Constantinople in the ninth century, especially monks from the Holy Land monasteries, who already had experience in Muslim/Christian dialogue."[172] Indeed, the passages I presented before substantiate Griffith's assumption of the cultural-religious origin of the Greek translation of the Quran: the fragments, which were modified, all deal with central points of discussion between Islam and Christianity. So we may conclude that these modifications are not made by chance but that they originate in a certain hermeneutical reading of the Quran.

This conclusion is the result of the analysis of selected examples of quranic verses in Greek and Arabic that are related to Christian–Muslim interreligious topics based on the manuscript evidence as preserved in the Vat. gr. 681 (without any editorial interpretations because of possible emendations, corrections, etc.) and on the Arabic text of the Quran (including the different *qirā'āt*). It is obvious and, thus, known that the translator(s) generally rendered the Arabic text accurately into Greek in terms of syntax and semantics.[173] However, the examples provided above furthermore demonstrate a highly sensitive method of translating the liturgically relevant terms and dogmatically relevant content of the Quran into a genuinely Byzantine-Greek context. Therefore, it does not appear convincing to give this translation a Muslim origin.[174] It is hardly possible that a Muslim would have modified crucial names, expressions, and concepts of Islam into expressions bearing genuine Christian connotations and evoking dogmatical associations as documented in the *Coranus Graecus*. In contrast, a Muslim would have paid special attention to these important points of disagreement with Christianity.

In addition, one would have had to explain the motivation for a Muslim environment to translate its sacred book into Greek language. The Arabic language is directly linked to the quranic text, and it is seen as the holy language of God's revelation to humankind that had originally been sent down by God διὰ ἀραβικῶν γραμμάτων (through Arabic letters).[175] If, as Høgel states, the origin of the translation had been in "a religious community whether for liturgy, missionary activities, or as help for the non-Arabic believer,"[176] special attention would have been paid to theologically relevant contexts in order not to leave dogmatic ambiguities, particularly in Christological and thus soteriological passages. As for the mentioned possible liturgical use, it remains unclear what kind of Muslim worship practice would use a Greek translation of the Quran, since Islamic prayer and worship (*ṣalāt*, *dhikr*, et al.) are exclusively performed in Arabic language due to their sacred nature in Islam.

Another possibility would be to assume an official origin of the translation, such "as an administrative tool in a Muslim, but (at least partly) Greek-speaking state."[177] However, it is not clear what need there would be for such a translation within Muslim administration. An argument against the translation's official origin might be its lack of homogeneity concerning transliterated proper names and the rendering of syntactical constructions; we find a number of different Greek transliterations of Arabic names,[178] and the very same Arabic syntagmata are constructed differently in the Greek version throughout the *Coranus Graecus*.[179] If there was "a need for a precise way of referring to the holy book also in the administrative language,"[180] we might expect that the translation would have been homogenous and coherent in itself regarding transliterations and grammatical constructions. In addition, the use of vulgar and colloquial Byzantine Greek within the translation is remarkable, as there are several expressions and constructions

Qur'an: Scholarship and Evaluations," suppl., *Orientalia Suecana* 61 (2012): 173–81, at 174; and Versteegh, "Greek Translations of the Qur'ān," 64–66.

172 S. H. Griffith, "Byzantium and the Christians in the World of Islam: Constantinople and the Church in the Holy Land in the Ninth Century," *Medieval Encounters* 3.3 (1997): 231–65, at 263.

173 Cf. the general remarks in Høgel, "Early Anonymous Greek Translation," 68–72 (introductory chapter).

174 In contrast to Høgel, "Early Anonymous Greek Translation," 67, 72–74, esp. 67, 73, and Høgel, "Greek Qur'an," 174.

175 *innā anzalnāhu Qur'ānan 'arabiyyan* (Q 12:2); cf. Conf. XI, 8–9.

176 Høgel, "Early Anonymous Greek Translation," 72.

177 Høgel, "Early Anonymous Greek Translation," 72 (see also 73); cf. Glei, "Der Mistkäfer und andere Missverständnisse," 24.

178 See above, n. 87.

179 See above, n. 86.

180 Høgel, "Early Anonymous Greek Translation," 73.

deriving from non-classical Greek.[181] We may object that other kinds of official documents (e.g., papyri) also make use of everyday language. However, the lack of homogeneity and coherence of the whole translation, as well as the use of non-erudite Greek, may point to a milieu other than the official administrations of the Eastern Roman Empire. We indeed find a more classical, reworked version of this quranic translation in the later work of Euthymius Zigabenus (mid-tenth/eleventh century) that is based on Nicetas's *Refutation of the Quran*. Euthymius wrote his *Armor of Doctrines*[182] at the command of Alexius I (ca. 1057–1118, r. from 1081), redacting an official work. He therefore systematically polished the colloquial Greek into classical forms.[183] Based on the philological characteristics of the *Coranus Graecus*, I am not convinced that the Greek translation of the Quran has official (imperial) origins in the Byzantine administration.

I rather expect it originated in another social milieu; the lack of homogeneity and inconsistency of the translation point to a group of authors rather than a single person.[184] The question is what their motivation was in translating the whole Quran[185] and what group would have the resources and, of course, the time to dedicate themselves to such an endeavor. We have also seen that the translator(s) undoubtedly also had intimate knowledge of Christian rites and their *termini technici* as well as Islamic rituals and everyday worship practices.[186] For example, the term *tayammama* (to prepare for prayer, rub yourself with earth instead of water) (Q 5:6) is rendered in the *Coranus Graecus* as καθαρίζειν [...] χώματι (to clean with soil) (Conf. IV, 7–8), which is a perfect paraphrase in Greek of the technical term for Muslim worship practice.[187] As Nicetas's paraphrases of the quranic text are based on the actual Greek translation,[188] this means that the translator of this passage must have not only known both languages very well but must have also been acquainted with the practical application and terminology of religious worship in both religions.

Therefore, a Christian environment is the most probable milieu for the origin of the early Greek translation of the Quran. Since there were many monasteries in the Eastern Mediterranean region and it was an area with an active spiritual life in late antiquity, it might be reasonable to suggest a monastic environment as the point of intellectual origin for the translation; maybe a monastic community in the *Oriens Christianus* was working on translating its neighbor's holy scripture. This would not only explain the differences in passages in the Greek text, which are identical in Arabic, but it would also reasonably explain the sensibility for liturgical terms and the knowledge of their *Sitz im Leben* in the respective religion, such as ἀνάγνωσμα (reading) for *al-Qurʾān* and ᾠδή (ode) for *sūra*. Eastern Christians could have easily been acquainted with this knowledge from firsthand experience through a lived religious coexistence with Muslims. In addition, clerics and especially monks who were living in the Islamicate world would have had a motive to translate the whole Quran: they wanted to understand the holy book of their new rulers and make its contents understandable to fellow Christians. As addressees of the Greek translation of the Quran, I therefore regard a Christian readership as plausible. We know about the same kind of heresiological interest in Islam since the very beginning of Christian–Muslim relations, such as in the argumentation of Anastasius of Sinai, followed by the sharp treatise of John of Damascus and the sophisticated dialogues of Theodore Abū Qurra. Translating the Quran could have been part of this larger scholarly interest among the monastic clergy in studying "the other." Besides that, monks were often multilingual, and they had the time, resources, and motivation to undertake such an endeavor.

181 αὐτὸς (Conf. I, 328–30 [cf. Q 2:168]; Conf. XII, 3–4 [cf. Q 13:2–3, 13:12, 13:17]); ἀπὸ (Conf. I, 328–30 [cf. Q 2:168]); ἄσπρον (Conf. I, 342–50 [cf. Q 2:185–87]); μέσα (Conf. II, 66–69 [cf. Q 3:64]); εἰς (Conf. II, 98–100 [cf. Q 3:96–97]; Conf. XX, 23–27 [cf. Q 11:6, 11:61–68]; Conf. XV, 13–14 [cf. Q 16:124]; Conf. XVIII, 46–47 [cf. Q 53:26]; Conf. XVIII, 112–14 [cf. Q 95:1–5]); σκυλίν (Conf. XVII, 12–19 [cf. Q 18:18, 18:21–22]); and ὁσπίτιν (Conf. XVIII, 33–36 [cf. Q 52:1–6]). See also the study by Trapp, "Koranübersetzung?," 11–14.

182 See above, n. 24.

183 Trapp, "Koranübersetzung?," 14; cf. Förstel, *Arethas und Euthymios Zigabenos*, 14.

184 See Høgel, "Early Anonymous Greek Translation," 72: "Whoever produced the translation (and more than one person may well have been involved in the process), it should be stressed that, despite the mentioned linguistic features that may seem to point to a humble origin, it is actually of high quality."

185 For evidence that the Quran was translated in its entirety, see Ulbricht, "Nachweis der Existenz."

186 See above, pp. 239–40.

187 We also find epexegetic insertions in quranic verses that regulate religious practices such as fasting (see Conf. I, 342–50 = Q 2:187).

188 See Ulbricht, "Verwendungsweise," 513–17.

In my opinion, there is no need to think a proselyte made the translation. A Muslim converting to Christianity would have known about the differing concepts in the two scriptures and it is thus difficult to explain why he should change the original meaning of the Quran in Greek.[189] For social reasons, it was more attractive for a Christian to become a Muslim, but a Christian convert to Islam would have also paid special attention to the theological differences. Regardless, the author(s) of the Greek translation of the Quran seem(s) to have read the Quran through a Christian prism. The translation was not necessarily intended as an attack on Islam, but it might rather be seen as the result of a translation process that was influenced by a Christian background. I have documented various philological indications for the argument presented here. Other estimations of the translation's possible origin are, in my opinion, difficult to support with the source material. Of course, I cannot prove unequivocally whether all the modifications within the transmitted text of the *Coranus Graecus* were done on purpose or by unconscious associations of the translator(s) due to his/their cultural-religious background. What is undisputed, however, is that the translation was not intended for polemics but rather that its author(s) held a sincere interest in and had knowledge of the religious customs, concepts, and worship practice of both Christianity and Islam. All this points to an Eastern Christian milieu of authorship.

The question of the intellectual origin of the translation, however, must be viewed independently from the question of where it was made geographically. The undertaking might have been realized in the capital of Constantinople by a Christian from the Middle East, as Griffith has proposed, although the text itself gives no indication of that.[190] Another question is how the translation finally found its way to Nicetas. Of course, we know about the rich library of Arethas of Caesarea (fl. first half of the tenth century), and it might be worth thinking about intellectual contexts like that in order to trace the provenience of the Greek translation. However, this would require additional research, including a wide-ranging study of the relevant manuscripts. These are aspects which lead the discussion into other directions worthy of study in different contexts. In any case, there are any number of tantalizing avenues for further exploration.

University of Notre Dame
Medieval Institute
715 Hesburgh Library
Notre Dame, IN 46556
manolis.ulbricht@nd.edu

189 In one passage Nicetas mentions a person "who has come over to the Christians" (Conf. I, 318–19). But Nicetas actually only says the following: Ὡς δὲ παρά τινος ἐξ αὐτῶν εἰς Χριστιανοὺς ἐλθόντος ἐμάθομεν, εἴδωλόν τι λίθινον κάθηται δῆθεν μέσον τοῦ οἴκου· καὶ οἱ τὴν πρόσταξιν τοῦ δαιμονιώδους τούτου πληροῦντες κεκλικότες τοὺς ἀθλίους αὐτῶν αὐχένας καὶ τὴν χεῖρα ὄρθιον πρὸς αὐτὸ ἐκτετακότες τῇ τε ἑτέρᾳ τὸ οὖς αὐτῶν κατέχοντες κυκλοτερῶς εἰλοῦνται, μέχρις ἂν σκοτοδινίᾳ ληφθέντες καταπέσωσι (As we have learned from one of their people who has come over to the Christians, a stone idol sits in the middle of the house. So the people who fulfill the instructions of this man possessed by the demon bow their miserable necks, stretch one hand out up to the idol, hold with the other their ear, and run in circles until they fall down gripped by giddiness) (Conf. I, 318–23).

190 Griffith, "Byzantium and the Christians in the World of Islam," 263.

☞ THIS PAPER WAS PREPARED FOR PUBLICATION during a Feodor Lynen Research Fellowship (May 2019 to October 2021) of the Alexander von Humboldt Foundation. I thank the foundation for its generous support as well as the host institution, the Department of Byzantine Philology and Folkloristics at the National and Kapodistrian University of Athens (Faculty of Philology), for its hospitality during my research fellowship. I thank Christian Høgel and Theodora Antonopoulou for their critical remarks on an earlier version of this article as well as the anonymous reviewers.

Archival Evidence and Byzantine Art in Fifteenth-Century Venetian Crete
The Case of Georgios Mavrianos and Konstantinos Gaitanas

ELEFTHERIOS DESPOTAKIS AND VASILIKI TSAMAKDA

Unfortunately the history of Byzantine art does not have sources such as Pliny the Elder's *Natural History* or Vasari's *Lives of the Most Excellent Painters, Sculptors, and Architects* at its disposal. Hence Our [*sic*] knowledge of the artists who worked on the territory of the Byzantine Empire and the regions under its cultural influence is rather scarce. It is mostly based on the rare signatures of artists and the even rarer mentions of their names or their works in written sources, usually in chronicles, private letters, hagiographies, legal documents[,] etc. The Late Byzantine period has fared somewhat better as more material [has] survived from this time. . . . Venetian archives are particularly important as they contain evidence on the work of Cretan artists from this period.

So Miodrag Marković began his presentation at the Byzantine Studies Colloquium entitled Monumental Painting in Byzantium and Beyond: New Perspectives held at Dumbarton Oaks in 2016.[1] Marković was certainly aware of the research of Father Mario Cattapan, who was the first to highlight the importance of archival documents for the study of Byzantine art on Crete under Venetian rule. In the late 1960s, Cattapan consulted over five hundred thousand acts from the archival series *Duca di Candia* and *Notai di Candia* and compiled a list of 132 painters active on Crete from 1313 to 1500. More than fifty years after Cattapan's research on the State Archives of Venice, the present article aims to connect for the first time commissions to painters documented in Veneto-Cretan notarial deeds with surviving church decoration programs. Specifically, we will connect published and unpublished contracts with wall paintings executed by two painters: Georgios Mavrianos in the churches of St. George in Vrachasi and Panagia in Kato Symi and Konstantinos Gaitanas in the Church of the Holy Apostles in Kato Karkasa. Their work will be thoroughly presented and analyzed in connection with the content of the relevant documents, and it will be placed within the context of contemporary art. With a view to evaluating the information given both by the documents referring to these three churches and the ensuing art-historical analysis, we begin with an overview of the published archival material and the pertinent information it provides on commissions of wall paintings and on the painters themselves.

Between 1969 and 1972, Cattapan published forty-two archival documents, among which we find contracts of apprenticeship, partnerships of painters, and contracts for Byzantine icons and wall-painting commissions.[2] Based on Cattapan's findings, scholarship has

1 M. Marković, "Painters in the Late Byzantine World (1204–1453)" (paper, Byzantine Studies Colloquium, Dumbarton Oaks, 4 November 2016).

2 M. Cattapan, "Nuovi elenchi e documenti dei pittori in Creta dal 1300 al 1500," Θησαυρίσματα 9 (1972): 202–35; cf. Cattapan's first

so far focused on icon commissions with little attention paid to the commissions of wall paintings in Venetian Crete.[3] As Cattapan has already observed, the churches decorated with wall paintings outnumber by far the preserved contracts.[4] Indeed, Cattapan published eight archival documents of wall-painting commissions and mentioned three more, which prove that a contract between the artist and the person who made the commission existed. However, none of these contracts has ever been connected to any of the 845 churches listed by Giuseppe Gerola and Kostas Lassithiotakes, nor to any other surviving church.

Cattapan published contracts of wall-painting commissions that involved the following painters: (1) Nikolaos Vassalos, employed by Markos Mouatsos (*Mudacio*) to paint the Church of Panagia in Varvari (*Vairvari*) (1331);[5] (2) Ioannes Gradenigos, employed by the hieromonk Daniel Gastreas to paint the Church of Christ Pantokrator, probably in Chandax (1353);[6] (3) Ioannes Frangos, employed by Konstantios Gerardos to paint the Church of St. George in Kyrmousi (1371);[7] (4) Georgios Mavrianos, employed by the Venetian noble Nicola Corner to paint subjects from the life of Jesus Christ and the Virgin in the Church of Panagia in Kato Symi (1419);[8] (5) Emmanuel Souranas (*Surana*, read by Cattapan as *Hurana*) and Andronikos Synadenos, both engaged by Georgios Piperes to paint the Church of Panagia in Malia (*Damalia*) (1399);[9] (6) Angelos Apokafkos, employed by Markos Pavlopoulos to paint the Last Judgment in the Church of Panagia of the Angels (*Sancta Maria Angelorum*) in Chandax (1421; modern Heraklion);[10] (7) Georgios Mavrianos (*Mauriano*, read by Cattapan as *Mancuso*), employed by the commissaries of the Venetian noble Anna Correr (*Corrario*, read by Cattapan as *Cornario*) to paint Christ the Savior and other saints in the Church of Christ the Savior in Kitharida (*Chitharida*, read by Cattapan as *Chitanda*) (1422);[11] and (8) Georgios Pelegrin, engaged by Lauro Querini, commissary of the Venetian noble Mandalucia Querini, to paint the Crucifixion in the Church of St. Hieronymus, probably in Chandax (1470).[12] Three additional documents have been left by Cattapan without transcription and unfortunately without archival references. These refer to (9) the abovementioned Georgios Mavrianos, who received a payment for his work in the Church of St. George in Vrachasi (*Vraghassi*, read by Cattapan as *Veargassi*) (1401); (10) Konstantinos Moschatos, who returned the payment he had received in advance because he had not finished his work at an unnamed church (1402); and (11) Alexios Apokafkos, who promised to paint some curtains after his return from Valsamonero (1412).[13]

3 See, for example, M. Vassilaki, "Looking at Icons and Contracts for Their Commission in Fifteenth-Century Venetian Crete," in *Paths to Europe: From Byzantium to the Low Countries*, ed. B. Coulie (Milan, 2017), 101–16; M. Vassilaki, "Commissioning Art in Fifteenth-Century Venetian Crete: The Case of Sinai," in *I Greci durante la venetocrazia: Uomini, spazio, idee (XIII–XVIII sec.); Atti del convegno internazionale studi; Venezia, 3–7 dicembre, 2007*, ed. C. Maltezou, A. Tzavara, and D. Vlassi (Venice, 2009), 741–48, 839–43; and M. Constantoudaki–Kitromilides, "Aspetti della committenza artistica a Creta veneziana secondo documenti d'archivio (pittura, argenteria, oreficeria)," in *Economia e arte, secc. XIII–XVIII: Atti della trentatreesima Settimana di studi, 30 aprile–4 maggio 2001*, ed. S. Cavaciocchi (Firenze, 2002), 601–10, at 606–7.

4 Cattapan, "Nuovi elenchi," 231; for an incomplete list of Cretan churches decorated with wall paintings, see G. Gerola, *Elenco topografico delle chiese affrescate di Creta* (Venice, 1935), also published in Greek translation by K. E. Lassithiotakes: G. Gerola and K. E. Lassithiotakes, *Τοπογραφικός κατάλογος τῶν τοιχογραφημένων ἐκκλησιῶν τῆς Κρήτης* (Heraklion, 1961). Lassithiotakes added more churches to Gerola's initial list.

5 Cattapan, "Nuovi elenchi," 227, doc. 26. This contract was later canceled with the consent of both parties.

6 Cattapan, "Nuovi elenchi," 227–28, doc. 27.

7 Cattapan, "Nuovi elenchi," 228, doc. 28.

8 Cattapan, "Nuovi elenchi," 228–29, doc. 29.

9 Cattapan, "Nuovi elenchi," 229–30, doc. 30.

10 Cattapan, "Nuovi elenchi," 230, doc. 31. The subject of the Last Judgment was erroneously transcribed by Cattapan as *dhestera parisia* instead of *Deftera Parusia*.

11 Cattapan, "Nuovi elenchi," 230–31, doc. 32.

12 Cattapan, "Nuovi elenchi," 231, doc. 33.

13 Cattapan, "Nuovi elenchi," 226, 232. This document, however, does not disclose the nature of Apokafkos's business in Valsamonero. For the attribution of some of the wall paintings of the church to this painter, see M. Constantoudaki-Kitromilides, "Alexios and Anghelos Apokafkos, Constantinopolitan Painters in Crete (1399–1421): Documents from the State Archives in Venice," *Proceedings of the 21st CIEB* (London, 2006), 45–46, and A. Katsiote, "Τὸ κλίτος τοῦ ἁγίου Ἰωάννη τοῦ Προδρόμου," in *Οἱ τοιχογραφίες τῆς Μονῆς τοῦ Βαλσαμονέρου: Ἀπόψεις καὶ φρονήματα τῆς ὕστερης βυζαντινῆς ζωγραφικῆς στὴ βενετοκρατούμενη Κρήτη*, ed. M. Acheimastou-Potamianou, A. Katsiote, and M. Borboudake (Athens, 2020), 181–290, esp. 183–85, with the earlier bibliography.

In the 132 painters listed by Cattapan, there are only eleven cases in which the place of the painters' origin is stated. More specifically, four painters were from Constantinople (Theodoros Museles, Georgios Chrysokephalos, Emmanuel Ouranos, and Ioannes *Tu Maistro*), four from Venice (Gioacchino Tedaldo, Benedetto Gradenigo, Fantino Morante, and Nicola Storlando), two from the Peloponnese (Ioannes Strilitsas of Bathas and Georgios Strilitsas of Bathas), and one from Cyprus (Bailianos Katellanos).[14] In the contracts of wall-painting commissions published by Cattapan, none of the painters are from Constantinople.[15] Cattapan indicated Tenedos as the place of origin of Alexios Apokafkos, and perhaps also of Nikolaos Philanthropenos, but did not mention his sources.[16] This might be a conjecture based on a source other than the archival documents, and this is why Cattapan did not mention it. Among the hundreds of dedicatory inscriptions on Crete, there is only one that mentions the painter's place of origin. At the Church of Agioi Pateres in Ano Floria, the inscription states that the frescoes were created in 1470 by Xenos Digenes from the Peloponnese (Morea).[17] This painter is not included in Cattapan's list because he does not appear in the Veneto-Cretan archival documents.

Declaring the place of origin was common in the notarial deeds only for those who were on Crete temporarily or for those who had just arrived to Crete as immigrants due to economic or other reasons.[18] It follows that in the great majority of cases when no place of origin was given, the painters were from Crete. This is particularly important in view of the discussion about the origin of the painters who created several Cretan church decorations of high quality in the first half of the fifteenth century. These high-quality programs, combined with the fact that Crete was a place of refuge, have led scholars to attribute arbitrarily a Constantinopolitan origin to painters active on Crete during that period.[19] A further reason for

14 See nos. 11, 13, 15, 20, 21, 28, 32–33, 38, 111–12 of Cattapan's list (Cattapan, "Nuovi elenchi," 203–8). A questionable entry is that of the monk (*frate*) Antonio da Negroponte (no. 109), whose Euboean origin is not clearly affirmed by Cattapan.

15 Emmanuel Ouranos from Constantinople has been previously identified by Cattapan and other scholars with Emmanuel Souranas, who was hired together with Andronikos Synadenos to paint the Church of Panagia in Malia in 1399 (see above, p. 246). Cattapan lists this painter as "Urana (Uranò) Emmanuele di Con. poli, 1399–1414" (Cattapan, "Nuovi documenti," 37, no. 33; cf. Cattapan, "Nuovi elenchi," 204, no. 33). Indeed, this is the way the painter was recorded in the notarial registers in: (a) 1402 (*Urano*) (Archivio di Stato di Venezia [henceforth A.S.V.], *Notai di Candia*, b. 145 [Costanzo Maurica], quad. 1, fol. 241r; cf. Cattapan, "Nuovi elenchi," 219, doc. 14); (b) 1413 (*Vrana*) (A.S.V., *Notai di Candia*, b. 245 [Andrea Sevasto], fol. 47v); and (c) 1413 (*Urana*) (A.S.V., *Notai di Candia*, b. 245 [Andrea Sevasto], fol. 47v). The painter's name has been understood by Maria Constantoudaki-Kitromilides as "Vranas" (M. Constantoudaki-Kitromilides, "Viaggi di pittori tra Costantinopoli e Candia: Documenti d'archivio e influssi sull'arte [XIV–XV sec.]," in *I Greci durante la venetocrazia* [cf. n. 3], 709–23, at 712–13). However, both Venetian notaries, namely Costanzo Maurica and Andrea Sevasto, use a clear form for the Latin letter "v" that should not be read as a "u" at the beginning of the word (e.g., *vocato*, *vobis*, *viri* instead of *uocato*, *uobis*, *uiri*). Therefore, the use of "v" in the first document of 1413 probably constitutes an exception. Finally, the aforementioned two documents of 1402 and 1413 refer to Emmanuel Ouranos as originating from Constantinople. Notwithstanding, the document of 1399 concerning the wall-painting commission for the Church of Panagia in Malia refers to a certain Emmanuel Souranas without mentioning his place of origin. For this reason, the identification of Emmanuel Souranas with Emmanuel Ouranos from Constantinople should at present be considered incorrect.

16 Cattapan, "Nuovi elenchi," 232.

17 G. Gerola, *Monumenti veneti nell'isola di Creta*, 4 vols. (Venice, 1905–1932), 4:449–51, no. 24. For the correct reading of the date, see P. L. Vocotopoulos, "Ἡ χρονολογία των τοιχογραφιών του Ξένου Διγενή στα Απάνω Φλώρια Σέλινου," in Ἀρχαιολογικά Ἀνάλεκτα ἐξ Ἀθηνών 16.1–2 (1983): 142–45, esp. 145. On the dedicatory inscriptions of Cretan churches, see V. Tsamakda (with A. Rhoby), *Die griechischen Inschriften Kretas (13.–17. Jh.)* (forthcoming).

18 See, for example, a contract of apprenticeship referring to the temporary presence on Crete of the Constantinopolitan scholar Ioannes Argyropoulos in 1423: *Manifestum facio ego, Iohannes Argiropulo de Constantinopoli, moram presentialiter trahens Candide* . . . (I, Ioannes Argyropoulos of Constantinople, temporarily being delayed in Chandax, make public . . .) (T. Ganchou, "Iôannès Argyropoulos, Géôrgios Trapézountios et le patron crétois Géôrgios Maurikas," Θησαυρίσματα 38 [2008]: 105–212, at 210–11, doc. 2]). Many other examples can be offered for several immigrants from the island of Tenedos who moved to Crete after 1381. See *Manifestum facio [ego,] Hemanuel Thelimatari de Tenedo, nunc habitator burgi Candide* . . . (I, Emmanuel Thelimatares of Tenedos, now resident of the suburbs of Chandax, make public . . .) (A.S.V., *Notai di Candia*, b. 273 [Niccolò Tonisto], fol. 5 [6]v [act of 26 August 1385]), and *Manifestum facio ego[,] Michael Orffano de Tenedo, nunc habitator burgi Candide* . . . (I, Michael Orfanos of Tenedos, now resident in the suburb of Chandax, make public . . .) (A.S.V., *Notai di Candia*, b. 273 [Niccolò Tonisto], fol. 7 [8]v [act of 23 September 1385]).

19 The attribution of such works to painters from Constantinople was mainly promoted by M. Borboudakes, "Ἡ τέχνη κατὰ τὴ Βενετοκρατία," in *Κρήτη: Ἱστορία καὶ πολιτισμός*, ed. N. M. Panagiotakes (Heraklion, 1988), 2:231–88, at 261, and K. Gallas, K. Wessel, and M. Borboudakes, *Byzantinisches Kreta* (Munich, 1983), 125–27. Cf.

this attribution is that some painters' surnames are the same as those of famous Byzantine families, such as Phokas, Philanthropenos, Apokafkos, or Synadenos.[20] However, the surnames of Phokas and Synadenos are witnessed on Crete in numerous sources in the first half of the fourteenth century.[21] Consequently, if the first Phokas members left Constantinople for Crete by the thirteenth century, the painters by the same name active on Crete during the fifteenth century had no Constantinopolitan training, formation, or such artistic background. As Stavros Maderakes has argued, we cannot presume that non-Cretan painters were responsible for the appearance of the academic style found in ca. 1400 on Crete, since this is not in the written record.[22]

In these Veneto-Cretan contracts, we find painters who were residents in Chandax or in its suburbs, but also in villages. For example, Nikolaos Vassalos and the priest Ioannes Frangos resided in the villages of Komes and Pala, respectively. Most of the people who made commissions also resided in Chandax. This is the case with Markos Mouatsos, Daniel Gastreas, and Konstantios Gerardos. Markos Pavlopoulos and

Georgios Piperes were living in the suburbs of Chandax and in the village of Malia, respectively. It is worth noting that, apart from the priest Ioannes Frangos, many other painters listed by Cattapan were connected to the priesthood: Georgios,[23] Nikolaos Philanthropenos, son of the priest Georgios,[24] Nikolaos and Vlasios Klontzas, sons of the priest Konstantinos,[25] Georgios Phokas, son of the priest Michael,[26] Antonios Papadopoulos, son of the priest Basilios,[27] and so on,[28] while Antonio da Negroponte was a frate.[29] Among the painters we also find a person with an additional occupation, the *organista* Gasparino Bembo.[30] Among the people who made commissions, we find members from noble Venetian families, such as the Corner, Correr, Venier, and Querini. One of these people, Daniel Gastreas, was a hieromonk, and another one, Markos Pavlopoulos, was a priest.

All contracts of wall paintings published by Cattapan provide a wealth of information about the process of employment and shed light on the details of the agreements between painters and clients. First and foremost, it is possible to inspect the remuneration of the painters and its adjustments throughout a period of 140 years (1331–1470). Evidently, the agreed price depended on various factors, such as the artist's expertise and qualifications, the size of the church, the specific themes to be painted, and the deadline for the completion of the work. In 1331, the price agreed upon between the painter Nikolaos Vassalos and Markos Mouatsos for the countryside Church of Panagia in Varvari in the

M. Bissinger, *Kreta: Byzantinische Wandmalerei* (Munich, 1995), 216, who calls attention to methodological problems with the aforementioned scholarship on this topic.

20 See, for example, Constantoudaki-Kitromilides, "Viaggi di pittori," especially at 713–19 (cf. M. Constadoudaki-Kitromilides, "The Wall-Paintings in the Katholikon of the Saint Neophytos Monastery: Iconography, Artistic Identity, and the Cretan Theophanis in Venetian Cyprus," Δελτ.Χριστ.Άρχ.Ετ. 42 [2021]: 197–236, at 217), and M. Vassilaki, "From Constantinople to Candia: Icon Painting in Crete around 1400," in *The Hand of Angelos: An Icon Painter in Venetian Crete*, ed. M. Vassilaki (Farnham, 2010), 58–65.

21 See, for example, C. Gaspares, ed., *Franciscus de Cruce: Νοτάριος στον Χάνδακα, 1338–1339* (Venice, 1999), 160, doc. 207: *Nicolaus Fucha, principalis, habitator in casali Dhionissi* (Nikolaos Pho[u]kas, principal, resident of the village of Dionisi); Gaspares, *Franciscus de Cruce*, 321–22, doc. 467: *Nicolaus Synadhino, dictus Dhiaco* (Nikolaos Synadenos, so-called Diakos); and A. Lombardo, ed., *Zaccaria de Fredo: Notaio in Candia (1352–1357)* (Venice, 1968), 53, doc. 76: *Andreas Sinadhino aurifex* (Andreas Synadenos, goldsmith). See also A.S.V., *Notai di Candia*, b. 13 [Egidio Valoso], fol. 98v: *Xeno Fucha, habitator casalis Cato Marathiti* (Xenos Pho[u]kas, resident of the village of Kato Marathiti) [act of 7 April 1371], and A.S.V., *Notai di Candia*, b. 273 [Niccolò Tonisto], fol. [66] 67v: *Dimitrius Fucha, habitator casalis Caçaba* (Demetrios Pho[u]kas, resident of the village of Katsaba) [act of 6 November 1387].

22 S. N. Maderakes, "Βυζαντινή ζωγραφική από την Κρήτη στα πρώτα χρόνια του 15ου αιώνα," in *Πεπραγμένα του ΣΤ' διεθνούς Κρητολογικού συνεδρίου* (Chania, 1991), 2:265–315, at 271.

23 Cattapan, "Nuovi elenchi," 204, no. 19.

24 Cattapan, "Nuovi elenchi," 204, no. 30.

25 Cattapan, "Nuovi elenchi," 205, nos. 47–48.

26 Cattapan, "Nuovi elenchi," 206, no. 72.

27 Cattapan, "Nuovi elenchi," 206, no. 75.

28 In no. 84 of Cattapan's list, we find the entry, "Alessandro (Comata) Giorgio, protopapà, vescovo" (Cattapan, "Nuovi elenchi," 206), which is probably based on a document of 27 March 1450 where we actually read the following: *Georgius Alefandro, pinctor, habitator burgi Candide* (Georgios Alefandos, painter, resident of the suburbs of Chandax) (A.S.V., *Notai di Candia*, b. 294 [Luca Zen], fol. 110 [260]r). Thus, the identification with Georgios Alexandros Chomatas, vice-protopapas of Chandax and later Latin bishop of Arkadi on Crete, is erroneous. On Georgios Alexandros Chomatas, see E. Despotakis and T. Ganchou, "Géôrgios Alexandros Chômatas, successeur de Dèmètrios Chalkokondylès à la chaire de Grec de l'Université de Padoue (1475/76–1479)," *REB* 76 (2018): 233–65.

29 Cattapan, "Nuovi elenchi," 207, no. 109.

30 Cattapan, "Nuovi elenchi," 205, no. 42.

former province of Pediada was twelve Cretan hyperpera. In 1353, the painter Ioannes Gradenigos demanded sixteen Cretan hyperpera from Daniel Gastreas for his work at the Church of Christ Pantokrator.[31] Given that it would have taken the painters approximately five months to complete the work—perhaps even fewer[32]—such amounts seem relatively fair when compared to the compensation of other contemporary professions that did not require advanced artistic skills, such as shoemaker (*caligarius*), butcher (*beccarius*), or builder (*murarius*), whose yearly wages were around ten hyperpera during the fourteenth century.[33] In the second half of the fourteenth century, the amount requested for the decoration of two countryside churches, St. George in Kyrmousi (1371) and Panagia (*Sancta Maria*) in Malia (*Damalia*) (1399),[34] was sixty Cretan hyperpera

each. During the first half of the fifteenth century, the painter's fee seems to fluctuate from seventy (1419) to one hundred hyperpera (1422), while in 1470 the latter sum was received by Georgios Pelegrin for the wall painting of just one composition—the Crucifixion—in the Church of St. Jerome in Chandax. In most cases, the painter was paid in two or three installments.

Two documents reveal the amount of time needed by the painter to complete his work. Angelos Apokafkos pledged to start working on the composition of the Last Judgment on 15 May 1421 and to conclude it by the end of July, if not earlier. The other case is that of Georgios Mavrianos, who, on 28 April 1422, promised to paint images of Christ the Savior and other saints in the Church of the Savior in Kitharida by the end of September, if not earlier. All the contracts imply that the best time to start the work of wall paintings was the beginning of spring at the earliest. Thus, Nikolaos Vassalos was employed on 25 July (and he agreed to start his work within the next fifteen days), Ioannes Gradenigos on 31 July, Georgios Mavrianos on 28 April and 21 May, and Angelos Apokafkos on 1 March. With the exception of Vassalos, there is no mention in the other agreements of the time in which the painter should start his work in loco. On the other hand, in two contracts made on 6 November 1399 and 31 October 1371, the painters pledged to start their work after the day of Resurrection, that is, in the end of March and beginning of April, respectively.[35] This practice related to the optimal climatic conditions, that is, to low levels of humidity for the wall treatment.[36] Finally, there is one case in which the person who commissioned the work hired two painters to create frescoes in his church. This was the Church of Panagia in Malia, whose decoration Georgios Piperes assigned

31 Since there is no toponym following the Church of Christ Pantokrator, we assume that it was situated in Chandax. Cattapan erroneously transcribed the surname of the hieromonk Gastreas as *Trasthrea*. Certainly, this is the hieromonk Daniel Gastreas whose testament was composed by the notary Giovanni Gerardo on 27 March 1359 (S. McKee, ed., *Wills from Late Medieval Venetian Crete: 1312–1420* [Washington, DC, 1998], 1:208–9, doc. 164). Gerardo also wrote the notarial deed between Gastreas and the painter Gradenigos. Unfortunately, there is no mention of the Church of Christ Pantokrator in his testament.

32 Cf. the case of Georgios Mavrianos, below.

33 E. Santschi, "Contrats de travail et d'apprentissage en Crète Vénitienne au XIVᵉ siècle d'après quelques notaires," *SZG* 19 (1969): 34–74, at 70. See also the considerations about the painters' economic status and activities in fifteenth-century Crete in C. Maltezou, "Τὸ ἐπάγγελμα τοῦ ζωγράφου στη βενετοκρατούμενη Κρήτη τον 15ο αἰώνα," in *Μουσείο Μπενάκη* 13–14 (2013/14): 43–55, at 51–53.

34 This church has been identified with reservation by Stella Papadake-Oekland with Panagia Zoodochos Pege, which is situated in the village Damania in the prefecture of Heraklion. As Papadake-Oekland has observed, only a few fresco fragments have been preserved, and their status does not allow for speculations about the identity of the painters or their style (S. Papadake-Oekland, "Ἀπό τη ζωή των ζωγράφων στην Κρήτη κατά τους πρώτους αιώνες της Ενετοκρατίας," in *Πεπραγμένα τοῦ Η΄ διεθνούς Κρητολογικοῦ συνεδρίου* [Heraklion, 2000], 2.2:155–76, at 158–59, n. 8). On the other hand, Constantoudaki-Kitromilides reads this toponym as "da malia" and proposes its identification with the Church of Panagia in the village of Malia in the former province of Pediada (Constantoudaki-Kitromilides, "Viaggi di pittori," 712). We consider this hypothesis to be more convincing; see also S. G. Spanakes, *Πόλεις και χωριά της Κρήτης στο πέρασμα των αιώνων (μητρώον των οικισμών)*, 3rd ed. (Heraklion, 2006), 2:501, referring to the alternative appellation of Malia as "Demalia," as mentioned by Francesco Barozzi in 1577. The murals of the church in Malia lack a dedicatory inscription and are unpublished. Despite this, studying them should tell us if they were

indeed painted by Souranas and Synadenos in 1399, as stated in the contract mentioned on p. 250.

35 Easter fell on 6 April in 1371 and on 30 March in 1399; see V. Grumel, *Traité d'études byzantines*, vol. 1, *La chronologie* (Paris, 1958), 310.

36 Cf. the instructions for the art of mural painting of Dionysios of Fourna: Dionysios of Fourna, "Ἑρμηνεία τῆς ζωγραφικῆς τοῦ τοίχου, ἤτοι πῶς νὰ ἱστορίζῃς εἰς τοίχον καὶ πῶς νὰ κατασκευάζῃς κονδύλια τοῦ τοίχου," in *Ἑρμηνεία τῆς ζωγραφικῆς τέχνης καί αἱ κύριαι αὐτῆς ἀνέκδοτοι πηγαί, ἐκδιδομένη μετὰ προλόγου νῦν τὸ πρῶτον πλῆρης κατὰ τὸ πρωτότυπον αὐτῆς κείμενον*, ed. A. Papadopoulos-Kerameus (St. Petersburg, 1909), 36–43, and the English translation of P. Hetherington, ed., *The "Painter's Manual" of Dionysius of Fourna*, 2nd ed. (Torrance, Calif., 1989), 12–15.

to the painters Emmanuel Souranas and Andronikos Synadenos. Among our written sources, this is a unique case in which two painters were hired to work in the same church, and it might relate to the client's desire to have the church decorated as quickly as possible. It is also possible that this double commission was due to an extant *societas* between Souranas and Synadenos, similar to the one between Nikolaos Philanthropenos and Nicola Storlando in 1400.[37]

Based on the information from the notarial deeds, we can conclude that all work expenses (e.g., for the pigments, which are mentioned in most of the published documents) were covered by the painters themselves and were therefore included in the requested amount. Whenever something was not included in the final price, it was always mentioned separately. For example, Angelos Apokafkos asked Markos Pavlopoulos, the future protopapas of Chandax,[38] to provide him the lime and the scaffolding. Ioannes Gradenigos required Daniel Gastreas to provide lime and water for his work, as well as food. By contrast, according to the agreement of 1371 between the painter Ioannes Frangos and Konstantios Gerardos, the scaffolding was to be provided by the painter, not by Gerardos.

In many cases, it is safe to assume that the painter did not work alone. Though the archival documents do not mention this explicitly, it should be considered self-evident for various reasons. First, several notarial deeds indicate that apprentices were entrusted to painters in order to work for them and also learn the art of painting. This is the case of Michael, son of Nikolaos Charchiopoulos, whose father entrusted him to Georgios Mavrianos for ten years (see below, p. 253). Apprentices who learned the art of painting from a teacher-painter who specialized in icon painting did not necessarily leave the latter's workshop in the city

center or the suburbs. However, those teacher-painters who had to leave their permanent residence for distant villages and work in loco for four or five months brought their trainees with them and provided for their needs, as promised to their fathers in the contract of the apprenticeship. According to the documents, the person who made the commission was often obliged to provide food for the painter and, in turn, the painter pledged to provide food for his apprentices who accompanied him to his work.

Specific clauses in the contracts seem to have been relatively frequent. An interesting case is that of the painter Nikolaos Vassalos, whose final work was to be checked and evaluated positively by two other people before receiving his payment. Another case is that of the painter Alexios Apokafkos, who agreed that if he did not complete the work by the predetermined date, the client reserved the right to assign it to other painters at Apokafkos's expense. It is also worth mentioning that in the agreement between the priest and painter Ioannes Frangos and Konstantios Gerardos, the latter did not dictate what subjects were to be painted in the Church of St. George in Kyrmousi. Instead, he asked Frangos to copy subjects from the Church of the Savior in the village of Tylisos (*Delese*)[39] and not to leave any interior space without painting. The same contract mentions explicitly that the light blue color (*açuro*) was to be used along with other colors of quality (*aliis bonis coloribus*). The good quality of the colors as a part of the agreement is also mentioned in the contract between Nikolaos Vassalos and Markos Mouatsos in 1331. In the contract of 1353 between Ioannes Gradenigos and Daniel Gastreas, we find explicit mention of the painter's commitment to execute the iconographic program that Gastreas would dictate (*Et teneor facere in dicta ecclesia omnes ystorias quas ordinabis mihi*) (And I am obligated to paint in the aforementioned church all the pictures that you ordered me). This must have been a self-evident condition in other contracts, since all painters were at the service of their clients. For example, in the agreement between the painters Souranas and Synadenos and the church owner Piperes, we read

37　In the agreement between Philanthropenos and Storlando, we read that the painters would jointly run the same workshop (*apothecam*) and share the revenue and expenses for three years. On this document, see M. Constantoudaki-Kitromilides, "Conducere apothecam, in qua exercere artem nostram: Το εργαστήριο ενός βυζαντινού και ενός βενετού ζωγράφου στην Κρήτη," *Byzantina Symmeikta* 14 (2001): 291–300. In the documents of Venetian Crete, the term *societas* is used to describe partnerships between craftsmen, artisans, or peasants. On this term, see C. Gaspares, *Η γη και οι αγρότες στη μεσαιωνική Κρήτη: 13ος–14ος αι.* (Athens, 1997), 44; cf. J. H. Pryor, "The Origins of the *Commenda* Contract," *Speculum* 52 (1977): 5–37.

38　On this person, see in general *PLP* 22084.

39　Most likely, it is about the Church of Christ (also known as Metamorphosis), which still preserves fourteenth-century Byzantine frescoes. On this church, see A. Mylopotamitake, "Βυζαντινά και μεταβυζαντινά μνημεία της επαρχίας Μαλεβιζίου," in *Το Μαλεβίζι από τα προϊστορικά χρόνια μέχρι σήμερα*, ed. N. Psilakes (Heraklion, 1998), 113–144, at 138.

that the painters would have worked in the church following the instructions of Piperes (*et fideliter laborando in ea prout nobis dixeris et ordinaveris*) (and faithfully working in this [church] in accordance with what you have said to us and ordered).

The content of the iconographic program was not always mentioned in the agreements. The contracts between Vassalos and Mouatsos, Gradenigos and Gastreas, Frangos and Gerardos, and Souranas/Synadenos and Piperes do not mention it at all. The agreements that include specific mentions of the content of the iconographic program are those referring to: (a) Georgios Mavrianos, who agreed to paint subjects from the life of Jesus Christ and the Virgin in the Church of Panagia in Kato Symi and images of Christ and other saints in the Church of the Savior in Kitharida; (b) Georgios Pelegrin, hired to paint the Crucifixion in the Church of St. Jerome; and (c) Angelos Apokafkos, hired to paint the Last Judgment in the Church of Panagia of the Angels. We can also observe that the person who made the commission was always the one who owned the church. In all cases, the painter involved in a wall-painting contract addresses the client using the possessive pronouns *ecclesiam tuam*, *in tua ecclesia*, or *ecclesiam . . . positam in casali tuo*. The few exceptions are indirect commissions made by executors empowered to act by the owner's request, such as in the case of Georgios Mavrianos and the executors of Anna Correr, and that of Georgios Pelegrin and Lauro Querini, executor of Mandalucia Querini.

According to Maderakes's reading of the agreement between Ioannes Gradenigos and Daniel Gastreas, the painter pledged to respect the Orthodox iconographic tradition in his work and not include heretical allusions. Maderakes argues that this is a reference to the problem of Western influences on Byzantine art, namely the introduction of Western iconographic motifs.[40] Maderakes came to this conclusion because of the phrase *bona fide, sine fraude et malo ingenio* (faithfully, without fraud and evil disposition), which he erroneously connected to the Church's iconographic program. However, the phrase was commonly used in the Veneto-Cretan notarial deeds to imply the

satisfactory completion of the work in the context of the agreements.[41] In fact, it refers to the quality of Gradenigos's work and the ensuing success of the agreement, not to the contents of the iconographic program.

Regarding the information provided by the wall-painting commissions published by Cattapan, Maderakes concluded "It is a pity that such pieces of information are relatively few and that we have not been able to identify any monuments that would help us understand the real value of these testimonies."[42] This is the lacuna that the present article aims to fill. It has three objectives; the first is to link the commissions of Georgios Mavrianos to the churches of St. George in Vrachasi and Panagia in Kato Symi, a connection that has so far remained unnoticed by Cattapan and other scholars. We will show that the names of Mavrianos's clients and the location of the churches to which his work is linked are indicative of the latter's renown in fourteenth- to fifteenth-century Venetian Crete. Our second objective is to present one more contract of employment, this time regarding the painter Konstantinos Gaitanas. The importance of this new document resides in the richness of information it provides. Furthermore, it refers to the well-known Church of the Holy Apostles in Kato Karkasa, where the Cretan hieromonk and scholar Neilos Damilas lived during the late fourteenth and early fifteenth centuries.[43] All

40 S. N. Maderakes, *Η εκκλησία του Αρχάγγελου Μιχαήλ στα Έξω Λακώνια Μεραμπέλλου* (Agios Nikolaos, 2000), 134, n. 322.

41 See, for example, an agreement of 1357 according to which the Jew Ysahac promised to serve for three years as the agent of Kalli: *Promitto tibi ac teneor servire tibi et procurare tua negocia et agenda in civitate et burgo Candide tam in curia quam alibi, prout opus fuerit et sicut michi dixeris et ordinaveris, bona fide, sine fraude . . .* (I promise you and I pledge to assist you and represent you in affairs and obligations in the city center and in the suburbs of Chandax, in the Curia and elsewhere, wherever it may be necessary, and you will tell me and command me, faithfully and without deceit . . .) (N. Tsougarakis, "The Documents of Dominicus Grimani, Notary in Candia [1356–1357]," *DOP* 67 [2013]: 227–89, at 264, doc. 80). See also a contract of apprenticeship stipulated in 1487 where Basileios Lithinos entrusted his son Ioannes to the carpenter Markos Bonos for ten years: *quo toto tempore tibi servire debeat intus, foris, bene et fideliter sine fraude aliqua . . .* (during which time John should serve you at home and outside, good and faithfully, without deceit . . .) (A. van Gemert, ed., *Zuane Longo, publicus notarius Candide et Rethimi: Κατάστιχο 131 [1479–1511/12]*, vol. 1, *Ρέθυμνο 1487, Χάνδακας 1479–1511/12* [Heraklion, 2017], 94–95, doc. P25).

42 Maderakes, *Έξω Λακώνια*, 134, n. 322.

43 On Neilos Damilas, see M. M. Nikolidakes, "Νείλος Δαμιλάς" (PhD diss., University of Ioannina, 1981), and E. Despotakis and A. Rigo, "Neilos Damilas, John Climacus and Other Ascetic Authors

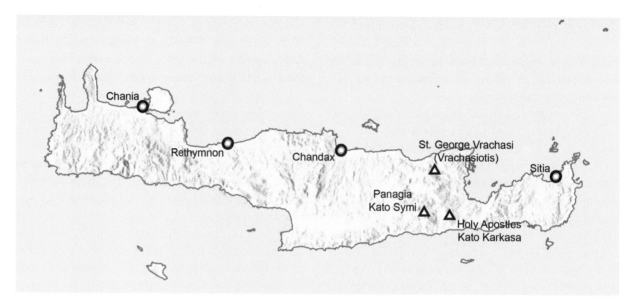

Fig. 1. Map of Crete. Map courtesy of Wikimedia Commons, with additions by authors.

three churches are situated in eastern Crete (Fig. 1), and their wall paintings are still partially preserved. With the exception of the newly restored Church of St. George in Vrachasi, the wall paintings in Kato Symi and Kato Karkasa are unknown or have received little attention. Thus, our third objective is to present and discuss them here for the first time in order to place the work of Mavrianos and Gaitanas in the context of contemporary Palaeologan and Cretan art and to investigate their work with respect to the information given by the notarial deeds. The analysis of the pictorial program, iconography, and style of their church decorations will reveal to what extent the stipulations of the relevant contracts were implemented by the painters and whether the information transmitted by the documents can be confirmed by the wall paintings.

Georgios Mavrianos and the Church of St. George in Vrachasi

Three archival documents are linked to the artistic activity of Georgios Mavrianos in eastern Crete, while a fourth one demonstrates that he was an established painter since at least 1390.

The earliest information we possess for the surname "Mavrianos" (*Mauriano*) on Crete is limited to

two painters listed by Cattapan, "Mauriano Frangulo (1367–1383)" and "Mauriano Giorgio (1389–1420)."[44] Both are mentioned as residents of the city of Chandax, but Cattapan does not state if they were related. Some earlier testimonies connect this surname to other locations, such as Constantinople, Chalkidiki, and Serres.[45] On Crete, the name appears in the dedicatory inscription of the Church of Saints Constantine and Helen in Voukolies, which dates to the beginning of the fifteenth century.[46] The inscription mentions among the donors who contributed to the erection and decoration of the church a certain Ioannes Mavrianos and a certain Georgios whose surname can be reconstructed as Mavrianos. It is unknown if he is the same person as the painter mentioned by Cattapan.

The earliest document published by Cattapan concerning the activity of Mavrianos is a contract of

in Late Medieval Crete (14th–15th Centuries)," in *The Ladder of John of Sinai*, ed. P. Van Deun and M. Venetskov (Leuven, forthcoming).

44 Cattapan, "Nuovi elenchi," 204, nos. 23–24.

45 *PLP* 17409–12, 17414–16, 17418–19.

46 Gerola, *Monumenti veneti*, 4:414, no. 10. The dates 1452–1462 proposed by Gerola cannot be correct. Today, only the first two letters from the date are still legible. A series of graffiti dating from before 1452 (the earliest is from 1416; see D. Tsougarakes and E. Aggelomate-Tsougarake, Σύνταγμα *(Corpus) χαραγμάτων εκκλησιών και μονών της Κρήτης* [Athens, 2015], 92–93, no. 18) points to a date at the beginning of the fifteenth century. Moreover, the hand of the scribe is identical to that found at the Church of Archangel Michael in Prines, which is dated 1410. For the correct dating, also supported by stylistic criteria, see Tsamakda, *Die griechischen Inschriften*.

apprenticeship from the year 1390 (Appendix, doc. 1).[47] On 11 February, Nikolaos Charchiopoulos, resident of the village of Megalo Chorio (*Megachorio*) in the area of Hierapetra,[48] entrusted his son, Michael, to Georgios Mavrianos for ten years to learn the art of painting. As was customary, the teacher was required to provide lodging, clothing, footwear, and maintenance for the apprentice.[49] In exchange, Michael was to be at Mavrianos's service, assisting him with his work and thus learning the art of painting himself. Although this notarial act has all the characteristics of a common contract of apprenticeship, we should underline that, unlike similar contracts, this one is a contract of both adoption and apprenticeship, an extremely rare case, as Elisabeth Santschi has observed.[50] This contract indicates that in 1390 Georgios Mavrianos was both a middle-aged painter in Chandax and an artist already known beyond the borders of the capital.

Another document of 27 July 1404 mentions Georgios Mavrianos as a guarantor in a prenuptial agreement between Maria, widow of the priest Demetrios Kornaros, and Ioannes (*Zanachius*) Kornaros, for the latter's marriage to Eleni, daughter of the aforementioned Maria. At the end of the notarial deed, we read:

Ad hec autem, manifestum facio ego, Georgius Mavriano, pinctor, habitator Candide, cum meis heredibus, tibi, suprascripto Zanachio et tuis heredibus, quia constituo me tibi plecium pro suprascripta papadia, socru tua, de tota repromissa et donis suprascriptis solvendis et attendendis tibi ad terminum suprascriptum . . .[51]

With regard to this, I, Georgios Mavrianos, painter, resident of Chandax, with my successors, make public to you, the aforementioned Ioannes and to your successors, that I make myself your guarantor for the aforementioned priest's wife, your mother-in-law, for the whole dowry and for the aforementioned gifts, already granted and to be granted to you, at the aforementioned deadline . . .

The latest document referring to Georgios Mavrianos is an agreement of a wall-painting commission of 28 April 1422 (Appendix, doc. 4). This document was previously published by Cattapan, though with errors that significantly alter its content.[52] According to this document, on 28 April 1422, the painter Georgios Mavrianos, resident of Chandax, was employed by the executors of the testament of Anna Correr to paint the frescoes in the Church of the Savior in Kitharida with all work expenses covered by the painter himself. This church was in the middle of other churches situated in the same area. The contract mentions painting images of Christ the Savior and some other saints on which Mavrianos and the executors had already agreed. Mavrianos was to complete his work by September of the same year, if not earlier. The price agreed upon for his work was one hundred hyperpera, an amount that Anna Correr had left for the wall paintings in that church.

The commission of Byzantine frescoes in the area of Kitharida—along with the mention of the precise amount of one hundred hyperpera—is reminiscent of the will of Anna Correr, widow of the Venetian noble Marco Correr, whose testament was redacted by the notary Giovanni Dono on 19 October 1418.[53] From Anna's testament, we learn that the executors were Symeon Greco, his wife, Margarita, and Maria, widow of the Venetian noble Tommaso Salamon. During the

47 Cattapan, "Nuovi elenchi," 218, doc. 11.

48 According to Gaspares's research, this village was close to Giannitsi (*Ianizi* or *Ianiçi*) (C. Gaspares, *Catastici feudorum Crete: Catasticum sexterii Dorsoduri; 1227–1418* [Athens, 2004], 1:159; 2:436–39, docs. 817–23), which is currently named Vainia, and is in southeastern Crete, very close to Hierapetra.

49 See all contracts of apprenticeship published in Cattapan, "Nuovi elenchi," 218–24, docs. 10 and 12–24, along with those published by Cattapan, "Nuovi documenti," 44–45, docs. 7–9. The same custom of providing for the apprentice was present in contracts of apprenticeship of most arts in Venetian Crete (see Santschi, "Contrats de travail," 39).

50 Santschi, "Contrats de travail," 40.

51 A.S.V., *Notai di Candia*, b. 23 [Andrea Cauco], quad. 1, fol. 16 [48]r. This act is followed by another one in which the mother of the aforesaid Maria, the nun Anixia Tourkopoula, guarantees Mavrianos that her daughter will grant all gifts promised to Ioannes Kornaros.

52 Cattapan, "Nuovi elenchi," 230–31, doc. 32. Cattapan transcribed erroneously: (a) the date (*18*, instead of *28* April 1422); (b) the painter's name (*Mancuso*, instead of *Mauriano*); (c) the testator's surname (*Cornario*, instead of *Corrario*); (d) the place where the church was situated (*Chitanda*, instead of *Chitharida*); and (e) the number of subjects to be painted (*figuram Solemnis Salvatoris*, instead of *figuras Solemnis Salvatoris*).

53 E. Papadake, ed., *Johannes Dono, νοτάριος Χάνδακα, 1416–1422* (Heraklion, 2018), 157–62, doc. 40 [74]; cf. E. Papadake, "Η παράδοση του βίου του οσίου Ιωσήφ Σαμάκου και η εποχή της δράσης του στο Χάνδακα," *Θησαυρίσματα* 29 (1999): 109–62, at 137–40, doc. 4.

late years of her life, Anna Correr was a resident in the monastery of Kitharida, namely the monastery of Kyria Eleousa.[54] As Eirene Papadake has argued, Anna Correr was the wealthiest testator among those recorded in the registers of Giovanni Dono.[55] In her testament, she left one hundred hyperpera for the execution of the wall paintings in the aforementioned church, that is, the katholikon of Kyria Eleousa's monastery (*Item dimitto yperpera centum pro pinctura fienda in dicta ecclesia pro anima mea*) (Moreover, I leave one hundred hyperpera for a painting to be made in the aforementioned church for my soul).

In contrast to what we read in the testament, the agreement between Georgios Mavrianos and the executors indicates that Anna Correr left one hundred hyperpera for the execution of wall paintings in the Church of the Savior and not for that of Kyria Eleousa. The Church of the Savior has not been preserved, but that of Kyria Eleousa, whose frescoes are unpublished, is still standing in the area of Kitharida. Two more churches were spotted by Gerola in the same area; one was dedicated to St. Anthony, while the other's dedication remains unkown.[56] At this point we can assume that the latter was once the Church of the Savior, which was located—as the document of 1422 attests—among other churches in that area, likely those of Kyria Eleousa and St. Anthony.

The Document on the Church of St. George in Vrachasi

On 2 August 1401, the painter Georgios Mavrianos, a resident of Chandax, acknowledged the receipt of twenty-three hyperpera from Emanuele Venier, also a resident of Chandax (Appendix, doc. 2). This amount constituted the rest of a sum of 120 hyperpera that, according to a juridical decision, Venier was obliged to pay Mavrianos for the latter's work in the Church of St. George in *Vraghassi*. Cattapan mistakenly transcribed the word

Vraghassi as *Veargassi*,[57] and this is why the church mentioned in the document was never located and identified. This toponym certainly refers to the well-known village of Vrachasi, which Veneto-Cretan documents designate as *Vracasio*, *Vrachassi*, *Vraghassi*, and *Vagrassi*.[58] This mural-painting commission refers thus to the katholikon of the St. George Vrachasiotis monastery in the former province of Merambelo in the prefecture of Lasithi.

The document speaks indirectly of a commission for the execution of wall paintings. The sum of 120 hyperpera seems relatively high when compared to other payments agreed upon in the same period, such as that of Emmanuel Souranas and Andronikos Synadenos, who were to receive a total of sixty hyperpera for their work in Malia in 1399.

This is a unique case in which an agreement between a painter and a client ends up at court. Unfortunately, since this is not a document of a wall-painting commission but an echo of a preexisting contract between Georgios Mavrianos and Emanuele Venier, it is impossible to determine the nature of their dispute. Based on what we have seen above with regard to the terms included in a wall-painting commission contract, an agreement could be easily violated in several ways, such as the materials provided by the painter or the client, the date by which the frescoes should be finished, the subjects chosen, and so on. It seems that Emanuele Venier refused to pay off the total sum of 120 hyperpera agreed upon for the creation of the frescoes at St. George in Vrachasi to Georgios Mavrianos, or maybe a part thereof.

The noble surname "Venier" (*Venerio*) belongs to one of the most ancient Venetian families, whose members were sent to colonize Crete at the beginning of the thirteenth century.[59] A fifteenth-century document mentions Emanuele Venier as the owner of Vrachasi.[60]

54 For the history of this monastery, see D. Tsougarakes and E. Aggelomate-Tsougarake, "Τα γυναικεία ορθόδοξα μοναστήρια του Χάνδακα και της ευρύτερης περιοχής του κατά τη Βενετοκρατία," *Μεσαιωνικά και Νέα Ελληνικά* 12 (2016): 9–132, esp. 29–31; T. Detorakes, "Το μοναστήρι της Ελεούσας στην Κρήτη: Ειδήσεις των πηγών," in *Βενετοκρητικά Μελετήματα (1971–1994)* (Heraklion, 1996), 277–83; and N. Psilakes, *Μοναστήρια και ερημητήρια της Κρήτης* (Heraklion, 2002), 1:155–62.

55 Papadake, *Johannes Dono*, 64–65.

56 Gerola, *Monumenti veneti*, 4:502, no. 6, and Gerola and Lassithiotakes, *Τοπογραφικός κατάλογος*, 70, no. 423.

57 See Cattapan, "Nuovi elenchi," 226, 232.

58 Gaspares, *Catastici feudorum Crete*, 1:165. For further citations, see Spanakes, *Πόλεις και χωριά*, 1:202.

59 On this topic, see Gaspares, *Catastici feudorum Crete*, 1:19–57. Members of the Venier family are attested in all documents concerning the first Venetian arrivals to Crete (G. L. F. Tafel and G. M. Thomas, eds., *Urkunden zur älteren Handels- und Staatsgeschichte der Republik Venedig mit besonderer Beziehung auf Byzanz und die Levante*, 2nd rev. ed. [Amsterdam, 1964], 2:134, doc. 229; 238, doc. 263; 478, doc. 322).

60 A.S.V., *Notai di Candia*, b. 23 [Andrea Cauco], prot. 1, fol. 15 [47]v [act of 2 July 1404].

Other sources too connect the surname "Venier" to Vrachasi; the earliest can be traced back to 1352 and refers to a certain Marco Venier (*Marcus Venerio, habitator casalis Vracassi*) (Marco Venier, resident of the village of Vrachasi).[61] Moreover, in 1391, *Andrea Venerio quondam Marci de Vrachasi* (Andrea Venier, son of the late Marco Venier of Vrachasi) asked permission from the local Venetian authorities for Ioannikios Skordiles to leave Crete in order to get ordained.[62]

Archival evidence rarely refers to the religious identity of the individuals in Venetian Crete, especially before the Council of Ferrara–Florence in 1439.[63]

Therefore, it would be risky to make speculations about Venier's religious identity based on his connection to the Orthodox monastery of St. George in Vrachasi. It is certain that countryside churches or monasteries like St. George Vrachasiotis were frequented by Orthodox peasants—residents of the village that constituted the core of the feud[64]—who were at the service of the Venetian feudatory, in this case of Emanuele Venier.

The Church of St. George in Vrachasi

ARCHITECTURE

The katholikon of the monastery,[65] dedicated to St. George, was originally a single-aisled edifice with a barrel vault.[66] The church was initially lower than it is today. A transverse arch divides it into two bays. The church was erected over an older building. Parts of this building, in all probability an older church with wall paintings,[67] were spotted under the foundations of the north wall after an excavation. The quatrefoil window high in the western wall is original, while the window in the northern wall was likely added later. The cylindrical apse in the east has a narrow window. In 1558, according to an inscription,[68] a three-story bell tower was erected to the west, and a large arch was opened in the western wall, connecting the church to it. In 1592 a second nave

61 Lombardo, *Zaccaria de Fredo*, 24, doc. 27.

62 E. Santschi, *Régestes des arrêts civils et des mémoriaux (1363–1399) des archives du duc de Crète* (Venice, 1976), 313, doc. 1398; cf. Psilakes, *Μοναστήρια*, 1:342, and Spanakes, *Πόλεις και χωριά*, 1:202. Until the end of the fifteenth century, prospective priests had to reach the Venetian colonies of Maina, Methone, or Corone in Peloponnese to get ordained (see N. V. Tomadakes, "Οἱ Ὀρθόδοξοι παπάδες ἐπὶ Ἐνετοκρατίας καὶ ἡ χειροτονία αὐτῶν," *Κρ.Χρον.* 13 [1959]: 39–72). Similar acts of permission were published by M. Chairete, "Νέα στοιχεία περί τῆς χειροτονείας Ὀρθοδόξων ἱερέων Κρήτης ἐπί βενετοκρατίας," in *Πεπραγμένα τοῦ Γ΄ διεθνοῦς Κρητολογικοῦ συνεδρίου* (Athens, 1974), 2:333–41.

63 After 1439, the receptiveness shown by the Catholics to Orthodoxy must have apparently been a recurring phenomenon in the Levant and especially in Venetian Crete, where Greeks and Latins coexisted since the beginning of the thirteenth century. This fact provoked the reaction of Pope Nicholas V, who issued a bull addressed to his delegate in the Levant on 6 September 1448. According to the bull's content, the pope was surprised by the conversion of the Catholics into the rite of the Greeks, and this was something that the Council of Florence never permitted. For this reason, the "inquisitor" was to suppress this practice and, if necessary, benefit from the assistance of the political authorities (*Bullarum diplomatum et privilegiorum sanctorum Romanorum Pontificum*, vol. 5, *Taurinensis editio locupletior facta collectione novissima plurium brevium, epistolarum, decretorum actorumque S. Sedis a s. Leone Magno usque ad praesens: Clemens X [ab. an. MDCLXX ad ann. MDCLXXVI]* [Torino, 1860], 100–101, doc. 2). The pope's concerns were justified given that at least since 1449 we encounter in the archival material Cretan priests performing liturgical services for Venetian nobles in Chandax. This is the case exposed by a notarial deed of 7 March 1449, according to which the priest Ioannes Tsengas received a sum from Marieta, *filie quondam viri nobilis ser Iohannis Gradonico, quondam domini Thome* (daughter of the late nobleman Sir Giovanni Gradenigo, son of the late Tommaso), for commemorations for her mother and grandmother, which were held on Saturday and forty days after the funeral (*sabatiatico* and *sarandamero*) (A.S.V., *Notai di Candia*, b. 246 bis [Giovanni Sevasto], fol. 47v). The noble origin of Marieta is evident in the use of the epithets *nobilis* and *domini* for her father Giovanni and her grandfather Tommaso (on this topic, see K. Lambrinos, "Η κοινωνική διάρθρωση στη βενετική Κρήτη: Ιεραρχίες, ορολογία και κατάλογοι κοινωνικής θέσης," *Κρ.Χρον.* 31 [2011]: 221–39). More

examples of Cretan priests performing liturgical services for Venetian nobles are found in E. Despotakis, *John Plousiadenos (1423?–1500): A Time-Space Geography of His Life and Career* (Leuven, 2020), 48.

64 Gaspares, *Η γη και οι αγρότες*, 58.

65 On the monastery of Vrachasi, see Gerola, *Monumenti veneti*, 2:363–65 (on the bell tower), 3:184; N. Platakes, "Παλαιές εκκλησίες στο Βραχάσι," *Αμάλθεια* 10.3 (1972): 97–120, at 111–17; T. Detorakes, "Δύο παλαιά μοναστήρια στο Βραχάσι," *Κρητολογία* 14–15 (1982): 57–75; Psilakes, *Μοναστήρια*, 1:341–51; D. Chronake, "Μοναστήρια της περιοχής επάνω Μεραμπέλλου κατά τη Βενετοκρατία," *Θησαυρίσματα* 27 (1997): 231–72, at 249; M. G. Andrianakes and K. D. Giapitsoglou, *Χριστιανικά μνημεία της Κρήτης* (Heraklion, 2012), 203; D. Chronake, "Ο ναός του αγίου Γεωργίου Βραχασώτη: Εργασίες στερέωσης και αποκατάστασης," in *Αρχαιολογικό έργο Κρήτης: Πρακτικά της 4ης συνάντησης, Ρέθυμνο, 24–27 Νοεμβρίου 2016*, ed. P. Karanastase, A. Tzigounake, and C. Tsigonake (Rethymno, 2020), 1:610–28; and G. Moschove, "Νέα στοιχεία για το καθολικό της Μονής του Αγίου Γεωργίου Βραχασώτη: Η αρχιτεκτονική και ο τοιχογραφικός διάκοσμος του ναού," in *Αρχαιολογικό έργο Κρήτης: Πρακτικά της 4ης συνάντησης, Ρέθυμνο, 24–27 Νοεμβρίου 2016*, 1:597–609.

66 On the architecture and the building stages of the church, see Moschove, "Νέα στοιχεία," 598–601.

67 Moschove, "Νέα στοιχεία," 600, 607.

68 Gerola, *Monumenti veneti*, 4:518, no. 3.

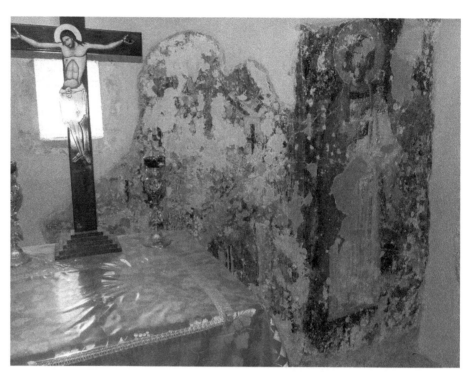

Fig. 2.
Church of St. George,
Vrachasi, sanctuary.
Photo by authors.

dedicated to St. Demetrios was added to the south.[69] Two arches were opened on the southern wall of the old church, connecting the two chapels. The two sanctuaries were also connected by a further opening. Finally, the height of the walls of the old church was increased. Today, the entrance to the katholikon is through the bell tower in the northern nave and through the southern wall of the southern nave.

THE WALL PAINTINGS

Only the northern chapel was decorated with wall paintings,[70] which are unfortunately very fragmentarily preserved.[71] The majority of the murals were destroyed during the aforementioned alterations. We do not know how comprehensive the original iconographic program was; what remains is the following.

In the sanctuary in the right part of the half-cylinder of the apse, there are a few remnants of at least two concelebrating bishops (Fig. 2). The left bishop, flanking the altar, can be identified as St. Basil of Caesarea due to his dark hair and long beard.[72] He is holding a scroll with a variant of a text taken from his liturgy:[73] ΚΑΙ ΠΙΗϹΟΝ | ΜΕΝ ΑΡΤΟΝ | ΤΟΥ[ΤΟΝ.] ΑΥΤΩ Τ[Ο] | [ΤΙ]ΜΙΟΝ ϹΩ | ΜΑ ΤΟΥ Κ[ΥΡΙΟ]Υ Κ[ΑΙ] | [ΘΕΟ]Υ Κ[ΑΙ] Ϲ[ΩΤΗΡΟ]Ϲ ΗΜ | ΩΝ Ι[ΗϹΟ]Υ Χ[ΡΙϹΤΟ]Υ. | ΑΜΙΝ ΤΟ ΔΕ | ΕΝ ΤΩ ΠΟΤ | ΙΡΙ[Ω] . . . (And make this bread be the honorable Body of our Lord and God and Savior Jesus Christ. Amen . . . in the cup . . .). The right bishop holds a scroll, the text of which is illegible.

69 On the inscription above the entrance of this chapel with the date of its construction, see Gerola, *Monumenti veneti*, 4:518, no. 4.

70 When no bibliographical references are cited for the comparative material discussed, this means that the monuments or parts thereof are unpublished, and the comparison relies on personal observations.

71 The wall paintings are first mentioned by Platakes, "Παλαιές εκκλησίες," 116; for their publication after the restoration, see Moschove, "Νέα στοιχεία," 601–5.

72 On the iconography of St. Basil, see A. Chatzinikolaou, "Heilige," *RBK* 2:1041–48; J. Myslivec, "Basilius der Große," *LChrI* 5:337–41; and I. Spatharakis, *Byzantine Wall Paintings of Crete*, vol. 1, *Rethymnon Province* (London, 1999), 322.

73 In fact, the text also contains elements from the Liturgy of St. John Chrysostom: see P. N. Trempelas, *Αἱ τρεῖς λειτουργίαι κατὰ τοὺς ἐν Ἀθήναις κώδικας* (Athens, 1982), 114–15, 183, and F. E. Brightman, *Liturgies, Eastern and Western, Being the Texts Original or Translated of the Principal Liturgies of the Church*, vol. 1, *Eastern Liturgies*, 2nd ed. (Oxford, 1967), 330; cf. G. Babić and C. Walter, "The Inscriptions upon Liturgical Rolls in Byzantine Apse Decoration," *REB* 34 (1976): 269–80, at 271, nos. 18–19.

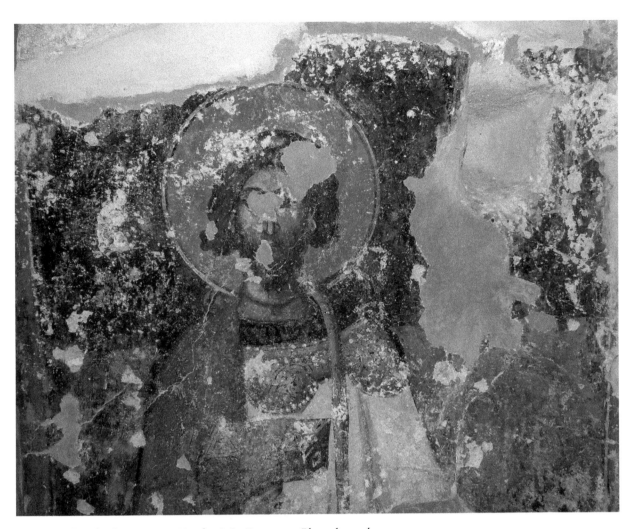

Fig. 3. Church of St. George, Vrachasi, St. Romanos. Photo by authors.

On the eastern wall to the right of the apse is a tonsured deacon holding a censer and a pyxis. He has a brown beard and wears white and red vestments (Fig. 3). He is not accompanied by an inscription but can be identified as St. Romanos on iconographic grounds.[74]

In the naos, only parts of the northern and western walls have preserved frescoes (Fig. 4, and below, Fig. 6). In the lower zone of the western part of the northern wall, there is a row of full-figure saints, and above them are remnants of the personifications of the Earth and the Sea, which formed part of the Last Judgment.[75] Both of them are fragmentarily preserved. On the left there

74 On the iconography of St. Romanos, see G. Kaster, "Romanus der Melode von Konstantinopel," *LChrI* 8:279–80; for Crete, see K. D. Kalokyres, *Αἱ βυζαντιναὶ τοιχογραφίαι τῆς Κρήτης* (Athens, 1957), 119–20; Spatharakis, *Rethymnon*, 329; and V. Tsamakda, *Die Panagia-Kirche und die Erzengelkirche in Kakodiki: Werkstattgruppen, kunst- und kulturhistorische Analyse byzantinischer Wandmalerei des 14. Jhs. auf Kreta* (Vienna, 2012), 61–63.

75 On the iconography of the Last Judgment, see B. Brenk, "Weltgericht," *LChrI* 4:513–23; B. Brenk, *Tradition und Neuerung in der christlichen Kunst des ersten Jahrtausends: Studien zur Geschichte des Weltgerichtsbildes* (Vienna, 1966); and D. Milošević, *Das Jüngste Gericht* (Recklinghausen, 1963). For Crete, see Kalokyres, *Αἱ βυζαντιναὶ τοιχογραφίαι*, 101–4; S. N. Maderakes, "Η κόλαση και οι ποινές των κολασμένων σαν θέμα της Δευτέρας Παρουσίας στις εκκλησίες της Κρήτης," *Ύδωρ εκ Πέτρας* 1 (1978): 185–236; 2 (1979): 21–80; 3 (1981): 51–130; Spatharakis, *Rethymnon*, 314–20; and Tsamakda, *Kakodiki*, 192–210. See also more recently *Hell in the Byzantine World: A History of Art and Religion in Venetian Crete and the Eastern Mediterranean*, vol. 2, *A Catalogue of the Cretan Material*, ed. A. Lymberopoulou and R. Duits (Cambridge, 2020). The catalogue of hell scenes in this publication is incomplete.

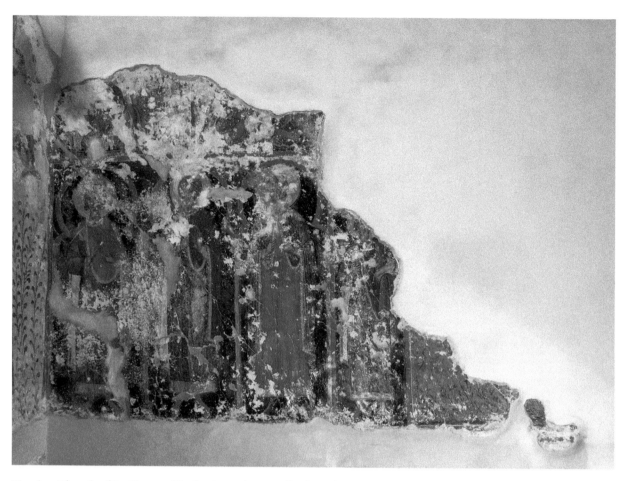

Fig. 4. Church of St. George, Vrachasi, northern wall. Photo by G. Moschove.

is probably a lion, on which the Earth is sitting. Behind the lion's tail there is a snake and other animals with body parts in their mouths. In the foreground the dead, wrapped in shrouds, are rising from their tombs. In the second scene, only fish and other sea creatures with limbs in their mouths are discernible, while the personification of the Sea riding on a large fish is almost totally destroyed.

Below these scenes, there are four standing saints. They are placed under arches decorated with green branches, supported by columns with capitals. All of them are clad in luxurious garments. Their identification is difficult because the accompanying inscriptions have been lost. Beginning from the west, the first saint is beardless and dressed in a purple himation and red chiton. He holds the cross of a martyr. He has been identified as St. Tryphon, but this is not certain.[76] The second

saint (Fig. 5), a bearded man clad in green and red and wearing dark headgear, is also probably a martyr, since he likely also held a martyr's cross with his right hand, like the previous saint.[77] The third figure is another martyr, a beardless man wearing red and green clothes. The fourth saint, represented on a smaller scale,[78] is damaged in the upper and right parts. He wears green

76 Moschove, "Νέα στοιχεία," 602, fig. 6–6a. On the iconography of this saint, see B. Böhm, "Tryphon von Phrygien," *LChrI* 8:501–2, and Spatharakis, *Rethymnon*, 340.

77 Moschove, "Νέα στοιχεία," 602, suggests an identification with St. Anthony. However, he regularly holds in his right hand a staff or makes a speech gesture while holding an open scroll in his left hand; see A. Chatzinikolaou, "Heilige," *RBK* 2:1061–69; E. Sauser, "Antonius Abbas (der Große), Stern der Wüste, Vater der Mönche," *LChrI* 5:205–17; and Spatharakis, *Rethymnon*, 340.

78 This difference in scale can be noted in several churches for saints placed below consoles of transverse arches, such as at St. John the Baptist in Kritsa (1360); see M. Katifore, "Ο ναός του Αγίου Ιωάννη Προδρόμου στην Κριτσά Μεραμπέλου," in *Αρχαιολογικό έργο Κρήτης: Πρακτικά της 3ης συνάντησης. Ρέθυμνο, 5–8 Δεκεμβρίου 2013*, ed. P. Karanastase, A. Tzigounake, and C. Tsigonake (Rethymno, 2015), 2:595–606, fig. 2.

Fig. 5.
Church of St. George,
Vrachasi, unknown saint.
Photo by authors.

and red garments and holds a cross in his right hand and a small goat in his left one. He can be safely identified as St. Mamas.[79] The adjacent saint to the right was probably on horseback, as suggested by the traces of a snake and a horse's tail. This was possibly the patron saint of the church.

The wall paintings on the western wall (Fig. 6) were partially destroyed when the bell tower was added in 1558, and a large arch was built into the left side of the wall. The upper half of the wall is decorated with the Last Judgment.[80] What remains is the depiction of the seated apostles and the angels behind them, both following the standard iconography of the scene. They are holding open books on their laps with various texts, but not all of them correspond to those prescribed in

79 Cf. Moschove, "Νέα στοιχεία," 602. On the iconography of St. Mamas, see G. Kaster, "Mam(m)as (Mamantos, Mammetos, Mammès) von Cäsarea," *LChrI* 7:483–85; Kalokyres, *Αἱ βυζαντιναὶ τοιχογραφίαι*, 122; Spatharakis, *Rethymnon*, 342; and Tsamakda, *Kakodiki*, 219–20.

80 Moschove, "Νέα στοιχεία," 603–4, fig. 7–7a.

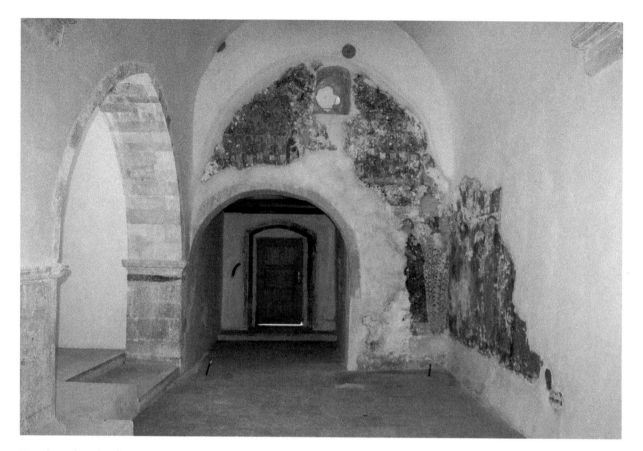

Fig. 6. Church of St. George, Vrachasi, western wall. Photo by G. Moschove.

the *Hermeneia* of Dionysios of Fourna.[81] The apostles turn toward the center of the composition, where we see the Deësis with the enthroned Christ in a mandorla in the middle surrounded by angels and flanked by the Virgin and St. John the Forerunner. Above the Deësis and the Tribunal of the Apostles, there are two flying angels flanking the window. They carry the unfurled heaven, which is placed above the window.[82]

The depiction of a male figure has been partially preserved on the right part of the lower half of the western wall (Fig. 7). The man is depicted frontally and has his hands crossed on his chest. He wears a white

himation, from which only the cuff is visible, a dark blue-green mantle,[83] and black pointed shoes. His face is missing, but his red hair is remarkable. In the upper-right corner, the half-figure of Christ appears, blessing the standing figure from heaven. This feature is rare among the extant Cretan portraits of individuals.[84] To the right of the figure there are plants.

81 On the sayings of the apostles in this composition, see Papadopoulos-Kerameus, Ἑρμηνεία τῆς ζωγραφικῆς, 287. For some examples of the apostles holding texts in the same context, see Spatharakis, *Rethymnon*, 317.

82 A parallel for this interesting composition can be found in the Church of the Savior in Potamies (last quarter of the fourteenth century); see C. Ranoutsaki, *Die Fresken der Soteras Christos-Kirche bei Potamies: Studie zur byzantinischen Wandmalerei auf Kreta im 14. Jahrhundert* (Munich, 1992), 106, fig. 30.

83 Moschove, "Νέα στοιχεία," 608, suggests that the deceased is wearing black garments and therefore would have been a priest. However, A. Mylopotamitake, "Παρατηρήσεις στις τοιχογραφημένες παραστάσεις των κτητόρων–αφιερωτών της Κρήτης," in *Ειλαπινή: Τόμος τιμητικός για τον καθηγητή Νικόλαο Πλάτωνα* (Heraklion, 1987), 1:139–50, at 143, asserts that dark garments are a sign of advanced age.

84 Compare this with an image in the western wall in the naos of the Church of the Savior in Meskla (1303) showing the donor with the church model turning to the blessing Christ, who appears in the upper-left corner in heaven: J. Schmidt, *Die spätbyzantinischen Wandmalereien des Theodor Daniel und Michael Veneris: Eine Untersuchung zu den Werken und der Vernetzung zweier kretischer Maler* (Mainz, 2020), 71–72. Another parallel can be found in the Church of the Holy Apostles in Kavousi in the depiction of a *presbyterissa* (layer of the fourteenth century). In the upper-right corner of

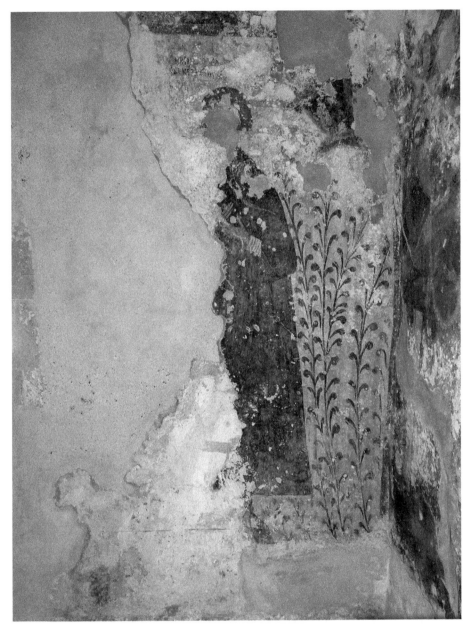

Fig. 7.
Church of St. George,
Vrachasi, portrait of the
deceased Veneris. Photo
by authors.

The plants, symbolizing paradise and in combination with the gesture of the figure, point to a portrait of a deceased person. This is confirmed by the accompanying inscription, which reads: +ΕΚΗΜΗΘΗ Ο ΔΟΥΛΟC Τ[ΟΥ ΘΕΟΥ] . . . Ο ΒΕΝΕΡΙC ΕΤΟC ͵ϛϡ . . . | ΜΑΙΟ [.]Γ΄ (The slave of God, . . . Veneres, passed away in the year 6900 . . . May [.]3).[85] Veneres can be identified with "ser Hemanueli Venerio" mentioned in the document of 1401 (see Appendix, doc. 2). This portrait and its inscription offer additional support for the identification of the church as the one referred to in the

the image field, the beams of a mandorla are still visible, which probably also contained a depiction of the blessing Christ; see Andrianakes and Giapitsoglou, *Χριστιανικά μνημεία*, 225.

85 The inscription was first published by D. Tsougarakes and E. Aggelomate-Tsougarake, "Ἀνέκδοτα χαράγματα καὶ ἐπιγραφές ἀπό μονές καὶ ναούς τῆς Κρήτης," in *Ἐνθύμησις Ν. Παναγιωτάκη* (Heraklion, 2000), 681–732, at 717, no. 435. On line 3, the authors read ΜΑΪΟΥ Γ; see also Moschove, "Νέα στοιχεία," 604, for a slightly different reading.

document published by Cattapan. Since, according to this document, Emanuele was the owner of the church and commissioned its wall paintings, it is reasonable to assume that he is the patron depicted on the western wall. Based on the inscription alone, in which the year is preserved fragmentarily, his death can be dated between 6900–6999, that is, 1392–1491. The document of 1401 serves as terminus ante quem for the murals but predates the death of Emanuele Venier, which can be theoretically placed between 1401 und 1491. We cannot exclude the possibility that another family member is depicted here.[86]

Venier's portrait is placed directly under the Tribunal of the Apostles on the right side of the composition, where personifications of the Sea and the Earth and/or the representations of hell and the damned are normally located.[87] Since the personifications were painted on the northern wall, as already stated, one would expect here images of hell. It is therefore possible that the portrait of Venier was created later than the surrounding frescoes (after his death), replacing the aforementioned scenes. A narrow strip between Venier's portrait and the Tribunal of the Apostles strengthens this possibility. What was originally depicted there is difficult to know. In its present state, the current overall composition and organization of the wall makes little sense. We suggest that this strip is what remains of the original part of the Last Judgment. In any case, the inclusion of this portrait in the composition of the Last Judgment communicates Venier's wish for the salvation of his soul and ensures the commemoration of

his name during the liturgy.[88] He was probably buried in the church.[89]

The document of 1401 informs us that the painter was Georgios Mavrianos. As Georgia Moschove has already observed, the wall paintings are stylistically not homogeneous.[90] Although there is uniformity in the use of predominantly green-turquoise and red colors, there are differences in the execution of the seated apostles and angels of the Last Judgment (Fig. 8) on the one hand, and the standing saints on the northern wall as well as the deacon on the eastern wall on the other (Fig. 3). The latter were painted more carefully and with faces rendered more plastically. The garments of the standing saints fall more naturally than those of the seated apostles, which are rendered in a more linear way, sometimes forming geometric patterns. On the other hand, the angels unrolling the sky are rendered in a classicizing style. The paintings of the western wall share stylistic similarities with those in the Panagia Keragrammeni in Kapistri (beginning of the fifteenth century), but attributing the paintings to the same artist requires a more thorough investigation.[91]

The different styles between standing saints and narrative scenes are a frequent feature in the decoration of churches. It might be the result of the different nature and dimensions of the depicted subjects, or it suggests the collaboration of more than one painter,

86 It was not unusual to build churches on the occasion of a family member's death. For a case on Crete attested through inscriptions, see Gerola, *Monumenti veneti*, 4:484–85, nos. 11–12; for a characteristic example from Rhodes, in which a couple built a church in memory of their three dead children, see M. Acheimastou-Potamianou, "Οι τοιχογραφίες της οικογένειας Βαρδοάνη στον Άγιο Νικόλαο στο Φουντουκλί της Ρόδου," in *Θωράκιον: Αφιέρωμα στη μνήμη του Παύλου Λαζαρίδη* (Athens, 2004), 247–62.

87 For the placement of representations of the Last Judgment within Cretan churches, see a brief mention in A. Lymberopoulou, "Hell on Crete," in *Hell in the Byzantine World: A History of Art and Religion in Venetian Crete and the Eastern Mediterranean*, vol. 1, *Essays*, ed. A. Lymberopoulou (Cambridge, 2020), 117–90, at 120; however, it does not represent the entire range of possibilities encountered on Crete.

88 For similar cases in which real people (donors or deceased people) are included in a representation of the Last Judgment, see V. Tsamakda, "Darstellungen realer Personen im Kontext christlicher Szenen," in *Privatporträt: Die Darstellung realer Personen in der spätantiken und byzantinischen Kunst*, ed. V. Tsamakda and N. Zimmermann (Vienna, 2020), 219–41, at 227–30.

89 In both chapels of the katholikon, several graves from various periods were found; see Moschove, "Νέα στοιχεία," 599, n. 3. None of the tombs can be connected to the deceased Venier.

90 Moschove, "Νέα στοιχεία," 604–5.

91 On the affinities between Vrachasi and Kapistri, mainly from an iconographic point of view, see Moschove, "Νέα στοιχεία," 605. On the church in Kapistri, see briefly *Ἀρχ.Δελτ.* 56 (2001–2004): 592–93. The frescoes of Kapistri are unpublished. The seated apostles in the Last Judgment scenes of the two churches (the one in Kapistri is also not included in Lymberopoulou and Duits, *Hell in the Byzantine World*) are comparable, as well as the relatively dark faces of the angels in Vrachasi and the ones flanking the seated Virgin on the northern wall in Kapistri.

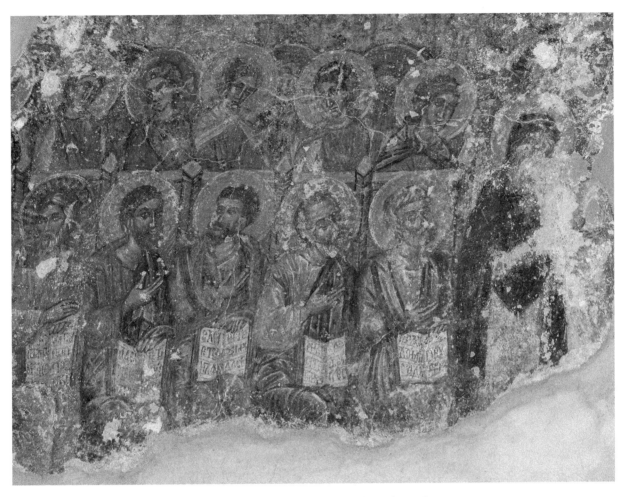

Fig. 8. Church of St. George, Vrachasi, Tribunal of the Apostles. Photo by authors.

especially for the execution of large painting programs.[92] The latter could also be the case in Vrachasi. Mavrianos was a master painter who trained apprentices. It is reasonable to assume that he led an artist's workshop with several assistants. In fact, from the contract of 1390 (Appendix, doc. 1), we are informed about one such apprentice, Michael Charchiopoulos.[93] Since it was agreed that he would learn the art of wall painting and assist Mavrianos for ten years, it is possible that this second painter was Charchiopoulos. However, this presupposes that Charchiopoulos was the only apprentice

of Mavrianos at that time and that he indeed remained his apprentice until the completion of the frescoes in Vrachasi. As in similar cases, only Mavrianos, as the leader of the workshop, signed the contract.[94] Studying the murals in Kato Symi, also executed by Mavrianos according to the contract of 1421 but including more narrative scenes, will help us gain insight into the organization, mode of operation, and development of his workshop over the course of time and better estimate the place of Mavrianos's painting in contemporary Byzantine art on Crete.

92 On this, see Tsamakda, *Kakodiki*, 110. Borboudakes, "Η τέχνη κατά τη Βενετοκρατία," 235, explains the differences in quality within one monument by the different artistic niveau of the participating main and secondary painters of a workshop.

93 See above, p. 253.

94 The same applies to the dedicatory inscriptions in which only the master painter is mentioned by name, although the participation of more than one artist in the execution of the decoration is sometimes obvious. For examples from the workshop of Ioannes Pagomenos, see Tsamakda, *Kakodiki*, 111.

Georgios Mavrianos and the Church of Panagia in Kato Symi

Several sources mention the area of Symi—situated at the borders between the prefectures of Heraklion and Lasithi—throughout the Venetian dominion.[95] Two documents of the thirteenth and fourteenth centuries refer to Symi as a single settlement.[96] However, from the early fifteenth century on, the same area began to be cited separately as Ano (or Apano) and Kato Symi.[97] This distinction has been preserved until today.

Until recently, the only known church in the area was St. George in Ano Symi, initially listed by Gerola because of its frescoes painted by Manuel Phokas shortly after the Fall of Constantinople in 1453.[98]

The Document on the Church of Panagia in Kato Symi

This document (Appendix, doc. 3) refers to another commission to Mavrianos, again in eastern Crete. The content of the contract can be summarized as follows: On 19 May 1419,[99] the Cretan painter Georgios Mavrianos made a quittance to the Venetian noble Nicola Corner for the wall paintings of the Church of Panagia in Symi, a village (*casale*)[100] that belonged to the latter. The plural form used in 1419 to indicate the settlement of Symi (*Simes*) clearly hints at the aforementioned distinction in Apano and Kato Symi since at least 1410.[101] The agreement specified that Mavrianos should paint all subjects from the life of Jesus Christ and Virgin Mary in small format (*in opera minuta*) so that all paintings fit in the available space. The painter should leave Chandax for Symi on 15 June 1419, and the payment agreed upon for his work was seventy hyperpera.

In contrast to the document of 1401, which implies that a contract between Georgios Mavrianos and Emanuele Venier already existed and thus omits the details of their previous agreement, this document includes for the first time details that shed light on the modus operandi of a wall-painting commission in a church, whose frescoes are partially preserved. Interestingly, the price agreed upon between Mavrianos and Corner in 1419 is evidently much lower in comparison to that agreed upon for the creation of the frescoes in the Church of St. George in Vrachasi in 1401, although the churches have almost the same dimensions. Since the payment of 120 hyperpera agreed upon by Mavrianos and Venier for the church in Vrachasi far exceeded the amount of sixty hyperpera agreed upon by Souranas and Synadenos and Georgios Piperes in 1399, this might be the reason for Venier's denial to pay off Mavrianos and the subsequent settlement of their dispute in court.

The information provided by the contract generally aligns with other similar contracts published by Cattapan (e.g., the time in which the painter's work should commence). Of particular interest here are the specific instructions about the small format of the compositions. Such a stipulation is unique in our sources, and it might be directly related to the available space in the church.[102]

As with Venier, members of the Venetian family of Corner were among the first to colonize Crete after 1211.[103] Nicola Corner, son of the late Andrea, could

95 Spanakes, Πόλεις και χωριά, 2:747.

96 A. Lombardo, ed., *Documenti della colonia veneziana in Creta* (Torino, 1942), 117 (*Symie*), and Santschi, *Régestes*, 194 (*Simi*), respectively.

97 See, for example, A.S.V., *Notai di Candia*, b. 23 [Giorgio Della Gronda], fol. 33 [119]r: *Eodem [die]* [XXI mensis Februarii 1409]. *Manifestum facio ego, Nicolaus Cornario, filius domini Andree de Venetie, habitator Candide, cum meis heredibus, tibi, Iohanni Demolin, diaco, habitatori casalis Catosimi* ... (On the same day [21 February 1409 (= 1410)]. I, Nicola Corner, son of Sir Andrea of Venice, resident of Chandax, with my successors, make public to you, Ioannes Demolinos, deacon, resident of the village of Kato Symi ...), and A.S.V., *Notai di Candia*, b. 235 [Giovanni Risino], quad. 7, fol. 22r: [XXVII mensis Aprilis 1464] *Theotochius Andrioti, habitator casalis Apano Simi, quia cum meis heredibus, do, concedo et in perpetuum transacto in gonico tibi, Marco Bonfilio, habitatori casalis Cato Simi et heredibus, quiddam molendinum* ... ([27 April 1464] I, Theotokes Andriotes, resident of the village of Apano Symi, with my successors, give, concede, and permanently sell to you, Marco Bonfilio, resident of the village of Kato Symi, and to your successors, one mill-house ...).

98 Gerola, *Monumenti veneti*, 4:577, no. 10, and Gerola and Lassithiotakes, Τοπογραφικός κατάλογος, 101, no. 741. See also Tsougarakes and Aggelomate-Tsougarake, *Corpus*, 217, no. 192, where two graffiti, one from the year 1478 and the other from 1502, are reported at the north side of the narthex.

99 The document is published by Cattapan with the wrong date of 21 May 1420 (Cattapan, "Nuovi elenchi," 228–29, doc. 29).

100 On this term, see C. Gasparis, "Il villaggio a Creta veneziana: XIII–XV sec.," in *Les villages dans l'Empire Byzantin: IVᵉ–XVᵉ siècle*, ed. J. Lefort, C. Morrisson, and J.-P. Sodini (Paris, 2005), 237–46.

101 Cf. above, n. 97.

102 Cf. below, p. 267.

103 Tafel and Thomas, *Urkunden*, 477.

Fig. 9. Church of Panagia, Kato Symi, view from the east. Photo by authors.

apparently be identified with *Nicolaum Cornario*, son and executee of Maria Cornario, *relicta domini Andree Cornario* (widow of Sir Andrea Corner), whose testament was written on 10 October 1382.[104] The testament mentions several Latin ecclesiastic foundations in Chandax and its suburbs that Maria frequented: the monastery of St. Francis, the nunneries of St. George and St. Catherine,[105] and others. As in the case of Venier,[106] there is no evidence of Corner's religious identity, but we have no reason to assume that it was different from his mother's. That a Venetian noble employed a Cretan painter to decorate an Orthodox church does not necessarily mean that the noble was Orthodox. Rather, it was an act of service to the subordinate Orthodox peasants who worked on his property.

104 McKee, *Wills*, 2:909–10, doc. 721.

105 These ecclesiastic foundations are identified with nos. 118, 126–27 of the list of G. Gerola, "Topografia delle chiese della città di Candia," *Bessarione* 34 (1918): 3–65, at 29; cf. Gerola, *Monumenti veneti*, 2:112–17, 129.

106 See above, p. 255.

The Church of Panagia in Kato Symi

Because of its poor state of preservation, the church has not attracted the attention of scholars, although its frescoes are of high quality. As the church and its frescoes are unknown, they were never connected to the document published by Cattapan. Additionally, the document lists the settlement where the church is located as Simes, something that may have also hindered the identification of the church.

ARCHITECTURE

The church is a single-aisled building (Fig. 9). Evidently, it partially collapsed at some point in the past and was rebuilt. Still visible are traces of two transverse arches that divided the church into three bays and were at some point removed. The western bay was demolished. Today, the entrance to the church is on the western wall. Only the southern wall and parts of the eastern one are original. Consequently, paintings survive only on these parts (Fig. 10).

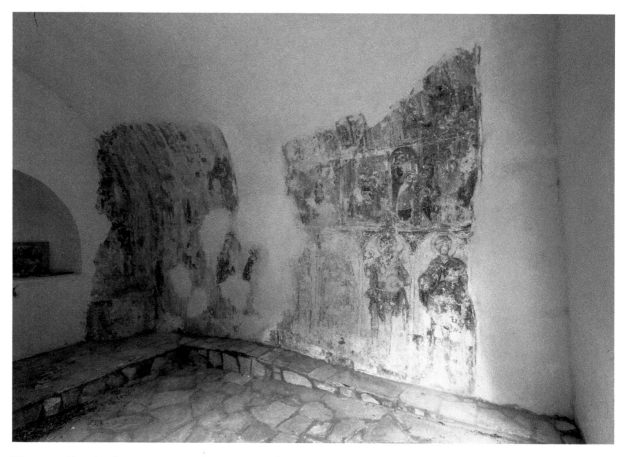

Fig. 10. Church of Panagia, Kato Symi, surviving frescoes on the eastern and southern wall. Photo by authors.

THE WALL PAINTINGS
Iconographic Program

Though a complete investigation of the pictorial program is impossible, many of the remaining subjects can still be identified. In the present state of preservation, the decoration comprises a Christological cycle, scenes from the Life of the Virgin, and full-figure saints. We can distinguish the following themes.

In the sanctuary, only fragments from the Virgin of the Annunciation and from a bearded deacon placed under an arch below her are still visible on the eastern wall to the right of the apse. The barrel vault of the sanctuary has scenes arranged in two registers; those of the upper register are unintelligible. The zone below shows two scenes from the cycle of Christ's appearances after the Passion: Christ Appearing to the Apostles (Peace be unto you) and Christ Appearing to the Two Marys (*Chairete*). The southern wall depicts three frontally standing bishops.

In the naos, wall paintings in poor condition can still be seen only on the southern wall of the middle bay. The barrel vault is divided into two registers. The upper register has the Entry into Jerusalem and the Betrayal. The register below contains three scenes from the Virgin cycle. From east to west, these are the Nativity of the Virgin, the Caressing, and the Presentation of the Virgin in the Temple. On the southern wall, the Deësis is depicted directly in front of the sanctuary with Christ located below the destroyed transverse arch. The depiction served as a proskynesis image.[107] Three military saints follow. All figures on the wall are placed under arches.

The iconographic program conforms to the basic principles of Byzantine church decoration. From the

107 On such prostration images on the lateral walls of Cretan churches, see A. Mailis, *Obscured by Walls: The Bēma Display of the Cretan Churches from Visibility to Concealment* (Mainz, 2020), esp. 53–106.

arrangement of the scenes, it is clear that the church was dedicated to the Virgin. The decoration seems to emphasize military saints. However, since so large a part of the iconographic program has been lost, all conclusions remain tentative.

The document of 1419 (Appendix, doc. 3) mentions only that Georgios Mavrianos had to paint all stories of Christ and of the Virgin (*omnes figuras istoriarum Jesu Christi et Beate Marie Virginis*). These subjects were indeed included in the program. Mavrianos had to make sure that these compositions were painted in the manner he thought best when considering the available space. This clause in the contract allowed the painter a great deal of freedom in creating the fresco decoration.

The phrase *in opera minuta* is of particular interest. It likely refers to the small format of these images. The small dimensions of the church may also account for this remark. In any case, it remains unique among the extant relevant documents. We can observe that the narrative scenes in the barrel vault are rendered on a much smaller scale than the saints on the walls. They are also smaller in scale compared to similar scenes in other churches.[108] The scenes of the Life of the Virgin are even more reduced in scale compared to the Christological cycle, to which it is as usual subordinated.

On the southern wall to the right of St. Theodore, there is a relief-like graffito of 1419 and a monogram below it made by a cross and the letters *C* and *n* (see below, Fig. 16). Perhaps it is no coincidence that these letters correspond to the initials of the noble Nicola Corner, who commissioned the wall paintings.[109] The monogram is identical to that in the Church of the Apostles in Lithines (1415).[110] According to the notarial act of 1419, the painter was to leave Chandax for Symi on 15 June. Thus, we can safely assume that the wall paintings were finished within the same year. Nicola

Corner likely added his monogram and the date in this prominent position upon seeing the finished work.[111]

Iconography

Only a few parts from the lower half of the Entry into Jerusalem are still visible, including the head of the ass on which Jesus rides, a naked child in the foreground, and a small branch of a tree between them. To the right, there are remnants of the city of Jerusalem and people standing before its gate. The scene follows contemporary trends in Palaeologan iconography.[112]

From the composition of the Betrayal of Judas, only the lower parts still survive (Fig. 11). The lower part of Judas's body is next to that of Christ, whom he probably embraced, following the standard iconography.[113] In the lower-right corner, Peter (inscribed as Π) is cutting off Malchus's ear, while behind him stand some figures. Since the scene is badly damaged, no further iconographic observations can be made.

For the same reason, the scene of Christ Appearing to the Apostles (Peace be unto you) cannot be described in detail. In the center of a symmetrical composition, Christ stands frontally and blesses with outstretched hands. An edifice with a green cupola is visible behind him. Christ is flanked by two groups of apostles, of which only the garments in the lower parts and some feet are visible. They are standing in front of buildings. The composition represents Christ Appearing to the Apostles (Peace be unto you) in a building *with the doors*

108 The difference in scale between the saints on the walls and the narrative scenes on the barrel vaults is common, but in the case of the church in Kato Symi, it is more conspicuous.

109 It is unknown if the first letter in a monogram refers to the name or the surname. In the case of the graffiti beginning with *hic fuit*, the surname always follows; on this, see Tsougarakes and Aggelomate-Tsougarake, *Corpus*, 39.

110 Tsougarakes and Aggelomate-Tsougarake, *Corpus*, no. 220.43. For cases of visitors who scratched their name in more than one church, see ibid., 50–53.

111 Such a case of inspection and approval is attested by the aforementioned contract signed in 1331 between the painter Nikolaos Vassalos and Markos Mouatsos (Cattapan, "Nuovi elenchi," 227, no. 26). According to the contract, after the completion of the work, two people were to judge the result and, if it was satisfactory, the painter would receive his payment. Interestingly, the contract was later annulled. This document implies that dissatisfaction on the part of the commissioners was perhaps frequently the case. Compare also with what was said above (p. 254) about the quarrel between Georgios Mavrianos and Emanuele Venier.

112 On the iconography of this subject, see E. Lucchesi Palli, "Einzug in Jerusalem," *LChrI* 1:593–97, and Lucchesi Palli, "Einzug in Jerusalem," *RBK* 2:22–30; for Crete, see Kalokyres, *Αἱ βυζαντιναὶ τοιχογραφίαι*, 68–70; Spatharakis, *Rethymnon*, 292–93; and Tsamakda, *Kakodiki*, 176–77.

113 On the iconography of the Betrayal, see J. Thüner, "Verrat des Judas," *LChrI* 4:440–43, and C. Papakyriakou, "Η Προδοσία του Ιούδα: Παρατηρήσεις στην μετεικονομαχική εικονογραφία της παράστασης," *Byzantina* 23 (2003): 233–60; for Crete, see Kalokyres, *Αἱ βυζαντιναὶ τοιχογραφίαι*, 85–86; Spatharakis, *Rethymnon*, 293–95; and Tsamakda, *Kakodiki*, 178–80.

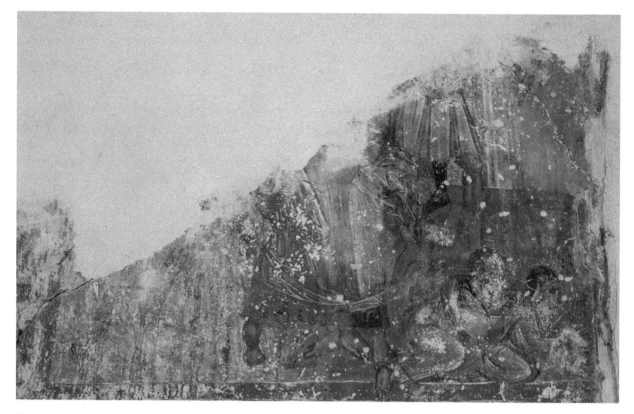

Fig. 11. Church of Panagia, Kato Symi, the Betrayal. Photo by authors.

locked, according to John 20:19 and 26, a subject that is relatively rare on Crete. The scene follows the standard iconography for this variant,[114] as seen for instance in the Church of the Savior in Ano Karkasa (end of the fourteenth century).[115]

The scene of Christ Appearing to the Two Marys (Chairete) is greatly damaged. It depicts Christ, recognizable by his cruciform nimbus, standing in the center and flanked by two nimbed people, most likely Mary Magdalene and "the other Mary" according to Matthew 28:1. The woman on the left wears dark

purple garments;[116] the one on the right has green ones. The incident unfolds in a landscape defined by two hills. The composition seems to follow the standard iconographic scheme according to which Christ is depicted blessing the two kneeling Marys with outstretched hands.[117] The posture of the women can vary. In Kato Symi, Christ does not extend both hands.[118] In this church, neither woman bends down to touch Christ's feet, but they seem to raise their hands

114 On the iconography of this subject, see K. Wessel, "Erscheinungen des Auferstandenen," *RBK* 2:383; J. Myslivec, "Apostel," *LChrI* 1:168; W. Medding, "Erscheinung Christi vor den Aposteln," *LChrI* 1:671–72; N. Gkioles, "'Πορευθέντες . . .' (Εἰκονογραφικές παρατηρήσεις)," *Δίπτυχα* 1 (1979): 104–42, esp. 130–40; A. W. Carr, "Appearances of Christ after the Passion," *ODB* 1:142–43; and N. Zarras, *Ο εικονογραφικός κύκλος των εωθινών ευαγγελίων στην παλαιολόγεια μνημειακή ζωγραφική των Βαλκανίων* (Thessaloniki, 2011), 190–208.

115 Zarras, *Ο κύκλος των εωθινών ευαγγελίων*, 192, fig. 81.

116 The woman on Christ's right wearing a purple *maphorion* is usually identified as the Virgin, an identification that was influenced by the writings of Gregorios Palamas (1294–1357), among others; see N. Zarras, "La tradition de la présence de la Vierge dans les scènes du 'Lithos' et du 'Chairete' et son influence sur l'iconographie tardobyzantine," *Zograf* 28 (2000–2001): 113–20, esp. at 115, 118–20.

117 On the iconography of this subject, see Wessel, "Erscheinungen des Auferstandenen," 379–83; W. Medding, "Erscheinung des Auferstandenen (2) vor den Frauen," *LChrI* 1:666–67; Carr, "Appearances of Christ after the Passion," 142–43; Zarras, "La tradition"; and Zarras, *Ο κύκλος των εωθινών ευαγγελίων*, 126–32.

118 On this relatively rare detail, see Zarras, *Ο κύκλος των εωθινών ευαγγελίων*, 128, with parallels.

toward him. A comparable composition, painted by Ioannes Pagomenos in 1328, is found in the Church of St. John at Trachiniakos.[119] Christ's posture and the colors of the women's vestments can be best compared to the images at the Valsamonero monastery of St. Phanourios (beginning of the fifteenth century)[120] and at St. George in Emparos (1436/37), painted by Manuel Phokas.[121]

In its present state of preservation, the Virgin cycle comprises three episodes, depicted in chronological sequence.[122] The cycle most probably continued on the opposite wall.

The Nativity of the Virgin is partially destroyed (Fig. 12). It shows Anne seated on a comparatively large rectangular bed leaning forward with crossed arms in a state of exhaustion. A midwife stands next to Anne looking at her and probably offering her support.[123] Two female servants carrying undefined objects, perhaps spices for the Virgin, approach from the right. In the lower-right corner, a woman sits in profile, turned to the left and holding what is likely a flabellum or a spindle; in front of her is the cradle, where the newborn Virgin lies wrapped in swaddling clothes. The scene takes place in front of an architectonical fantasy with walls and hanging draperies. The composition follows the standard iconographic scheme[124] and can be compared to the one in the Panagia in Palaia Roumata (1359/60),[125] the Panagia in Kapetaniana (1401/2),[126] and the Panagia in Sklaverochori (mid-fifteenth century).[127] Although its state of preservation is very bad, the version in Panagia Keragrammeni in Kapistri (beginning of the fifteenth century) seems to correspond exactly to the one in Kato Symi.

Following the standard iconographic scheme,[128] the scene of the Caressing of the Virgin represents the infant Mary caressed by her parents, Anne on the right and Joachim on the left (Fig. 13). Joachim's head is touching Mary's, while Anne is about to kiss her. The child is seated on Anne's knees and extends her left hand. In the background, there is an architectural setting flanked by curtains, implying that the scene takes place inside a house. The composition shares the standard iconography, for example, with the scene in Studenica (1314).[129] Among the Cretan comparative material, there are striking similarities to the Panagia Keragrammeni in Kapistri.

The Presentation of the Virgin in the Temple comprises two episodes: the Presentation and the Feeding by an Angel (Fig. 14). In the foreground, the High Priest Zacharias is depicted standing on the left and receiving Mary, who approaches him with extended arms. A maiden follows Mary and presents her to Zacharias. She is followed by another veiled maiden who holds a candle, as well as by her parents. Four more young girls with unveiled heads stand in the background. St. Anne turns her head in the direction of Joachim instead of looking at the Virgin. A seventh young girl

119 T. Ioannidou, "Το παρεκκλήσι του Αγίου Ιωάννου του Θεολόγου 'στων Τραχινιάκω(ν)' Καντάνου, της επαρχίας Σελίνου, νομού Χανίων: Συμβολή στο έργο του κρητικού ζωγράφου Ιωάννη Παγωμένου (α΄ μισό του 14ου αιώνα)" (master's thesis, Aristotle University of Thessaloniki, 2016), http://ikee.lib.auth.gr/record/295589?ln=en, pls. 53–54. On the wall paintings and their attribution to Ioannes Pagomenos, see also Tsamakda, *Kakodiki*, 116–17.

120 M. Borboudake, "Ο αρχικός ναός της Παναγίας της Οδηγήτριας," in *Οι τοιχογραφίες της Μονής του Βαλσαμονέρου*, 53–180, at 81–82, pls. 6, 24b.

121 I. Spatharakis, *Dated Byzantine Wall Paintings of Crete* (Leiden, 2001), 185.

122 On the iconography of the Virgin cycle, see G. M. Lechner, "Maria," *RBK* 6:95–109; M. Nitz, "Marienleben," *LChrI* 3:212–33; J. Lafontaine-Dosogne, *Iconographie de l'enfance de la Vierge dans l'Empire Byzantin et en Occident*, 2 vols., 2nd ed. (Brussels, 1992); and J. Lafontaine-Dosogne, "Iconography of the Cycle of the Life of the Virgin," in *The Kariye Djami*, vol. 4, *Studies in the Art of the Kariye Djami and Its Intellectual Background*, ed. P. A. Underwood (London, 1975), 161–94; for Crete, see Kalokyres, *Αἱ βυζαντιναὶ τοιχογραφίαι*, 104–16, and Spatharakis, *Rethymnon*, 307–11.

123 Compare with the mosaic in the inner narthex of the Monastery of Christ at Chora: P. A. Underwood, *The Kariye Djami* (New York, 1966), 2: pl. 98.

124 On the iconography of the Nativity of the Virgin, see Lafontaine-Dosogne, *L'enfance de la Vierge*, 1:89–120, and Lafontaine-Dosogne, "Life of the Virgin," 174–76; for Crete, see Kalokyres, *Αἱ βυζαντιναὶ τοιχογραφίαι*, 106–7. A good parallel outside Crete can be found, for example, in the Church of the Virgin Peribleptos (currently St. Clement) in Ohrid (1294/95); see Lafontaine-Dosogne, *L'enfance de la Vierge*, 1: fig. 20.

125 Spatharakis, *Dated Wall Paintings*, 109, 110.

126 Spatharakis, *Dated Wall Paintings*, 158.

127 M. Borboudakes, "Παρατηρήσεις στη ζωγραφική του Σκλαβεροχωρίου," in *Ευφρόσυνον: Αφιέρωμα στον Μανόλη Χατζηδάκη* (Athens, 1991), 1:375–99, at 378, pl. 190a.

128 On the iconography of the Caressing, see Lafontaine-Dosogne, *L'enfance de la Vierge*, 1:124–27, and Lafontaine-Dosogne, "Life of the Virgin," 177–78; for Crete, see Kalokyres, *Αἱ βυζαντιναὶ τοιχογραφίαι*, 107–8.

129 Lafontaine-Dosogne, *L'enfance de la Vierge*, 1: fig. 64.

Fig. 12.
Church of Panagia, Kato
Symi, the Nativity of the
Virgin. Photo by authors.

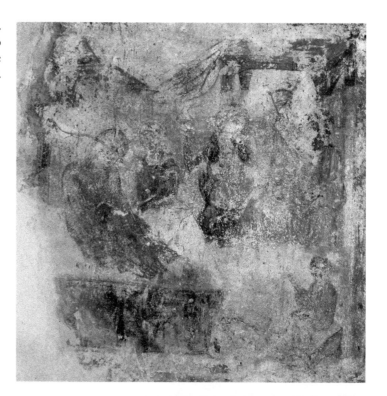

Fig. 13.
Church of Panagia, Kato
Symi, the Caressing of the
Virgin. Photo by authors.

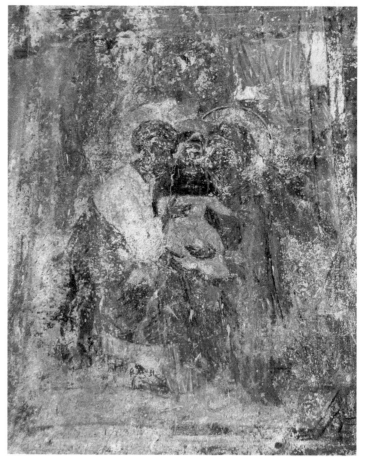

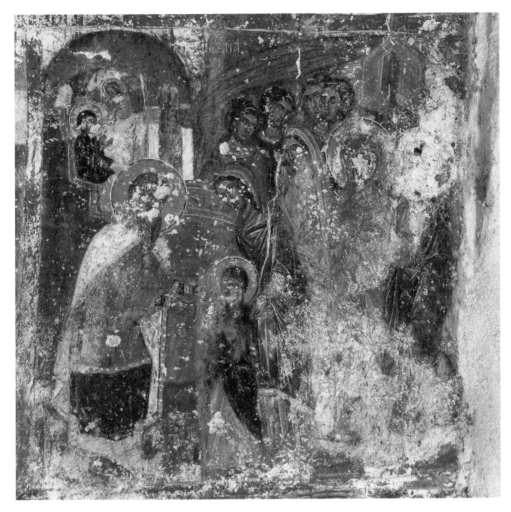

Fig. 14.
Church of Panagia,
Kato Symi, the
Presentation of the
Virgin in the Temple.
Photo by authors.

was perhaps depicted on the far right side, but this part of the composition has been destroyed. The second episode is placed in smaller scale in the upper-left corner. It shows Mary seated on the steps of the sanctuary below a ciborium. A flying angel approaches and brings her food, as described in apocryphal texts. The inscription reads: ΤΑ ΑΓΙΑ ΤΩΝ ΑΓΙΩΝ (the Holy of Holies). The scenes take place before an architectural setting that signifies the Temple. The representation adheres to established iconographic patterns found in many Macedonian monuments of the fourteenth century, according to which Mary is presented to Zacharias not by her parents but by one of the virgins.[130] On

Crete, very close parallels are found at the Panagia in Kapetaniana (1401/2),[131] the Panagia Kardiotissa in Voroi (beginning of the fifteenth century),[132] the Panagia in Sklaverochori (mid-fifteenth century),[133] and again at the Panagia in Malles (1431/32).[134] All

130 An example can be found in the Church of the King in Studenica (1313/14). On the iconography of the Presentation of the Virgin in the Temple and examples of this type, see Lafontaine-Dosogne, L'enfance de la Vierge, 1:136–67, and Lafontaine-Dosogne,

"Life of the Virgin," 179–83; for Crete, see Kalokyres, Αἱ βυζαντιναὶ τοιχογραφίαι, 110–11.

131 Spatharakis, Dated Wall Paintings, 158.

132 M. Borboudakes, "Παναγία Καρδιώτισσα Βόρων," in Πεπραγμένα Θ΄ διεθνούς Κρητολογικού συνεδρίου (Heraklion, 2004), 2.2:107–18, fig. 2.

133 Borboudakes, "Παρατηρήσεις," 381, 386, pl. 190b, and Maderakes, "Βυζαντινή ζωγραφική," 286.

134 T. M. Provatakes, "Παναγία η Μεσοχωρίτισσα: Ένας παλαιολόγειος ναός στις Μάλλες Λασιθίου Κρήτης," in Τιμητικό αφιέρωμα στον ομότιμο καθηγητή Κωνσταντίνο Δ. Καλοκύρη (Thessaloniki, 1985), 469–523, at 500–1, figs. 26–28, and M. Aspra-Vardavake, "Οι τοιχογραφίες της Παναγίας Μεσοχωρίτισσας στις Μάλλες Λασιθίου Κρήτης," Δίπτυχα

Fig. 15. Church of Panagia, Kato Symi, St. Spyridon. Photo by authors.

these scenes repeat the same iconography, which obviously goes back to a common archetype.

The depiction of the Deësis follows the standard scheme, showing Christ standing in the center holding a book and blessing, flanked by the Virgin on the left and St. John the Forerunner on the right. Both Mary and John raise their hands in supplication.[135] This type is very common on Crete and finds parallels among fifteenth-century church decorations,

such as at St. Isidore in Kakodiki (1421).[136] However, the placement of the figures of the Deësis under arches is rare. A parallel exists at the Panagia in Kastamonitsa (mid-fourteenth century).[137]

Three frontally standing bishops are depicted in the sanctuary, but their poor state of preservation precludes a secure identification. Only the first one could be identified, as St. Spyridon, on the basis of his characteristic headgear (Fig. 15).[138] Unlike the bishops in the sanctuary, the figures in the naos are all placed under arches. Three saints clad in military attire occupy the remaining wall surface to the right of the Deësis (Fig. 10). The first one is almost completely lost. The beardless saint is holding a sword and a shield and, based on his curly hair, could be identified as St. George.[139] The second saint is probably St. Demetrios. He is also beardless, has short and straight hair, and holds a lance, a small shield, and a bow.[140] The saint to the right, holding a lance and a sword, has curly hair and a short, dark, and round beard. He is probably St. Theodore Teron (Fig. 16).[141] A close parallel regarding the stance, military costume, and weapons of the saint is found in the nearly contemporaneous St. Nicholas in Skidia.[142] All these depictions of military saints are repeated in Cretan icons from the fifteenth century onward.[143]

The iconography of the church displays pronounced affinities with a group of wall paintings of the first half of the fifteenth century, including works in churches dedicated to the Virgin in Kapetaniana, Sklaverochori, Voroi, and Malles. These churches use common iconographic sources that in turn find correspondences in Macedonia and Mistras. However, these sources and parallels all date to the fourteenth century

Εταιρείας Βυζαντινών και Μεταβυζαντινών Μελετών 5 (1991): 172–250, at 222–23, pl. 24.

135 On the iconography of the Deësis, see T. von Bogyay, "Deesis," *RBK* 1:1178–1186, and M. Kazamia-Tsernou, *Ιστορώντας τη "Δέηση" στις βυζαντινές εκκλησίες της Ελλάδος* (Thessaloniki, 2003); for Crete, see Kalokyres, *Αἱ βυζαντιναὶ τοιχογραφίαι*, 99–101.

136 Maderakes, "Βυζαντινή ζωγραφική," 292, pl. 110a.

137 Mailis, *Obscured by Walls*, 79, fig. 122.

138 On the iconography of St. Spyridon, see C. Weigert, "Spyridon (Spiridon) von Trimithon," *LChrI* 8:387–89.

139 On the iconography of St. George, see E. Lucchesi Palli, "Georg," *LChrI* 6:365–73, and C. Walter, *The Warrior Saints in Byzantine Art and Tradition* (Aldershot, 2003), 123–34.

140 On the iconography of St. Demetrios, see J. Myslivec, "Demetrius von Saloniki," *LChrI* 6:41–45, and Walter, *The Warrior Saints*, 76–93.

141 On the iconography of St. Theodore Teron, see C. Weigert, "Theodor Tiro von Euchaïta (von Amasea)," *LChrI* 8:447–51, and Walter, *The Warrior Saints*, 55–66.

142 Maderakes, "Βυζαντινή ζωγραφική," 295, fig. 123b.

143 Maderakes, "Βυζαντινή ζωγραφική," 295, with examples.

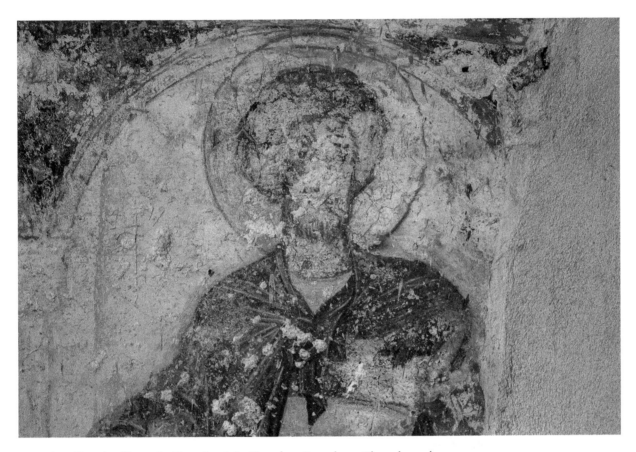

Fig. 16. Church of Panagia, Kato Symi, St. Theodore Stratelates. Photo by authors.

at the latest.[144] Scholars believe that they reflect Constantinopolitan art.[145]

Style

Like the wall paintings in Vrachasi, those in Kato Symi are not homogeneous in style. The frescoes of the sanctuary differ from those in the naos. The faces of the deacon on the eastern wall and of St. Spyridon on the southern wall are much darker than those of the naos. However, due to their poor state of preservation, it is difficult to ascertain whether or not these paintings were created by a different artist. At the same time, the frescoes of this painter also differ from the ones in Vrachasi. In Kato Symi, Georgios Mavrianos probably created the surviving frescoes of the naos, which are of outstanding quality. They exhibit close affinities to the ones in Vrachasi but also differences that can be explained by

the intervening twenty years separating the production of these two mural programs.

The paintings of the naos exhibit all the characteristics of the classicizing trends of the first half of the fifteenth century on Crete.[146] These tendencies were already perceptible in Vrachasi, but the evolution of Mavrianos over the course of twenty years is remarkable. What is at first glance impressive in Kato Symi is the color scale, dominated by very bright blue and green colors, as well as ochre and earth tones (Fig. 11). The painter is well acquainted with the Palaeologan volume style. As seen especially in the Betrayal scene (Figs. 11, 17), the space is rendered with depth, and the various groups are clearly placed at different levels between the foreground and the background. The buildings are likewise rendered three-dimensionally, as seen in the Virgin scenes (Figs. 12–14). Like the elegant movements of the

144 See also Maderakes, "Βυζαντινή ζωγραφική," 280.

145 M. Chatzidakes, "Τοιχογραφίες στην Κρήτη," Κρ.Χρον. 6 (1952): 59–91, at 69, and Maderakes, "Βυζαντινή ζωγραφική," 277.

146 On these tendencies, see Maderakes, "Βυζαντινή ζωγραφική," who examines a group of seventeen Cretan monuments dating between ca. 1400 and 1430.

Fig. 17.
Church of
Panagia, Kato
Symi, detail of
the Betrayal.
Photo by authors.

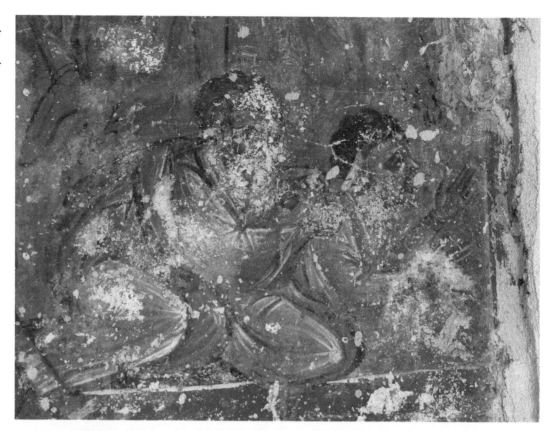

Fig. 18.
Church of
Panagia, Kato
Symi, detail of
the Presentation
of the Virgin
in the Temple.
Photo by authors.

figures, the faces also express calmness, except for the face of Malchus (Fig. 17). The draperies are rendered plastically with the aid of tone gradations and white highlights, which sometimes take geometrical forms. The folds fall somewhat hard and jagged; the reflection of the light awards them a metallic impression (Figs. 11, 17). The faces of the figures in the Presentation image are best preserved (Fig. 18): they are modeled with light to dark olive-green shadows and highlighted by thin white strokes, which strongly evoke the technique of icon painting.

Mavrianos's paintings belong in the group of wall paintings from the first half of the fifteenth century on Crete that are characterized by a classicizing style. The earliest dated monuments of this group are the Panagia in Kapetaniana and the Panagia Vryomeni in Meseleroi, both dated by inscription to 1401/2.[147] Most of these churches display the same academic style and, at the same time, a conspicuous influence from icon painting, a technique applied above all to the depiction of saints.[148] Further, there are similarities in the rendering of space, the rendering of the buildings, and the treatment of the garments. As we have seen, the iconography also invites comparison with the same group of churches. However, we cannot identify with certainty Georgios Mavrianos as having worked in one of these churches or any other church known to us. Nevertheless, his paintings significantly contribute to our knowledge of Byzantine art on Crete during that period, since they can serve as another reference point for dating other monuments.

From the study of the two church decorations in Vrachasi and Kato Symi, we can conclude that Mavrianos developed his style over a period of time and that he collaborated with other painters. As specified in the contract of apprenticeship of 1390, Mavrianos's apprentice would have assisted him in his work. The hands of such apprentices are thus certainly among the extant paintings but cannot be securely identified. The second painter in Kato Symi is not mentioned in the document,[149] but he probably belonged to someone in Mavrianos's workshop.[150]

Konstantinos Gaitanas and the Church of the Holy Apostles in Kato Karkasa

The sources on the fifteenth-century history of monasticism in the area of Karkasa (alias Karkasies) are limited and somehow ambiguous. Two churches, the Savior in Ano Karkasa and the Holy Apostles in Kato Karkasa, have been there since the beginning of the fifteenth century, if not earlier.[151] Both churches have preserved Late Byzantine wall paintings. In 1901–1902, Gerola took informal notes on these wall paintings and recorded some of the depicted subjects.[152] The frescoes remain, however, virtually unknown. Especially for the Holy Apostles's wall paintings, modern scholars have emphasized their excellent quality, which displays Constantinopolitan influence.[153]

The first mention of a monastic establishment in the area is found in manuscripts of the letters that the Cretan hieromonk Neilos Damilas sent to Maximus Chrysoberges. The earliest fifteenth-century manuscripts that preserve the letters do not mention Damilas as a resident of Karkasa (e.s., Patmos, Monastery of Saint John the Theologian, gr. 428 and gr. 669, and Alexandria, Patriarchal Library, gr. 341). The first such mention is found in Paris, Bibliothèque nationale de France, gr. 1295 (fifteenth to sixteenth centuries), where on f. 60v we read: Ποίημα κυροῦ Νείλου ἱερομονάχου καὶ πνευματικοῦ πατρός, τοῦ ἐπιλεγομένου Νταμιλᾶ τοῦ Κρητικοῦ, τοῦ ἐν τῇ ἱερᾷ μονῇ τῶν Καρκασίων (Work of the hieromonk and spiritual father, Sir Neilos, the so-called Damilas, from Crete, resident of the sacred monastery of Karkasa). This geographical information on Damilas's residence is repeated in Paris, Bibliothèque nationale de France, gr. 1286 (sixteenth century); Bremen, Staats- und Universitätsbibliothek,

147 Maderakes, "Βυζαντινή ζωγραφική," 273.

148 See Bissinger, *Kreta*, 217.

149 Among the published contracts, there is only one case in which a person hires two painters to paint a church; see above, pp. 249–50.

150 There is also the possibility, demonstrated by analogous contracts for the painting of icons, that a painter could hire another

painter to assist him for a specific commission; for example, see Cattapan, "Nuovi elenchi," 211, no. 4, and Vassilaki, "Looking at Icons and Contracts," 107. Such a division of labor presupposes that the workshop received a steady stream of commissions.

151 See mainly D. Tsougarakis and E. Angelomatis-Tsougarakis, "Monasteries of South-Eastern Crete during the Venetian Period," in *Εὐκοσμία: Studi miscellanei per il 75o di Vincenzo Poggi S. J.*, ed. V. Ruggieri and L. Pieralli (Catanzaro, 2003), 541–72, and Nikolidakes, *Νεῖλος Δαμιλᾶς*, 113–20.

152 Gerola and Lassithiotakes, *Τοπογραφικὸς κατάλογος*, 101–2, nos. 747–48.

153 Borboudakes, "Η τέχνη κατὰ τὴ Βενετοκρατία," 242, 246, and Maderakes, "Βυζαντινή ζωγραφική," 279, n. 35.

C 006; and Moscow, State Historical Museum, Sinod. gr. 207 (Vlad. 250) (seventeenth century). Along with the geographical information, this latter manuscript also reports the year in which the letters were written: ἔτει ἀπὸ Χριστοῦ, αυ΄ (1400).[154] According to this evidence, the place in which Damilas lived during the late fourteenth and early fifteenth centuries is generally mentioned as the monastery of Karkasa, without any reference to a church or a monastery dedicated to the Holy Apostles or to the Savior.

In the Church of the Savior, the earliest graffito preserved on its walls dates from the year 1436 and postdates the construction of the church and the execution of its wall paintings: *Adi p[ri]ma mazo 1436 hic fuit Dono . . . mas. Ilos . . . sancta p[er] t[ut]to morttallia corpora dio ete . . . possa dellibe . . . de detto mos. Amen* (On 1 May 1436 was here Dono . . . mas. To those . . . Holy and entirely mortal body, God . . .).[155] Much more information exists about the Church of the Holy Apostles in Kato Karkasa, which is located one kilometer away from that of the Savior. Regarding the date of its wall paintings, important evidence comes from two graffiti of the year ͵ϛϡλα΄ (1422/23), along with the partially preserved dedicatory inscription, first published by Demetrios Tsougarakes and Elene Aggelomate-Tsougarake.[156] The authors assume that these graffiti, incised twice beneath the dedicatory inscription, might repeat the partially preserved date at the end of the inscription: [ϛ]ϡ[λα].

At the end of the fifteenth century, the Cretan hieromonk and scholar Neilos Bertos mentions a monastery of the Holy Apostles that was inhabited by nuns: ποῦ αἱ ὁσίαι ἐκεῖναι γυναῖκες καὶ καλογρές, ποῦ ἡ εὐλογημένη ψυχὴ ἐκείνη κυρὰ ἡ Ὑπομονή, ἡ καθηγουμένη τῆς μονῆς τῶν ἁγίων Ἀποστόλων, καὶ αἱ ἕτεραι πρῶται μοναχαί . . . (where those holy women and nuns are, where that blessed soul is, the lady Ypomone, the Mother superior of the monastery of the Holy Apostles, and the other first nuns . . .).[157] The identification of the Holy Apostles monastery in Kato Karkasa as the one mentioned by Bertos has been proposed by Nikolidakes and has been followed by other scholars.[158] This, however, seems to contradict the information given by the sixteenth-century testament of Anthimos Donos, hegoumenos of the Holy Apostles monastery. According to this document, written in 1524, Anthimos was about to leave the monastery for his pilgrimage to Jerusalem. For this reason, he appointed the monk Paisios as his proxy to govern the monastery during his absence: Ἔπιτα ἀφήην κουμεσάρηων ἐν τι μονῆ τῶν Αγίων Ἀποστόλων τῶν γκαλογέρων τῶν κυρ Παήσιων, καθῶς ἤμουν ἐγώ, ἥνα ἔχη ἐξουσία να βάλη μοναχους καὶ νὰ ευγάλη ὀστῆς δεν του 'θελε ἀρέσι . . . (Moreover, I leave Sir Paisios as a commissary at the monastery of the Holy Apostles of the monks, as was I before him, so as to have the authority to invite monks and to expel anyone he does not like . . .).[159] Thanks to the same document, we also learn that a great part of Damilas's private library was once kept at the Holy Apostles monastery.[160] On the other hand, more sixteenth-century evidence attests that in the same period the monastery of the Savior was deserted, and Anthimos, after his return from the pilgrimage, was to provide for its revitalization, should admit or expel nuns, and do whatever was good for the monastery.[161]

This information does not help to clarify the situation in the area of Karkasa during the fifteenth century. It seems, however, that monks and nuns coexisted at some point in the same area in scattered monastic cells, but they were geographically divided based on

154 The following text was based on this manuscript: K. Arsenij (Ivascenko), *Nila Damily ieromonakha Kritskago otvĕt' grekolatinjaninu monakhu Maksimu na ego pis'mo v zaščitu latinskikh novostej v vĕrĕ: Grečeskij tekst I russkij perovod* (Novgorod, 1895). For the manuscript tradition and the stemmatic relation of the manuscripts, see Nikolidakes, *Νεῖλος Δαμιλᾶς*, 83–91.

155 Tsougarakes and Aggelomate-Tsougarake, *Corpus*, 217, no. 190. The wall paintings have been dated to the end of the fourteenth century; see Andrianakes and Giapitsoglou, *Χριστιανικά μνημεία*, 235.

156 Tsougarakes and Aggelomate-Tsougarake, *Corpus*, 216, no. 188. For the dedicatory inscription, see below, p. 281.

157 H. Aposkiti-Stammler, "Nathanael-Neilos Bertos: Vindobonensis Hist. gr. 91, Nr. 59" (PhD diss., University of Munich, 1974), 26, n. 2.

158 Nikolidakes, *Νεῖλος Δαμιλᾶς*, 115; Tsougarakis and Angelomatis-Tsougarakis, "Monasteries," 545; and Andrianakes and Giapitsoglou, *Χριστιανικά μνημεία*, 235. We should note that another church dedicated to the holy apostles is located in Andromyloi, near Lithines. Nevertheless, there is no evidence that there was a monastic establishment nearby. This church already existed at the beginning of the fifteenth century, as its frescoes are dated by inscription to 1415 (Gerola, *Monumenti veneti*, 4:586, no. 10). On this church, see also Spatharakis, *Dated Wall Paintings*, 167–69.

159 G. K. Mavromates, ed., *Ἰωάννης Ὀλόκαλος, νοτάριος Ἱεράπετρας: Κατάστιχο (1496–1543)* (Venice, 1994), 68–70, no. 31 [238].

160 On this subject, see Despotakis and Rigo, "Neilos Damilas" (forthcoming).

161 Cf. Tsougarakis and Angelomatis-Tsougarakis, "Monasteries," 546–47.

the location of the two churches, which, after Damilas passed away,[162] began to be referred to as two different monasteries. As Nikolaos Tomadakes suggested, the term μονή should be considered as referring to a group of separate monastic cells.[163] It is worth noting that on the eve of the fifteenth century, the matter of coexistence between monks and nuns on Crete provoked the reaction of both the patriarchate of Constantinople[164] and the local Venetian authorities.[165] Maybe for this reason, on 9 May 1399, Damilas started to build the nunnery of Theotokos Pantanassa in Vaionaia, almost 6 kilometers away from the area of Karkasa.[166]

The Document on the Church of the Holy Apostles in Kato Karkasa

The new evidence presented here sheds light on the fifteenth-century history of the Church of the Holy Apostles in Kato Karkasa. It also links a commission and one more painter to existing Byzantine wall paintings on Crete under Venetian rule.

According to the newly discovered document (Appendix, doc. 5),[167] on 13 October 1422, the painter Konstantinos (*Costas*) Gaitanas was hired by the priest and hieromonk Neophytos Paschales, a resident of the Holy Apostles monastery in Kato Karkasa, to create wall paintings throughout the entire church of the monastery, including the following subjects: all stories of the New Testament, which in Greek are called *Despotikes Eortes* (Feasts of the Lord); all stories from the life of the Mother of God; all those of the apostles; and the Last Judgment, which in Greek is called *Deftera Parusia*. The contract also specifies that this last subject should be placed in a certain part of the church called the *schutari* and that Gaitanas was free to choose the subjects for the remaining space of the church. Subsequently, Gaitanas states that he would begin his work at the Holy Apostles on 15 April 1423, with a view to finishing it during the summer of the same year. The agreed upon price was 185 Cretan hyperpera, plus the painter's sustenance.

In Cattapan's list of painters active on Crete, Konstantinos Gaitanas might correspond to no. 55: *Cumano Gatana Costa di Nichita*, resident of the suburb of Chandax, whose traces are found in the Veneto-Cretan archival documents in the years 1423–1443.[168] However, because of the methodology followed for the creation of this checklist, we are unable to ascertain if Cattapan had discovered within these years several documents related to Konstantinos Gaitanas or just two: namely, one concerning his activity in 1423 and another one mentioning him as dead in 1443. In any case, based on the current state of information, we should consider the year 1443 as the terminus ante quem for his death.

According to Cattapan's list, Gaitanas's family seems to be among the largest families of painters in fifteenth-century Chandax, along with those of the Clontzas (*Cloza*) and Phokas (*Fuca, Fucha*) families. He lists five artists in total, including the painter of the Church of the Holy Apostles: "Gaitana (Gatana) Giovanni (1424–1460 c. m.)" (no. 52); "Gaitana Nicola di Giovanni (1454–1463 m.)" (no. 53); "Gaitana Cocoli di Giovanni (1451–1482)" (no. 54); "Cumano Gatana Costa di Nichita (1423–1443 m.)" (no. 55); and "Gaitana (Gatana) Nicola di Costa (1444–1479)" (no. 56), all residents of the suburb of Chandax. Unlike other families such as Clontzas and Phokas, whose surname is included in archival documents of the sixteenth century,[169] the traces of the Gaitanas family seem to

162 See below, p. 279.

163 N. V. Tomadakes, "Ἐκκλησιαστικὰ τοπωνύμια καὶ ὀνόματα," Κρητολογία 3 (1978): 2–48, at 25, and Nikolidakes, Νεῖλος Δαμιλᾶς, 120, n. 21.

164 N. V. Tomadakes, "Μελετήματα περὶ Ἰωσὴφ Βρυεννίου: Α΄. Τὸ ζήτημα τῶν συνεισάκτων ἐν Κρήτῃ καὶ Κύπρῳ (περὶ τὸ 1400); Β΄. Χρονολογικὰ προβλήματα τῆς ζωῆς καὶ τοῦ ἔργου," Ἐπ.Ἐτ.Βυζ.Σπ. 29 (1959): 1–33, at 9–12.

165 Evidence of this is found in a decree issued by the duke of Candia, Marco Falier, according to which the coexistence of monks and nuns was strictly prohibited in both old and new monastic establishments. The penalty for the violation of this order was one year in prison, deportation from Crete, and fifty hyperpera: A.S.V., *Procuratori di San Marco, Chiesa, de supra*, b. 142, f. 7r–v: *Die 8 augusti 1402....*

166 On this note reported in the codex Oxford, Bodleian Library, Barocci 69, see Despotakis and Rigo, "Neilos Damilas" (forthcoming). Indeed, in his typikon sent to the nuns of Vaionaia, Damilas justified himself for coexisting with them in the same area because there was no other place for him to stay while constructing the new monastery. See also S. Petridès, "Le typikon de Nil Damilas pour le monastère de femmes de Bæonia en Crète (1400)," *IRAIK* 15 (1911): 92–111, at 103.8–14; cf. Nikolidakes, Νεῖλος Δαμιλᾶς, 120.

167 A.S.V., *Notai di Candia*, b. 23 [Giovanni Longo], fol. 104 [249]v.

168 Cattapan, "Nuovi elenchi," 205.

169 For the related entries of the sixteenth century, see M. Konstantoudake, "Οἱ ζωγράφοι τοῦ Χάνδακος κατὰ τὸ πρῶτον ἥμισυ τοῦ 16ου αἰῶνος, οἱ μαρτυρούμενοι ἐκ τῶν νοταριακῶν ἀρχείων," Θησαυρίσματα 10 (1973): 291–380, at 311, 317, 321, 350, 358; M. Konstantoudake, "Νέα

disappear. However, several people with a similar surname (Γαϊτάνης) appear in the sixteenth century in the area of Hierapetra.[170]

The difference between "Gaitana" and "Gatana" seems to be inconsequential; both variants must refer to the same family, since Cattapan noticed that nos. 52 and 56 were spotted in the documents spelled both ways. The same surname also appears spelled both ways in the thirteenth and fourteenth centuries, but outside Crete. *Prosopographisches Lexikon der Palaiologenzeit* records two persons, Theodoros Gaitanas (Γαϊτανᾶς) and Konstantinos Gaitanas (Γαϊτανᾶς) from Cephalonia in 1264,[171] and a Georgios Gatanas (Γατανᾶς) from Smyrni in 1281.[172] Other people with the same or similar surname (e.g., Gaitanes or Gatanes) are also found in Hierissos,[173] while a certain Leonardos Gaitanos from Famagusta appears on Crete in 1301.[174] Based on the archival evidence, we have no reason to doubt the Cretan origin of the fifteenth-century group of painters belonging to the Gaitanas family. All notarial deeds consulted by Cattapan state that all members were established in the suburb of Chandax, without mentioning any other place of origin.[175] Moreover, another

list compiled by Cattapan with regard to the contracts of apprenticeships shows that Kokoles and especially Nikolaos Gaitanas were among those who taught the art of painting in fifteenth-century Chandax.[176] Michael Kornaros, Ioannes Asprogites, Manuel Diminites, and Michael Scandalares are named as their disciples.[177] This fact, along with Neophytos Paschales's commission to Konstantinos Gaitanas at the Church of the Holy Apostles, indicates that Gaitanas's name was held in high esteem.

According to the contract of employment of October 1422 between Neophytos Paschales and Konstantinos Gaitanas, the latter was to begin his work in the Church of the Holy Apostles on 15 April 1423, with a view to finishing it during the summer of the same year. Like the contract between the executors of Anna Correr's will and Georgios Mavrianos in which it was stipulated that the painter was to start work in April 1422 and finish it in September of the same year, if not earlier, this recently discovered document also specifies that the decoration of the entire church was to be completed in about four months. Moreover, the year in which Gaitanas was hired coincides exactly with the year ͵ϛϡλαʹ (1423) incised twice under the dedicatory inscription.

The agreed-upon price was 185 Cretan hyperpera, plus the painter's sustenance. Such an amount far exceeds the payments to other contemporary commissions, namely those to Georgios Mavrianos, who received seventy and one hundred hyperpera in 1419

ἔγγραφα γιὰ ζωγράφους τοῦ Χάνδακα (ιϛʹ αἰ.) ἀπὸ τὰ ἀρχεῖα τοῦ Δούκα καὶ τῶν νοταρίων τῆς Κρήτης," in *Θησαυρίσματα* 14 (1973): 157–98, at 164–65, 168–70, 173, 185–86; and A. D. Paliouras, "Ἡ ζωγραφικὴ εἰς τὸν Χάνδακα ἀπὸ 1550–1600," in *Θησαυρίσματα* 10 (1973): 157–98, at 119–20, 123.

170 A. E. Chatzake, "Ἡ Καστελλανία της Ιεράπετρας κατά το 16ο αιώνα: Κοινωνικές και οικονομικές όψεις" (PhD diss., University of Corfu, 2013), 218, 362, 431, 438, 445. A certain "Gaitani Pietro detto Maruli" was a notary in sixteenth-century Chandax (A.S.V., *Notai di Candia*, b. 128).

171 *PLP* 3457–58.

172 *PLP* 3578.

173 *PLP* 3459–60, 3579.

174 R. Morozzo della Rocca, ed., *Benvenuto de Brixano: Notaio in Candia, 1301–1302* (Venice, 1950), 179, doc. 499.

175 This fact is also confirmed by our own research (e.g., A.S.V., *Notai di Candia*, b. 246 [Giovanni Sevasto], prot. 1, fol. 12v: *Eodem die* [XXX mensis Iunii 1441]. *Manifestum facio ego Iani Gaitana, pinctor, habitator burgi Candide*... [On the same day (30 June 1441). I, Ioannes Gaitanas, painter, resident of the suburbs of Chandax...]; and A.S.V., *Notai di Candia*, b. 187 bis [Leonardo Pantaleo], prot. 1, fol. 6v: *Eodem die* [XX mensis Decembris 1467]. *Manifestum facimus nos Nicola Gaitana, pinctor, principalis, et papas Iani Musuraqui, eius plecius, ambo habitatores burgi Candide*... [On the same day (20 December 1467). We, Nikolaos Gaitanas, painter, principal, and the priest Ioannes Muzurakes, his guarantor, both residents of the suburbs of Chandax...]).

176 Cattapan, "Nuovi elenchi," 217.

177 According to Cattapan's list of teachers and apprentices, unfortunately without archival references, Kornaros, Asprogites, and Scandalares became disciples of Nikolaos Gaitanas in the years 1461, 1464, and 1472, respectively, while Diminites was a disciple of Kokoles in the year 1465. In our research, however, we noticed that in the contract of 1465, the former apprentice of Kokoles Gaitanas was not Manuel Diminites but Michael Scandalares: *Eodem die* [VII mensis Maii 1465]. *Manifestum facio ego Michali Scadalari, pinctor, habitator burgi Candide, tibi, magistro Cocoli Gaitana, pinctori, habitatori dicti burgi, et tuis heredibus, quia afirmo me tecum in tuum laborem tunc artis tue suprascripte, a modo usque ad annum .1. proxime venturum*... (On the same day [7 May 1465]. I, Michael Scandalares, painter, resident of the suburbs of Chandax, make public to you, the master Kokoles Gaitanas, painter, resident in the aforementioned suburbs, and to your successors, that I entrust myself to be at your disposal with regard to your aforementioned art, from now on and for the coming year...]) (A.S.V., *Notai di Candia*, b. 279 [Francesco Vlacho], prot. 1, fol. 78 [160]r). It is possible that Cattapan confused the information provided by the documents and therefore transmitted them erroneously into his list.

and 1422, respectively (see above, p. 267). Gaitanas's payment is the highest in our sources so far, and it is a manifestation of his prominence on Crete during the first half of the fifteenth century. That the church is much bigger than the two painted by Mavrianos may have also played a role.

In comparison to a few other contracts published by Cattapan that as a rule mention creating frescoes throughout the entire church without specifying the subjects,[178] this new document is unique because it provides detailed information on the specific subjects of the iconographic program, as well as on the specific location, the so-called schutari, probably meaning a lunette (see below, p. 281), in which the Last Judgment should be placed. In addition, the precondition that Gaitanas could decide the compositions that would decorate any remaining spaces is not only unique in comparison to all other known agreements but also implies that Neophytos was the one who dictated the subjects mentioned in the document.

Evidently, and unlike all the other cases that we know, Neophytos did not act as the owner of the Church of the Holy Apostles. The involvement of Neophytos, whose name is probably also mentioned in the dedicatory inscription,[179] in such an important notarial deed raises a few questions: was Neophytos Paschales the successor of Neilos Damilas as a cleric-leader in the monastic establishment of Karkasa? Consequently, does the notarial deed of 13 October 1422 indicate the terminus ante quem for Damilas's death? Until now, the terminus post quem for the latter's death was 22 April 1417, when he composed the inventory of his manuscripts.[180] Although it has been cited by previous scholars as a "testament" based on Damilas's words (Εἰς τοὺς ͵αυιζ´ εἰς τὸν Ἀπρίλιον μήναν ἠκοστὴ δευτέρα καθομολογὸ ἐγὸ ὁ ἐν ἱερομονάχοις Νεῖλος ὁ Νταμιλᾶς καὶ γράφω τὴν διαθήκην ταύτην· τὰ βιβλία τὰ ἔχω ἰσὴ ταύτα . . .) (On 22 April 1417, I, the hieromonk Neilos Damilas, declare and write this testament; the books I possess are these . . .), this text is irrelevant for establishing when he passed away because there is no reference to the status of his health, to his postmortem will, or to any executors—in short, all the information that is commonly provided in proper testaments.[181] The appearance of the hieromonk Neophytos in Chandax in October 1422 and his subsequent involvement—without power of attorney on behalf of Damilas—in the commission of the wall paintings of the Church of the Holy Apostles to Konstantinos Gaitanas lead us to assume that Damilas had passed away by then.

No other evidence about Neophytos exists, but his last name is found in the area of Hierapetra during the sixteenth century.[182] The notarial Greek registers of Ioannes Olokalos include a deacon called Manuel Paschales (Πασχαλῆς) in 1525 and another person with the same name, Manuel Paschales (Πασκαλῆς), notary, in 1530.[183] The fact, however, that Neophytos was simply mentioned in the notarial deed as a resident (habitatori) of the Holy Apostles monastery and not as a hegoumenos, should prevent us from hasty conclusions about his role in the monastic area of Karkasa. The same consideration also applies to Neilos Damilas, whose status in Karkasa remains unclear. However, his initiative to found the Vaionaia monastery and his involvement in the theological controversies of his time imply that he had at least a leading spiritual role in the monastic community of Karkasa.

The Church of the Holy Apostles in Kato Karkasa

ARCHITECTURE

The church is a single-aisled building covered by a pointed barrel vault in the interior and a saddle roof on the exterior (Figs. 19–20). It has a cylindrical apse in the eastern wall and an original entrance in the southern wall. A second door was opened later in the northern wall, resulting in the destruction of some wall paintings. The interior is divided into three bays by two transverse arches. A modern window in the apse and a second one in the western wall illuminate the interior. The western wall does not bear any wall paintings. It was demolished at an unknown time and was rebuilt. The window on this wall was originally an entrance whose lower part was walled up.

178 We see this in contracts between Nikolaos Vassalos and Markos Mouatsos in 1331, Ioannes Gradenigos and Daniel Gastreas in 1353, Ioannes Frangos and Konstantios Gerardos in 1371, etc.; see above, p. 251.

179 See below, p. 281.

180 Nikolidakes, *Νεῖλος Δαμιλᾶς*, 47; cf. *PLP* 5085.

181 Despotakis and Rigo, "Neilos Damilas" (forthcoming).

182 The surname is broadly attested outside Crete from the thirteenth century onward; see *PLP* 21998–22013.

183 Mavromates, *Ἰωάννης Ὁλόκαλος*, 77, doc. 41, and 123, doc. 105.

Fig. 19.
Church of the
Holy Apostles, Kato
Karkasa, view from the
west. Photo by authors.

Fig. 20.
Church of the
Holy Apostles, Kato
Karkasa, view of the
interior, looking east.
Photo by authors.

THE FOUNDER'S INSCRIPTION

The dedicatory inscription is situated in the southern wall, to the left of the eastern transverse arch. The letters are faded and the inscription is partially damaged by later carbon inscriptions. It reads as follows:[184] Ἀνηκοδομ[ήθ]η κ[αὶ]| ἀν[ι]στ[ο]ρήθ[η ὁ θεῖ]| ος [κ(αὶ)] π[ά]νσ[ε]πτος οὗ| τος [να]ός τ[ῶ]ν ἁ[γίων]| [π] ανεφ[ήμων]...|...[συν]εργ[ίας]...|...[Νεο]φύτ[ου] ...|...ν...|...κε...|...[‚ς]∏)...|...(This divine and most revered church of the all-praiseworthy saints ... was erected and painted with the contributions ... of Neophytos ...69 ...).

The inscription informs us that the church was rebuilt and redecorated. However, several scholars have noted that the verbs ἀνοικοδομῶ and ἀνιστορῶ can be used as synonyms for the verbs οἰκοδομῶ and ἱστορῶ.[185] Therefore, we cannot be sure that an earlier church existed at this place. It is also impossible to ascertain if the church was painted immediately after its construction was completed. On the other hand, there is no older paint layer in the church. The epithets used in the inscription, combined with the iconographic program (see below), confirm that the church was dedicated to the Apostles Peter and Paul. No other details can be safely extracted from the inscription. From the date at the end, only the letter for the century is still visible. Two graffiti with the date ‚ς∏λα' (1422/23) in the southern wall offer a terminus ante quem or ad quem for the dating of the wall paintings.[186] Based on the discovered contract, we can safely date the wall paintings to the year 1423. The same document supplies the name of the donor, the priest and hieromonk Neophytos Paschales, who made the commission, and the name of the painter, Konstantinos Gaitanas.

THE WALL PAINTINGS
Iconographic Program

As it survives today, the pictorial program of the church comprises Christological and liturgical scenes, scenes from the life of the patron saints Peter and Paul, and several portraits of male and female saintly figures and prophets.[187] The representation of female saints is highly unusual but does not exclude the possibility that the church at least at that moment was the katholikon of a male monastery.[188]

According to the document, the painter Konstantinos Gaitanas was hired to paint the entire church (*depingere totam ecclesiam*).[189] As far as we can judge, he fulfilled this obligation. However, the western wall was rebuilt, resulting in the loss of the wall paintings there. It was agreed that the painter would decorate the church with the following subjects: all stories from the New Testament (Despotikes Eortes, meaning the feast cycle), all stories of the Virgin and the apostles, and the stories of the Last Judgment (Deftera Parusia). The painter could freely choose among the "known" subjects for the remaining surfaces, if there were any left. Furthermore, the agreement specifies that the Last Judgment should be painted in the schutari; the Greek word σκουτάριον, which means shield, probably describes a lunette in this context.[190] Since the church does not have a dome, the term likely refers to the lunette/tympanum of the western wall, where the theme of the Last Judgment was situated in Byzantine and Cretan church programs. Unfortunately, the paintings of this wall have not survived.

The church program does not include any scenes from the Life of the Virgin. It is not likely that these scenes were located on the destroyed western wall, since such cycles commonly appear in the bottom zone of the barrel vault. If the Last Judgment was placed there, there would not have been enough space left for a Virgin

184 The inscription was first published by Tsougarakes and Aggelomate-Tsougarake, "Χαράγματα," 715, no. 404.

185 See, among others, A. Mylopotamitake, "Κτητορικές επιγραφές και ίδρυση εκκλησιών στην Κρήτη κατά την περίοδο της Βενετοκρατίας," Ἰταλοελληνικά 4 (1991–1993): 69–85, at 74–75.

186 Tsougarakes and Aggelomate-Tsougarake, "Χαράγματα," 713–15, and Tsougarakes and Aggelomate-Tsougarake, *Corpus*, 215–17, no. 188. The authors convincingly argue that these graffiti repeat the date of the donor's inscription, since they were incised directly below it.

187 On the wall paintings of this church, see the brief comments by Borboudakes, "Η τέχνη κατὰ τὴ Βενετοκρατία," 246; Maderakes, "Βυζαντινὴ ζωγραφική," 277, n. 32; and Andrianakes and Giapitsoglou, Χριστιανικά μνημεία, 235.

188 This case is not unique. Female saints are also depicted at the St. Phanourios Monastery in Valsamonero; see M. Acheimastou-Potamianou, "Τὸ κλίτος του αγίου Φανουρίου," in Οι τοιχογραφίες της Μονής του Βαλσαμονέρου, 291–370, at 304.

189 This interesting remark confirms that there were also commissions for the partial painting of a church (cf. above, p. 249).

190 In other contexts, the word points to a round shape or form; see, for example, M. Parani, B. Pitarakis, and J.-M. Spieser, "Un exemple d'inventaire d'objets liturgiques: Le testament d'Eustathios Boïlas (avril 1059)," *REB* 61 (2003): 143–65, esp. at 158, L. 133, which refers to an enamel roundel.

cycle.[191] Moreover, such a combination would have been exceptional. Apart from this, one wonders why a church dedicated to the apostles should also include a Virgin cycle, even if such an inclusion is not unknown on Crete.[192] Be it as it may, it is obvious that the painter did not fully implement the agreement. Another interesting observation is that only the most important subjects were named in the contract, leaving the painter great freedom in choosing the remaining themes.

The Christological cycle, which forms the core of the decoration, begins in the sanctuary with the Annunciation, runs along the barrel vault of the naos in two or three registers per bay, and concludes in the sanctuary, where the Ascension and other Christological scenes are placed. The cycle emphasizes the Passion and includes rare scenes like Christ Ascending the Cross and the events after the Resurrection,[193] but it also includes one of Christ's Miracles. The enrichment of the Christological cycle with Miracles is rare in Cretan church programs, especially those of single-aisled churches.[194] The cycle with the scenes from the lives and the martyrdom of the Apostles Peter and Paul is very rare on Crete. Here it is subordinated to the Christological cycle and is placed on the lower zone of the northern part of the barrel vault. The Denial and Repentance of Peter are treated as part of the Christological cycle, placed among the Passion scenes on the southern part of the barrel vault as can be observed in the extant church programs and as is prescribed in the *Hermeneia* of Dionysios of Fourna.[195] The patron saints are also portrayed on the northern wall directly before the sanctuary, opposite the seated Mary and the Child on the southern wall. These two depictions function as proskynesis images.[196] The decoration of the western wall is destroyed, as we have already said. Since the Crucifixion is depicted on the northern wall, the entire wall was probably occupied by the Last Judgment, as was stipulated in the contract. Three of the missing scenes of the Dodekaorton (the Nativity, the Hypapante, the Entry into Jerusalem, or the Anastasis) could have been depicted on the destroyed upper parts of the barrel vault.

More precisely, the iconographic program consists of the following subjects.[197] In the sanctuary, a few remnants of the Pantokrator are visible in the half-dome of the apse (Fig. 21). The triumphal arch was decorated with the Hospitality of Abraham, from which only fragments of the table remain. The Annunciation is placed below it with the Archangel Gabriel on the left and the Virgin on the right. Fragments of one of the concelebrating bishops turned toward the altar are visible in the half-cylinder of the apse on the left. His placement under a painted arch is unusual. A second painted arch is discernible on the right, an indication that all bishops were depicted in this way. The eastern wall is taken up by deacons. On the northern and southern walls of the sanctuary, there are several frontally standing saints under arches, all in bad condition or destroyed. The barrel vault of the sanctuary shows in the western part in the upper zone the Ascension in two halves. To the east of it is the Pentecost, also divided in two parts. The bottom zone in the northern section shows two superimposed busts of saints, followed by the Entombment and the Empty Sepulchre. The southern section is decorated with the rare subject of Christ Appearing to the Apostles (Peace be unto you) and Christ Appearing to the Two Marys (Chairete).

191 To cite just one example, compare the western wall in the Church of the Savior in Potamies that bears a depiction of the Last Judgment and covers the entire wall; for an image, see Ranoutsaki, *Soteras Christos-Kirche*, fig. 30. The same applies to the western wall of the Church of the Savior in Ano Karkasa (this representation is missing from Lymberopoulou and Duits, *Hell in the Byzantine World*, and remains unpublished).

192 Scenes from the Life of the Virgin occasionally appear in other Cretan churches that are not dedicated to her, such as in St. Marina in Kalogerou (1300) (Spatharakis, *Dated Wall Paintings*, 20–21) or in Agioi Pateres in Ano Floria (1470) (Spatharakis, *Dated Wall Paintings*, 215–16). Outside of Crete, this phenomenon is common (see Nitz, "Marienleben," 215); in the relevant churches, however, the available surfaces for decoration were much larger.

193 On these scenes, see Zarras, *Ο κύκλος των εωθινών ευαγγελίων*, 421 and plan 19, for their placement within the iconographic program of the church at Kato Karkasa.

194 A parallel can be found in the Church of Panagia in Sklaverochori (mid-fifteenth century); see also Borboudakes, "Παρατηρήσεις," 376.

195 Papadopoulos-Kerameus, *Ἑρμηνεία τῆς ζωγραφικῆς*, 105; cf. Hetherington, "*Painter's Manual*," 38.

196 On proskynesis images with Mary and the Child, see Mailis, *Obscured by Walls*, esp. 82–99.

197 In 1901–1902, Gerola could recognize the following subjects: the Crucifixion, the Raising of Lazarus, the Baptism, two scenes of the Deposition from the Cross, the Last Supper, the Washing of the Feet, the Betrayal, Christ Appearing to the Two Marys (Chairete), the Ascension, and a bust of Christ; Gerola and Lassithiotakes, *Τοπογραφικός κατάλογος*, 101–2, no. 748.

Fig. 21. Church of the Holy Apostles, Kato Karkasa, sanctuary. Photo by authors.

The barrel vault of the naos is divided into three zones. In the western bay in the upper register of the northern part, there is a destroyed scene followed by the Raising of Lazarus. From the left scene below it, only a very small part survives. It could belong to the Helkomenos scene. Only the lower parts and the feet of at least two figures advancing to the right are visible. Next to this scene is the depiction of Christ Ascending the Cross. In the lower zone, scenes from the Martyrdom of St. Peter have been poorly preserved. Only Peter's Crucifixion on the right can be securely identified. The middle bay displays in the upper register the Last Supper and the Washing of the Feet, the Crucifixion, and the Deposition from the Cross below it, while in the lower register, there are three badly preserved scenes from the Life of St. Paul.

The scenes of the southern part of the barrel vault in the upper zone of the middle bay are destroyed. In the second register, there is a depiction of the Betrayal followed by Christ before Annas and Caiaphas. The Lamentation (Threnos) and the Anastasis are placed in the lower row. The western bay preserves in the upper register remnants of the Baptism and next to it the lower part of the Transfiguration. The central row shows the Denial and Repentance of Peter and the Flagellation, while the Incredulity of Thomas and the Healing of the Paralytic are represented below them.

The northern wall shows full-figure saints, including monastic saints. Some of them are destroyed, while others cannot be identified. To the right of the modern door is St. Nicholas. Saints Peter and Paul, the patrons of the church, are placed under the eastern transverse arch and embracing each other. The southern wall displays, from east to west, the enthroned Virgin with the Child flanked by two angels next to the modern wooden iconostasis, directly under the eastern transverse arch. Three full-figure military saints and three female saints follow, all placed under arches. The transverse arches were probably decorated by prophets, but only a limited number of figures are still preserved. They seem to have been placed within a floral frame.

The decorative program of Kato Karkasa emphasizes Christ's Passion and the notion of martyrdom. Such cycles were regularly included in iconographic programs of Palaeologan churches[198] and especially in katholika of monasteries because they express fundamental monastic ideals. In Kato Karkasa, there was a deliberate effort to create visual parallels between the Passion of Christ and the martyrdom of the patron saints. Both were placed on the northern vault. It is no coincidence that Peter's Crucifixion and Paul's Beheading are placed below the cycle of Christ's Crucifixion. The scenes of the Christological cycle are not presented in a sequential chronological order. Some apparent displacements, such as the inclusion of the Healing of the Paralytic at Bethesda in the events connected to the Resurrection and especially its placement next to the Incredulity of Thomas, can be explained by the influence of the liturgy, or more precisely the liturgical calendar and the order of the liturgical readings. In the period between Easter and Pentecost, Gospel readings on the Miracles are interposed between the pericopes about Christ's miraculous appearances.[199]

Iconography

Many scenes have suffered water damage and are covered by protective strips of gauze. For this reason, this study will concentrate on the better preserved and identifiable scenes and figures, beginning with those of the Christological cycle, continuing with the patron cycle, and concluding with some figures of saints.

The Annunciation[200] shows Gabriel on the left of the apse stepping to the right and extending his hand toward the Virgin, who is seated in a contrapposto stance on a wooden seat and raising her hand. No other details can be distinguished.

The Baptism is partially preserved (Fig. 22).[201] Only the feet of Christ, who stands in the river, and the feet of one of the angels, who attends to the right, are in good condition. The river swarms with fish. The personification of the Jordan River can be seen to the left. Jordan is depicted as a naked child turning his head in the direction of Christ and riding on a fish. This motif, which also appears at Protaton on Mount Athos, painted by the Astrapas workshop around 1300,[202] is found only at a few churches on Crete, like St. Andrew near the Hodegetria Monastery (beginning of the fourteenth century).[203] Dog-like heads protrude from the banks of the river, a feature inspired by the liturgy that also frequently appears in other churches. On the left riverbank, there is a tree with an axe laid at its root, a scene inspired by John the Forerunner's prediction in Matthew 3:10.

From the Transfiguration,[204] only fragments of Elijah's feet to the right of the composition and the three apostles who witnessed the Transfiguration are preserved. The disciples do not have haloes and are shown in a typical manner: Peter on the left is almost seated and raising his left hand; John is in the middle bending to the left; and James is falling backwards. The postures of the apostles correspond exactly to those of the Panagia in Kapetaniana (1401/2) and Sklaverochori,[205] and this is the composition that later Cretan icons will adopt.[206]

Only the lower part of the Raising of Lazarus is preserved. Christ advances to the right with a scroll in his left hand. This hand is at the same time directed at the two women prostrating in front of him: Lazarus's

198 See G. Millet, *Recherches sur l'iconographie de l'Évangile aux XIV^e, XV^e et XVI^e siècles, d'après les monuments de Mistra, de la Macédoine et du Mont-Athos* (Paris, 1916), 33–39, and S. Dufrenne, "L'enrichissement du programme iconographique dans les églises byzantines du XIII^ème siècle," in *L'art byzantin du XIII^e siècle: Symposium de Sopoćani 1965* (Belgrade, 1967), 35–46, at 41–44.

199 Dufrenne, "L'enrichissement," 42, and Ranoutsaki, *Soteras Christos-Kirche*, 33–36. A fundamental study on this topic is Zarras, *Ο κύκλος των εωθινών ευαγγελίων*.

200 On the iconography of the Annunciation, see J. H. Emminghaus, "Verkündigung an Maria," *LChrI* 4:422–37; for Crete, see Kalokyres, *Αἱ βυζαντιναὶ τοιχογραφίαι*, 59–61, and Spatharakis, *Rethymnon*, 285–86.

201 On the iconography of this subject, see "Taufe Jesu," *LChrI* 4:247–55; for Crete, see Kalokyres, *Αἱ βυζαντιναὶ τοιχογραφίαι*, 64–66; Spatharakis, *Rethymnon*, 289–90; and Tsamakda, *Kakodiki*, 172–74.

202 E. N. Tsigaridas, *Manuel Panselinos: From the Holy Church of the Protaton* (Thessaloniki, 2003), figs. 6–7. On the discovery of the signature of Eutychios Astrapas during conservation work of the wall paintings of Protaton, previously attributed to the legendary Manuel Panselinos, see A. Nastou, "Τὸ συνεργείο του Πρωτάτου και η πρόταση νέας χρονολόγησης," in *Πρωτάτο II: Η συντήρηση των τοιχογραφιών*, ed. I. Kanonides (Polygyros, 2015), 2:40–56.

203 On this church, see Bissinger, *Kreta*, 119–20, no. 86.

204 On the iconography of the Transfiguration, see J. Myslivec, "Verklärung Christi," *LChrI* 4:416–21; for Crete, see Kalokyres, *Αἱ βυζαντιναὶ τοιχογραφίαι*, 66–67, and Spatharakis, *Rethymnon*, 290–91.

205 Borboudakes, "Παρατηρήσεις," 379, pl. 196a–b, and Maderakes, "Βυζαντινή ζωγραφική," 284.

206 Maderakes, "Βυζαντινή ζωγραφική," 284, with examples.

Fig. 22. Church of the Holy Apostles, Kato Karkasa, detail of the Baptism. Photo by authors.

sister, Martha, holds Christ's foot with veiled hands with Mary, the other sister, behind her. In the background, the lower part of a man standing next to the tomb with the resurrected Lazarus is visible. A figure removing the marble slab of the tomb can barely be discerned in the right corner. The composition follows the contemporary iconographic scheme[207] and finds close parallels at the Panagia in Kapetaniana (1401/2)[208] and St. George in Emparos (1436/37).[209]

The upper half of the Last Supper[210] is destroyed. In the lower half we see the group of apostles seated on a wooden bench in front of a table. Their backs are turned to the viewer; some of them are shown in three-quarter view and talking to each other. Christ is sitting on the left, but the state of preservation does not allow for a more precise description. From the other side of the table in the background, Judas's hand reaches for the plate with the fish. The arrangement of the scene can be generally compared with that in the Church of the Savior in Akoumia (1389)[211] or the Holy Apostles in Lithines (1416).[212]

The upper part of the Washing of the Feet (Fig. 23)[213] is destroyed. The composition shows Christ on the left wearing a white cloth around his hips and drying with it the right foot of the seated apostle Peter. Peter's left

207 On the iconography of the Raising of Lazarus, see H. Meurer, "Lazarus von Bethanien," *LChrI* 3:33–38, and K. Wessel, "Erweckung des Lazarus," *RBK* 2:388–414; for Crete, see Kalokyres, *Αἱ βυζαντιναὶ τοιχογραφίαι*, 67–68, and Spatharakis, *Rethymnon*, 291–92.

208 M. Borboudakes, "3η Ἐφορεία Βυζαντινών Ἀρχαιοτήτων," *Ἀρχ. Δελτ.* 53 (1998): 2.3:889–912, at 895, pl. 394.

209 T. Gouma-Peterson, "Manuel and John Phokas and Artistic Personality in Late Byzantine Painting," *Gesta* 22.2 (1983): 162, fig. 3, and Spatharakis, *Dated Wall Paintings*, 185.

210 On the iconography of the Last Supper, see E. Lucchesi Palli and L. Hoffscholte, "Abendmahl," *LChrI* 1:10–18, and K. Wessel,

"Abendmahl," *RBK* 1:2–11; for Crete, see Kalokyres, *Αἱ βυζαντιναὶ τοιχογραφίαι*, 70–71, and Tsamakda, *Kakodiki*, 177–78.

211 Spatharakis, *Dated Wall Paintings*, 129.

212 Spatharakis, *Dated Wall Paintings*, 168.

213 On the iconography of the Washing of the Feet, see "Fusswaschung," *LChrI* 2:69–72, and K. Wessel, "Fusswaschung," *RBK* 2:595–608; for Crete, see Kalokyres, *Αἱ βυζαντιναὶ τοιχογραφίαι*, 84–85.

Fig. 23. Church of the Holy Apostles, Kato Karkasa, detail of the Washing of the Feet. Photo by authors.

foot is not depicted in the water basin, which is instead unusually painted at some distance. More apostles can be seen behind Peter seated on a high wooden bench, while in the foreground, a few more disciples are taking off their sandals. The composition is executed in a similar manner at St. George in Emparos (1436/37)[214] and at the Holy Apostles in Lithines (1416).[215]

The Betrayal of Judas (Figs. 24–25) does not include any unusual iconographic elements and essentially repeats the basic elements that the different representations of the theme have in common.[216] It shows in the middle of the composition Judas embracing and kissing Christ, who is directly looking at the viewer. The group is surrounded by priests, soldiers, and

laymen holding torches or weapons. One of the men is pulling Christ by the shoulders. In the lower-right corner, the kneeling Peter is cutting off Malchus's ear. Comparable to our scene is the scene in the Church of the Holy Apostles in Lithines (1416).[217] A very close parallel is offered by the composition in the narthex of the Valsamonero monastery (between 1431–ca. 1450), where the characteristic detail of Judas's left sole being turned toward the viewer is repeated.[218]

In the scene of Christ before the High Priests,[219] Christ is depicted standing to the right with arms

214 Spatharakis, *Dated Wall Paintings*, 186.

215 Spatharakis, *Dated Wall Paintings*, 168.

216 On the iconography of this subject, see above, p. 267.

217 Spatharakis, *Dated Wall Paintings*, 168.

218 M. Acheimastou-Potamianou, "Ὁ νάρθηκας," in *Οι τοιχογραφίες τῆς Μονῆς τοῦ Βαλσαμονέρου*, 371–428, at 388–89, pl. 97a. This detail can also be observed in Kato Symi; see above, p. 266, Fig. 10.

219 On the iconography of the scene, see K. Laske, "Synedrium," *LChrI* 4:233; for Crete, see also Ranoutsaki, *Soteras Christos-Kirche*, 83–85.

Fig. 24.
Church of the Holy
Apostles, Kato Karkasa,
the Betrayal. Photo
by authors.

Fig. 25.
Church of the Holy
Apostles, Kato Karkasa,
detail of the Betrayal.
Photo by authors.

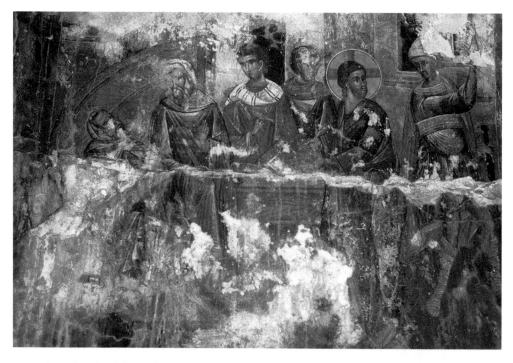

Fig. 26. Church of the Holy Apostles, Kato Karkasa, Christ before the High Priests.
Photo by S. Maderakes.

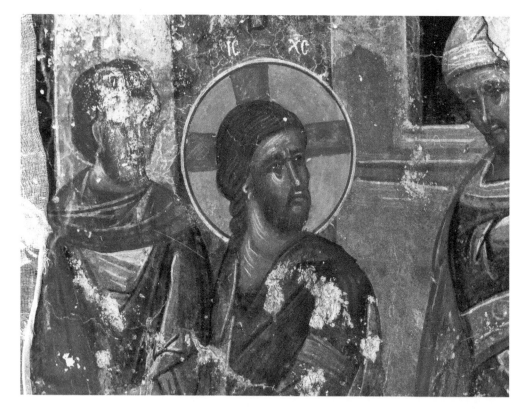

Fig. 27. Church of the Holy Apostles, Kato Karkasa, detail of Christ before the High Priests.
Photo by authors.

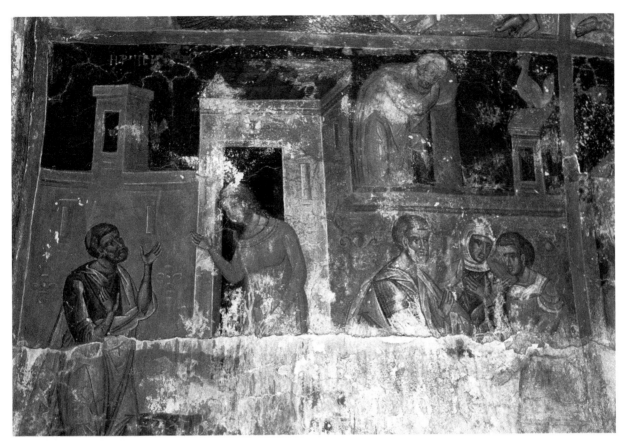

Fig. 28. Church of the Holy Apostles, Kato Karkasa, the Denial of Peter. Photo by S. Maderakes.

extended forward (Figs. 26–27). He moves to the left but turns his head backward, where a soldier is standing. The soldier is about to slap him. The High Priests Annas and Caiaphas are seated on the left on a round bench. In the foreground, Caiaphas is depicted tearing his robe. Between them and Christ stands a young man holding a writing tablet and a pen.[220] Another man stands behind him. A comparable but badly preserved scene on Crete is found at the Panagia in Kapetaniana (1401/2).[221] A very close parallel survives in the Church of Archangel Michael in Vlachiana (1447).[222]

The Denial of Peter (Fig. 28),[223] labeled as H AP[N]HCIC TOY [ΠΕΤΡΟΥ], comprises three episodes. The first, occupying the left half of the composition, shows Peter talking to a maiden. On the right he is depicted again, talking with two men who keep warm near the fire. Both scenes take place before an architectural background. Finally, the Repentance of Peter is placed in the upper-right part. Peter is behind the architectural setting weeping, while a cock is opposite him on the right. The combination of these three episodes in one composition has older antecedents, such as at St. Nicholas Orphanos in Thessaloniki (beginning

220 The text cannot be read due to the destruction of the surface. In the scene of Christ before Pilate at St. George in Emparos (1436/37), the text on the scroll lying on the table reads, "The king of the Jews" (O ΒΑCΙΛΕΥC ΙΟΥΔΑΙΩΝ).

221 Spatharakis, *Dated Wall Paintings*, 158.

222 G. I. Vlachakes, *Οι ιεροί ναοί Μιχαήλ Αρχαγγέλου και Τιμίου Σταυρού Αγγενικής* (Heraklion, 1999), 34, fig. 9. Many similarities can be also found in the Church of the Savior in Potamies (last quarter of the fourteenth century), where, however, the episode is combined

with Pilate Washing His Hands; see Ranoutsaki, *Soteras Christos-Kirche*, 83–85, pl. II, figs. 21, 23. The scheme of Kato Karkasa was later employed by the Cretan painter Theophanes in the katholikon of the Lavra monastery (sixteenth century); see G. Millet, *Monuments de l'Athos I: Les peintures* (Paris, 1927), pl. 125.2.

223 On the iconography of this subject, see K. Laske, "Verleugnung Petri," *LChrI* 4:437–40.

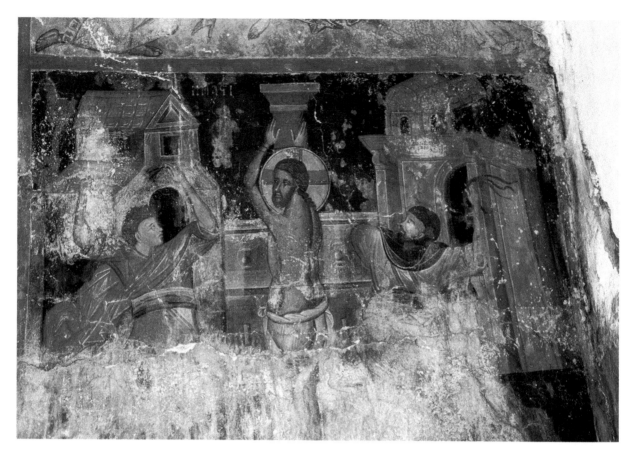

Fig. 29. Church of the Holy Apostles, Kato Karkasa, the Flagellation. Photo by S. Maderakes.

of the fourteenth century).[224] The most telling comparison of the image in Kato Karkasa is at St. George in Emparos (1436/37), which differs from the one in our church only in minor details.[225]

The Flagellation,[226] inscribed as Η ΜΑ϶Ι[ΓΩϹΙϹ] and which rarely appears in Cretan church programs, unfolds in front of an architectural setting (Fig. 29). It shows Christ in the middle wearing a cloth around his hips with his back turned to the viewer and his raised hands tied to a column. Two people are flanking and whipping him with forceful movements. The image adopts the iconography developed from the fourteenth century onward and does not display any peculiarities.[227] Other examples from Crete can be found in the Church of the Savior in Agia Irini (1357/58),[228] the Church of St. John the Forerunner in Lithines (Andromyloi) (fifteenth century), and the Church of the Savior in Chantras (beginning of fifteenth century).[229] In this last scene,

224 C. Bakirtzes, Ἅγιος Νικόλαος Ὀρφανός: Οἱ τοιχογραφίες (Athens, 2003), pl. 45.

225 Spatharakis, Dated Wall Paintings, 185, 187. For a different arrangement of the subject comprising four scenes separated by frames, see the unpublished wall paintings in the Church of St. John the Forerunner in Lithines (Andromyloi) dating to the fifteenth century; compare also the scenes in the Church of the Savior in Chantras: M. Horn, Adam-und-Eva-Erzählungen im Bildprogramm kretischer Kirchen: Eine ikonographische und kulturhistorische Objekt- und Bildfindungsanalyse (Mainz, 2020), 95, 100, pl. 103.2.

226 On the iconography of this scene, see C. Schweicher, "Geisselung Christi," LChrI 2:127–30, and A. Tourta, "Εἰκόνα μὲ σκηνὲς Παθῶν στὴ Μονὴ Βλατάδων," Μακεδονικά 22 (1982): 154–78, esp. 163–67.

227 A fourteenth-century icon with scenes of the Passion from the Vlatadon Monastery in Thessaloniki offers a good comparison; see Tourta, "Εἰκόνα," pl. 4.

228 Spatharakis, Dated Wall Paintings, 104.

229 G. Fousteres, "Ὁ ναὸς τοῦ Σωτῆρος στὴ θέση Μέσα Παντέλι Χαντρά Σητείας: Παρατηρήσεις στὸ εἰκονογραφικὸ πρόγραμμα," in Μαργαρίται: Μελέτες στὴ μνήμη τοῦ Μανόλη Μπορμπουδάκη, ed. M. Patedakes and K. Giapitsoglou (Siteia, 2016), 382–409, fig. 6, and Horn, Adam-und-Eva-Erzählungen, 101, pl. 104.2.

Fig. 30. Church of the Holy Apostles, Kato Karkasa, Christ Ascending the Cross. Photo by authors.

the postures of the figures are virtually identical to those in Kato Karkasa.

Christ Ascending the Cross (Fig. 30) is partially destroyed. The scene takes place in front of a low wall denoting Jerusalem's city walls. Christ is in the middle wearing a loincloth, frontally depicted on a ladder before the Cross with his arms tied back. He is being pulled up by two servants who also stand on ladders. A group of laymen and soldiers watches from the right, and one of them points to Christ. Due to the destruction in that part, we cannot ascertain whether the scene was combined with the episode of the Nailing to the Cross or not. The composition of our church is rarely pictured on Crete or elsewhere.[230] This depiction closely resembles the scene at St. George in Emparos (1436/37).[231]

The churches of Peribleptos and St. Sophia in Mistras offer a reduced version of the same basic iconography.[232]

The Crucifixion follows the customary iconography[233] and shows Christ on the Cross in the hanging type. His eyes are closed, and his head is bent to the left. The Virgin is on the left slightly falling backward and supported by three more women. To the right of the Cross, John the Evangelist makes the usual mourning

230 On the iconography of this subject, see M. Boskovits, "Kreuzbesteigung," *LChrI* 2:602–5.

231 Spatharakis, *Dated Wall Paintings*, 186–87. This basic type recurs later in the Cretan School: for two examples at the Lavra monastery in Athos (1535, painted by Theophanes from Crete) and

the Great Meteoron (1552), see M. Chatzidakes and D. Sofianos, *Τὸ Μεγάλο Μετέωρο: Ἱστορία καὶ τέχνη* (Athens, 1990), fig. on p. 119, and M. Constantoudaki-Kitromilides, "Ὁ Θεοφάνης, ὁ Marcantonio Raimondi, θέματα all'antica καὶ grottesche," in *Εὐφρόσυνον: Ἀφιέρωμα στὸν Μανόλη Χατζηδάκη* (Athens, 1991) 1:271–81, at 273–74, pl. 132.

232 G. Millet, *Monuments byzantins de Mistra: Matériaux pour l'étude de l'architecture et de la peinture en Grèce aux 14ème et 15ème siècles* (Paris, 1910), pls. 123.3, 134.5.

233 On the iconography of the Crucifixion, see M. Mrass, "Kreuzigung Christi," *RBK* 5:283–355, and E. Lucchesi Palli and G. Jászai, "Kreuzigung Christi," *LChrI* 2:606–20; for Crete, see Kalokyres, *Αἱ βυζαντιναὶ τοιχογραφίαι*, 71–74; Spatharakis, *Rethymnon*, 297–99; and Tsamakda, *Kakodiki*, 183–84.

gesture, and the Centurion points to Christ. Two tiny angels are flying above the groups of people flanking the Cross, but their bad state of preservation does not allow for a more precise description. A low wall can be seen in the background. The same basic composition, though somewhat abbreviated, that includes the rare motif of the fainting Mary can be seen at the Holy Apostles in Lithines (1416),[234] the Church of the Savior in Chantras (beginning of the fifteenth century),[235] and St. George in Emparos (1436/37).[236] The scheme of Kato Karkasa is also adopted in the icon with the Mary and the Child and Crucifixion scenes in the Benaki Museum in Athens, no. 3051, variously attributed to Andreas Ritzos (ca. 1420–before 1503) or to his circle, and dating to the second half of the fifteenth century.[237]

The Deposition from the Cross (Fig. 31), inscribed Η Α[ΠΟΚΑ]ΘΥΛ[ΩϹΙϹ], takes place before the city walls of Jerusalem. In the middle, the lifeless body of Christ is held by the waist by Joseph of Arimathea, who stands on a ladder to the right, and the Virgin, who embraces the upper part of the body and presses her face against Christ's face. Christ's feet are still nailed to the Cross. The group is flanked on the left by a group of three myrrh-bearers (one of whom kisses Christ's hand) and on the right by John the Evangelist, who makes a mourning gesture. On either side of the Cross appear mourning angels. The lower part of the composition, where usually Nicodemus is shown removing the nails, is badly damaged.[238] The scenes in the narthex of the Church of the Savior in Agia Irini (fifteenth century)[239] and in the Church of Archangel Michael

at Exo Lakonia (1431–1432)[240] share the basic iconographic formula and certain iconographic features with our church. However, its counterparts in the works of the Astrapas painting workshop, like those in St. George in Staro Nagoričino[241] (1316/17), the composition in St. Andrew in Treska (1388/89),[242] and especially those in Peribleptos in Mistras (third quarter of the fourteenth century),[243] offer the closest parallels for this specific composition. These compositions certainly derive from the same archetype,[244] which was also adopted in the aforementioned icon in the Benaki Museum.[245]

The Lamentation (Threnos) is poorly preserved but seems to exhibit the standard components of the Byzantine scheme for this subject.[246] It shows the Virgin on the left bending over Christ's body and bringing his head to her cheek. Christ's body lays on the *lithos*, the stone of anointing. At least one figure, probably a lamenting woman, is visible behind the stone, while St. John is on the right kissing Christ's hand. A few more figures are to the right of the composition, of which the one in the foreground bending over the feet of Christ is probably Joseph of Arimathea. The scene takes place before the Cross, which stands before a low wall. This specific compositional type already appears in some Macedonian

234 Spatharakis, *Dated Wall Paintings*, 168, fig. 148.

235 Fousteres, "Παντέλι Χαντρά Σητείας," fig. 7.

236 Spatharakis, *Dated Wall Paintings*, 187.

237 N. Chatzidakis, *Icons of the Cretan School (15th–16th Century)* (Athens, 1983), no. 18. For the attribution to his son, Nikolaos Ritzos, see D. Fotopoulos and A. Delivorrias, *Greece at the Benaki Museum* (Athens, 1997), no. 459; see also *The Hand of Angelos: An Icon Painter in Venetian Crete*, ed. M. Vassilaki (Farnham, 2010), 210, no. 53 [A. Drandake], with a dating to ca. 1500. The icon features no mourning angels.

238 On the iconography of the Deposition from the Cross, see M. Boskovits and G. Jászai, "Kreuzabnahme," *LChrI* 2:590–95, and Y. Nagatsuka, *Descente de Croix: Son développement iconographique des origines jusqu'à la fin du XIVᵉ siècle* (Tokyo, 1979); for Crete, see Kalokyres, *Αἱ βυζαντιναὶ τοιχογραφίαι*, 87–88, and Spatharakis, *Rethymnon*, 299–300.

239 Spatharakis, *Dated Wall Paintings*, 104.

240 Spatharakis, *Dated Wall Paintings*, 182–83, and Maderakes, Ἔξω Λακώνια, 94–95.

241 B. Todić, *Staro Nagoričino* (Belgrade, 1993), fig. 88, and N. Zarras, "The Passion Cycle in Staro Nagoričino," *JÖB* 60 (2010): 181–213, at 198–99, fig. 17.

242 J. Prolović, *Die Kirche des Heiligen Andreas an der Treska: Geschichte, Architektur und Malerei einer palaiologenzeitlichen Stiftung des serbischen Prinzen Andreaš* (Vienna, 1997), 159–61, fig. 32.

243 Millet, *Monuments byzantins de Mistra*, pl. 122.3.

244 For a discussion of this variant at the Peribleptos in Mistras in comparison with a very similar depiction by Duccio di Buoninsegna in the Museo dell'Opera del Duomo, Siena (1308–1311), see Millet, *Recherches*, 475–78.

245 Fotopoulos and Delivorrias, *Greece at the Benaki Museum*, no. 459.

246 On the iconography of the Lamentation (Threnos), see E. Lucchesi Palli and L. Hoffscholte, "Beweinung Christi," *LChrI* 1:278–82, and I. Spatharakis, "The Influence of the Lithos in the Development of the Iconography of the Threnos," in *Byzantine East, Latin West: Art-Historical Studies in Honor of Kurt Weitzmann*, ed. C. Moss and K. Kiefer (Princeton, NJ, 1995), 435–46; for Crete, see Kalokyres, *Αἱ βυζαντιναὶ τοιχογραφίαι*, 88–89; Spatharakis, *Rethymnon*, 300–302; and Tsamakda, *Kakodiki*, 184–86.

Fig. 31. Church of the Holy Apostles, Kato Karkasa, the Deposition from the Cross. Photo by authors.

monuments, such as St. Demetrios in Peć (ca. 1320).[247] On Crete, it is encountered, for example, at St. George in Skinias (beginning of the fifteenth century)[248] and at the Holy Apostles in Lithines (1416).[249]

The Entombment is in very bad condition. One discerns three figures carrying the body of Christ wrapped like a mummy, according to the standard iconographic scheme.[250] No other details are visible. A corresponding scene from Crete is found, for instance, at St. Isidore in Kakodiki (1421).[251]

247 G. Subotić, *The Church of St Demetrius in the Patriarchate of Peć* (Belgrade, 1964), figs. 20–21.

248 G. Moschove, "Τοιχογραφημένοι ναοί στην περιοχή του Δήμου Αγίου Νικολάου," in *Ο Άγιος Νικόλαος και η περιοχή του* (Agios Nikolaos, 2010), 145–88, fig. on p. 188.

249 Spatharakis, *Dated Wall Paintings*, 168.

250 On the iconography of the Entombment, see C. Schweicher, "Grablegung Christi," *LChrI* 2:192–96; for Crete, see Spatharakis, *Rethymnon*, 300–302.

251 S. N. Maderakes, "Βυζαντινά μνημεία του Νομού Χανίων: Ο Άγιος Ισίδωρος στο Κακοδίκι Σελίνου," *Κρητική Εστία* 4.1 (1987):

In the badly preserved Anastasis,[252] one barely discerns Christ in a mandorla standing in the middle of the composition, slightly bending to the right. He extends his hand toward the kneeling Adam, who wears purple garments. Eve, dressed in red, can be seen in the background on the right accompanied by a group of standing figures. Another group is behind Christ on the left. The image is placed against a landscape defined by two mountains. Under Christ's feet, only remnants of the dark cave of Hades are visible, but no other details. The basic type of Christ Descending, with Adam and Eve grouped on one side of the composition and Eve standing behind Adam, recurs in a similar manner in other monuments, such as in Sklaverochori and at the Panagia in Kapetaniana (1401/2),[253] the Holy Apostles in Lithines (1416),[254] and the Church of the Savior in Chantras (beginning of the fifteenth century).[255]

The Empty Sepulchre[256] shows on the left a woman clad in purple, approaching the angel who sits on a sarcophagus. The angel holds a staff and points to the right, where the empty tomb, now badly damaged, is situated. The scene is badly preserved. As a result, one cannot distinguish if soldiers were depicted in the lower-right corner, but they were probably not included. It is also unclear whether Mary was accompanied by other women or whether the image only shows Mary Magdalene, as Nektarios Zarras proposes.[257] The same scene at Saints Constantine and Helen in Avdou (1445), painted by Manuel and Ioannes Phokas, offers a good parallel.[258]

The representation of Christ Appearing to the Two Marys (Chairete) (Fig. 32) follows the standard iconographic scheme,[259] in which the composition is arranged symmetrically. Christ stands in the center flanked by the kneeling women, Mary Magdalene and the other Mary. The scene unfolds against a mountainous landscape. Christ raises his right hand in a gesture of speech or blessing and points with the left one to the woman to his right, who wears a purple maphorion. As in the case of Kato Symi, the image in Kato Karkasa invites comparison with the corresponding scenes at St. Phanourios Monastery in Valsamonero (beginning of the fifteenth century) and St. George in Emparos (1436/37).[260]

In the scene of Christ Appearing to the Apostles (Peace be unto you) (Fig. 32), Christ stands frontally and makes a gesture of blessing or speech. He is flanked by two groups of disciples. The man leading the left group seems to be inclining his head toward Christ. The scene takes place in front of a landscape with a hill behind each group. Unlike the scene in Kato Symi, here it represents the appearance of Christ to the eleven disciples on a mountain in Galilee based on Matthew 28:16–20.[261] Our depiction belongs to the type represented, for example, in Dečani (1345–1350).[262] On Crete, such compositions are infrequent because the type of Christ appearing in front of the closed doors prevails. The one at the Panagia in Kamariotis (beginning of the fifteenth century) corresponds to the scene in our church, but there Christ blesses with both hands.[263] The groups of the disciples are headed by the Apostles Peter and Paul. This is perhaps another reason why this scene was chosen to be included in the pictorial program of the Holy Apostles in Kato Karkasa.

The Incredulity of Thomas conforms to a standard Byzantine formula,[264] showing in a symmetrical composition Christ in the middle standing in front of a door, slightly inclining his head, and raising his right arm. With his left hand, he draws his garment

85–109, at 96, pl. 42a, and Spatharakis, *Dated Wall Paintings*, 174–75, fig. 156.

252 On the iconography of this subject, see E. Lucchesi Palli, "Anastasis," *RBK* 1:142–48; on the creation of this subject, see also A. D. Kartsones, *Anastasis: The Making of an Image* (Princeton, NJ, 1986); for Crete, see Kalokyres, Αἱ βυζαντιναὶ τοιχογραφίαι, 74–79; Spatharakis, *Rethymnon*, 302; and Tsamakda, *Kakodiki*, 186–87.

253 Borboudakes, "Παρατηρήσεις," 380–81, pl. 200a-b.

254 Spatharakis, *Dated Wall Paintings*, 167.

255 Fousteres, "Παντέλι Χαντρά Σητείας," fig. 8.

256 On the iconography of this subject, see J. Myslivec and G. Jászai, "Frauen am Grab," *LChrI* 2:54–62; for Crete, see Spatharakis, *Rethymnon*, 303, and Tsamakda, *Kakodiki*, 165–66.

257 Zarras, Ο κύκλος των εωθινών ευαγγελίων, 217, fig. 104.

258 Spatharakis, *Dated Wall Paintings*, 197.

259 On this iconography, see n. 117.

260 See above, pp. 268–69.

261 On the iconography of this episode, see Zarras, Ο κύκλος των εωθινών ευαγγελίων, 137–48.

262 Zarras, Ο κύκλος των εωθινών ευαγγελίων, 140–41, figs. V and 33, for this and further examples of the scene.

263 Zarras, Ο κύκλος των εωθινών ευαγγελίων, 428, fig. 34.

264 On the iconography of this subject, see "Thomaszweifel," *LChrI* 4:301–3, and Zarras, Ο κύκλος των εωθινών ευαγγελίων, 241–51, with numerous parallels outside Crete; for Crete, see Kalokyres, Αἱ βυζαντιναὶ τοιχογραφίαι, 90, and Spatharakis, *Rethymnon*, 304.

Fig. 32. Church of the Holy Apostles, Kato Karkasa, Christ Appearing to the Apostles and to the Two Marys. Photo by authors.

aside to uncover his wound. The doubting Thomas is about to place his finger in the wound. The group of disciples behind him is barely visible. Another disciple stands on the right. The scene takes place in front of an architectural background. Corresponding scenes of the same type on Crete can be found, for example, at Archangel Michael in Prines (1410)[265] and at the Holy Apostles in Lithines (1415).[266] A close parallel is offered by St. George in Emparos (1436/37).[267]

The Ascension of Christ (Figs. 33–34)[268] is divided into two parts, each showing six apostles. The summit of the barrel vault, where Christ seated in a mandorla usually appears, is destroyed. On the southern half, the Virgin is portrayed standing frontally, flanked by two angels who raise their hands towards Christ. The group is surrounded by the apostles, who gaze at the ascending

Christ. On the northern half of the composition, one distinguishes another angel, clad in military costume (Fig. 33). He stands in the middle of the apostles holding a lance and an open scroll with the text [ΑΝΔΡΕC ΓΑΛΙ]ΛΕ | ΟΙ Τ[Ι] ΕϚΗ | [ΚΑ]ΤΕ ΒΛΕ | [Π]ΟΝΤΕC Ε | [Ν ΤΩ ΟΥ]ΡΑΝΩ | ... (Men of Galilee, why do you stand here looking into the sky ...).[269] These words are usually written above the apostles.[270] The relevant passage in the Acts speaks of only "two men dressed in white" who speak these words to the disciples. The insertion of a third angel in the composition is

265 Zarras, Ὁ κύκλος τῶν ἑωθινῶν εὐαγγελίων, 430.

266 Zarras, Ὁ κύκλος τῶν ἑωθινῶν εὐαγγελίων, 243, 431, fig. 126.

267 Spatharakis, *Dated Wall Paintings*, 185, and Zarras, Ὁ κύκλος τῶν ἑωθινῶν εὐαγγελίων, 248.

268 On the iconography of this subject, see A. A. Schmid, "Himmelfahrt Christi," *LChrI* 2:268–76; K. Wessel, "Himmelfahrt," *RBK* 2:1224–62; and N. Gkioles, Ἡ Ἀνάληψις τοῦ Χριστοῦ βάσει τῶν μνημείων τῆς ἀχιλιετηρίδος (Athens, 1981); for Crete, see Kalokyres, Αἱ βυζαντιναὶ τοιχογραφίαι, 79–80; Spatharakis, *Rethymnon*, 305–6; and Tsamakda, *Kakodiki*, 161–63.

269 This is a slight variation of Acts 1:11: οἳ καὶ εἶπαν· ἄνδρες Γαλιλαῖοι, τί ἑστήκατε [ἐμ]βλέποντες εἰς τὸν οὐρανόν; οὗτος ὁ Ἰησοῦς ὁ ἀναλημφθεὶς ἀφ᾽ ὑμῶν εἰς τὸν οὐρανὸν οὕτως ἐλεύσεται ὃν τρόπον ἐθεάσασθε αὐτὸν πορευόμενον εἰς τὸν οὐρανόν ("Men of Galilee," they said, "why do you stand here looking into the sky? This same Jesus, who has been taken from you into heaven, will come back in the same way you have seen him go into heaven").

270 Examples of the angel holding the scroll with this text can be found at the Pantanassa in Mistras (dedicated 1428) (M. Aspra-Vardavake and M. Emmanouel, Ἡ Μονή τῆς Παντάνασσας στον Μυστρά: Οἱ τοιχογραφίες του 15ου αἰώνα [Athens, 2005], 143, pl. 54), at the Panagia Kardiotissa in Voroi (beginning of the fifteenth century), at St. George in Emparos (1436/37), and at the Panagia in Mikri Episkopi (1444; see Spatharakis, *Dated Wall Paintings*, fig. 171), where the angels, however, are clad in white.

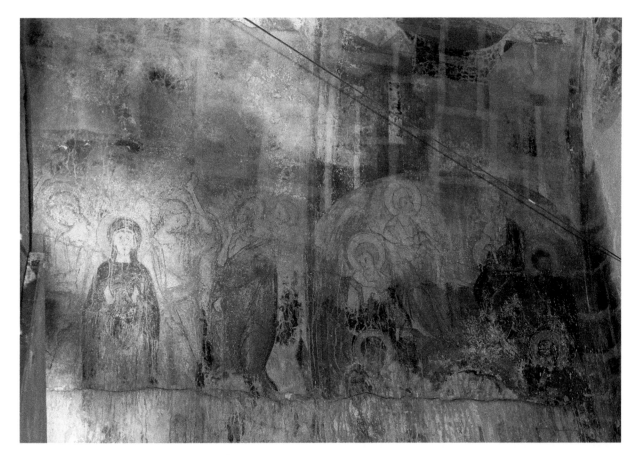

Fig. 33. Church of the Holy Apostles, Kato Karkasa, Ascension and Pentecost, southern halves. Photo by authors.

relatively rare.[271] But what is exceptional here is the angel's depiction in military costume, which is a clear reference to the Archangel Michael.[272] This angel never appears in the context of the Ascension in this way. This unparalleled departure strengthens the eschatological overtones that the scene of the Ascension already encompasses because of its connection with the Second Coming.[273] Here, the angel has been identified as the Archangel Michael, whose role in the Second Coming as leader of the souls is well known. This interpretation

could have been influenced by liturgical or exegetical texts.[274] The iconography of the scene closely resembles that at St. George in Emparos (1436/37).[275]

The partially preserved Pentecost (Fig. 33)[276] is divided into two parts, each comprising six apostles. Each half is arranged in similar fashion: they show the apostles seated on a semicircular bench looking in different directions. Peter and Paul, the patron saints of the church, are placed as usual in the middle of the

271 For the angels included in the scene of the Ascension, see Gkioles, Ἡ Ἀνάληψις τοῦ Χριστοῦ, 315–21. This study, however, focuses on monuments of the Middle Byzantine period.

272 Furthermore, his hieratical depiction has been modeled upon the Archangel Michael as a guardian of the church. In this function, the Archangel Michael, clad in military costume and bearing a sword, is painted near the entrance of numerous Cretan churches; on this, see Kalokyres, Αἱ βυζαντιναὶ τοιχογραφίαι, 117, and Tsamakda, *Kakodiki*, 83 and passim.

273 See above the relevant passage, n. 269.

274 There are apocryphal texts identifying one of the angels as the Archangel Michael, and there exist depictions of Gabriel and Michael in connection with the Ascension in earlier monuments in Egypt and Cappadocia, but in none of them do the angels appear in military costume; see Gkioles, Ἡ Ἀνάληψις τοῦ Χριστοῦ, 39, 120, 123–24, 144 with n. 108, 257, 300–301.

275 Spatharakis, *Dated Wall Paintings*, 185–86, fig. 164. In Emparos, however, the Virgin is accompanied only by one angel.

276 On the iconography of this subject, see S. Seeliger, "Pfingsten," *LChrI* 3:415–23; for Crete, see Kalokyres, Αἱ βυζαντιναὶ τοιχογραφίαι, 80–81, and Spatharakis, *Rethymnon*, 306–7.

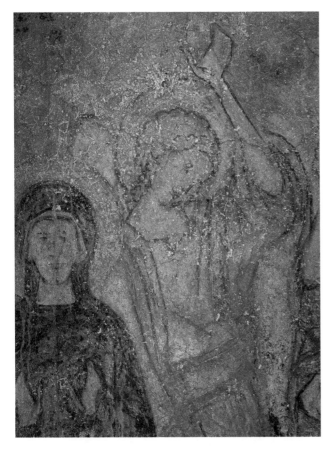

Fig. 34. Church of the Holy Apostles, Kato Karkasa, details from the Ascension. Photo by authors.

northern group. Behind the bench, an architectural background is visible. The depiction of the Holy Spirit in the summit of the barrel vault, usually pictured as a segment from which beams of light descend, does not survive in this church. Neither are beams or tongues of light visible above the heads of the apostles. The personification of the Cosmos, denoting the cosmic significance of the Pentecost, is rendered as a bearded and crowned man holding a drapery fold with scrolls, placed in the middle of the apostles in both halves. As already noted, a close parallel regarding both the position and the iconography of the scene can be found at St. George in Emparos (1436/37).[277] The iconography also recalls that of Sklaverochori.[278]

The Healing of the Paralytic (Fig. 35)[279] shows Christ standing on the left of the composition. He is turned to the right, raising his right hand in a gesture of speech while blessing with his left one. A group of disciples stands behind him. On the right, the cured paralytic is advancing to the right. He carries his bed on his back and turns his head backward toward Christ. In the lower-right corner, a small, haloed head is barely visible. The scene takes place in front of an edifice. The composition in our church follows the basic scheme exemplified by St. Nicholas Orphanos in Thessaloniki (beginning of the fourteenth century), which is, however, fragmentarily preserved, as well as by other relevant monuments.[280] A similar representation of this Miracle on Crete can be found at St. George in Ano Symi (shortly after 1453),

277 For the scene in Emparos, see Spatharakis, *Dated Wall Paintings*, 186–87. The position of the scene in Emparos is identical to that in Kato Karkasa, as is the placement of the Pentecost.

278 Borboudakes, "Παρατηρήσεις," pl. 187. The positions of the Ascension and Pentecost are here reversed compared to our church.

279 On the iconography of this subject, see M. Kazamia-Tsernou, "Η ίαση του Παραλυτικού στην παλαιοχριστιανική και βυζαντινή εικονογραφία" (PhD diss., Aristotle University of Thessaloniki, 1994).

280 Kazamia-Tsernou, *Η ίαση του Παραλυτικού*, 206, pl. 61.

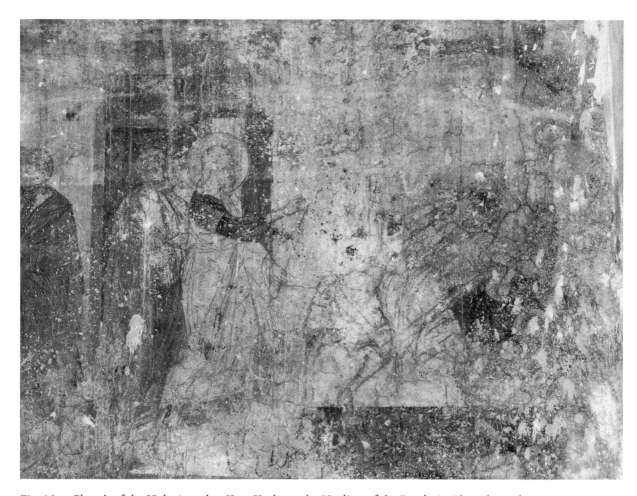

Fig. 35. Church of the Holy Apostles, Kato Karkasa, the Healing of the Paralytic. Photo by authors.

painted by Manuel Phokas,[281] where, however, the scene is reversed. In the narthex of the Valsamonero monastery (between 1431–ca. 1450),[282] the relevant scene corresponds exactly to the one in Kato Karkasa not only in its general arrangement but also in almost all details. The juxtaposition with this scene also offers a clue for the reading of the detail on the right corner: a flying angel stirring the water in the Bethesda pool, as recounted in the Gospel of John (John 5:4). This motif is found infrequently in monumental art.

The cycle of the patron saints comprised at least four scenes that are in a very bad state of preservation.

They occupy the northern part of the vault in the middle and western bay, placed in the lower register. The great value of this imagery lies in the fact that cycles of Peter and Paul are very rare in Byzantine (monumental) art and especially in the Palaeologan period.

Apart from the well-known monumental tradition of these cycles in Rome, the best-known medieval cycles are the ones of the twelfth-century Sicilian churches in Palermo and Monreale.[283] These two comprehensive

281 Spatharakis, *Dated Wall Paintings*, 202.

282 Acheimastou-Potamianou, "Ο νάρθηκας," 386–87, pl. 96a. The same iconography also follows the scene at Timios Stavros near the Valsamonero monastery; see Acheimastou-Potamianou, "Ο νάρθηκας," 386–87, with a dating to the beginning of the fifteenth century.

283 O. Demus, *The Mosaics of Norman Sicily* (London, 1949), 294–99, pls. 40–43, 77–83. For earlier cycles in Rome, see A. van Dijk, "Jerusalem, Antioch, Rome, and Constantinople: The Peter Cycle in the Oratory of Pope John VII (705–707)," *DOP* 55 (2001): 305–28. As already stated, we do not include here the Denial and Repentance of Peter, which appear in illustrations of the Gospels and in Byzantine church programs as part of the Christological cycle; see, for example, these two scenes included in the illustration of the BnF, gr. 54 (thirteenth century): K. Maxwell, *Between Constantinople and Rome:*

cycles were entirely different from the Roman ones.[284] Additionally, some cycles are also found in illustrated Acts of the Apostles,[285] and some scenes are scattered in other illustrated manuscripts with different content. No apostolic cycles appear in the illustrated menologia.[286] Comparable cycles are also absent from the painted menologia in Palaeologan churches.[287] An important cycle of the Acts of the Apostles containing 16 scenes from the Life of Peter and Paul is found in Dečani (fourteenth century).[288] Only one subject of this cycle corresponds to the Karkasa cycle (see below, p. 303). A small cycle of Peter and Paul also survives at the Belli Kilise in Soğanlı (end of the tenth century)[289] and at Balkan Deresi 4 in Ortahisar.[290]

On Crete, three more cycles are known to us. At St. Paul in the village of Agios Ioannes (1303/4),[291] fresco fragments on the tympana of the northern and southern arches most probably belonged to such a cycle. In the central register of the tympanum of the northern arch, an inscription naming St. Paul has been preserved to the left of a narrative scene. However, not enough of the scene survives to allow for an identification of the subject. An unpublished cycle is found in the Church of the Holy Apostles in Agios Myronas and can be dated to the fourteenth century. It is located on the lower register of the barrel vault of the naos and consists of the following scenes: Peter and Paul before Nero, based on an apocryphal joint martyrdom account of the Chief Apostles;[292] Peter Imprisoned and Visited by an Angel, based on Acts 12:7; the Crucifixion of Peter; and the Beheading of Paul. Another cycle of Peter and Paul, unknown until now, is found in the Church of the Holy Apostles in Rokka (fifteenth century).[293] It includes the following scenes, located on the upper and lower register of the northern part of the barrel vault of the naos: Peter and Paul before Nero,[294] the Beheading of Paul, and the Crucifixion of Peter. A fourth scene placed to the west of the martyrdom scenes is partially preserved but cannot be identified. Finally, there is a scene from Peter's cycle in the Church of the Holy Apostles in Prodromi (mid-fourteenth century) showing Peter Imprisoned and Visited by an Angel. Additionally, the

An Illuminated Byzantine Gospel Book (Paris gr. 54) and the Union of Churches (Farnham, 2014), pls. X (the Denial of Peter), XI (the Remorse of Peter), table 6.8.

284 On the difference between the Roman and Sicilian apostolic sequences and their development, see Demus, *Norman Sicily*, 296–97.

285 The codex of Acts and Epistles owned by the Robinson Trust in London (dated 1107) contains scenes of the Conversion and Martyrdom of Paul; see H. Buchthal, "Some Representations from the Life of St. Paul in Byzantine and Carolingian Art," in *Tortulae: Studien zu altchristlichen und byzantinischen Monumenten*, ed. W. N. Schumacher (Rome, 1966), 43–48. The codex BnF, gr. 102, depicts the Healing of a Lame Man and St. Peter's Release from Prison; see H. L. Kessler, "Paris. Gr. 102: A Rare Illustrated Acts of the Apostles," *DOP* 27 (1973): 209–16, at 211–13, fig. 1. A larger and dense cycle is included in the Rockfeller-McCormick New Testament in Chicago (late twelfth or early thirteenth century); see A. W. Carr, "Chicago 2400 and the Byzantine Acts Cycle," *ByzSt* 3.2 (1976): 1–29. On this subject, see also L. Eleen, "Acts Illustration in Italy and Byzantium," *DOP* 31 (1977): 253–78.

286 N. P. Ševčenko, *Illustrated Manuscripts of the Metaphrastian Menologion* (Chicago, 1990), 187, concludes that very few menologia include narrative cycles, though not cycles of Peter and Paul, only individual scenes.

287 As a rule, the menologia in monumental art depict the martyrdoms of Peter and Paul together as their common feast is 29 June; see P. Mijović, *Menolog: Istrojsko-umetnička istraživanja* (Belgrade, 1973), 281, 303, 340, 373, drawings 28, 73, figs. 100, 225, 273.

288 A. Davidov Temerinski, "Ciklus dela apostolskih," in *Mural Painting of Monastery of Dečani*, ed. V. J. Djurić (Belgrade, 1995), 165–79. For an enumeration of these scenes, see Davidov Temerinski, "Ciklus dela apostolskih," 178.

289 It shows Peter and Paul before Nero, the Apostles Being Led to the Prison, and the Apostles Imprisoned; see M. Restle, *Die byzantinische Wandmalerei in Kleinasien* (Recklinghausen, 1967), 3: no. 47, figs. 445–48, and C. Jolivet-Lévy, *La Cappadoce: Un siècle après Guillaume de Jerphanion* (Paris, 2015), 261, pl. 244.2.

290 It consists of the Martyrdom of Paul and Peter before Nero; see Jolivet-Lévy, *La Cappadoce*, 177, pls. 176.3, 177.5–6.

291 Spatharakis, *Dated Wall Paintings*, 29–30, with the older bibliography.

292 On these accounts, see *BHG* nos. 1490–1; R. A. Lipsius, ed., *Acta apostolorum apocrypha post Constantinum Tischendorf*, part 1, *Acta Petri, Acta Pauli Acta Petri et Pauli, Acta Pauli et Theclae, Acta Thaddaei* (Leipzig, 1891), 118–222; and D. L. Eastman, *The Ancient Martyrdom Accounts of Peter and Paul* (Atlanta, 2015), 161–385.

293 On this church, see briefly K. E. Lassithiotakes, "Ἐκκλησίες τῆς Δυτικῆς Κρήτης, Α´: Ἐπαρχία Κισάμου," *Κρ.Χρον.* 21 (1969): 177–233, at 233, no. 35; the author does not mention the cycle of the apostles. On the style, see Bissinger, *Kreta*, 196, no. 168, with dating to the 1380s.

294 The rare depiction of Peter and Paul before Nero is always related to the Dispute with Simon Magus, as seen, for example, in Monreale (Demus, *Norman Sicily*, 119, pl. 83) and in Mateič (1356/60; see V. J. Djurić, *Byzantinische Fresken in Jugoslawien* [Munich, 1976], fig. 71). However, in Rokka, the apostles are not standing but kneeling before the emperor, perhaps an indication that the scene depicts them receiving their sentence as described in the apocryphal account; see Eastman, *The Ancient Martyrdom Accounts*, 305–7.

Fig. 36.
Church of the Holy
Apostles, Kato Karkasa,
the Conversion of Paul.
Photo by authors.

Embrace of Peter and Paul is depicted next to this scene as a proskynesis icon.[295]

The scenes from the Lives of Peter and Paul in Kato Karkasa are in such a bad state of preservation that a detailed description and a secure identification are impossible.

The cycle of Paul begins with his Conversion on his way to Damascus (Fig. 36). In the upper part of the composition, the haloed Christ is in the middle, probably seated and extending his right arm. He seems to be flanked by two other people. One more person is in the lower-right corner against a yellow background and bent

to the left. In all probability, another figure was on the left. There was no standardized iconography for Paul's Conversion.[296] In most of the cases, Christ is shown as a half-figure in a heaven segment, while Paul, struck with blindness by the apparition, is about to fall to the ground, as, for example, in Codex Ebnerianus, Oxford,

295 On this church, see M. Studer-Karlen, *Christus Anapeson: Bild und Liturgie* (Basel, 2022), 287–89, figs. 117–18.

296 On the iconography of this subject, see M. Lechner, "Paulus," *LChrI* 8:140. The painter's guide of Dionysios of Fourna describes the scene as follows: "Saint Paul lying with his face on the ground, with his hands to his eyes; above him is heaven with Christ. A bright light divided into rays descends from heaven on to the head of Paul, with these words written in them: 'Saul, Saul, why persecutes thou me?' Near him four men with fur hats and turbans stand in amazement" (Hetherington, *"Painter's Manual,"* 66); for the Greek text, see Papadopoulos-Kerameus, Ἑρμηνεία τῆς ζωγραφικῆς, 179.

Fig. 37. Church of the Holy Apostles, Kato Karkasa, Paul Dictating. Photo by authors.

Bodleian Library, Auct. T. inf. 1. 10, fol. 312v (twelfth century),[297] or he is shown in prostration as in the Cathedral of Monreale (twelfth century).[298] There are also compositions combining two or more episodes from the account, such as Christ Addressing Paul and Paul Struck Prostrate to the Ground, like the miniature in the Robinson Trust codex, fol. 121v (see above, n. 285).[299] In Dečani, where the Conversion unfolds in three scenes, Saul is rendered in the act of falling and raising his head

in the direction of Christ blessing from above.[300] As the image in Kato Karkasa does not find close parallels, it could be a deliberate reinterpretation of one of these models, or it reflects an unknown pictorial source.[301]

The next scene, whose upper part is badly damaged, shows on the left a seated person in dark garments whose face is destroyed (Fig. 37). On the right, one sees another seated person with a halo, wearing a white tunic

297 C. Meredith, "The Illustration of Codex Ebnerianus: A Study in Liturgical Illustration of the Comnenian Period," *JWarb* 29 (1966): 419–24, at 423–24, pl. 70d.

298 Demus, *Norman Sicily*, fig. 40a.

299 On this and other conversion cycles, see Buchthal, "Some Representations."

300 Davidov Temerinski, "Ciklus dela apostolskih," 174, fig. 11; for a color reproduction, see G. Subotić, *Spätbyzantinische Kunst: Geheiligtes Land von Kosovo* (Düsseldorf, 1998), pl. 70.

301 A survey of the monuments of Western Europe returned no results for this specific type represented by Kato Karkasa; on Pauline iconography in Western monuments up to the thirteenth century, see L. Eleen, *The Illustration of the Pauline Epistles in French and English Bibles of the Twelfth and Thirteenth Centuries* (Oxford, 1982).

and a red mantle and writing down text. It is possible that a basket with scrolls is depicted before the scribe in the foreground. The scene takes place in a landscape. This image immediately recalls the well-known scene of St. John the Evangelist dictating to his scribe Prochoros.[302] In the context of Paul's cycle, the fresco at Kato Karkasa most probably represents St. Paul Dictating to Luke.[303] This rare subject is known mainly from the illustration of the Byzantine Gospels and is based on *hypotheseis* holding that the Gospel of Luke was dictated by Paul in Rome.[304] The subject is present in similar iconography, in the type of St. Paul opposite Luke, for example, on fol. 105v of the illustrated Gospel manuscript Jerusalem, Greek Patriarchal Library, Taphou 56 (eleventh century)[305] and on fol. 76v of the Gospel manuscript, St. Petersburg, National Library of Russia, gr. 101 (thirteenth century),[306] both prefacing the Gospel of Luke. In these miniatures, the compositions are reversed, and both figures are placed against an architectural background indicating an interior space. In addition, Paul is standing instead of sitting. The same type is represented by Baltimore, Walters Art Museum, W.524, fol. 6v (tenth century), where, however, Paul is also seated like at Kato Karkasa but retains the reversed arrangement

and the architectural background.[307] Although this subject was quite rare, there existed further similar images. A poem by John Mauropous (ca. 1000–ca. 1085) echoes this pictorial tradition showing Paul dictating and his association with Luke. The poem is entitled "Εἰς τὸν Ἅγιον Παῦλον ὑπαγορεύοντα, καὶ Λουκᾶν καὶ Τιμόθεον παρεστῶτας καὶ γράφοντας" ("On Saint Paul Dictating, and Luke and Timothy Standing by Him and Writing").[308] The ekphrasis following this title does not help reconstruct the exact iconography of the image that Mauropous saw, but it is clear that the wall painting at Kato Karkasa depicted only one of the scribes. We may exclude Timothy since he was a bishop and is usually pictured in bishop's garments,[309] so the identification of Luke seems safe. However, it should be noted that St. Paul Dictating to Luke is not prescribed or described in the *Hermeneia*, which, apart from Paul's Conversion and Paul's Martyrdom, mainly refers to the apostle's Miracles and other events of his life.[310]

Next to St. Paul Dictating to Luke is the Martyrdom of Paul (Fig. 38). Paul is in the foreground clad in long, dark vestments and bending to the left with extended hands. An executioner stands behind him and is about to behead him; only the leg of the executioner is visible. The decapitation takes place in a landscape rendered in ochre-yellow as in the other scenes. The upper part of the composition is destroyed.[311] In the corresponding scene in Rokka, only Paul's head on the left

302 This image often functions as the opening illustration for the Gospel of John and is also found in icons and murals; see M. Lechner, "Johannes der Evangelist," *LChrI* 7:114–15. On Crete, we can find such a representation, for example, at the Panagia Kardiotissa in Voroi (beginning of fifteenth century); for a detail, see Borboudakes, "Παναγία Καρδιώτισσα Βόρων," fig. 7.

303 The interruption of Paul's cycle at this point would constitute a conspicuous and highly unusual disturbance of the pictorial program and its inner logic.

304 Such a *hypothesis* precedes, for example, the fourteenth-century Gospel manuscript, Athens, National Library of Greece, gr. 151, fol. 143v; see G. Galavaris, *The Illustrations of the Prefaces in Byzantine Gospels* (Vienna, 1979), 61. The miniature following fol. 143v represents Paul standing behind Luke the Evangelist and dictating in his ear; see Galavaris, *The Illustrations of the Prefaces*, 62, fig. 39; on the relevant hypotheseis, see also R. S. Nelson, *The Iconography of Preface and Miniature in the Byzantine Gospel Book* (New York, 1980), 8–9.

305 Galavaris, *The Illustrations of the Prefaces*, 59, fig. 35, and Vocotopoulos, *Byzantine Illuminated Manuscripts of the Patriarchate of Jerusalem* (Jerusalem, 2002), 35, fig. 8. On the subject of authors combined with various "inspiration" motifs and their textual foundations, see Galavaris, *The Illustrations of the Prefaces*, 50–72, and Nelson, *The Iconography of Preface*, 75–91.

306 Galavaris, *The Illustrations of the Prefaces*, 62, fig. 43, and Nelson, *The Iconography of Preface*, 80, fig. 55.

307 Nelson, *The Iconography of Preface*, 77–78, fig. 49.

308 F. Bernard and C. Livanos, eds. and trans., *The Poems of Christopher of Mytilene and John Mauropous* (Cambridge, MA, 2018), 356–57, no. 22, 571. Timothy is mentioned as an assistant in Rom. 16:21, Luke in Philem. 1:24.

309 We see this, for example, in the illustrated Praxapostolos, Baltimore, The Walters Art Museum, W.533, fols. 239r, 247v, and 287r (early twelfth century), where Timothy is portrayed as co-author of some of the Pauline Epistles; see J. C. Anderson, "The Walters Praxapostolos and Liturgical Illustration," Δελτ.Χριστ.Ἀρχ.Ἑτ. 19 (1996–1997): 9–38, fig. 16, with further examples for the representation of Paul and Timothy.

310 These are: (1) Paul Called by God; (2) Paul Baptized by Ananias; (3) Paul Escapes Damascus in a Basket; (4) Paul Blinds the Sorcerer Bar-Jesus; (5) Paul Heals the Woman Possessed by the Spirit Python; (6) Paul Shakes off the Viper That Bit Him into the Fire; and (7) St. Paul Dies by the Sword; see Papadopoulos-Kerameus, Ἑρμηνεία τῆς ζωγραφικῆς, 179–80, and Hetherington, *"Painter's Manual,"* 66–67.

311 The city of Rome appears occasionally in the composition; see, for example, Demus, *Norman Sicily*, 299, pl. 77A. On the iconography of this subject, see also Lechner, "Paulus," 8:143.

Fig. 38.
Church of the
Holy Apostles,
Kato Karkasa,
the Beheading of
Paul. Photo
by authors.

and a small part of a building in the upper-right corner are visible. The corresponding scene in Agios Myronas is much better preserved and repeats the iconography in Kato Karkasa. The representation of the theme is based on the apocryphal Acts of Paul.[312] Depictions of Paul's Beheading can be found, for example, in the ninth-century Homilies of Gregory of Nazianzus, BnF, gr. 510, fol. 32v[313] and in the Robinson Trust manuscript,

fol. 121v.[314] Our image is similar to that on fol. 62v of the BnF, gr. 1528 (eleventh/twelfth century) (illustrated menologion), in which, however, the scene is reversed,[315] and that in Dečani (fourteenth century).[316] The scene in Kato Karkasa only generally follows the description in the *Hermeneia*, which adds to the composition more soldiers surrounding Paul and a one-eyed woman nearby

312 Eastman, *The Ancient Martyrdom Accounts*, 126–37, esp. 134–35.

313 L. Brubaker, *Vision and Meaning in Ninth-Century Byzantium: Image as Exegesis in the Homilies of Gregory of Nazianzus* (Cambridge,

1999), 248, fig. 8. This is the earliest preserved depiction of the subject in Byzantine art.

314 Buchthal, "Some Representations," pl. 9.

315 Ševčenko, *Menologion*, 140, fig. 4A12.

316 Mijović, *Menolog*, fig. 225.

Fig. 39. Church of the Holy Apostles, Kato Karkasa, the Crucifixion of Peter. Photo by authors.

looking toward him.[317] Our scene rather follows a conventional formula and has innumerable parallels to representations of the martyrdom of other saintly figures.[318]

To the west of the cycle of Paul, the Martyrdom of Peter has been preserved (Fig. 39). Only the saint hanging upside down on the Cross clad with a piece of cloth around his hips is visible. A servant on the left is nailing the saint's feet, while another one on the right is nailing the saint's hand. Peter's Crucifixion has also survived in Agios Myronas in a very similar composition. It has a group of soldiers on the right holding round shields.

This element helps us understand the image at Kato Karkasa, where similar undefined round structures appear at the same spot. The two images follow the same model. The scene at the Holy Apostles in Rokka, on the contrary, differs in some details, like the body positions of the soldiers and the fact that the composition is dominated by the city walls in the background.

Peter's Crucifixion is based on the apocryphal Μαρτύριον τοῦ ἁγίου Πέτρου τοῦ ἀποστόλου (the Martyrdom of St. Peter the Apostle), which constitutes the final section of a larger cycle of legends known as the Acts of Peter.[319] Cycles from the life of this apostle, which, however, do not include martyrdom scenes, can be traced back to early Christian imagery in Rome. Perhaps the earliest depiction of Peter's reversed

317 Papadopoulos-Kerameus, Ἑρμηνεία τῆς ζωγραφικῆς, 180, and Hetherington, *"Painter's Manual,"* 67. It is unclear if Paul's eyes at Kato Karkasa are covered by the scarf of Perpetua, as narrated in the apocryphal sources; see Eastman, *The Ancient Martyrdom Accounts,* 306–7.

318 Cf. Buchthal, "Some Representations," 43.

319 Eastman, *The Ancient Martyrdom Accounts,* 1–25, esp. 18–19.

Crucifixion can be seen in BnF, gr. 510, fol. 32v.[320] It represents a reduced composition, showing only the crucified St. Peter and a group of men on the left. This abbreviated version is also found in the menologia illustrations in manuscripts[321] and in monumental art.[322] The composition in Kato Karkasa echoes a more elaborate version that is reminiscent of the description in the *Hermeneia*: "Peter, crucified head down, dies. A cross planted in the earth; St. Peter is crucified with his feet uppermost and his head downwards. A crowd of soldiers are in a circle round him, some nailing his hands, others his feet."[323] A similar version is represented at the Cathedral of Monreale (twelfth century).[324]

The cycle of the titular saints in Kato Karkasa clearly focuses on Paul, whose cycle consists of three scenes, while Peter's cycle is limited to two scenes at most, if one adds the destroyed scene adjacent to his martyrdom. We can only speculate about the missing scene from Peter's cycle. It could have been a Miracle, as prescribed in the *Hermeneia*,[325] or Peter's Liberation, as in Prodromi and Agios Myronas.[326] Given the limited available space in the church, the main reason for the selection of these scenes was that they represented the most meaningful events of the apostles' lives. The cycle emphasizes conversion and faith attested through martyrdom but not the apostles' function as miracle workers, as is the case in the *Hermeneia*. The importance of the scene of St. Paul Dictating to Luke remains difficult to elucidate, as we cannot be absolutely sure about the identity of the scribe. His identity is perhaps irrelevant, and the choice of this subject aims to underscore Paul's

authority as a writer and missionary along with his status and significance as a martyr.

The textual sources for these cycles are the Acts[327] and the apocryphal Passion, which is transmitted in a plethora of versions.[328] But where did the iconographic models come from? For three of the scenes (Paul's Conversion and the two martyrdoms), one finds antecedents in various media in Byzantine art, even if the iconography in Kato Karkasa seems to follow a somewhat different tradition. For the scene of St. Paul Dictating to Luke, extant Byzantine parallels can be found only in illuminated manuscripts. It is likely that the scenes were excerpted from an extensive narrative cycle of the Lives of Peter and Paul, but there is no sufficient evidence that would allow us to determine the nature of the pictorial source, whether it was an illustrated manuscript or another kind of medium.

The depiction of the Embrace of Peter and Paul stands out (Fig. 40). Both of them, nimbed and clad in tunics and mantles, stand under an arch, embracing each other. Peter is on the left and Paul on the right. The sides of their faces are touching, and the apostles are about to kiss. The representation repeats a well-known formula established in the early Christian period. The theme initially appeared within apostolic cycles but became autonomous after Iconoclasm.[329] In the

320 Brubaker, *Vision and Meaning*, 247–48, fig. 8.

321 An example is in the BnF, gr. 1528, fol. 62v; see Ševčenko, *Menologion*, 140, fig. 4A12.

322 An example can be found in Dečani; see Mijović, *Menolog*, fig. 225.

323 Hetherington, *"Painter's Manual,"* 66, and Papadopoulos-Kerameus, Ἑρμηνεία τῆς ζωγραφικῆς, 179.

324 Demus, *Norman Sicily*, 119, 299, pl. 81a.

325 The scenes listed in the *Hermeneia* are: (1) Peter Heals the Lame Man; (2) Peter Kills Ananias and Sapphira; (3) Peter Raises Tabitha; (4) Peter Baptizes Cornelius and Those with Him; (5) Peter Freed from Prison by the Angel; and (6) Peter Kills Simon Magus; see Papadopoulos-Kerameus, Ἑρμηνεία τῆς ζωγραφικῆς, 178–79, and Hetherington, *"Painter's Manual,"* 66.

326 This scene was exceedingly popular in the Acts cycles; see Carr, "Chicago 2400," 12.

327 It is generally assumed that the Acts cycles in monumental art derive from an extensively illustrated Acts manuscript; see, among others, Demus, *Norman Sicily*, 299, and Carr, "Chicago 2400."

328 *BHG* nos. 1451–52, 1458–59, 1483–85, 1490–92h, and Eastman, *The Ancient Martyrdom Accounts*.

329 Earlier representations depict the saints in isolated scenes rushing to meet each other, like the one on a carved ivory found in Castellammare di Stabia (fifth century), or integrated in narrative contexts; see H. L. Kessler, "The Meeting of Peter and Paul in Rome: An Emblematic Narrative of Spiritual Brotherhood," *DOP* 41 (1987): 265–75, at 267, fig. 3. The type showing the apostles in full length, standing and closely embracing each other in an emblematic image, seems to first appear after Iconoclasm, such as on lead seals like the one of Nikephoros, sebastophoros of Antioch (1063–1067); see K. Kreidl-Papadopoulos, "Die *Ikone mit Petrus und Paulus* in Wien: Neue Aspekte zur Entwicklung dieser Rundkomposition," Δελτ.Χριστ. Ἀρχ.Ἑτ. ser. 4, 10 (1980–81): 339–56, at 349, pl. 98a. In full length and against an architectonical background, they are also depicted on fol. 3r of the Psalter, Athens, National Library of Greece, gr. 7 (second half of the twelfth century): see A. Cutler, *The Aristocratic Psalters in Byzantium*, Bibliothèque des Cahiers Archéologiques 13 (Paris, 1984), no. 2. An early fresco example (second half of the twelfth century) that is fragmentarily preserved, showing only the faces of the apostles, is found in Vatopedi; see *Le Mont Athos et l'empire byzantine: Trésors de*

Fig. 40. Church of the Holy Apostles, Kato Karkasa, the Embrace of Peter and Paul.
Photo by authors.

Middle Byzantine period, the subject was still popular, as a poem entitled "On the Embrace of Peter and Paul" by John Mauropous indicates,[330] but it is found mainly in illuminated manuscripts and on some lead seals. The theme becomes more popular in the Palaeologan period. It is conceived as a double portrait of the saints but reflects a narrative incident from their lives, namely their legendary encounter in Rome, an episode based on an apocryphal tradition.[331] The representation occasionally appears in Cretan frescoes, mostly in eastern Crete, as for example in the Church of the Savior in Potamies (last quarter of the fourteenth century),[332] in which the two saints are blessed by Christ, who appears above them, or in the Church of the Holy Apostles in Prodromi, which is, however, partially damaged.[333] In Panagia Zoodochos Pege in Prinos (fifteenth century),[334]

the image is reversed, something that recalls the Sicilian counterparts of the twelfth century.[335] Placed under an arch, the image recurs also at Agia Paraskevi in Episkopi (first half of the fifteenth century)[336] and in the narthex of the Valsamonero monastery of St. Phanourios (between 1431 and ca. 1450).[337] In all these images, the facial characteristics are almost identical. All images probably derive from the same archetype. Connected with the Valsamonero monastery is the painter Angelos Akotantos, active in Venetian Crete from ca. 1425 to 1450,[338] who has painted a significant number of icons with this subject and eventually introduced this theme into Cretan icon painting.

The theme of Peter and Paul embracing can be read on more than one level. First of all, it conveys the notion of spiritual brotherhood.[339] The basic spiritual association and brotherly unity of the Embrace is also addressed by John Chortasmenos (1370–ca. 1437), who, looking at an icon of this type, mentions that Peter embraces Paul as a brother (ὡς ἀδελφὸν ἀσπάζῃ) and refers to the concerted mission of the apostles.[340] The

la Sainte Montagne, ed. H. Studievic (Paris, 2009), 190, fig. 87. Apart from these examples, there exists a series of rectangular icons and tondi dating from the fourteenth century on, depicting a bust of the saints embracing each other; see M. Vassilaki, "A Cretan Icon in the Ashmolean: The Embrace of Peter and Paul," *JÖB* 40 (1990): 405–22; E. N. Tsigaridas, "Ὁ Ἀσπασμός των ἀποστόλων Πέτρου καὶ Παύλου στη βυζαντινή καὶ μεταβυζαντινή τέχνη," in Πρακτικά του διεθνούς επιστημονικού συνεδρίου "Ὁ Χριστός στο κήρυγμα του Ἀποστόλου Παύλου: 2000 χρόνια χριστιανικής ζωής, ιστορίας, καὶ πολιτισμού" (Veroia, 2000), 80–90; V. Kepetzi, "Autour d'une inscription métrique et de la représentation des apôtres Pierre et Paul dans une église en Élide," in *Art and Ritual: Byzantine Essays for Christopher Walter*, ed. P. Armstrong (London, 2006), 160–81; and Ranoutsaki, *Soteras Christos-Kirche*, 118–21. The motif of apostles embracing each other is also included in some representations of the Communion of the Apostles; see S. E. J. Gerstel, "Apostolic Embraces in Communion Scenes of Byzantine Macedonia," *CahArch* 44 (1996): 141–48.

330 Bernard and Livanos, *The Poems*, 360–61, no. 25, 572; on this epigram, see also Kepetzi, "Autour d'une inscription métrique," esp. 163–64, 177–80.

331 Eastman, *The Ancient Martyrdom Accounts*, 280–81. The embrace can be interpreted as either a greeting or a goodbye. That the image in Late Byzantium was not perceived as part of the apostles cycle can be deduced from the fact that in the *Hermeneia* of Dionysios of Fourna it is not among the scenes of the apostolic cycles but is mentioned *hors-série* in another place; see Papadopoulos-Kerameus, Ἑρμηνεία τῆς ζωγραφικῆς, 178–80, 232. In illustrated menologia, the image sometimes prefaces the part concerning the Martyrdom of Peter and Paul, like in BnF, gr. 1528, fol. 47v; see Ševčenko, *Menologion*, 140, fig. 4A11.

332 Ranoutsaki, *Soteras Christos-Kirche*, 118–21, fig. 38.

333 Studer-Karlen, *Christus Anapeson*, figs. 117–18.

334 O. Gratziou, Ἡ Κρήτη στην ύστερη μεσαιωνική εποχή: Ἡ μαρτυρία της εκκλησιαστικής αρχιτεκτονικής (Heraklion, 2010), 283, fig. 309, with a dating in the second half of the fifteenth century; I. Spatharakis, *Byzantine Wall Paintings of Crete*, vol. 2, *Mylopotamos Province* (Leiden,

2010), no. 27, 249, with a dating to ca. 1420; and Andrianakes and Giapitsoglou, Χριστιανικά μνημεία, 282, who repeat the old dating in the beginning of the sixteenth century. For more examples of the Embrace of Peter and Paul in Byzantine art, see Kessler, "The Meeting of Peter and Paul," 265–66, and Ranoutsaki, *Soteras Christos-Kirche*, 119.

335 Demus, *Norman Sicily*, figs. 43A, 83.

336 On this church, see S. Papadake-Oekland, "Μεσαιωνικά Κρήτης," Ἀρχ.Δελτ. 21 (1968): 2.2:434–35, and Andrianakes and Giapitsoglou, Χριστιανικά μνημεία, 106–7.

337 Acheimastou-Potamianou, "Ὁ νάρθηκας," 417–18, pl. 114a.

338 For an icon in the Hodegetria Monastery signed by this painter, see Vassilaki, "A Cretan Icon in the Ashmolean," 410, fig. 10, and Vassilaki, *The Hand of Angelos*, 152, no. 25 [M. Borboudakis]. This type differs slightly from the one in Kato Karkasa in that only the chins of the apostles touch. The touching of the sides of the faces is typical for the tondi and other icon formats painted by or attributed to Angelos; see, for example, Vassilaki, *The Hand of Angelos*, 154–57, nos. 26 [C. Kephala], 27 [M. Vassilaki].

339 Kessler, "The Meeting of Peter and Paul." The motif of the embrace was also adopted to depict the spiritual brotherhood between St. Basil and Gregory of Nyssa; see a miniature on fol. 204r of the BnF, gr. 550 (twelfth century), and G. Galavaris, *The Illustrations of the Liturgical Homilies of Gregory Nazianzenus,* Studies in Manuscript Illumination 6 (Princeton, NJ, 1969), fig. 416.

340 Kreidl-Papadopoulos, "Die *Ikone mit Petrus und Paulus*," 348. The Mauropous poem cited above (p. 302) also highlights the idea of brotherly unity and ecumenical peace: Ὅθεν συνεργὸν προσλαβὼν τὸν γεννάδαν, σκέπτεσθε κοινὴν σκέψιν, ὡς σεσωσμένην Χριστῷ παραστήσαιτε τὴν οἰκουμένην (Therefore take this bearded man as a comrade, and devise a common plan for how to save the world and

Embrace has also liturgical overtones, as it is reminiscent of the prayer at the end of Proskomide and the Kiss of Peace exchanged by clergy at the altar before Communion.[341] As this embrace of the founders of the Eastern and Western Churches becomes popular in late Palaeologan art, the old concept of the *concordia apostolorum* and ecumenical peace has been frequently seen in relation to the Union of the Churches and the Councils of Lyon (1274) and Ferrara–Florence (1438/39). The apostles' reconciliation in Rome was thus associated with the efforts to bring about reconciliation between the Western and Eastern Churches. Already in the fourteenth century, the poet Manuel Philes interpreted it as an image propagating the Union of the Orthodox and Latin Churches.[342] This also led to ambivalent interpretations among modern scholars. Many frequently argue that these images always contained allusions to actual church politics.

Although it has been generally accepted that the subject alludes to the Union of the Churches, especially in the context of the Latin-dominated areas, this idea cannot be applied to each case. It is impossible to prove that a pro-Union message underlies all extant representations of the subject.[343] In our case, the inclusion

of the Embrace in the pictorial program, its prominent placement in the naos, and its function as a proskynesis icon are clearly due to the fact that Peter and Paul are the titular saints.[344] Furthermore, there is no evidence suggesting that a conscious support or promotion of the Union of the Churches was intended by employing this motif or through other images of the pictorial program at Kato Karkasa. Even more significant, there is no mention of this image nor an explicit wish for its inclusion in the iconographic program in the relevant contract between the patron and the painter.[345] This is an important point in the discussion about the role of the images and the extent to which they should or could convey certain messages.[346]

Such a pro-Union intention, aiming at the submission of the Orthodox to the Roman Catholic Church, is furthermore unthinkable within the walls of Orthodox monasteries whose representatives were demonstrably against the Union of the Churches.[347] The monastery in Kato Karkasa was considered one of the most significant strongholds of Orthodoxy on Crete. We have already referred to Neilos Damilas, who was a zealous Orthodox hieromonk,[348] a scholar, and an opponent of

to present it to Christ [translation according to Bernard and Livanos, *The Poems*, 361]).

341 On this aspect, see N. Gkioles, "Εικονογραφικά θέματα στη βυζαντινή τέχνη εμπνευσμένα από την αντιπαράθεση και τα σχίσματα των δύο Εκκλησιών," in *Θωράκιον*, 263–84, at 271, n. 40.

342 His epigram no. 184 interprets the Embrace of Peter and Paul as follows: Τὸ μυστικὸν φίλημα τῶν Πρωτοθρόνων / τὴν τοῦ γένους ἕνωσιν ἡμῖν δεικνύει / Τῷ σφίγματι γὰρ τῶν παρ᾽ἀμφοῖν δογμάτων (The secret kiss of the two *Protothronoi* / demonstrates the union of our nations / through the clamping of both doctrines); E. Miller, ed., *Manuelis Philae carmina*, 2nd ed. (Amsterdam, 1967), 1:354–55. See also Gkioles, "Εικονογραφικά θέματα," 276–77, and Ranoutsaki, *Soteras Christos-Kirche*, 121, for further literature. Vassilaki argues that Angelos painted such a great number of icons depicting this subject because he was pro-Unionist; see, among others, Vassilaki, *The Hand of Angelos*, no. 27. However, one should bear in mind that the painter worked on demand, something that would transfer a possible pro-Union attitude to the various clients who commissioned or bought these icons; cf. Katsiote, "Τὸ κλίτος του αγίου Ιωάννη του Προδρόμου," 259. On the various purposes and functions that the image of Peter and Paul embracing served, see also Kessler, "The Meeting of Peter and Paul," 274–75.

343 Cf. Katsiote, "Τὸ κλίτος του αγίου Ιωάννη του Προδρόμου," 259, and Acheimastou-Potamianou, "Ὁ νάρθηκας," 417–18. In our opinion, a pro-Union message is not confirmed by the inscriptions accompanying the Embrace at the Church of the Holy Trinity in Ano Divri (second half of the fourteenth century). For the opposite view, see

Kepetzi, "Autour d'une inscription métrique," 167 (inscriptions), 175–81. These inscriptions are pertinent to this pictorial subject according to the *Hermeneia* (see Papadopoulos-Kerameus, *Ἑρμηνεία τῆς ζωγραφικῆς*, 232), but in this case, the actions of Peter and Paul are reversed. The emphasis is put on Peter, but a pro-Union attitude of the depiction on the basis of this feature remains ungrounded, especially since there were apparently problems in the correspondence between the depiction and the epigram; on this, see A. Rhoby, *Byzantinische Epigramme auf Fresken und Mosaiken* (Vienna, 2009), 215.

344 Even in churches dedicated to other saints that include the subject, a pro-Union attitude is not automatically more plausible but has to be supported by substantial evidence.

345 Since, according to the agreement, the painter was free to add subjects as he wished, it is possible to ascribe to the painter a pro-Union attitude. However, the pictorial program must have generally been discussed, and the result must have been approved by the patron or their agent.

346 A case-by-case approach is needed in order to ascertain who was responsible for the design of the iconographic program in each church. For the role that painting workshops played on Crete and their practices in this respect, repeating in very different commissions their favorite subjects, and for the interaction between artists and patrons or their agents, see Tsamakda, *Kakodiki*, esp. 248–51.

347 On this issue, see Despotakis, *John Plousiadenos*, esp. 6–12.

348 He is characterized by Nathanael Bertos as ὁ ὑπέρμαχος τῆς ὀρθοδοξίας (the proponent of Orthodoxy); see Despotakis and Rigo, "Neilos Damilas" (forthcoming).

the Union of the Churches. Consistent with this view, even if the decoration of the church postdates his death, it is doubtful that the attitude of the monastery towards the Union drastically changed within just a few years.[349] The dedication of the church to the Chief Apostles and their image of Embrace manifest the same obvious veneration and appreciation of Peter and Paul as do the writings of Damilas[350] and the works of Joseph Filagrios, another prominent opponent of the Union who was active in roughly the same period and devoted a homily to Peter and Paul.[351] Both Filagrios and Damilas engaged in a peaceful coexistence with the two Churches,[352] a notion best expressed through the Embrace image. Regardless of this basic inherent message, if the Embrace is to be viewed in light of the actual religious policies a few decades before the Council of Ferrara–Florence, one would rather favor an interpretation toward a union on Orthodox terms. This means that in order for the Union to be achieved, the Roman Catholic Church should revert to Orthodoxy,[353] whose dogmas trace their legitimacy in Orthodoxy's continuity with the early Church. In this thinking, the Chief Apostles played a decisive role, as they were the most important representatives of the early Church.

As Herbert Kessler has also pointed out, the Late Byzantine renderings of the theme probably allude to the final emotional encounter of the apostles before their martyrdoms as recorded in a letter

of Pseudo-Dionysius (sixth century).[354] Given that the pictorial program of the church in Kato Karkasa includes the scenes of the Martyrdom of Peter and Paul and emphasizes Christ's Passion, this additional interpretation of our scene as the final embrace becomes more evident and plausible than the assumption that it declares support of the Union of the Churches.

Because of the poor state of preservation, very few of the other saintly figures can be identified. They appear in groups. On the northern wall, there is from the west to the east a series of monks followed by a frontally standing bishop who bears the facial features of St. Nicholas (Fig. 41). Unusually, he does not hold a closed book but an open one, the text of which is no longer visible.[355] Such a depiction of a bishop holding an open book is very rare in wall paintings but not unprecedented; it finds parallels in the narthex of the monastery of Valsamonero[356] and at Panagia Kardiotissa in Voroi.[357] In later icons of St. Nicholas, this version is common, though the saint is depicted sitting. The text written on the open Gospel book he holds is always John 10:9 (ἐγώ εἰμι ἡ θύρα, δι᾽ ἐμοῦ ἐάν τις εἰσέλθῃ σωθήσεται καὶ εἰσελεύσεται καὶ ἐξελεύσεται καὶ νομὴν εὑρήσει) (I am the gate; whoever enters through me will be saved. They will come in and go out and find pasture), a passage from the lectionary read on the feast day of St. Nicholas.[358] The few letters still readable in Kato Karkasa indicate that here the text was different. As in Valsamonero, the passage written and prominently displayed at that location in the church was certainly not chosen arbitrarily.

On the southern wall from east to west are the enthroned Virgin with the Child flanked by two angels,

349 The date of Damilas's death is unknown, but, as we argue above, he must have been dead at the time the contract with Gaitanas was signed; see also Despotakis and Rigo, "Neilos Damilas" (forthcoming). Thus, the attribution in Borboudakes, "Ἡ τέχνη κατὰ τὴ Βενετοκρατία," 246, of the commission of the wall paintings in the Karkasa monastery to Neilos Damilas is also wrong for this reason.

350 Damilas frequently uses passages from the Pauline Epistles to back up his arguments and urges priests to imitate Paul; see Nikolidakes, Νεῖλος Δαμιλᾶς, 93–94, 96.

351 On Filagrios and his work, see G. Papazoglou, Ἰωσὴφ Φιλάργης ἢ Φιλάγριος, ἕνας λόγιος Κρητικός ἱερωμένος καὶ Ἀριστοτελικός σχολιαστής τοῦ 14ου αἰώνα: Συμβολὴ στὴν ἱστορία τῆς Βενετοκρατίας στὴν Κρήτη (Komotini, 2008).

352 Nikolidakes, Νεῖλος Δαμιλᾶς, 60–61.

353 Katsiote, "Τὸ κλίτος τοῦ ἁγίου Ἰωάννη τοῦ Προδρόμου," 259, and Acheimastou-Potamianou, "Ὁ νάρθηκας," 418. On the interpretation of Unionist art, see also R. Cormack, ". . . And the Word Was God: Art and Orthodoxy in Late Byzantium," in Byzantine Orthodoxies: Papers from the Thirty-Sixth Spring Symposium of Byzantine Studies, University of Durham, 23–25 March 2002, ed. A. Louth and A. Casiday (Aldershot, 2006), 111–20, at 116–20.

354 Kessler, "The Meeting of Peter and Paul," 269, n. 19, and 274.

355 The text assigned to St. Nicholas in the Painter's Manual reads: Ὁ τὰς κοινὰς ταύτας καὶ συμφώνους . . . (These common and harmonious . . .); see Papadopoulos-Kerameus, Ἑρμηνεία τῆς ζωγραφικῆς, 154, and Hetherington, "Painter's Manual," 54. This text differs from the one in Kato Karkasa as far as the fragmented state of preservation allows for a comparison. Moreover, it refers to St. Nicholas holding an unfurled scroll as co-officiating bishop; cf. Bábic and Walter, "The Inscriptions upon Liturgical Rolls," 271.

356 Acheimastou-Potamianou, "Ὁ νάρθηκας," pl. 112a–b.

357 The depiction is unusually placed on the eastern wall to the right of the apse. On the church, see Borboudakes, "Παναγία Καρδιώτισσα Βόρων," where the depiction is, however, not mentioned.

358 See M. Vassilaki, "Μεταβυζαντινή εικόνα του αγίου Νικολάου," in Ἀντίφωνον: Ἀφιέρωμα στον καθηγητή Ν. Β. Δρανδάκη (Thessaloniki, 1994), 229–45, at 243, figs. 1–2, 4.

Fig. 41.
Church of the Holy
Apostles, Kato
Karkasa, St. Nicholas.
Photo by authors.

followed by military saints and female martyrs. There are several examples of the enthroned Virgin that act as a proskynesis icon on Crete, but only a few show the Virgin flanked by angels.[359] Such a composition can also be found in the apse of Christ the Savior in Chantras (beginning of the fifteenth century)[360] and in numerous icons from the fifteenth century onward.[361] One of the military saints could be identified as St. George,

359 For this subject as a prostration icon in Cretan churches, see Mailis, *Obscured by Walls*, 88–99, figs. 140, 152, 154; for iconographic parallels of the composition, see Tsamakda, *Kakodiki*, 68–69.

360 Fousteres, "Παντέλι Χαντρά Σητείας," fig. 4.

361 See, for example, the central panel of the aforementioned icon in the Benaki Museum, p. 292.

while the bearded one next to him could be Theodore Teron or Theodore Stratelates.[362]

Of the prophets on the transverse arches gazing at the Christological scenes and holding open scrolls, only David can be identified, depicted next to the Anastasis. He is holding a scroll with text that can be reconstructed as Psalms 131:8: [ΑΝΑCΤΗΘ]Ι Κ[ΥΡΙ]Ε ΕΙC ΤΗΝ ΑΝΑΠΑΥCΙΝ COΥ [CΥ ΚΑΙ Η ΚΙΒΩΤΟC ΤΟΥ ΑΓΙΑCΜΑΤΟC COΥ] (Ἀνάστηθι, Κύριε, εἰς τὴν ἀνάπαυσίν σου, σὺ καὶ ἡ κιβωτὸς τοῦ ἁγιάσματός σου) (Arise, Lord, and come to your resting place, you and the ark of your might).[363]

In sum: From an iconographic point of view, the frescoes of Gaitanas in Kato Karkasa are highly interesting and innovative, as they include rare compositions and unique representations. Despite some differences, the wall paintings in Kato Karkasa are closely related to a group of church programs from the first half of the fifteenth century and especially those of St. George in Emparos, painted by Manuel Phokas. For several of the compositions (e.g., the Denial of Peter, Christ Appearing to the Two Marys [Chairete], and the Pentecost), Emparos offers the closest iconographic parallels. This suggests at least the use of common iconographic sources. Nevertheless, one is tempted to assume a direct relationship between the two painters and their workshops. There are various explanations for this connection. Thirteen years separate the paintings of Gaitanas in Kato Karkasa from the earliest known work of Manuel Phokas,[364] so an apprenticeship of Manuel Phokas with Gaitanas cannot be excluded.[365] In a document from 9 June 1505, there is mention of a certain Maria Gaitana, whose daughter was married

to the painter Michael Phokas.[366] Another possibility would be a common origin or learning background or a collaboration[367] for which, however, we do not possess any kind of proof.

There are also iconographic affinities and parallels with other wall-painting programs of the fifteenth century in eastern Crete, like in Chantras, Kapetaniana, and Lithines, whose wall paintings were partially painted by the same workshop.[368] Nevertheless, this closeness is eclectic. Our church shares only certain iconographic types with these churches, but these types are not shared by all these monuments. Rather, these apparent iconographic similarities indicate that the same drawings were in circulation among painters who were based in Chandax.[369] Moreover, Kato Karkasa can be now added to the list of monuments that played an essential role in the formation of the Cretan School.[370] Many of the iconographic themes of the Cretan icons depend on compositions that already existed in Cretan

362 On the iconography of these saints, see above, p. 272.

363 Cf. A.-M. Gravgaard, *Inscriptions of Old Testament Prophecies in Byzantine Churches: A Catalogue* (Copenhagen, 1979), 33. The *Hermeneia* connects this text held by David to the Koimesis scene that is not depicted here; see Papadopoulos-Kerameus, Ἑρμηνεία τῆς ζωγραφικῆς, 82.

364 On the work of this workshop, see Gouma-Peterson, "Manuel and John Phokas." The earliest known work of Manuel Phokas is St. George in Emparos (1436/37), followed by Saints Constantine and Helen in Avdou (1445), where he collaborated with Ioannes Phokas; St. George in Ano Symi was painted soon after 1453 by Manuel Phokas.

365 As we have seen, some documents provide us with information on the duration of apprenticeships; see Cattapan, "Nuovi elenchi," 217. According to these contracts, the apprenticeship lasted between one to ten years, but it is not always stated if the pupils were taught icon painting only or the art of fresco painting as well.

366 Konstantoudake, "Οἱ ζωγράφοι τοῦ Χάνδακος," 317. Some of the painters based in Candia were related to others through intermarriages. Nikolaos Ritzos, who married the daughter of the painter Ioannes Sakellares, is one such case; see M. Cattapan, "I pittori Andrea e Nicola Rizo da Candia," Θησαυρίσματα 10 (1973): 238–82, at 263, no. 22.

367 The written sources inform us about the collaboration between painters in Candia, like, for example, the painters associated with Andreas Ritzos; see Cattapan, "I pittori Andrea e Nicola Rizo," 248, 251, 258 no. 8, 261 no. 16, 262 no. 21, and M. Chatzidakes and E. Drakopoulou, Ἕλληνες ζωγράφοι μετὰ τὴν Ἅλωση (1450–1830) (Athens, 1997), 324. See also above, pp. 262–63.

368 All these monuments are linked to each other not only through their iconography but also because of their painting programs that enrich the Christological cycle with Passion scenes, post-Resurrection events, and Miracles. On this group, see Maderakes, "Βυζαντινή ζωγραφική."

369 We are informed through the written sources that painters sold their working drawings to other painters; for examples of this practice, see Cattapan, "I pittori Andrea e Nicola Rizo," 251 and 262, no. 19, referring to 54 drawings (sqinasmata) that Ioannes Acotantos received from Andreas Ritzos in 1477 as a deposit for a loan.

370 On the relationship between certain Cretan monuments, the art of Constantinople, and the art of Cretan icon painters who later worked off the island, see A. Xyngopoulos, Σχεδίασμα ἱστορίας τῆς θρησκευτικῆς ζωγραφικῆς μετά τήν Ἅλωσιν (Athens, 1957); M. Chatzidakis, "Les débuts de l'école crétoise et la question de l'école dite italo-greque," in Μνημόσυνον Σοφίας Ἀντωνιάδη (Venice, 1974), 169–211; Borboudakes, "Ἡ τέχνη κατὰ τὴ Βενετοκρατία," esp. 257–62; Borboudakes, "Παρατηρήσεις," esp. 382–92; Maderakes, "Βυζαντινή ζωγραφική"; and Bissinger, *Kreta*, 215–21.

wall paintings of the first half of the fifteenth century.[371] Analysis of their interrelations expands the Cretan School to include the work of Gaitanas, who is one of the most important precursors of the members of the School, as stylistic analysis will also show.

Style

In terms of its stylistic qualities, the Church of the Holy Apostles in Kato Karkasa is a monument of considerable importance among Cretan churches of the Palaeologan period.[372] Many of these paintings have lost their upper painting layer, revealing thus the drawing underneath (Figs. 33–35). As is visible mostly in the vault of the sanctuary, the painter incised the wall surface and only made an imprecise sketch, mainly consisting of red outlines. But even these drawings reveal the outstanding quality of Gaitanas's art that exhibits the typical features of the so-called academic style: the scenes are characterized by pictorial symmetry and balanced compositions. The serene and restrained movements of the figures, as well as their calm faces, contribute to the same classicizing effect. This elegance and grace are apparent even in the drawing of the angels of the Ascension (Figs. 33–34). Statue-like figures, like Christ in the Healing scene, ultimately follow ancient models. Only a few scenes, such as the Deposition from the Cross, are more expressive, because they follow an older iconographic type. The paintings are characterized by clarity and precision of forms. Plasticity was reached with the aid of tone gradations, shadows, and highlights in the treatment of garments, which sometimes acquire a metallic look. The faces, which exhibit a facial type not encountered in other monuments, were softly modeled and accentuated with green and red shadows and fine white lines. The well-proportioned figures freely move in a clearly defined space, in which several successive planes can be distinguished. The three-dimensional architectural settings with their typical Palaeologan monochrome rendering contrast with the vivid colors of the figures and emphasize the people in front of them. The landscapes function similarly, responding to the movements of the figures in the foreground. A background defined by two triangular mountains on the sides with their slopes reflecting the light, such as in the Anastasis scene, is typical for the group of academic fresco decorations of this period.[373]

We have repeatedly observed an especially pronounced iconographic affinity with a group of monuments dating from the first half of the fifteenth century. The plastic qualities of Gaitanas's paintings, in combination with the clarity of his compositions and the technique applied, particularly resemble the works of Kapetaniana, Sklaverochori, the Phokas workshop, and related works. However, Gaitanas employs somewhat smoother forms. In his work, he combines the vividness of the group discussed by Maderakes, dating between ca. 1400 and 1430, and the works of later decades that are more influenced by icon painting.

The painters of all these churches are regarded as precursors to the Cretan School. They share the same classicizing stylistic idiom, employed, however, by different artists and resulting in different aesthetic impressions and degrees of classicism. Some of these artists supposedly came from the capital and mirror the lost art of Constantinople.[374] Mavrianos and especially Gaitanas must now be added to this group of high-quality painters. They both broaden our knowledge of the art of the fifteenth century substantially, especially the decisive first half of that century, as they help us better understand later artistic developments. The interrelationships of the Cretan church-decoration programs of this group, its inner evolution,[375] their artistic links to the art of Constantinople and other major Byzantine centers, as

371 For a comparison of the iconography between church decorations of this period and icon painting, see Maderakes, "Βυζαντινή ζωγραφική," 280–86.

372 Cf. Borboudakes, "Η τέχνη κατὰ τὴ Βενετοκρατία," 246, who underlines the frescoes' excellent quality, which he assigns to Constantinopolitan influence; see also Maderakes, "Βυζαντινή ζωγραφική," 279, n. 35.

373 On this, see Maderakes, "Βυζαντινή ζωγραφική," 297–300.

374 As mentioned earlier, this is the common explanatory framework for the high-quality paintings appearing at this time (see above, p. 247).

375 It is indicative that a key monument of the group, the church in Sklaverochori, was set by Borboudakes at the beginning of the group, dating it to the end of the fourteenth century, while Bissinger regards it as the ending point of this development and dates it to the 1460s; see Borboudakes, "Η τέχνη κατὰ τὴ Βενετοκρατία," 242–46, and Bissinger, *Kreta*, 220, 240–41, no. 222. Maderakes, "Βυζαντινή ζωγραφική," 276–77, dates it to the first quarter of the fifteenth century. The dating difficulties and the inability to determine the stylistic development of the group led Maderakes to date the murals of Kato Karkasa to the beginning of the fifteenth century; see Maderakes, "Βυζαντινή ζωγραφική," 277, n. 32. Borboudakes, "Η τέχνη κατὰ τὴ Βενετοκρατία," 242, dates it to around 1400, while Andrianakes and Giapitsoglou, *Χριστιανικὰ μνημεία*, 234, place the monument in the fifteenth century generally.

well as their relationship to icon painting and the Cretan School, need to be investigated more systematically.[376]

Conclusions

In scholarship on Byzantine mural painting in general, as well as on Byzantine mural painting on Crete under Venetian rule specifically, there exist different views and speculations about the interaction between patrons, donors, and painters, their role in each particular commission, and the content of their agreements. For example, peculiarities in the pictorial programs and anything that does not conform to the norm or deviations from established iconography are interpreted as the preferences or personal wishes of the donors. In terms of style and especially with regard to Crete at the beginning of the fifteenth century, church decorations of high quality are automatically attributed to artists from Constantinople. Such assumptions have been made so far due to the lack of contracts or other documents that could be linked to existing church programs. Information about the artistic work of certain painters on Crete in this period has been one-sided, either based only on some pertinent written sources or on existing frescoes, about which, however, no written information existed, except in rare cases when donor inscriptions provide some information about the painters.

Our contribution has partially remedied this situation, since it makes possible for the first time a connection and comparison of archival material and wall paintings that still exist today. The evaluation of the already published contracts from the Venetian period on Crete allowed us to gather important information about the identity of the people who made commissions and the painters, as well as to identify certain patterns in their relationship, communication, and the process of the artists' employment. This rich information provides insight into the remuneration of the painters, the amount of time needed to complete their work, the obligations of both parties signing the

contracts, and several other specific clauses and details of the agreements.

Our introductory analysis provides the framework for the evaluation of the documents we presented. Considered together, they show that some of the assertions and assumptions mentioned above are unfounded or need to be revised. In this context, it is particularly important to note that none of the painters working on Crete and mentioned in the contracts originated from Constantinople. This conclusion is consistent with what is stated in the founders' inscriptions of the Cretan churches. Thus, the claim that Constantinopolitan painters were responsible for the high-quality church decorations in fifteenth-century Crete is unfounded.

Through the contracts published here, the names of two of these painters can be linked to specific church decorations: Georgios Mavrianos created the paintings at St. George in Vrachasi around 1400 and the Panagia in Kato Symi in 1419, while Konstantinos Gaitanas painted the Church of the Holy Apostles in Kato Karkasa in 1423. Both painters were residents of Chandax and were renowned artists who received commissions outside the capital.

With the exception of the church in Vrachasi, the other fresco programs were virtually unknown to scholars despite their outstanding quality. Their presentation in this paper substantially contributes to greater knowledge of fifteenth-century art. Furthermore, a thorough discussion of their iconography and style was necessary, not only in order to classify and evaluate the quality of Mavrianos's and Gaitanas's work, but also to compare it with the content of the relevant archival material. By examining the paintings of these two artists in detail, we are now able to present a clearer view of the art-creation process based on the combination of both sources, archival evidence—that is, the contracts between painters and their clients—and the corresponding wall paintings that still exist.

The available space in each church obviously played an important role, which requires an exact view of the wall paintings in relation to the buildings' size and architecture. This is indicated by the specification found in the contract regarding Kato Symi that Mavrianos should paint the specific subjects in small format (*in opera minuta*) so that all paintings fit in the available space. Even if this expression remains unique, it demonstrates, like the clause to paint the Last Judgment in the *schutari* in Kato Karkasa, that

376 Maderakes, "Βυζαντινή ζωγραφική," 265–70, delineates the methodological problems related to preceding studies of the beginnings and roots of the Cretan School, which was based primarily on icons and archival material but did not sufficiently consider the Cretan wall paintings, many of which are dated. He rightly questions the common assumption that the high quality of works, such as those in Kato Karkasa, can only be explained by the arrival of Constantinopolitan painters to Crete.

the dimensions of each church and the architecture in general played a great role in the creation of the iconographic program and the placement of its scenes.

Regarding the placement of these wall paintings in the context of fifteenth-century Byzantine art on Crete and Palaeologan art in general, analysis of the pictorial programs has shown that they in general conform to the basic principles of Byzantine church programs. It should also be highlighted that all three iconographic programs presented here are doubtless Orthodox. Their content shows profound theological knowledge and, at the same time, nothing in these programs implies pro-Union intention.

The contracts normally do not mention the content of the iconographic programs. When they do, they do not name the subjects to be painted in all available spaces in the churches but only list the most important ones. In this respect, the document concerning Kato Karkasa is particularly important for listing several subjects that Gaitanas had to paint. Its comparison with the surviving wall paintings has surprising results. Gaitanas obviously did not fully implement the agreement, since he ignored Neophytos's demand to include scenes from the Life of the Virgin. Furthermore, Neophytos dictated several subjects to be painted, but he also allowed Gaitanas to paint the remaining surfaces as he wished. Even if the contract stated that Gaitanas could freely choose among the "known" subjects, the church program contains some rare scenes, among them the cycles of the patron saints. We cannot confirm whether Gaitanas was an exception, but these observations shed a completely different light on the role of the painters, who apparently had much more freedom than previously thought.

The painters' artistic freedom also evidently extended to the iconographic and stylistic features of the paintings, for which, as a rule, no provisions are stated in the contracts. Art-historical analysis of the wall paintings enables us to establish that both painters were well-informed of contemporary trends in Palaeologan art using established iconographic patterns while at the same time offering rare or unique motifs. In Kato Karkasa, Gaitanas employs innovative and highly interesting compositions. The cycles of Peter and Paul, which are very rare in Byzantine (monumental) art and especially in the Palaeologan period, deserve special mention. Mavrianos's iconography displays pronounced affinities with a group of wall paintings in the churches in Kapetaniana, Sklaverochori, Voroi, and Malles, all dedicated to the Virgin and dating to the first half of the fifteenth century. Their iconography finds correspondences above all in Macedonia and Mistras. Gaitanas's wall paintings find very close iconographic parallels in churches painted by Manuel Phokas, especially St. George in Emparos. It is possible that Manuel Phokas was Gaitanas's disciple. Another important conclusion is that Gaitanas must be counted among the most important precursors of the Cretan School. His academic style exhibits a conspicuous influence from icon painting. The skill of these painters is not due to their Constantinopolitan origin; on the contrary, everything indicates that both Mavrianos and Gaitanas were from Crete.

The detection of different hands at work on the wall paintings and the fact that the wall paintings in Vrachasi and Kato Symi are stylistically not homogeneous confirm the assumption based on the documents that painters did not work alone but led organized workshops including apprentices and assistants, as well as cooperated with other painters.

The combined interdisciplinary view of archival material and art enables the understanding of the creation of art in a particular environment and time and allows these processes to be reconstructed, at least to a certain extent. Especially in the case of Mavrianos, by whom two fresco decorations survive, detailed art-historical analysis grants insight into the structure, modus operandi, and development of his workshop over time that would not be possible only on the basis of the relevant documents. This is more generally applicable to fifteenth-century Crete under Venetian dominion. The discovery of analogous documents linked to surviving wall paintings will further demonstrate if such processes are also representative of other periods and regions.

Appendix

Note: All names of witnesses appearing at the end of the notarial acts are rendered in the way they appear in the documents and therefore in italics, since it is impossible at this stage of work to make speculations about the witnesses' origin.

DOC. 1

11 FEBRUARY 1390

CHANDAX

Contract of apprenticeship between the painter Georgios Mavrianos and Nikolaos Charchiopoulos.

Previously published by Cattapan (Cattapan, "Nuovi elenchi," 218, doc. 11).

A.S.V., *Notai di Candia*, b. 24 [Giovanni Catacalo], fol. 80r

Eodem die [XI Februarii 1389]. *Manifestum facio ego Nicolaus Charchiopulo, habitator casalis Megachorio de Ca' Cornario, cum meis heredibus, tibi, Georgio Mauriano, pinctori, habitatori Candide et tuis heredibus, quia afirmo tecum Michali, filium meum in filium tuum adoptivum, qui esse et stare debeat tecum in domo tua et tibi servire iuxta suum posse et scire ad omnia spectantia ad artem tuam predictam hinc ad annos decem proxime venturos. Tu vero teneris dicto termino ipsum pascere, vestire, calceare et hospitium sibi dare ipsumque bona fide docere dictam tuam artem. Si igitur etc. Pena yperperorum X, contractu firmo.*

Testes suprascripti. Complere et dare.

On the same day [11 February 1389]. I, Nikolaos Charchiopoulos, resident of the village of Megalo Chorio, of the house of Corner, with my successors, make public to you, Georgios Mavrianos, painter, resident of Chandax, and to your successors, that I entrust you my son, Michael, as your adoptive son. He has to be and stay in your house and assist you in all aspects related to your aforementioned art, according to his capability and knowledge, from this point on for the next ten years. Until then, however, you are obligated to feed him, dress him, give him shoes, and host him, and faithfully teach him your aforementioned art. Therefore, etc. I sign the agreement under penalty of ten hyperpera.

The aforementioned witnesses. Completed and released.

DOC. 2

2 AUGUST 1401

CHANDAX

Georgios Mavrianos acknowledges the receipt of twenty-three hyperpera paid to him by Emanuele Venier by decision of a juridical process. This sum constitutes the debt redemption of a total of 120 hyperpera for Mavrianos's labor in the Church of St. George in Vrachasi.

Previously mentioned by Cattapan, without archival reference (Cattapan, "Nuovi elenchi," 226 and 232).

A.S.V., *Notai di Candia*, b. 25 [Giorgio Chandachiti], quad. 1, fol. 64v

Die secundo [mensis Augusti 1401]. *Plenam et irrevocabilem securitatem facio ego, Georgius Mauriano, pictor, habitator Candide, cum meis heredibus, tibi, ser Hemanueli Venerio quondam ser Marci, habitatori Candide, et heredibus tuis, de solutione integra unius sententie late per advocatores, quam obtinui contra te de yperpera XXIII, resto yperperorum centum et XX que mihi dare promisisti pro laborerio quod feci tibi in ecclesia tua vocata Sanctus Georgius de Vraghassi. Nunc autem quia de dictis yperperis XXIII que sunt complere dicte sententie ac in expensis eius tenes mihi integraliter dare et persolvere. A modo, si igitur etc. Pena yperperorum viginti quinque, contractu firmo.*

2 [August 1401]. I, Georgios Mavrianos, painter, resident of Chandax, with my successors, fully and irrevocably assure you, Sir Emanuele Venier, son of the late Sir Marco, resident of Chandax, and to your successors, of the full payment according to a verdict issued by the counselors. I have reached this verdict regarding an amount of twenty-three hyperpera against you as the remainder of a sum of 120 hyperpera, which you promised to give me for my labor in the church of yours called St. George in Vrachasi. But now, the payment of the aforementioned twenty-three hyperpera fulfills the aforementioned verdict and provides and pays for its costs to me in full. Henceforth and therefore, etc. I sign the agreement under penalty of twenty-five hyperpera.

DOC. 3

19 MAY 1419

CHANDAX

Contract of wall-painting employment for the Church of Panagia in Kato Symi between the painter Georgios Mavrianos and the Venetian noble Nicola Corner.

Previously published by Cattapan with wrong date "1420, 21 maggio" (Cattapan, "Nuovi elenchi," 228–29, doc. 29).

A.S.V., *Notai di Candia*, b. 26 [Gasparino Cauco], fol. 94v

Eodem die [XVIIII mensis Maii 1419]. *Manifestum facio ego Georgius Mauriano, pictor, habitator Candide, cum meis heredibus, tibi, nobili viro ser Nicolao Cornario quondam domini Andree, et tuis heredibus, habitatori ibidem, quia promitto tibi et obligo me tibi depingere quandam ecclesiam intitulatam Sanctam Dei Genitricem, positam in Casali tuo Simes, cum coloribus meis, faciendo omnes figuras istoriarum Jesu Christi et Beate Marie Virginis in opera minuta, sicut dicta ecclesia continere poterit in locis ubi erit expediens et melius. Et pro solutione et labore meo teneris michi dare et deliberare yperpera septuagina, de quibus confiteor a te habuisse et recepisse yperpera XX et de eis securum te reddo, et alia yperpera XX teneris michi dare quum de hinc recedere in die XV, mensis Junii proxime venturi et deinde recedere non possim neque valeam donec complevero dictas operas sive picturas, faciendo michi expensas oris donec ibi stetero. Si igitur etc. Pena yperperorum XXV, contractu firmo.*

Testes. Petrus de Torcello, Georgius Gixi et Christoforus Paulo. Complere et dare.

On the same day [19 May 1419]. I, Georgios Mavrianos, painter, resident of Chandax, with my successors, make public to you, the nobleman Sir Nicola Corner, son of the late Sir Andrea, resident of the same place, and to your successors, that I promise and pledge myself to paint a certain church called Holy Mother of God, situated in the village of yours called Simes, using my own colors, and painting all figures from the stories of Jesus Christ and the Blessed Virgin Mary in small format so that they fit in the aforementioned church's spaces, wherever it is expedient and preferred. And as remuneration for my work, you are obligated to give me and pay me seventy hyperpera, from which I admit to have had and received twenty hyperpera from you, and for these I give you proof. You are obligated to give me twenty more hyperpera upon my departure from here, on the 15th of next June (and neither can I nor will I leave from there until I have finished my aforementioned work, namely, the paintings), covering my expenses for food as long as I am there. Therefore, etc. I sign the agreement under penalty of twenty-five hyperpera.

Witnesses: *Petrus de Torcello, Georgius Gixi,* and *Christoforus Paulo.* Completed and released.

DOC. 4

28 APRIL 1422

CHANDAX

Contract of wall-painting employment for the Church of Christ the Savior in Kitharida between the painter Georgios Mavrianos and the commissaries of Anna Correr.

Previously published by Cattapan with several errors (Cattapan, "Nuovi elenchi," 230–31, doc. 32).

A.S.V., *Notai di Candia*, b. 145 [Costanzo Maurica], quad. 6, fol. 71v [617v]

Eodem die [XXVIII mensis Aprilis 1422]. *Manifestum facio ego Georgius Mauriano, pictor, habitator Candide, cum meis heredibus, vobis omnibus commissariis domine Anne Corrario et vestris successoribus, quia promitto vobis et sum contentus, omnibus meis expensis, pingere totam ecclesiam intitulatam Sanctus Salvator, que est in medium aliarum ecclesiarum positarum in casali vocato Chitharida, faciendo figuras Solemnis Salvatoris et quasdam alias ymagines sanctorum prout nos sumus concordes. Quod quidem totum opus debeam habere completum amodo in antea usque per totum mensem septembris proxime venturum vel antea. Vos autem mihi dare et solvere promisistis yperpera cretensia centum et non aliquid aliud, que quidem sunt illa que dicta quondam domina Anna dimisit per suum testamentum pro pictura dicte ecclesie. De quibus habui a vobis yperpera LX, reliqua vero yperpera XL quando complevero dictum opus. Si igitur etc. Pena yperperorum L, contractu firmo.*

Testes. Franciscus et Iohannes Fradelo. Co. Fo. Iohannes et C. Ashuano. Complere et dare.

On the same day [28 April 1422]. I, Georgios Mavrianos, painter, resident of Chandax, with my successors, make public to all of you, commissioners of the lady Anna Correr, and to your successors, that I promise you and I am pleased to paint at my expense the entire church called Holy Savior, which is situated in the middle of the other churches located in the village called Kitharida, by executing pictures of the Holy Savior and some other images of saints as we have agreed. Indeed, I should finish all this work starting from now until the end of the month of next September or even earlier. Therefore, you have promised to give me and pay me a hundred Cretan hyperpera and nothing else, since this is the amount left by the aforementioned lady Anna through her testament for the painting of the aforementioned church. From this [amount], I have already received from you sixty hyperpera, and I will receive the remaining forty hyperpera when I finish the aforementioned work. Therefore, etc. I sign the agreement under penalty of fifty hyperpera.

Witnesses: *Franciscus* and *Ioannes Fradelo. Co. Fo. Ioannes* and *C. Ashuano.* Completed and released.

DOC. 5

13 OCTOBER 1422

CHANDAX

Contract of wall-painting employment for the Church of the Holy Apostles in Kato Karkasa between the painter Konstantinos Gaitanas and the hieromonk Neophytos Paschales.

A.S.V., *Notai di Candia*, b. 23 [Giovanni Longo], fol. 104v [249v]

Eodem die [XIII mensis Octubris 1422]. *Manifestum facio ego Costas Gatana, pinctor, habitator burgi Candide, ac premitto cum meis heredibus, tibi, papati Neofito Paschali, yeromonacho, habitatori monasterii Sanctorum Apostolorum de Cato Carcasia, et tuis successoribus, depingere totam ecclesiam predicti monasterii Sanctorum Apostolorum, videlicet ut quantum spectat ad muros, omnibus expensis, coloribus ac prestamentis meis, excepta tamen calcem, quamquidem tu ponere debeas. Ita quod in dicta ecclesia specialiter infrascriptas pincturas, videlicet omnes ystorias Novi Testamenti, que grece dicuntur Despotiches Eortes, ac omnes ystorias Dei Genetricis et omnium Sanctorum Apostolorum, necnon etiam ystoriam Iudicii, que grece dicitur Deftera Parusia, quam quidem ystoriam depingere debeam in loco dicte ecclesie ubi vocatur Schutari. In reliquo vero spacio dicte ecclesie si quid fuerit pingere debeam omnes illas ystorias seu pincturas honestas atque denotas, que mihi videbuntur. Quod quidem opus Deo favente incipere debeam a quinto decimo die, mensis Aprilis proxime venturis mihi illoque taliter continuare qui nunquam absque tua licentia illud dimitteri debeam donec ipsum percomplevero. Tu vero toto tempore quo in dicto operi laboravero, tenens mihi faceri expenses victus competentur iuxta mandatum conditionem mihi quem dari pro mea solutione sive premio dicti mei laboris, yperpera Cretensia centum octuaginta quinque hoc modo, videlicet yperpera vigintiquinque per totum mensem Novembrem proxime venturis, et restum eorum in perficione dicti operis, si ipsum estate proxime venturis perficero. Verum si illud in dicta estate non perficiam, tunc tenueris mihi dare medietatem resti dictorum denariorum, et reliquam medietatem statim cum dictum opus preficero, hac in super declaratione apposita, que quotienscumque pro predicto operi dicte ecclesie mihi opus fuerit illuc venire atque me huc reddire cum quibusvis rebus meis opportunis, semper venire atque redire debeam, omnibus tuis expensis.*

Ego vero suprascriptus papas versa vice sum contentus de predictis omnibus et singulis predictorum. Et premitto effectualiter attendere et observare omnia et singular suprascripta modo et forma predictis. Si quis igitur etc. Pro pena yperpera XXV, contractu firmo manente.

Testes. suprascripti. Complere et dare.

On the same day [13 October 1422]. I, Konstantinos Gaitanas, painter, resident of the suburbs of Chandax, with my successors, make public and I promise to you, Neophytos Paschales, priest and hieromonk, resident of the monastery of the Holy Apostles in Kato Karkasa, and to your successors, to paint the entire church of the aforementioned monastery of the Holy Apostles, namely as much as fits on the walls, all at my expense, with my colors and supplies, except for the limestone, which, indeed, you are obligated to provide. Therefore, I am obligated to specifically execute the following subjects, viz., all the stories from the New Testament that in Greek are called "Despotikes Eortes," all the stories of the Holy Mother of God, and all the Holy Apostles, as well as the subject of the Last Judgment, which in Greek is called "Deftera Parousia" and which I have to paint in that place of the aforementioned church called "Schutari." In the remaining part of the aforementioned church, if there is any at all, I am obligated to paint all those respected and well-known subjects of my choice. Therefore, God willing, I should start my work on the 15th of next April and continue with it in such a way that I will never quit it without your permission until I have completed it. During the whole time that I am doing the aforementioned work, you are obligated to cover the expenses for my food according to my needs and to give me as my payment, namely, as remuneration for my aforementioned works, 185 Cretan hyperpera in this way: namely, twenty-five hyperpera until the end of the coming month of November and the rest at the completion of the aforementioned work, if I have finished it by next summer. But if I have not finished it in said summer, you will have to give me half of the rest of said money and the other half as soon as I have finished said work. By this way, in accordance with the statement above, with regard to my aforementioned work at said church, whenever it is necessary for me to come thither and to return hither with all my necessary things, I must always come and return all at your expense.

In turn, I, the aforementioned priest, am satisfied with each and every one of the aforementioned things. And I promise to effectively attend to and respect all the aforementioned particulars in the aforesaid manner and form. If anyone then, etc. I sign the permanent agreement under penalty of twenty-five hyperpera.

The abovementioned witnesses. Completed and released.

Eleftherios Despotakis
National Hellenic Research Foundation
Institute of Historical Research
Section of Byzantine Research
48 Vassileos Constantinou Ave.
11635 Athens
Greece
edespot@eie.gr

Vasiliki Tsamakda
Johannes Gutenberg-Universität Mainz
Institut für Kunstgeschichte und
 Musikwissenschaft
Abteilung Christliche Archäologie und
 Byzantinische Kunstgeschichte
Georg Forster-Gebäude (Campus), 1. OG
Jakob-Welder-Weg 12
55128 Mainz
Germany
tsamakda@uni-mainz.de

❧ WE WOULD LIKE TO THANK THE EPHORATES of Antiquities of Heraklion (Vasiliki Sythiakaki and Eleni Kanaki), Lassithi (Chryssa Sofianou and Georgia Moschovi), and Chania (Eleni Papadopoulou and Athanasios Mailis) as well as the Holy Metropolis of Hierapetra and Siteia (His Eminence Metropolitan Kyrillos) for their support regarding visits of the monuments presented in this paper. We are also indebted to Vasileios Marinis for his helpful corrections and remarks and to the editorial team for their excellent support.

A Unique Image of the Holy Patriarch Germanos I on a Lead Seal

JOHN COTSONIS*

In memory of John W. Nesbitt

Dumbarton Oaks acquired a new Byzantine lead seal for its collection recently, from the Leu Numismatik Web Auction 16, lot 4127 (Fig. 1).[1] This seal, previously unpublished, is a particularly fine example of carving—of both sphragistic image and inscription. Its imagery is also exceptional; it bears the figure of a church hierarch, identified by inscription as Saint Germanos. The figure is beardless, a quite unusual feature for a Byzantine bishop (an iconographic detail which narrows the identification of the figure considerably), and this image of Saint Germanos is unique for Byzantine seals. Its owner is identified by the inscription on the reverse as a certain Germanos, monk and abbot of a monastery dedicated to Saint Phokas. The entry of this seal at the Leu Numismatik auction house identifies the figure as the saint Germanos who was the sixth-century bishop of Capua, and states that the monastic house of its owner was located in Trebizond. From the arguments set forth in this paper, however, it is determined that the image is that of another—the eighth-century patriarch of Constantinople, Germanos I—and that the owner of this seal belonged to the Constantinopolitan monastery of Saint Phokas.

On the obverse of the seal there is a bust-length image of a haloed bishop, wearing on his shoulders the episcopal *omophorion* decorated with crosses, blessing with his right hand, and holding the Gospel book in his left. As said, the figure is beardless, which is most uncommon for a bishop, but of which there are a few known examples.[2] Immediately flanking the holy hierarch is the vertical identifying inscription: Ⓐ|Γ|Є|Р‐ М|А|N, Ὁ Ἅ(γιος) Γερμαν(ός) (Saint Germanos), where Ⓐ is a common ligature for *agios* (saint or holy). In the upper half of the obverse is a circular invocative inscription preceded by a cross: +ΚЄРΟΗΘЄΙΤΩϹΩΔΟΥΛ, +Κ(ύρι)ε Βοήθει τῷ σῷ δούλ(ῳ) (Lord, help your servant). On the reverse, the inscription in five lines reads: +ΓЄР МА|NΩΜΟΝΑΧΩ|Κ΄ΗΓΟΥΜЄΝΟ|ΜΟΝΗϹΤΥΑ| ΓΙΥΦΩΚ΄: +Γερμανῷ μοναχῷ κ(αὶ) ἡγουμένῳ μονῆς τοῦ Ἁγίου Φωκ(ά) (Germanos, monk and *hegoumenos* of the monastery of Saint Phokas). The full inscription in translation, therefore, is: "Lord, help your servant Germanos, monk and hegoumenos of the monastery of Saint Phokas." Both the obverse and reverse bear a circular dot border. There are traces of faint surface cracks along the line of the channel on the obverse. The seal has a diameter of 2.6 cm.

The seal is datable to the tenth to eleventh century based on several details of its composition and its overall general aesthetic: the form of the letter *B* in the circular invocative inscription on the obverse, with its

* Bishop Joachim of Amissos

1 For a photograph and description of the seal provided by the auction house, see https://leunumismatik.com/en/lot/26/4127. The new accession number for this specimen in the Dumbarton Oaks collection is BZS.2020.010.

2 See note 13, below.

 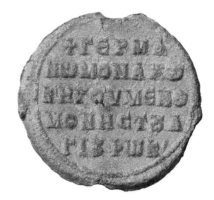

Fig. 1. Lead seal of Germanos, monk and *hegoumenos* of the monastery of Saint Phokas, tenth to eleventh century, obv.: bust of Saint Germanos, Dumbarton Oaks BZS.2020.010 (d. 26 mm). Photo courtesy of Dumbarton Oaks, Byzantine Collection, Washington, DC.

open lower loop resembling the Latin letter *R*;[3] the form of the letter Δ with its base extended beyond the corners of the triangle;[4] the use of the ligature ȣ for the two letters of *O* and *U* in the fourth and fifth lines of the inscription on the reverse, which generally fell out of use after the first third of the eleventh century;[5] the circular invocative inscription in the field of the obverse, which is most commonly encountered on specimens dating from the tenth through the mid-eleventh centuries;[6] and the linear, calligraphic rendering of the figure, with little modeling, large, arched eyebrows, and oversized ears, recalling figures found on seals assigned to the tenth and early eleventh centuries.[7]

Among 12,666 seals bearing religious figural imagery from the major published collections, the image of the saintly hierarch Germanos—whom the

Leu Numismatik Web Auction asserts is on the seal— is not found. Germanos, the sixth-century bishop of Capua, which was part of the Ostrogothic kingdom, led the papal delegation to Constantinople in 519–520 to resolve the Akakian schism between the eastern and western churches.[8] Although his memory was revered and celebrated in the West, especially in the region of Cassino and Capua, [9] there does not appear to be any commemoration or cult dedicated to him in the Eastern Church. The name Germanos of Capua does not appear among the saintly figures named Germanos in the tenth-century *Synaxarion of Constantinople*,[10] and it is therefore most unlikely that the figure depicted on the newly acquired Dumbarton Oaks seal is that of the Latin bishop Germanos of Capua.

The *Synaxarion of Constantinople,* however, does list six saints that bear the name Germanos, of which only one was of episcopal rank: Germanos, the eighth-century patriarch of Constantinople.[11] It is known that Patriarch Germanos was also a eunuch, having been castrated in 669 at the order of the emperor Constantine IV Pogonatos, after Germanos's father was executed for participating in the conspiracy that

3 N. Oikonomides, *A Collection of Dated Byzantine Lead Seals* (Washington, DC, 1986), 159.

4 Oikonomides, *Dated Seals*, 160.

5 Oikonomides, *Dated Seals*, 162–63.

6 Oikonomides, *Dated Seals*, 153; and see G. Zacos, *Byzantine Lead Seals*, vol. 2, ed. J. Nesbitt (Bern, 1984), nos. 791–948, pls. 78–89.

7 For some examples, see Zacos, *Byzantine Lead Seals*, vol. 2, nos. 446, 818, 857, 860, 870, and 894; *DOSeals* 1, no. 10.1; *DOSeals* 2, nos. 8.31, 23.1, 64.1, and 72.3; *DOSeals* 3, nos. 37.1, 71.21, and 82.1; *DOSeals* 4, nos. 1.7, 11.9, 22.36, 24.4, and 62.1; *DOSeals* 5, nos. 6.19 and 42.34; *DOSeals* 7, nos. 9.9, 9.10, 13.1, 15.41, and 16.87; M. Campagnolo-Pothitou and J.-C. Cheynet, *Sceaux de la collection George Zacos au Musée d'art et d'histoire de Genève* (Milan, 2016), nos. 38 and 156; and A.-K. Wassiliou-Seibt and W. Seibt, *Der byzantinische Mensch in seinem Umfeld: Weitere Bleisiegel der Sammlung Zarnitz im Museum August Kestner* (Rahden, 2015), nos. 45 and 48.

8 https://leunumismatik.com/en/lot/26/4127. For a brief overview of the Akakian schism, see *ODB* 1:42–43.

9 For an overview of Germanos of Capua, see *DHGE* 20:905–6; and *Encyclopedia of Ancient Christianity*, ed. A. Di Berardino, trans. J. T. Papa et al., 3 vols. (Downers Grove, IL, 2014), 2:124–25.

10 *Synaxarium CP*, 1069.

11 *Synaxarium CP*, 1069.

led to the assassination of Constans II.[12] These hagiographic details correspond with the beardless image of the saintly hierarch on our seal, further reinforcing the identification of the sphragistic image with that of the eighth-century Constantinopolitan hierarch. Germanos is also consistently represented as beardless in the few surviving images of him from the Byzantine and post-Byzantine period.[13]

Germanos was patriarch for fifteen years (715–730). As an iconophile, he came into conflict with the iconoclastic policies of the emperor Leo III and was forced to resign the patriarchal throne in 730, when he was replaced by the iconoclast patriarch Anastasios. Germanos retired to Platanion, most likely in the Blachernai region of Constantinople, his family home, where he died on 12 May, possibly by 741. He was buried in the monastery of the Chora in Constantinople.[14]

12 For an account of this event in the life of the hierarch, see *Synaxarium CP*, 678; and L. Lamza, *Patriarch Germanos I. von Konstantinopel (715–730): Versuch einer endgültigen chronologischen Fixierung des Lebens und Wirkens des Patriarchen, mit dem griechisch–deutschen Text der* Vita Germani *am Schluß der Arbeit* (Würzburg, 1975), 63–64 and 202. The Greek text of the *Vita* (*BHG* 697), with an accompanying German translation, is found at 200–41, and Lamza's discussion concerning the eleventh-century date of the *Vita* is found at 11–15. See also O. F. A. Meinardus, "The Beardless Patriarch: St. Germanos," *Μακεδονικά* 13 (1973): 178–86; and *ODB* 2:846. More recently, C. Messis, *Les eunuques à Byzance, entre réalité et imaginaire* (Paris, 2014), 127–28, notes that there have been varying scholarly opinions concerning the date of the *Vita*, placing it between the eighth and eleventh centuries, or even later, as cited in ibid., n. 44.

13 Meinardus, "Beardless Patriarch." For the eleventh-century fresco depicting the beardless hierarch Germanos in the church of Saint Nicholas of the Roof on Cyprus, see P. Karlin-Hayter, "Iconoclasm," in *The Oxford History of Byzantium*, ed. C. Mango (New York, 2002), 155. For discussion and dating of these eleventh-century frescoes, see A. and J. Stylianou, "Ὁ Ναὸς τοῦ Ἁγίου Νικολάου τῆς Στέγης παρὰ τὴν Κακοπετριάν: Ἄγνωστον Μουσεῖον Βυζαντινῆς Τέχνης," *Κυπρ.Σπ.* 10 (1946): 95–196, esp. 116–17 for the image of Germanos; M. Soteriou, "Αἱ Ἀρχικαὶ Τοιχογραφίαι τοῦ Ναοῦ τοῦ Ἁγ. Νικολάου τῆς Στέγης Κύπρου," in *Χαριστήριον εἰς Ἀναστάσιον Κ. Ὀρλάνδον*, ed. M. Nikolaïde-Gavrile, vol. 3 (Athens, 1966), 133–41; and M. Sacopoulo, "A Saint-Nicolas-du-Toit: Deux effigies inédites de patriarches constantinopolitains," *CahArch* 17 (1967): 193–202, esp. 199 and fig. 7 for Germanos. For the image of the beardless Germanos appearing in the third row of the May calendar icon, ca. 1200, on Mount Sinai, see G. Soteriou and M. Sotiriou, *Εἰκόνες τῆς Μονῆς Σινᾶ*, 2 vols. (Athens, 1956 and 1958), 1: pls. 128 and 130, 2:117–19. See also Sacopoulo, "A Saint-Nicolas-du-Toit," 199. In her study of the Sinai calendar icons, N. P. Ševčenko, "Marking Holy Time: The Byzantine Calendar Icons," in *Byzantine Icons: Art, Technique and Technology*, ed. M. Vassilaki (Heraklion, 2002), 51–62, at 55–56 (repr. in eadem, *The Celebration of the Saints in Byzantine Art and Liturgy*, Variorum Collected Studies Series [Abingdon, UK, 2013], IV), discusses the Sinai May icon and the presence of the image of the beardless eunuch Patriarch Ignatios the Younger for the commemoration of the Third Finding of the Head of Saint John the Baptist at the celebration of 25 May, but does not mention the presence of the image of the beardless hierarch Germanos in the same icon. For a depiction of the eunuch, beardless, sainted Ignatios the Younger, patriarch of Constantinople (847–858, 867–877), see C. Mango, *Materials for the Study of the Mosaics of St. Sophia at Istanbul* (Washington, DC, 1962), 52, fig. 62; and C. Mango and E. J. W. Hawkins, "The Mosaics of St. Sophia at Istanbul: The Church

Fathers in the North Tympanum," *DOP* 26 (1972): 1–41, at 9–11, 28–30, figs. 12–16, for the late ninth-century mosaic of this hierarch in the north tympanum of Hagia Sophia. See also A. Grabar, "Un calice byzantin aux images des patriarches de Constantinople," *Δελτ.Χριστ.Ἀρχ.Ἑτ.* 4 (1964/1965): 45–51; Sacopoulo, "A Saint-Nicolas-du-Toit," 195–99, fig. 5; K. M. Ringrose, *The Perfect Servant: Eunuchs and the Social Construction of Gender in Byzantium* (Chicago, 2003), 118–19, fig. 3; S. F. Tougher, "Holy Eunuchs! Masculinity and Eunuch Saints in Byzantium," in *Holiness and Masculinity in the Middle Ages*, ed. P. H. Cullum and K. J. Lewis (Cardiff, 2004), 93–108; idem, *The Eunuch in Byzantine History and Society* (London, 2008), 70, 87, and 112; and B. Krsmanović and L. Milanović, "Beards That Matter: Visual Representations of Patriarch Ignatios in Byzantine Art," *Zograf* 41 (2017): 25–36. For a discussion of Patriarch Ignatios's seals and their imagery understood in the context of ninth-century Iconoclasm, see J. Cotsonis, "The Imagery of Patriarch Ignatios' Lead Seals and the *Rota Fortunae* of Ninth-Century Byzantine Ecclesio-Political Policies," in *Servant of the Gospel: Studies in Honor of His All-Holiness Ecumenical Patriarch Bartholomew*, ed. T. FitzGerald (Brookline, MA, 2011), 52–98 (repr. in idem, *The Religious Figural Imagery of Byzantine Lead Seals*, vol. 1, *Studies on the Image of Christ, the Virgin and Narrative Scenes*, Variorum Collected Studies [Abingdon, UK, 2020], 75–109). For a discussion of the prominent position of various eunuchs during the middle Byzantine period, see Ringrose, *Perfect Servant*, 111–41 and 163–83; Tougher, *Eunuch in Byzantine History and Society*, esp. 54–67; idem, "Byzantine Court Eunuchs and the Macedonian Dynasty (867–1056): Family, Power and Gender," in *Celibate and Childless Men in Power: Ruling Eunuchs and Bishops in the Pre-Modern World*, ed. A. Höfert, M. M. Mesley, and S. Tolino (Abingdon, UK, 2018), 229–45; and Messis, *Les eunuques à Byzance*, 97–118.

14 *Synaxarium CP*, 678–80; and Lamza, *Patriarch Germanos I.*, 218–41. See also A. Kazhdan, *A History of Byzantine Literature (650–850)*, ed. L. F. Sherry and C. Angelidi (Athens, 1999), 55–59; D. Stein, "Germanos I (715–730)," in *Die Patriarchen der ikonoklastischen Zeit: Germanos I.–Methodios I. (715–847)*, ed. R.-J. Lilie (Frankfurt am Main, 1999), 5–21; and K. Staurianos, Ὁ Ἅγιος Γερμανὸς Α' ὁ Ὁμολογητὴς Πατριάρχης Κωνσταντινουπόλεως: Βίος-Ἔργα-Διδασκαλία, Συμβολὴ στὴν περίοδο τῆς Εἰκονομαχίας (Athens, 2003), 19–41. For more recent discussion of Germanos as a moderate defender of sacred images, and not the staunch iconophile apologist as described in posthumous Byzantine texts, see M.-F. Auzépy, "La destruction de l'icône du Christ de la Chalcé par Léon III: Propagande ou réalité?," *Byzantion* 60 (1990): 445–92, at 458–60 and 489 (repr. in eadem, *L'histoire des iconoclastes* [Paris, 2007], 154–56 and 175–76); Stein,

He was condemned by the iconoclast Synod of Hiereia in 754 (Γερμανῷ τῷ διγνώμῳ καὶ ξυλολάτρῃ ἀνάθεμα),[15] but subsequently was rehabilitated and acclaimed by the iconophile Synod of Nicaea II in 787 (Γερμανοῦ τοῦ ὀρθοδόξου αἰωνία ἡ μνήμη)[16] and in the *Synodikon of Orthodoxy* of 843, along with the other Constantinopolitan iconophile patriarchs Tarasios, Nikephoros, and Methodios (Γερμανοῦ, Ταρασίου, Νικηφόρου καὶ Μεθοδίου, τῶν ὡς ἀληθῶς ἀρχιερέων Θεοῦ καὶ τῆς ὀρθοδοξίας προμάχων καὶ διδασκάλων, αἰωνία ἡ μνήμη).[17] In the ninth/tenth-century *typikon* of the Great Church, found in the monastery of Saint John the Theologian on Patmos,[18] as well as in the tenth-century typikon of the Great Church of Hagia Sophia,[19] his liturgical commemoration is celebrated on 12 May and prescribed for celebration in Hagia Sophia. As noted above, Germanos is commemorated in the tenth-century *Synaxarion of Constantinople* on 12 May. Thus, he relatively quickly entered the choir of the saints, and close in time to the liturgical sources outlined here, he also enters the realm of the sphragistic saintly figures. A similar rapid enrollment in the ranks of the saints

and subsequent sigillographic imagery is also observed with another patriarch in the tenth and eleventh centuries, Patriarch Antony II Kauleas, who died in 901 and is listed in the *Synaxarion of Constantinople* for commemoration on 12 February.[20] He is included in the *Menologion* of Basil II, Vat. gr. 1613, ca. 1000, with his image accompanying the hagiographic text,[21] and is depicted on a seal assigned to the eleventh century.[22]

The earliest surviving image of the sainted patriarch Germanos I is that of the mosaic fragment in the room above the southwest vestibule in Hagia Sophia in Constantinople, assigned to the 870s.[23] The fragment is missing the head and is thus not of service for a comparison of the portrait features of the mosaic and seal, but there are the remains of his nimbus and he is depicted wearing the remains of his episcopal omophorion decorated with crosses. He is clearly

"Germanos I (715–730)," 14; Staurianos, Ὁ Ἅγιος Γερμανὸς Α´, 135–40; L. Brubaker and J. Haldon, *Byzantium in the Iconoclastic Era, c. 680–850: A History* (New York, 2011), 79–80, 94–105, 122–25 (124, n. 184 for the location of Platanion), and 136–39; R. Price, trans., *The Acts of the Second Council of Nicaea (787)*, TTH 68 (Liverpool, 2018), 250–58; and A. Louth, "The Theological Argument about Images in the 8th Century," in *A Companion to Byzantine Iconoclasm*, ed. M. Humphreys (Leiden, 2021), 401–24. See also "Germanos 8" in the index of names for the Prosopography of the Byzantine Empire: pbe .kcl.ac.uk/data/D30/F50.htm (accessed 22 January 2022).

15 E. Lamberz, ed., *Concilium universale Nicaenum secundum: Concilii actiones VI–VII*, Acta conciliorum oecumenicorum, series secunda 3.3 (Berlin, 2016), 782, 3. For an English translation, see Price, *Acts of the Second Council of Nicaea*, 539. See also Lamza, *Patriarch Germanos I.*, 180; Stein, "Germanos I," 5–6 and 15–16; and Staurianos, Ὁ Ἅγιος Γερμανὸς Α´, 45–47.

16 Lamberz, *Concilium universale Nicaenum secundum*, 856, 6 (Engl. trans., Price, *Acts of the Second Council of Nicaea*, 578). See also Lamza, *Patriarch Germanos I.*, 180–81; Stein, "Germanos I," 6 and 15–17; and Staurianos, Ὁ Ἅγιος Γερμανὸς Α´, 48–51.

17 J. Gouillard, "Le Synodikon de l'Orthodoxie," *TM* 2 (1967): 1–316, at 53. See also Lamza, *Patriarch Germanos I.*, 181 and 187, n. 9; and Stein, "Germanos I," 17.

18 A. Dmitrievskij, *Opisane liturgičeskich rukopisej*, vol. 1 (Kiev, 1895; repr. Hildesheim, 1965), 72. See also Lamza, *Patriarch Germanos I.*, 181; and Staurianos, Ὁ Ἅγιος Γερμανὸς Α´, 43.

19 J. Mateos, *Le typicon de la Grande Église: Ms. Sainte-Croix no. 40, Xᵉ siècle*, vol. 1 (Rome, 1962), 290–91. See also Lamza, *Patriarch Germanos I.*, 181; and Staurianos, Ὁ Ἅγιος Γερμανὸς Α´, 43.

20 *Synaxarium CP*, 462.

21 *El "Menologio" de Basilio II Emperador de Bizancio (Vat. gr. 1613)* (Madrid, 2005), 393. See also https://digi.vatlib.it/view/MSS_Vat .gr.1613. For the dating of the manuscript, see A. Cutler, "The Psalter of Basil II: Part II," *Arte Veneta* 31 (1977): 9–15.

22 J. Cotsonis and J. Nesbitt, "An Eleventh-Century Seal with a Representation of Patriarch Antony II Kauleas," *Byzantion* 74 (2004): 517–26 (repr. in J. Cotsonis, *The Religious Figural Imagery of Byzantine Lead Seals*, vol. 2, *Studies on Images of the Saints and on Personal Piety* [Abingdon, UK, 2020], 43–51).

23 P. A. Underwood, "A Preliminary Report of Some Unpublished Mosaics in Hagia Sophia: Season of 1950 of the Byzantine Institute," *AJA* 55.4 (1951): 367–70, first suggested a date of the late ninth century for the mosaics in this room; shortly later, in idem, "Notes on the Work of the Byzantine Institute in Istanbul: 1954," *DOP* 9/10 (1956): 291–300, at 292, he considers the mosaics to belong to the second half of the ninth century. Mango, *Materials*, 44–46, lists and describes the mosaics in the southwest vestibule, and at pp. 97–99 provides a general dating for the figural decorative program of Hagia Sophia as the late ninth and early tenth centuries. Even later, R. Cormack and E. J. W. Hawkins, "The Mosaics of St. Sophia at Istanbul: The Rooms above the Southwest Vestibule and Ramp," *DOP* 31 (1977): 175–251, at 223–24 and 235–47, fig. 41, assigned this mosaic, and those in the room over the ramp, to the decade of the 870s. Lamza, *Patriarch Germanos I.*, 181, refers to the mosaic fragment of Germanos's portrait, and provides in note 12 (pp. 188–91) an extensive quote about the mosaics in the room above the southwest vestibule from A. Grabar, *L'iconoclasme byzantin* (Paris, 1957), 193–94, but in the photograph found in Lamza's volume he erroneously identifies as the patriarch Germanos the bearded figure who appears to the right of Germanos, a figure whose inscription has not survived but who has been identified by subsequent scholars as the iconophile patriarch Nikephoros. This error is repeated by Stein, "Germanos I," 16, n. 49, and Staurianos, Ὁ Ἅγιος Γερμανὸς Α´, 43.

identified by the surviving flanking inscription: Ο ΑΓΙΟΣ ΓΕΡΜΑΝΟΣ (Saint Germanos).

Although visually grouped there with the other sainted iconophile patriarchs Tarasios, Methodios, and Nikephoros, and commemorated with them in the text of the *Synodikon of Orthodoxy*, Germanos does not appear in the late and post-Byzantine icons of the Triumph of Orthodoxy, even though other holy figures who were not contemporary with the 843 celebration, such as Theodosia and Theodore the Stoudite (759–826), are represented.[24] When Germanos is depicted in middle, late, and post-Byzantine art, he is consistently shown as a beardless hierarch, as in the arch of the *diakonikon* in the church of Saint Nicholas of the Roof on Cyprus,[25] in the Sinai May calendar icon,[26] and in the apse fresco of the church of the Virgin Peribleptos–Saint Clement in Ohrid.[27]

Related to the discussion here are two interesting seals already in the Dumbarton Oaks collection that are similar (Figs. 2 and 3): they bear on the obverse a bust image of a beardless hierarch, dressed in his phelonion and omophorion, holding a cross in his right hand and a Gospel book in his left, and flanked by crosslets. The monogram of the owner on the reverse has been read as "Germanos," and the editors of the Dumbarton Oaks seal database have assigned these specimens to the late seventh to early eighth century.[28] These two seals were previously published by George Zacos and Alexander Veglery, who assigned them to the early eighth century, noting the high quality of their engraving and stylistic resemblance to the solidi issued during the

second reign of the emperor Justinian II (705–711).[29] The Dumbarton Oaks database commentary for these two specimens suggests the possibility that the bishop depicted is Germanos of Capua. Yet this is most unlikely for the reasons outlined above. Another puzzling detail of these two specimens is that the hierarch has no nimbus, leading to the online commentary noting that this may not be the image of a saint. That, too, is unlikely since there are numerous examples of seals from the sixth through the tenth centuries with saintly images without a nimbus.[30]

On early Byzantine seals, flanking crosses are seen accompanying only holy figures.[31] These images would not be the "portrait" of the seal owner; except for emperors, empresses, and caesars, those who issued seals did not place their own images alone on either the obverse or reverse,[32] and there are just seven examples of the owner of a seal depicted in the presence of a saintly figure among the 12,666 seals bearing religious figural imagery drawn from the major published collections.[33] Furthermore, since the hierarch on these two Dumbarton Oaks seals holds the cross of a martyr or confessor, it is most certainly an image of a sainted hierarch, as is seen on sphragistic examples of the Church Father John Chrysostom, who is recognized as a confessor because of the hardships he suffered in exile.[34] Therefore, these two seals bear on their obverses an image of an as yet unidentified saintly, beardless

24 For the icon, ca. 1400, in the British Museum, see H. Evans, ed., *Byzantium: Faith and Power (1261–1557)* (New York, 2004), no. 78. For a discussion of this icon in comparison with later examples of the Triumph of Orthodoxy, see A. Markopoulos, "Ὁ Θρίαμβος τῆς Ὀρθοδοξίας στὴν Εἰκόνα τοῦ Βρετανικοῦ Μουσείου: Τὰ Πρόσωπα καὶ τὰ Κείμενα," *Δελτ.Χριστ.Ἀρχ.Ἑτ.*, per. 4, 26 (2007): 345–52.

25 See n. 13 above.

26 See n. 13 above.

27 S. E. J. Gerstel, *Beholding the Sacred Mysteries: Programs of the Byzantine Sanctuary* (Seattle, 1999), fig. 42, in which Germanos is depicted as the first on the left of the row of bust-length images of hierarchs. See also Meinardus, "Beardless Patriarch," 178–86; and Staurianos, Ὁ Ἅγιος Γερμανὸς Α´, 43–44.

28 See www.doaks.org/resources/seals/byzantine-seals/BZS.1955.1.224 and www.doaks.org/resources/seals/byzantine-seals/BZS.1958.106.5599.

29 G. Zacos and A. Veglery, *Byzantine Lead Seals*, vol. 1.2 (Basel, 1972), no. 1300a and b, pl. 102. For the solidi of Justinian II, see J. D. Breckenridge, *The Numismatic Iconography of Justinian II (685–695, 705–711 A.D.)* (New York, 1959), esp. 59–62, 90 and pl. IX, fig. 38.

30 Zacos and Veglery, *Byzantine Lead Seals*, vol. 1.2, nos. 1260–67, 1269–71, and 1307; vol. 2.3, no. 2966; and Zacos, *Byzantine Lead Seals*, vol. 2, no. 821.

31 For example, see Zacos and Veglery, *Byzantine Lead Seals*, vol. 1.2, nos. 1099–1324, passim, pls. 92–103.

32 For series of seals with effigies of emperors and empresses, see Zacos, *Byzantine Lead Seals*, vol. 2, nos. 1–128; and *DOSeals 6*, nos. 1–109.

33 V. Laurent, *Les corpus des sceaux de l'empire byzantin*, vol. 5.1, *L'église de Constantinople: La hiérarchie* (Paris, 1963), nos. 464 and 803; ibid., vol. 5.2, *L'église de Constantinople: Le clergé et les moines* (Paris, 1965), no. 1436; ibid., vol. 2, *L'administration centrale* (Paris, 1981), no. 542; Campagnolo-Pothitou and Cheynet, *Genève*, nos. 74 and 386A and B (B = Zacos, *Byzantine Lead Seals*, vol. 2, no. 533).

34 For example, Zacos, *Byzantine Lead Seals*, vol. 2, no. 513. For a brief discussion of the term "confessor," as one who suffered for the faith but not to the point of death as a martyr, see *ODB* 1:493–94.

Fig. 2. Lead seal of Germanos, seventh to eighth century, obv.: bust of a bishop saint, Dumbarton Oaks BZS.1955.1.224 (d. 31 mm). Photo courtesy of Dumbarton Oaks, Byzantine Collection, Washington, DC.

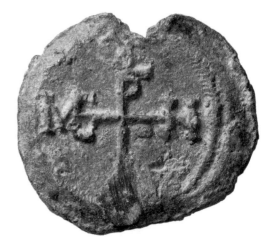

Fig. 3. Lead seal of Germanos, seventh to eighth century, obv.: bust of a bishop saint, Dumbarton Oaks BZS.1958.106.5599 (d. 34 mm). Photo courtesy of Dumbarton Oaks, Byzantine Collection, Washington, DC.

hierarch who was a confessor, and were issued by an owner with the name Germanos.

Although it is tempting to identify this holy, beardless hierarch with that of the saintly, beardless patriarch Germanos depicted on the newly acquired Dumbarton Oaks seal, the identification is most unlikely in light of the date assignment to the late seventh to early eighth century given the two seals. As noted above, the memory of Germanos was not rehabilitated until the iconophile synod of Nicaea II in 787, which would require a seal dating, at the earliest, to

the late eighth century. In addition, statistically there is not a high correspondence between the names of seal owners and the sphragistic images of their homonymous saints.[35] In Rodolphe Guilland's study of eunuchs in the Byzantine empire, there are no pre-iconoclastic

35 J. Cotsonis, "Onomastics, Gender, Office and Images on Byzantine Lead Seals: A Means of Investigating Personal Piety," *BMGS* 32.1 (2008): 5–10 (repr. in idem, *Religious Figural Imagery*, vol. 2, 215–20).

eunuch bishops listed.[36] Shaun Tougher's select list of late Roman and Byzantine eunuchs includes two bishops belonging to the pre-iconoclastic period, yet neither of them is recorded as a saint.[37] And in Charis Messis's recent volume dedicated to the history and role of the Byzantine eunuch, which includes a survey of the *Synaxarion of Constantinople*, there is reference to just one pre-iconoclastic, saintly, eunuch hierarch—Makedonios, patriarch of Constantinople (496–511).[38] He is commemorated on 25 April by the Byzantine Church.[39] Messis recounts, however, that Makedonios was not known to be a eunuch until he was falsely accused of pederasty and proved his innocence by revealing his castrated condition.[40] According to Messis, either Makedonios was bearded, due to castration later in life, or the author of the history had repeated a literary trope in which saintly figures are falsely accused and by dramatic revelations are proved innocent. Nevertheless, it is most unlikely that these two similar seals from the Dumbarton Oaks collection bear the image of the sainted patriarch Makedonios, and the identity of their beardless, holy hierarch remains uncertain.

The owner of the newly acquired Dumbarton Oaks seal with the image of the saintly patriarch Germanos was an abbot of a monastery dedicated to Saint Phokas. This saint has a complicated hagiographic tradition, and may be a conflation of three literary traditions: a martyred gardener from Sinope; a son of a noble shipwright from Herakleia Pontike; and a bishop of Sinope martyred during the reign of Trajan.[41] In the *Synaxarion of Constantinople*, Phokas the gardener and Phokas the bishop are both commemorated

on 22 September and on 22–23 July, and for the latter dates there is also a commemoration of Phokas the bishop and the translation of his relics.[42] As archbishop of Constantinople (398–404), John Chrysostom composed a homily on the occasion of the arrival of Phokas's relics at the capital, which took place sometime between 400 and 404, but his text does not specify which Phokas is celebrated, only that the relics were brought from Pontus.[43] By the tenth century, the commemoration of this translation was celebrated in the chapel of Saint Phokas located within the precinct of the church of Saint John the Evangelist, near the Great Church of Hagia Sophia.[44] Finally, a martyr Phokas is commemorated on 18 December[45] and a Saint Phokas is celebrated on 2 August.[46] When Phokas the saint is depicted, it is usually as the bishop.[47]

It is uncertain which monastic house of Saint Phokas the owner was abbot of. The editors of the Leu Numismatik Web Auction assert that the monastery dedicated to Saint Phokas was located in Trebizond; at least one monastic foundation dedicated to Saint Phokas in Trebizond is known to have existed since the middle of the ninth century.[48] Yet there is a Constantinopolitan monastery dedicated to Saint Phokas that can be traced to the second half of the ninth century.[49] Originally it was a palace built by Arsaber, the brother of the iconoclast patriarch John VII Grammatikos, but it was subsequently acquired by the emperor Basil I, who converted it to

36 R. Guilland, "Les eunuques dans l'empire byzantin: Étude de titulature et prosopographie byzantines," *Études byzantines* 1 (1943): 197–238 (repr. in idem, *Recherches sur les institutions byzantines*, vol. 1 [Berlin, 1967], 165–97).

37 Tougher, *Eunuch in Byzantine History and Society*, 154 (no. 124, Leontius) and 157 (no. 144, Narses).

38 Messis, *Les eunuques à Byzance*, 108.

39 *Synaxarium CP*, 630.

40 For the historical account, see Evagrios Scholastikos, *Church History* 3.32, in Évagre le Scholastique, *Histoire ecclésiastique*, ed. J. Bidez and L. Parmentier, trans. A.-J. Festugière, B. Grillet, and G. Sabbah (Paris, 2011), 478–79. For an English translation, see M. Whitby, trans., *The Ecclesiastical History of Evagrius Scholasticus*, TTH 33 (Liverpool, 2000), 172–73.

41 *ODB* 3:166–67.

42 *Synaxarium CP*, 67–70, 835–36, 837 (line 42) and 840 (line 43).

43 PG 50:699–706. For an English translation, see John Chrysostom, *The Cult of the Saints: Select Homilies and Letters*, trans. and annot. W. Meyer (Crestwood, NY, 2006), 75–87, where Meyer notes that later tradition associated this homily with Phokas the bishop from Sinope.

44 *Synaxarium CP*, 67–70, 835–36, 837 (line 42) and 840 (line 43). For this chapel, see R. Janin, *La géographie ecclésiastique de l'empire byzantin*, pt. 1, *Le siège de Constantinople et le patriarcat oecuménique*, vol. 3, *Les églises et les monastères*, 2nd ed. (Paris, 1969), 497.

45 *Synaxarium CP*, 324.

46 *Synaxarium CP*, 866.

47 *ODB* 3:167.

48 R. Janin, *Les églises et les monastères des grands centres byzantins: Bithynie, Hellespont, Latros, Galèsios, Trébizonde, Athènes, Thessalonique* (Paris, 1975), 293–94, refers to various sources that indicate the possibility of another monastery dedicated to Saint Phokas.

49 Janin, *Géographie ecclésiastique*, 498–99; the author also testifies to the existence of two Constantinopolitan churches or chapels dedicated to Saint Phokas.

a monastery.[50] This emperor erected numerous buildings, endowed the foundation with much property, and installed a community of pious monastics.[51] He even appointed the abbot, Peter of Galatia, a well-known solitary of Mount Olympus, who was later sainted.[52]

Given the history of the Constantinopolitan monastery of Saint Phokas, it is more likely that Germanos, the owner of the newly acquired Dumbarton Oaks seal, was the abbot of this monastic foundation rather than one in the faraway region of Trebizond. The abbot likely selected the image of his homonymous saint for the obverse of his seal, even though, as noted above, homonymity was not a strong factor in determining one's sphragistic imagery. Yet in this case, it is extremely fitting that he would choose his like-named saint, since Patriarch Germanos I was the first patriarch to suffer as a confessor for iconophile orthodoxy during the trials of the iconoclast period. The patriarch's image on this seal vindicates the triumph of the iconodule party, especially given that this monastic property had once been so closely associated with the iconoclast heretics, but now had been converted into a religious house by the pious and iconophile emperor Basil I. The monastery's history is recounted in the texts of the *Theophanes Continuatus* and in the *Vita Basilii*, both composed in the middle years of the tenth century under the

supervision of Constantine VII Porphyrogennetos,[53] and thus relatively close in time to the period of the newly acquired Dumbarton Oaks seal. The memory of the historic events of the religious house's foundation would still have been preserved in the zeitgeist of Abbot Germanos and his contemporaries. In addition, as outlined above, the relics of Saint Phokas were also in Constantinople, and the yearly commemoration of this translation took place in a prestigious church in the center of the city. Similarly, as previously mentioned, the saintly Germanos was buried in the Constantinopolitan monastery of Chora, and the annual liturgical celebration of his feast on 12 May was prescribed for Hagia Sophia, the cathedral of the city. All these factors would lend further prestige to the position of Germanos, the abbot or hegoumenos of the monastic foundation of Saint Phokas. By placing an image of the sainted Patriarch Germanos on his seal, along with the prayerful invocation addressed to the hierarch, the abbot Germanos visually expressed his personal hopes in the saint's efficacious intercession, participating in the prestigious aura of two holy hierarchs' presence and liturgical memory in the capital city, while simultaneously proclaiming membership among those iconophiles on the right side of ecclesiastical history.

Holy Cross Greek Orthodox
School of Theology
Archbishop Iakovos Library
50 Goddard Avenue
Brookline, MA 02445
jcotsonis@hchc.edu

50 Theophanes Continuatus 4.8, in M. Featherstone and J. Signes-Codoñer, eds., *Chronographiae quae Theophanis Continuati nomine fertur libri I–IV*, CFHB 53 (Berlin, 2015), 222–25. See also Janin, *Géographie ecclésiastique*, 498.

51 *Vita Basilii* 94, in I. Ševčenko, ed., *Chronographiae quae Theophanis Continuati nomine fertur liber quo Vita Basilii Imperatoris amplectitur*, CFHB 42 (Berlin, 2011), 306–7. See also Janin, *Géographie ecclésiastique*, 498.

52 *Synaxarium CP*, 125–26. See also Janin, *Géographie ecclésiastique*, 498.

53 Theophanes Continuatus 4.8 (Featherstone and Signes-Codoñer, *Chronographiae*, 224–25, line 4) and *Vita Basilii* 94 (Ševčenko, *Chronographiae*, 306–7, lines 16–21).

❧ I WISH TO THANK JONATHAN SHEA, CURATOR of Coins and Seals, Dumbarton Oaks Research Library and Collection, for bringing this newly acquired seal to my attention, for offering me the opportunity to publish this specimen, and for his insightful comments upon reading an earlier version of this paper. I also wish to express my appreciation to John Nesbitt, Special Emeritus Advisor in Byzantine Sigillography, Dumbarton Oaks Research Library and Collection, who also read a preliminary draft of this paper and for his helpful suggestions for its improvement. Appreciation is also extended to the two anonymous readers for their thoughtful suggestions for improving this paper, as well as to Colin Whiting, Managing Editor in Byzantine Studies.

Major Recent Additions to the Dumbarton Oaks Collection of Greek Manuscripts (DO MS 6 and DO MS 7)

Codicological and Paleographic Descriptions and Analyses

NADEZHDA KAVRUS-HOFFMANN

In 2016 and 2018, the Dumbarton Oaks Museum added two manuscripts to its increasingly comprehensive collection of Greek manuscripts: the early tenth-century Four Gospels and the ninth-century codex of forty-four homilies on the Gospel of Matthew by John Chrysostom. Ninth- and tenth-century Greek manuscripts are rarely offered for sale, and Dumbarton Oaks was fortunate to acquire both manuscripts, which were in private collections but have now become available to scholars. With these acquisitions, the Dumbarton Oaks collection of manuscripts encompasses the entire period of minuscule-manuscript production in Byzantium from the ninth to fifteenth centuries and exemplifies all major writing styles of this period. I was privileged to examine both manuscripts soon after their acquisition, and this article summarizes the results of my research. The article combines a cataloguing format with extensive paleographic and codicological analyses and complements my previous publications in *Dumbarton Oaks Papers* on DO MSS 1, 3, 4, and 5.[1]

DO MS 6 (the Benton Gospels)

The Four Gospels (Gregory-Aland 669; Diktyon 76481).[2] <Constantinople>, the first half of the tenth century.

Contents

Fols. 1r–3v: The Gospel of Matthew, incomplete. Inc. mut:]Ἰωσὴφ ἐνετύλιξεν αὐτὸ . . . (Matthew 27:59). E. Nestle, E. Nestle, B. Aland, and K. Aland, eds., *Novum Testamentum Graece*, 27th ed. (Stuttgart, 2006) (hereafter NTG), 1–87, at 85–87.

Fol. 3v: Subscription to the Gospel of Matthew: Ε᾿ΥΑΓΓΈΛΙ- | ΟΝ ΚΑΤᾺ | ΜΑΤΘΑῖ- | ΟΝ.

1 N. Kavrus-Hoffmann, "Greek Manuscripts at Dumbarton Oaks: Codicological and Paleographic Description and Analysis," *DOP* 50 (1996): 289–312, and N. Kavrus-Hoffmann, "A Newly Acquired Gospel Manuscript at Dumbarton Oaks (DO MS 5): Codicological and Paleographic Description and Analysis," *DOP* 70 (2016): 293–324.

2 Each Greek New Testament manuscript is assigned a Gregory-Aland number: K. Aland, *Kurzgefasste Liste der griechischen Handschriften des Neuen Testaments*, 2nd ed. (Berlin, 1994). Also, each Greek manuscript is given a Diktyon number in *Pinakes*, a database of Greek manuscripts created by the Institut de recherche et d'histoire des textes in Paris. All manuscripts cited in this article are provided with a Diktyon number when a manuscript is first mentioned. The following abbreviations are used throughout: BAV = Vatican City, Biblioteca Apostolica Vaticana; BnF = Paris, Bibliothèque nationale de France; BNM = Venice, Biblioteca Nazionale Marciana; EBE = Athens, Εθνική Βιβλιοθήκη της Ελλάδος (National Library of Greece); GIM = Moscow, Gosudarstvennyi Istoricheskii Muzei (State Historical Museum); ÖNB = Vienna, Österreichischen Nationalbibliothek; and NLR = St. Petersburg, National Library of Russia.

Fols. 4r–5v: List of chapter titles for the Gospel of Mark (1–48). Title: Τοῦ κατ(ὰ) Μάρκον ἁγ(ίου) εὐα(γγελίου) τὰ κε(φάλαια). Inc.: α′ Πε(ρὶ) τοῦ δαιμονιζομένου. H. von Soden, *Die Schriften des Neuen Testaments in ihrer ältesten erreichbaren Textgestalt hergestellt auf Grund ihrer Textgeschichte*, vol. 1, *Untersuchungen*, part 1, *Die Textzeugen* (Göttingen, 1911), 407–9.

Fol. 6r–v, mutilated: Only a narrow stub (25 mm at widest point) remains from a folio that was probably a full-page miniature of Mark.

Fols. 7r–70v: The Gospel of Mark. Title: ΕΥΑΓΓΕ- | ΛΙΟΝ | ΚΑΤΑ | ΜΑΡΚΟΝ. Inc.: Ἀρχὴ τοῦ εὐαγγελίου Ἰ(ησο)ῦ Χ(ριστο)ῦ Υ(ἱο)ῦ τοῦ Θ(εο)ῦ ὡς γέγραπται . . . NTG, 88–149.

Fol. 70v: Subscription to the Gospel of Mark: Εὐαγγέλιον. | κατὰ Μάρκον·.

Fols. 71r–72v: List of chapter titles for the Gospel of Luke, incomplete (1–66 out of 83). Title: Τὰ κεφάλ(αια) τοῦ κατ(ὰ) Λουκ(ᾶν) ἁγ(ίου) εὐαγγελ(ίου). Inc.: α′ Περὶ τῆς ἀπογραφῆς; des. mut: ξς′ Περὶ τοῦ πορευθέντος λαβεῖν ἑαυτῷ βασιλείαν. Von Soden, *Schriften des Neuen Testaments*, 409–11, at 409–10.

Fols. 73r–172v: The Gospel of Luke; the beginning is missing. Inc. mut.: Μαριὰμ καὶ τὸν Ἰωσὴφ . . . (Luke 2:16). NTG, 150–246, at 157–246.

Fol. 172v: Subscription to the Gospel of Luke: Εὐαγγέλιον | κατὰ Λουκᾶν.

Fols. 173r–249v: The Gospel of John; the beginning is missing. Inc. mut.: <ἐθεα>]σάμεθα τὴν δόξαν αὐτοῦ· (John 1:14). NTG, 247–319.

Lacunae in John: Lacuna of one folio between folios 178v and 179r: des. mut.: . . . λέγει πρὸς αὐτὸ(ν)[(John 3:4); inc. mut.:]ἀπόληται ἀλλ᾽ ἔχῃ ζωὴν αἰώνιον (John 3:16). Two small lacunae on folio 220, which was torn and lost its bottom half: des. mut.: . . . καὶ ὅπου εἰ<μὶ ἐγὼ ἐκεῖ καὶ> ὁ διάκον[<ος> (John 12:26); inc. mut.:]ἦλθεν οὖν φωνὴ ἐκ τοῦ οὐ(ρα)νοῦ· (John 12:28); des. mut.: . . . ὑψω<θῶ ἐκ τῆς γῆς> πάντας ἑλκύσω <πρὸς ἐμαυτόν. Τοῦτο δὲ> ἔλεγε(ν). Ση[<μαίνων> (John 12:32–33); inc. mut.:]υἱὸν τοῦ ἀνθρώπου·

. . . (John 12:34).[3] Lacuna of one folio between fols. 223v and 224r: des. mut.: . . . ἐὰν ποιῆτε αὐτά·[(John 13:17); inc. mut.] λαβὼν οὖν τὸ ψωμίον . . . (John 13:30).

Fol. 249v: Subscription to the Gospel of John: Εὐαγγέλιον | κατὰ Ἰωάννην.

Fols. 250r–270r: Lectionary tables (Synaxarion). Title: Ἐκλογάδ(ιον) τῶν Δ′ εὐα(γγελιστῶν)· διά τε τῆς ἀρχῆς καὶ τοῦ τέλους· τὴν περικοπὴν ἑκάστου [sic] εὐα(γγελιστοῦ)· ἅμα δὲ τὴν τῶν κε(φαλαίων) παρασημείωσιν, ἀκριβῶς διαγορεύων· περιέχων δὲ τὴν ἀρχὴν· ἀπὸ τὸ ἅγιον Πάσχα· καὶ τελειοῦται τὸ Μηνολόγην [sic].

Fols. 250r–252v: List of Gospel Readings from John, daily. Inc.: Τῇ ἁγίᾳ καὶ μεγάλη κυριακη τοῦ Πάσχα·. Cf. C. R. Gregory, *Textkritik des Neuen Testaments*, vol. 1 (Leipzig, 1900), 344–47.

Fols. 253r–257v: List of Gospel Readings from Matthew, daily; the end is missing. Inc.: Τῇ β′ τῆς α′ ἑβδ(ομάδος); des. mut.: τῇ ς′ τῆς ιγ′ ἑβδ(ομάδος). Cf. Gregory, *Textkritik*, 347–51.

Fols. 258r–259r: List of Gospel Readings from Luke, daily; the beginning is missing. Inc. mut.: Τῇ β′ τῆς ιζ′ ἑβδ(ομάδος. Cf. Gregory, *Textkritik*, 347–51.

Fols. 259r–260r: List of Gospel Readings for the Vigils (Παννυχίδες), Lent (Νηστεῖαι), and Holy Week (Ἡ ἁγία καὶ μεγάλη ἑβδομάς), Saturday and Sunday only. Inc.: Σα(ββάτῳ) α′ τῶν νηστειῶν. Cf. Gregory, *Textkritik*, 361–62.

Fol. 260r–v: List of Gospel Readings for the Twelve Passions (Πάθη). Title: Εὐα(γγέλιον) τ(ῶν) ἁγ(ίων) Παθ(ῶν). Inc.: Εὐα(γγέλιον) α′. Cf. Gregory, *Textkritik*, 363.

Fol. 261r: Readings for Good Friday (for the Hours and the Liturgy) and Holy Saturday (Ὧραι). Cf. Gregory, *Textkritik*, 363.

3 After the words "υἱὸν τοῦ ἀνθρώπου·" the scribe missed a line with similar words and inserted it in the top margin in cursive: τ(ίς) ἐστιν οὗτο(ς) ὁ υἱὸ(ς) τοῦ ἀν(θρώπ)ου·.

Fols. 261r–268v: List of Gospel Readings for the Menologion. Title: Ἀρχὴ τοῦ Μηνολογίου. Inc.: Μηνὶ Σεπτεμ(βρίου) α'. . .

Fols. 268v–269v: List of eleven morning Gospel readings for the Resurrection (Ἑωθινά). Title: Ἀρχὴ τελεία τῶν ια' εὐαγγελίων ἑωθινῶν. Inc.: Εὐαγγέλιον ἑωθινὸν α'. . . . Cf. Gregory, *Textkritik*, 364.

Fols. 269v–270r: List of Gospel Readings for various occasions. Inc.: Εἰς ἐγκαίνια ἐκκλησίας. . . .

Physical Description

The manuscript is written on parchment and contains 270 folios. The size of the manuscript is 170–172 × 130 mm. The non-scribal foliation is in the upper right corner in Greek numerals. The first six folios are not foliated; the first number appears on fol. 7r (ρζ' = 107); therefore, the first hundred folios are missing. One col.; the written surface is 110 × 73–75 mm. The text is written in 17 lines with interlinear space of 5–6 mm. The ruling was made on the hair side of the parchment with a sharp instrument. The text is positioned on the line.[4] The ruling system is 1. The ruling pattern is Leroy B 48D1d (Fig. 1).[5] This ruling pattern is not listed in Jacques-Hubert Sautel's *Répertoire de réglures dans les manuscrits grecs sur parchemin*, and similar ruling patterns are found only in a small number of manuscripts.[6]

Thirty-three of forty-seven original quires remain; collation: <1–12>, 13^{8-7} (fol. 1), 14^{8+1} (fols. 2–10), $15–19^8$

Fig. 1. Ruling pattern Leroy B 48D1d. Drawing by the author.

(fols. 11–50), $20–21^{10}$ (fols. 51–70), 22^2 (fols. 71–72), <23>, $24–34^8$ (fols. 73–160), $35–36^6$ (fols. 161–72), <37>, 38^{8-2} (fols. 173–78), $39–43^8$ (fols. 179–218), 44^{8-1} (fols. 219–25), $45–47^8$ (fols. 226–49). The first twelve quires are missing; the thirteenth quire lacks the first seven folios; the fourteenth quire has an additional folio inserted in the middle of the quaternion (the inserted folio likely had a miniature of Mark the Evangelist; only a stub remains); the twenty-third quire is missing; the thirty-seventh quire is missing; the thirty-eighth quire lacks the first and eighth folios (the outer bifolium); and the forty-fourth quire lacks the sixth folio. Probably in the fifteenth century, three additional quires with lectionary tables were added to the manuscript, bringing the total number of quires to fifty; collation: $48–49^8$ (fols. 250–65) and 50^5 (fols. 266–70). There are no original quire signatures, which were most likely cut off during rebinding when the manuscript was cropped. Non-scribal quire signatures were added by the person who foliated the manuscript. The signatures are in the lower-left corner of a quire; most of them are cropped.

4 On the significance of positioning of the minuscule script on or across the ruled lines for dating a manuscript, see M. L. Agati, *Il libro manoscritto: Introduzione alla codicologia*, Studia archaeologica 124 (Rome, 2003), 196, and N. Kavrus-Hoffmann, review of Agati, *Il libro manoscritto*, in *Chrysograph: Gatherings in Honor of G. Z. Bykova*, vol. 2, ed. E. Dobrynina (Moscow, 2005), 296–305, esp. 303f.

5 The three horizontal lines on the top margins are not always visible because of cropping. On ruling patterns and systems, see J. Leroy, *Les types de réglure des manuscrits grecs* (Paris, 1976); J. Leroy, "Quelques systèmes de réglure des manuscrits grecs," in *Studia codicologica*, ed. K. Treu et al., Texte und Untersuchungen zur Geschichte der altchristlichen Literatur 124 (Berlin, 1977), 291–312; J.-H. Sautel, *Répertoire de réglures dans les manuscrits grecs sur parchemin: Base de données établie par Jacques-Hubert Sautel à l'aide du fichier Leroy et des catalogues récents à l'Institut de recherche et d'histoire des textes*, Bibliologia 13 (Turnhout, 1995).

6 See the frequency table of ruling patterns in Sautel, *Répertoire de réglures*, 345–51.

The parchment is of good but not excellent quality. Its thickness varies from medium-thick to thick. The parchment was carefully prepared: it is smooth, and there are no imperfections such as scalloping, holes, or patches; dark hair follicles, which are typically found in lesser quality manuscripts, are absent. The flesh side is creamy-white, and the hair side is yellowish. The parchment is warped because the manuscript has been without a cover for a long time.

The parchment of the last three quires (fols. 250–70) with non-scribal lectionary tables is of inferior quality; it is thick and badly warped with a strong contrast between a yellowish-white flesh side and yellow-brownish hair side. Nonetheless, the parchment was well prepared, and hair follicles were carefully removed on most folios, although on some folios the wavy pattern of the follicles is visible. The pattern consists of double rows of smaller and larger follicles, which is typical of goat skin.

The ink of the main text is light brown. The ink of the non-scribal lists of chapter titles is magenta. The ink of the non-scribal lectionary tables is light brown with grayish tint.

Chapter titles (τίτλοι) were written by the scribe in Alexandrian majuscules in bright red ink (cinnabar) and placed in the top margins.[7] The numbers of the τίτλοι were repeated in the left margins at the beginning of a chapter. The Ammonian section numbers and Eusebian canon numbers were also executed by the scribe himself. These numbers are smaller than those of the τίτλοι. The Ammonian section numbers are written in the ink of the text and placed in the left margins at the beginning of each section. Under these numbers are the Eusebian canon numbers, written in bright red ink.

The lectionary apparatus was added by the scribe of the lectionary tables, probably in the fifteenth century. The apparatus was written in the margins in faded beige or bright red ink (the words ἀρχή and τέλος, which often are inserted in the text of the Gospels, were not used).

The manuscript has no colophon. A note in the top margin of fol. 250r (above the beginning of the lectionary tables), which was written by the same hand who copied the tables: ὦ Χ(ριστ)έ μου τάχυνον τὸ(ν) δὲ δρόμον τῆς χειρός μου (O Christ, speed the movement of my hand).

Binding

The manuscript is not bound and is kept in a box. The manuscript is sewn at four stations, and the sewing is exposed. The bottom end-band is missing; the top end-band consists of plain thread. The spine lining is missing, and only a small piece of blue cloth remains under the top end-band.

Condition of the Manuscript

The condition of the manuscript is fragile due to the lack of covers. Sewing is falling apart in several quires in the beginning of the manuscript. Parchment folios are warped; there are wax stains and some soiling throughout the manuscript, and some folios have water stains in the outer margin. The first folio is loose and torn around the edges; the recto of the folio is soiled and darkened because of exposure, and the text is barely legible. The second folio is torn at the outer margin, but the text is not affected.

Script

One scribe, anonymous, copied DO MS 6. His script is an elegant minuscule *bouletée élancée,* which is small, vertical, clear, and uniform (Fig. 2).

The writing style bouletée élancée is a subtype of the writing style minuscule bouletée, which was widely employed by Constantinopolitan calligraphers in the first half of the tenth century. Minuscule bouletée is an exceptionally beautiful example of Byzantine calligraphy. Minuscule bouletée uses more valuable parchment than other contemporaneous scripts, and manuscripts written in this writing style are therefore more expensive. Many manuscripts written in minuscule bouletée are beautifully illuminated. This script was predominantly employed in luxury manuscripts commissioned by wealthy clientele.

The minuscule bouletée was first identified by Viktor Gardthausen, who named it *Diamantschrift* ("Diamond script").[8] Jean Irigoin examined several manuscripts written with this style and named it *écriture bouletée* because of distinctive tiny bulges or balls

7 On Alexandrian majuscule, see J. Irigoin, "L'onciale grecque de type copte," *JÖBG* 8 (1959): 29–51, and G. Cavallo, "Γράμματα Ἀλεξανδρῖνα," *JÖB* 24 (1975): 23–54.

8 V. Gardthausen, *Griechische Palaeographie: Zweiter Band; Die Schrift, Unterschriften and Chronologie im Altertum und im byzantinischen Mittelalter,* 2nd ed. (Leipzig, 1913), 210.

Fig. 2.
DO MS 6, fol. 23r.
Mark 5:25–31.

(*boules* in French) at the ends of many letters.[9] Irigoin also differentiated among four types of minuscule bouletée: early bouletée, canonic bouletée (or "true" bouletée), bouletée *italique* (bouletée with inclination to the right), and imitative bouletée (bouletée in decline). Irigoin also established chronological boundaries of minuscule bouletée, underscoring that minuscule bouletée was primarily used in the first half of the tenth century.

Inspired by Irigoin's article, I have identified a dozen bouletée manuscripts in Russian collections and published descriptions and analyses of these manuscripts.[10] The next major step in the study of minuscule bouletée was made by Maria Luisa Agati, who published a two-volume monograph with detailed descriptions and illustrations of more than a hundred manuscripts written in minuscule bouletée.[11]

9 J. Irigoin, "Une écriture du Xe siècle: La minuscule bouletée," in *La paléographie grecque et byzantine: Paris, 21–25 octobre 1974*, Colloques internationaux du Centre national de la recherche scientifique 559 (Paris, 1977), 191–99. I am indebted to the late Professor Jean Irigoin for sending me an offprint of this article when it was not available in the Soviet Union and Soviet scholars were cut off from Western scholarship by the Iron Curtain.

10 N. F. Kavrus, "'Almaznoe' pis'mo v grecheskikh rukopisiakh Moskvy i Leningrada," *VizVrem* 47 (1986): 191–204.

11 M. L. Agati, *La minuscola "bouletée"*, 2 vols., Littera antiqua 9.1 (Vatican City, 1992).

In addition to the four types of minuscule bouletée denoted by Irigoin, Agati differentiated another type, bouletée with elongated strokes, which she called bouletée élancée.[12]

Only a few manuscripts written in minuscule bouletée are securely dated. The earliest dated manuscript written in minuscule bouletée is the well-known codex EBE, 2641 (Diktyon 4673), copied in 913/914 CE by the cleric Joseph for the patrician Samonas, a favorite of Emperor Leo VI.[13] The latest precisely dated manuscript written in "true" minuscule bouletée is Oxford, Bodleian Library, Auct. E. 2. 12 (Diktyon 47007), copied in 953 CE.[14]

The early minuscule bouletée retains some features of the ninth-century scripts, such as ancient elongated minuscule (*minuscola antica oblunga*), which is characterized by the angularity of the script and extended lower strokes of the letters zeta and xi, and minuscule *pre-bouletée*, which has many characteristics of minuscule bouletée but is almost pure with only occasional majuscule forms of letters.[15] The examples of manuscripts written in early minuscule bouletée include Tirana, National Archives of Tirana, Beratinus 2 (Diktyon 63361); NLR, gr. 53 / Granstrem 81 (Diktyon 57123); and New York, Morgan Library and Museum, MS M. 652 (Diktyon 46634).[16] These codices were

probably produced in the last quarter of the ninth century or in the beginning of the tenth.

The canonic minuscule bouletée is distinguished by relatively large, rounded letters that are vertical or have a slight inclination to the left. Most letters can be inscribed in a circle or square, and upper and lower strokes are significantly reduced and end with tiny bulges. The letters are widely spaced, creating the impression of airiness. The best examples of this style are BnF, gr. 70 (Diktyon 49631) and gr. 139 (Diktyon 49706).[17]

The minuscule bouletée élancée has many characteristics of the canonic bouletée, but in bouletée élancée, the letters are smaller, and the upper and lower strokes of many letters, especially zetas, phis, and xis, are elongated. Chronologically, bouletée élancée probably precedes canonic bouletée because it has many characteristics of earlier writing styles. For example, small size and bulges at the ends of the strokes resemble minuscule pre-bouletée of such manuscripts as BNM, gr. Z 538 (Diktyon 70009), copied in 904/905 CE, and GIM, Sinod. gr. 103/Vladimir 100 (Diktyon 43728), attributed to the end of the ninth century or the beginning of the tenth.[18]

The minuscule of DO MS 6 has all the characteristics of bouletée élancée: it is small and vertical, most letters are rounded, and the upper and lower strokes of many letters are elongated, especially deltas, epsilons, etas, zetas, lambdas, xis, and phis (Fig. 3).

Small bulges at the end of strokes of many letters are frequent, especially at the end of strokes of majuscule lambdas. The bottom stroke of the letters zeta, phi, and xi ends with a small hook. After eta or upsilon,

12 Agati, *La minuscola "bouletée"*, 1:201–42.

13 See detailed paleographic analysis of EBE, 2641 in N. Kavrus-Hoffmann, "Lost and Found Folios of Codex Athens, National Library of Greece 2641: Philadelphia, Free Library, Fragment Lewis E 251," *RSBN* 42 (2005): 93–104.

14 K. Lake and S. Lake, *Dated Greek Minuscule Manuscripts to the Year 1200*, vol. 2 (Boston, 1934), vol. 2: pls. 98–99, MS no. 54, and L. T. Lefort and J. Cochez, *Palaeographisch album van gedagteekende grieksche minuskelhandschriften uit de IXe en Xe eeuw* (Leuven, 1943), pl. 32.

15 On minuscola antica oblunga, see E. Follieri, "La minuscola libraria dei secoli IX e X," in *Paléographie grecque et byzantine*, 139–65, esp. 144, repr. in E. Follieri, *Byzantina et italogreca: Studi di filologia e di paleografia*, ed. A. A. Longo, L. Perria, and A. Luzzi, Storia e letteratura 195 (Rome, 1997), 205–48. On minuscule pre-bouletée, see Follieri, "La minuscola libraria," 145–46, and N. Kavrus-Hoffmann, "From Pre-Bouletée to Bouletée: Scribe Epiphanios and the Codices Mosq. Synod. gr. 103 and Vat. gr. 90," in *The Legacy of Bernard de Montfaucon: Three Hundred Years of Studies on Greek Handwriting; Proceedings of the Seventh International Colloquium of Greek Palaeography (Madrid–Salamanca, 15–20 September 2008)*, 2 vols., ed. A. Bravo García and I. Pérez Martín, Bibliologia 31A, 31B (Turnhout, 2010), 31A:55–66, 31B:693–700.

16 On Beratinus 2 and NLR, gr. 53, see A. Džurova, *Manuscrits grecs enluminés des Archives Nationales de Tirana (VIe–XIVe siècles): Études*

choisies, Scriptorium Balcanicum 1 (Sofia, 2011), 1:23–41, 2: pls. 11–31, and N. Kavrus-Hoffmann, "Producing New Testament Manuscripts in Byzantium: Scribes, Scriptoria, and Patrons," in *The New Testament in Byzantium*, ed. D. Krueger and R. S. Nelson, Dumbarton Oaks Byzantine Symposia and Colloquia (Washington, DC, 2016), 117–45, at 128–32, figs. 5.6–5.7. On MS M. 652, see N. Kavrus-Hoffmann, "Catalogue of Greek Medieval and Renaissance Manuscripts in the Collections of the United States of America, Part IV.2: The Morgan Library and Museum," *Manuscripta* 52:2 (2008): 207–324, esp. 212–30.

17 On the codices BnF, gr. 70 and 139, see Agati, *La minuscola "bouletée"*, 1:118–21, 2: pls. 3, 72, 73.

18 On the codex BNM, gr. Z 538, see Lefort and Cochez, *Palaeographisch album*, pl. 14. On the codex GIM, Sinod. gr. 103/Vladimir 100, see Kavrus, "'Almaznoe' pis'mo," 192–94, pl. 1, and Kavrus-Hoffmann, "From Pre-Bouletée to Bouletée."

Fig. 3.
DO MS 6, fol. 128r.
Luke 13:29–34.

a b c

Fig. 4.
DO MS 6. Distinctive letters:
(a) lambda, fol. 15r; (b) zeta,
fol. 9r; and (c) an ancient form
of nu in τὴν, fol. 10r.

the scribe often uses an ancient form of nu, which resembles an open omega (Fig. 4). Many majuscule forms of letters are incorporated into the minuscule: gamma (rarely); delta (occasionally); narrow epsilon (frequently); kappa, which consists of two parts (frequently); lambda, either with a straight oblique stroke or a curved one (frequently); nu (occasionally; mostly at the end of a line); and lunate sigma, which occasionally incorporates a following vowel. Diacritics are small; both smooth and rough breathing marks are angular. In general, the script of DO MS 6 is formal, controlled, and professional.

The chapter titles were written by the scribe in the top margins in large, elongated, and calligraphic

Fig. 5.
DO MS 6, fol. 4v. List
of chapter titles for
Mark 16–32 (ις–λβ').

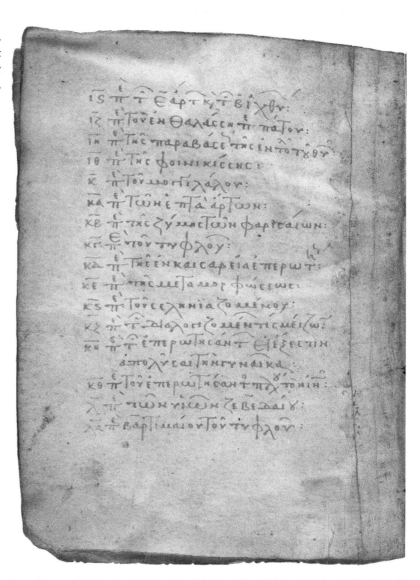

Alexandrian majuscules in bright red ink (Figs. 2–3). The same bright red ink was used in the subscription to the Gospel of Matthew (εὐαγγέλιον κατὰ Ματθαῖον). The subscription was written in large, distinguishing, epigraphic majuscules.[19]

The lists of chapter titles for Mark and Luke were probably inserted in the first half of the twelfth century (Fig. 5).[20] The lists were written by one hand in

Alexandrian majuscules in magenta ink (carmine). The twelfth-century paleographic features include enlarged letters, such as "beach-ball" theta, kappa, and lambda that descends below other letters, as well as enlarged circumflexes (Fig. 6).

The list of chapter titles for Mark was inserted inside the original fourteenth quire as the third and fourth folios, which were glued to the stubs left after the original folios were cut out. The list of chapter titles for Luke was written on a bifolium and inserted between the twenty-second and twenty-fourth quires.

19 On distinguishing, epigraphic majuscules, see H. Hunger, "Epigraphische Auszeichnungsmajuskel: Beitrag zu einem bisher kaum beachteten Kapitel der griechischen Paläographie," *JÖB* 26 (1977): 193–210.

20 The lists of chapter titles for Matthew and John are missing. In the brief auction description of the Benton Gospels, which was

provided by Sotheby's, the lists of chapter titles for Mark and Luke are attributed to an eleventh-century hand.

a b c d

Fig. 6. DO MS 6, fol. 5r. Distinctive letters of the twelfth-century scribe: (a) "beach-ball" theta; (b) kappa; (c) descending lambda; and (d) enlarged circumflex.

The bifolium replaced the twenty-third quire that is now missing.

The scribe of the lectionary tables employed cursive script, which can be attributed to the fifteenth century.

Dating, Origin, and Related Manuscripts

The small minuscule script of DO MS 6 closely resembles scripts of the early tenth-century manuscripts written in early minuscule bouletée—for example, the script of Joseph in EBE, 2641, and the anonymous scribe I in GIM, Sinod. gr. 128/Vladimir 159 (Diktyon 43753).[21] But the exquisite, elongated strokes of many letters of DO MS 6's scribe make the script look fluid and graceful, not static and somewhat rigid as that of the scribe Joseph. DO MS 6 belongs to a separate subgroup of

21 On EBE, 2641 and the scribe Joseph, see Lefort and Cochez, *Palaeographisch album*, pl. 19; Lake and Lake, *Dated Greek Minuscule Manuscripts*, 1: pls. 58, 63; C. Paschou, "Le codex Atheniensis 2641 et le patrice Samonas," *Byzantion* 69.2 (1999): 366–95, figs. 1–8; and Kavrus-Hoffmann, "Lost and Found Folios," 93–104. On the codex GIM, Sinod. gr. 128/Vladimir 159, see Kavrus, "'Almaznoe' pis'mo," 194–96, pls. 2–4, and E. N. Dobrynina, *Svodnyi katalog grecheskikh illiuminovannykh rukopisei v rossiiskikh khranilishchakh: Tom 1; Rukopisi IX–X vv.* (Corpus of Greek illuminated manuscripts in Russian collections, vol. 1, manuscripts of the 9th–10th century at the State Historical Museum, part 1) (Moscow, 2013), 106–19, no. 11a, pls. 81–112.

manuscripts written in early minuscule bouletée: bouletée élancée. DO MS 6 can be confidently attributed to the first half of the tenth century—the relatively short period of time during which minuscule bouletée was developed and flourished. The elegant writing style of the DO MS 6's scribe is free of the artificial mannerism of mature canonic bouletée of such codices as BnF, gr. 70 and 139, and it can be very likely attributed to the first third of the tenth century. The position of the script on the ruled lines also supports the early tenth-century date for this manuscript.

The scribe of DO MS 6 was obviously a professional calligrapher. He displays a highly controlled and uniform script with only a few distinctive features, but they enabled me to identify his hand in several other manuscripts. For example, at the end of a line, the scribe often extends strokes of letters such as alpha, epsilon, eta, and kappa (in an abbreviated form of καί) into the outer margin with a slight curve upward, and in the last line of a page, the scribe sometimes extends the lower-oblique stroke of tachygraphic abbreviations for καί into the bottom margin in a vertical flourish, and he decorates the flourish with a short, wavy, horizontal or oblique line (Fig. 7).

A similar but shorter flourish is sometimes found in the middle of a page. These distinctive features are

a b c d 1 d 2

Fig. 7. DO MS 6. Distinctive letters: extended strokes of (a) alpha, fol. 14v; (b) epsilon, fol. 23r; and (c) eta, fol. 23r; and (d) abbreviated forms of καί, fols. 16r and 15v.

found in several manuscripts, which were likely copied by the same scribe as DO MS 6:[22]

- Berlin, Staatsbibliothek, Phill. 1538 (Diktyon 9439). *Hippiatrica* (Fig. 8). The Berlin codex is attributed to the period of the reign of Constantine VII Porphyrogennetos as sole emperor (945–959).[23] The exceptional elegance and uniformness of the bouletée élancée of the Berlin codex signifies the acme of the career of this gifted scribe. Elina Dobrynina, a Russian art historian, noted that some features of the decoration and script of the Berlin codex look archaic and suggested that "the origin of his activities should be sought in the first quarter of the [tenth] century."[24] The headpieces of the codex Berlin, Phill. 1538 display an artistic design different from that of DO MS 6, but some decorative details are similar, such as a small ciborium on top of the headpiece on fol. 2r (Fig. 9).

- Berlin, Staatsbibliothek, gr. fol. 73 (Diktyon 9163). Gregory of Nazianzos, *Homilies*.[25]

- Mount Athos, Holy Community and Monastery of Stavronikita, 13 (Diktyon 30074), and NLR, gr. 336 / Granstrem 132 (Diktyon 57408). Patristic homilies (Fig. 10).[26]

- Mount Athos, Vatopedi Monastery, 108 (Diktyon 18252). Gregory of Nazianzos, *Homilies*.[27]

- NLR, gr. 331 / Granstrem 176 (Diktyon 57403). Gregory of Nazianzos, *Homilies*, fragment (Fig. 11).[28]

- BAV, Barb. gr. 310, fols. 8r–111v (Diktyon 64853). Scribe I, anacreontic poems.[29]

These are other manuscripts closely related by script to DO MS 6:

- EBE, 413 (Diktyon 2709). Basil the Great, *Homilies*.[30]

- Kalavryta, Megalou Spelaiou Monastery, 1 (Diktyon 36434). Four Gospels. The Kalavryta manuscript is also related to DO MS 6 by decoration (see below, pp. 342–43).[31]

- GIM, Sinod. gr. 99/Vladimir 99 (Diktyon 43724). John Chrysostom, *Homilies*.[32]

- BnF, gr. 713 (Diktyon 50294) and Suppl. gr. 240, fols. 238r–241v (Diktyon 53004). John Chrysostom, *Homilies*. The hand is remarkably similar to that of DO MS 6's scribe, but the form of the letter xi is different.[33]

- BnF, gr. 480 (Diktyon 50054). Basil the Great, *Homilies*. The manuscript is written by the same scribe as the abovementioned codex BnF, gr. 713.[34]

22 My identification of this scribe differs from that of Agati: Agati, *La minuscola "bouletée"*, 1:202–17. The Benton Gospels manuscript (DO MS 6) was not known to Agati.

23 L. Cohn, "Bemerkungen zu den Konstantinschen Sammelwerken," *BZ* 9 (1900): 154–60; K. Weitzmann, *Die byzantinische Buchmalerei des 9. und 10. Jahrhunderts* (Berlin, 1935), 16–17, pl. XIX, fig. 104; and Agati, *La minuscola "bouletée"*, 1:212, 215.

24 E. N. Dobrynina, "Illuminated Manuscripts from the Family of the Hippiatrika Codex (Berlin, Staatsbibliothek, Phillipps 1538)," *Scripta & e-Scripta* 14–15 (2015): 365–72, esp. 369, figs. 1–8.

25 D. Harlfinger, ed., *Kleine Handschriftenausstellung am Rande des II. Internationalen Kolloquiums Griechische Paläographie und Kodikologie (Berlin und Wolfenbüttel, 17.–21. Oktober, 1983)* (Wiesbaden, 1983), and Agati, *La minuscola "bouletée"*, 1:214, 2: pl. 145.

26 Weitzmann, *Die byzantinische Buchmalerei*, 19, pl. XXIII, figs. 125–26; Agati, *La minuscola "bouletée"*, 1:214, pl. 144; and Kavrus, "Almaznoe' pis'mo," 198–99, pls. 9–10.

27 Agati, *La minuscola "bouletée"*, 1:202, 2: pl. 138.

28 Kavrus, "'Almaznoe' pis'mo," 198, pls. 7–8, and Agati, *La minuscola "bouletée"*, 1:215. The fragment is from the collection of Porfirii Uspenskii, who left a note that the folios were taken from the manuscript in the "lower library of the Lavra of St. Sabas." Athanasios Papadopoulos-Kerameus identified the parent manuscript as Jerusalem, Library of the Greek Patriarchate, Hagiou Saba, 233 (Diktyon 34489). This identification is recorded in abovementioned publications and in *Pinakes*. The microfilm of Hagiou Saba, 233 is digitized and available on the Library of Congress website. After close examination of the digitized Jerusalem manuscript, I concluded that the St. Petersburg fragment did not originate from the Hagiou Saba, 233.

29 Agati, *La minuscola "bouletée"*, 1:202, 2: pl. 139.

30 Agati, *La minuscola "bouletée"*, 1:217–18, pl. 146, and A. Marava-Chatzinicolaou and C. Toufexi-Paschou, Κατάλογος μικρογραφιών βυζαντινών χειρογράφων τῆς Ἐθνικῆς Βιβλιοθήκης τῆς Ἑλλάδος, Γ΄, Ὁμιλίες πατέρων τῆς ἐκκλησίας καί μηνολόγια 9ου–12ου αιώνα (Athens, 1997), 70–73, no. 6, pls. 84–92.

31 Agati, *La minuscola "bouletée"*, 1:202–3, 2: pl. 140.

32 Kavrus, "'Almaznoe' pis'mo," 200–201, pls. 11–12, and Agati, *La minuscola "bouletée"*, 1:203–4.

33 Agati, *La minuscola "bouletée"*, 1:204–5, pls. 8, 142, 143.

34 Agati, *La minuscola "bouletée"*, 1:204, pl. 7.

Fig. 8. Berlin, Staatsbibliothek, Phill. 1538, fol. 80r. *Hippiatrica*.

Fig. 9. Berlin, Staatsbibliothek, Phill. 1538, fol. 2r, upper part. *Hippiatrica*.

Fig. 10. St. Petersburg, National Library of Russia, gr. 336/Granstrem 132, fol. 2v. Gregory of Nyssa, fragment.

Fig. 11. St. Petersburg, National Library of Russia, gr. 331/Granstrem 176, fol. 2v. Gregory of Nazianzos, *Homilies*, fragment.

- BnF, Coisl. 46 (Diktyon 49188). Basil the Great, *Homilies*.[35]

- Patmos, St. John the Theologian Monastery, 43 (Diktyon 54287). Gregory of Nazianzos, *Homilies*. The hand is very similar to that of DO MS 6's scribe.[36]

- Patmos, St. John the Theologian Monastery, 44 (Diktyon 54288). Gregory of Nazianzos, *Homilies*. The same scribe executed the abovementioned Patmos, St. John the Theologian Monastery, 43.[37]

- Patmos, St. John the Theologian Monastery, 272 (Diktyon 54516). Patristic homilies. The manuscript's bouletée élancée is very similar to that of DO MS 6. It is possible the Patmos, St. John the Theologian

Monastery, 272 was copied by the same scribe as DO MS 6, but without access to the entire manuscript, I cannot make a definite identification.[38]

- BNM, gr. Z 360 (Diktyon 69831). Menologion. The script is very similar to that of DO MS 6's scribe. It is possible this codex was copied by the same scribe as DO MS 6, but without access to the entire manuscript, I cannot make a definite identification.[39]

Decoration

Most of the decoration of DO MS 6 is missing. There is one headpiece to the Gospel of Mark and a decorated initial alpha on fol. 7r (Fig. 12). The headpiece is in the shape of a ciborium. The title of the Gospel is written

35 Agati, *La minuscola "bouletée"*, 1:218–19, pl. 11.

36 Agati, *La minuscola "bouletée"*, 1:205, pl. 9.

37 Agati, *La minuscola "bouletée"*, 1:205, pl. 10.

38 Agati, *La minuscola "bouletée"*, 1:232, pl. 153.

39 Agati, *La minuscola "bouletée"*, 1:219, pl. 12.

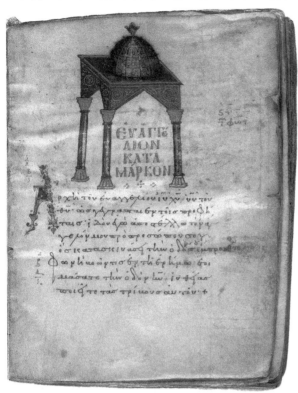

Fig. 12.
DO MS 6, fol. 7r.
Headpiece and
initial alpha.

Fig. 14. DO MS 6, fol. 7r. Initial alpha.

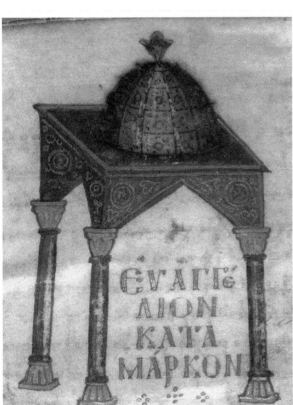

Fig. 13. DO MS 6, fol. 7r, upper part. Headpiece in the shape of a ciborium.

in hollow-bar style: the letters are outlined with red ink and filled with gold ink.

The ciborium consists of a domed canopy supported by three Corinthian columns (Fig. 13). The round bodies of the columns are painted blue and have gold tops and bases. The sides of the canopy are shaped as triangle arches. They are painted dark green and decorated with small, gold patterns, which are concentric circles, single circles, and hearts or heart-shaped leaves. The flat surface of the canopy and the dome are painted purple. The ribbed sides of the dome are decorated with small, gold circles. On the top of the dome is a stylized flower, which is outlined with red ink and filled with dark green and blue pigments and some gold.

The initial alpha is exquisitely executed in hollow-bar style: the letter is outlined with red ink and filled with gold (Fig. 14). The right stroke is oblique (inclined

to the left) and elongated, and a small, stylized flower painted in blue is on top. This flower looks like a diminutive copy of the flower that rests on top of the ciborium's dome. The right stroke is also decorated with a narrow, double line, which is winding and vine-like, and was painted with blue pigment, now partially flaked. A similar winding, vine-like, narrow, double line, which is outlined with red ink and filled with gold, can be found in the decoration of the canon tables in the codex Messina, Biblioteca Regionale Universitaria, F. V. 18, a.k.a. the Dionysios Gospels (Diktyon 40648).[40] The Dionysios Gospels are attributed by Antonio Iacobini and Lidia Perria to the end of the ninth century or beginning of the tenth.

The left stroke consists of a short, horizontal bar and a vertical bar that has a slight inclination to the right. A second horizontal bar forms the letter alpha, and the enclosed space is filled with blue pigment. The blue pigment in the enclosed space was applied sloppily and was probably added later to replace the flaked original blue pigment. The lower ends of the strokes are decorated with small, heart-shaped buds and tendrils in gold and blue. A similar decorative motif is found in the codex Mount Athos, Vatopedi Monastery, 108, which was likely penned by the same scribe who copied DO MS 6.[41]

On fol. 173r, where the Gospel of John begins, there is an offset of a lost headpiece (Fig. 15). The pigment of the headpiece penetrated the folio and imprinted a faint but perceptible image of the headpiece. This headpiece is also in the shape of a ciborium but has a configuration that is different from the headpiece to the Gospel of Mark on fol. 7r: the offset looks like a double arch that rests on four short columns. On the top of the ciborium is a small flower similar to that on fol. 7r. As is common in Byzantine manuscripts, the headpieces differ from each other in details and even in shape or design but adhere to the same artistic scheme. For example, the codex BnF, gr. 70 (the Four Gospels) has four headpieces, all of which are in the shape of ciboria, but each ciborium has a different design.[42]

The ciborium motif in headpieces is relatively rare. It can be found in a handful of manuscripts produced in the first half of the tenth century—for example, BnF, gr. 70; Kalavryta, Megalou Spelaiou Monastery, 1; BNM, gr. I 8 (Diktyon 70104); and Mount Athos, Holy Community and Monastery of Stavronikita, 13. One of the earliest manuscripts with a ciborium headpiece is the codex NLR, gr. 53 / Granstrem 81. This Gospel manuscript was probably produced in the last quarter of the ninth century. It was written entirely in gold on purple parchment with marginal commentaries written in silver ink. The manuscript features early minuscule bouletée, and one of the headpieces is in the shape of a ciborium.[43]

Two other manuscripts were decorated with early-style ciboria: EBE, 211 (Diktyon 2507) and London, British Library, Harley 5540 (Diktyon 39505). The EBE, 211 is written in the ancient elongated minuscule (minuscola antica oblunga) and can be attributed to the end of the ninth century.[44] The Harley manuscript was written in early minuscule bouletée, and the headpiece to the Gospel of Matthew on fol. 4r was probably a rough copy of the ciborium headpiece in NLR, gr. 53.[45]

The following is a list of manuscripts related to DO MS 6 by decoration:

- Kalavryta, Megalou Spelaiou Monastery, 1. Four Gospels. Lists of chapter titles are decorated with ciborium headpieces.[46] The gospel headpieces' decoration is similar to that in BnF, gr. 70.[47] The

40 A. Iacobini and L. Perria, *Il Vangelo di Dionisio: Un manoscritto bizantino da Costantinopoli a Messina*, Milion: Studi e ricerche d'arte bizantina 4 (Rome, 1998), pls. IX, XVIII.

41 Agati, *La minuscola "bouletée"*, 2: pl. 138 (initial tau).

42 Weitzmann, *Die byzantinische Buchmalerei*, figs. 79–82.

43 E. E. Granstrem, "Katalog grecheskikh rukopisei leningradskikh khranilishch: Vypusk 1; Rukopisi IV–IX vekov," *VizVrem* 16 (1959): 236–37; V. D. Likhachova, *Vizantiiskaia miniatiura: Pamiatniki vizantiiskoi miniatiury IX–XV vekov v sobraniiakh Sovetskogo Soiuza/ Byzantine Miniature: Masterpieces of Byzantine Miniature of IXth–XVth Centuries in Soviet Collections* (Moscow, 1977), 13–14, pl. 3; *Katalog grecheskikh rukopisei Rossiiskoi Nazional'noi Biblioteki*, ed. I. N. Lebedeva (St. Petersburg, 2014), 77, no. 79, pl. 4; and Džurova, *Manuscrits grecs enluminés*, 1:25–41, 2: pl. 25. Additional bibliographic references for NLR, gr. 53 can be found in https://pinakes.irht.cnrs.fr/.

44 On the EBE, 211, see Marava-Chatzinicolaou and Toufexi-Paschou, *Κατάλογος*, 24, no. 2, pls. 33, 35. The manuscript is fully digitized, and the headpieces in the shape of ciboria are on fols. 226r and 264r.

45 The Harley 5540 is fully digitized, and the headpiece in the shape of a ciborium is on fol. 4r.

46 Limited access to the digitized microfilm of the Kalavryta manuscript is available on the website of the Institute for New Testament Textual Research at the University of Münster (https://ntvmr.uni-muenster.de/manuscript-workspace?docID=32224).

47 Weitzmann, *Die byzantinische Buchmalerei*, pl. XVII, figs. 89–91, and Agati, *La minuscola "bouletée"*, 1:202–3, 2: pl. 140.

Fig. 15. DO MS 6, fol. 173r, upper part. Offset of the lost headpiece to the Gospel of John.

Kalavryta manuscript is also related to DO MS 6 by script.

- Mount Athos, Dionysiou Monastery, 34 (Diktyon 20002) and NLR, gr. 286 / Granstrem 149 (Diktyon 57358). Four Gospels. The ciborium headpieces are very similar to that in DO MS 6 and to those in Megalou Spelaiou Monastery, 1, and BnF, gr. 70 (Fig. 16a).[48]

- Mount Athos, Iveron Monastery, 27 (Diktyon 23624). Gregory of Nazianzos, *Homilies*. The ciborium headpieces are similar to that in DO MS 6 (Fig. 16b).[49]

- BnF, gr. 70. Four Gospels. The manuscript is written in beautiful canonic bouletée. The ciborium headpieces are very similar to that in DO MS 6 and

to those in Mount Athos, Dionysiou Monastery, 34 (Fig. 16c).[50]

- Mount Athos, Holy Community and Monastery of Stavronikita, 13 and NLR, gr. 336 / Granstrem 132. Patristic homilies. Ciborium headpieces are very similar to that in DO MS 6 and to those in BNM, gr. I 8 (Fig. 16d).

- BNM, gr. I 8. Four Gospels. The ciborium headpieces are very similar to that in DO MS 6 and to those in Mount Athos, Holy Community and Monastery of Stavronikita, 13 (Fig. 16e).[51]

The ciboria in all abovementioned manuscripts are almost identical or so similar that it is reasonable to assume that the same artist decorated these codices.

48 Weitzmann, *Die byzantinische Buchmalerei*, pl. XXXIII, figs. 183–91.

49 Weitzmann, *Die byzantinische Buchmalerei*, pl. XVIII, figs. 99–101, esp. fig. 99, and G. Galavaris, *Holy Monastery of Iveron: The Illuminated Manuscripts* (Mount Athos, 2002), 21–24, figs. 9–12.

50 Weitzmann, *Die byzantinische Buchmalerei*, pl. XV, figs. 78–82, and Agati, *La minuscola "bouletée"*, 1:118–19, pls. 3, 72.

51 Weitzmann, *Die byzantinische Buchmalerei*, pl. XVII, figs. 92–93.

Fig. 16a–e.
Headpieces in the shape of
ciboria in manuscripts related to
DO MS 6: (a) Mount Athos,
Dionysiou Monastery, 34,
fols. 9r, 116r, and 183r, and
St. Petersburg, National Library
of Russia, gr. 286/Granstrem
149, fol. 1r, after Weitzmann, *Die
byzantinische Buchmalerei*,
pl. XXXIII:187–90;
(b) Mount Athos, Iveron
Monastery, 27, fol. 88r, after
Weitzmann, *Die byzantinische
Buchmalerei*, pl. XVIII:99;
(c) BnF, gr. 70, fols. 9r, 110r,
180v, and 305r, after Weitzmann,
Die byzantinische Buchmalerei,
pl. XV:79–82; (d) Mount Athos,
Holy Community and
Monastery of Stavronikita, 13,
fols. 1r and 2r, courtesy Athos
Digital Heritage; and (e) BNM,
gr. I 8, fols. 13r and 3r, after
Weitzmann, *Die byzantinische
Buchmalerei*, pl. XVII:92–93.

a 1

a 2

a 3

a 4

b

c 1

c 2

c 3

d 1

d 2

e 1

e 2

Provenance

DO MS 6 is one of the first biblical manuscripts brought to the United States. It was acquired by the Episcopal missionary Rev. George Benton (1808–1862) in Chania, Crete, and brought by him to the United States in 1844. In 1862 the manuscript was inherited by Benton's son, Angelo Ames Benton (1836–1912), and subsequently by grandchildren William Lane Hall Benton and Elizabeth Ames Benton, who in 1913 donated the manuscript to the General Theological Seminary in New York, NY. The manuscript became known as the Benton Gospels. At the seminary's sale (Christie's, 1 October 1980, lot 137) the manuscript was bought by an American Bible scholar, Dr. Charles Caldwell Ryrie (1925–2016), for his private collection. At his sale (Sotheby's, 5 December 2016), the manuscript was acquired by the Dumbarton Oaks Research Library and Collection.

Bibliography

C. C. Edmunds and W. H. P. Hatch, *The Gospel Manuscripts of the General Theological Seminary,* Harvard Theological Studies 4 (Cambridge, Mass., 1918), 7, 50–68 (contains a full collation of the text and two images); S. De Ricci, with W. J. Wilson, *Census of Medieval and Renaissance Manuscripts in the United States of America and Canada,* 3 vols. (New York, 1935–40), 2:1284 (attributes MS to the eleventh century); K. W. Clark, *A Descriptive Catalogue of Greek New Testament Manuscripts in America* (Chicago, 1937), 83–85 (attributes MS to the tenth century); Kurt Aland, *Kurzgefasste Liste der griechischen Handschriften des Neuen Testaments,* 2nd ed. (Berlin, 1963), 96; *Formatting the Word of God: the Charles Caldwell Ryrie Collection. An Exhibition at Bridwell Library, Perkins School of Theology, Southern Methodist University, October 1998 through January 1999,* ed. V. R. Hotchkiss and Ch. C. Ryrie (Dallas, 1998), 1.2. I omitted the bibliographic references where the manuscript is only briefly mentioned (they can be found in Clark, *A Descriptive Catalogue;* see above).

Concluding Remarks

The end of the ninth century to the first half of the tenth was a period of relative prosperity in Byzantium, the so-called Macedonian Renaissance, and many people of means—clergy, courtiers, administrative bureaucrats, and military officers—wanted to have a personal Bible and created a demand for small-sized Gospel books. At the same time, the manuscripts became more affordable because of the spread of the minuscule script, which enabled a scribe to make a manuscript smaller and therefore produce it faster. DO MS 6 is one of many diminutive Gospel books produced during the Macedonian Renaissance, but a particularly elegant script and ciborium decoration make this manuscript stand out of the crowd. DO MS 6 was probably produced in a Constantinopolitan ergasterion where several scribes and artists created deluxe manuscripts to cater to the changing tastes of their demanding clientele.[52]

DO MS 6 belongs to a small number of Greek manuscripts written in an exceptionally beautiful minuscule script: bouletée élancée. Only about thirty manuscripts written in this script are known to have survived, and they are dispersed throughout the world. This writing style was employed only for a short period, probably in the first third of the tenth century and most likely in Constantinople. To the best of my knowledge, there are no other manuscripts written in bouletée élancée in the libraries of the United States.

DO MS 6 has lost most of its decoration but retains a headpiece in the shape of a ciborium, which is an important example of early Byzantine manuscript illumination. Only a handful of Byzantine manuscripts with this kind of decoration are known; all of them are deluxe manuscripts probably produced in the same Constantinopolitan ergasterion. The ciborium-shaped headpieces were in fashion for a short time during the end of the ninth and the first half of the tenth centuries, and this fashion abruptly disappeared after that period. Although ciboria continue to appear in manuscript illumination, they are mostly found in miniatures as architectural decorations, not as headpieces.[53]

52 On this hypothetical ergasterion, see Kavrus-Hoffmann, "Producing New Testament Manuscripts in Byzantium," 130–39.

53 For example, ciboria are featured in several miniatures in BAV, Vat. gr. 1613, a.k.a. the Menologion of Basil II, created between 976 and 1025 (see the digitized manuscript on the Vatican Library website, esp. pages 14, 61, and 324).

DO MS 7 (Diktyon 8916)

John Chrysostom, *Homilies on the Gospel of Matthew*, 1–44 (CPG 4424). <Constantinople>, the first half or the middle of the ninth century (fols. 2r–272v); <Constantinople>, the last quarter of the thirteenth century or the first quarter of the fourteenths (replacement fols. 1r–v and 273r–274v).

Contents

The Greek text and diacritics are presented in diplomatic transcription except for iota subscriptum, which was not used by the scribe but added here. There are almost no iotacisms in the text, but diacritics are often missing and sometimes erroneous.[54]

Fol. 1r–v (replacement folio): Homily 1. Title: Ὁμιλία Α'. Τοῦ ἐν ἁγίοις π(ατ)ρ(ὸ)ς ἡμῶν Ἰω(άννου) ἀρχ(ι)επισκόπου Κωνσταντινουπό(λεως) τοῦ Χρυσοστόμ(ου)· ἑρμινεία εἰς τὸ κατὰ Ματθαῖον ἅγιον εὐαγγέλιον· ὑπόμνημα ἤτοι προοίμιον. Inc.: Ἔδει μὲν ἡμᾶς μηδὲ δεῖσθαι τῆς ἀπὸ τῶν γραμμάτων βοηθείας...; des.: ...μᾶλλον δὲ εἰς τὸν θρόνον τὸν[. PG 57:13–15, line 30.

Fols. 2r–8v (original ninth-century folios): Inc.:] βασιλικὸν ἀνενεχθείσης·... PG 57:15–24, line 30.

Fols. 8v–15r: Homily 2. Title: Ὁμιλία Β'. Κεφ(άλαιον) α'. Βίβλος γενέσεως Ἰ(ησο)ῦ Χ(ριστο)ῦ υ(ἱο)ῦ Δα(υῒ)δ υ(ἱο)ῦ Ἀββραάμ. Inc.: Ἄρα μέμνησθε τῆς παραγγελίας·... PG 57:23–32.

Fols. 15r–21r: Homily 3. Title: Ὁμιλία Γ'. Κεφ(άλαιον) α'. Βίβλος γενέσεως Ἰ(ησο)ῦ Χ(ριστο)ῦ υ(ἱο)ῦ Δα(υῒ)δ υ(ἱο)ῦ Ἀββραάμ. Inc.: Ἰδοὺ τρίτη διάλεξις. PG 57:31–40.

Fols. 21r–33r: Homily 4. Title: Ὁμιλία Δ'. Κεφ(άλαιον) β'. Πᾶσαι οὖν αἱ γενεαὶ ἀπὸ Ἀββραὰμ· ἕως Δα(υῒ)δ· γενεαὶ δεκατέσσαρες· κ(αὶ) ἀπὸ Δα(υῒ)δ· ἕως τῆς μετοικεσίας Βαβυλῶνος γενεαὶ δεκατέσσαρες κ(αὶ) ἀπὸ τῆς μετοικεσίας Βαβυλῶνος ἕως τοῦ Χριστοῦ γενεαὶ δεκατέσσαρες. Inc.: Εἰς τρεῖς διεῖλεν μερίδας τὰς γενεὰς ἀπάσας·... PG 57:39–54.

54 The references are to *Patrologia Graeca*. On the history of previous editions of the text of these homilies, see J. P. Langan, "The Text of Chrysostom's Homily 46 on Matthew in the Light of the Codex Guelferbytanus" (MA thesis, Loyola University Chicago, 1966), https://ecommons.luc.edu/luc_theses/2153.

Fols. 33r–38r: Homily 5. Title: Ὁμιλία Ε'. Κεφ(άλαιον) Δ'. Τοῦτο δὲ ὅλον γέγονεν ἵνα πληρωθῇ τὸ ῥηθὲν ὑπὸ τοῦ Κ(υρίο)υ διὰ τοῦ προφήτου λέγοντος· ἰδοὺ ἡ Παρθένος ἐν γαστρὶ ἕξει· κ(αὶ) τέξεται υἱὸν· κ(αὶ) καλέσουσιν τὸ ὄνομα αὐτοῦ Ἐμμανουήλ. Inc.: Πολλῶν ἀκούω λεγόντων· ὅτι παρόντες μὲν.... PG 57:55–62.

Fols. 38r–46r: Homily 6. Title: Ὁμιλία Ϛ'. Τίτλο(ς) Α'. Κεφ(άλαιον) Δ'. Τοῦδε Ἰ(ησο)ῦ γεννηθέντος ἐν Βηθλεὲμ τῆς Ἰουδαίας ἐν ἡμέραις Ἡρώδου τοῦ βασιλέως ἰδοὺ μάγοι ἀπὸ ἀνατολῶν παρεγένοντο εἰς Ἱεροσόλυμα λέγοντες· Ποῦ ἐστὶν ὁ τεχθεὶς βασιλεὺς τῶν Ἰουδαίων· εἴδομεν γὰρ αὐτοῦ τὸν ἀστέρα ἐν τῇ ἀνατολῇ κ(αὶ) ἤλθομεν προσκυνῆσαι αὐτῷ. Inc.: Πολλῆς ἡμῖν δεῖ τῆς ἀγρυπνίας· πολλῶν τῶν εὐχῶν... PG 57:61–72.

Fols. 46v–53r: Homily 7. Title: <Ὁμιλία Ζ'. Κεφάλαιον> Δ'. Καὶ συναγαγὼν πάντας τοὺς ἀρχιερεῖς κ(αὶ) γραμματεῖς τοῦ λαοῦ· ἐπυνθάνετο παρ' αὐτῶν ποῦ ὁ Χ(ριστὸ)ς γεννᾶται· οἱ δὲ εἶπον αὐτῷ· ἐν Βηθλεὲμ τ(ῆς) Ἰουδαί(ας). Inc.: Εἶδες ἅπαντα εἰς ἔλεγχον γινόμενα Ἰουδαϊκόν·... PG 57:73–82.

Fols. 53v–58v: Homily 8. Title: Ὁμιλία Η'. Τίτλο(ς) Α'. Κεφάλαιον Ϛ'. Καὶ εἰσελθόντες εἰς τὴν οἰκίαν· εἶδον τὸ παιδίον μετὰ Μαρίας τῆς μητρὸς αὐτοῦ. Inc.: Πῶς οὖν ὁ Λουκᾶς φησὶν ὅτι ἐπὶ τῆς φάτνης κείμενον ἦν·... PG 57:81–90.

Fols. 58v–65r: Homily 9. Title: <Ὁμιλία Θ'>. Τότε Ἡρώδης ἰδὼν ὅτι ἐνεπαίχθη ὑπὸ τῶν μάγων ἐθυμώθη λίαν. Inc.: Καὶ μὴν οὐκ ἐχρῆν θυμωθῆναι ἀλλὰ φοβηθῆναι.... PG 57:89–184.

Fols. 65r–71v: Homily 10. Title: Ὁμιλία Ι'. Τίτλο(ς) Γ'. Κεφά(λαιον) Ζ'. Ἐν ταῖς ἡμέραις ἐκείναις παραγίνεται Ἰωάννης ὁ Βαπτιστὴς κηρύσσων ἐν τῇ ἐρήμῳ τῆς Ἰουδαίας κ(αὶ) λέγων μετανοεῖται ἔγγικεν γὰρ ἡ βασιλεία τῶν οὐρανῶν. Inc.: Ποίαις ἡμέραις ἐκείναις· οὐδὲ γὰρ τότε ἡνίκα παῖς ἦν·... PG 57:183–92.

Fols. 71v–80r: Homily 11. Title: Ὁμιλία ΙΑ'. Τίτλο(ς) Γ'. Κεφ(άλαιον) ἱ'. Ἰδὼν δὲ πολλοὺς τῶν Φαρισαίων κ(αὶ) Σαδδουκαίων ἐρχομένους ἐπὶ τὸ βάπτισμα εἶπεν αὐτοῖς· γεννήματα ἐχιδνῶν τίς ὑπέδειξεν ὑμῖν φυγεῖν ἀπὸ τῆς μελλούσης ὀργῆς. Inc.: Πῶς οὖν φησιν ὁ Χ(ριστὸ)ς ὅτι οὐκ ἐπίστευσαν Ἰωάννη·... PG 57:191–202.

Fols. 80r–85r: Homily 12. Title: Ὁμιλία ΙΒ'. Τίτλος Γ'. Κεφά(λαιον) ΙΓ'. Τότε παραγίνεται ὁ Ἰ(ησοῦ)ς ἀπὸ τῆς Γαλιλαίας εἰς τὸν Ἰορδάνην. Inc.: Μετὰ τῶν δούλων

ὁ Δεσπότης· μετὰ τῶν ὑπευθύνων ὁ Κριτὴς ἔρχεται βαπτισθησόμενος· ... PG 57:201–8.

Fols. 85r–92v: Homily 13. Title: Ὁμιλία ΙΓ΄. Τίτλο(ς) Γ΄. Κεφ(άλαιον) ΙΕ΄. Τότε ὁ Ἰ(ησοῦ)ς ἀνήχθη εἰς τὴν ἔρημον ὑπὸ τοῦ πν(εύματο)ς πειρασθῆναι. Inc.: Τότε πότε· μετὰ τὴν τοῦ πν(εύματο)ς κάθοδον· ... PG 57:207–18.

Fols. 92v–97r: Homily 14. Title: Ὁμιλία ΙΔ΄. Τίτλος Γ΄. Κεφά(λαιον) ΙΗ΄. Ἀκούσας δὲ ὁ Ἰ(ησοῦ)ς ὅτι Ἰωάννης παρεδόθη· ἀνεχώρησεν εἰς τὴν Γαλιλαίαν. Inc.: Τίνος ἕνεκεν ἀνεχώρησεν [ἀναχωρεῖ; in PG] πάλιν· παιδεύων ἡμᾶς. ... PG 57:217–22.

Fols. 97v–110r: Homily 15. Title: <Ὁμιλία ΙΕ΄>. Κεφάλαιον ΚΔ΄. Ἰδὼν δὲ ὁ Ἰ(ησοῦ)ς τοὺς ὄχλους ἀνέβη εἰς τὸ ὄρος· κ(αὶ) καθίσαντος αὐτοῦ προσῆλθον αὐτῷ οἱ μαθηταὶ αὐτοῦ· κ(αὶ) ἀνοίξας τὸ στόμα αὐτοῦ ἐδίδασκεν αὐτοὺς λέγων. Inc.: Ὅρα τὸ ἀφιλότιμον καὶ ἀκόμπαστον· ... PG 57:223–38.

Fols. 110r–122r: Homily 16. Title: Ὁμιλία ΙϚ΄. Τίτλ(ος) Ε΄. Κεφ(άλαιον) <ΛΓ?>.[55] Μὴ νομίσητε ὅτι ἦλθον καταλῦσαι τὸν νόμον τοῦ ἢ τοὺς προφήτ(ας). Inc.: Τίς γὰρ τοῦτο ὑπώπτευσεν· ἢ τίς ἐνεκάλεσεν ... PG 57:237–54.

Fols. 122r–130v: Homily 17. Title: Ὁμιλία ΙΖ΄. Τίτλο(ς) Ε΄. Κεφ(άλαιον) ΛΖ΄. Ἠκούσατε ὅτι ἐρρήθη [ἐρρρέθη in PG] τοῖς ἀρχαίοις· Οὐ μοιχεύσεις· ἐγὼ δὲ λέγω ὑμῖν· ὅτι πᾶς ὁ ἐμβλέπων γυναικὶ προς τὸ ἐπιθυμῆσαι αὐτήν· ἤδη ἐμοίχευσεν αὐτὴν ἐν τῇ καρδίᾳ αὐτοῦ. Inc.: Ἀπαρτίσας τοίνυν τὴν προτέραν ἐντολὴν ... PG 57:255–66.

Fols. 131r–137v: Homily 18. Title: Ὁμιλία ΙΗ΄. Τίτλο(ς) Ε.΄ Κεφά(λαιον) ΛΖ΄. Ἠκούσατε ὅτι ἐρρήθη [ἐρρέθη in PG] ὀφθαλμὸν ἀντὶ ὀφθαλμοῦ· κ(αὶ) ὀδόντα ἀντὶ ὀδόντος· ἐγὼ δὲ λεγω ὑμίν μὴ ἀντιστῆναι τῷ πονηρῷ ἀλλ᾽ οστις σε ραπίσει εἰς τὴν δεξιὰν σιαγόνα στρέψον αὐτῷ κ(αὶ) τὴν αλλην· κ(αὶ) τῷ θέλοντί σοι κριθῆναι κ(αὶ) τὸν χιτωνά σου λαβεῖν άφες αὐτῷ κ(αὶ) τὸ ιμάτιον. Inc.: Ὁρᾷς ὅτι οὐ περι ὀφθαλμου τα προτερα ελεγεν ...[56] PG 57:265–74.

Fols. 137v–147v: Homily 19. Title: Ὁμιλία ΙΘ΄. Τίτλο(ς) Ε΄. Κεφά(λαιον) ΜΒ΄. Προσέχετε τὴν

ἐλεημοσύνην ὑμῶν μη ποιεῖν ἐμπροσθεν τῶν ἀν(θρώπ)ων προς τὸ θεαθῆναι αὐτοῖς. Inc.: Τὸ τυραννικώτερον πάντων λοιπον ἐξορίζει πάθος· ... PG 57:273–86.

Fols. 147v–153v: Homily 20. Title: <Ὁμιλία Κ΄>. Ὅτ᾽ ἂν [Ὅταν in PG] δὲ νηστεύητε· μὴ γίνεσθε ὥσπερ οἱ ὑποκριταὶ σκυθρωποί· ἀφανίζουσιν γὰρ τὰ πρόσωπα ἑαυτῶν [αὐτῶν in PG] ὅπως φανῶσιν τοῖς ἀν(θρώπ)οις νηστεύοντες. Inc.: Καλὸν ἐνταῦθα στενάξαι μέγα καὶ οἰμώξαι [ἀνοιμώξαι in PG] πικρὸν· ... PG 57:285–94.

Fols. 153v–157r: Homily 21. Title: Ὁμιλία ΚΑ΄. Τίτλο(ς) Ε΄. Κεφά(λαιον) ΜΗ΄. Οὐδεὶς δύναται δυσὶν κυρίοις δουλεύειν· ἢ γὰρ τὸν ἕνα μισήσει κ(αὶ) τὸν ἕτερον ἀγαπήσει· ἢ ἑνὸς ἀνθέξεται κ(αὶ) τοῦ ἑτέρου καταφρο(νήσει). Inc.: Ὁρᾷς πῶς κατὰ μικρὸν τῶν ὄντων ἀφίστησιν· ... PG 57:293–300.

Fols. 157v–162v: Homily 22 (the end is missing). Title: Ὁμιλία ΚΒ΄. Τίτλ(ος) Ε΄. Κεφάλαιον ΜΕ΄. Καταμάθετε τὰ κρίνα τοῦ ἀγροῦ πῶς αὐξάνει· οὐ κοπιᾷ οὐδὲ νήθει· λέγω δὲ ὑμῖν ὅτι οὐδὲ Σολομῶν ἐν πάσῃ τῇ δόξῃ αὐτοῦ περιεβάλλετο ὡς ἓν τούτων. Inc.: Εἰπὼν περὶ τῆς ἀναγκαίας τροφῆς ...; des. mut.: ... ἐπιζητεῖ μόνον τοῦτο τὸ πῦρ[. PG 57:299–308; des. mut. at 306, line 49.

Fols. 163r–165v: Homily 23 (most of the homily's text is missing from the beginning). Inc. mut.: <ἄκρι>] βῆ σοι παρέσχον τὴν ἀπο τῶν ἔργων διάγνωσιν. ... PG 57:307–20; inc. mut. at 317, line 4.

Fols. 165v–170v: Homily 24. Title: Ὁμιλία ΚΔ΄. Τίτλο(ς).[57] Κεφά(λαιον) ΝΘ΄. Οὐ πᾶς ὁ λέγων μοι Κ(ύρι)ε Κ(ύρι)ε εἰσελεύσεται εἰς τὴν βασιλείαν τῶν οὐ(ρα)νῶν ἀλλ᾽ ὁ ποιῶν τὸ θέλημα τοῦ Π(ατ)ρ(ό)ς μου τοῦ ἐν ου(ρα)νοις. Inc.: Δια τί μη εἶπεν αλλ᾽ ὁ ποιῶν τὸ θέλημα τὸ ἐμὸν· ... PG 57:321–28.

Fols. 171r–175v: Homily 25. Title: Ὁμιλία ΚΕ΄. Τίτλο(ς). Κεφάλαιον.[58] Καὶ ἐγένετο ὅτε ἐτέλεσεν ὁ Ἰ(ησοῦ)ς τοὺ(ς) λόγους τούτου(ς) ἐξεπλήσσοντο οἱ ὄχλοι ἐπι τῇ διδαχῇ αὐτοῦ. Inc.: Καὶ μὴν ἀκόλουθον ἦν· ἀλγεῖν αὐτοὺς πρὸς τὸ φορτικὸν τῶν εἰρημένων. ... PG 57:327–34.

Fols. 176r–185r: Homily 26. Title: Ὁμιλία ΚϚ΄. Τίτλο(ς). Κεφάλαιον.[59] Εἰσελθόντι δὲ αὐτῷ εἰς Καπερναούμ· προσῆλθεν αὐτῷ ἑκατόνταρχος

55 The number of the chapter is cropped at the top.

56 Note many missing diacritics in this title and the *incipit*. Some diacritics were added by a later hand in brown ink with a grayish tint.

57 A number is not given.

58 Numbers for the Τίτλο(ς) and Κεφάλαιον are not given.

59 Numbers for the Τίτλο(ς) and Κεφάλαιον are not given.

παρακαλῶν αὐτὸν κ(αὶ) λέγων· Κ(ύρι)ε ὁ παῖς μου βέβληται ἐν τῇ οἰκίᾳ παραλελυμένος [παραλυτικὸς in PG]· δεινῶς βασανιζόμενος. Inc.: Ὁ μεν λεπρὸς καταβάντι ἀπο τοῦ ὄρους προσῆλθεν· . . . PG 57:333–44.

Fols. 185r–190r: Homily 27. Title: Ὁμιλία ΚΖ'. Τίτλο(ς) Η'. Κεφάλαιον ΞΖ'. Καὶ ἐλθὼν ὁ Ἰ(ησοῦ)ς εἰς τὴν οἰκίαν Πέτρου· εἶδεν τὴν πενθερὰν Πέτρου [αὐτοῦ in PG] βεβλημένην κ(αὶ) πυρέσσουσαν· κ(αὶ) ἥψατο τῆς χειρὸς αὐτῆς· κ(αὶ) ἀφῆκεν αὐτὴν ὁ πυρετὸς· κ(αὶ) ἠγέρθη κ(αὶ) διεκόνει [sic; διηκόνει in PG] αὐτῷ. Inc.: Ὁ δὲ Μάρκος· κ(αὶ) εὐθέως προσέθηκεν· . . . PG 57:343–50.

Fols. 190r–196v: Homily 28. Title: Ὁμιλία ΚΗ'. Ἐμβάντι δὲ αὐτῷ εἰς τὸ πλοῖον· ἠκολούθησαν αὐτῷ οἱ μαθηταὶ αὐτοῦ· κ(αὶ) ἰδοὺ σεισμὸς [χειμὼν in PG] μέγας ἐγένετο ἐν τῇ θαλάσσῃ· ὥστε καλύπτεσθαι τὸ πλοῖον ὑπο τῶν κυμάτων. Αὐτὸς δὲ ἐκάθευδεν. Inc.: Ὁ μεν Λουκᾶς ἀπαλλάττων ἑαυτὸν τοῦ ἀπαιτηθῆναι. . . . PG 57:349–58.

Fols. 196v–200r: Homily 29. Title: Ὁμιλία ΚΘ'. Τίτλο(ς) ΙΒ'. Κεφ(άλαιον) Ο'. Καὶ ἐμβὰς εἰς τὸ πλοῖον διεπέρασεν κ(αὶ) ἦλθεν εἰς τὴν ἰδίαν πόλιν· κ(αὶ) ἰδοὺ προσέφερον [προσήνεγκαν in PG] αὐτῷ παραλυτικὸν ἐπι κλίνης βεβλημένον· κ(αὶ) ἰδὼν ὁ Ἰ(ησοῦ)ς τὴν πίστιν αὐτῶν. Λέγει [εἶπε in PG] τῷ παραλυτικῷ θάρσει τέκνον ἀφέωνταί σοι αἱ ἁμαρτίαι σου [ἀφέωνταί σου αἱ ἁμαρτίαι in PG]. Inc.: Ἰδίαν αὐτοῦ πόλιν ἐνταῦθα τὴν Καπερναὺμ λέγει· . . . PG 57:357–62.

Fols. 200r–207v: Homily 30. Title: Ὁμιλία Λ'. Τίτλο(ς) ΙΔ'. Κεφά(λαιον) ΟΑ'. Καὶ παράγων ὁ Κ(ύριο)ς [ὁ Ἰησοῦς in PG] ἐκεῖθεν εἶδεν ἀν(θρωπ)ον ἐπι το τελωνιον [corrected to τελωνεῖον by a later hand] καθήμενον Ματθαῖον λεγόμενον. Κ(αὶ) λέγει αὐτῷ ἀκολούθη μοι. Inc.: Ποιήσας γὰρ τὸ θαῦμα [the last three accents were added by a later hand] οὐκ ἔμεινεν· [ἐπέμεινεν in PG] ἵνα μη τὸν ζῆλον ἐξάψῃ. . . . PG 57:361–70.

Fols. 207v–212v: Homily 31. Title: Λόγος ΛΑ' [in top margin by a later hand]. Ταυτα αυτου λαλοῦντος αυτοῖς ἰδοὺ ἄρχων εἰσελθὼ(ν) προσεκύνει αὐτὸν λέγων ἡ θυγάτηρ μου αρτι ἐτελεύτησεν. Ἀλλὰ ἐλθὼν ἐπίθες τὴν χεῖρά σου επ' αὐτὴν κ(αὶ) ζήσεται. Inc.: Κατέλαβεν τοὺς λόγους τὸ ἔργον. Ὥστε πλέον τοὺς Φαρισαίους [a second sigma was added by the scribe above the

iota and middle sigma] ἐπιστομισθηναι· . . . [sic for all diacritics]. PG 57:369–76.

Fols. 212v–218v: Homily 32 (the end is missing). Title: Λόγος ΛΒ'. Καὶ παράγοντι ἐκεῖθεν τῷ Ἰ(ησο)ῦ ἠκολούθησαν δύο τυφλοι κράζοντες κ(αὶ) λέγοντες ἐλέησον ἡμας υἱ(ε) Δα(υὶ)δ· κ(αὶ) ἐλθοντος αὐτοῦ εἰς τὴν οἰκίαν προσηλθον αὐτῷ οἱ τυφλοι κ(αὶ) λέγει αὐτοῖς ὁ Ἰ(ησοῦ)ς πιστεύετε ὅτι δύναμαι τοῦτο ποιῆσαι· λέγουσιν αὐτῷ ναὶ Κ(ύρι)ε· τότε ἤψατο [sic] τῶν ὀφθαλμῶν αὐτῶν λέγων κατα τὴν πίστιν ὑμῶν γενηθήτω ὑμῖν κ(αὶ) ἠνεῴχθησαν [ἀνεῴχθησαν in PG] αὐτῶν οἱ ὀφθαλμοί. Inc.: Τί δήποτε παρέλκει αὐτοὺς κράζοντας· . . .; des. mut.: . . . εἶτα αὐτῆς τὸ ἀξίωμα ἑρμηνεύων ἐπήγαγεν·[. PG 57:377–88; des. mut. at 384, line 29.

Fols. 219r–220v: Homily 33 (most of the homily's text is missing). Inc. mut.:]ἐπειδὴ καὶ παρόντων οὐκ ἐπεθύμει· [αὐτῶν after παρόντων in PG] . . . PG 57:387–98; inc. mut. at 395, line 46.

Fols. 220v–225r: Homily 34. Title: Λόγος ΛΔ'. Ὅταν διώκωσιν ὑμᾶς ἐν τῇ πόλει ταύτῃ φεύγετε εἰς τὴν ἑτέραν· ἀμὴν γὰρ λέγω ὑμῖν οὐ μη τελέσητε τὰς πόλεις τοῦ Ἰ(σρα)ήλ· ἕως ἂν ἔλθη ὁ υἱ(ὸ)ς τοῦ ἀν(θρώπ)ου. Inc.: Εἰπὼν ἐκεῖνα τα φοβερὰ καὶ φρικώδη ἃ καὶ ἀδάμαντα. . . . PG 57:397–404.

Fols. 225r–231r: Homily 35. Title: Λόγος ΛΕ'. Μη νομίσητε ὅτι ἦλθον βαλεῖν εἰρήνην ἐπι τὴν γῆν. Οὐκ ἦλθον βαλεῖν εἰρήνην ἀλλὰ μάχαιραν. Inc.: Πάλιν τα φορτικώτερα τίθησιν καὶ μετα πολλῆς περιουσίας [τῆς περιουσίας in PG]. . . . PG 57:405–12.

Fols. 231r–235v: Homily 36. Title: Λόγος ΛϚ'. Καὶ ἐγένετο ὅτε ἐτέλεσεν διατάσσων [ὁ Ἰησοῦς before διατάσσων in PG] τοῖς δώδεκα μαθηταῖς· μετέβη ἐκεῖθεν τοῦ διδάσκειν καὶ κηρύσσειν ἐν ταῖς πόλεσιν αυτῶν. Inc.: Ἐπειδὴ γὰρ αὐτοὺς ἔπεμψεν ὑπεξήγαγε λοιπὸν ἑαυτὸν· . . . PG 57:413–20.

Fols. 235v–242v: Homily 37. Title: Λόγος ΛΖ'. Τούτων δὲ πορευομένων ἤρξατο ὁ Ἰ(ησοῦ)ς λέγειν τοῖς ὄχλοις περὶ Ἰωάννου· τί ἐξήλθατε [a small epsilon was added by the scribe above alpha; ἐξήλθετε in PG] εἰς τὴν ἔρημον θεασασθαι καλαμον υπο ἀνέμου σαλευόμενον· ἀλλὰ τι ἐξήλθατε [ἐξήλθετε in PG] ἰδεῖν ἄνθρωπον ἐν μαλακοῖς ἱματίοις ἠμφιεσμένον· ἰδοὺ οἱ τα μαλακὰ φοροῦντες ἐν τοῖς οἴκοις τῶν βασιλείων [sic; βασιλέων in PG] εἰσίν· αλλα τί ἐξήλθατε [ἐξήλθετε in PG] προφήτην ἰδεῖν· ναὶ λέγω ὑμῖν κ(αὶ)

περισσότερον προφήτου. Inc.: Τὰ [Τὸ in PG] μὲν γὰρ κατα τοὺς μαθητὰς Ἰωάννου ᾠκονομήθη καλῶς· . . . PG 57:419–28.

Fols. 242v–246r: Homily 38. Title: Λόγος ΛΗ΄. Ἐν ἐκείνῳ τῷ καιρῷ ἀποκριθεὶς ὁ Ἰ(ησοῦ)ς εἶπεν ἐξομολογοῦμαί σοι Π(άτ)ερ Κ(ύρι)ε τοῦ οὐ(ρα)νοῦ κ(αὶ) τῆς γῆς· ὅτι ἀπέκρυψας ταῦτα πάντα ἀπο σοφῶν κ(αὶ) συνετῶν· κ(αὶ) απεκάλυψας αὐτὰ νηπίοις· ναὶ ὁ Π(ατ)ήρ ὅτι οὕτως ἐγένετο εὐδοκία ἔμπροσθέν σου. Inc.: Ὅρα [Ὁρᾷς in PG] δια πόσων αὐτοὺς ἐνάγει εἰς τὴν πίστιν· . . . PG 57:427–34.

Fols. 246v–249v: Homily 39. Title: Λόγος ΛΘ΄. Ἐν εκείνω τῷ καιρῷ ἐπορεύθη ὁ Ἰ(ησοῦ)ς τοῖς σάββασι δια τῶν σπορίμων· οἱ δὲ μαθηταὶ αὐτοῦ [ἐπείνασαν, καὶ before ἤρξαντο in PG] ἤρξαντο τίλλειν τοὺς στάχυας καὶ ἐσθιειν. Inc.: Ὁ δὲ Λουκᾶς φησιν ἐν σαββάτῳ δευτέρῳ πρώτῳ· [δευτεροπρώτῳ in PG] ὅτ᾽ ἂν [ὅταν in PG] διπλῆ ἡ ἀργία ἦ. . . . PG 57:433–38.

Fols. 250r–254r: Homily 40. Title: Λόγος Μ΄. Καὶ μεταβὰς ἐκεῖθεν ἦλθεν εἰς τὴν συναγωγεῖν [συναγωγὴν in PG] κ(αὶ) ἰδοὺ ἄν(θρωπ)ος ἔχων τὴν χεῖρα ξηράν. Inc.: Πάλιν ἐν σαββάτῳ θεραπεύει· ὑπερ τῶν παρα τῶν μαθητῶν γεγενημένων ἀπολογούμενος. . . . PG 57:439–46.

Fols. 254v–258v: Homily 41. Title: Λόγος ΜΑ΄. Εἰδὼς δὲ ὁ Ἰ(ησοῦ)ς τὰς ἐνθυμήσεις αὐτῶν εἶπεν· πᾶσα βασιλεία μερισθεῖσα καθ᾽ ἑαυτῆς ἐρημωθήσεται· καὶ πᾶσα πόλις καὶ οἰκία μερισθεῖσα καθ᾽ ἑαυτῆς οὐ σταθήσεται· κ(αὶ) εἰ ὁ Σατανᾶς τὸν Σατανᾶν ἐκβάλλει ἐφ᾽ ἑαυτον ἐμερίσθη· πῶς οὖν σταθήσεται ἡ βασιλεία αὐτοῦ. Inc.: Καὶ ἤδη τοῦτο κατηγόρησαν ὅτι ἐν τῷ Βεελζεβοὺλ ἐκβάλλει τα δαιμόνια· . . . PG 57:445–52.

Fols. 258v–262v: Homily 42. Title: Λόγος ΜΒ΄. Ἢ ποιήσατε τὸ δένδρον καλὸν καὶ τὸν καρπον αὐτοῦ καλόν· ἢ ποιήσατε τὸ δένδρον σαπρὸν καὶ τὸν καρπον αὐτοῦ σαπρόν· ἐκ γαρ τοῦ καρποῦ τὸ δένδρον γινώσκεται. Inc.: Πάλιν ἑτέρως αὐτοὺς καταισχύνει· καὶ οὐκ ἀρκεῖται τοῖς πρότερον λεχθεῖσι· [προτέροις ἐλέγχοις in PG] . . . PG 57:451–56.

Fols. 262v–268v: Homily 43. Title: Λόγος ΜΓ΄. Τότε ἀπεκρίθησαν αὐτῷ τινὲς τῶν γραμματέων καὶ Φαρισαίων λέγοντες· διδάσκαλε θέλωμεν [θέλομεν in PG] ἀπο σοῦ σημεῖον ἰδεῖν· ὁ δὲ ἀποκριθεὶς εἶπεν· γενεὰ πονηρὰ καὶ μοιχαλὶς σημεῖον ἐπιζητεῖ καὶ σημεῖον οὐ δοθήσεται αὐτῇ εἰ μη τὸ σημεῖον Ἰωνᾶ. Inc.: Ἄρα τι

γένοιτο ἂν τούτων ἀπο<?>τότερον [should be ανοητότερον] μᾶλλον δὲ ἀσεβέστερον· . . . PG 57:455–64.

Fols. 268v–272v (original ninth-century folios): Homily 44. Title: Λόγος ΜΔ΄. Ἔτι δε αὐτοῦ λαλοῦντος τοῖς ὄχλοις ἰδοὺ ἡ μ(ήτ)ηρ αὐτοῦ καὶ οἱ ἀδελφοὶ αυτου εἱστήκησαν [εἱστήκεισαν in PG] ἔξω ζητοῦντες αὐτῷ λαλῆσαι· εἶπεν δέ τις αὐτῷ· ἰδοὺ ἡ μ(ήτ)ηρ σου καὶ οἱ ἀδελφοί σου ζητοῦσίν σοι λαλῆσαι· ὁ δε αποκριθεὶς εἶπεν· τις ἐστιν ἡ μ(ήτ)ηρ μου καὶ οἱ ἀδελφοί μου· καὶ ἐκτείνας τὴν χεῖρα αὐτοῦ επι τοὺς μαθητὰς αὐτοῦ εἶπεν· ἰδοὺ ἡ μ(ήτ)ηρ μου καὶ οἱ ἀδελφοί μοι· [μου in PG] ὅστις γὰρ ποιήσῃ τὸ θελημα τοῦ Π(ατ)ρ(ὸ)ς μου· αὐτός μου καὶ ἀδελφος καὶ ἀδελφή καὶ μ(ήτ)ηρ ἐστιν. Inc.: Ὅπερ πρώην ἔλεγον ὅτι ἀρετῆς χωρὶς ἅπαντα περιττὰ· . . .; des.: . . . καὶ τὴν τῶν παρόντων ὑπερο[<ψίαν>]. PG 57:463–69, line 57.

Fols. 273r–274v (replacement folios): Inc.: <ὑπερο>] ψίαν· ταῦτ᾽ οὖν ἀκούοντες. . . . PG 57:469, line 57–472.

Physical Description

The manuscript is written on parchment and contains 274 folios. Modern foliation is in pencil in the upper-right corner. There are four modern parchment flyleaves (two at the beginning of the manuscript and two at the end). The folios measure 300–305 × 210–220 mm. The text is written in one column with the written surface of 228–243 × 144–155 mm. The text is written in thirty-three lines with interlinear space of 7 mm. The ruling patterns are Leroy C 01C1a and C 01A1a (Fig. 17).[60] The first letter of the ruling patterns' code (C), the second numeral (1), and a lowercase letter (a) at the end of the code signify that there is one horizontal line in the top margin, which extends only to the right justification line. This horizontal line was cropped on most folios during binding but is clearly visible on fols. 71, 72, 80, and several other folios. In the fourth quire (fols. 25–32) the ruling patterns are 10C1m and 20C1,[61] but it

60 Ernst Gamillscheg and Michel Aubineau have identified DO MS 7's ruling patterns as 00C1 and 00A; these scholars apparently did not notice the horizontal line in the top margins: E. Gamillscheg and M. Aubineau, "Eine unbekannte Chrysostomos-Handschrift (Basel, Universitätsbibliothek, B. II. 25)," *Codices manuscripti* 7.4 (1981): 101–4, esp. 102.

61 Gamillscheg and Aubineau have erroneously identified the ruling patterns in the fourth quire as 020B1 [sic] and 10B1. The code B is

| C 01C1a | C 01A1a | 10C1m | 20C1 | 20D1 |

Fig. 17. DO MS 7. Ruling patterns. Drawings by the author.

Leroy 1 Maniaci 19 Leroy 10

Fig. 18. DO MS 7. Ruling systems. Drawings by the author.

is possible that these ruling patterns originally included an additional horizontal line in the top margin, which was cropped. If so, these patterns might have been C 11C1a and C 21C1a. The ruling system is Leroy 1, except for the third, fourth, twenty-third, twenty-fourth, twenty-seventh, thirtieth, and thirty-first quires, where the ruling system is Maniaci 19, and the thirty-third quire, where the ruling system is Leroy 10 (Fig. 18).[62]

The folios were ruled with dry sharp point. Pricking was mostly trimmed during binding; remaining punctures are in the bottom margins in the shape of small slits or round, apparently made with a knife. The script is positioned on the ruled lines and occasionally across the lines.[63] By my estimate, originally there were thirty-six quires, collation: 1^{-1+1} (fols. 1–8), 2–15^8 (fols. 9–120), 16^{10} (fols. 121–30), 17–20^8 (fols. 131–62), $<21^{8?}>$, 22–28^8 (fols. 163–218), $<29^{8?}>$, 30–35^8 (fols. 219–66), and 36^{8-2+2} (fols. 267–74).[64] The first quire lacks the first original folio, which was replaced at the end of the thirteenth century or in the beginning of the fourteenth; the twenty-first and twenty-ninth quires are missing with loss of text; the thirty-sixth quire lacks the seventh and eighth original folios, which were replaced at the end of the thirteenth century or in the beginning of the fourteenth; all other quires are regular quaternions except for the sixteenth quire, which is a quinion. Original quire signatures are missing; they were likely cropped during rebinding when the folios were heavily trimmed. Non-scribal signatures are in the middle of the bottom margins of fols. 16v, 24v, and 32v (the last folios of the second, third, and fourth quires). The non-scribal signatures were probably added in the fourteenth century; most were cropped during rebinding. The ink is medium brown

used when the horizontal lines extend from the inner edge of a folio to the vertical line(s) in the outer margin; the code C is used when the horizontal lines extend from the inner edge of a folio to the single- or double-justification line. The code A is used when the horizontal lines extend from the inner edge of a folio to the outer edge of a folio.

62 On ruling systems, see Leroy, "Quelques systèmes de réglure des manuscrits grecs"; Sautel, *Répertoire de réglures*; M. Maniaci, "Nuove considerazioni sui sistemi di rigatura: Fra teoria e osservazione," in *Alethes philia: Studi in onore di Giancarlo Prato*, ed. M. D'Agostino and P. Degni (Spoleto, 2010), 489–504; M. Maniaci, "Per una nuova definizione e descrizione dei sistemi di rigatura: Considerazioni di metodo," in *Legacy of Bernard de Montfaucon*, 333–45; and J.-H. Sautel, "Quelques perspectives sur l'étude des systèmes de réglure des manuscrits grecs," *Scriptorium* 72.1 (2018): 3–29.

63 On the significance of positioning of the minuscule script on the ruled lines, see above, n. 4.

64 I have estimated that two quires—the twenty-first (between fols. 162v and 163r) and twenty-ninth (between fols. 218 and 219), probably quaternions—are missing. This estimate is based on my calculations of how many lines of Chrysostom's text in PG fit onto one page of the manuscript.

and light brown with a chestnut tint. The *kalamos* is thin. The quality and thickness of the parchment folios vary. The parchment is smooth, ivory white (flesh side) and yellowish to yellow (hair side); it is not of the best quality but carefully prepared. There are some imperfections (holes and scalloping); the dark hair follicles were thoroughly removed, and some holes were carefully patched. Fol. 213v is left blank because of defective parchment (there is no lacuna between fol. 213r and 214r). Wax stains are on some folios, as well as occasional soiling. Some flaking of text is on fols. 262v–263r and 266v–267r.

In the thirty-first quire, between fols. 229v and 230r, there is a strip of parchment with late twelfth-century or early thirteenth-century writing.[65] A blank stub, which is part of the strip with the writing, is placed between fols. 232v and 233r and is glued to fol. 232v. Evidently, the strip was used for a repair to reconnect a loose folio to the quire. Apparently, DO MS 7 was deemed so valuable that a newer manuscript was used to repair the older one.

Replacement Folios

There are three replacement parchment folios (one in the beginning of the manuscript and two at the end). The text of the replacement folios is written in one column with the written surface of 222 × 140–143 mm. The text is written in thirty-four lines with interlinear space of 7 mm. The ruling pattern is Leroy 20D1. The script is suspended from the ruled lines. The parchment of these folios is thick and smooth; the contrast between the white flesh side and yellow hair side is pronounced; dark hair follicles are visible on fols. 273r and 274v. The replacement folios, which were inserted in the first and last quires, do not follow the so-called Gregory's rule of quire composition, which stipulates that the flesh side should face the flesh side, the hair side should face the hair side, and the flesh side should be on the outside of a quire. Therefore, a quire and a manuscript usually begin and end with a flesh side on the

outside, which prevents folios from curling. Why the restorer did not follow this rule cannot be determined.

Script

The original manuscript was written by a single anonymous scribe. His script is small, clear, and rounded minuscule with slightly elongated upper and lower strokes of many letters (Fig. 19). Although there is a general impression of roundness, the elongated strokes add some angularity to the script. The script is almost upright with a slight inclination to the left. The minuscule is pure; the one exception I found is a majuscule double lambda on fol. 26r in the word ἔμελλεν (the first lambda is at the end of a line, and the second begins the next line). There are some small bulges at the upper end of strokes of some letters, such as eta, iota, and kappa. These bulges are not as pronounced and consistent as those in the minuscule of the manuscripts of the "philosophical collection" (attributed by scholars to the middle or to the third quarter of the ninth century) and those in the minuscule of the manuscripts written in minuscule pre-bouletée and bouletée (dated or attributed to the last quarter of the ninth century and to the first half of the tenth century, respectively).[66] The scribe

65 Because the number of fragmented words is insufficient, I was not able to identify the text. One word on the strip, ἐθρήνει (*imperfectum indicativi activi* of θρηνέω), is a relatively rare form, which is registered in only 255 instances in TLG. In twenty-four of these instances, this form is found in works by Chrysostom, so it is possible the strip was taken from a different Chrysostom manuscript to repair DO MS 7.

66 On the manuscripts of the philosophical collection, see T. W. Allen, "Palaeographica III: A Group of Ninth-Century Greek Manuscripts," *JPh* 21.41 (1893): 48–55; Follieri, "La minuscola libraria," 139–65, esp. 145f, pls. 6a–6c; B. L. Fonkič, *Scriptoria* bizantini: Risultati e prospettive della ricerca," *RSBN* 17–19 (1980–1982): 73–118, at 93–99; L. Perria, "Scrittura e ornamentazione nei codici della 'collezione filosofica,'" *RSBN* 38 (1991): 45–111; L. Perria, "Alle origini della minuscola libraria greca: Morfologia e stilizzazioni," in *I manoscritti greci tra riflessione e dibattito: Atti del V Colloquio Internazionale di Paleografia Greca (Cremona, 4–10 ottobre 1998)*, ed. G. Prato, Papirologica Florentina 31 (Florence, 2000), 1:157–67, 3: pls. 13–14; A. Cataldi Palau, "Un nuovo codice della 'collezione filosofica': Il palinsesto *Parisinus graecus* 2575," *Scriptorium* 55.2 (2001): 249–74; M. Rashed, "Nicolas d'Otrante, Guillaume de Moerbeke et la 'collection philosophique,'" *StMed*, 3rd ser., 43 (2002): 693–717; G. Cavallo, "Da Alessandria à Costantinopoli? Qualche riflessione sulla 'collezione filosofica,'" *Segno e testo* 3 (2005): 249–63; G. Cavallo, "Qualche riflessione sulla 'collezione filosofica,'" in *The Libraries of the Neoplatonists: Proceedings of the Meeting of the European Science Foundation Network "Late Antiquity and Arabic Thought: Patterns in the Constitution of European Culture" Held in Strasbourg, March 12–14, 2004 under the Impulsion of the Scientific Committee of the Meeting, Composed by Matthias Baltes, Michel Cacouros, Cristina D'Ancona, Tiziano Dorandi, Gerhard Endreß, Philippe Hoffmann, Henri Hugonnard Roche*, ed. Cristina D'Ancona (Leiden, 2007), 155–65; D. Marcotte, "Le corpus géographique de Heidelberg (*Palat. Heidelb. gr.* 398) et les origines de la 'collection philosophique,'" in *The Libraries of the*

Fig. 19. DO MS 7, fol. 89r. The hand of the ninth-century scribe.

of DO MS 7 used a pen that distributed ink unevenly, and the transition from the pen full of ink to the almost empty one is clearly visible. When the pen was full of ink, small, rounded letters such as alpha and omicron

as well as upper loops of the letters delta and phi were often filled with ink (Fig. 20a–b).

The script can be characterized as a hybrid between the so-called Nikolaos style and *minuscola antica rotonda* (ancient rounded minuscule).[67] Distinctive letters and ligatures include minuscule kappa, which sometimes is written with a single stroke of a pen (Fig. 20c) and sometimes has an ancient form and consists of two strokes: a tall vertical stroke similar to iota, to which a rounded short stroke is attached (Fig. 20d). Double gamma is in the shape of a "w" (Fig. 20e). Minuscule double lambda has two forms (Fig. 20f). Double tau has an ancient form, in which the second tau resembles gamma (Fig. 20g). Zeta and xi have various forms (Figs. 20h–i). An alpha at the end of a line

Neoplatonists, 167–75; F. Ronconi, "Il Palat. Heid. gr. 398: Un miscellaneo nella 'collezione filosofica,'" in F. Ronconi, *I manoscritti greci miscellanei: Ricerche su esemplari dei secoli IX–XII* (Spoleto, 2007), 33–75, figs. 1–15; N. Kavrus-Hoffmann, "Cataloguing Greek Manuscripts in the Collections of the USA: New Findings and Identifications," in B. Atsalos and N. Tsironi, eds., *Πρακτικά του ς' Διεθνούς Συμποσίου Ελληνικής Παλαιογραφίας (Δράμα, 21–27 Σεπτεμβρίου 2003)/Actes du VIᵉ Colloque International de Paléographie Grecque (Drama, 21–27 septembre 2003)* (Athens, 2008), 2:809–14; N. Kavrus-Hoffmann, "Catalogue of Greek Medieval and Renaissance Manuscripts in the Collections of the United States of America: Part V.3; Harvard University, the Houghton Library and Andover-Harvard Theological Library," *Manuscripta* 55.1 (2011): 1–108, at 17–29; F. Ronconi, "La collection philosophique: Un fantôme historique," *Scriptorium* 67 (2013): 119–40; and D. Bianconi and F. Ronconi, eds., *La "collection philosophique" face à l'histoire: Péripéties e tradition*, Miscellanea 22 (Spoleto, 2020). On the minuscule pre-bouletée and bouletée, see above, nn. 7, 8, 9, and 13.

67 The term "hybrid style" was proposed by Santo Lucà: S. Lucà, "Osservazioni codicologiche e paleografiche sul Vaticano Ottoboniano greco 86," *BollGrott* 37 (1983): 105–46, esp. 121–22, pls. 1–18. On the Nikolaos style and minuscola antica rotonda, see Follieri, "La minuscola libraria," 143–44.

Fig. 20. DO MS 7. Distinctive letters and ligatures: (a) alpha, fol. 10v; (b) phi, fol. 4r; (c) kappa, fol. 4r; (d) kappa, fol. 225r; (e) double gamma, fol. 6r; (f) double lambda, fols. 225r and 231r; (g) double tau, fol. 4r; (h) zeta (two forms), fols. 231r and 232r; (i) xi (three forms), fols. 21r, 232r, and 236r; (j) tau and alpha, fol. 157v; (k) αὐτῶ[ν], fol. 161r; (l) epsilon and sigma, fols. 232r and 172r; (m) καί, fols. 21r, 231r, and 21r; and (n) epsilon and rho, fol. 52v.

sometimes is attached to the preceding consonant letter and is written above it (Fig. 20j). A nu at the end of a line is occasionally abbreviated; the abbreviation is marked with a short horizontal line, which has small hooks at the ends (Fig. 20k). Some letters at the end of a line have an elongated horizontal flourish, especially epsilon and sigma (Fig. 20l). Tachygraphic abbreviation for καί is usually in the shape of a zigzag with a small hook at the bottom but sometimes consists of a vertical line and a zigzag (Fig. 20m). Occasionally, ligature epsilon-rho is written in the shape of an *as de pique*, especially in marginal notes (Fig. 20n). This ligature is commonly found in papyri and in early minuscule.

Diacritics are small; both smooth and rough breathings are angular. Grave accents are shorter than acute ones. Diaeresis is used above iotas and upsilons. Nomina sacra are abbreviated; the abbreviations are marked with a simple short horizontal line, which sometimes has small hooks at the ends. Punctuation marks are *ano teleia, koronis,* and periods; semicolons (Greek question marks) are not used.

Accents and breathings are irregular and often missing, especially above prepositions and auxiliary words such as ἀπό, δέ, ἐπί, μετά, πρός, τίς, ὑπό, but also above some ordinary words. These irregularities are indications of an early minuscule, probably of the first half of the ninth century, the time of transition from the majuscule script, which utilized diacritics only sporadically, to the minuscule script, which became fully equipped with diacritics by the end of the ninth century except for iota subscript (the use of iota subscript was not established until the twelfth century).[68] Scribes of some early ninth-century minuscule manuscripts employed diacritics irregularly—for example, scribe II of BAV, Vat. Ottob. gr. 86 (Diktyon 65327), attributed by Lucà to the first half of the ninth century and identified by him as a product of the Stoudios scriptorium.[69]

The titles of the homilies and citations from the Gospels are written in Alexandrian distinguishing majuscules in the same ink as the main text.[70] This distinguishing script is only slightly larger than the minuscule script of the main text.

Scripts similar to that of DO MS 7 can be found in manuscripts such as London, British Library, Arundel 532 (scribe Nikephoros; Diktyon 39283); Mount Athos, Karyes, Library of the Protaton, 18 (Diktyon 18047); Munich, Bayerische Staatsbibliothek, gr. 331 (scribe I; Diktyon 44779) and gr. 457 (Diktyon 44905); Patmos, St. John the Theologian Monastery, 742 (Diktyon 54980); BnF, Coisl. 347 (Diktyon 49488); NLR, gr. 219 (scribe Nikolaos, ca. 835; Diktyon 57291); BAV, Vat. gr. 2079 (Diktyon 68709), Vat. Ottob. gr. 86, and Vat. Palat. gr. 123 (Diktyon 65855); BNM, gr. Z 99 (Diktyon 69570); and ÖNB, Phil. gr. 100 (Diktyon 71214) and Theol. gr. 108 (Diktyon 71775).[71]

Script of Replacement Folios

The replacement folios (fols. 1r–v and 273r–274v) were written by a single scribe, who restored the lost or damaged original folios. The title on fol. 1r is written in vertical Alexandrian distinguishing majuscules. The word ΌΜΙΛΊΑ Α′ is written in large and vertical epigraphic distinguishing majuscules in the top margin.[72] The script of the replacement folios is a medium-size, vertical, archaizing minuscule of the end of the thirteenth century or the first half of the fourteenth.[73] The scribe of the replacement folios was obviously an

68 On dating early Greek minuscule manuscripts, see B. L. Fonkič, "Sulla datazione dei codici greci del secolo IX," in *Legacy of Bernard de Montfaucon*, 31A:37–43.

69 Lucà, "Osservazioni."

70 On the Alexandrian distinguishing majuscules, see above, n. 7.

71 For bibliographic references and links to digitized images of these manuscripts, see https://pinakes.irht.cnrs.fr/. On the codex Munich, Bayerische Staatsbibliothek, gr. 331, see B. Mondrain, "Une écriture cursive grecque inconnue du Xᵉ siècle dans le manuscrit de Munich gr. 331," *Scriptorium* 54.2 (2000): 252–67, pls. 42–45. On the codex Munich, Bayerische Staatsbibliothek, gr. 457, see L. Perria, "Paleographica," *RSBN*, n.s. 37 (2000): 43–72, pls. 1–4; on BAV, Vat. Ottob. gr. 86, see Lucà, "Osservazioni."

72 On epigraphic distinguishing majuscules, see above, n. 19.

73 On the archaizing minuscule, see G. Prato, "Scritture librarie arcaizzanti della prima età dei Paleologi e loro modelli," *Scrittura e civiltà* 3 (1979): 151–93, pls. 1–20, repr. in G. Prato, *Studi di paleografia greca* (Spoleto, 1994), 73–114, pls. 1–24; G Prato, "I manoscritti greci dei secoli XIII e XIV: Note paleografiche," in *Paleografia e codicologia greca: Atti del II colloquio internazionale (Berlino-Wolfenbüttel, 17–21 ottobre 1983)*, ed. D. Harlfinger and G. Prato with M. D'Agostino and A. Doda (Alexandria, 1991), 1:131–49, 2: pls. 1–16, repr. in Prato, *Studi di paleografia greca*, 115–31, pls. 1–24; H. Hunger and O. Kresten, "Archaisierende Minuskel und Hodegonstil im 14. Jahrhundert," *JÖB* 29 (1980): 187–236; G. De Gregorio and G. Prato, "Scrittura arcaizzante in codici profani e sacri della prima età paleologa," *Römische historische Mitteilungen* 45 (2003): 59–101; and I. Pérez Martín, "El 'estilo Hodegos' y su proyección en las escrituras constantinopolitanas," *Segno e testo* 6 (2008): 389–458, repr. in Πρακτικά, 1:71–130.

Fig. 21.
DO MS 7, fol. 1r. The
hand of the restorer
(the last quarter of the
thirteenth or the first
quarter of the
fourteenth century).

accomplished calligrapher, who probably worked in Constantinople (Fig. 21).

Paleographic features of the archaizing script of the replacement folios include enlarged majuscule epsilons, zetas, and kappas. Majuscule deltas are flattened (Fig. 21, line 4 of the main text). Some majuscule zetas are in the shape of an upper part of a question mark, which is common in the archaizing minuscule of the end of the thirteenth century and throughout the fourteenth. The minuscule zetas are in the shape of the number "3" and are enlarged. Closed forms of theta are somewhat enlarged and have a straight inner horizontal

line, which is usually placed in the lower part of the oval body (Fig. 21, lines 2, 6, 7). The lower strokes of majuscule lambdas descend below the line (Fig. 21, lines 2, 3, 4). Taus are often tall (Fig. 21, line 3). Some upsilons are also enlarged and are in the shape of a shallow bowl (Fig. 21, lines 10, 11 *ab imo*). Some letters are "glued" together—for example, phi and theta on fol. 1v. At the end of a line, strokes of many letters are elongated and extend to the right margin, especially the upper stroke of sigma.

Diacritics are regular. Breathings are small and rounded. Acute and grave accents are of medium size,

Fig. 22. DO MS 7, fol. 80r. Division bar.

and they are almost upright. Circumflexes are enlarged and are in the shape of an arc. Contraction signs over *nomina sacra* are in the form of a straight line or tilde.

Similar archaizing scripts can be found in many manuscripts produced at the end of the thirteenth century or in the first half of the fourteenth—for example, Florence, Biblioteca Medicea Laurenziana, Plut. 11, 22 (Diktyon 16176), which was copied by the *presbyteros* Strategios in 1285; the so-called Smyrna Lectionary, which was copied by the monk David in 1298;[74] Ann Arbor, Mich. Ms. 34 (Diktyon 891), probably copied by the same monk David; London, British Library, Add. MS 29714 (Diktyon 39083), copied in 1305/1306 by the scribe Ignatios; Rome, Biblioteca Vallicelliana, F 17 (Diktyon 56337), copied by the priest Michael Kalothetos in 1330; EBE, 2251 (Diktyon 4283); Oxford, Bodleian Library, Canon. gr. 84 (Diktyon 47634); BnF, gr. 2948 (Diktyon 52588) and Coisl. 311 (Diktyon 49452); and BAV, Vat. gr. 1302 (Diktyon 67933).[75] All these manuscripts are either part of the so-called Palaiologina group or are closely related to this group.[76]

The manuscripts of the Palaiologina group were produced in Constantinople for the members of the elite of Byzantine society. Many of these manuscripts are of deluxe quality and richly illuminated, but some are not decorated, especially those with secular content. In the view of Inmaculada Pérez Martín, the manuscripts of the Palaiologina group were produced in the Hodegon Monastery in Constantinople, and the archaizing writing style of these manuscripts was the first step in the development of the "Hodegon writing style" of the fourteenth century.[77] Pérez Martín's identification of the main scribe of the Palaiologina group as the monk David corroborates her hypothesis.

Decoration

The original decoration is minimal and purely functional. The beginning of each homily is marked with a cross. Narrow division bars separate homilies (Fig. 22). The bars are made of small zigzag or triangular patterns and are flanked on both sides by small heart-shaped leaves and/or small diagonal crosses with a horizontal bar or dots (❋). The bars were obviously drawn by the scribe himself with the ink of the main text. Most initials are written in minuscule and not ornamented; they are slightly enlarged and placed in the margins. Only two initials, at the beginning of homilies ten (fol. 65r) and fifteen (fol. 97v), are enlarged and slightly pen-ornamented (Fig. 23).

74 The scribe-monk David is listed in M. Vogel and V. Gardthausen, eds., *Die griechischen Schreiber des Mittelalters und der Renaissance*, Beiheft zum Zentralblatt für Bibliothekswesen 33 (Leipzig, 1909, repr. 1966), 100, and in *PLP* 3: no. 5013. The current location of the Smyrna Lectionary is not known, and it is presumed to be lost. Several images from this manuscript were preserved and published in S. Papadakis-Oekland, "Οι μικρογραφίες ενός χαμένου χειρογράφου του 1298," Δελτ. Χριστ.Άρχ.Ετ. 8 (1975–76): 29–54, pls. 14–39.

75 For bibliographic references and links to digitized images of these manuscripts, see https://pinakes.irht.cnrs.fr/.

76 On the Palaiologina group, see H. Buchthal and H. Belting, *Patronage in Thirteenth-Century Constantinople: An Atelier of Late Byzantine Book Illumination and Calligraphy* (Washington, DC, 1978), 95; Fonkič, "*Scriptoria* bizantini," 113–16; K. Maxwell, "Another Lectionary of the 'Atelier' of the Palaiologina, Vat. gr. 352," *DOP* 37 (1983): 47–53; R. S. Nelson and J. Lowden, "The Palaeologina Group: Additional Manuscripts and New Questions," *DOP* 45 (1991): 59–68; "Byzantine Studies Conference Archives: Twenty-Sixth Annual

Byzantine Studies Conference; Harvard University, Cambridge, Massachusetts: October 26–29, 2000 Harvard University," Byzantine Studies Association of North America, Inc., https://bsana.net/conference/archives/2000/abstracts_2000.php; I. Hutter, "Schreiber und Maler der Palaiologenzeit in Konstantinopel," in Πρακτικά, 2:159–90; and Pérez Martín, "El 'estilo Hodegos,'" 1:94–111, 3:950–77, esp. 950–55.

77 Pérez Martín, "El 'estilo Hodegos.'"

Fig. 23.
DO MS 7. Initials
(a) pi, fol. 65r; and
(b) omicron, fol. 97v.

a b

Fig. 24. DO MS 7. Connective signs. Drawings by the author.

Decoration of the Replacement Folio

Replacement folio 1r, which begins the manuscript, features a narrow headband and a slightly pen-floriated initial epsilon (Fig. 21). The headband measures 142 × 7 mm, and the initial is 32 mm tall. The headband was executed in the hollow style: that is, the ornament is left blank, and the background is colored. The ornament consists of an undulating vegetal garland. The headband has small teardrop finials at the four corners. The headband was almost certainly created by the scribe of the replacement folios, who used pale, pinkish-brownish ink for the headband, initial, and title. This kind of pale, pinkish-brownish ink was popular at the end of the thirteenth century and the first half of the fourteenth and was used for the simple decoration of manuscripts that lack elaborate illumination.

Colophon

None.

Marginalia

Throughout the manuscript, one finds numerous glosses, comments, corrections, and variant readings, most of which are by the hand of the main ninth-century scribe. Quotation marks indicate biblical passages. The scribe used several different connective signs to link marginalia to a particular place in the main text.[78] The sign ⁒ was most frequently used. The other connective signs are pictured on Fig. 24.

On several folios, the main scribe wrote σημείωσαι (*nota bene*), ὡραῖον (beautiful/fine or useful), and occasionally χρηστός (useful). These words were usually written in an abbreviated form in the margins. The scribe also indicated dogmatic and ethical (moral) passages by writing the words δογμα(τικός) [λόγος] and ἠθ(ι)κό(ς) [λόγος], and he added some comments in the margins. Many comments on top margins were cropped. In the margin of fol. 258r the main scribe wrote: ση(μείωσαι) φοβερόν (nota bene: frightening), thereby marking the passage about burning in hell if one neglected poor people.

Some marginal notes were written in informal, slanted cursive by a different contemporaneous scribe, who used a sharper pen and lighter ink. Some of this scribe's marginalia begin with the words "ἐν ἄλλῳ <sc. βιβλίῳ>," i.e., "in other <sc. manuscript>"—for

78 The connective signs in the early Greek minuscule manuscripts have not been systematically studied. On this subject, see B. Atsalos, "Les signes de renvoi dans les manuscrits grecs," in *Paleografia e codicologia greca*, 1:211–31, and Perria, "Scrittura e ornamentazione."

example, on fols. 111v, 120v, 179r, 185r, 198r, 200r, 201v, 202r, 202v, and 209v. These marginalia indicate that this scribe had a second manuscript in front of him, and he was comparing the texts. Some σημείωσαι signs were also written by this second scribe.

At the beginning of each homily a later hand (fifteenth century?) added the word φύλλ(α) and a Greek letter-numeral to indicate how many folios a particular homily occupies. This word and the number are written in the outer margin next to the title of a homily in grayish-brown ink.

There are lection notes in bright-red ink throughout the manuscript. They were written at a later date, probably in the second half of the fourteenth century or the beginning of the fifteenth. The lection notes indicate days of the week when a lection should be read, and they mark αρχή (the beginning of reading) and τέλος (the end of reading).

Binding

The manuscript was probably rebound twice: once at the end of the thirteenth century or the beginning of the fourteenth, when the original binding together with the first and last two folios was replaced. The restoration was probably done in Constantinople, possibly in the Hodegon Monastery. The second rebinding was done circa 1900 in England by a British bookbinder, Douglas Cockerell. The cover consists of thick oak boards, quarter bound with morocco leather, which is blind stamped with Arts & Crafts ornament. Two woven leather straps are at the back cover, and two metal catches are in the front fore-edge.

Interpretation and Analysis

The writing style of the main scribe of DO MS 7 combines core features of the Nikolaos style and minuscola antica rotonda. This hybrid style indicates that the manuscript was copied in the ninth century. Ernst Gamillscheg and Michael Aubineau have proposed the late ninth-century date for this manuscript and its possible origin in the Studios scriptorium.[79] These scholars' conclusion is based on the similarity of DO MS 7's script with that of Nikolaos of Studios and the similarity of ruling patterns with those in Studite manuscripts BAV, Vat. gr. 1660 (the scribe Ioannes, ca. 916;

Diktyon 68291), 1667 (attributed to the first half of the tenth century; Diktyon 68298), and 1671 (attributed to the first half of the tenth century; Diktyon 68302).

But reliable criteria for dating and localizing ninth-century minuscule manuscripts are sorely lacking. Very few (about ten) manuscripts from that period are securely dated and localized. Only one manuscript from the first half of the ninth century is dated and localized by a scribal colophon—codex NLR, gr. 219, the so-called Uspenskii Gospels, which was written by the scribe and *hegoumenos* of the Studios Monastery, Nikolaos, in 835. The second ninth-century manuscript dated by colophon is Greece, Meteora, Metamorphosis Monastery, 591 (Diktyon 42002), which was written by the monk-scribe Eustathios in 862/63 in the monastery of St. Anna in Bithynia, probably in the Studite metochion. All other securely dated ninth-century manuscripts were produced in the last quarter of the ninth century.

Codex NLR, gr. 219, was written in small, pure minuscule, which is characterized by the angularity of letters and "energetic" letter xi (Nikolaos style). Other manuscripts written in a similar style are, for example, the previously mentioned Patmos, St. John the Theologian Monastery, 742, and BAV, Vat. Ottob. gr. 86 (see above, p. 355). Greece, Meteora, Metamorphosis Monastery, 591, was also written in pure minuscule, which is larger and more angular than that of Nikolaos and with elongated strokes of many letters. The script of the Meteora codex has been characterized by Enrica Follieri as minuscola antica oblunga. Similar scripts can be found in several Studite manuscripts of the second half of the ninth century and the beginning of the tenth—for example, GIM, Sinod. gr. 254/Vladimir 117 (Diktyon 43879), copied by the scribe Athanasios in 880. Follieri views the Nikolaos style and the minuscola antica rotunda as identical writing styles. Lucà, however, sees differences between the two styles and proposes a third term, the "hybrid style," which combines the features of both the Nikolaos style and minuscola antica rotonda.[80] I agree with Lucà that these two writing styles are different, where one is angular and the other is rounded, and that many early ninth-century manuscripts are written in the hybrid style.

79 Gamillscheg and Aubineau, "Eine unbekannte Chrysostomos-Handschrift," 102.

80 Follieri, "La minuscola libraria," 143, and Lucà, "Osservazioni," 119–22.

Unfortunately, none of the manuscripts written in minuscola antica rotonda or the hybrid style are securely dated. Therefore, some other features in addition to the writing styles must be used for dating DO MS 7. One such feature is the pureness of the minuscule, which means that no or almost no majuscule forms of letters were used by the scribe except for the titles or citations. All securely dated manuscripts from the second half of the ninth century and later have majuscule letters inserted into the minuscule. In general, the more majuscule letters are present in the minuscule, the later the date of the manuscript, although attempts to calculate precise correlation have failed.[81] DO MS 7 features pure minuscule, so it is quite likely that this manuscript was produced in the first half of the ninth century.

The second auxiliary feature is the absence or irregularity of diacritics. The importance of this feature for dating a manuscript has been studied in detail by Boris Fonkič, who observes that manuscripts written in early minuscule often have irregular diacritics or lack them altogether.[82] As I observed earlier, in DO MS 7 accents and breathings are irregular and often missing (see above, p. 355), and this feature also points to the first half of the ninth century as the most likely period of DO MS 7's production. Although some manuscripts copied in the second half of the ninth century display irregular diacritics—for example, Oxford, Bodleian Library, D'Orville 301 (Euclid, *Elements*; Diktyon 47906), which was written by Stephanos *klerikos* for Arethas of Caesarea in 888—such manuscripts differ paleographically from DO MS 7. The script of Stephanos, the scribe of D'Orville 301, can be characterized as pre-bouletée, which has more in common with the script of the manuscripts of the philosophical collection than with minuscola antica rotonda and the hybrid style of DO MS 7.

Taking into consideration all paleographic features of DO MS 7, I conclude that this manuscript was likely produced in the first half of the ninth century

and almost certainly no later than the middle of the ninth century. Therefore, DO MS 7 is probably the earliest surviving manuscript of the text of the first forty-four of Chrysostom's *Homilies on the Gospel of Matthew* and is important for any future critical edition of these homilies.

Now I will focus on the localization of DO MS 7. Localization of the ninth-century manuscripts presents the same difficulty as dating: only in a handful of manuscripts has a scribe identified the place of production. Stoudios Monastery is the only known center where several ninth-century manuscripts were copied, most of them in the last quarter of the century. Gamillscheg and Aubineau have suggested that DO MS 7 was possibly copied in the Stoudios scriptorium because of the similarity of the DO MS 7's script to that of Nikolaos of Stoudios. But my paleographic analysis demonstrates that although DO MS 7's minuscule has some features similar to the Nikolaos style, it also has many features of minuscola antica rotonda and therefore can be characterized as a hybrid script.

But the most persuasive argument against the Stoudite origin of DO MS 7 is its codicological features, which are very different from the Stoudite tradition of making manuscripts. This tradition was established by Theodore of Stoudios (759–826).[83] It includes distinctive codicological features common to *all* ninth- and early tenth-century Stoudite manuscripts: there was careful preparation of the parchment, which was of average quality, and the ruling of the quires was made with a sharp instrument either on the four bifolia (system 3) or two bifolia (system 11) stacked one on the top of the other.[84] The ruling in early Stoudite manuscripts was made on the flesh side of the parchment, and this tradition differs from a common Byzantine practice, in which rulings were made on the hair side. The Stoudite scribes did not use ruled lines for the text, and the ruling patterns had only a frame, often with a horizontal line in the middle. Another hallmark of early Stoudite manuscripts is the use of crosslets (one to four) in addition to quire signatures. The crosslets were placed in the top margins of the first folio of each quire. These

81 See, for example, P. Thillet, "Insertions d'oncials et abbreviations dans le cod. Venetus Marcianus gr. 258 (=668)," in *Miscellanea marciana di studi Bessarionei (a coronamento del V centenario della donazione nicena)*, Medioevo e umanesimo 24 (Padua, 1976), 387–406.

82 B. L. Fonkič, "Aux origines de la minuscule stoudite (les fragments moscovite et parisien de l'œuvre de Paul d'Égine)," in *I manoscritti greci tra riflessione e dibattito: Atti del V Colloquio Internazionale di Paleografia Greca (Cremona, 4–10 ottobre 1998)*, ed. G. Prato (Florence, 2000), 1:169–86, and Fonkič, "Sulla datazione dei codici greci."

83 On this subject, see Fonkič, "Aux origines de la minuscule stoudite." On Theodore of Stoudios, see *ODB* 3:2044–45.

84 On codicological features of early Stoudite manuscripts, see N. F. Kavrus, "Studiiskii scriptorii v IX v. po materialam rukopisei Moskvy i Leningrada," *Vizantiiskii Vremennik* 44 (1983): 98–111, esp. 108–9.

codicological characteristics are very consistent in Stoudite manuscripts produced in the ninth century, and the combination of these characteristics has not been found in any manuscript produced elsewhere.[85] These consistent characteristics enable scholars to assign several ninth-century manuscripts without colophons to the Stoudite ergasterion—for example, BAV, Ottob. gr. 86 and Gruber 152 (Diktyon 12966).[86]

All DO MS 7's codicological features are different from those of the ninth-century manuscripts produced in the Stoudios Monastery's ergasterion. Therefore, I conclude that it is unlikely that DO MS 7 was copied in the Stoudios monastery. But this manuscript was very likely produced in a major center of manuscript production, probably in Constantinople. The excellent quality of script attests that the anonymous scribe was a highly trained professional calligrapher. During the entire ninth century and in the first half of the tenth, a major effort was undertaken to transliterate the vast patristic and homiletic literature from majuscule to the new writing style—minuscule—and DO MS 7 was evidently a part of that effort. This task was enormous, and probably no monastery or scriptorium could accomplish this task single-handedly. Because the existence of ninth-century Constantinopolitan scriptoria other than the Stoudite ergasterion cannot be documented, I can only hypothesize that transliteration of patristic literature from majuscule to minuscule was undertaken under the patronage of patriarchs and emperors, and it is possible that there was a patriarchal scriptorium and library, where DO MS 7 was created.

DO MS 7 contains the first forty-four homilies out of ninety on the Gospel of Matthew by Chrysostom. It was tempting to find the second volume—a companion to DO MS 7—containing homilies forty-five through ninety. Only one ninth-century manuscript with such content is known: Greece, Meteora, Metamorphosis Monastery, 591 copied in 862/63 in the monastery of St. Anna in Kios, Bithynia. But it is unlikely that this codex could be the second volume of DO MS 7. The Meteora codex has all codicological characteristics of the Stoudite manuscripts and was evidently produced in the Stoudite tradition of manuscript making. And, as Gamillscheg and Aubineau have already noted, the Meteora manuscript's paleographic tradition is very different from that of DO MS 7.

The further history of DO MS 7 is connected with Constantinople, where the missing and damaged folios of the manuscript were restored in the end of the thirteenth century or the first half of the fourteenth, during the period in Byzantine history known as the "Palaeologan Renaissance." This work was almost certainly done in one of the major monasteries, such as the Hodegon, which is well-known for its restoration of old manuscripts. For example, the lectionary GIM, Sinod. gr. 511 (Diktyon 44136), was written entirely in gold over carmine ink in the last quarter of the eleventh century and was restored by the famous Hodegon calligrapher Ioasaph II, who in the second half of the fourteenth century replaced several lost and damaged folios.[87]

In sum, my paleographic and codicological analyses of DO MS 7 enable me to date this manuscript to the first half of the ninth century and to conclude that it was created in one of the Constantinopolitan centers of manuscript production, quite possible in the patriarchal scriptorium. It is likely that this manuscript was a part of a major project to transliterate manuscripts written in majuscule script into minuscule. This project is comparable with the transfer of texts from manuscripts to printed books and with the recent project of digitizing books and manuscripts.

85 See the table of codicological characteristics of all known Stoudite manuscripts of the ninth century in Kavrus, "Studiiskii scriptorii," 109.

86 Lucà, "Osservazioni"; N. Kavrus-Hoffmann, "Catalogue of Greek Medieval and Renaissance Manuscripts in the Collections of the United States of America, Part IX: Chicago, Illinois, the Lutheran School of Theology at Chicago, the Jesuit-Krauss-McCormick Library," *Manuscripta* 59.1 (2015): 61–134, esp. 117–31; and Kavrus-Hoffmann, "Producing New Testament Manuscripts in Byzantium," 123–26, fig. 5.5. Codex BAV, Gruber 152 was in the Jesuit-Krauss-McCormick Library in the Lutheran School of Theology at Chicago. In 2017, the manuscript was given to Patriarch Bartholomew I and is now housed in the library of the Ecumenical Patriarchate in Istanbul.

87 On GIM, Sinod. gr. 511, see N. F. Kavrus, "Imperatorskii skriptorii v XI veke," *VizVrem* 49 (1988): 134–42, esp. 139f, fig. 11; A. Zakharova, "Grecheskoe Evangelie-Aprakos Sin. gr. 511 iz GIMa: Istoriia, kodikologiia, tekst i dekorativnoe oformlenie," *Khudozhestvennoe nasledie: Khranenie, issledovaniia, restavratsiia* 20 (2003): 7–19; and V. G. Putsko, "Konstantinopol'skii 'Zolotoi Kodeks' Uspenskogo Sobora Moskovskogo Kremlia," in *Monfokon: Issledovaniia po paleografii, kodikologii i diplomatike* (Moscow, 2007), 116–37. On the restoration of manuscripts in Byzantium, see D. Bianconi, *Cura et studio: Il restauro del libro a Bisanzio*, Hellenica 66 (Alexandria, 2018), and E. Dobrynina, "'Spolia' as a Phenomenon in Greek and Latin Illuminated Manuscripts: An Approach to the Question," *Scripta: An International Journal of Codicology and Palaeography* 11 (2018): 67–73.

Fig. 25. DO MS 7. Coat of arms of Freiherr von Selchow.

Provenance

DO MS 7 was created in the first half of the ninth century, most likely in Constantinople.[88] In the end of the thirteenth century or the beginning of the fourteenth, the manuscript underwent restoration when damaged folios, one at the beginning and two at the end, were replaced. The restoration probably took place in the Hodegon Monastery in Constantinople.

Nothing is known about the manuscript's whereabouts before 1909, when it was offered for sale at Bernard Quaritch Ltd, London (no. 271), offered again in 1910 (no. 290), and sold to a German book dealer, Karl W. Hiesermann of Leipzig, in 1914. Probably immediately in 1914, the manuscript was acquired by a member of a prominent German family, Freiherr von Selchow. An ex libris with the coat of arms is inside the front cover (Fig. 25).

In Sotheby's auction catalogue ("Medieval and Renaissance Manuscripts and Continental and Russian

Books," London, 3 July 2018, lot 8), the owner of the coat of arms was identified as Bogislav Freiherr von Selchow (1877–1943), a writer and naval officer.[89] The next owner of the manuscript was Martin Wahn (1883–1970). It is not known how the manuscript came into his possession; it's possible, as was suggested in Sotheby's catalogue, that it came through Bogislav's sister Anni von Gottberg, who was a member of the same Confessing Church as Wahn. According to the note signed by Christina Jaensch, née Wahn (Martin Wahn's daughter?), after Martin Wahn's death the manuscript was inherited by his grandson, Wilfrid Jaensch (1941–2015). On 23 June 1980, the manuscript was deposited at the University Library (Universitätsbibliothek) in Basel by Mara Hofmann of Sotheby's on behalf of Maria Jaensch. The manuscript was given the shelf mark B II 25. On 29 March 2018, the manuscript was returned to Maria Jaensch and on 3 July 2018 was purchased by the Dumbarton Oaks Research Library and Collection at the Sotheby's auction in London.

Bibliography

E. Gamillscheg and M. Aubineau, "Eine unbekannte Chrysostomos-Handschrift (Basel, Universitätsbibliothek, B. II. 25)," *Codices Manuscripti* 7 (Heft 4, 1981): 101–8; A. Cataldi Palau, "Legature costantinopolitane del monasterio di Prodromo Petra tra i manoscritti di Giovanni di Ragusa († 1443)," *Codices Manuscripti* 37/38 (2001): 11–50 at 16;[90] P. Andrist, "Structure and History of the Biblical Manuscripts Used by Erasmus for His 1516 Edition," in *Basel 1516 Erasmus' Edition of the New Testament*, ed. M. Wallraff, S. Seidel Menchi, and K. von Greyerz (Tübingen, 2016), 81–124, at 85, n. 14 (Andrist refuted Cataldi Palau's hypothesis that John of Ragusa once owned DO MS 7); *Pinakes*, Diktyon 8916.

88 I thank Elizabeth Dospěl Williams for sharing with me her extensive research on the provenance of DO MS 7.

89 The link to Sotheby's auction catalogue: http://www.sothebys.com /en/auctions/ecatalogue/2018/medieval-and-renaissance-manuscripts -and-russian-books-l18403/lot.8.html.

90 Annaclara Cataldi Palau tentatively identified DO MS 7 as codex no. 23, which once belonged to a Croatian Dominican theologian, John of Ragusa (Giovanni di Ragusa; ca. 1380–1443). The Italian scholar emphasized that only the content of the manuscript allowed her to link these two manuscripts. Elizabeth Dospěl Williams's findings on the binding and provenance of the DO MS 7 makes this identification highly unlikely.

The two newly acquired manuscripts, DO MS 6 and DO MS 7, significantly enrich the Dumbarton Oaks collection of Greek manuscripts. Being the earliest manuscripts in Dumbarton Oaks' collection, they complement the existing collection of mostly eleventh-century manuscripts, thereby broadening and deepening Dumbarton

Oaks' ability to help scholars, students, and museum visitors visualize and better understand the development of Byzantine calligraphy and manuscript illumination.

Washington, DC
kavrushoffmann@gmail.com

I WISH TO THANK JAN ZIOLKOWSKI, DIRECTOR of Dumbarton Oaks (2007–2020), for inviting me to study the two newly acquired manuscripts, DO MSS 6 and 7. I am thankful to the staff of the museum, especially Gudrun Buehl, museum director and curator (2004–2018), Elizabeth Dospěl Williams, curator of the Byzantine Collection, Joni Joseph, collections manager (2015–2020), and the Dumbarton Oaks library staff for their assistance. And I thank the two anonymous reviewers for their helpful suggestions.

Ancient Histories and History Writing in New Rome

Traditions, Innovations, and Uses

DUMBARTON OAKS SYMPOSIUM, 5–6 MAY 2023

LEONORA NEVILLE AND JEFFREY BENEKER, SYMPOSIARCHS

History writing is a key site for the construction of ethical and political consciousness as well as historical memory. It allows individuals and communities to create and articulate their identity and positionality within the sweep of human history. In ancient Greece and the classical and medieval phases of the Roman Empire, histories not only recorded past events but either implicitly or explicitly told audiences how the past defined current communities and set moral and political agendas for future action. Different conceptualizations of the past amount to debates about who the authors thought they were, what was moral, and who their contemporaries ought to be. The study of traditions of historical writing is therefore an archaeology of civic identity, ethics, and politics.

This interdisciplinary symposium brought together scholars of ancient and medieval historical writing to explore connections and interactions between ancient Greek, biblical, classical Roman, and medieval Roman histories. Authors writing histories in eastern Roman society interacted variously with earlier Roman and Greek histories, as well as biblical histories, to construct conceptions of their community's identities and relationships with the past. Rhetorical alignments signaled conformity with or breaking from pervious strands with these complex cultural traditions. Our explorations of the various ways medieval writers used, adapted, distorted, or ignored earlier texts helped us understand the complexities and nuances of medieval eastern Roman culture, community identity, and politics. In turn, the study of medieval uses of the classical historiographical tradition yielded fresh insights into the ways medieval attitudes and decisions shaped the preservation and creation of the classical canon.

Friday, 5 May

Welcome

Thomas B. F. Cummins and
 Nikos D. Kontogiannis

Introduction

Leonora Neville

Frameworks

Chair: John Duffy

*Changing Continuities: Eighth and Ninth Century
 Reckonings with the Eusebian Revolution*
 Jesse Torgerson, Wesleyan University

*Getting from Adam to Alexios: Roman History
 Looks Back*
 Leonora Neville, University of Wisconsin–Madison

HERODOTUS AND THUCYDIDES IN BYZANTINE HISTORIES

Chair: Ioli Kalavrezou

Mirroring Herodotus: Sources, Truth, and Truth Effects in Laonikos Chalkokondyles
Emily Baragwanath,
University of North Carolina, Chapel Hill

The Clash of East and West: The Subversive Classicism of Kritoboulos, the Biographer of the Turkish Sultan Mehmet II (1451–1481)
Scott Kennedy,
Bilkent University

POLITICS OF ROMAN ANTIQUITY IN BYZANTINE HISTORIES

Chair: Dimiter Angelov

Rewriting the Republic in Byzantium: Republican History and Political Memory in Tenth-Century Byzantium
Christopher Mallan,
University of Western Australia

John Zonaras and the Fall of the Roman Republic
Jeffrey Beneker, University of Wisconsin–Madison

SATURDAY, 6 MAY

LIVES AND HISTORIES

Chair: George Demacopoulos

The Synaxarion of Constantinople as Historiography
Stratis Papaioannou,
National Hellenic Research Foundation, Athens

Symeon Metaphrastes and Plutarch's Lives
Noreen Humble, University of Calgary

Historiography, Novel, Schedography: The Many Lives of Xenophon's Cyropaedia in the Twelfth Century
Aglae Pizzone, University of Southern Denmark

HELLENISM IN THE ROMAN EMPIRE

Chair: Elizabeth Bolman

The Romanitas of "Hellenism" in Byzantine Art
Sarah Bassett, Indiana University

A Preoccupation with Decline and Other Roman Aspects of Byzantine Historiography
Anthony Kaldellis, University of Chicago

FINAL DISCUSSION

Jeffrey Beneker

Abbreviations

AA	*Archäologischer Anzeiger*	*BMGS*	*Byzantine and Modern Greek Studies*
AbhGött, Philol.-hist.Kl.	Akademie der Wissenschaften, Göttingen, Philologisch-historische Klasse, Abhandlungen	*BNJ*	*Byzantinisch-Neugriechische Jahrbücher*
		BollGrott	*Bollettino della Badia greca di Grottaferrata*
AbhMünch, Phil.-hist.Kl.	Abhandlungen der Bayerischen Akademie der Wissenschaften, Philosophisch-historische Klasse	*BSAC*	*Bulletin de la Société d'archéologie copte*
ACO	*Acta conciliorum oecumenicorum*, ed. E. Schwartz and J. Straub (Berlin, 1914–)	*BSl*	*Byzantinoslavica*
		BSR	*Papers of the British School at Rome*
ActaOrHung	*Acta orientalia*, Academiae Scientiarum Hungaricae	*ByzF*	*Byzantinische Forschungen*
AH	*Art History*	*ByzSt*	*Byzantine Studies/Études byzantines*
AJA	*American Journal of Archaeology*	*BZ*	*Byzantinische Zeitschrift*
AnatArch	*Anatolian Archaeology. British Institute at Ankara Research Reports*	*CAH*	*Cambridge Ancient History*
		CahArch	*Cahiers archéologiques*
AnatSt	*Anatolian Studies*	CCCM	Corpus Christianorum, Continuatio mediaevale
AnnHistCon	*Annuarium historiae conciliorum*	CCSG	Corpus christianorum, Series graeca
AntTard	*Antiquité tardive*		
ArchCl	*Archeologia classica*	CFHB	Corpus fontium historiae byzantinae
ArtB	*Art Bulletin*	*CIC Nov*	*Corpus iuris civilis*, vol. 3, *Novellae*, ed. F. Schoell and G. Kroll (Berlin, 1928; repr. 1993)
BASOR	*Bulletin of the American Schools of Oriental Research*		
BASP	*Bulletin of the American Society of Papyrologists*	*CJ*	*Classical Journal*
BHG	*Bibliotheca hagiographica graeca*, 3rd ed., ed. F. Halkin, SubsHag 47 (Brussels, 1957; repr. 1969)	*CPG*	*Clavis patrum graecorum*, ed. M. Geerard and F. Glorie (Turnhout, 1974–87)
		CPh	*Classical Philology*

CPL	*Clavis patrum latinorum*, 3rd ed. (Steenbrug, 1995)	*JDAI*	*Jahrbuch des Deutschen Archäologischen Instituts*
CQ	*Classical Quarterly*	*JEChrSt*	*Journal of Early Christian Studies*
CSCO	Corpus scriptorum christianorum orientalium	*JEH*	*Journal of Ecclesiastical History*
CSEL	Corpus scriptorum ecclesiasticorum latinorum	*JHS*	*Journal of Hellenic Studies*
		JLA	*Journal of Late Antiquity*
CSHB	Corpus scriptorum historiae byzantinae	*JÖB*	*Jahrbuch der Österreichischen Byzantinistik*
DHGE	*Dictionnaire d'histoire et de géographie ecclésiastiques*	*JÖBG*	*Jahrbuch der Österreichischen Byzantinischen Gesellschaft*
DOML	Dumbarton Oaks Medieval Library	*JPh*	*Journal of Philology*
DOP	*Dumbarton Oaks Papers*	*JRA*	*Journal of Roman Archaeology*
DOS	Dumbarton Oaks Studies	*JRS*	*Journal of Roman Studies*
DOSeals	N. Oikonomides and J. Nesbitt, eds., *Catalogue of Byzantine Seals at Dumbarton Oaks and in the Fogg Museum of Art* (Washington, DC, 1991–)	*JTS*	*Journal of Theological Studies*
		LChrI	*Lexikon der christlichen Ikonographie*, ed. E. Kirschbaum et al. (Rome, 1968–76)
		Loeb	Loeb Classical Library
EI²	*Encyclopaedia of Islam*, 2nd ed. (Leiden, 1960–2004)	LSJ	H. G. Liddell, R. Scott, H. S. Jones et al., *A Greek-English Lexicon* (Oxford, 1968)
EME	*Early Medieval Europe*	MAMA	Monumenta Asiae Minoris Antiqua
EO	*Echos d'Orient*		
GOTR	*Greek Orthodox Theological Review*	*MDAIRA*	*Mitteilungen des Deutschen Archäologischen Instituts, Römische Abteilung*
GRBS	*Greek, Roman, and Byzantine Studies*	*MÉFRA*	*Mélanges de l'École française de Rome: Antiquité*
HA	*Handes amsorya*	*MIB*	W. Hahn, *Moneta Imperii Byzantini*, 3 vols. (Vienna, 1973–81)
HTR	*Harvard Theological Review*		
IG	*Inscriptiones graecae* (Berlin, 1973–)	*MIBEC*	M. A. Metlich and W. Hahn, *Money of the Incipient Byzantine Empire (Anastasius I–Justinian I, 491–565)* (Vienna, 2009)
IGRRP²	*Inscriptiones graecae ad res romanas pertinentes*, ed. R. Cagnat et al., 2nd ed. (Rome, 1964)		
		MusHelv	*Museum helveticum*
ILCV	*Inscriptiones latinae christianae veteres*, ed. E. Diehl et al. (repr. Berlin, 1961–67)	*OCA*	*Orientalia christiana analecta*
		ODB	*The Oxford Dictionary of Byzantium*, ed. A. Kazhdan et al. (New York, 1991)
IRAIK	*Izvestiia Russkogo arkheologicheskogo instituta v Konstantinopole*	*PAPS*	*Proceedings of the American Philosophical Society*
JbAC	*Jahrbuch für Antike und Christentum*		

PG	Patrologiae cursus completus, Series graeca, ed. J.-P. Migne (Paris, 1857–66)	*StItalFCl*	*Studi italiani di filologia classica*
		StMed	*Studi medievali*
PL	Patrologiae cursus completus, Series latina, ed. J.-P. Migne (Paris, 1844–80)	*StP*	*Studia patristica*
		Synaxarium CP	*Synaxarium ecclesiae Constantinopolitanae: Propylaeum ad Acta sanctorum Novembris*, ed. H. Delehaye (Brussels, 1902)
PLP	*Prosopographisches Lexikon der Palaiologenzeit*, ed. E. Trapp et al. (Vienna, 1976–)		
PLRE	*The Prosopography of the Later Roman Empire*, vol. 1, ed. A. H. M. Jones, J. R. Martindale, and J. Morris (Cambridge, 1971); vols. 2–3, ed. J. R. Martindale (1980–92)	*SZG*	*Schweizerische Zeitschrift für Geschichte*
		TAPA	*Transactions of the American Philological Association*
		Teubner	Bibliotheca scriptorum Graecorum et Romanorum Teubneriana
PO	*Patrologia orientalis*	*TIB*	*Tabula imperii byzantini*, ed. H. Hunger (Vienna, 1976–)
PTS	Patristiche Texte und Studien		
RBén	*Revue bénédictine*	TLG	Thesaurus Linguae Graecae
RBK	*Reallexikon zur byzantinischen Kunst*, ed. K. Wessel (Stuttgart, 1963–)	*TM*	*Travaux et mémoires*
		TTH	Translated Texts for Historians
RCCM	*Rivista di cultura classica e medioevale*	*VChr*	*Vigiliae christianae*
		VetChr	*Vetera christianorum*
RE	*Paulys Real-Encyclopädie der classischen Altertumswissenschaft*, new rev. ed. by G. Wissowa and W. Kroll (Stuttgart, 1894–1978)	*VizVrem*	*Vizantiiskii vremennik*
		WByzSt	Wiener byzantinistische Studien
		WJKg	*Wiener Jahrbuch für Kunstgeschichte*
REArm	*Revue des études arméniennes*	*ZDMG*	*Zeitschrift der Deutschen Morgenländischen Gesellschaft*
REAug	*Revue des études augustiniennes*		
REB	*Revue des études byzantines*	*ZPapEpig*	*Zeitschrift für Papyrologie und Epigraphik*
REG	*Revue des études grecques*		
RH	*Revue historique*	*ZRVI*	*Zbornik radova Vizantološkog instituta, Srpska akademija nauka*
RHR	*Revue de l'histoire des religions*		
RIC	*Roman Imperial Coinage*, 10 vols. (London, 1923–94)	*ZSavKan*	*Zeitschrift der Savigny-Stiftung für Rechtsgeschichte, Kanonistische Abteilung*
RSBN	*Rivista di studi bizantini e neoellenici*		
SBMünch	Sitzungsberichte der Bayerischen Akademie der Wissenschaften, Philosophisch-historische Klasse	*Ἀρχ.Δελτ.*	*Ἀρχαιολογικὸν δελτίον*
		Δελτ.Χριστ.Ἀρχ. Ἑτ.	*Δελτίον τῆς Χριστιανικῆς ἀρχαιολογικῆς ἑταιρείας*
SBS	*Studies in Byzantine Sigillography*	*Ἐπ.Ἑτ.Βυζ.Σπ.*	*Ἐπετηρὶς ἑταιρείας βυζαντινῶν σπουδῶν*
SC	Sources chrétiennes		
SIG	*Sylloge inscriptionum graecarum*, ed. W. Dittenberger (Leipzig, 1915–24)	*Κρ.Χρον.*	*Κρητικὰ χρονικά*
		Κυπρ.Σπ.	*Κυπριακαὶ σπουδαί*